LANDSCAPE PAINTING OF THE 19th CENTURY

by Marco Valsecchi

New York Graphic Society Ltd.
Greenwich, Connecticut

Translated from the Italian by Arthur A. Coppotelli

International Standard Book Number 0-8212-0395-9
Library of Congress Catalog Card Number 70-134333

© 1969 in Italy by Electa Editrice® - Industrie Grafiche Editoriali S.p.A.
English language edition first published 1971 in
the United States of America by New York Graphic Society Ltd.

Printed and bound in Italy

Contents

43. Jean-Baptiste-Camille Corot: *The Cathedral of Chartres*. Paris, Louvre.

44. Jean-Baptiste-Camille Corot: *The Pond with the Overhanging Tree*. Reims, Musée des Beaux-Arts.

45. Jean-Baptiste-Camille Corot: *The Cathedral of Mantes*. Reims, Musée des Beaux-Arts.

46. Jean-Baptiste-Camille Corot: *The Palace of the Popes at Avignon*. London, National Gallery.

47. Eugène Delacroix: *Turkish Women Bathing*. Hartford, Connecticut, Wadsworth Atheneum.

48. Alfred De Dreux: *Knights and Amazons by the Lake of Pierrefonds*. Paris, Louvre.

49. Auguste Ravier: *The Tiber at Ostia, at Night*. Paris, Louvre.

50. Théodore Rousseau: *The Pond*. Paris, Louvre.

51. Jules Dupré: *Watering Animals by the Great Oak*. Paris, Louvre.

52. Charles Daubigny: *The Locks at Optevoz*. Paris, Louvre.

53. Charles Daubigny: *Gobelle's Mill at Optevoz*. New York, Metropolitan Museum of Art.

54. Gustave Courbet: *Ten O'Clock Crag*. Paris, Louvre.

55. Gustave Courbet: *The Brook of the Black Well*. Paris, Louvre.

56. Gustave Courbet: *The Wave*. Bremen, Kunsthalle.

57. Gustave Courbet: *The Cliffs of Etretat after the Storm*. Paris, Louvre.

58. Jean-François Millet: *The Shepherdess*. Paris, Louvre.

59. Théodore Rousseau: *Cows at the Pond*. Paris, Louvre.

60. Jean-François Millet: *The Church at Gréville*. Paris, Louvre.

61. Edouard Manet: *Le Déjeuner sur l'Herbe* (detail). London, Courtauld Institute.

62. Eugène Boudin: *The Empress Eugénie on the Beach at Trouville*. Glasgow, Art Gallery and Museum (Burrel Collection).

63. Eugène Boudin: *The Jetty at Deauville*. Paris, Louvre.

64. Claude Monet: *The Beach at Sainte-Adresse*. Chicago, Art Institute.

65. Claude Monet: *Quai du Louvre*. The Hague, Haags Gemeentemuseum.

66. Claude Monet: *La Grenouillère*. New York, Metropolitan Museum of Art.

67. Pierre-Auguste Renoir: *Skaters at Longchamps in the Bois de Boulogne* (detail). Basel, Robert von Hirsch Collection.

68. Alfred Sisley: *The Saint Martin Canal in Paris*. Winterthur, Oskar Reinhart Collection.

69. Camille Pissarro: *The Coach at Louveciennes*. Paris, Louvre.

70. Camille Pissarro: *Entrance to the Village of Voisins*. Paris, Louvre.

71. Edgar Degas: *Carriages at the Races*. Boston, Museum of Fine Arts.

72. Claude Monet: *The Regatta at Argenteuil*. Paris, Louvre.

73. Pierre-Auguste Renoir: *The Seine at Argenteuil*. Paris, Louvre.

74. Claude Monet: *The Sea at Etretat*. Paris, Louvre.

75. Alfred Sisley: *Ile Saint-Denis* (detail). Paris, Louvre.

76. Paul Cézanne: *Dr. Gachet's House at Auvers-sur-Oise*. Paris, Louvre.

77. Detail of 78.

78. Alfred Sisley: *Louveciennes in Winter*. Washington, D.C., The Phillips Collection.

79. Paul Cézanne: *La Maison du Pendu*. Paris, Louvre.

80. Pierre-Auguste Renoir: *Path through the High Grass* (detail). Paris, Louvre.

81. Camille Pissarro: *Garden at the Hermitage, Pontoise*. Paris, Louvre.

82. Claude Monet: *Winter at Argenteuil*. Buffalo, Albright-Knox Art Gallery.

83. Edgar Degas: *At the Races, Jockeys by a Carriage*. Paris, Louvre.

84. Vincent Van Gogh: *Montmartre*. Chicago, Art Institute.

85. Paul Cézanne: *Mill near Pontoise*. Berlin, National Gallery.

86. Paul Cézanne: *The Viaduct at L'Estaque*. Helsinki, Museum.

87. Paul Cézanne: *The Viaduct at L'Estaque*. Oberlin, Ohio, Allen Memorial Art Museum, Oberlin College.

88. Claude Monet: *Cliff at Etretat*. New York, Metropolitan Museum of Art.

89. Pierre-Auguste Renoir: *The Bench in the Garden*. Merion, Pennsylvania, Barnes Foundation.

90. Paul Cézanne: *Mont Sainte-Victorie*. Amsterdam, Stedelijk Museum (1885-87).

91. Paul Cézanne: *Mont Sainte-Victorie*. Basel, Kunsthaus (1904-6).

92. Paul Cézanne: *Mont Sainte-Victorie*. London, Courtauld Institute (1885-87).

93. Paul Cézanne: *Mont Sainte-Victorie*. Zurich, Kunsthaus (1904-6).

94. Pierre-Auguste Renoir: *Mont Sainte-Victoire*. Merion, Pennsylvania, Barnes Foundation.

95. Claude Monet: *Rouen Cathedral, Morning*. Paris, Louvre.

96. Claude Monet: *Rouen Cathedral and the Albane Belfry, Morning*. Paris, Louvre.

97. Claude Monet: *Rouen Cathedral and the Albane Belfry, Midday*. Paris, Louvre.

98. Claude Monet: *London, The Houses of Parliament, Sun through the Fog*. Paris, Louvre.

99. Claude Monet: *Venice: The Ducal Palace*. Brooklyn, Museum.

100. Georges Seurat: *Field of Poppies, La Luzerne, Saint-Denis*. London, Courtauld Institute.

101. Georges Seurat: *Sunday Afternoon on the Island of La Grande Jatte* (final study). New York, Metropolitan Museum of Art.

102. Georges Seurat: *Le Bec du Hoc, Grandcamp*. London, Tate Gallery.

103. Georges Seurat: *The Bridge at Courbevoie*. London, Courtauld Institute.

104. Paul Signac: *The Lighthouse at Port-Rieux*. Otterlo, Kröller-Müller Museum.

105. Camille Pissarro: *River, Early Morning, Rouen*. Philadelphia, Museum of Art.

106. Paul Gauguin: *Brittany, Cows at the Stream*. Milan, Gallery of Modern Art, Grassi Collection.

107. Paul Sérusier: *Landscape at the Bois d'Amour, The Talisman*. Paris, private collection.

108. Maurice Denis: *The Muses, or The Sacred Wood*. Paris, Musée National d'Art Moderne.

109. Paul Gauguin: *Les Alyscamps*. Paris, Louvre.

110. Paul Gauguin: *Bonjour, Monsieur Gauguin*. Prague, National Gallery.

111. Vincent Van Gogh: *View of Arles*. Munich, Neue Staatsgalerie.

112. Vincent Van Gogh: *Summer Evening at Arles (Dusk)*. Winterthur, Kunstmuseum (Emil Hahnloser Bequest).

113. Vincent Van Gogh: *The Garden of the Hospital at Arles*. Winterthur, Oskar Reinhart Collection.

114. Vincent Van Gogh: *The Church of Auvers-sur-Oise*. Paris, Louvre.

115. Vincent Van Gogh: *Landscape at Auvers in the Rain*. Moscow, Pushkin Museum.

116. Gustave Moreau: *The Triumph of Alexander the Great*. Paris, Moreau Museum.

117. Odilon Redon: *Landscape at Peyrelebade*. Paris, Ari Redon Collection.

118. Giacinto Gigante: *Marketplace at Castellammare*. Sorrento, Museo Correale.

119. Giacinto Gigante: *Dusk at Pozzuoli*. Milan, Giacomo and Ida Jucker Collection.

120. Filippo Palizzi: *Herd of Buffalo*. Piacenza, Ricci Oddi Gallery.

121. Marco De Gregorio: *Archways*. Florence, Gallery of Modern Art.

122. Federico Rossano: *Road on Vesuvius* (detail). Naples, Capodimonte Museum.

123. Giuseppe De Nittis: *Westminster Bridge* (detail). Barletta, Civic Museum, De Nittis Gallery.

124. Giuseppe De Nittis: *The Ofantino River* (detail). Milan, Enrico Piceni Collection.

125. Giuseppe De Nittis: *Crossing the Apennines*. Naples, Capodimonte Museum.

126. Giuseppe De Nittis: *London, The National Gallery*. Paris, Petit Palais.

127. Giuseppe De Nittis: *Paris, Place des Pyramides*. Milan, Gallery of Modern Art.

128. Giuseppe De Nittis: *Along the Ofanto River*. Barletta, Civic Museum, De Nittis Gallery.

129. Luigi Basiletti: *View of Lake Iseo*. Brescia, Pinacoteca Tosio Martinengo.

130. Giovanni Migliara: *Porta Nuova, Milan*. Milan, Museum of Milan.

131. Giovanni Migliara: *The Bridge of the Trophy, The Pavian Canal at Porta Ticinese*. Milan, Museum of Milan.

132. Angelo Inganni: *Milan, La Scala*. Milan, La Scala Theater Museum.

133. Giuseppe Canella: *Corsia dei Servi, Milan*. Milan, Museum of Milan.

134. Giuseppe Canella: *Paris, Rue de Rivoli* (detail). Paris, Musée Carnavalet.

135. Giovanni Carnovali, called Il Piccio: *Along the Brembo*. Piacenza, Ricci Oddi Gallery.

136. Giovanni Carnovali: *Landscape with Trees*. Milan, Gallery of Modern Art.

137. Gerolamo Induno: *Pescarenico*. Turin, Gallery of Modern Art.

184. Detail of 182.

185. Giovanni Fattori: *Roman Countryside*. Leghorn, Civic Museum.

186. Giovanni Fattori: *Oxen Grazing*. Florence, Gallery of Modern Art.

187. Giovanni Fattori: *La Rotonda Palmieri*. Florence, Gallery of Modern Art.

188. Detail of 187.

189. Massimo D'Azeglio: *An Italian Vendetta*. Milan, Gallery of Modern Art.

190. Cesare Della Chiesa di Benevello: *Forest*. Turin, Gallery of Modern Art.

191. Antonio Fontanesi: *The Poplars*. Piacenza, Ricci Oddi Gallery.

192. Antonio Fontanesi: *April*. Turin, Gallery of Modern Art.

193. Antonio Fontanesi: *On the Banks of the Po near Turin*. Piacenza, Ricci Oddi Gallery.

194. Enrico Reycend: *From the Hills around Turin*. Turin, Gallery of Modern Art.

195. Enrico Reycend: *Square with Trees, Houses and Bell Tower*. Turin, Gallery of Modern Art.

196. Lorenzo Delleani: *Flowering Heath*. Turin, Gallery of Modern Art.

197. Giuseppe Pellizza da Volpedo: *The Clump of Briars* (detail). Piacenza, Ricci Oddi Gallery.

198. Angelo Morbelli: *Sunday Dawn*. Piacenza, Ricci Oddi Gallery.

199. Lorenzo Delleani: *Arch of Titus, Rome*. Piacenza, Ricci Oddi Gallery.

200. Giuseppe Pellizza da Volpedo: *The Mirror of Life*. Turin, Gallery of Modern Art.

201. Giuseppe Pellizza da Volpedo: *Clothes in the Sun*. Milan, Sacerdoti Gallery.

202. Carlo Fornara: *Alpine Church*. Milan, Giacomo and Ida Jucker Collection.

203. Rudolf von Alt: *Vienna, Cathedral of St. Stephen*. Vienna, Österreichische Galerie.

204. Matthias Rudolf Thoma: *Landscape and View of Vienna*. Vienna, Österreichische Galerie.

205. Ludwig Ferdinand Schnorr von Carolsfeld: *Mont Blanc Seen from Chamonix*. Vienna, Österreichische Galerie.

206. Ferdinand Georg Waldmüller: *Landscape with Oak Tree*. Vienna, Österreichische Galerie.

207. Joseph Anton Koch: *Apollo and the Thessalian Shepherds*. Copenhagen, Thorvaldsens Museum.

208. Karl Schuch: *Trees at Purkersdorf*. Vienna, Österreichische Galerie.

209. Anton Romako: *The Valley of Gastein*. Vienna, Österreichische Galerie.

210. Theodor von Hörmann: *View of Prague*. Vienna, Österreichische Galerie.

211. Carl Moll: *Marketplace in Vienna*. Vienna, Österreichische Galerie.

212. Gustav Klimt: *Flowering Field*. Vienna, Österreichische Galerie.

213. Emil Jacob Schindler: *The Pond in the Woods*. Vienna, Österreichische Galerie.

214. Caspar David Friedrich: *Trees by Moonlight*. Cologne, Wallraf-Richartz Museum.

215. Caspar David Friedrich: *Summer*. Munich, Neue Pinakothek.

216. Caspar David Friedrich: *Monastery Cemetery in the Snow*. Berlin, Nationalgalerie.

217. Philipp Hackert: *Capri*. Caserta, Royal Palace.

218. Karl Friedrich Schinkel: *The Tall Spires of the Cathedral*. Munich, Neue Pinakothek.

219. Eduard Gärtner: *Bridge in Berlin*. Munich, Neue Pinakothek.

220. Adolf von Menzel: *Storm over the Tempelhofer*. Cologne, Wallraf-Richartz Museum.

221. Anself Feuerbach: *Landscape with Waterfall*. Munich, Schackgalerie.

222. Franz von Lenbach: *The Alhambra*. Munich, Schackgalerie.

223. Arnold Böcklin: *Villa by the Sea*. Munich, Schackgalerie.

224. Hans Thoma: *Landscape with River*. Munich, Neue Pinakothek.

225. Lovis Corinth: *Holiday in Hamburg*. Cologne, Wallraf-Richartz Museum.

226. Henri de Brakeleer: *Horticulturist's Garden*. Antwerp, Musée Royal des Beaux-Arts.

227. Willem Vogels: *The Pond*. Antwerp, Musée Royal des Beaux-Arts.

228. Hippolyte Boulanger: *The Valley of Josafat*. Antwerp, Musée Royal des Beaux-Arts.

229. Willem Vogels: *My Garden*. Antwerp, Musée Royal des Beaux-Arts.

230. Henri Evenepoel: *The Fair at Les Invalides*. Antwerp, Musée Royal des Beaux-Arts.

231. James Ensor: *Grey Shore*. Antwerp, Musée Royal des Beaux-Arts.

232. Théo van Rysselberghe: *Reef near Roscoff, Brittany (Point Perkiridec)*. Otterlo, Kröller-Müller Museum.

233. Isidoor Verheyden: *Pilgrimage in Campine*. Antwerp, Musée Royal des Beaux-Arts.

234. Henri Van de Velde: *Woman at the Window*. Antwerp, Musée Royal des Beaux-Arts.

235. James Ensor: *Port of Ostend*. Antwerp, Musée Royal des Beaux-Arts.

236. Anton Sminck Pitloo: *View of Ischia*. Naples, Capodimonte Museum.

237. Johannes Weissenbruch: *View of the Church of St. Denis at Liège*. Amsterdam, Rijksmuseum.

238. Johannes Weissenbruch: *Old Gate at Leerdam*. Amsterdam, Rijksmuseum.

239. Wijnand Jan Joseph Nujen: *Ruins*. Amsterdam, Rijksmuseum.

240. Johan Barthold Jongkind: *Canal at Delft*. The Hague, Haags Gemeentemuseum.

241. Johan Barthold Jongkind: *The Castle of Miheung*. The Hague, Haags Gemeentemuseum.

242. Matthijs Maris: *Souvenir of Amsterdam*. Amsterdam, Rijksmuseum.

243. Anton Mauve: *House on the Canal*. Amsterdam, Rijksmuseum.

244. Willem Maris: *Meadow with Cows*. Amsterdam, Rijksmuseum.

245. Hendrik Willem Mesdag: *Landscape with Boat*. The Hague, Mesdag Museum.

246. Jan Toorop: *Flower Garden near Oedstgeest*. The Hague, Haags Gemeentemuseum.

247. Jens Juel: *View of the Little Belt at Hindsgavl*. Copenhagen, Thorvaldsens Museum.

248. Pierre Chauvin: *The Garden of Villa Falconieri at Frascati*. Copenhagen, Thorvaldsens Museum.

249. Johan Christian Clausen Dahl: *Mountain Landscape with Waterfall, Norway*. Copenhagen, Thorvaldsens Museum.

250. Johan Christian Reinhardt: *Italian Landscape with Hunter*. Copenhagen, Thorvaldsens Museum.

251. Joseph Steingrübel: *View of Florence*. Copenhagen, Thorvaldsens Museum.

252. Heinrich Reinhold: *View of St. Peter's from the Park of Villa Doria Pamphili*. Copenhagen, Thorvaldsens Museum.

253. Johan Thomas Lundbye: *Landscape near Arreso, with a View of the Dunes of Tisvilde*. Copenhagen, Thorvaldsens Museum.

254. Edvard Munch: *A Spring Day in Karl Johann Street*. Bergen, Billedgalleri.

255. Edvard Munch: *Rue Lafayette*. Oslo, National Gallery.

256. Alexis Savrasov: *The Crows Have Arrived*. Moscow, Tretjakov Gallery.

257. Gregor Soroka: *Fishermen*. Leningrad, Russian Museum.

258. Vasili Vasilievich Vereshchagin: *Kirgiz Tents on the River*. Moscow, Tretjakov Gallery.

259. Vasili Ivanovich Surikov: *Winter in Moscow*, Moscow, Tretjakov Gallery.

260. Isaak Levitan: *Tolling of the Evening Bells*. Moscow, Tretjakov Gallery.

261. Isaak Levitan: *Eternal Peace*. Moscow, Tretjakov Gallery.

262. Washington Allston: *Moonlit Landscape*. Boston, Museum of Fine Arts.

263. Edward Hicks: *Niagara Falls*. Williamsburg, Virginia, Abby Aldrich Rockefeller Collection of Folk Art.

264. Thomas Doughty: *In Nature's Wonderland*. Detroit, Detroit Institute of Arts.

265. Alvan Fisher: *Sugar Loaf Mountain*. Boston, Museum of Fine Arts.

266. Asher Brown Durand: *Kindred Spirits*. New York Public Library.

267. Thomas Cole: *The Course of Empire: Desolation*. The New-York Historical Society.

268. Fitz Hugh Lane: *Ships in Ice off Ten Pound Island, Gloucester*. Boston, Museum of Fine Arts.

269. William Sidney Mount: *Long Island Farmhouses*. New York, Metropolitan Museum of Art.

270. George Caleb Bingham: *Landscape with Fisherman*. St. Louis, Missouri Historical Society.

271. John Frederick Kensett: *View from West Point*. The New-York Historical Society.

272. George Henry Durrie: *Returning to the Farm*. The New-York Historical Society.

273. Martin Johnson Heade: *Approaching Storm: Beach near Newport*. Boston, Museum of Fine Arts.

274. Sanford Robinson Gifford: *In the Wilderness*. Toledo, Toledo Museum of Art.

275. Worthington Whittredge: *Camp Meeting*. New York, Metropolitan Museum of Art.

276. Jasper Francis Cropsey: *Autumn on the Hudson River*. Washington, D.C., National Gallery of Art.

277. George Inness: *Lackawanna Valley*. Washington, D.C., National Gallery of Art.

278. Frederick Edwin Church: *Sunrise off the Maine Coast*. Hartford, Connecticut, Wadsworth Atheneum.

279. Thomas Eakins: *Sailboats Racing on the Delaware*. Philadelphia Museum of Art.

280. John Henry Twachtman: *Niagara in Winter*. New Britain, Connecticut, New Britain Museum of American Art.

281. Albert Bierstadt: *The Rocky Mountains*. New York, Metropolitan Museum of Art.

282. John La Farge: *Bridle Path, Tahiti*. Cambridge, Massachusetts, Fogg Art Museum.

283. Winslow Homer: *Early Morning After a Storm at Sea*. Cleveland, Museum of Art.

284. Albert Pinkham Ryder: *Moonlit Cove*. Washington, D.C., The Phillips Collection.

285. Ralph Albert Blakelock, *Moonlight*. The Brooklyn Museum.

Introduction

To understand the resistance landscape painting as a genre was still meeting with from critics and artists themselves at the end of the eighteenth century, we need consider only two quite significant events. In 1763, Canaletto presented his candidacy at the Venetian Academy. He was nearly seventy and already had behind him his major works. He had brought a fresh vision to painting, a new way of grasping the natural world in all its concreteness, a new mode in the landscape genre, the view. The mathematical exactness required by the perspective, and the imagination demanded to avoid reducing a scene to a mere topographical likeness or a rhetorical stage set, make of the view a complex visual transcription of the truth, and Canaletto had achieved it.

At the time of his candidacy, Canaletto was an important figure in European art and enjoyed great prestige, especially in England where his works had been introduced by the English consul in Venice, Joseph Smith, a very wise and discerning expert. We can go so far as to say that Canaletto's role in the genre determined its future — in terms of the sensibility and painterly qualities it represents — as the genre that was to become the most characteristic of the nineteenth century. But Canaletto, with all his success and fame, was turned down by the Academy because his candidacy did not receive enough support. At the same session, however, the Academy elected to its ranks Zuccarelli, Gradizzi and Pavona, all rather modest painters except for Zuccarelli, a Florentine who had come to live in Venice. The choice the academicians made in favor of Zuccarelli would seem a contradiction, since Canaletto's reputation in the same area was so much greater. But Zuccarelli was probably admitted to the Academy because his paintings could ultimately be considered figurative, peopled as they were with rustic characters, or plumed cavaliers dallying with peasant girls, or country maids in the role of dancing nymphs and muses. The Academy probably did not consider the fact that his landscapes indicated a new feeling toward the natural world, with their golden, weightless atmosphere, the softened horizons, glowing colors and transparencies, the vague melancholy of hazy distances and long summer sunsets. After all, by virtue of this Arcadian content, Zuccarelli could still be counted among the traditional genre painters, for whom the landscape was just a frame or background to sacred and profane events. The pedantic Venetian academicians continued to show their contempt for landscape painting for two more decades, excluding, for instance, Francesco Guardi from their ranks until 1784, when he was finally elected to the Academy as a "perspective painter" with nine votes for him and two against. And yet, with his *vedute* of Venice, overwhelmed in light and air, sparkling with reflections, shot through with the sudden play of light from the lagoon, views that were fantastical and lively and yet authentic records of a dying period in history, Guardi, during those years of stunning creativity, was laying the foundations for impressionist painting.

One finds it difficult to understand why the academicians denied, or at least underrated, the importance of landscape painting, when it was Venetian artists themselves who had expressed the most profound feeling for nature throughout their long tradition. We can go as far back as Mantegna. His depiction of towns gone to ruin, with their crumbling walls and columns (but the arches still

miraculously holding), responds to his heroic, archeological ideal of a classic past to be revived as a suitable background to the divine or regal figures in his compositions. But it remains, nonetheless, a revelation of the world. In the frescoes of the *Camera degli Sposi* in Mantua, the sky appears serene over the vineyards, blue next to the green of the hills and the tree boughs, pervaded with the freshness of a dawning day. In this same mood of Mantegna's, Giovanni Bellini depicts nature with moving sensitivity. In the *Transfiguration* in the Correr or the *Pietà* in the Brera, nature is a dim presence, something to fill in the emptiness of the horizon. But with the ceiling panel of *Christ in the Garden*, to which the scene Mantegna painted a few years earlier for the altarpiece in the church of San Zeno acts as counterpoint, the feeling is entirely new: the hills, the barren fields, the stark olive trees, form a world throbbing with light, the rocks are tactile, the grass changes tone as the wind sweeps over it. This is no longer just an abstract, mute ground, a backdrop. We see nature in rhythm with the men who inhabit it, reflecting even their feelings as they take shelter from the sun in the shade of a tree, or plow the fields with their oxen.

That nature exists for Giovanni Bellini is unquestionable, when we consider the attention he gives to the phenomena of light and air and to the concreteness of the visible world. It is demonstrated even more clearly by his careful observation, almost documentary in precision, of the belfries, the towers and the cupolas that can be recognized and named as they appear here and there in his paintings, put there not so much as evidence of his knowledge, but as a fond record, an intimate recounting, of a trip he had taken, or a monument he had seen somewhere whose image he wanted to preserve for himself and others. In Mantegna can be rediscovered an ancient nobility the world possesses; in Giovanni Bellini, it is the present we rediscover, permeating things and saddening or delighting his creatures. The two figures conversing among the early evening shadows behind the Virgin in the painting in the Brera can be understood as a paradigm of this new curiosity and confidence man has in his world.

Gone now are the fearsome beasts and the cataclysms of the millennium that haunted man in the Middle Ages, as we see them so vividly portrayed on Gothic doorways. Faith in earthly life is renewed, a faith in a natural environment where man can recognize himself. No painter has ever felt the existence of nature as Bellini did, with a certainty that comes not only from an ideal, but also from a daily intimacy. A sure knowledge that enabled him to specify the hour of the day, and the color and pathos it brings with it. We might even go so far as to say his discovery of tonal color springs from this inner knowledge. It was not a simple evolution in the use of color, it was a discovery — communicated in his paintings with all the passion his spirit was capable of — about man's condition within a nature that embraces and not repels him, in a light that engulfs the atmosphere and quickens a flat surface with the pulse of life. In other words, a light that is capable of expressing a whole range of feelings as well as just natural phenomena. Giovanni Bellini was the first artist to treat landscapes romantically; that is, as states of the soul. If Bellini's painting were lacking this conception of things, a conception as fully intellectual as Piero della Francesca's because it is realized in unerring perspective, but fleshed out, as it were, by his intuition, then it would be a bare exercise in color, quite competent but emptied of that human content that is the essence of its freshness and charm.

By the time Bellini was painting, Venetian art had already at least indicated all the possibilities of the landscape genre. We have just said that these possibilities all stemmed strictly from the Venetians' intuitive sense of space. Mantegna's archeological ideal imposed a spatial conception that was geometric and clear-cut, with masses that are hard and unyielding to natural process. His rocks and trees and caves and even the wreaths of fruit framing *St. George* are all made out of the same stony material. A superb vision of nature, but a nature that seems to have been taken from some excavation where it

was as neatly preserved as if it had been a frieze from an ancient temple. But Bellini's conception of space differed quite radically from this glacial ideal. His conception depends on an emotional dialectic in the play of light, which attains an extremely sensitive balance between feeling and tonal harmony without disturbing the lucid and still unsophisticated proportions. Bellini does not dramatize nature, and his lack of sophistication enables one of his followers, Cima da Conegliano, to depict all the rustic grace of mountain country and peasantry with an innocence that is somewhere between the primitive and the marvelous. Carpaccio, however, is more taken up with the daily life of the city, and his town-scapes, while a faithful, even detailed chronicle of events and customs, have a surprising capacity to evoke a sense of fable. In his paintings, you can recognize the famous monuments of Venice, the bridges still built of wood, the breezy roof-terraces, the lace of the Gothic windows of the Palazzo Ducale, the islands in the lagoon, and the cupolas of San Marco, but there is nonetheless in all this representationalism a strong feeling for the fabulous. Even the precise segment of a shadow cast by a column becomes a sundial out of a dream, with vague evocations of the East. Even if Carpaccio's landscapes are realistic, taking for example the precise vegetation in the *Cavalier* in the Thyssen Collection, or the equally scrupulous mineralogy of the stones and rocks scattered among the ridges in the *Mourning of Christ* in Berlin, they are among the most lucid perceptions of nature that we have from any artist of that period, and can hold their own when compared to the landscape of houses and a river painted almost a century earlier by Jan Van Eyck, as a background to his *Madonna with Chancellor Rolin*. His landscapes serve ultimately to accentuate the surprise and the absurd unreality of that world so minutely recorded.

The mystery of nature returns to the fore with the art of Giorgione. This feeling for nature, between reverential and fearful, had already been expressed by the Gothic artists of the North with their dense forests filled with imaginary ferocious animals. These landscapes, which are still present in the works of Pisanello and Dürer, can certainly be called "natural" but they seem to be intended as, or perhaps elevated to, the level of a symbolic *horror vacui* that, we are given to understand, only religious faith can fill. Indeed there is an obvious contrast between the dense vegetation and thorny undergrowth in those paintings and the gold grounds and magical gardens in the Rhenish paintings of the Virgin. Here she is protected by the flower trellises of the *hortus conclusus*, as she holds the Holy Child and listens to the song of the birds among the trees. A symbolic landscape, therefore, suited to the Christian dialectic of that age: on the one hand, the forest we are lost in, the symbol of chaos, and on the other, the myth of the enchanted garden renewed by divine grace, the symbol of salvation, perfection, eternity. On the same symbolic order are the miniature landscapes of the brothers De Limbourg, done around 1410 for *Les Très Riches Heures du Duc de Berry*. With the task of representing the signs of the zodiac corresponding to the months of the year and the seasonal work they impose, those great miniaturists recorded on parchment human moments and meteorological happenings that are movingly realistic. The same intent had been expressed in the mid-fourteenth century with Ambrogio Lorenzetti's frescoes in the Town Hall of Siena, entitled *Good and Bad Government*; that is, the representation of nature as the embodiment of a moral concept. We see, too, the same symbolic motif of beauty as the aristocracy of the spirit that inspired Simone Martini's landscapes, or the exquisite flowering nature Benozzo Gozzoli painted in the *Journey of the Magi* for the Palazzo Medici in Florence. Van Eyck looks directly at nature to find the concrete and compelling aspects that attract the eye of an artist who had freed himself from the frightening chains of the Middle Ages. He is the first artist to recognize the earth as man's home. The craggy mountain Giotto depicted in the Assisi frescoes is imposing and majestic to match the heroic virtue of St. Francis, but the landscape in Van Eyck's *Adoration of the Lamb* is hospitable to man, who is human before he is an image of God. From this

point on, we find the attempt to render nature as it is, with the play of light and space within a defined volume, that Bellini, for example, presents not only as habitable, but also consonant with human feeling.

With the typical realistic attitude of the Flemish, the Van Eycks display in their landscapes a profound, instinctive empiricism. Among the Italians, it was Fra Angelico first, with all the power of his lyric intuition, and then Piero della Francesca with his intellectual preciseness, not to mention Paolo Uccello and his mathematical abstractions, or Baldovinetti and Pollaiuolo with their amazing aerial landscapes that open out like great panoramic maps, who carry on the empirical discoveries of the Van Eycks. They added the more precise knowledge of perspective that had been put into practice by the Florentine architects Brunelleschi and Alberti, and theorized about by mathematicians such as Paciolo and Piero della Francesca himself. But what enables the Italians to avoid being mere topographers is the concrete feeling they have for nature, a nature that is real and not fictitious or imprisoning, a nature that can be solemn and grand and harmonious, reflecting the absolute perfection of divine wisdom, but always in relation to the equally concrete reality of man himself. This revolutionary insight into the appearance and function of nature, the place where man realizes his ideals as well as lives, freed him in large measure from the conflict with the world which theology had imposed, and from his alienation.

We referred earlier to the "forests" one can still see in works as late as those of Pisanello and Dürer. They still have a Gothic quality about them, not only in an iconographical sense, but also in their emblematic value. That is, they reflect the brooding mentality that seeks out (or creates) fearful labyrinths everywhere. But the mathematical certainty of Piero della Francesca or Fra Angelico, along with the empiricism of the Flemish masters, had contributed to dispelling fear and encouraging a thirst for knowledge. The landscape, although still subordinated to symbolic meanings, becomes a larger area of interest, a mode of expression by which man confirms his knowledge as well as his being. The new experiences which enable him to extend his knowledge and to gain his independence little by little, also enlarge his field of vision. Instead of a closed and horrifying world, the place where he must expiate his original sin, nature becomes the source of his freedom, liberating him from the tyranny of traditional belief — a place where he can reason. The change that took place in theories of art is strictly linked to man's increased knowledge and curiosity about the natural world. Pisanello's and Dürer's forests are still teeming with extraordinary events — with miracles, if you will, rather than monsters — but we notice at once that the inquiring spirit these two artists reveal is analytic in a different way from that of the Gothic artists. Now, in addition to a decorative and superbly symbolic scene, we find a place disclosed not by divine grace, but by human reason. The scrupulous treatment of each branch and leaf and stone, and the care with which the perspective is handled, are no longer dictated by conventions of decorum and preciosity, but by a universal love for the same truth, whether it be in the vast horizon where heaven and earth meet, or in the smallest detail. Another Flemish painter of realistic landscapes is Pieter Bruegel. Nature is present in his paintings with the same frank everydayness we find in his depiction of peasant life. From his trip to Italy, he was to derive the idea of the panoramic view, exemplified by the Bay of Naples, which appears in several paintings, notably *The Fall of Icarus*, a view that is all-embracing and idealized, and that he uses again to bolster the narrative in *The Tower of Babel*. But when Bruegel turns to peasant themes, or to winter hunts, or to harvests, or to the grotesques of carnival time and Pantagruelian feasts, the world is represented with such authenticity that not only the reality of the events is apparent, but the season of the year and the hour of the day as well. Bruegel thus can be considered as anticipating the naturalism that bursts forth so vigorously in Holland in the seventeenth century. For Bruegel, na-

ture is no longer a static background or a pretext for symbolic machinery, but a real presence and man's daily environment, the direct source of his existence.

Alongside the work of these painters, who in a wide sense and in different ways can be said to prefigure realistic landscape painting and landscapes constructed according to mathematical rules, there also appears a broad current of imaginary landscape painting in European art. For the artists who paint this sort of landscape, the world is really a screen against which they project images of unreal events with esoteric meanings. They depict a nature so lush and dense that the human figures seem subjugated to it, when they do not disappear altogether. This relationship between a dominating nature and a submerged figure is ample proof of how important nature was to these artists. In a certain sense, we can see the same disproportion in size that Gothic artists decreed between their diminutive human figures and their overpowering figures of the saints and of God. In the presence of a nature so majestic and compelling, man can only be awed... or be willing to accept a new mythology. With a new way of looking at things, he certainly will not be satisfied with the old way, that is, with the classical ideal of harmony. Typically Nordic — born, one might say, out of the dark forests and the misty plains of the North — these imaginary landscapes come to assert an anticlassical force, a compelling but disquieting energy that creates uncertain horizons and whimsical forms. How far they are from the scientific and philosophical certainties of the Renaissance! These imaginary landscapes sometimes derive from a radically different and negative theology, in which sin is such a dominant factor that redemption cannot be hoped for, and so nature can only reflect the horror of damnation, or the dominion of Evil. To Altdorfer and Grünewald, nature is not terrifying in itself; they depict it with precisely defined outlines and open, almost dizzying perspectives, with much the same serenity found in so many Florentine landscapes of the same period that were panoramic surveys of the Arno Valley seen as if it were a tidily patterned carpet spread out before the painter's eyes. The menace in Altdorfer's and Grünewald's paintings is the grotesque presence of witches and demons, so that by reflection the microscopically detailed depiction of nature seems itself to be the work of the devil! And to Hieronymus Bosch, sin's blot is so deep as to contaminate the very roots of nature, which conceals Evil in everything, from the fruit hanging on trees to the caverns in the earth, and even in the heart of the rocks from whose every crack spring the flames of hell and in whose shadows monstrous human and animal mutations are generated. Such a conception of Evil arises, certainly, from a rigorous Christianity, bereft of the least vestige of the golden pagan ages of the past, when the world was an innocent and fabulous kingdom. But this assertion of the prevalence of Evil ends by compromising the religious conception of the world itself, which would then appear to be an ungovernable hell, rather than the creation of divine providence.

In Patinir's paintings, the landscape dominates every other element, be it the saintly hermit in his cave, a knight riding across the countryside or the procession to Calvary. Each detail is fantastical: the rocky steeps looming in awesome perspective against the clouds blowing across the incredible sky, the whole cast in strange light and unreal colors. Nature, then, as an extraordinary spectacle — this was an image shared by Piero di Cosimo, who interprets it, however, by means of the symbolic and visual conventions of the older Florentine culture, and accentuates the fabulous components. In a certain sense, the landscapes of Leonardo da Vinci are also fantastical, with that fascinating intricacy of rocks, caverns, wind-lashed waters, murky twilights and incredibly bright flowers among the stones. The nature he depicts is the product of his urge to experiment, but it is also exceptionally true to life, a nature so carefully observed as to reveal fresh insights; the marvels he discloses make his landscapes more than real and exact; they border on the realm of the imaginary.

In Giorgione's landscapes, too, pulses a mysterious life. Light spreads throughout his paintings,

becoming, as it had become in Bellini, the principal agent in the dynamic of his art. It diffuses through the composition with a visible creative function, picking out the distances and gilding them with the subtlest tonalities. The plain rising gently toward the clear mountains on the horizon's edge is not filled with detail, as in the works of perspective painters or the Tuscan realists. A few clumps of vegetation can be discerned because their color is warmer; from a tower flutters a banner; here and there we make out some straw rooftops, a half-hidden stream. The topography is real enough, but simplified, perhaps not to impede the soft flow of light. Nature in his painting *The Tempest* is silent but not inert. A tension is in the air, a suspended calm, in which something unusual could take place: the approaching storm, the lightning flash, the indifferent soldier and the woman suckling her baby (a gypsy, said Michiel, who wrote at the time of Giorgione). Each figure, each element, is real, but its meaning is hidden by a subtle play of the imagination. Again we might ask what lies beyond the trees that shelter the figures in Giorgione's *Three Philosophers* (Vienna, Kunsthistorisches Museum). The world he paints is classifiable by all the scientific standards of his time, but the viewer is nonetheless puzzled. Not surprise or anxiety, but a realization that reality and fantasy are conceived together with extraordinary balance; the mind is dazzled by the intuitions. Venetian critics even then noted the completely psychological meaning of the silent tenderness and at the same time the wonder that Giorgione's paintings express, and were forced to use a literary term to identify what they meant, "poems." And the landscapes that are so natural and yet so secretive, enshrouding rather than containing Lotto's figures, Dosso's, Beccafumi's, they, too, seem poems. In their paintings, there is a continual shift in feeling from the figures to the greenery, the water, the light of dusk, arousing and amplifying the tenderness that is reinforced by the deep and luminous richness of the chiaroscuro. One can easily find musical affinities in these landscapes, a perceptible complexity of hearing and feeling, as well as seeing. Titian, on the other hand, imbues nature with even more vital energy, in keeping with his heroic temperament, but in doing so, he loses that subtle, airy quality of contemplation. But it is the energy of Titian's landscapes, their reality and substance, with which Rubens fires his opulent and romantic baroque style.

The mannerists, whether Italian, French or German, put off the issue of realism for several decades and dedicated their complicated art to the concept of beauty. Theirs became an exclusive cult, laden with complexity and preciosity, overflowing with allusions, even to the psychology of earlier art, to the extent that their pictorial elegance becomes affected virtuosity laced with quotations from the traditions of other times and places. The mannerists worked for the most aristocratic courts in Europe — Florence, Rome, Fontainebleau, Prague — and the continual practice of a refined art took them always further away from the natural. And so it is all the more surprising to come upon the work of Veronese at Villa Maser. Veronese was certainly not unfamiliar with the mannerist ideas then predominant. But Venetian artistic traditions had developed more organically and coherently, and consequently, for instance, Veronese's devotion to Palladio's classical ideals spared him from certain stylistic extremes that were valuable in certain contexts, but alien. His landscapes are mainly architectonic — composed of arches, loggias, arcades, façades — and dominated inevitably by classical proportions. Nature herself seems to obey the rules. Veronese had made a choice, obviously, in the direction of formal values, but equally true is the fact that he had to keep in mind the official and representational function of the paintings and frescoes commissioned from him by the Venetian Republic and religious orders. At Villa Maser, on the other hand, a summer residence in a splendid natural setting that had not been overly contrived, a place where nature and a gracious way of life combined perfectly, Veronese allowed himself greater imaginative rein, relaxing the rigorous architectonic standards he usually applied to his art in favor of the fresh feelings inspired in him by

the hills, the woods, the open skies and the distant horizon of the Veneto region. He did several landscape frescoes that bring the outdoors into the villa, so that when his imagination was at its best, the continuity of the countryside is not interrupted. Because of the *trompe-l'oeil* effects, the summer visitor has the impression of being in the shade, looking out at the country around him through the archways. The urge to render ever more realistic the trees, the glimpses of countryside, the fountains, the paths, the hedges, even the people who peer from half-open doors, causes him to use quick, fluid brushwork and to create both realistic and imaginary qualities, dissolved in an airy luminosity that gives us all the subtle shading of the foliage and the fading colors of the sky. This blending of impressions and concretions renders the full sense of the day, and in this we can justifiably find an anticipation of the best painting produced by the French impressionists in the nineteenth century. But these frescoes were an exception to the run of European mannerist art and remained such for about half a century. They are indicative enough, however, of what was possible in art, and of how much more could have been achieved if social problems had not put serious obstacles in the way. We see the rebirth of realistic landscape painting in Holland in the seventeenth century. Dutch painters represented scenes from the life of a bourgeois society that was anti-aristocratic by moral choice and by the necessity to defend itself from the ambitions of the aristocratic governments around Holland, and furthermore, a society that was anti-classical primarily because the Dutch preferred reality as it is, with its daily rhythm of nature and commerce that constituted their life as wise artisans, farmers and merchants. Once class distinctions, and the function of art as a symbol of prestige, had been eliminated, so too were eliminated the distinctions among the genres and the academic prejudices that sustained them, since academic values had been the product of an aristocracy. For the Dutch painters of the seventeenth century, nature was a reality that could not be masked, even for religious purposes; they recognized it as God's creation and man's environment. These artists therefore painted things as they are without attempting to idealize them. They drew inspiration from the flat fields and even from the puffy clouds scurrying along the wide horizon. In short, their curiosity was not at all intellectual, but quite existential. Van Goyen and Van de Velde looked to the broad skies over the lowlands for that soft, transparent light that is reflected and diffused to airy thinness in the ponds and canals that thread through the countryside. Hobbema and De Koning saw the immediacy of trees with the same intensity with which they would study a human face.

By that time considerable advances had been made in the sciences, and one might say Salomon van Ruysdael, in the spirit of the times, applied scientific observation to his views of rivers, woods and broad expanses of meadow. His nephew Jacob, thirty years later, introduced an element of disquiet; his landscapes are always stormy, blown by the wind that tosses the old oaks. The whole is realistic enough but expresses something more, the terror the natural phenomenon arouses, both as spectacle and as mood. In the mid-seventeenth century, the Dutch painters who depict the countryside are paralleled by the painters of town life, who can draw inspiration from a street or humble courtyard, like the great Vermeer; or from a building, usually a church pale as ivory, as in Saenredam's paintings, where the light is so suggestive and idealized as to give the impression of a dreamscape. This worship of daily life and realistic detail would seem to reduce painting to a trite record of natural phenomena and of humble, perhaps even vulgar, events. This occasionally happens. But in the works of the masters, and here we can cite De Hooch, Metsu and Jan Steen, reality has the energy of a still-original idea, with all the ferment and moral complexity that habit and formula have not dissipated. A particular moment, even a negligible one, can be used to realize a work of art, and we need only cite Vermeer's masterpiece, *A View of Delft*; the ideas that make this painting great, and fundamental besides to the development of modern European art, unite to produce a superbly realistic visual whole, an extraor-

dinary pictorial harmony, a poetic metamorphosis of an ordinary scene. Italian painters, too, might have been able to profit from this insight into reality had they been able to understand fully the fresh ideas Caravaggio brought to painting. Of course it is true Caravaggio himself, who had painted a dramatic sunset in the *Sacrifice of Isaac*, more to identify than to comment on the painful scene of a father about to immolate his son, did not continue in this direction because of his greater interest in dramatic Christian episodes. His brief example did not go unheeded, however, since we find traces of it in the animated shadows and the nights glowing with distant fires that Elsheimer painted. I will not say, certainly, that Rembrandt derives from Caravaggio, or from Titian. But his familiarity with Italian art, and his participation in the spiritual travail of his age, enabled him to paint several exceptional landscapes, interpretations of the many Italian paintings he had seen or so perspicaciously added to his own collection, but landscapes that were at the same time essentially tied to the Dutch landscape tradition, which he renewed with his universality.

Caravaggio's influence can be seen also in the paintings, the *"bambocciate,"* of the Dutch and Flemish painters who worked in Rome. Their art seems to be a happy union of traditional Nordic realism with the picturesque scenes, the farmhouses and ruins, scattered through the Roman countryside. But more related to the work of the town painters from Vermeer to Saenredam, are the itinerants who wandered around Italy painting whatever was most characteristic and creating thereby an original genre we call the "view" that became quite popular throughout Europe, especially after the Venetian *vedutisti* had brought it to perfection. The work of the Venetians was sought after by the new collectors, and several of the artists themselves, including Canaletto and Bellotto, personally brought their art to the attention of several European capitals. But this is a history that Giuliano Briganti has so admirably studied and elucidated, and the reader is referred to his work, which is very recent.

The "ideal landscape" so subtly realized by Giorgione was not neglected in the seventeenth century. As a matter of fact, the century so favored it that it came to rival the realistic landscapes of the Dutch. Giorgione's use of light and serene settings is the source from which two great French painters, Claude Lorrain and Poussin, drew their first inspiration. The luminous wash filtered through transparencies of air vaguely shimmering on the Venetian flatland that we see in Giorgione's paintings is the same as the soft tones we see in the plants and on the distant horizons of Lorrain's. Rome was the center of this rebirth; one might say it could only have been among its ruins, its ancient walls, obelisks, and basilicas that the ideal landscape was realized to the fullest. But the origins of the ideal landscape are really in Bologna, in the works of the Carracci. The accusation that they were eclectic painters weighed against them too long; it was an accusation based on a rather mechanical and superficial standard, according to which they had simply added, academically, certain formulaic motifs to Michelangelesque painting, and this, it was claimed, they had admitted themselves ("Venetian color and Roman form"). But to the contrary, the Carracci were aware of the new historical movements and the new cultural issues that derived from the turn the religious feeling of their age had taken, and how necessary, therefore, it was to renew the terms of their artistic tradition without rejecting it totally. They recognized, in other words, that their tradition was not available to the new creative requirements of their times. In effect, they transferred the new ideals to their painting, which betrays the restlessness of their age, an age which science had fired with curiosity and the urge to experiment. But to counterbalance this dynamic, they asserted order, and expressed the yearning in their art for the renewal of fundamental values. So we see the outlines of a fresh classicism in their paintings, shaped by intelligence and spirit more than by stylistic canons. Their art was definitely not a decorative blend of Greek and Roman motifs, but a reasonable assimilation of all that they considered valid in their tradition. The order they imposed does not contradict the fluidity and imagination of their style.

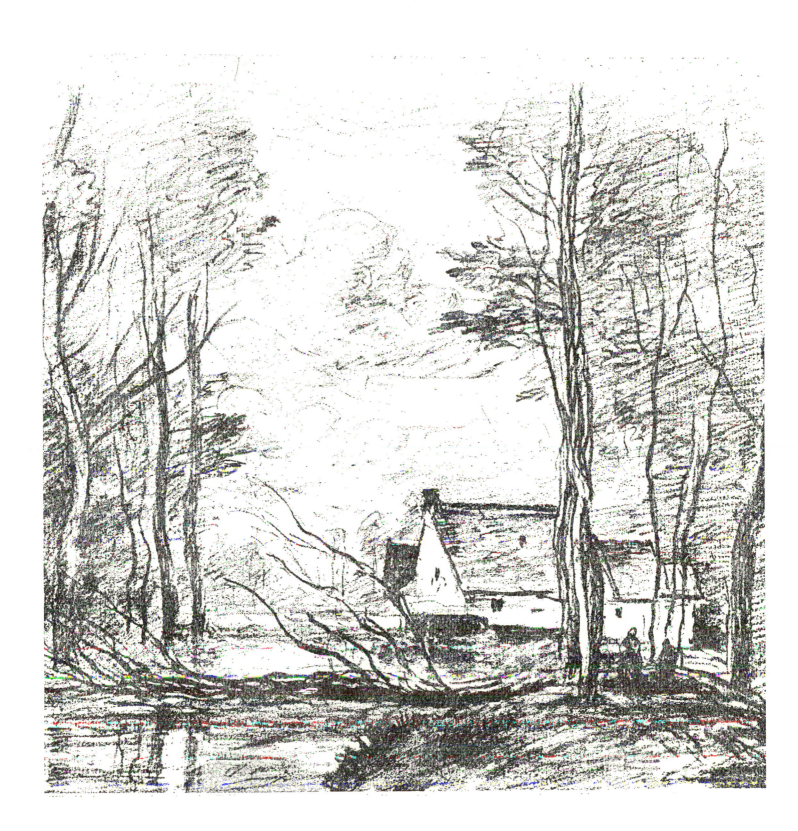

The historical or religious themes we find in their work are, in a certain sense, eclectic, not to please the vanity of some aristocrat, but rather to answer a cultural necessity. We must recall that the Counter-Reformation — itself a new look at old precepts — had posed new religious ideals; the Carracci attempted to attain to them without giving up the images of ordinary life. Both Ludovico Carracci, with greater balance between fantasy and reason, and Annibale Carracci, with a somewhat greater show of passion, express a subdued and unoppressive sensuality that was to be taken up and realized more fully in the lively, cosmopolitan atmosphere of the Roman baroque. They do not ignore the natural world or the troubled events of history, but they do select subjects that offer fresh sensations, with a decided taste for "the feeling of a place" which is already pre-romantic. At the same time, they wanted to achieve a noble, original pictorial idiom that would retain a certain elegance, a capacity to blend themes and a capacity to evoke a mythological age whose heroes were men with ordinary human qualities. Their concept of painting is realized best — with great exuberance, lightness of touch, humor — in the decoration of the Palazzo Farnese in Rome. And this elaborate decor begins the new century, as the date 1600 Annibale recorded over a cornice testifies, and was destined to influence European painting for the next two centuries. Significantly, this new sensibility, combining reason and fantasy, chose to express itself in landscapes that reflect, in their treatment, a genuine emotion felt before nature; the Carracci painted radiant forests, fresh streams flowing across green fields, castles towering on the plain, and the soft light of the horizon against which rise incredibly blue mountains. One is immediately struck, in looking at these scenes, by how the Carracci renewed the landscape idiom in terms of a nature directly related to man's feelings. Their vision of the world still has traces of ancient glory, and expresses confidence in the fullness of life and the beauty of creation, but we notice a subtle melancholy about the loss of innocence and the golden age, a melancholy which turns these landscapes into moving elegies.

The sense of history permeating Rome, and the charm of its ruins and monuments, led Brill, Domenichino and Albani to give more attention to the historicity of this ancient world. They created — within the framework of the ideal landscape — a related genre, the classical landscape, the major exponents of which were to be Claude Lorrain and Poussin. The Bolognese artist, Domenichino, is more directly heir to Annibale Carracci's shimmering sensuousness than to Ludovico's subtle intellectuality. He emphasizes the essential, bucolic aspect of nature; his greenery is richer, his valleys more striking in the play of light and shadow, and his skies are more intensely highlighted; that is, nature is more detailed and concrete. But reinforcing Annibale's break from mannerism, and carrying it even further by reasserting a classical ideal, Domenichino rigorously selects the themes that will convey immediate pictorial beauty. His idiom becomes absolute in order to give greater importance to the "story," assuring at the same time the faultlessness of the formal values. In Domenichino's landscapes, the example set by the Carracci takes on a more studied spatial rhythm, a more defined, linear composition. And as to color, he preferred the clear, idealized tones of Raphael to the luxuriant Venetian hues so dear to Annibale. Thus it is that his painting constituted an undoubted influence upon so many artists of his time, and his formulation of classicism held sway well into the period of neoclassical theorizing. The later theorists, however, unlike Domenichino, ignored the vitality of Carracci's naturalism. Although dominated by the strictly formal framework, his naturalism was always lighted from within by a genuine fondness for the real world and its least important happening, source of so much of his inventiveness and his simplicity which had not yet been touched by the triumphal artifices of the baroque.

For these reasons, Domenichino was the immediate and indispensable forerunner of Poussin. Claude Lorrain, on the other hand, had the quicker eye of an impressionist painter in following the tran-

sient effects of light and atmosphere. By means of his indefinable luminosity, his views of the Roman countryside — so restrained, yet so airy — are imbued with the same mystery as Giorgione's paintings. Always faithful to reality, they are transfigured by the artist's perception of the subtle relationship between light and transparency, and human response. The hour of the day is clear, the landscape simple in all of its unsophisticated naturalness. But almost by magic, the figures in them seem to have come from some golden age. These paintings were very popular with the English, and indeed became a great influence on eighteenth-century English painting. Constable had them in mind no doubt, even though his landscapes are more concerned with the ephemeral aspects of nature than with allusions to the past or to mythology. Poussin counterposes to Claude Lorrain's surprising impressionism a lucidly rational, contemplative mode. Kenneth Clark has justly commented that the intellectual content of Poussin's paintings cannot be emphasized enough. From this prevalence of rationality, which, however, never overwhelms Poussin's interest in everyday reality, we see that he had a predilection for Domenichino over the Carracci. It seems he is always trying to establish some sort of order in nature's confused vitality. His classic landscapes seem to be caught in a tension between rigorous principles of composition and the emotional immediacy of the rendering; the emotion, in fact, is filtered through the supremely lucid geometricity. If anything, the lyrical quality in his paintings, which is excluded from the forms themselves, is communicated by the color, which even if reminiscent of the Venetians, is modified, or at least renewed, by Poussin, in the direction of Raphael's purer classicism. By virtue of his articulate principles, Poussin can resist, even combat, the showy convolutions of the Roman baroque, especially as handled by Pietro da Cortona. The nature in Poussin's paintings is "natural" enough, as we can see by observing the minute care with which the silhouettes of leaves are drawn, and other details. But as the painter continued to work in Rome, particularly after 1630, he turned more and more to the ideals of classical decorum, which he realized with complex gradations of space, with chromatic and architectonic masses, and with the noble poses of his figures. The indescribable strength of these paintings derives, in fact, from what his eye sees in nature and the order with which his mind arranges and governs it. But it would be a mistake to consider these glimpses of nature as simple backdrops in a brilliant set design. They preserve, rather, a primordial essence, and at the same time reflect the spirit of the new science propounded by Galileo and Descartes. We find a compelling urge to coordinate feelings, to restrict mere show, to contain emotional exuberance, but nonetheless one can detect in the deep distances and in the graduated planes of Poussin's landscapes a perturbed intuition of the infinite. This "other" dimension does not contradict the measured and grave solemnity of the scene, but rather confers on it a surprising emotional quality. Poussin's close friendship with his brother-in-law, Gaspard Dughet, who painted splendid landscapes in Domenichino's classical manner, but with more interest in the feeling aroused by untamed nature, had some reflection in Poussin's duality. Dughet created, no doubt, the premises for the romantic ideas that were to fire the Barbizon School in the mid-nineteenth century.

Consequently, the picturesque, fantastic landscapes of Salvator Rosa are not out of place in the developments of the seventeenth century, which was substantially characterized by the realistic landscapes of the Dutch and the ideal landscapes of the Italians and the French. In a certain sense, Rosa continues the Nordic tradition of the fantastic landscape, touching extremes of the grotesque not dissimilar to Bosch's. The difference lies in the fact that the fantastical in Bosch has theological origins; he distorts nature because of the corruption pressing in on it from the outside, whereas in Rosa's landscapes, the fantastical is part of nature itself, in its wild, desolate, tangled reaches. His depiction of intricate vegetation, rocks gaping with huge cracks, caves and blasted moors, on which

frequently gleams dull moonlight that increases the spectral appearance, might approach the artificial aspects of certain northern Gothic symbolic landscapes. But Rosa's art is different because it does not allude to sin or to hell; his landscapes are painted with the detailed, analytic concern of the realists, but they aim at unusual, tortured effects. The artist undoubtedly invented these landscapes, blowing up the details of real ones, but he does so without attempting to create allegories about expiation or corruption that spreads from the spiritual order to contaminate the physical. On the contrary, the artist seems to enjoy lingering over his deformities, as if they were as delightful as a flowering meadow under clear skies. Rosa makes no pretense of justifying his choices by claiming for them spiritualizing value. If anything, they have the opposite effect; his peculiar style is theatrical, the product of a daring and complicated intelligence, opening the way for the proliferation of visionary painters in the eighteenth century and again during late romanticism. They all have in common a seeking after some form of sublimity, with means that are far from, indeed contrary to, the classical ideal. There is great harmony and acute observation in these paintings, too, and surprising inventiveness in their compositions and colors, but it is a harmony of contrasts and unusual themes, which are not, however, the aberrations later indulged in by so many Romantics and Decadents. Although interpreting life variously, and motivated by differing spiritual concerns, man's imaginative bent remains fundamentally the same in the course of time, reacting, that is, to a cycle of reversals and renewals so that every condition has its counterpart in an opposing condition. Think, for instance, of nature's serenity in the work of Constable and Valenciennes (who prefigures Corot), and the immediate counterpart (or antithesis) in the visionary, imagistic style of Blake, in the shadowy fantasies of Samuel Palmer or in the uncontainable anxiety of Caspar David Friedrich—a disquiet that prods nature with a mysterious force, that yearns for deserted places, cataclysms, abandoned cemeteries, the immensity of the sea and the lonely mountains.

This conception of things never appealed, except in rare cases, to Italian sensibility. Although not touching the extremes these Northern painters did, Salvator Rosa's depiction of a savage nature inspired the Genoese painter Magnasco, who portrays impenetrable forests and thickets and terrible, spectacular storms with a prodigious inventiveness for drama and hellish light. He envisioned a nature full of pitfalls, a place for hermits to punish themselves, yet he provided generative ideas for romantic landscape painting, and ultimately, we must add, he too was attracted by the symbolism of sin and the fall. Marco Ricci, insofar as he is free from these expiatory concerns, is more modern, and for this independence of his imagination, he can be truly considered the founder of Venetian landscape painting, which came to be the greatest expression of the genre during the entire eighteenth century. Nature in his landscapes is not burdened with ideal or symbolic structures. He rejected the magniloquence of the baroque, as well as the pale decorum of the neoclassical painters. At first he played imaginatively with a range of dramatic themes, and with the contrast between light and dark, pursuing the unusual in nature, much in the manner of Salvator Rosa and Magnasco. Later he discovered a more concrete theme which he developed theatrically, trying, however, to render things as they appear in actual conditions of light and atmospheric change. His technique marks a point of basic progress toward the modern conception of landscape painting as an autonomous activity. For one thing, his perception of the function of light will be of great value to the later *vedutisti*, to Canaletto in particular, and even to Guardi, who employs bursts of light and fine atmospheric effects. For another, Ricci's observation of the real world will be of great usefulness to Zais and to Zuccarelli, the former's style being more rustic and melancholy, the latter's being more elegant and chatty. Ricci's paintings soon reached England: in 1706, Lord Irvin brought over eighteen of Ricci's landscapes and storm scenes he had purchased in Venice, and twice Ricci himself

went to England, first in 1708, then in 1712 for a five-year stay. Through his influence, as well as that of the seventeenth-century Dutch painters, English artists took to the empiricism of the continent from the very start, and continued with it throughout the century that saw the flowering of English landscape painting. This naturalism was to be profoundly transformed by the brilliant talent of Constable and Turner. And we must not ignore the vogue Venetian views had in England. The consul Smith in Venice had appointed himself a sort of dealer for Canaletto and insisted the artist come to London, where he in fact went in 1746, to remain several years, returning in 1753 and 1755, as substantiated by several landscapes owned by Hollis, on which Canaletto had written "*fatti a Londra*" (done in London). Once more we might properly emphasize that a "view" is quite different from a "landscape," not merely because the subjects are different, but because the esthetics of each are different. A view demands a certain topographical fidelity, without alterations of the real place, in its depiction. Canaletto resorted to the *camera obscura* to insure this fidelity in his views of this or that quarter of Venice. This documentary intention does not detract from his paintings, in the first place because of his masterly technique, his sense of perspective (with those low horizons that allow such extraordinary explosions of sheer space); and in the second place, because of his subtle transcription of an atmosphere steeped in crystalline light and, of course, his modulated coloring. One realizes at once that Canaletto's is a new conception of the panoramic landscape, which achieves stupendous effects of verisimilitude and imagination by the skillful juxtaposition of humble everyday subjects and grandiose architecture. Francesco Guardi opens the panorama of the same places even further, depicting unexpected and unreal perspectives which he fills with crackling light. One has the sensation that Venice is being consumed in an immense fire, holding out for a second more before disappearing in a final cloud of silvery ashes. In Canaletto, however, the light is clean and firm; everything takes its consistency from it by some sort of unnatural power. His nephew, Bernardo Bellotto, does without this device to record the actuality of Venice and, later, of various European capitals — Dresden, Vienna, Warsaw, where he lived from 1747 to 1780 — with an objectivity the Enlightenment boasted, without being allusive or symbolic or classical or romantic. His is a visual fidelity that is neither passive nor detached, but a deliberate attempt to depict the truth of things, to restore to nature all its substance and concreteness, its validity in its own right and not by virtue of any allegorical or poetic function to which it had so often been subordinated.

The demands of visual fidelity and perspective drawing do not, in any case, prevent fancy from roaming freely even within the confines imposed by the view. Another genre is born, the imaginary view, that in its extreme form becomes known as a *capriccio*. The imaginary view does not distort the geometry or alter the appearance of a panorama or a monument, but freely locates buildings and things in space, next to unexpected elements, for instance, which also are displaced from their natural surroundings. The whole effect, of course, is one of complete surprise, a *jeu*. Bellini had already tried the technique in several of his backgrounds. Marco Ricci took it up again, exploiting the artifice to achieve spectacular effects, especially in the landscapes he did in Rome among the ruins of the Forum, which he set against rather imaginative architectural elements. Thus he originated another variation in landscape painting, the view of ruins, which was later to be exploited skillfully, even if with tiresome amusement, by rococo painters. Canaletto, along with Marieschi and Guardi, dedicated himself to imaginary views and *capricci*. The realistic precision of these imaginary views tends to increase one's surprise and in a certain sense serves to mitigate the rather rigid mechanism of visual fidelity. Later, purely imaginary buildings and places were introduced to complicate the imaginary views: towers, arches, crumbling walls, glimpses of the Venetian lagoon next to Roman ruins, eerie constructions. The "feeling for the place" took on such importance for these

artists that it became the source of wholly imagined and ingenious landscapes (nature having failed to provide adequate places to have a feeling for). A burgeoning variety of crosses between actuality and fantasy ensued, in which the mind essentially amuses itself and at times discovers new kinds of feeling. Relevant in this regard is the letter Algarotti wrote to his friend Prospero Pesci on September 29, 1759, concerning an imaginary Palladian view Canaletto had just painted at his suggestion. Canaletto had placed the Rialto Bridge, which Palladio had designed but not completed, on the Grand Canal in Venice, but at either end of the bridge — amid golden highlights and reflecting waters — he depicted two buildings from Vicenza, the Chiericati palace and the Cathedral. Francesco Algarotti wrote about this painting: "We have spoken before of a new genre, I would almost say, of painting, which consists in taking an actual scene and decorating it with buildings borrowed from here or there, or else imagined. In this way, art and the craft of painting are united, and a rare hybrid can be formed, as painting has more of the studied about it, and art more of the simple, and in this simplicity, besides, there is a certain variety in the execution and in the accidental effects that the most excellent artist would have difficulty imagining. The first painting I commissioned in this style was a view of our Rialto Bridge from the northeast side.... Therefore in place of the Rialto we see there now... has been set the bridge Palladio designed for that site, which is the loveliest and most ornate edifice one could hope to see.... I cannot begin to tell you what a beautiful effect [this structure] has, especially reflected in the water below... [This design] was justly praised by its architect, depicted and washed with sunlight by the brush of Canaletto, the artist I commissioned...."

The letter clearly tells us what the new esthetic current was, a taste for artifice, for beautiful effects achieved by imaginary juxtapositions and, of course, by the "variety in the execution and accidental effects." Soon the novelty of this style gave way to a deeper understanding of those aspects of a landscape that enrich it and at the same time communicate feelings, sensations, ideas and ideals; in short, the interior dimension we sense in a painting, its tone or mood. Guardi's *Gondola on the Venetian Lagoon*, now at the Poldi Pezzoli Museum in Milan, is an imaginary view, a *capriccio*. Besides projecting a stunning pictorial effect — the pale expanse of water, the dark gondola slipping quietly between the two areas of ashen light, the sky and the sea, the distant houses lining the horizon in the noonday silence — the caprice communicates an inner state, a yearning, a fantasy, a feeling independent of the subject of the painting, yet aroused by the reality of it.

We can understand how the views Piranesi etched of Rome, with their exact perspective design, prepared the way for his more complicated and romantic *Carceri d'Invenzione* (The Prisons), the stupendous representation of dramatic ruins and dark scenes of torture, death and decay. Never before had such states of the soul been so graphically rendered. By now the panoramic view is no longer just another genre, but the expression of finer shades of feeling and imagination. It is significant that in the same period (1751-72), the French Encyclopedia, which gathered together the culture of the Enlightenment, considered the landscape as one of the "richest, most pleasant and most fertile genres of painting." And so it is even more surprising that the Venetian academicians, in the face of such varied and imaginative works by landscapists of their own city, from Canaletto to Guardi, should express such disdainful opinions and vote so arrogantly against them.

On the basis of the long history of contradictions and wonderful achievements which we have summarized here, touching only the high points, we now turn to the art of the nineteenth century, in which landscape painting plays a major role, since it came to be the genre closest to the intelligence and sensibility of the age. The artists of the nineteenth century attempted, and realized, many new things, inspired by different purposes and different approaches, both in their creative impulse and

their theories — even, toward the end of the century, in a scientific vein with the divisionists, or pointillists, who analyzed the phenomenon of light and the behavior of colors when broken down into their component hues. But after all, these steps forward were taken after history had prepared the way, and no matter how conscious the age became of creative autonomy, it was inevitable that it should be influenced by the historical and intellectual conditions from which it emerged.

The new century opens out onto two chief esthetic prospects, the first being a rational art, the product of the intelligence alone without the intuitive process, the other being a natural art, an appeal to nature as it is, and not as it should be on the basis of religious and philosophical values. We see the former in the revival of neoclassical art and the latter in the naturalism that will later turn into impressionism. And if the first appears as a necessary antidote to baroque and rococo extravagance, naturalism then, modified by the romantic currents of the age, will end by confirming visual data as its essential principle, and not ideas. We see the neoclassical painters imitating nature, but choosing the themes and applying the rules classical artists before them had evolved in the name of the sublime. This was a procedure that artists attracted by the classical mode had already adopted, from the Carracci to Poussin. The purpose of art to them was the realization of the beautiful, in which are inherent serenity, simplicity, majesty, purity of form and pose — all criteria to be contrasted to the changeability of the moment, and to the lack of control due to passion or fancy. But there is a profound difference between these neoclassical painters and the practitioners of the *beau idéal*, such as Poussin, Claude Lorrain, and the seventeenth-century Bolognese artists who painted "classical landscapes." In them, classicism had been the consequence of an emotional choice, a voluntary, felt participation in the idea behind that style, whereas the neoclassical painters were working from rules and precepts that had been articulated for them by neoclassicists such as Mengs, Algarotti, Milizia and Winckelmann, to mention only a few. These rules had become an uncompromising esthetic code that would have ended by embalming art. The mistake these theorists made, and the artists who followed their rules, was to reduce artistic creation to a formula.

The artistic renaissance the new century was witness to resulted from the real necessity for imposing order and clarity on the harried, irrational and tired culture of the baroque. Europe was seeking a new simplicity and directness, a logic and a fresh application of reason to the moral issues posed by existence and society. The need for reform was answered by writers, philosophers, architects and even statesmen responding to the radical political changes. Fresh archeological discoveries in Rome, Athens and Pompeii gave new life to classical principles with sublime examples of ancient art. But in the end, unfortunately, dogmatism won out over what should have been a natural impulse of the mind and the imagination. Since ideal beauty had already been realized by the Greeks and Romans, the modern artist had only to imitate their forms. Neoclassicism, however, which came to have such profound influence not only on esthetic criteria but on social customs as well, remained imprisoned in its own rules and formulas that once, it is true, had led to the *beau idéal*, but now, schematized, simply froze feeling and passion. These theories, vigorously defended and diffused by Northern esthetes, Mengs and Winckelmann in particular, but by some Italians as well, such as Lodoli, Bossi, Cicognara, became gospel to at least three generations of artists, right down to the middle of the century. The rules were applied with a mastery we ought not to ignore or disparage, by sculptors, painters, architects alike, and we need mention but a few: the Dane Thorvaldsen; the Italians Canova and Appiani; the French David and Houdon. A trip to Rome, Pompeii and Sicily became a must for all European artists. France not only founded an Academy in Rome in the early 1700's, but in 1816 the self-educated but singular painter Valenciennes, called "the David of landscapes," established a prize for historical landscapes which was won first by the young Michallon, who died

at the age of twenty-six. The prize was given until 1863. Neoclassical theories had, in fact, freed painting from sacred themes, but replaced them with mythology and ancient heroes. Just as style had to correspond to the idea of the beautiful, so too did the subjects have to celebrate the highest civil and personal virtues, namely those of the great men of the ancient world.

The French Academy in Rome received a host of French artists, from Wleughels, who became its director in 1724, to Joseph Vernet and Clérisseau, both great admirers of Giovanni Panini, the painter of Roman architecture; from Fragonard to Hubert Robert, both of whom painted and drew in the open air, choosing not only the monuments, but also the characteristic corners of the city as their subjects. Ingres, who was a *pensionnaire* from 1805, became director in 1835 and remained until 1841, when he returned to France permanently. As director, he called many young artists to Rome, among whom was the talented Théodore Chassériau. Of course, views of Italy had been a constant subject in the tradition of French art: Claude Lorrain, Poussin, Dughet had been the ablest interpreters of the Italian scene. Many other French artists beside the winners of the Prix de Rome came to Italy for a tour of her historic sites, among whom, along with Valenciennes, was the great Corot, who visited several times, enchanted always by the Italian landscape and its golden, enveloping light. Germain Bazin claims, in fact, that there is an Italian line in French painting that comes down to Renoir and Monet. When he came to Italy in 1881 and saw for himself the whole range of Italian art, Renoir was induced on the example of Raphael and other Renaissance masters to close the rather fragile feathering of late impressionism into solid forms. Monet came to Italy for the first time in 1883 for just a few days, but he came back the next year and stayed near Genoa. In the strong Mediterranean colors he found the possibility for resolving his problem with highlighting (in terms of perception). In a letter dated January 23, 1884, he wrote to Durand-Ruel, "The enemies of blue and pink will complain perhaps, because it is precisely this splendor, this fantastic light, I am trying to render, and those who have never seen this country, or have seen it badly, will cry out, I am sure, against the unlikeness, despite the fact that I am understating reality: everything here is '*gorge de pigeon*' and punch-red flame. It all shines, the countryside is more beautiful each day, I am enthusiastic about the place." Monet returned once more to Italy, in 1908, this time to Venice. The city captivated him, especially its light that washes everything with color from the reflections and fragmentations of chromatic forms in the water of the canals, where sky and palaces are mirrored. With these natural examples before him, Monet succeeded in overcoming his fond attachment to subject matter in favor of an independent and pure lyricism of light. In a letter of December 7, 1908, he expressed regret to his friend Gustave Geffroy for having missed his opportunity: "I am sorry I did not come here when I was younger and was willing to attempt any audacity."

Neoclassicism insisted that Idea was the basis of art. But Idea is valueless without nature, as Poussin so poetically revealed. Rules impose a choice of elements that go to make up the *beau idéal*, and therefore the ideal landscape also. But with all these theoretical discriminations, the artist must still always turn to nature. And as long as inspiration is not held back by theory, it will, in the actuality of the moment, the time, the place, manage to capture and transmit at least a glimmer of feeling. Nordic painters, the Germans and the Danes, cling to neoclassical formulas with rigorous fidelity. In Rome, there had formed around Thorvaldsen, the emulator and rival of Canova, a small band of admiring painters — Reinhardt, Reinhold, Steingrübel — for whom Thorvaldsen's art was the most consistent embodiment of Mengs' and Winckelmann's theories, which were dogma to them. Perhaps the eighteenth-century tradition regarding the use of light was still vital to Jens Juel, Chauvin (a Frenchman, but a frequent visitor among the Danish circle), and Lundbye; perhaps the Italian landscape fascinated them with its history, its festive colors, its light, its bucolic and picturesque life;

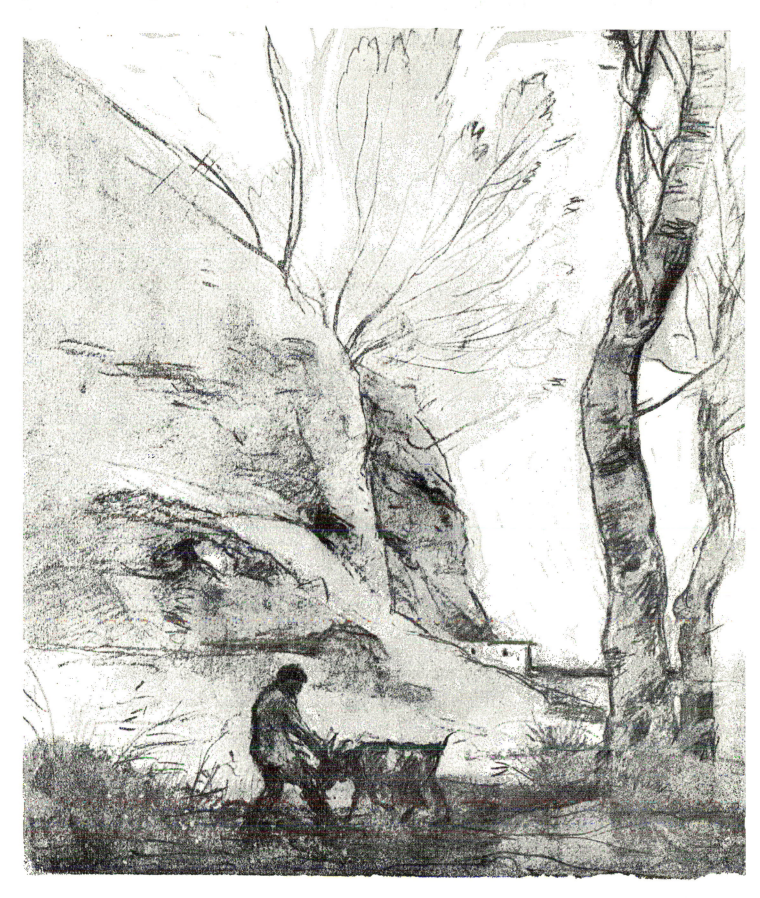

perhaps they were impressed by the customs and lightheartedness of the Italian folk — whatever the reason, these painters, with all their theoretical apparatus, were capable to some degree of an ingenuousness, a freshness, a felt observation of the country that give their paintings genuine spirit. The fascination the Italian landscape of those days could exert is seen in the French painters as well, who, although bound to the principles of their Academy, roamed the countryside and the outskirts of Rome, the Tiber and the Alban Hills, in search of things to paint and draw, deriving from nature the feelings their sensibilities required. Fragonard and Hubert Robert, for example, meticulously depicted the ruins in Rome and those scattered about the countryside. In all their drawings and paintings, we find at least a degree of sentiment, attesting to the free response they felt in their direct encounter with nature, the kind of encounter that was to be so important to later romantic painters. At one point, some German painters decided to lay their neoclassical formulas aside and turn to the artists of the Florentine Quattrocento, the purists in line and color from Filippo Lippi to Fra Angelico, and so were able to escape from the tedious chiaroscuro of the imitators of classical antiquity. They remained loyal, however, to the principles of ideal beauty: noble form and clear, static composition, and the celebration of heroic virtues, which they now took from Christian tradition rather than from the ancient world. Their interest in the artists of the Quattrocento rather than in the marbles of Phidias enabled Overbeck, Peter Cornelius, Joseph Anton Koch, Schnorr von Carolsfeld (to mention just a few of the painters who chose to live in community in a Roman monastery, and were known as the Nazarenes) to find a mood and an energy that brought them more fully into the spirit of creativity. Their ascendancy was brief, but besides reviving interest in the Middle Ages — thereby anticipating the romantics — and in the Renaissance, they created a compelling style and a taste for the mystical and the contemplative. We see traces of their influence in the Pre-Raphaelites, for instance, who used literary rather than religious themes, and even in Gustave Moreau's lush neo-Byzantine style.

Neoclassical rules were not so rigid as to prevent any spiritual or creative variation from the norm, even when those variations were unorthodox or indeed openly contradictory. Suffice it to mention the name of the Swiss painter Johann Heinrich Fuseli (Füssli), to bring home the point that a powerful imagination can overcome or bypass any theoretical barrier. Fuseli left his native country under dramatic circumstances and went to Vienna, then to Berlin and London, where he met Reynolds, and finally to Rome, where he lived from 1770 to 1778, an enthusiast of Michelangelo's, especially of the frescoes in the Sistine Chapel. He returned to England to settle there, became a member of the Royal Academy and was named professor of painting in 1800; among his students was William Blake. The peculiarity of Fuseli lies in the way he employs the full panoply of neoclassical motifs, with temples, agoras, togas, and subjects taken from history and medieval legends, only to insert deformed figures, nightmarish beasts, a nocturnal atmosphere of madness and visionary transport. Bosch, many centuries earlier, had discovered the devil in the recesses of nature; Fuseli discovered an entire hell in himself. His vision was turned inward; external reality was made to react to his strange illuminations. Even if not totally deliberately, his art nonetheless touched the limits of depth psychology. If its formal basis was more or less bound to classical, medieval or renaissance traditions, the expressed forms were bent and twisted by the complex relations within the unconscious of an artist particularly open to visionary fantasies.

Classical norms are violated and give way to the precarious instability of the subconscious, thus undermining confidence in the world, in its reality and in the possibility of ideals. Fuseli had gone far beyond even the extremes of romanticism. True, romantic painters rejected neoclassical theory and idiom in order to rediscover the instinctual response and the inspiration that comes from un-

mediated feeling. But essentially their style was still based on the certainty of things, on the natural-ness of the senses and the emotions, on the rapport between the inquiring self and nature. They wanted to remove the austere and noble mask that had been forced on nature and reassert its func-tion as a haven to man, who can recognize in it his primordial innocence and the hope of his rebirth. Visionary artists such as Fuseli and Blake share this much of the romantic disposition, but their obsession with fantasy, with hallucination perhaps, forces them into obscure reaches where the in-definable blurs their perceptions. Hallucination takes on the same consistency and lucidity as ration-ality. And, as we shall see, this fascination with the night and its apparitions (which had already gripped Salvator Rosa and the Nordic painters of Sin, and in the course of the century would pre-occupy writers such as Baudelaire and Poe) would leave a profound mark on the art of the nineteenth century, from Fuseli's nightmares to the arcane subjectivity of Caspar David Friedrich, to the pre-cious, symbolist decadence of Gustave Moreau and the allegorical happenings of Böcklin. These artists penetrated into the blind areas of consciousness, accomplishing intuitively what Freud later was to do scientifically, thus opening a vast new field of thematic and stylistic possibilities to artists of the succeeding century, including De Chirico, the metaphysical painters and the various currents of surrealism.

Romanticism straddled two centuries, the eighteenth and the nineteenth, as a reaction against the rigidity of neoclassicism and as a vindication of the imagination. In place of a static art, there was now a demand for movement, in place of the studied and the deliberate, there was a call for the spontaneous, and in place of the great idealized themes of classicism, there was an appeal to contem-porary life, its beauty and its horror alike. The criterion was to be man's personal freedom; the need was for a return to nature without the mediation of religion, history, class or academic strictures. Nature became one of the most vital ideals of romanticism, both as an existential and as a visual model. Romanticism did not arise from a specific esthetic formula, even if many critics have dis-cussed the movement as an independent phenomenon. After all, any creative operation in which an artist's imagination and feeling are involved can be said to be — consciously or not — romantic. Romanticism discovered man's inner self and the reality of his feelings. What is more, romanticism also discovered the variety and depth of nature, because the romantics as a whole were free of doc-trinal prejudices and could enjoy the range of what she offered. They ended by pouring the full torrent of their feelings and their profound and passionate aspirations into nature.

At this point we recall the lively rusticity of Annibale Carracci's landscapes, the pathetic charm of Claude Lorrain's, the silent but animated night in Elsheimer's paintings, the rustling gardens of Watteau and Fragonard, the imaginative *capricci* of Marco Ricci, the tangled forests of Magnasco, the broad expanses of noonday light in Zuccarelli's and Zais' paintings, the melancholy of the spar-kling light on the Venetian lagoon captured by the alert eye of Francesco Guardi, and in these brief examples we can see the forerunners of romanticism.

Taking their inspiration from the landscapes and *vedute* of the eighteenth-century Venetians, English landscape painters appear as the natural continuators of the Venetian genres. They did not have behind them the glorious tradition the Italians had, but this was to their advantage in a way, since they were freer to accept and put to use the new ideas and techniques of their times. The positivist and naturalist currents in English philosophy, an empirical frame of mind, one might say, also con-tributed to their immediate understanding and acceptance of the great Dutch realists of the seven-teenth century. In other words, they could choose the best of two worlds; the cultural grounds from which English painting proceeded are clear. Gainsborough is primarily a figure painter, but the landscapes he painted shortly after 1750 can be considered an exceptional synthesis of the two

33

schools, the Italian and the Dutch. For this reason, he will be the mediating artist for many of his fellow countrymen, particularly the painters of the Norwich School, which was founded in 1803 by John Crome and included such painters as John Sell Cotman and James Stark. Nature in their paintings is an immensely tranquil place filled with luxuriant trees. The few figures appearing in them do not alter this real dimension, nor is there any necessity for narrative, legend or symbolism. Men and animals count in the composition no more and no less than the trees, the ponds, the paths that wind into the deeps of the forest. These landscapes have the air of a fable: the broad, limitless perspective, the deep silence, the startling oblique light cutting across the twilight sky. We must add to this chapter in English landscape painting, which had considerable relevance in the development of nineteenth-century European art in general, a note about the watercolorists. If the Norwich School painters prefer the solidity of the Dutch, the watercolorists are more interested in the example set by the Venetians, especially Canaletto in his London period, for the simple reason that their medium was singularly adapted to catching the transparent effects of light in all its gradations. The Old Water Colour Society was founded in 1804 and, in the course of the century, proved especially congenial to the particular bent of the English toward landscape art. Among its members were such talented artists as Thomas Girtin, who taught Turner; John Varley, famous for his skill with transparent washes; David Cox, who preferred depicting rainy days; Peter de Wint, a master at broad, airy skies; Copley Fielding, equally gifted in the spacious representation of lakes and mountains.

The importance of nineteenth-century English artists stems from the extraordinary pictorial values they expressed, but they are equally important for the open and sensitive way they approached the landscape, their very conception of it. To them we owe the credit for having done so in painterly terms, without the machinery of sacred or allegorical themes from history. For them, nature is a concrete presence; there is no need to elaborate it with other structures in order to create a complete work of art. A hierarchy of genres such as prevailed in France and Italy was rendered obsolete by the great achievements of the English painters, and in fact this hierarchy disappeared altogether once the neoclassical norm — aristocratic, idealized, theoretical — had ceased functioning. As we have already observed, this confident and productive encounter between the inquiring spirit and nature's reality took place along two lines: a strictly romantic one on the one hand, where the painter transfers the dialectic of his feelings and imagination to the landscape (and we noted, too, the extremes the visionary painters were brought to by identifying the world with their own distraught psyches), and on the other, a naturalist line, concerned mostly with representing nature as it is, with its atmosphere and light changing from day to day, often with grandiose effects. In this sense, we can appreciate Constable's endless admiration for the things of creation. It was he, in fact, who opposed the notion of a "beautified nature" with the principle that in no case are corrections ever to be made on nature. He answered the proponents of contrived beauty by saying he had never seen anything ugly in nature.

English landscape painting reached its highest point in the nineteenth century with the work of two artists quite different from one another, but kindred in their absolute faith in the truth of nature: Joseph Mallord William Turner and John Constable, the former born in 1775, the latter in 1776. Turner was a restless spirit given to fantasy, Constable was of a quieter temperament and more reflective, imaginative enough but always in relation to his acute powers of observation. Turner had a difficult life and was rather withdrawn. He made many trips to the continent, especially to Italy, where he visited several times. In 1819 he reached Rome, and between 1819 and 1840 he returned four times, touring the whole country. Constable, on the other hand, practically never left England; rather than trying new techniques, or striking out in new directions, he preferred deepening his

own natural instincts for landscape with the scenes most familiar to him. Turner's works are difficult to date, but on close view, one can see how he developed his attitude toward landscape, and the ideas on light and color with which to express it. After an early, brief period (1802-08) during which he painted mythological scenes influenced in large measure by Titian's and Poussin's works in Paris, his interest turned exclusively to landscape painting. His work now develops formally, his colors become accentuated, and as his knowledge increases technically and visually, his paintings become fantastic transcriptions of natural space. Until he went to Rome in 1819, his English landscapes, the views of London and nearby areas, show rather free drawing from nature, but his Italian experience, especially his stay in Venice, where he returned in 1835 and 1840, modified his outlook considerably. The natural frankness of his earlier landscapes, in which are evident Dutch influences as well as that of Constable, is replaced by a quite original and expressive feeling-tone that radiates from the very luminous color. While in Venice, he was inspired by the view of the Ducal Palace, St. Mark's Square and the bay seen from the tip of the Giudecca. In his painting, he placed the figure of Canaletto on the bank, working at his easel, an apparent homage to the Venetian master. But despite this obeisance, Turner oddly enough disposes the light by means of the transparent sails and the speckling of highlights through the composition in a way that is much closer to Guardi's manner. As the years pass, his subjects slowly give way to these pure renderings of light and atmosphere. Things and trees and the houses clinging to the hillsides — from Spoleto to Volterra — all seem to drown in the layers of air the light incandesces. Outlines blur, volumes diffuse and ignite in the vibrant atmosphere made up of sudden and violent splashes of color. The natural content of the landscape dissolves into an enchanted sea of flame that casts infinite reflections into the air. Among Turner's paintings, we find a special interest in the action of fire: the fires along the Thames docks, the burning of Parliament, and the effects of moonlight on water and on woods. The paintings he exhibited in London caused some perplexity and considerable criticism, to the point that Ruskin intervened to defend him. His sensitivity to the effects of light in the atmosphere found particular expression in his studies of storm centers and fog on the sea. Turner did not have a literary sense, but he was unusually gifted visually, with an instinct for color and image that enabled him to realize paintings in which light is the sole agent, distilling airy transparencies or thick areas of color or bursting into highlights. Monet and Pissarro surely saw these paintings in London when they fled there in 1870. With their masterly display of light and atmosphere, these paintings can be considered preludes to impressionism, but because of their creative freedom, almost formlessness, they prefigure abstract painting as well. Monet's famous painting, *An Impression, Sunrise*, which Nadar showed, to everyone's horror, at the first exhibition of impressionist painting in Paris in 1874, and which became a sort of emblem for the impressionist movement, derives directly from these paintings of Turner's, describable only as luminous whirlwinds of air and flame, where things exist only as fleeting apparitions of color. Turner is a romantic artist who invested nature with feeling, and the intense psychological commitment which compelled him to the extreme rarefactions of his last works places him among the great visionary painters of the century.

In the same opening years of the century, another painter underwent a development parallel to Turner's, Caspar David Friedrich, a German, born in 1774, a student at the Academy in Copenhagen, who chose to live in Dresden. Participating fully in the romantic surge in his country, he associated with the painter Philipp Otto Runge, with whom he shared much by way of temperament and interest, and with the writers Ludwig Tieck and Novalis. A passionate, lonely man, an acute observer of nature, he soon became the exponent of a special taste and a particular romanticism, in which mysticism and realism, detailed representation and cosmic vagueness, love of creation and fear of

the unknown combine. During his development, Turner had discovered new technical and expressive means, while Friedrich probed the symbolic meanings of nature by refining details to the extreme, almost with the eye of the illuminator. His paintings are marked by a highly sensitive and lyrical tone, and his fine execution enabled him, paradoxically enough, to express an inner longing by assiduous observation of foliage, the deserted moors, the ruins of cloisters and churches, the crosses in abandoned cemeteries. Where in Turner we see a crescendo of sensations in light and color, in Friedrich there grows a painful sense of precariousness, as if the world were burdened with too many enigmas, and were about to collapse within the fine web of his introspection. Significantly, Friedrich, who was steeped in radical romanticism, never made the trip to Italy considered so essential to the formation of artists at that time. His tortured sensibility, which doubtlessly widened our perception of the world about us, ended by glorying in the complexities of his own soul and rendering finally unreal the real world he so scrupulously depicted. German romanticism is made up of artists from Friedrich to the Nazarenes, from Koch to Waldmüller and the landscapists of "Old Vienna" who, although quite different in their purposes and styles, were clearly bound together by their common affinity for the anti-naturalistic and even metaphysical concerns which came to have such resonance in symbolist painting at the end of the century, and in the irrational and Freudian art of the twentieth century. In a certain sense, the romantic naturalism that nineteenth-century English, French and Italian art share is quite different from that which we find in German art of the same period. The German artists working in the first half of the century aspire beyond the visible world: they yearn to find the world-soul with which they can identify themselves in some ineffable way. For instance, the few figures that appear in Friedrich's paintings seem terrified in the face of nature, lost in wonder amid the undecipherable symbols of that unyielding presence. This substantial difference in the *Weltanschauung* of the two groups made the achievements of the Germans practically uncommunicable to the prevailing French and English culture of the age. A comparison, for instance, between German romantic artists and Delacroix and Géricault is unthinkable. For the French, psychological intensity is always to be contained within the bounds of the known world, in its concrete aspects, and in the certainty we can have of its reality. Their inquiry into nature is motivated by emotion, but the inquiry is satisfied by the natural scene as it is, and if excessive feeling invades the canvas, it is directed toward the light, the wide horizons, the colors that are found in reality. Theirs is a constant dialogue between communicating realities, and not, as in the Germans, a disquieting projection on canvas of the wonder and fear they feel in the presence of an indifferent nature which seems to increase their anguish by its stubborn and often inimical silence. Delacroix's world is full of dreams, of generous ideals, of exotic charm, of feminine grace; we sense a fullness of life when we see his paintings. Géricault's world is shot through with drama: storms, the reek of blood and the chill breath of death, but we feel man's power in it as he is tossed to and fro by the elements, as for instance on the tragic *Raft of the Medusa*.

Despite these differences, and the tendency toward an extrasensory, metaphysical universe, German romanticism provides a fundamental experience for art. Its subtle, vaguely terrifying anguish, and the unworldly symbolism of its imagery are authentic psychological equivalents — an inner world — of external reality and thus anticipate the most esoteric expression of the twentieth century.

Constable is Turner's antagonist. His love of nature unquestionably has a romantic basis, but where Turner gives free rein to his imaginary interpretations that merely make use of nature's colors and atmospheric effects, Constable represents the natural world with sensitive fidelity and respect, offering the viewer a serene vision of the world. His handling of light moving across the broad skies and pleasant valleys of Suffolk reveals his admiration for the Dutch landscapists, especially the Ruysdaels.

As noble as Poussin's paintings are, they never achieved much popularity in England. English artists — the watercolorists in particular — preferred the simplicity and delicacy of Claude Lorrain. Constable, too, looked to Claude for the stupendous play of light he could produce, without subscribing to his rarefied effects that tend to dissipate real shapes into colored thinness. Constable was unquestionably a painter of light, but he was equally interested in shadow. It was he who first located and articulated in painterly terms the chiaroscuro of nature. He noticed in the harmonious unity of the elements a latently dramatic contrast between light and dark, which he succeeded in capturing with his fresh, notational manner. Constable painted his large canvases in his studio, especially the ones he showed periodically at the Royal Academy, but his most genuine efforts are the many small studies, marvelous sketches between light and shadow with color overflowing in freshness and spontaneity, which he did directly from nature. The spiritual dimension he sought was not outside nature, but in its very concreteness, and thus in a faithful representation of the masses of greenery, the mirrors of water and the billowing clouds, which he rendered simply and unaffectedly. But at the same time he could avoid the naive excesses of representationalism. His paintings present us with landscapes that strike a balance between reality and emotion, between observation and pictorial treatment. For this reason we find his vigorous realism surprisingly modern, and indeed there are such realistic details we can go so far as to say he prefigures Courbet. But within this strictly natural frame, the great painter conferred affection and a sense of meditation, a delicate elegiac quality. And the French painters who joined together to live in the forest at Fontainebleau, in the village of Barbizon, to work in contact with nature, must have noticed these qualities in Constable's paintings when they saw the ones exhibited at the Paris Salon in 1824. In the years following, his dense masses of color took on striking silvery highlights, almost a dusting of snow. This marked an increased perception of light, that now appeared in rapid flashes and fleeting touches which dissolved the thick chiaroscuro. Endowed with a placid temperament, Constable had lived through a number of esthetic issues in those years without being overwhelmed by them, thus setting an example especially to the younger painters and influencing both realists and impressionists.

Richard Parkes Bonington was active in these same years. His early death at the age of twenty-six cut short what his paintings indicate might have been a notable career. Born in England, he went as a young boy to France with his parents. His paintings, executed for the most part in Normandy, clearly reveal a sensitive, introspective, withdrawn temperament, content with quiet village life and the bright marine light suspended between sky and sea. Removed from the polemics between classicists and romanticists, he painted nature with broad, vibrant strokes. Leaning toward the English and Dutch landscape masters, impelled by Constable's example and Turner's freedom, Bonington developed a particularly inclusive, rapid, convincing style. In 1827 several of his paintings were exhibited along with Constable's at the Paris Salon, and even if his indebtedness to his fellow countryman had to be acknowledged, it was equally clear that his paintings offered something new, a spare, broader technique, the surface glowing with suspended luminosity, realized with such painterly spontaneity it seemed there had been no obstacles or material problems to surmount. This, too, represents another definite step toward French impressionism in the second half of the century.

Landscape painting as a genre developed relatively late in America. The painters of the eighteenth century devoted themselves virtually exclusively to the most utilitarian mode, the portrait, though late in the century history painting became important too. The first American painters to achieve some international prominence, Benjamin West and John Singleton Copley, worked within these modes, and landscapes were largely incidental in their paintings.

Interest in landscape coincided with the growth of romanticism. America's first purely romantic

painter, Washington Allston, also produced some of its earliest notable landscapes—though Allston, like West, and later Cole, aspired to the grand tradition of history painting and considered landscape a lower form of art. Allston's landscapes at times approach the sublimity of Fuseli or the bucolic quietude of Claude, but they also reveal the peculiarly American quality of evocative luminism, the manipulation of light which expresses an infinite time, a crystallized memory.

As the young nineteenth century progressed, landscape painting became increasingly acceptable in America, and even, toward mid-century, the most desirable category: Nature, the unsurpassed grandeur of the unique, immense land, was the greatest source of national pride.

Thus Thomas Cole, now viewed as the father of his adopted country's landscape school, was an anachronism, a painter consumed by the desire to express a noble and heroic ideal in history painting but working at a time when the public wanted the presentation of the real, especially the exaltation of the native landscape. Forced to compromise to suit his public, Cole transferred his ideals of history painting into the context of landscape. Drawing on European precedents, he emulated Claude in the rendering of the picturesque and Salvator Rosa and John Martin in depicting the sublime. Responding to the demands of his patrons, he relied in some paintings on natural elements rather than formulae to dictate composition.

The Hudson River School, America's first landscape movement, centered around Cole and carried forward the aspect of his art that involved direct confrontation with nature. Asher B. Durand, a leading painter of the Hudson River School, attempted ideal themes in imitation of Cole and produced salon landscapes in the tradition of Claude, but his objective strain, manifest in intimate glimpses of nature rendered freely and impressionistically, links him with his most advanced European contemporaries. His fresh vision and respect for physical reality, as well as his broken stroke and color, are close to Courbet's. Jasper Cropsey, another Hudson River painter, was, like Durand, often more successful in his free, proto-impressionistic sketches of glimpses of nature than in his panoramas.

The dichotomy between the ideal and the real is evident in much of the painting of the Hudson River School. Spectacular theatrical landscapes were produced by Frederick Edwin Church, Cole's only pupil. His renderings of exotic and sensational views combined idealized, formulaic compositions with accumulations of microscopically observed and painted details. Albert Bierstadt, though capable of modest, serene views, more often chose the overwhelming and sensational scenes which fascinated his public. His art, like that of Church, is often redeemed only by its luminous, enveloping, emanating light.

This luminism must be considered the most important development of American art of the nineteenth century. More than simply a way of painting light, it relates to a peculiarly American attitude toward the expression of an eternalized moment in time. It is in luminist painting that the reconciliation between an expression of the ideal and a depiction of the real is achieved in the most aesthetically satisfying way. Through the effacement of his own presence, the eradication of his stroke, the artist places the spectator in direct confrontation with the object in nature. He combines an ideal, highly controlled composition of classically distributed forms with an intense realism achieved through careful probing of objects and of the light in which they are bathed. Through hyper-clarity of vision, functioning within a carefully defined conceptual framework, the artist captures a moment of reality which becomes eternalized and idealized.

The luminist attitude toward time, light, and the object is the esthetic key to the *American-ness* of American painting. A synergistic blend of conceptual and perceptual, it explains and links the super-real glow of Copley draperies, the evocative stillness of many landscapes of Kensett and Gif-

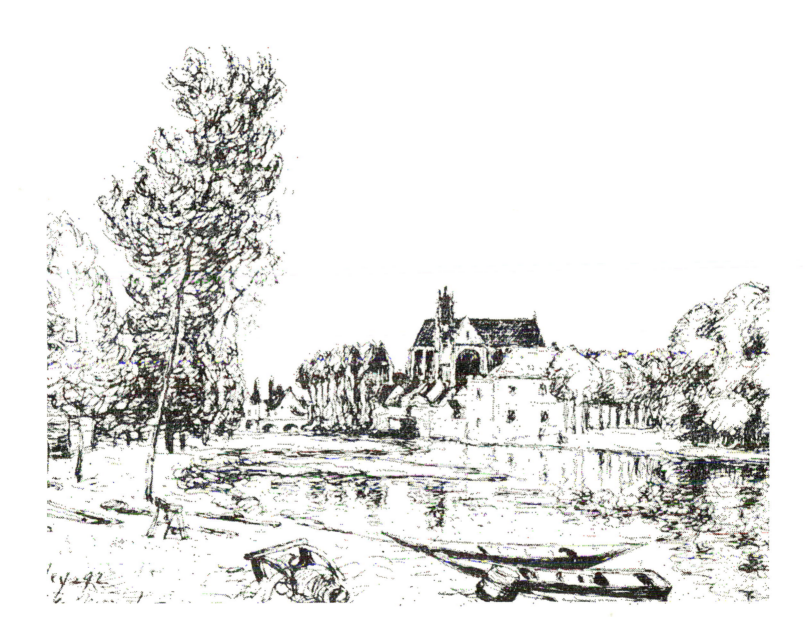

ford, and the classical stasis of landscapes and genre paintings of Mount and Bingham.

To some extent, luminism is exemplified by the landscapes of Martin Johnson Heade, which combine careful compositional control with an intense probing of the character of objects, be they rocks or ocean waves, to produce an effect which borders simultaneously on the primitive and the surreal. Luminism is most clearly defined, however, by the sea and harbor paintings of Fitz Hugh Lane. His *Ships in Ice Off Ten-Pound Island, Gloucester* reveals a consciousness of light as a radiating substance, a stillness which evokes a sense of tension through its implication of imminent action. Through conscious probing into the character of his objects and their controlled, classic distribution in space and on the surface, Lane achieves a realism which assumes characteristics of the ideal. The real and the ideal become inseparable and the conflict which had absorbed American painters for half a century is philosophically and esthetically resolved.

In France in the second quarter of the nineteenth century, Corot was creating a new sunlit world in landscape. Like many of his countrymen, he made a tour of Italy. Not being very patient with examinations, he did not apply for the Prix de Rome, and his family subsidized his first trip in 1825. From his first efforts, it is clear Corot had no propensity toward Constable's naturalism despite the recognition the Englishman was receiving (he had won the gold medal at the Paris Salon the year before). Not that Corot did not like the spirit of observation and the straightforwardness he saw in Constable, but his preference was for Poussin. One of Corot's first paintings was a copy of one by Michallon, the painter who had been the first winner of the prize Valenciennes had established for landscape painting at the French Academy in Rome. That was already a sure sign. Throughout his life, he took part in the various Salons, submitting the paintings he had done just for that purpose. Corot did not have a radical bent, but he seemed very much aware of the dangers of academic training. An intuitive genius, as Germain Bazin, one of the most acute of the Corot scholars, has described him, he had the courage and the constancy to pursue his talent. He was very conscious of Poussin's classicism, his decorum, his version of a select nature, his treatment of enveloping light and his sense of attenuated yet intense color. But Corot preferred simplicity, and the effects of color in a glowing atmosphere. The colors in the paintings he finished in the opening decades of his career seem tinged with a golden wash that accentuates the chromatic masses. In a certain sense, we observe here the light and color of the numerous and suggestive landscape studies Valenciennes made in Rome. But Corot avoids the panoramic tendency in Valenciennes, who ultimately was still under the influence of the eighteenth century. Corot shows a freer hand, even if his compositions and his balanced arrangement of colors and planes seem too calculated; he was more aware, nonetheless, of the vitality of the real world, and reacted immediately to real things. His brushwork, although heavier and more deliberate, achieves a more acute and juster definition of the scene observed by means of tonal values. Ingres, however, preferred portraiture and historical subjects, but in the few landscape paintings he did in Rome we see that he, too, had understood the effectiveness of descriptive simplicity and enveloping light.

Corot's immediate reaction to nature caused him to paint directly, but he maintained a sense of fine reserve. The way he handled details is not so much a description as a translation into emotive terms embodied in light values and impasted color. Nature, to Corot, has its own life, silent but intense, and he captured and animated its unity by the sheer number of accents and highlights that build up the whole. In this we already detect an impulse toward impressionism, especially in the paintings he did after 1860, in which he succeeded so brilliantly in rendering the silvery mists among the trees, the banks of fog rising from the rivers and ponds, the sudden encounter of light and shadow in the large architectonic or vegetal masses. Corot always said how important it is "never to lose the first

impression that strikes us." Certain views of Volterra and Rome, and later views of Provence and the French provinces — especially the ones he did in the forest at Fontainebleau, or along the Marne — show the rich and vibrant luminosity which so affected the impressionists, including Sisley. Corot's lyric, serene *intimiste* scenes, from which so many masterpieces descend, are of key importance in nineteenth-century realism. From his earlier link to Poussin's classicism, he had gone on to a more personal interpretation of the natural world which brought him close to the romantic spirit, yet his pictorial directness is so frank we cannot place him far from the realists. His perception of atmospheric phenomena and the play of light led him to shape a visual experience from which the impressionists were to learn an important lesson.

Corot influenced the painters of the Barbizon School; especially exemplary were his love for and fidelity to nature. And the interest Théodore Rousseau, Jules Dupré and Charles-François Daubigny took in English landscape painting and the masters of the Dutch seventeenth century persuaded them to find inspiration in the world of nature. From the Dutch they learned the importance of revealing the life and movement in plants and trees; they determined to treat the fields, the groves, the ponds and streams, the airy foliage they found in their surroundings at Fontainebleau in terms of proper perspective and color values. For Constable nothing in nature was ugly; for the Barbizon painters, nothing in it was corrupt. Nature for them preserved its primordial innocence, and thus was the only possible haven available to man's salvation. Their love of nature, in short, had become the worship of nature; their withdrawal to the village of Barbizon represented, they claimed, a return to the regular cycle of the seasons that would bring them to a renewal of man's original happiness.

Millet, especially, never doubted this. Born of a farmer family, he was fond of portraying peasants and shepherds at their humble tasks. Many of the Dutch and Belgian painters of the same period, and Segantini in Italy, shared the same interest. The Barbizon painters were trying to flee civilization, really, anticipating Gauguin's self-imposed exile to the uncorrupted islands of the Pacific. They rejected conventional and academic styles in order to find fresh expression, and a new personal rapport with the natural world as well. But in pursuing their purposes, they arrived at another convention — more sensitive, lyrical, infused with quiet pathos — but nonetheless a convention limited to certain motifs: trees, foliage, glistening pools, hazy distances and deep green silences. They brought to their art a close observation of detail; they used luminous impasto to render the thickness of plants and trees, the swift passage of sunsets, with a new and subtle perceptiveness in the use of color. But their worship of nature still held back from open expression, it was too understated; art and the perception of the world would have made little progress. Rousseau's style, for instance, is as damp with elegiac sentiment as it is with night dew. His work and that of his colleagues did achieve greater insights and finer rendering with respect to naturalism than did the work of the English painters — Crome, Girtin, Cox, Cotman and even Bonington — but their art was confined to an only partial realization. The Nordic naturalists, such as Köbke, Dahl and Waldmüller, to mention a few, will never arrive at the same pathos or pictorial refinement, but they do succeed in coming closer to nature; their contact is more lucid, and even if modest, more alive. Among the Barbizon painters, Charles-François Daubigny seems to have gone through the greatest development. His temperament was livelier, his imagination for color more vivid. His explorations of the natural world were expressed with light and atmospheric effects that were vigorous, if not stimulating. Of them all, he is the painter who transmits directly to the impressionists. Not by chance did he prefer painting in the open, while boating on the Oise. Turner loved to do the same in order to capture the effects of fog, light and color along the banks of the Thames, and later Monet used the same means.

In answer to the critics and artists who contended that nature had to be improved in favor of the

ideal, Gustave Courbet affirmed that "the beautiful is in nature, and one can find it there under the most diverse forms." Courbet, consequently, would not admit that anyone had the privilege of expanding on visual data; he added, "The beautiful given in nature is superior to all artistic conventions." But it was not so much the beautiful as reality that interested the painter. Not to paint anything but what one sees was one of his basic tenets. And to this must be added the proposition that the most ordinary subjects, the most common daily occurrences, in short, reality without a veneer, could be used as models. In effect he brought to a logical conclusion what the romantic painters began; and what had been for the painters of ideal landscapes, whose place was now taken by the neoclassicists, only ugliness to be avoided, he affirmed as central to art. Courbet was very radical in this regard, claiming that "we must bring art down a few notches, my contemporaries have been making ideal art for too long now." Despite the resistance these ideas met with, they were reinforced by political events, such as the revolution of 1848, and were seminal in one of the main currents of French nineteenth-century art. The Barbizon painters had already accepted the ugly as characteristic of reality, and attempted to express their sincere attitude toward nature by representing anything that drew its strength from honest feeling. The ideas Courbet expressed, and other artists and writers shared — absorbing whatever they could from romanticism and other ideological forces averse to "artifying" nature — constituted the backbone of the realist movement. Courbet, in fact, was its most ardent practitioner and partisan. And if one thinks of the artists painting at the same time, Corot, Géricault, Delacroix, Daumier, to cite a few of the leading names, one can readily see the substantial creative vigor of French art in the frame of European art as a whole.

Realism, especially Courbet's, was based on, and at the same time was an embodiment of, social doctrines, but it was primarily a powerful and passionate appeal for the genuine objectification of the real world, down to its humblest events, with an absolute faith in the equality of men and in the popular revolutions that were to sweep away the traditional preconceptions of art and academic norms, along with the privileged classes against which the uprisings were aimed. And without the groundwork laid by the Barbizon painters, Courbet would have had greater difficulty arriving at his full realization and winning the place modern art now accords him. A comparison with Théodore Rousseau, however, will cast immediate light on the differences in esthetic attitude and personal behavior between Courbet and the Barbizon group, and throw into relief Courbet's more activist relationship with the world. In the first place, the Barbizon painters isolated themselves from urban life in the forest of Fontainebleau, while Courbet plunged into that very life, trying to enact his convictions however he could. No doubt Rousseau's, Daubigny's, Dupré's painterly techniques left their mark on Courbet; his works prior to 1848 are strictly romantic in intent. For the painters of the Barbizon School, nature inspired contemplation, for Courbet it inspired conflict. In Rousseau, human redemption comes about through solitude and individual catharsis, which he sets in an elegiac mood. Courbet seeks redemption in social commitment. He is more akin to Millet; they are both concerned with humble folk, who take the place of the sacred and profane heroes of earlier art, and become the new protagonists; the peasants, the shepherdesses and the winnowers of Millet, and the stone breakers of Courbet. Immersed as he is in social reality, the master of Ornans feels all the natural solemnity of death as well. His *Burial at Ornans*, with those rough, severe figures drawn up around the grave in the dusk that casts livid light on the rocky banks of the Loue, the same river he will represent at other times with sunlight and livelier scenes, serves also to demonstrate what profound dignity common people have in the presence of death.

With the same vehemence with which he argued his ideas on art, Courbet took an active role in social protest. In 1855 the Paris International Exposition accepted several of his paintings, but rejected

others, among which was *Burial at Ornans*. Courbet refused to acknowledge the official status of the Exposition and lined up his works, including fourteen landscapes, in a structure he had built near the Exposition site. He wrote a preface to his own catalogue explaining his artistic principles, which became realism's manifesto. In 1870, along with Daumier, he refused to accept the Legion of Honor from Napoleon III, in keeping with his republican sentiments. After the restoration, he was imprisoned for having participated in destroying the Vendôme Column, symbol of imperial power. Courbet attracted much enthusiasm for his works, but much criticism as well. Baudelaire himself, who profoundly admired Courbet, saw in his realism a force destructive of the imagination, which he found in the highest degree in the pictures of Delacroix. For other critics, painting reality as it is observed was vulgar, and the same prejudice was at work when academicians and public alike rejected Manet's *Déjeuner sur l'Herbe* and all the rest of the impressionist paintings exhibited by Nadar for the first time in 1874. Realist painting, said some, is for those who do not change their linen. In any case, Courbet, for all his protestations of fidelity to nature in all its harshness, is still an artist who shows some degree of reflection in his painting. Although not sentimental, his sentiment is a response to the beauty implicit in natural things, and he expresses it with his stupendous images of the sea, the dark woods where deer take refuge, the mossy rocks or the sheer cliffs along the Normandy coast, as in his paintings of Etretat, and even with the foliage of an old oak, or the thick swell of a frothy wave. Mind has the task of reshaping the terms imposed by existence, but the eye and the sensibility can still recognize how fascinating nature's light and colors are in themselves. It takes an artist like Courbet to go beyond social issues and historical and moral considerations and candidly reveal a reserved and manly affection for nature's beauty.

Courbet's counterpart in America was Winslow Homer, nearly a generation younger than the Frenchman. Homer's assertive, tactile handling of viscous paint, awareness of the effect of light on space and forms, and attention to the play of controlled geometries produced some of the most profound and monumental interpretations of land, sea, and rocks in the history of landscape.

Homer was one of many American artists who had been to Europe. A desire for foreign inspiration and training was a constant element in American art from its beginnings, varying in strength with the artists' attitudes of self-confidence and satisfaction with local professional discipline. During the first half of the nineteenth century most artists effectively assimilated European attitudes into styles that remained essentially native in content and technique. Most of those who went abroad did so after their styles had been formed, with an awareness of what they specifically needed to gain from European contact. Upon their return they adapted to American conditions without trauma; few became expatriates.

A change in this pattern appeared in the decades just after the Civil War. With great material expansion came wealth, leisure, and wider international contacts, increasing the general demand for art. The importation of European works in great numbers awakened in artists an acute sense of the inadequacy of native artistic resources and a desire to secure patronage by themselves producing what the new millionaires wanted to buy.

Many European art centers were accessible, but from the mid-1850's Paris became an increasingly attractive goal for American artists. The Academy, Barbizon, and the impressionists were successive — at times concurrent — magnets.

American figure painters sought the discipline in drawing, values, and construction offered in the studios of Gérôme, Bonnat, Bastien-Lepage, Bouguereau, and others. Thomas Eakins absorbed the ideal of the nude as the foundation of a system of teaching in the atelier of Gérôme, then considered France's greatest living painter. Eakins later abandoned the academic procedures taught by Gérôme

in favor of a technique of successive painting and glazing derived from a study of Velázquez and Ribera. His rugged, homely art is a synthesis of European linear and painterly traditions.

William Morris Hunt, after a period of study with Couture, found in the ideals and works of the Barbizon painters a corrective to the inflated naturalism and dinosaurism of the late Hudson River School. The personal, subjective Barbizon landscapists aroused the enthusiasm of American collectors and the sensibilities of such artists as John La Farge, George Inness, Homer Martin, Alexander Wyant and Dwight Tryon.

Independent of any foreign aesthetic or philosophical attitude, Albert Ryder, America's greatest romantic visionary, translated thought into forms of immense expressive power. Ignoring the superficial details of reality, drawing on evocative contrasts of light and dark, and utilizing the suggestive effects of tactile pigment, he produced landscapes which express an extraordinary inner vision of nature in completely resolved abstract terms.

At this point in the history of French art, the situation is ripe for the coming of impressionism. If we can assert that one phase in art follows upon another, even though when talking about this succession it seems we emphasize only the differences and the contrasts between them, we have to grant that all ideas, including art, always arise from determinable conditions. And it is frequently the fact that artists recognize them, and express them, before the general public is aware of what it is all about. Realism, for example, arises from the social conditions in economies that are mostly agricultural, while impressionism arose, it can be claimed, from the conditions in a largely bourgeois society of urban dwellers. Impressionist paintings, in fact, reveal a preference for city views: the banks of the Seine crowded with pedestrians and horse carriages, the Paris boulevards gleaming with gas lamps and lighted shop windows, music at the Tuileries, boxes at the theater, the cafés or dinners in the garden, the canoes on the river, and the horse races. Certainly we continue to see landscapes with woods and ancient villages set amid the green fields and orchards. But we could not understand impressionist painting if we did not take into account the various currents and influences, coming out of a rich tradition, that bore on it, including the candor of the seventeenth-century landscapists, the perspectives and the atmosphere of the Venetian *vedutisti*, Constable's respect for nature and Turner's lyric transformations, the passionate concern for natural scenes in Corot and the romantics, the objectivity of Courbet and the realists. In contrast to Millet and Courbet, for whom nature was the source and conditioning force of existence, the impressionists considered nature as a show to be basked in for amusement and relaxation: the regattas on the Seine, strolls in flowers gardens, summer afternoons spent swinging in a hammock while billowy clouds sail across a blue horizon. Typical of this relationship that they found between nature and life are Monet's regattas at Argenteuil, Renoir's bathers at La Grenouillère, Manet's beer drinkers, Degas' ballerinas in their tutus and his working women. Pissarro was more inclined to the rustic, with his gardens and streets in the villages of Pontoise and Louveciennes. Sisley was subtler and more delicate, depicting the poplars along the Oise, and barges slipping down the river between silent banks. The relationship they expressed, in other words, was one of easy harmony with the universe; man can ultimately realize his life without pain. Thus, in their terms, color and light ought to be an exaltation of the senses, and so painting must be transformed, technique must be made to answer the need to express this contentment of the mind and senses. The result, as we know, is light, bright hues and transparent washes, to interpret best the joy of life in the beauty of the atmosphere and the freshness of nature. Obviously, this chromatic purity that even abolished traditional ways of rendering shadow (with the discovery that shadows contain color) can be traced to Venetian tonality, and the perception of light engulfing the atmosphere to Francesco Guardi and Turner. We have already indicated that Monet, when visiting

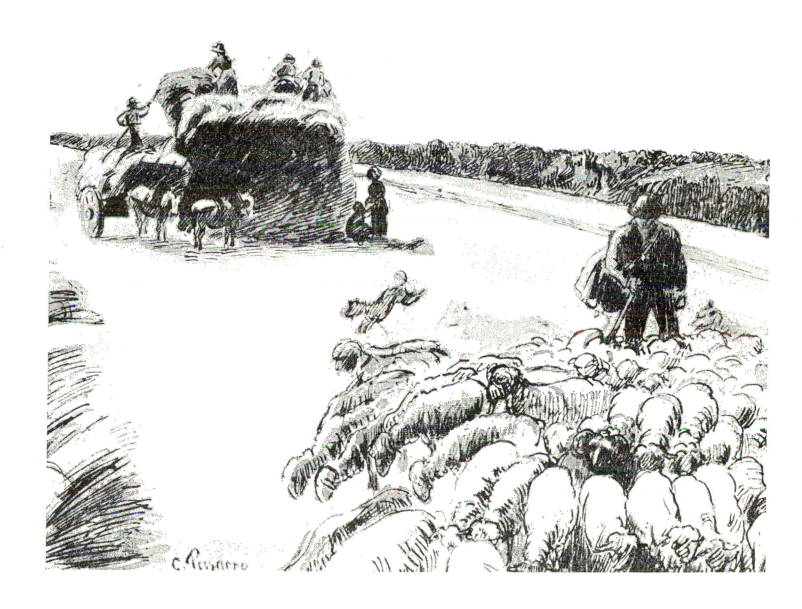

London in 1870, learned valuable lessons from the way Turner depicted the atmosphere swirling with light and color in his riverscapes along the Thames and in his storm scenes, and from the rapid chiaroscuro technique of Constable, which seemed scarcely less than sacrilege to the adherents of the *tutto finito* ("finished" painting).

What distinguishes impressionist painting is precisely this apt sensuousness, the broad, rapid rendering of the totality of a given scene, and the transience of visual sensation. The eye must capture this fleeting moment. Although nature has physical consistency, it is perceived by us under rapid changes of light, which in turn affect color tonalities. Thus what the eye discovers at a glance must be transferred to canvas immediately in order to "fix" the sensation, and this need to work rapidly gives rise to a new technique, consonant with a conception of reality that the Norman painter Eugène Boudin had anticipated many years before. Boudin had taught Monet at Honfleur and Trouville. The Dutch painter Johan Barthold Jongkind, who along with Isabey had come to Paris in 1845 with his canvases, had already picked up and developed the same intuitions about the role of light that Bonington and Corot had had. These painters were not as talented as the impressionists, but their empirical sense was acute enough to realize the new possibilities that were in store for painting. It was Boudin, in fact, who had said with deep conviction: "The romantics have run their course. Now we must seek the simple beauties in nature, seen in their variety and freshness." Renoir succeeded, judged by the standard implied in this statement, in rendering an almost tactile sense of light with the fleshy redolence of his color. Monet conveys to us an almost feverish awareness of light changing and flowing. His rapid brushwork is obviously nervous as he tries to capture the phenomena of light and air. Cézanne, who at first had listened to Pissarro and become convinced about impressionism, only to change his mind after 1880 and turn to a less fragile consistency, said at one point: "Monet is only an eye, but what an eye!" Monet, with the exceptions perhaps of Pissarro and Sisley, was the greatest practitioner of impressionism. About 1865, he presented a *Déjeuner sur l'Herbe* to demonstrate what amazing and immediate effects could be obtained by painting in the open — as a sort of friendly criticism of Manet, who continued to paint in his studio, picking up ideas from prints and paintings by such masters of the past as Velázquez and Goya. In the years following 1870 Monet turned his attention almost completely to the study and representation of the impressions created by light, as we see in his *An Impression, Sunrise*, which he painted in London. For Monet, light was the real theme of his paintings, and nature, after 1880, merely the place where light existed. To carry out this notion, he painted series of canvases on the same subject, different only in the modulation of the light: his sheaves of wheat, his trees along the canals, his cathedrals. In order to follow the variations of light at different times of the day on the ancient stones of the cathedral at Rouen, he rented some rooms facing the cathedral, so that by keeping watch at his window he would not miss the rapid changes. Monet was always loyal to this principle, even after his short trips to the Italian Riviera in 1884, where he was impressed by the livelier colors of the Mediterranean coast and began to use his imagination more freely, less bound to naturalism. We can see this freedom in the landscapes he painted in Venice in 1908 and in the famous water lilies he painted in his garden at Giverny. Here the light's refraction breaks up the structure or the sinuosities of the plants into bright globs of color so they appear to be some shimmering substance rather than flowers and leaves. It is probably from these very late paintings of Monet that the abstract expressionism dominant in the 1950's developed.

Towards the end of the nineteenth century a number of American artists strongly reflected French impressionist attitudes in their work. Earlier, within the American tradition of interest in light and its influence on the perception of color and form, Asher B. Durand and Winslow Homer had worked

towards a peculiarly native impressionism. Though it shared the French concern with a fresh vision of the everyday and of the brilliant effects of sunlight, this American impressionism relied consistently on solid, earthy local colors. The later American version of French impressionism was derivative rather than original and, lagging behind French advances by several decades, was hardly revolutionary.

Theodore Robinson opened himself to Monet's teachings in Giverny in 1877 and actively espoused impressionism. Contact with Robinson stimulated John Twachtman to adopt a light, evanescent palette and impressionist technique to record the changing moods of nature in small, intimate views. Childe Hassam produced an American translation of the French movement and used it to interpret New England churches and New York streets analogous to Monet's cathedrals and Pissarro's Parisian boulevards.

However much these artists derived their palettes and techniques from French impressionism, they consistently revealed an attachment to the traditional American concern with the integrity of the object. However extensive their exploration and depiction of light and air, they never sacrificed object-clarity for broken color or atmospheric mists.

As academic training and Barbizon influence had been assimilated into American painting by those artists capable of building personal styles within the American tradition, so impressionism became a language through which native characteristics continued to be expressed. The acceptance of the impressionist mode was consistent with the late-nineteenth-century reaction against inflated naturalism and the return to subjective interpretations of nature. Conditioned by their acceptance of the Barbizon manner, Americans were sympathetic to the decorative impulse of those American impressionists who modified the color and atmosphere of French impressionism in terms of their own tradition of linear realism.

Impressionism was a true explosion of existential joy that carried "the return to nature" to the extreme. That appeal had been heard many centuries earlier, but never so insistently as in the eighteenth and the early decades of the nineteenth century. The concern the impressionists had for the problems of light was not shared by Degas, who was more interested in the problem of representing bodily movement. We see the figures in his paintings, whether ballerinas or horses, always at the culminating point of a movement or gesture; they seem to move into the painting from the outside, for their dance, or race, or whatever it may be. More than an impression of light, his is an impression of action. Among the impressionists, it was Degas who brought his paintings to the finish of museum pieces. He got his artistic training by studying the old masters in the Louvre and the works he saw in Naples, where his family lived for a time because of his father's banking interests there, and in Florence at the Uffizi. During the time he spent in Florence, around 1860, he admired Bronzino, perhaps with Ingres' drawings in mind. But his main passion was always contemporary life and its characteristic figures. Later he discovered the beauty of Japanese prints, the work of Hokusai and Hiroshige, and learned from them the expressive value of space and line in a vortex.

The intention to express images taken directly from reality as immediate impressions, and to use subjects from daily life, was of course common to these artists, but they went about realizing this intention in quite different ways, which sometimes created difficulties among them. By the time the Fifth Impressionist Exhibition was set up in 1880, the difficulties were such that the main group of impressionists stayed away. Besides their individual differences, continuing developments in art, combined with pressures for change from the younger artists, had widened the gaps among them, and ultimately provoked the crisis. Monet, as already noted, renewed his vision with color; Cézanne became disenchanted with the kind of painting that pursues only momentary qualities of light and

movement and claimed he wanted "to do Poussin over again, from Nature." He went on to achieve a solid plasticity through geometric synthesis. Renoir went to Italy in 1881 and discovered Raphael, from whom he learned more compact composition and intensely formal values. It was Renoir who put his finger on the essential reason for the break among the impressionists: "By painting directly from nature, one ends by seeking only effects and not composing any more, and that falls quickly into monotony." Impressionism's greatest practitioners had come to the realization that the themes and methods of their art had run out of energy, and would have to be radically renewed. Furthermore, the 1880 Exhibition saw the arrival on the scene of several younger artists, such as Gauguin and Odilon Redon, both destined, each in his own way, to open new paths in painting. The 1886 Exhibition accepted the paintings of two other young men, Seurat and Signac, who had radically renewed the techniques of impressionism with their *pointillisme* (or divisionism), which analyzed colors into their component hues and used only dabs of these pure, complementary colors next to one another with the idea that they would be recomposed in the eye of the viewer with greater vibrancy. Thus was born what Félix Fénéon named neo-impressionism, the *neo* referring not so much to the close connection between the two schools as to the break between them.

But we must also realize that divisionist technique is only the more apparent aspect of the movement headed by Seurat and Signac. They had other concerns as well, on a symbolic plane; that is, their awareness of the close connection between the external world of colors and forms and the inner world of ideas and feelings, a connection that lies in the fact that both worlds exist in a space, and in the shape of lines, curves, circles, associations and contrasts. For these artists, therefore, transforming these programmatic notions about the mechanics and the psychology of art into painting was a clear-cut procedure. It would no longer be a matter of representing what is seen, but rather of synthesizing it, using freely interpreted landscapes and figures to achieve an organic whole that would express not an impression upon the artist, but a sensation, an attitude toward that whole. In fact, divisionist technique does permit greater luminosity than is possible by mixing colors on a palette. By varying the density of the points of color applied within the outline of a figure or a landscape, the pointillists could arrive at extremely subtle effects of shading and modelling. They derived their ideas on color from the scientific theories propounded by three Frenchmen, Blanc, Chevreul and Rood; applying them methodically, Seurat painted the pointillist masterpiece, *Sunday Afternoon on the Island of La Grande Jatte*, in 1886 (now in The Art Institute of Chicago). It is not difficult to understand why the impressionists were hostile to Seurat, except for Pissarro, who had taken the side of the young artists the year before this painting was shown. Less understandable is the hostility of the symbolist writers, because Seurat's divisionism tends to rarefy the images of the natural world to create a hieratic, cool, melancholy vision that is elegant and formally austere. Pointillist art did not have, in other words, ideational limitations, and should have been regarded as a style consonant with the poetics of the symbolist writers. True, it continued to employ the full perceptive range of impressionism, but it broke the long hold naturalism had had on it. In visual terms, pointillism had moved over to a symbolist esthetic, whose aim was to discover "correspondences" to states of the mind as Baudelaire had envisioned them, and to express a complex emotion in the artist's psyche through objective correlatives. An understanding of nature that had been sought and graphically realized for more than a century by naturalist painting now shifted away from the world of the senses and concentrated on subjective reality. Recalling certain landscapes of a few romantic painters such as Delacroix and Turner and especially the Germans Runge and Friedrich, where imagination had reshaped reality, the imaginary landscape had a rebirth, this time imbued with the concept of autonomous forms. Although the French artists handled these imaginary landscapes with quite radical definition, notably different

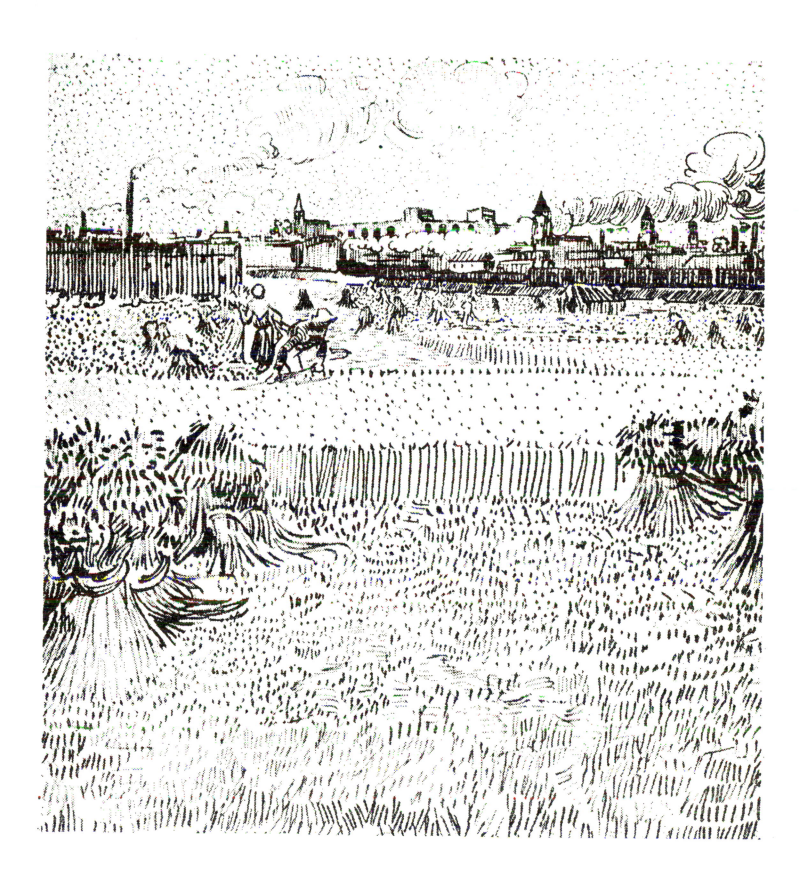

from the intricate and psychologically burdened products of the visionary Germans, the new techniques in art, and the perception of a "metaphysical" area of sensation, take place on contingent levels. Pictorial values become enmeshed with literary insights in order to grasp the constantly shifting refractions of the mind, and the revolution is complete: painting has turned to interpreting an inner world, not the one spread out before our eyes. To describe this cultural shift more closely, we recall what Ruskin said — that the arrangement of colors and tones is an art analogous to musical composition, and is totally independent of the representation of events, and what Maurice Denis claimed, somewhat along the same lines, that before being a horse in battle, a nude woman or an anecdote, a painting is essentially a flat surface covered with colors arranged in a certain order.

In the meantime, European art continues the naturalist tradition begun with the English and notably developed by the French, from the romanticism of the Barbizon School to the realism of Courbet through the variations of impressionism and divisionism, the artists in each country following the, patterns of their own national cultures. The Dutch continue in the naturalist vein with particularly good results, due, no doubt, to their own centuries-old tradition. They pour their humanitarian instincts into their painting, motivated by a range of social and religious concerns. They faithfully represent their typical landscapes: the green fields crossed by canals, the wind-swept flatlands, the frozen dunes, the windmills, the boats dragged to the shore. We are given an acute sense of the hard life of the farmers and fishermen in the paintings of the brothers Jacob and Matthijs Maris, of the more vigorous Mesdag, of Weissenbruch, and of Anton Mauve. Mauve had his young cousin Vincent Van Gogh with him for a time. Before Van Gogh set out for Paris on what was to be a fierce, tortured journey on the discovery of his own art, he was distinctly a naturalist, having portrayed peasants in the fields and those obliged to live on a diet of potatoes, in a series of paintings that are a dolorous ode to the toil these people had to endure.

French influence, along the line of Barbizon-Courbet-Impressionism-Divisionism, spread throughout Europe. In Belgium, the situation was more or less parallel to that of The Hague School in Holland: vivid studies of reality with a profoundly thoughtful cast. Robust and frank in Verheyden, realism takes on a familiar, everyday quality in Henri de Brakeleer's landscapes, while it becomes tinged with gloomy greys and suffocated in a foggy atmosphere in Willem Vogels. Closer to Daubigny in style. Hippolyte Boulanger captures the silvery light, the bright reflections in the canals and the ragged outlines of the bare trees.

The intellectual climate that gave rise to the great Russian realist novels also induced a group of painters from Moscow and St. Petersburg to repudiate academicism and the conventional art of the upper classes and to travel around Russia (thus earning the name "Wayfaring Artists"). They were trying to learn by direct experience what they could of their vast country and to arouse interest in art among the people by representing events in their history, and by rendering the places, the seasons, the light on those infinite horizons. Vereshchagin, with his realist talent, left us a documentary of the scenes and costumes of the various Russian peoples; Ivanovich Surikov was a successful painter of Russian history; Gregor Soroka reveals a romantic and gently melancholy temperament, while Alexis Savrasov is still moving in the direction of impressionist luminosity with his famous snow-covered, overcast landscape entitled *The Crows Have Come*.

Confirming the fact that realism had spread throughout Europe, even the German-speaking artists in the second half of the century attempted to represent modern life in terms of the truth of nature, thereby resisting the temptation to follow in the footsteps of Goethe and romanticism, or the Nazarenes and classicism, or Runge and Friedrich and their visionary fantasies. Thus from the landscapes of Dahl the Norwegian and Blechen, we go on to livelier styles of Adolf von Menzel and Emil

Schindler, they also drawn to the rapid, notational technique of the impressionists, as were Romako, von Hörmann and Carl Moll. We may glance in passing at the Courbet-like paintings of Leibl, Schuch and Thoma, and come finally to the breezy color and atmospheric luminosity of Lovis Corinth, who prefigured many twentieth-century developments, including expressionism, his free coloring affecting even a painter like Kokoschka.

Even if deeply involved in the political chaos and the wars leading to her unification in 1870, Italy was not out of touch with the artistic life of the rest of Europe, much of which had been inspired by her traditions. The Venetian *veduta* had its effects on English landscape painting; Turner had been considerably influenced by Guardi's use of light; numberless painters from all over Europe had come to Italy in the nineteenth century and had been impressed with her beauty, her colors, and her ancient ruins. When Cézanne declares he wants "to do Poussin over again, from Nature," he is alluding to the Italian classical ideal working on him through the seventeenth-century French master. Renoir took his inspiration for a time from Raphael, and Monet openly avowed that he owed his new conception of color to the light and vivid colors of the Italian landscape, which he discovered during his stay on the Italian Riviera in 1883-84. The neoclassicism espoused by Winckelmann, Mengs and Thorvaldsen, which affected European art for several decades, was not only a reflection of the art of ancient Rome, which had made such an impression on Ingres, but was also an extension of the culture of the larger Italian cities of that age, from Rome to Milan; in fact, as capital of Napoleon's Italian empire Milan became the center of neoclassical taste. Some acute intuitions Gian Domenico Tiepolo had had in rendering the quality of reality, even if not exactly naturalistic, were ignored, and Italian art lost a valuable opportunity. But not ignored was the profound and realistic objectivity in the views painted by Bernardo Bellotto, who lived for over thirty years in Germany and Poland, and died in Warsaw in 1780. We must observe, too, that if neoclassicism was simply an archeological obsession, as many critics contend, then that obsession never took hold in Naples. In fact, in all the bright splendor of the Neapolitan landscape, those artists who might have been drawn into the neoclassical current, such as Hackert and Pitloo (who incidentally became director of the Naples Academy), were led to a more realistic style, one even folkloristic perhaps, yet definitely related to the naturalism prevalent in Europe at the time. It was not by accident that around 1830 the Resina School should have been formed in Naples around Gigante and De Nittis, providing a good example of a naturalist group, even if regional. And regional does not always mean provincial. Even with the obstacles presented by the political upheaval of the time, the regional Italian school continued the great traditions of past schools, although it must be conceded that this traditional regionalism in art and culture hindered any meaningful participation in the artistic developments then taking place across the continent.

Despite the fact that romanticism was in large measure nurtured by the fascination Italy exercised on so many artists with her landscapes and ruins and her unspoiled, primitive countryside, the romantic attitude never took hold with Italian artists, especially the landscapists. The historical painters, from Hayez to Stefano Ussi, Mussini, Bezzuoli, all of them with neoclassical tendencies, show some romantic characteristics. Romanticism of course permeated the music of Bellini, Verdi and Donizetti, and the writings of Foscolo, Leopardi and Manzoni. The only real exceptions in painting were the Lombard artists Piccio and Faruffini, whose romanticism led to the rebellious movement among young Lombard writers and painters known as the *Scapigliatura* (literally, the tousle-haired) around 1880. Even the realism of Mosè Bianchi and Emilio Gola was singularly bohemian. Despite some attention paid to impressionism, it, too, remained outside the mainstream of Italian painting, except for the work of Reycend, who did remarkable landscapes of the country around Turin. We will not

call Delleani an impressionist, despite the body and sensuousness of his naturalism, because his painting does not achieve the vibrancy of light and atmosphere so essential to impressionism.

A rather remarkable phenomenon does take place in Florence near mid-century, and that is the work of the young artists who rebelled against academicism and came to be known as the *Macchiaioli* (from the various meanings of *macchia*: spot, woods, sketch). Their name, at first used disparagingly, was in fact an appropriate pun because they painted with integrated, gemlike areas of color, preferably out-of-doors in the country, and directly from their subject, which was usually a scene from contemporary life, the humbler the better. These were the tenets essentially of the Barbizon School and Courbet. The *Macchiaioli* roamed the Tuscan countryside, the riverflats along the Arno, the orchards of Pergentina, the hill pastures around Pistoia and the wild Maremma region (with dense *macchie* of scrub pine) in search of things to paint. For them as for Courbet, whatever was real was the primary component of beauty, but if the French master interpreted reality even in its rudest appearance — sometimes even vulgarly, his critics claimed — the *Macchiaioli* retained a formal distance from the nature they depicted. Several of them, Lega, Sernesi, Borrani and Abbati, were especially sensitive to nature and admired the work of the Barbizon painters, some examples of which were to be found in the Demidoff Collection housed in a villa near Florence. In 1855 two of them, De Tivoli and Altamura, took a trip to Paris to see for themselves what was going on in the arts at the International Exposition. But even after their firsthand experience with French painting, they never lost their traditional way of perceiving distinctly, with a kind of neatness and purism they admired in the Florentine artists of the Quattrocento.

Giovanni Fattori, who had studied and copied Lippi's works, broke away from academic painting and joined the *Macchiaioli*. Many of his smaller paintings, done on wooden cigar box covers, are full of a genuine affection for nature, an affection he conveys even in his battle scenes and military vignettes. His is a strong emotion, a deep and rigorous insight, a simple and sincere style. But he too, like the more acute Signorini, cannot break away from the measured, limpid and, in a sense, purist style that comes down to him from centuries of Florentine tradition typified by lucid, rational creativity. Fattori was the most impetuous of the *Macchiaioli*, feeling nature to be at a peaceful remove from life's problems and ideological commitment.

With all the problems it posed for convinced realists, and because of its near-hedonism, impressionism was never accepted by the *Macchiaioli*; they could not even conceive of it as a way of painting. Impressionism captures life in the moment it takes place, with the fluidity light gives it, but the *Macchiaioli* painted static images, and their rendering of light only intensified this repose. Both held original conceptions of how to represent reality, but with no points in common. Significantly, for instance, when Fattori went to Paris, he admired the work of Meissonier, who specialized in battle scenes, and remained indifferent to Manet and Monet. True, the stylistic rigor Fattori and Signorini had advocated earlier gave way to a rougher and more dramatic rendering of reality after 1880. Signorini's style became drastically objective in the paintings he did during his trip to Edinburgh, and in the scenes of the ghetto and markets in Florence. Fattori's reverence for nature diminished, and he began to express a dramatic contrast in his later paintings, a conflict between his ideals and the impassivity of nature. In his last years, his landscapes lose the clarity of his earlier period, and in their shadows and malarial mists one can only sense man's solitude and helplessness. His paintings become more profound and dramatic, certainly, but too pessimistic, thus cutting off any further possibilities.

Fontanesi, too, paints his naturalist landscapes with a sense of moral burden, almost a lay religiosity. Like Ravier, he was sympathetic to what the Barbizon painters were trying to do, but his own style

had a more definite melancholy about it. He can render wide, spacious skies over Piedmont with great sensitivity, but the oblique light at dusk and the dreary evening mists that rise from the woods cast a pall of gloom over these paintings. He is better in his more intimate paintings, in which the silvery greys recall the elegiac quality of the later Corot, or in other paintings where stronger color piles up a density infused with dramatic accents.

The radical change that took place in French painting around 1885 with the reaction of the symbolists and divisionists against the philosophy and esthetic ideas behind naturalism was reflected in the art of other countries within a few years. Seurat's and Signac's divisionism, as mentioned before, was picked up in Belgium by the more middle-class and intellectual Théo van Rysselberghe, and by Van de Velde, who was more precise in his formal composition but more *intimiste* in his subjects — often women sitting peacefully by their windows. In Holland, Jan Toorop emphasized the decorative aspect of his painting with a sinuous line and unreal color, showing the early influence of *art nouveau*. A similar cultural mixture, complicated by a more elegant and decadent *esprit*, makes its appearance in the sophisticated style of Klimt, a master of refinement and apprehension, a style that was to be useful to Kandinsky, among the other elements he borrowed from the vast matrix of fin-de-siècle symbolism.

There were also some very capable Italian painters who subscribed to divisionism. Vittore Grubicy introduced it into Italy, since he travelled frequently to Holland and to Paris and had seen the first controversial shows Seurat and Signac held at the Salon des Indépendants. Segantini's friend, and his dealer as well, Grubicy encouraged that artist's humanitarian ideals right from the start. Segantini felt the panic element in nature, but was preoccupied with the sadness of the human condition. He was deeply persuaded that the only salvation lay in a return to nature, which he felt as an ennobling force. In a certain sense, his search for scenes to paint, from the plains of his Brianza up to the Alpine pastures and finally up to the peaks themselves, where he found clearer light and unspoiled landscapes, might be termed a spiritual journey. The divisionist technique, applied in his case intuitively rather than systematically as the French had done, was more of an attempt at approaching and grasping natural images than a stylistic ploy or a device for achieving symbolic values. Previati's divisionist theories were more methodical, and he wrote several treatises on them. But in practice, he was the least methodical of the Italian divisionists, and indeed expressed his impatience with theoretical systems several times. Divisionism enabled him to emphasize his symbolist tendencies, which were charged with religious pathos as well as a somewhat precious Wagnerian idealism. His sinuous, undulant style and his unreal colors led him gradually away from any semblance of naturalism toward a more involuted, literary symbolism. Morbelli's and Pellizza da Volpedo's handling of divisionist techniques was much more deliberate. They, too, were attracted by Millet's social consciousness, and were aware of the conditions the proletariat of Northern Italy lived in, which eventually led to the first working-class demonstrations. They tried to participate in this struggle for social justice through their painting. Pellizza da Volpedo caught the drama of the situation and communicates a sense of deep discontent that does not, however, lapse into sentimentality because he avoided recherché symbolic or literary devices, even though he did use some of the perceptions of the symbolist movement to convey his sense of unity with the proletarian cause, notwithstanding a persistent strain of pessimism even in his enthusiastic moments.

Although the backgrounds of the landscapes Van Gogh and Gauguin painted were still deeply imbued with naturalism, and in Van Gogh's case with a definite Millet-like naturalism, they both were instrumental in bringing the impressionist crisis to a radical new turn around 1888 — Gauguin, by embracing the new symbolist doctrines when he met Mallarmé through a mutual friend, De Mon-

fired; Van Gogh, by turning inward. Both these painters had been very much attracted by impression-ism. Van Gogh, who in 1884 was still immersed in his "black period," depicting the poor who had only potatoes to eat, in the pathos-ridden, realistic vein of Israels and his own cousin, Anton Mauve, found in impressionism the incentive to brighten his palette. The result seemed to be a happy and complete rapport with nature. Laying aside his commitment to realism and to the peasants and min-ers in their struggle against misery, Van Gogh plunged into the beautiful Mediterranean world of Provence, and lived a frenetic, albeit brief, adventure. It was this frenzy — this joyous rediscovery of nature, even in the moral sense — that ignited his imagination for color. He reveled in the sen-suous green of the gardens and the piercing yellow of the wheat fields, and at the same time he de-termined to use the same vivid colors to express violent human passions. With ever more contorted and nervous lines, he drew in the cypresses, the famous cypresses, and the poppy fields. With pure reds and yellows he created a style of pure chromatic contrasts. But guided by a sure creative sense, he succeeded in imposing order on the nervous energy of his design and color. At first, no one recog-nized his talent except his kind and generous brother Théo. In fact, he was never able to sell a single painting in his life. Ten years after his violent death in 1890, that bold, exciting style was plundered for ideas by the Fauves and the expressionists of Dresden and Munich.

Gauguin was also compelled to dig deep within himself to overcome the impressionist crisis. For a brief and anxious time, which was nonetheless productive, Gauguin's painting approached Van Gogh's, but the two artists, who tried sharing the same studio at Arles in order to help one another, inevita-bly broke. Gauguin was better educated, and his literate sensibility could not be satisfied with Van Gogh's instinctive enthusiasm, which — as time revealed more and more — had firm roots in his evangelical background. The period Gauguin spent at Pont-Aven in Brittany produced a mixture of primitivism, symbolism and a definite decorativeness, with which he tried to break away from me-chanical reality. Simplifying formal problems as much as possible, Gauguin evolved a two-dimension-al style in which the forms are outlined by a heavy black line, as binding as the lead strips in a stained-glass window, and then filled in with intense, unvaried color without regard to representa-tional needs. But if the colors in Van Gogh's work seem to explode violently, in Gauguin's, who was a more complicated spirit, the colors take on an ecstatic primitive quality, and force the painting toward a mythic vision, perhaps even a mystical sense of nature's primordial force. The line and color are thereby put into high decorative relief.

His flight from Paris to the Pacific islands was motivated by his yearning to rediscover innocence; in the name of this illusion, he began painting in a studiedly primitive style, a manner that is at once spiritualistic and mythical. Van Gogh's daring will benefit the *Fauves* and the expressionists, while Gauguin's elegant primitivism will be picked up by Sérusier, Bonnard and Vuillard, the most original of the young men who in 1888 formed the group called *Les Nabis* in Paris after they had seen a sym-bolist landscape Sérusier had done at Pont-Aven under Gauguin's instructions. Despite their antag-onism to representational art, *Les Nabis* still found inspiration in a natural environment and in daily events, which they tried to translate into their elegant, *intimiste* idiom, which was imbued with nostalgia and a sense of repose. Lacking even these minimal ties to reality are the paintings of Gus-tave Moreau and Arnold Böcklin. Their styles, impelled by their fertile and often recherché imagi-nations, recall elements typical of the visionary romanticism of the early-nineteenth-century German painters. Moreau is completely obsessed by his esoteric visions and Byzantine dreams, his paintings at times resembling oriental stage sets replete with bizarre and undefinable cultural bric-a-brac. His art was an absolute flight into an imaginary world that was sumptuous and suffocating under the sheer weight of symbols and idealizations. Böcklin, on the other hand, searches out rather special

places: flowering woods, marble temples mirrored in fountains, lonely islands crowned with cypresses, and peoples them with incredible nymphs, satyrs and mythic images that displace reality to some remote age. His fantasy created these unreal figures all in flowing white veils and ecstatic poses surrounded by equally unreal flowers, bubbling brooks, mists and froth. And yet his amazing theatricality, enchanting as it may be, and intended to be so, is corroded with sudden fear and dark premonitions. We feel it in the clouded and lightning-torn sky, the eerie calm of the sea in front of the island landing, the mysterious figure on the shore. Without breaking the enchanted mood, anxiety and tense expectation hover in the background. We can sense that we are in the presence of an irony that hints at the ironies De Chirico is to present us with in his metaphysical paintings. Ensor, too, with his reddish light and skeletons and the parade of masqueraders accompanying Christ through the streets of Brussels, was already brushing against that mad, painful, anarchic land the expressionist were to cross. And so we have arrived at the twentieth century.

After securing accommodations, and ordering a dinner at one of the inns, the next thing to be done was unquestionably to walk directly down to the sea. They were come too late in the year for any amusement or variety which Lyme, as a public place, might offer; the rooms were shut up, the lodgers almost all gone, scarcely any family but of the residents left — and, as there is nothing to admire in the buildings themselves, the remarkable situation of the town, the principal street almost hurrying into the water, the walk to the Cobb, skirting round the pleasant little bay, which in the season is animated with bathing machines and company, the Cobb itself, its old wonders and new improvements, with the very beautiful line of cliffs stretching out to the east of the town, are what the stranger's eye will seek; and a very strange stranger it must be, who does not see charms in the immediate environs of Lyme, to make him wish to know it better. The scenes in its neighbourhood, Charmouth, with its high grounds and extensive sweeps of country, and still more its sweet retired bay, backed by dark cliffs, where fragments of low rock among the sands make it the happiest spot for watching the flow of the tide, for sitting in unwearied contemplation; — the wooded varieties of the cheerful village of Up Lyme, and, above all, Pinny, with its green chasms between romantic rocks, where the scattered forest trees and orchards of luxuriant growth declare that many a generation must have passed away since the first partial falling of the cliff prepared the ground for such a state, where a scene so wonderful and so lovely is exhibited, as may more than equal any of the resembling scenes of the far-famed Isle of Wight: these places must be visited, and visited again, to make the worth of Lyme understood.

Persuasion, 1770-72. JANE AUSTEN

Near to the spot on which Snow Hill and Holborn Hill meet, there opens, upon the right hand as you come out of the City, a narrow and dismal alley leading to Saffron Hill. In its filthy shops are exposed for sale huge bunches of second-hand silk handkerchiefs, of all sizes and patterns; for here reside the traders who purchase them from pickpockets. Hundreds of these handkerchiefs hang dangling from pegs outside the windows or flaunting from the door-posts; and the shelves, within, are piled with them. Confined as the limits of Field Lane are, it has its barber, its coffee-shop, its beer-shop, and its fried-fish warehouse. It is a commercial colony of itself: the emporium of petty larceny: visited at early morning, and setting-in of dusk, by silent merchants, who traffic in dark back-parlours, and who go as strangely as they come. Here, the clothesman, the shoe-vamper, and the rag-merchant, display their goods, as sign-boards to the petty thief; here, stores of old iron and bones, and heaps of mildewy fragments of woollen-stuff and linen, rust and rot in the grimy cellars.

Near to that part of the Thames on which the church at Rotherhithe abuts, where the buildings on the banks are dirtiest and the vessels on the river blackest with the dust of colliers and the smoke of close-built low-roofed houses, there exists the filthiest, the strangest, the most extraordinary of the many localities that are hidden in London, wholly unknown, even by name, to the great mass of its inhabitants.

In such a neighbourhood, beyond Dockhead in the Borough of Southwark, stands Jacob's Island, surrounded by a muddy ditch, six or eight feet deep and fifteen or twenty wide when the tide is in, once called Mill Pond, but known in the days of this story as Folly Ditch.

In Jacob's Island, the warehouses are roofless and empty; the walls are crumbling down; the windows are windows no more; the doors are falling into the streets; the chimneys are blackened, but they yield no smoke. Thirty or forty years ago, before losses and chancery suits came upon it, it was a thriving place; but now it is a desolate island indeed. The houses have no owners; they are broken open, and entered upon by those who have the courage; and there they live, and there they die. They must have powerful motives for a secret residence, or be reduced to a destitute condition indeed, who seek a refuge in Jacob's Island.

Oliver Twist, 1837. CHARLES DICKENS

My plan originally had been to travel northwards — viz., to the region of the English Lakes. That little mountainous district, lying stretched like a pavilion between four well-known points — viz., the small towns of Ulverstone and Penrith as its two poles, south and north; between Kendal, again, on the east, and Egremont on the west — measuring on the one diameter about forty miles, and on the other perhaps thirty-five — had for me a secret fascination, subtle, sweet, fantastic, and even from my seventh or eighth year spiritually strong. The southern section of that district, about eighteen or twenty miles long, which bears the name of Furness, figures in the eccentric geography of English law as a section of Lancashire, though separated from that county by the estuary of Morecambe Bay: and therefore, as Lancashire happened to be my own native county, I had from childhood, on the strength of this mere legal fiction, cherished as a mystic privilege, slender as a filament of air, some fraction of denizenship in the fairy little domain of the English Lakes. The major part of these lakes lies in Westmoreland and Cumberland: but the sweet reposing little water of Esthwaite, with its few emerald fields, and the grander one of Coniston, with the sublime cluster of mountain groups, and the little network of quiet dells lurking about its head all the way back to Grasmere, lie in or near the upper chamber of Furness; and all these, together with the ruins of the once glorious abbey, had been brought out not many years before into sunny splendour by the great enchantress of that generation — Anne Radcliffe. But more even than Anne Radcliffe had the landscape painters, so many and so various, contributed to the glorification of the English lake district; drawing out and impressing upon the heart the sanctity of repose in its shy recesses — its alpine grandeurs in such passes as those of Wastdale-head, Langdale-head, Borrowdale, Kirkstone, Hawsdale, etc., together with the monastic peace which seems to brood over its peculiar form of pastoral life, so much nobler (as Wordsworth notices) in its stern simplicity and continual conflict with danger hidden in the vast draperies of mist overshadowing the hills, and amongst the armies of snow and hail arrayed by fierce northern winters, than the effeminate shepherd's life in the classical Arcadia, or in the flowery pastures of Sicily.

Amongst these attractions that drew me so strongly to the Lakes, there had also by that time arisen in this lovely region the deep deep magnet (as to me *only* in all this world it

then was) of William Wordsworth. Inevitably this close connexion of the poetry which most of all had moved me with the particular region and scenery that most of all had fastened upon my affections, and led captive my imagination, was calculated, under ordinary circumstances, to impress upon my fluctuating deliberations a summary and decisive bias. But the very depth of the impressions which had been made upon me, either as regarded the poetry or the scenery, was too solemn and (unaffectedly I may say it) too spiritual, to clothe itself in any hasty or chance movement as at all adequately expressing its strength, or reflecting its hallowed character.

But at the very door of the inn I was suddenly brought to a pause by the recollection that some of the servants from the Priory were sure on every forenoon to be at times in the streets. The streets, however, could be evaded by shaping a course along the city walls; which I did, and descended into some obscure lane that brought me gradually to the banks of the river Dee. In the infancy of its course amongst the Denbighshire mountains, this river (famous in our pre-Norman history for the earliest parade of English monarchy) is wild and picturesque; and even below my mother's Priory it wears a character of interest. But, a mile or so nearer to its mouth, when leaving Chester for Parkgate, it becomes miserably tame; and the several reaches of the river take the appearance of formal canals. On the right bank of the river runs an artificial mound, called the Cop. It was, I believe, originally a Danish work; and certainly its name is Danish (*i.e.* Icelandic, or old Danish), and the same from which is derived our architectural word *coping*. Upon this bank I was walking, and throwing my gaze along the formal vista presented by the river. Some trifle of anxiety might mingle with this gaze at the first, lest perhaps Philistines might be abroad; for it was just possible that I had been watched. But I have generally found that, if you are in quest of some certain escape from Philistines of whatsoever class — sheriff-officers, bores, no matter what — the surest refuge is to be found amongst hedgerows and fields, amongst cows and sheep: in fact, cows are amongst the gentlest of breathing creatures; none show more passionate tenderness to their young when deprived of them; and, in short, I am not ashamed to profess a deep love for these quiet creatures.

Confessions of an English Opium-Eater, 1821. THOMAS DE QUINCEY

A wide plain, where the broadening Floss hurries on between its green banks to the sea, and the loving tide, rushing to meet it, checks its passage with an impetuous embrace. On this mighty tide the black ships — laden with the fresh-scented fir planks, with rounded sacks of oil-bearing seed, or with the dark glitter of coal— are borne along to the town of St. Ogg's, which shows its aged, fluted red roofs and the broad gables of its wharves between the low wooded hill and the river brink, tinging the water with a soft purple hue under the transient glance of this February sun. Far away on each hand stretch the rich pastures and the patches of dark earth, made ready for the seed of broad-leaved green crops, or touched already with the tint of the tender-bladed autumn-sown corn. There is a remnant still of the last year's golden clusters of beehive ricks rising at intervals beyond the hedgerows; and everywhere the hedgerows are studded with trees: the distant ships seem to be lifting their masts and stretching their red-brown sails close among the branches of

the spreading ash. Just by the red-roofed town the tributary Ripple flows with a lively current into the Floss. How lovely the little river is, with its dark, changing wavelets! It seems to me like a living companion while I wander along the bank and listen to its low placid voice, as to the voice of one who is deaf and loving. I remember those large dipping willows. I remember the stone bridge.

And this is Dorlcote Mill. I must stand a minute or two here on the bridge and look at it, though the clouds are threatening, and it is far on in the afternoon. Even in this leafless time of departing February it is pleasant to look at — perhaps the chill damp season adds a charm to the trimly kept comfortable dwelling house, as old as the elms and chestnuts that shelter it from the northern blast. The stream is brimful now, and lies high in this little withy plantation, and half drowns the grassy fringe of the croft in front of the house. As I look at the full stream, the vivid grass, the delicate bright-green powder softening the outline of the great trunks and branches that gleam from under the bare purple boughs, I am in love with moistness, and envy the white ducks that are dipping their heads far into the water here among the withes, unmindful of the awkward appearance they make in the drier world above.

The wood I walk in on this mild May day, with the young yellow-brown foliage of the oaks between me and the blue sky, the white starflowers and the blue-eyed speedwell and the ground ivy at my feet — what grove of tropic palms, what strange ferns or splendid broad-petalled blossoms could ever thrill such deep and delicate fibres within me as this home scene? These familiar flowers, these well-remembered bird-notes, this sky with its fitful brightness, these furrowed and grassy fields, each with a sort of personality given to it by the capricious hedgerows — such things as these are the mother tongue of our imagination, the language that is laden with all the subtle inextricable associations the fleeting hours of our childhood left behind them. Our delight in the sunshine on the deep-bladed grass to-day, might be no more than the faint perception of wearied souls, if it were not for the sunshine and the grass in the far-off years, which still live in us, and transform our perception into love.

It is one of those old, old towns which impress one as a continuation and outgrowth of nature, as much as the nests of the bower-birds or the winding galleries of the white ants: a town which carries the traces of its long growth and history like a millennial tree, and has sprung up and developed in the same spot between the river and the low hill from the time when the Roman legions turned their backs on it from the camp on the hillside, and the long-haired sea-kings came up the river and looked with fierce eager eyes at the fatness of the land. It is a town "familiar with forgotten years." The shadow of the Saxon hero-king still walks there fitfully, reviewing the scenes of his youth and love-time, and is met by the gloomier shadow of the dreadful heathen Dane, who was stabbed in the midst of his warriors by the sword of an invisible avenger, and who rises on autumn evenings like a white mist from his tumulus on the hill, and hovers in the court of the old hall by the river-side — the spot where he was thus miraculously slain in the days before the old hall was built. It was the Normans who began to build that fine old hall, which is like the town, telling of the thoughts and hands of widely-sundered generations; but it is all so old that we look with loving pardon at its inconsistencies, and are well content that they who built the stone oriel, and they who built the Gothic façade and towers of finest small brickwork with the trefoil ornament, and the windows and battlements defined with stone, did not sacrilegiously pull down the ancient half-timbered body with its oak-roofed banqueting hall.

But older even than this old hall is perhaps the bit of wall now built into the belfry of the parish church, and said to be a remnant of the original chapel dedicated to St. Ogg, the patron saint of this ancient town.

One of her frequent walks, when she was not obliged to go to St. Ogg's, was to a spot that lay beyond what was called the "Hill" — an insignificant rise of ground crowned by trees, lying along the side of the road which ran by the gates of Dorlcote Mill. Insignificant I call it, because in height it was hardly more than a bank; but there may come moments when Nature makes a mere bank a means towards a fateful result, and that is why I ask you to imagine this high bank crowned with trees, making an uneven wall for some quarter of a mile along the left side of Dorlcote Mill and the pleasant fields behind it, bounded by the murmuring Ripple. Just where this line of bank sloped down again to the level, a by-road turned off and led to the other side of the rise, where it was broken into very capricious hollows and mounds by the working of an exhausted stone-quarry — so long exhausted that both mounds and hollows were now clothed with brambles and trees, and here and there by a stretch of grass which a few sheep kept close-nibbled.

The Mill on the Floss, 1860. GEORGE ELIOT

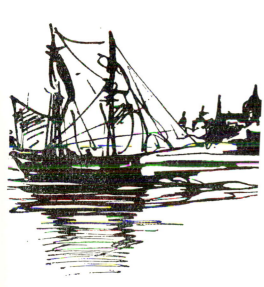

Twenty years ago, there was no lovelier piece of lowland scenery in South England, nor any more pathetic in the world, by its expression of sweet human character and life, than that immediately bordering on the sources of the Wandle, and including the lower moors of Addington, and the villages of Beddington and Carshalton, with all their pools and streams. No clearer or diviner waters ever sang with constant lips of the hand which "giveth rain from heaven"; no pastures ever lightened in springtime with more passionate blossoming; no sweeter homes ever hallowed the heart of the passer-by with their pride of peaceful gladness — fain-hidden — yet full-confessed. The place remains, or, until a few months ago, remained nearly unchanged in its larger features; but, with deliberate mind I say, that I have never seen anything so ghastly in its inner tragic meaning, — not in Pisan Maremma, — not by Campagna tomb, — not by the sand-isles of the Torcellan shore, — as the slow stealing aspects of reckless, indolent, animal neglect, over the delicate sweetness of that English scene: nor is any blasphemy or impiety — any frantic saying or godless thought — more appalling to me, using the best power of judgment I have to discern its sense and scope, than the insolent defilings of those springs by the human herds that drink of them. Just where the welling of stainless water trembling and pure, like a body of light, enters the pool of Carshalton, cutting itself a radiant channel down to the gravel, through warp of feathery weeds, all waving, which it traverses with its deep threads of clearness, like the chalcedony in moss-agate, starred here and there with white grenouillette; just in the very rush and murmur of the first spreading currents, the human wretches of the place cast their street and house foulness; heaps of dust and slime, and broken shreds of old metal, and rags of putrid clothes; they having neither energy to cart it away, nor decency enough to dig it into the ground, thus shed into the stream, to diffuse what venom of it will float and melt, far away, in all places where God meant those waters to bring joy and health. And, in a little pool, behind some houses farther in the village, where another spring rises, shattered stones of the well, and of the little fretted channel which was long ago built and traced for it by gentler hands, lie scattered, each from each, under a ragged bank of mortar, and scoria, and bricklayers' refuse, on one side, which the clean water nevertheless chastises to purity; but it cannot conquer the dead earth beyond; and there, circled and coiled under festering scum, the stagnant edge of the pool effaces itself

into a slope of black slime, the accumulation of indolent years. Half a dozen men, with one day's work, could cleanse those pools, and trim the flowers about their banks, and make every breath of summer air above them rich with cool balm; and every glittering wave medicinal, as if it ran, troubled of angels, from the porch of Bethesda. But that day's work is never given, nor will be; nor will any joy be possible to heart of man, for evermore, about those wells of English waters.

When I last left them, I walked up slowly through the back streets of Croydon, from the old church to the hospital; and, just on the left, before coming up to the crossing of the High Street, there was a new public-house built. And the front of it was built in so wise manner, that a recess of two feet was left below its front windows, between them and the street-pavement — a recess too narrow for any possible use (for even if it had been occupied by a seat, as in old time, it might have been, everybody walking along the street would have fallen over the legs of the reposing way-farers). But, by way of making this two feet depth of freehold land more expressive of the dignity of an establishment for the sale of spirituous liquors, it was fenced from the pavement by an imposing iron railing, having four or five spearheads to the yard of it, and six feet high; containing as much iron and iron-work, indeed, as could well be put into the space; and by this stately arrangement, the little piece of dead ground within, between wall and street, became a protective receptacle of refuse; cigar ends, and oyster shells, and the like, such as an open-handed English street-populace habitually scatters from its presence, and was thus left, unsweepable by any ordinary methods.

Crown of Wild Olive, 1870. JOHN RUSKIN

Dear Theo, Welwyn 17 June 1876

Last Monday I started from Ramsgate to London. It is a long walk; when I left it was very hot, and it stayed so until the evening, when I arrived in Canterbury. I went still a little farther that same evening, till I arrived at a few large beech and elm trees near a little pond; there I rested for a while. At half past three in the morning the birds began to sing at sight of dawn and I set off again. It was fine to walk then.

In the afternoon I arrived at Chatham. There one can see in the distance between partly flooded low-lying meadows, with elm trees here and there, the Thames full of ships. I believe the weather is always gray. I met a cart which took me a few miles farther, but then the driver went into an inn and I thought that he would stay a long time, so I continued on my way.

I arrived in the familiar suburbs of London toward evening, and walked to the city along the long, long "roads." I stayed two days in London and have been running from one part to another to see different persons, including a clergyman whom I had written to. Enclosed is a translation of that letter; I am sending it so that you may know that I begin with a feeling of "Father, I am not worthy" and "Father, have mercy upon me." If I should find anything, it will probably be a position between clergyman and missionary among the working people in the suburbs of London. Do not speak of it to anybody yet. My salary at Mr. Stokes's will be very small probably — only board and lodging and some free time to give lessons; if there is no free time to spare, it will be twenty pounds a year at the most.

But to continue. One night I stayed at Mr. Reid's and the next day at Mr. Gladwell's, where they were very, very kind. Mr. Gladwell kissed me good night that evening and it did me good; may it be given to me in the future to prove my friendship for his son now and then.

I wanted to go on to Welwyn that very evening, but they kept me back literally by force because of the pouring rain. However, when it began to let up about four o'clock in the morning, I set off for Welwyn. First a long walk from one end of the city to the other. In the afternoon at five o'clock I was with our sister and was very glad to see her. She is looking well, and you would like her little room as much as I do, with the "Good Friday," "Christ in the Garden of Olives," "Mater Dolorosa" framed in ivy.

My boy, when you read the letter to the clergyman you will perhaps think of me: "He is not so bad after all." But I am *sure* he is. Whatever he may be, think of him once in a while. A firm handshake from Your loving brother, Vincent

Dear Theo, Isleworth

It is more than time for you to hear from me again. Thank God you are recovering. I am longing so much for Christmas — that time will be here perhaps before we know it, though it seems long now.

Theo, your brother has preached for the first time, last Sunday, in God's dwelling, of which is written, "In this place, I will give peace." Enclosed a copy of what I said. May it be the first of many.

It was a clear autumn day and a beautiful walk from here to Richmond along the Thames, in which the great chestnut trees with their load of yellow leaves and the clear blue sky were mirrored. Through the tops of the trees one could see that part of Richmond which lies on the hill: the houses with their red roofs, uncurtained windows and green gardens; and the gray spire high above them; and below, the long gray bridge with the tall poplars on either side, over which the people passed like little black figures.

When I was standing in the pulpit, I felt like somebody who, emerging from a dark cave underground, comes back to the friendly daylight. It is a delightful thought that in the future wherever I go, I shall preach the Gospel; to do that *well*, one must have the Gospel in one's heart. May the Lord give it to me.

Letters, 1876-1889. VINCENT VAN GOGH

A Saturday afternoon in November was approaching the time of twilight, and the vast tract of unenclosed wild known as Egdon Heath embrowned itself moment by moment. Overhead the hollow stretch of whitish cloud shutting out the sky was as a tent which had the whole heath for its floor.

The heaven being spread with this pallid screen and the earth with the darkest vegetation, their meeting-line at the horizon was clearly marked. In such contrast the heath wore the appearance of an instalment of night which had taken up its place before its astronomical hour was come: darkness had to a great extent arrived hereon, while day stood distinct in the sky. Looking upwards, a furze-cutter would have been inclined to continue work; looking down, he would have decided to finish his faggot and go home. The distant rims of the world and of the firmament seemed to be a division in time no less than a division

in matter. The face of the heath by its mere complexion added half an hour to evening; it could in like manner retard the dawn, sadden noon, anticipate the frowning of storms scarcely generated, and intensify the opacity of a moonless midnight to a cause of shaking and dread.

In fact, precisely at this transitional point of its nightly roll into darkness the great and particular glory of the Egdon waste began, and nobody could be said to understand the heath who had not been there at such a time. It could best be felt when it could not clearly be seen, its complete effect and explanation lying in this and the succeeding hours before the next dawn: then, and only then, did it tell its true tale. The spot was, indeed, a near relation of night, and when night showed itself an apparent tendency to gravitate together could be perceived in its shades and the scene. The sombre stretch of rounds and hollows seemed to rise and meet the evening gloom in pure sympathy, the heath exhaling darkness as rapidly as the heavens precipitated it. And so the obscurity in the air and the obscurity in the land closed together in a black fraternization towards which each advanced half-way.

The place became full of a watchful intentness now; for when other things sank brooding to sleep the heath appeared slowly to awake and listen. Every night its Titanic form seemed to await something; but it had waited thus, unmoved, during so many centuries, through the crises of so many things, that it could only be imagined to await one last crisis — the final overthrow.

It was a spot which returned upon the memory of those who loved it with an aspect of peculiar and kindly congruity. Smiling champaigns of flowers and fruit hardly do this, for they are permanently harmonious only with an existence of better reputation as to its issues than the present. Twilight combined with the scenery of Egdon Heath to evolve a thing majestic without severity, impressive without showiness, emphatic in its admonitions, grand in its simplicity. The qualifications which frequently invest the façade of a prison with far more dignity than is found in the façade of a palace double its size lent to this heath a sublimity in which spots renowned for beauty of the accepted kind are utterly wanting. Fair prospects wed happily with fair times; but alas, if times be not fair! Men have oftener suffered from the mockery of a place too smiling for their reason than from the oppression of surroundings oversadly tinged. Haggard Egdon appealed to a subtler and scarcer instinct, to a more recently learnt emotion, than that which responds to the sort of beauty called charming and fair.

Indeed, it is a question if the exclusive reign of this orthodox beauty is not approaching its last quarter. The new Vale of Tempe may be a gaunt waste in Thule: human souls may find themselves in closer and closer harmony with external things wearing a sombreness distasteful to our race when it was young. The time seems near, if it has not actually arrived, when the chastened sublimity of a moor, a sea, or a mountain will be all of nature that is absolutely in keeping with the moods of the more thinking among mankind. And ultimately, to the commonest tourist, spots like Iceland may become what the vineyards and myrtle-gardens of South Europe are to him now; and Heidelberg and Baden be passed unheeded as he hastens from the Alps to the sand-dunes of Scheveningen.

The most thorough-going ascetic could feel that he had a natural right to wander on Egdon: he was keeping within the line of legitimate indulgence when he laid himself open to influences such as these. Colours and beauties so far subdued were, at least, the birthright of all. Only in summer days of highest feather did its mood touch the level of gaiety. Intensity was more usually reached by way of the solemn than by way of the brilliant, and such a sort of intensity was often arrived at during winter darkness, tempests, and mists. Then Egdon was aroused to reciprocity; for the storm was its lover, and the wind its friend. Then it became the home of strange phantoms; and it was found to be the hitherto unrecognized original of those wild regions of obscurity which are vaguely felt to be compassing us about in midnight dreams of flight and disaster, and are never thought of after the dream till revived by scenes like this.

It was at present a place perfectly accordant with man's nature — neither ghastly, hateful, nor ugly: neither commonplace, unmeaning, nor tame; but, like man, slighted and enduring; and withal singularly colossal and mysterious in its swarthy monotony. As with some persons who have long lived apart, solitude seemed to look out of its countenance. It had a lonely face, suggesting tragical possibilities.

This obscure, obsolete, superseded country figures in Domesday. Its condition is recorded therein as that of heathy, furzy, briary wilderness — 'Bruaria.' Then follows the length and breadth in leagues; and, though some uncertainty exists as to the exact extent of this ancient lineal measure, it appears from the figures that the area of Edgon down to the present day has but little diminished. 'Turbaria Bruaria' — the right of cutting heath-turf — occurs in charters relating to the district. 'Overgrown with heth and mosse,' says Leland of the same dark sweep of country.

Here at least were intelligible facts regarding landscape — far-reaching proofs productive of genuine satisfaction. The untameable, Ishmaelitish thing that Egdon now was it always had been. Civilisation was its enemy; and ever since the beginning of vegetation its soil had worn the same antique brown dress, the natural and invariable garment of the particular formation. In its venerable one coat lay a certain vein of satire on human vanity in clothes. A person on a heath in raiment of modern cut and colours has more or less an anomalous look. We seem to want the oldest and simplest human clothing where the clothing of the earth is so primitive.

To recline on a stump of thorn in the central valley of Egdon, between afternoon and night, as now, where the eye could reach nothing of the world outside the summits and shoulders of heathland which filled the whole circumference of its glance, and to know that everything around and underneath had been from prehistoric times as unaltered as the stars overhead, gave ballast to the mind adrift on change, and harassed by the irrepressible New. The great inviolate place had an ancient permanence which the sea cannot claim. Who can say of a particular sea that it is old? Distilled by the sun, kneaded by the moon, it is renewed in a year, in a day, or in an hour. The sea changed, the fields changed, the rivers, the villages, and the people changed, yet Egdon remained. Those surfaces were neither so steep as to be destructible by weather, nor so flat as to be the victims of floods and deposits. With the exception of an aged highway, and a still more aged barrow presently to be referred to — themselves almost crystallized to natural products by long continuance — even the trifling irregularities were not caused by pickaxe, plough, or spade, but remained as the very finger-touches of the last geological change.

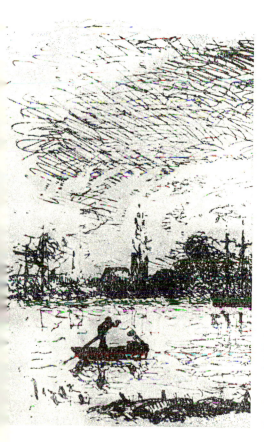

The above-mentioned highway traversed the lower levels of the heath, from one horizon to another. In many portions of its course it overlaid an old vicinal way, which branched from the great Western road of the Romans, the Via Iceniana, or Ikenild Street, hard by. On the evening under consideration it would have been noticed that, though the gloom had increased sufficiently to confuse the minor features of the heath, the white surface of the road remained almost as clear as ever.

The scene before the reddleman's eyes was a gradual series of ascents from the level of the road backward into the heart of the heath. It embraced hillocks, pits, ridges, acclivities, one behind the other, till all was finished by a high hill cutting against the still light sky. The traveller's eye hovered about these things for a time, and finally settled upon one noteworthy object up there. It was a barrow. This bossy projection of earth above its natural level occupied the loftiest ground of the loneliest height that the heath contained. Although from the vale it appeared but as a wart on an Atlantean brow, its actual bulk was great. It formed the pole and axis of this heathery world.

The weather was far different from that of the evening before. The yellow and vapoury sunset which had wrapped up Eustacia from his parting gaze had presaged change. It was

one of those not infrequent days of an English June which are as wet and boisterous as November. The cold clouds hastened on in a body, as if painted on a moving slide. Vapours from other continents arrived upon the wind, which curled and parted round him as he walked on.

At length Clym reached the margin of a fir and beech plantation that had been enclosed from heath land in the year of his birth. Here the trees, laden heavily with their new and humid leaves, were now suffering more damage than during the highest winds of winter, when the boughs are specially disencumbered to do battle with the storm. The wet young beeches were undergoing amputations, bruises, cripplings, and harsh lacerations, from which the wasting sap would bleed for many a day to come, and which would leave scars visible till the day of their burning. Each stem was wrenched at the root, where it moved like a bone in its socket, and at every onset of the gale convulsive sounds came from the branches, as if pain were felt. In a neighbouring brake a finch was trying to sing; but the wind blew under his feathers till they stood on end, twisted round his little tail, and made him give up his song.

Yet a few yards to Yeobright's left, on the open heath, how ineffectively gnashed the storm! Those gusts which tore the trees merely waved the furze and heather in a light caress. Egdon was made for such times as these.

The Return of the Native, 1878. THOMAS HARDY

Here, then. The site was a good one. From this part of the climbing road one looked over the lower valley of the Exe, saw the whole estuary, and beyond that a horizon of blue sea. Fair, rich land, warm under the westering sun. The house itself seemed to be old, but after all was not very large; it stood amid laurels, and in the garden behind rose a great yew-tree. No person was visible; but for the wave-like murmur of neighbouring pines, scarce a sound would have disturbed the air.

Godwin walked past, and found that the road descended into a deep hollow, whence between high banks, covered with gorse and bracken and many a summer flower, it led again up a hill thick planted with firs; at the lowest point was a bridge over a streamlet, offering on either hand a view of soft green meadows. A spot of exquisite retirement: happy who lived here in security from the struggle of life!

Before long, the carriage was stopped that he might enjoy one of the pleasantest views in the neighbourhood of the city. A gate, interrupting a high bank with which the road was bordered, gave admission to the head of a great cultivated slope, which fell to the river Exe; hence was suddenly revealed a wide panorama. Three well-marked valleys — those of the Creedy, the Exe, and the Culm — spread their rural loveliness to remote points of the horizon; gentle undulations, with pasture and woodland, with long winding roads, and many a farm that gleamed white amid its orchard leafage, led the gaze into regions of evanescent hue and outline. Westward, a bolder swell pointed to the skirts of Dartmoor. No inappropriate detail disturbed the impression. Exeter was wholly hidden behind the hill on which the observers stood, and the line of railway leading thither could only be descried by special

search. A foaming weir at the hill's foot blended its soft murmur with that of the fir branches hereabouts; else, no sound that the air could convey beyond the pulsing of a bird's note. All had alighted, and for a minute or two there was silence. When Peak had received such geographical instruction as was needful, Warricombe pointed out to him a mansion conspicuous on the opposite slope of the Exe valley, the seat of Sir Stafford Northcote. The house had no architectural beauty, but its solitary lordship amid green pastures and tracts of thick wood declared the graces and privileges of ancestral wealth. Standing here alone, Godwin would have surveyed these possessions of an English aristocrat with more or less bitterness; envy would, for a moment at all events, have perturbed his pleasure in the natural scene. Accompanied as he was, his emotion took a form which indeed was allied to envy, but had nothing painful.

He extended his walks in every direction, sometimes rambling up the valley to sleepy little towns where he could rest in the parlours of old inns, sometimes striking across country to this or that point of the sea-coast, or making his way to the nearer summits of Dartmoor, noble in their wintry desolation. He marked with delight every promise of returning spring. When he could only grant himself a walk of an hour or two in the sunny afternoon, there was many a deep lane within easy reach, where the gorse gleamed in masses of gold, and the little oak trees in the hedges were ruddy with last year's clinging leafage, and catkins hung from the hazels, and the fresh green of sprouting ivy crept over bank and wall. Had he now been in London, the morning would have awakened him to fog and slush and misery. As it was, when he looked out upon the glow of sunrise, he felt the sweet air breathing health into his frame and vigour into his mind. There were moments when he could all but say of himself that he was at peace with the world.

As on a morning towards the end of March, when a wind from the Atlantic swept spaces of brightest blue amid the speeding clouds, and sang joyously as it rushed over hill and dale. It was the very day for an upland walk, for a putting forth of one's strength in conflict with boisterous gusts and sudden showers, that give a taste of earth's nourishment.

Born in Exile, 1892. GEORGE GISSING

The Cockney pilgrimage passed into a pleasant lane overhung with chestnut and laburnum trees. The spring had been late, and the white blossoms stood up like candles — the yellow dropped like tassels, and the streaming sunlight filled the leaves with tints of pale gold, and their light shadows patterned the red earth of the pathway. But very soon this pleasant pathway debouched on a thirsting roadway where tired horses harnessed to heavy vehicles toiled up a long hill leading to the Downs. The trees intercepted the view, and the blown dust whitened the foliage and the wayside grass, now in possession of hawker and vagrant. The crowd made way for the vehicles; and the young men in blue and grey trousers, and their girls in white dresses, turned and watched the four horses bringing along the tall drag crowned with London fashion, and the unwieldy omnibus, and the brake filled with fat girls in pink dresses and yellow hats, and the spring cart drawn up under a hedge. The

cottage gates were crowded with folk come to see London going to the Derby. Outhouses had been converted into refreshment bars, and from these came a smell of beer and oranges; farther on there was a lamentable harmonium — a blind man singing hymns to its accompaniment, and a one-legged man holding his hat for alms; and not far away there stood an earnest-eyed woman offering tracts, warning folk of their danger, beseeching them to retrace their steps.

The great landscape, half country, half suburb, glinted beneath the rays of a setting sun; and through the white dust, and the drought of the warm roads, the brakes and carriages and every crazy vehicle rolled towards London; orange sellers, tract sellers, thieves, vagrants, gipsies, made for their various quarters — roadside inns, outhouses, hayricks, hedges, or the railway station. Down the long hill the vast crowd made its way, humble pedestrians and carriage folk, all together, as far as the cross-roads. At the "Spread Eagle" there would be stoppage for a parting drink, there the bookmakers would change their clothes, and there division would happen in the crowd — half for the railway station, half for the London road. It was there that the traditional sports of the road began. A drag, with a band of exquisites armed with pea-shooters, peppering on costers who were getting angry, and threatening to drive over the leaders. A brake with two poles erected, and hanging on a string quite a line of miniature chamber-pots. A horse, with his fore-legs clothed in a pair of lady's drawers. The horse stepping along so absurdly that Esther and Sarah thought they'd choke with laughter.

Esther Waters, 1894. GEORGE MOORE

I have a strange longing for the great simple primeval things, such as the Sea, to me no less of a mother than the Earth. It seems to me that we all look at Nature too much, and live with her too little. I discern great sanity in the Greek attitude. They never chattered about sunsets, or discussed whether the shadows on the grass were really mauve or not. But they saw that the sea was for the swimmer, and the sand for the feet of the runner. They loved the trees for the shadow that they cast, and the forest for its silence at noon. The vineyard-dresser wreathed his hair with ivy that he might keep off the rays of the sun as he stooped over the young shoots, and for the artist and the athlete, the two types that Greece gave us, they plaited into garlands the leaves of the bitter laurel and of the wild parsley which else had been of no service to man.
We call ourselves a utilitarian age, and we do not know the uses of any single thing. We have forgotten that Water can cleanse, and Fire purify, and that the Earth is mother to us all. As a consequence our Art is of the Moon and plays with shadows, while Greek art is of the Sun and deals directly with things. I feel sure that in elemental forces there is purification, and I want to go back to them and live in their presence.

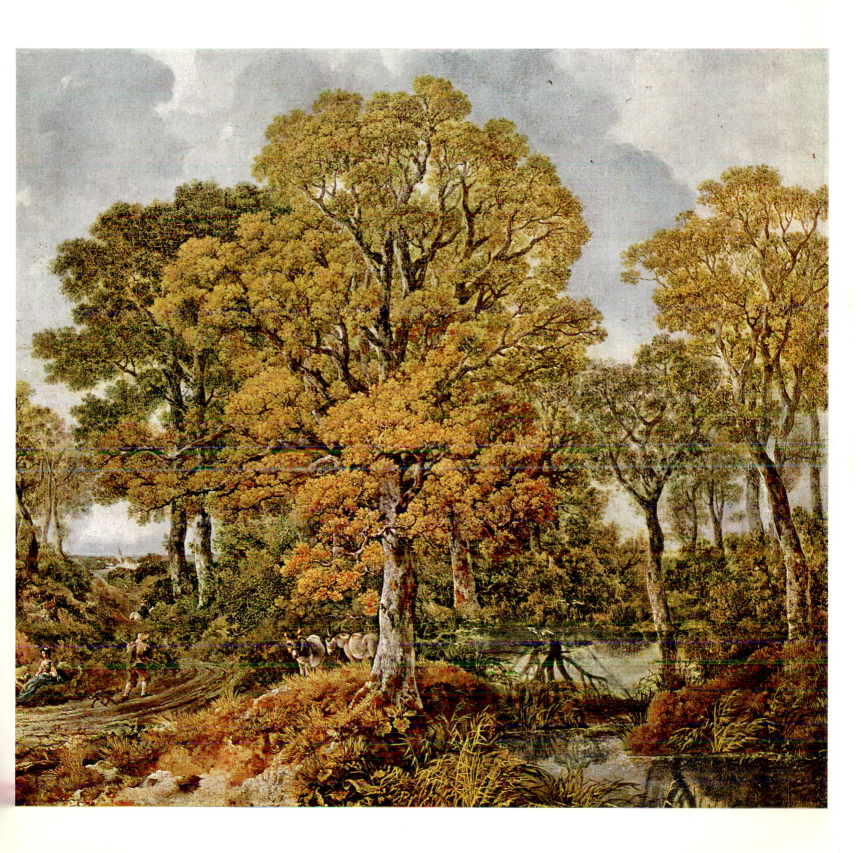

2. Thomas Gainsborough: *Gainsborough's Forest*. 1748. Oil on canvas, 47¼ x 59 inches. London, National Gallery.

A youthful work, it indicates the painter's talent for landscape, interpreted in a showy manner, somewhat theatrically.

3. Thomas Gainsborough: *Port with Sailboat*. 1783. Oil on glass, 11 x 13⅛ inches. London, Victoria and Albert Museum.

This is one of twelve landscapes painted on glass, perhaps to take advantage of the light shining through from the back. The artist achieved limpid and luminous atmospheric effects that anticipate Constable.

4. John Varley: *Dolgelly, Wales* (detail). 1811. Watercolor, entire painting 8⅝ x 18⅞ inches. London, Victoria and Albert Museum.

Their perfect technique and acute perception of flowing light and color enabled the English watercolorists to prepare the way for modern landscape art.

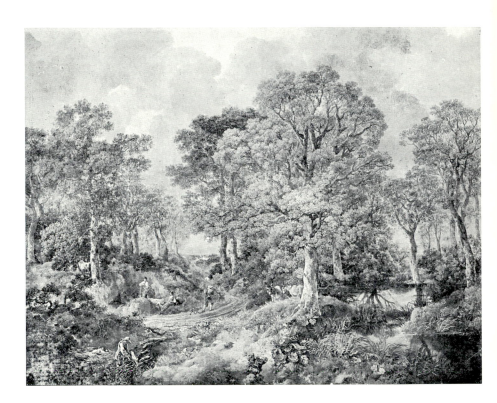

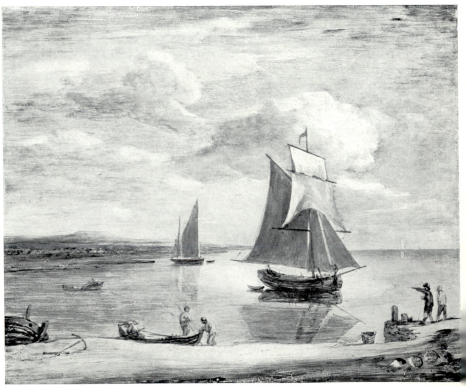

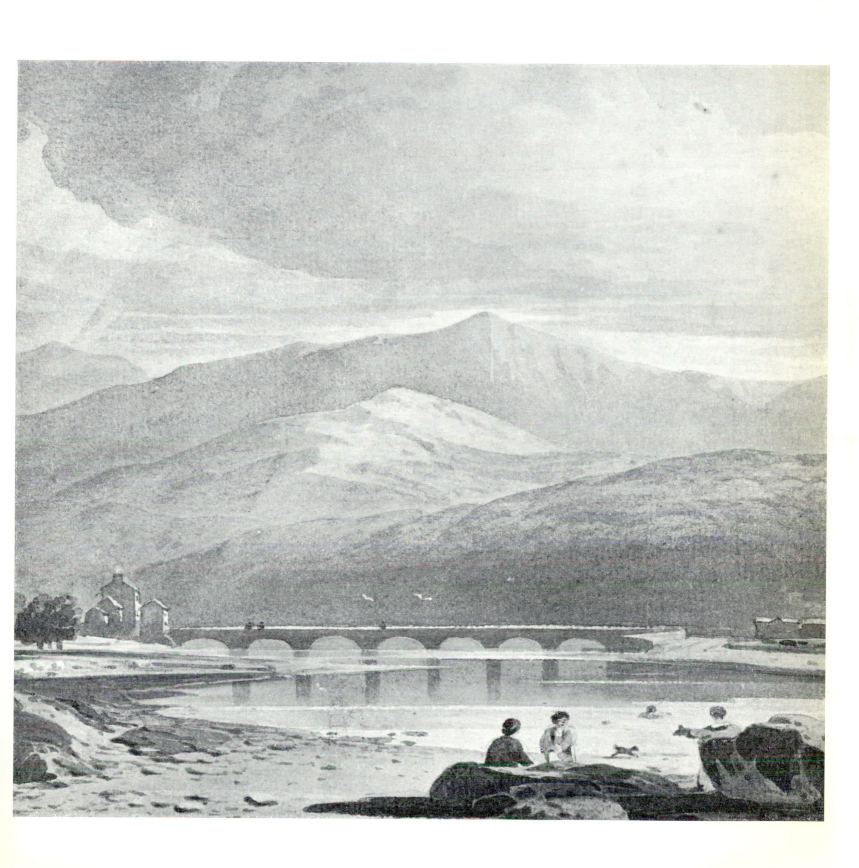

5. J.M.W. Turner: *View of Orvieto*. 1828. Oil on canvas, 36 x 48 inches. London, Tate Gallery.

Turner travelled through several European countries. On his first trip to Italy in 1819, he visited Rome, Naples and Venice. He returned to Rome several times, and to Venice in 1835 and 1840, attracted not only by the beauty of the city, but also by Venetian painting, especially the work of the vedutisti. *In this view of Orvieto, feeling is still contained within representational bounds.*

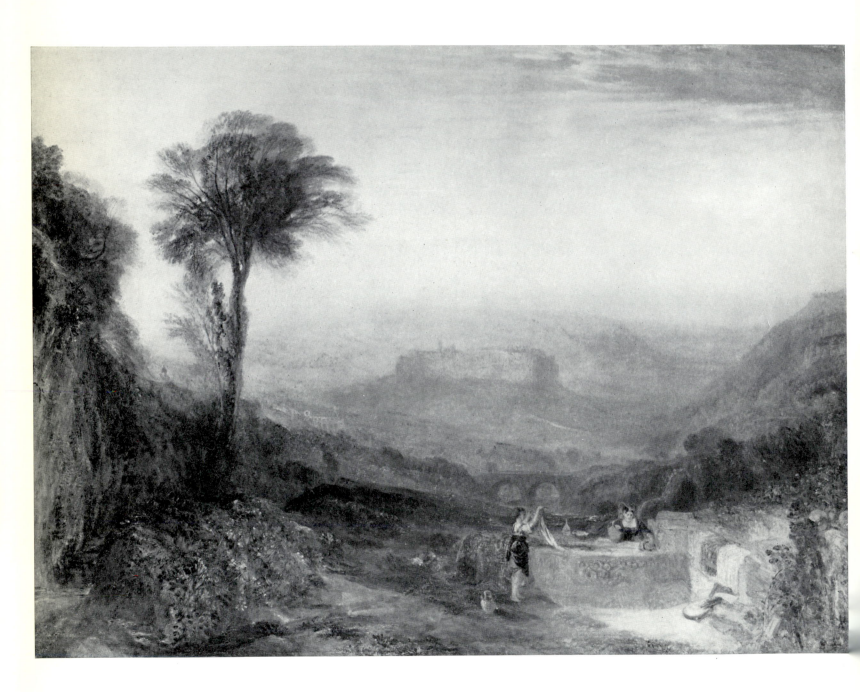

6. J.M.W. Turner: *The 'Fighting Téméraire' Tugged to Her Last Berth to Be Broken Up.* 1839. Oil on canvas, $35\frac{3}{8}$ x $47\frac{1}{4}$ inches. London, National Gallery.

The ship played an important part in the battle of Trafalgar (1805). In 1838 when she was being towed to her destruction, Turner depicted her last voyage in fantastic light, in triumph, like a hero being conducted in glory to his last resting place.

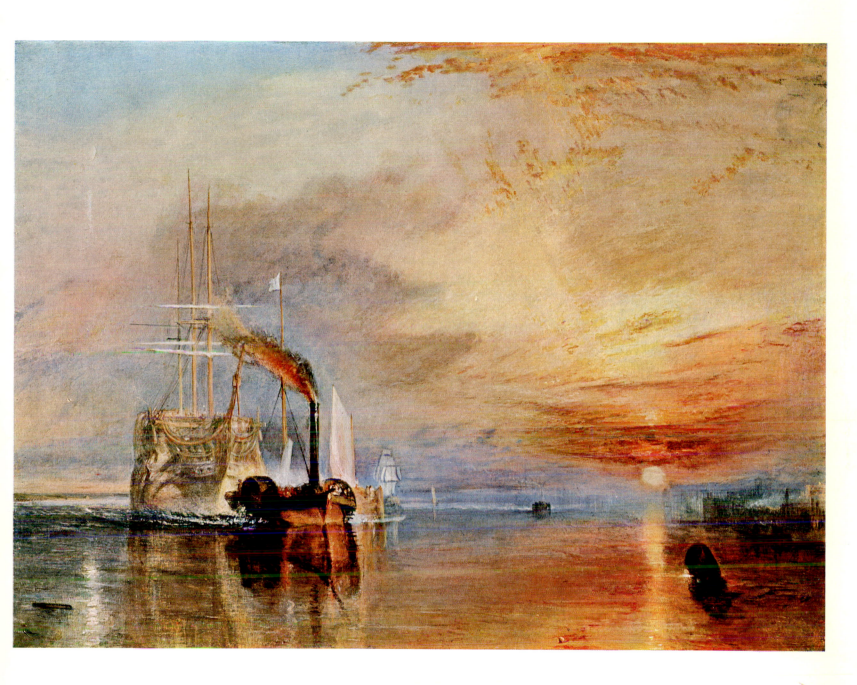

7. J.M.W. Turner: *Bridge of Sighs, Ducal Palace, and Custom House, Venice: Canaletto painting.* 1833. Oil on panel, 20 x 31⅞ inches. London, Tate Gallery.

The painting was done in London from drawings Turner had made during his first trip in 1819. It is possible he had a view of Canaletto's in mind as an homage to the Venetian artist, whom we see in the act of painting at the lower left.

8. J.M.W. Turner: *Keelmen Heaving In Coals by Moonlight.* 1835. Oil on canvas, 36¼ x 48¼ inches. Washington, D.C., National Gallery (Widener Collection).

In this night scene the painter finds fertile ground for his imagination in the extraordinary variations of light, the reflections in the water, the vaporous atmosphere caught between the silver moonlight and the glare of the fires burning on the ships.

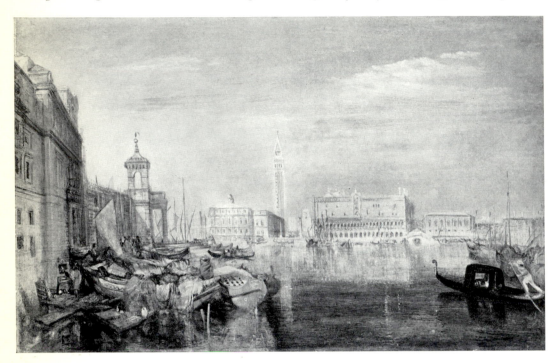

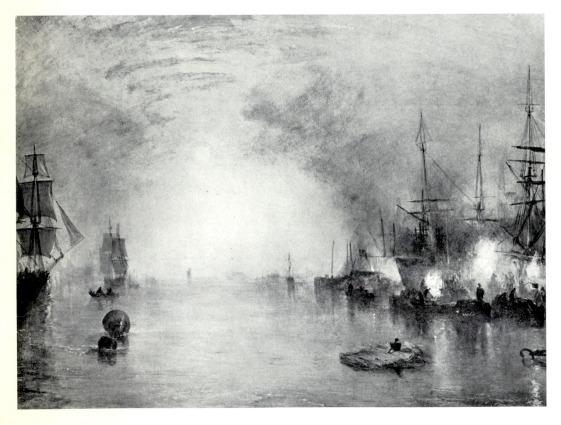

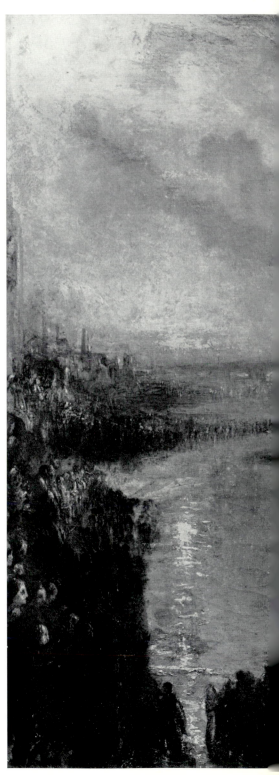

9. J.M.W. Turner: *The Burning of The Houses of Parliament.* 1835. Oil on canvas, 37 x 48⅜ inches. Cleveland, Museum of Art.
The fire raged (October 1834), and Turner was there making sketches, which he used later in his studio as the basis of several paintings. This painting appears to be the view from Waterloo Bridge. The mass of flame rises in the night, casting dramatic highlights which Turner accentuates with thick brushfuls of color.

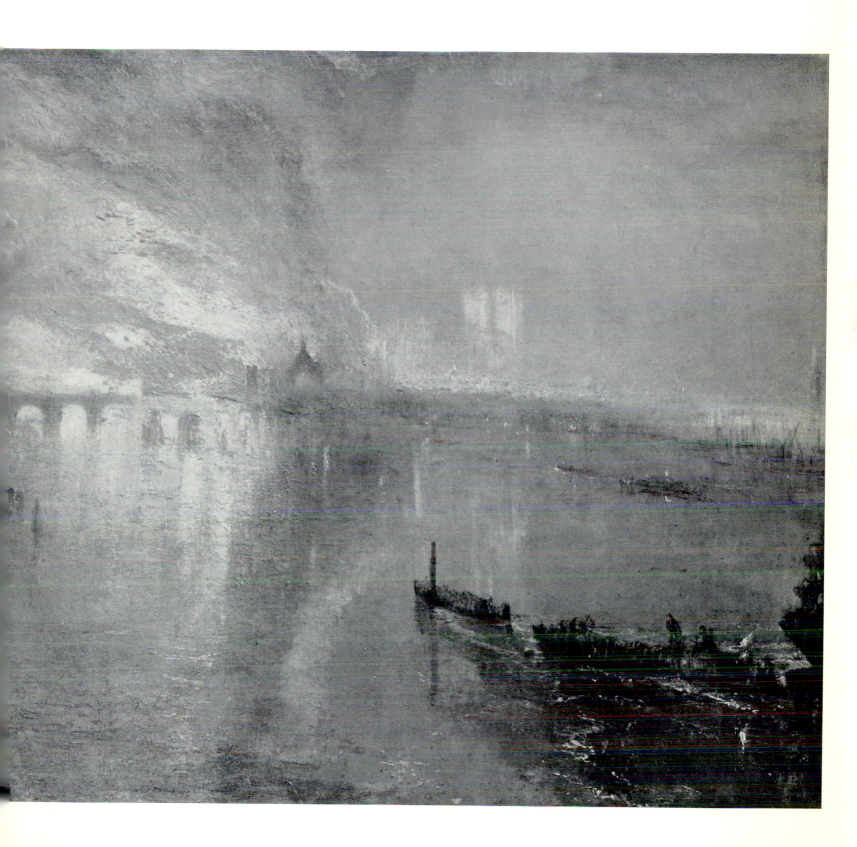

10. J.M.W. Turner: *Venice, The Piazzetta with the Ceremony of the Doge Marrying the Sea.* 1840. Oil on canvas, $35\frac{7}{8}$ x 48 inches. London, Tate Gallery.

Here we see depicted the ceremony of the Marriage with the Sea. By this time the painter has foregone the clear perspective of Canaletto and is realizing all the possibilities he found in Guardi's looser brushwork. Turner here evokes rather than describes the scene with broad strokes of color and veiled transparencies.

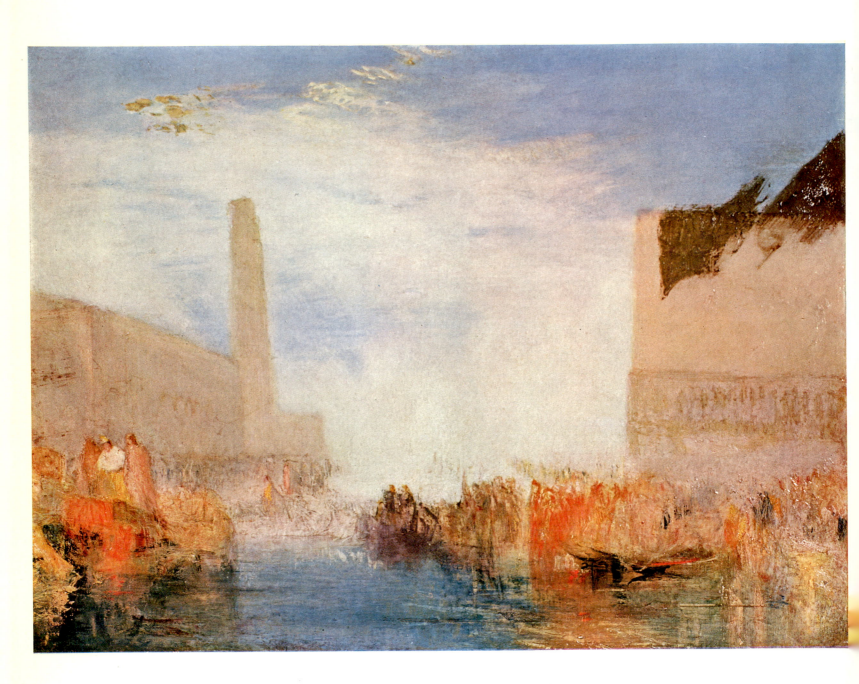

11. J.M.W. Turner: *Snowstorm.* 1842. Oil on canvas, 35⅜ x 47¼ inches. London, Tate Gallery.
This is one of Turner's most celebrated late paintings, in which the subject and the forms dissolve in the light and the atmosphere. When it was first exhibited in London in 1842, the title attempted to clarify what the painting was about: "Snowstorm: steamboat off a harbour's mouth making signals in shallow water and going by the lead."

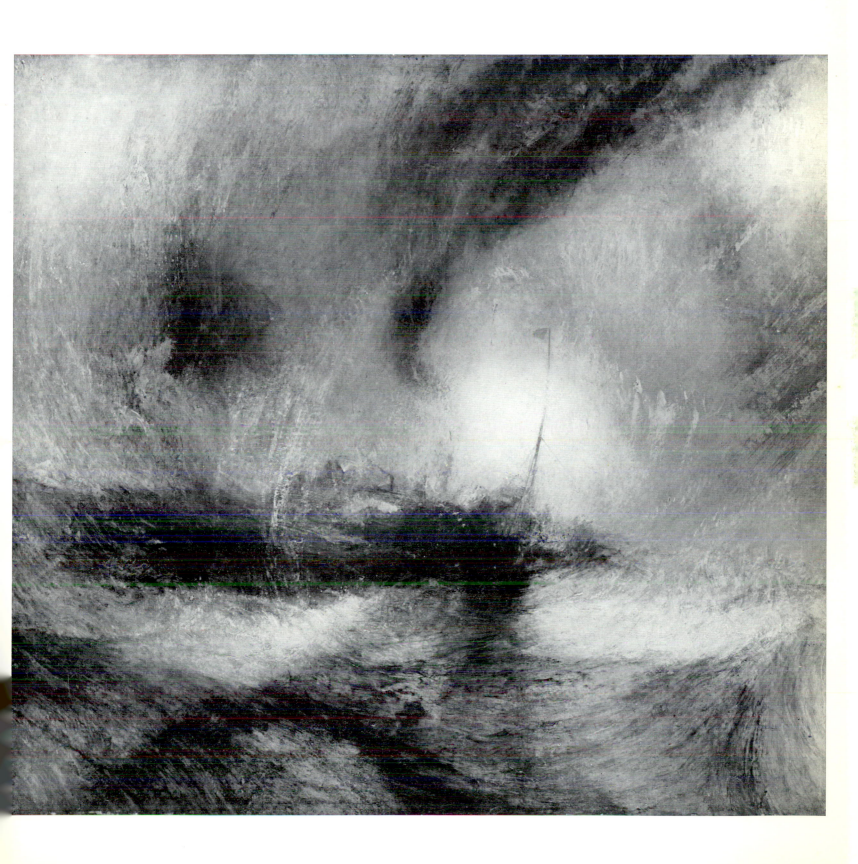

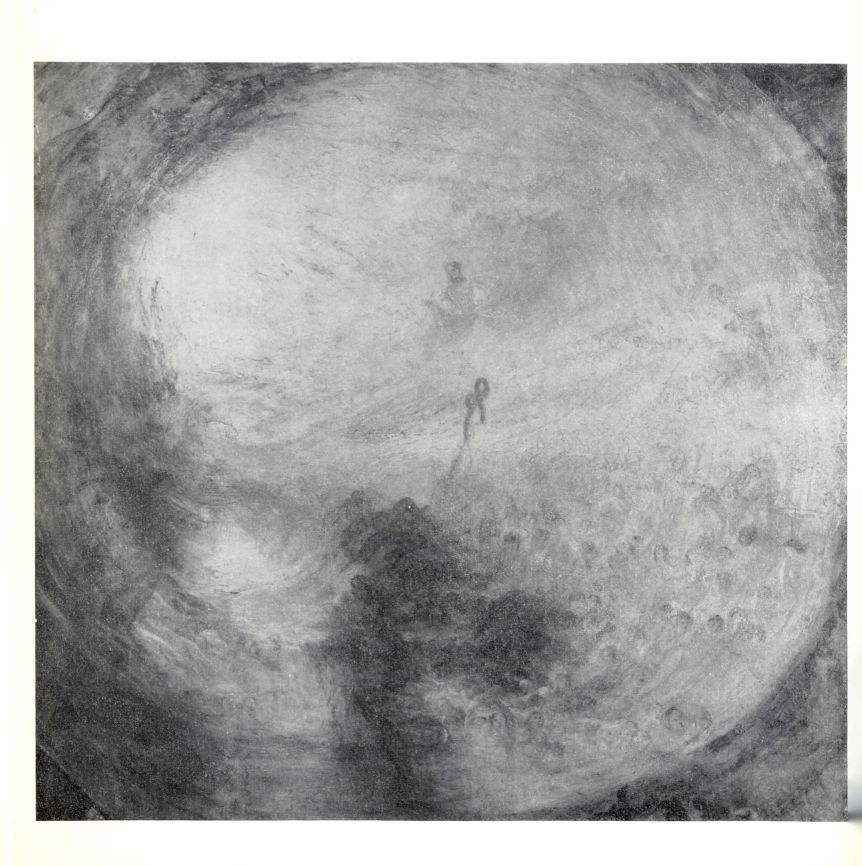

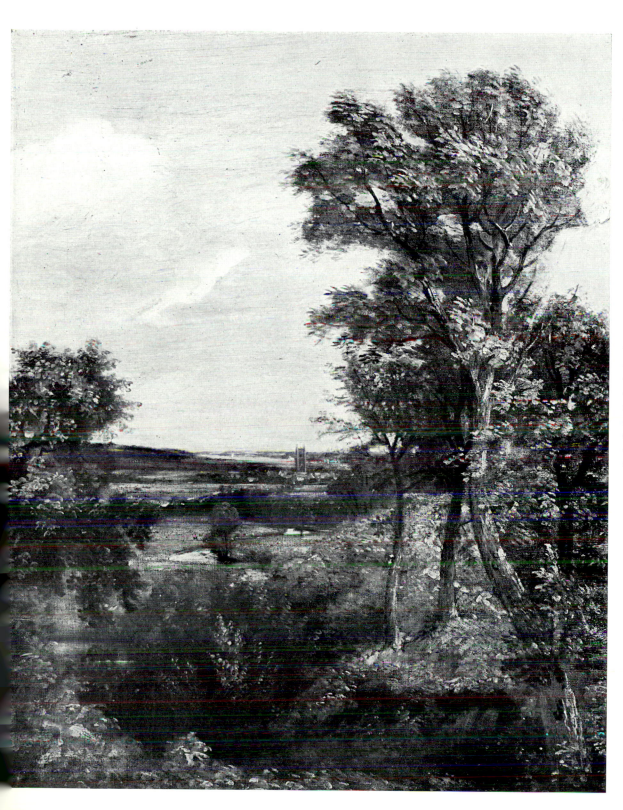

12. J.M.W. Turner: *The Morning After the Deluge*. 1843. Oil on canvas, 30¼ x 30¼ inches. London, Tate Gallery.

In his later years, Turner frequently painted storm scenes. But more than the dramatic spectacle of such a scene, he wanted to render the play of light and air in purely painterly terms. In this painting, as the artist's own title declared, we see "Light and color (Goethe's theory) the morning after the deluge — Moses writing the Book of Genesis," and the eternal conflict between Light and Shadow, Good and Evil.

13. John Constable: *Dedham Valley*. 1802. Oil on canvas, 17⅛ x 11¾ inches. London, Victoria and Albert Museum.

Constable was to paint a number of landscapes in this valley. This is among the first, and while revealing his close observation of the natural world, it also shows signs of his admiration for Marco Ricci's Venetian landscapes, which were well known in England, and for the art of Claude Lorrain.

14. John Constable: *Flatford Mill from a Lock on the Stour*. c. 1811. Oil on canvas, 9¾ x 11¾ inches. London, Victoria and Albert Museum.

The painting was executed rapidly as a sign of emotional rather than representational intention. The mill belonged to his father, and Constable was to depict it at several different times. By the time he did this version, he had overcome any attachment to the classical mythology or historical legend considered proper subjects by neoclassicism, as we can see in this lively, directly observed scene from nature.

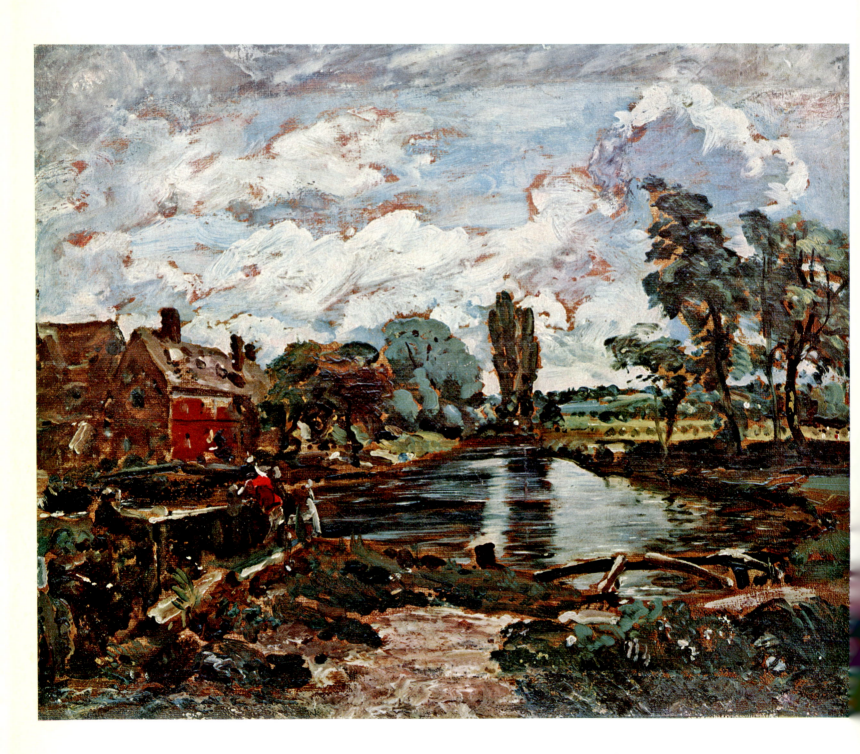

15. John Constable: *Stoke-by-Nayland*. 1820 (?). Oil on canvas, 14 x 17½ inches. London, Tate Gallery.
Even if not an " impression " of the natural world as painted by the French artists some sixty years later, it is nonetheless an important forerunner of that kind of naturalism, rendered with a freedom not even the Barbizon painters were to achieve thirty years later.

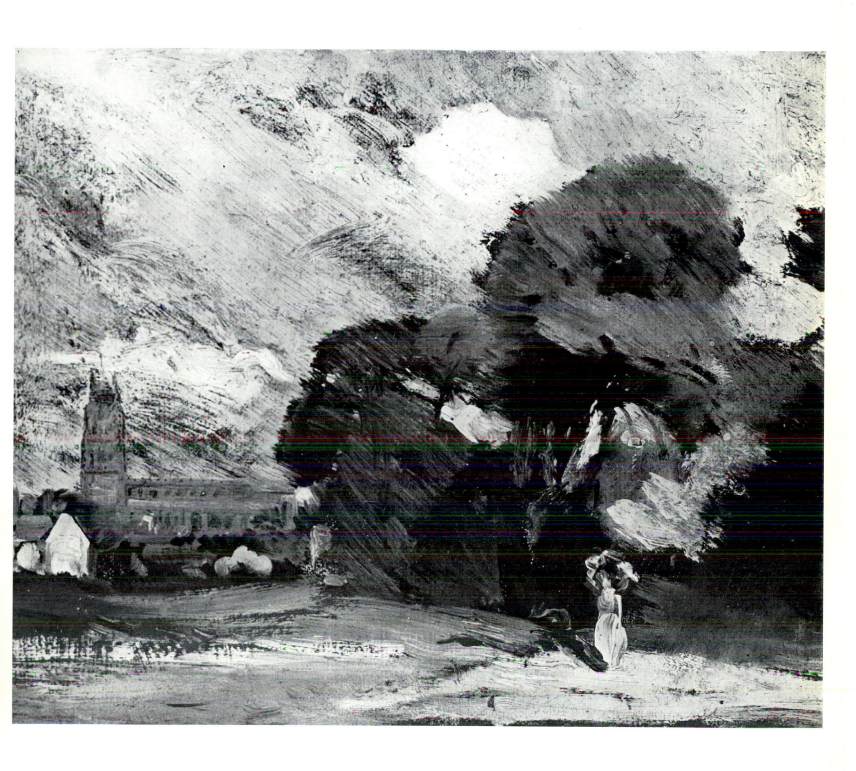

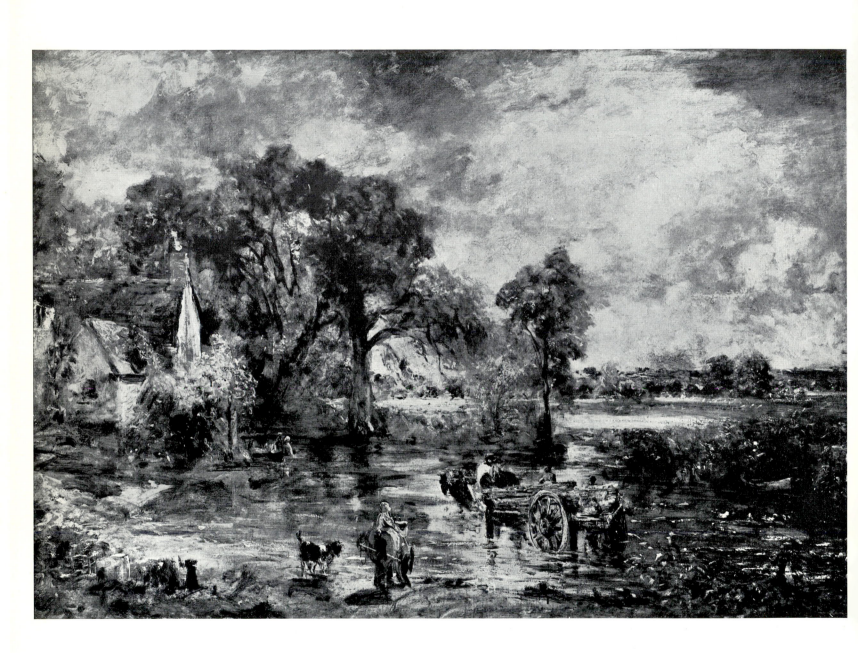

16. John Constable: *Study for 'The Hay Wain.'* 1821. Oil on canvas, 53⅞ x 74 inches. London, Victoria and Albert Museum.

This is the first version of the painting he was to exhibit in London and Paris in 1824. Taking full advantage of the landscape the canal passes through, with its green current against whites and deep browns and the great clouds streaked with blue, the painting is superb proof of the artist's romantic invention. The painting amazed Paris and confirmed to young painters the striking possibilities available to them in painting outdoors.

17. John Constable: *Salisbury Cathedral and Archdeacon Fisher's House, from the River.* 1820. Oil on canvas, 20¾ x 30¼ inches. London, National Gallery.

From the time the artist visited Salisbury in 1811, the cathedral was to appear often in his drawings and paintings, always in a different mood. In this version, the river and the trees are caught with a freshness of vision that gives fluidity and luminosity to the painting.

18. John Constable: *Salisbury Cathedral and Archdeacon Fisher's House, from the River* (detail).

This detail of the river shows with what fluidity and immediacy Constable painted, especially his rendering of reflections playing on water.

19. John Constable: *Hampstead Heath*. 1820. Oil on canvas, 25¼ x 30⅛ inches. Cambridge, Fitzwilliam Museum.

In the summer of 1819, Constable went to stay at Hampstead, north of London. He returned there for several summers and painted the landscape from various points of view. In this painting we see, over the skillfully rendered green expanse of the plain, the immense spaciousness of the sky and the bright patches of light on the ground below.

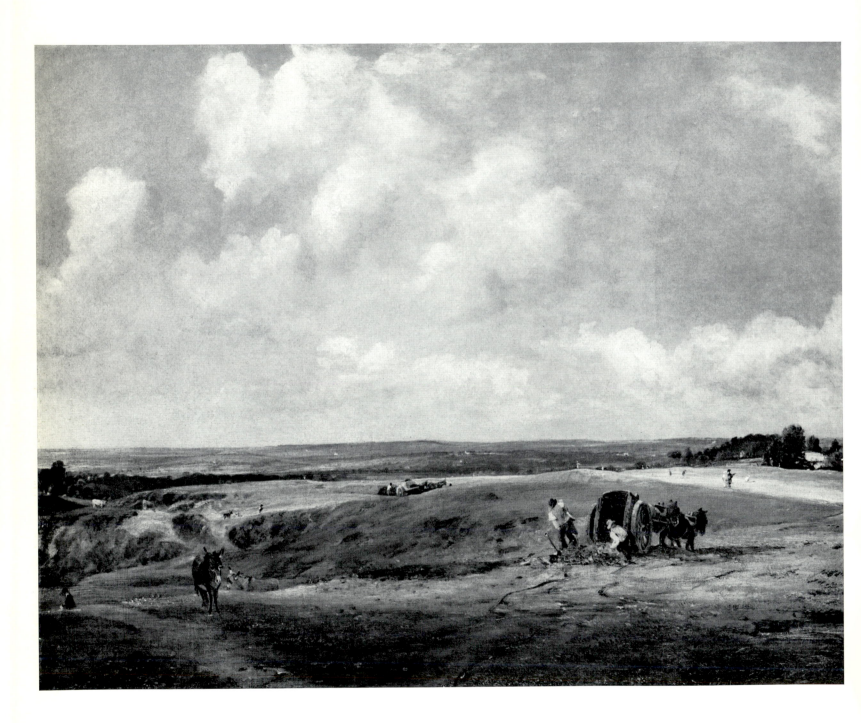

20. John Constable: *Salisbury Cathedral from the Bishop's Grounds.* 1823. Oil on canvas, $34\frac{1}{2}$ x 44 inches. London, Victoria and Albert Museum.

This is the most famous of several views of the cathedral. The painting was commissioned by Archdeacon Fisher, but he did not like it. His rejection may have been due to the unusual arrangement of light and shadow: the foreground in shadow putting into relief the cathedral bathed in unreal light. The intensity of the colors is striking, but in comparison to the other more freely handled versions, this version suffers somewhat from the fussiness of the details that takes it back in feeling to the eighteenth-century view of the natural world.

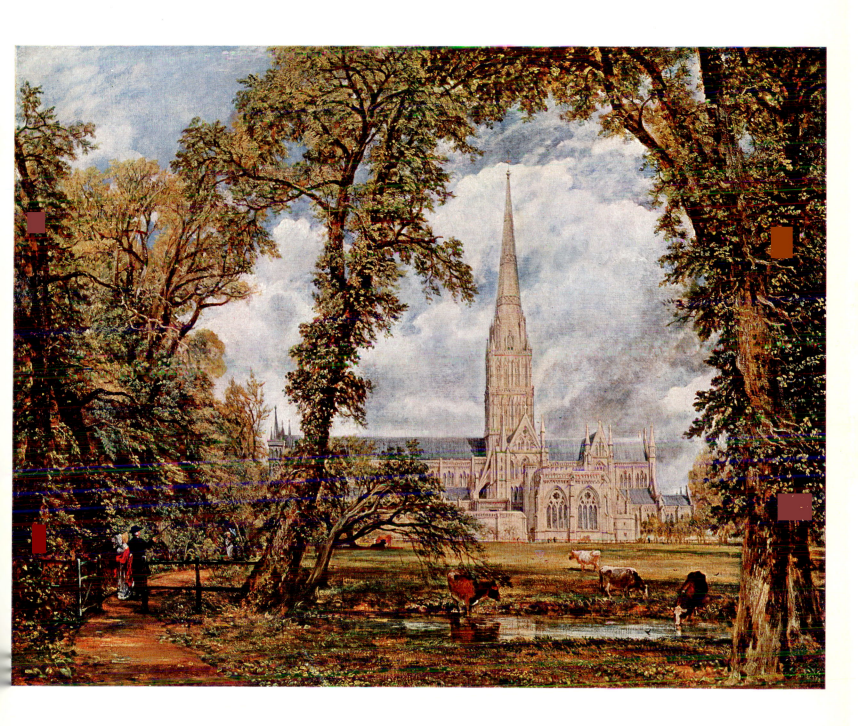

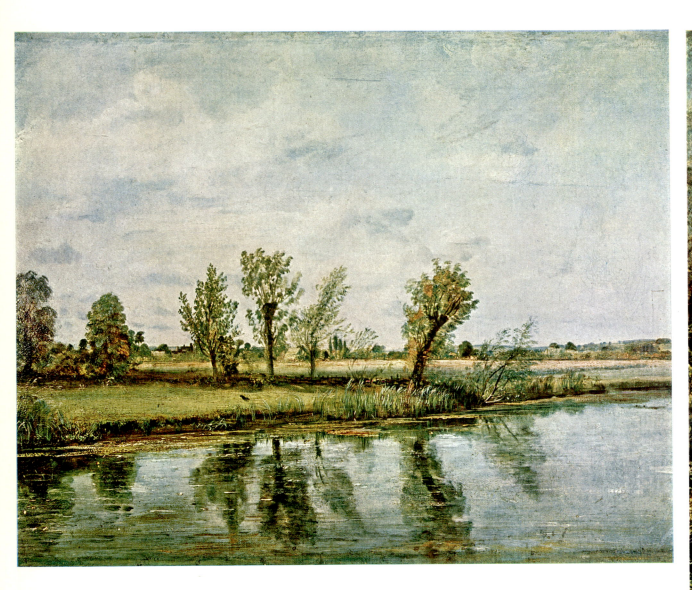

21. John Constable: *Water-Meadows Near Salisbury.* 1829. Oil on canvas, 18 x 21¾ inches. London, Victoria and Albert Museum.
We must take into account the period in which this was painted in order to appreciate the novelty of such a subdued scene: water lapping gently at the field and a few trees and clumps of cane. The artist has avoided complexity to convey the silence and solitude of the landscape. When he submitted it to the Royal Academy in 1830, it was rejected.

22. John Constable: *Study for 'The Leaping Horse.'* c. 1825. Oil on canvas, 50⅞ x 74 inches. London, Victoria and Albert Museum.
River landscapes were especially congenial to Constable's imagination, and he rendered them with intense colors thickly applied but with flowing brushwork. Usually, however, Constable preferred open and serene landscapes that expressed, it seems, the Olympian quality of nature. Here instead, the wind foreshadows the storm gathering in the sky, creating a purplish light and frightening the horse.

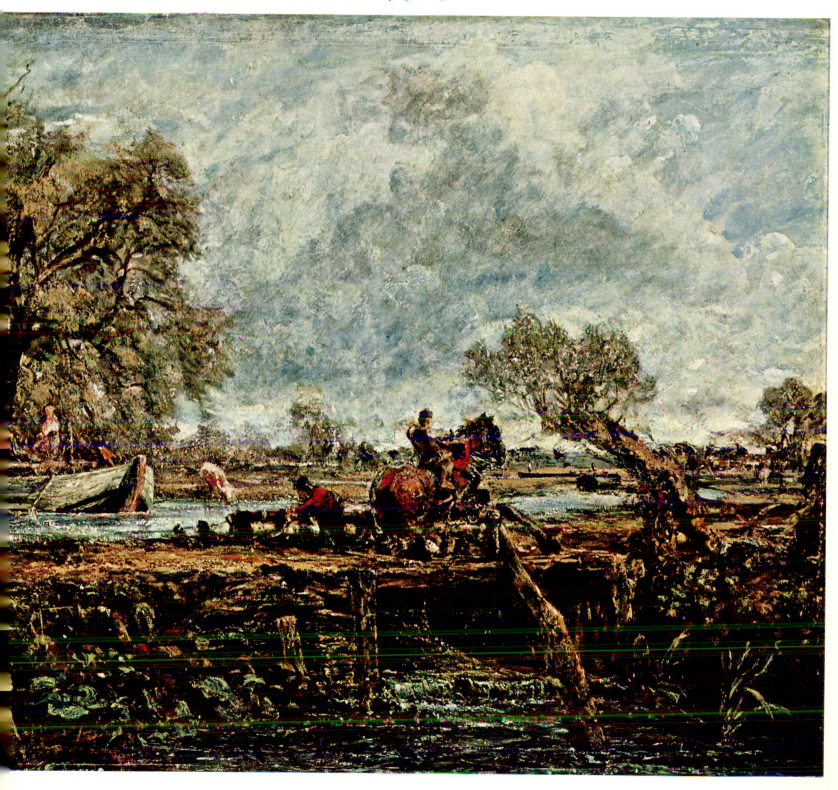

23. John Constable: *Summer Morning: Dedham from Langham*. c. 1830. Oil on canvas, 8½ x 12 inches. London, Victoria and Albert Museum.

Despite its small dimensions and its function as an oil sketch, this painting is remarkable for its rapid, sure, free rendering. The silvery light permeates the space and each element in it, giving the whole a very airy quality.

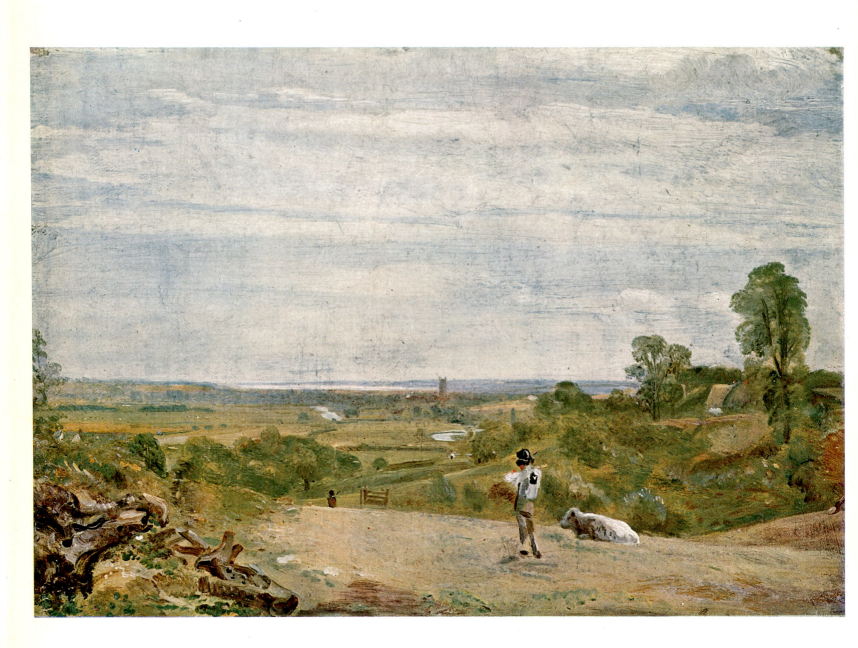

24. John Constable: *Sketch for 'The Valley Farm.'* c. 1835. Oil on canvas, 10 x 8¼ inches. London, Victoria and Albert Museum.

In his last years, Constable's painting became more and more summary and subjective. Wide spaces give way to scenes viewed close up, and details blur in favor of masses and chromatic densities, painted with broad brushstrokes and rapid dashes of light.

25. Richard Parkes Bonington: *Landscape with Mountains*. c. 1826. Oil on canvas, 9⅞ x 13 inches. Edinburgh, National Gallery of Scotland. *This small painting was done in Italy, in a valley near a lake perhaps. The sure simplicity of the representation and the clarity of the color are remarkable.*

26. Richard Parkes Bonington: *Coast of Normandy*. 1823-24. Oil on canvas, 17¾ x 15 inches. Paris, Louvre.
Living in Calais enabled him to paint numerous landscapes of the seashore. Free from the neoclassical norms then dominant in France, the artist pursued his own fresh, airy style in these views of the coast, rendered in luminous tones. In 1824 he exhibited at the Paris Salon and was awarded a gold medal.

27. John Crome: *Slate Pits*. 1802-1805. Oil on canvas, 52 x 61¾ inches. London, Tate Gallery.

He founded the Society of the Artists of Norwich, known as the Norwich School. At that time Norwich was the second largest English city. Among his early works we find this mountainous and rugged landscape.

28. James Stark: *The Path in the Forest*. Oil on panel, 20⅛ x 29⅞ inches. Norwich, Castle Museum.

Stark was one of Crome's pupils after he started the Norwich School and from him learned to observe nature directly. His paintings bring out even more the elements his teacher had appreciated in the Dutch painters of the seventeenth century.

29. John Sell Cotman: *The Wagon*. c. 1835. Oil on panel, 16⅛ x 13¾ inches. Norwich, Castle Museum.

The vivid colors, the dramatic sense of landscape, the rich impastos and the diffused light in this evocative painting indicate that Cotman was the most gifted of the Norwich painters.

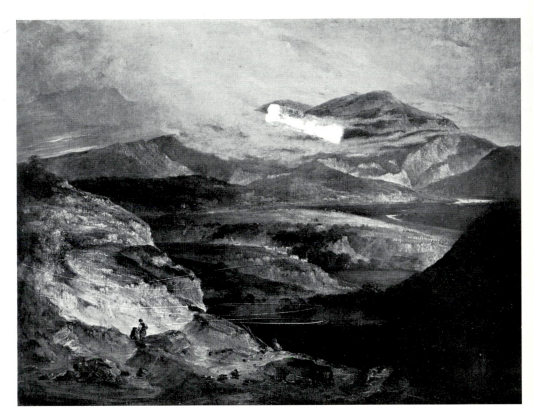

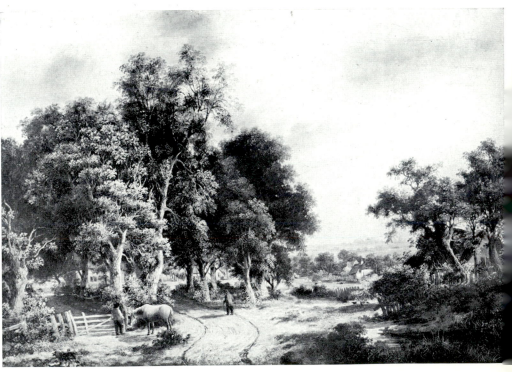

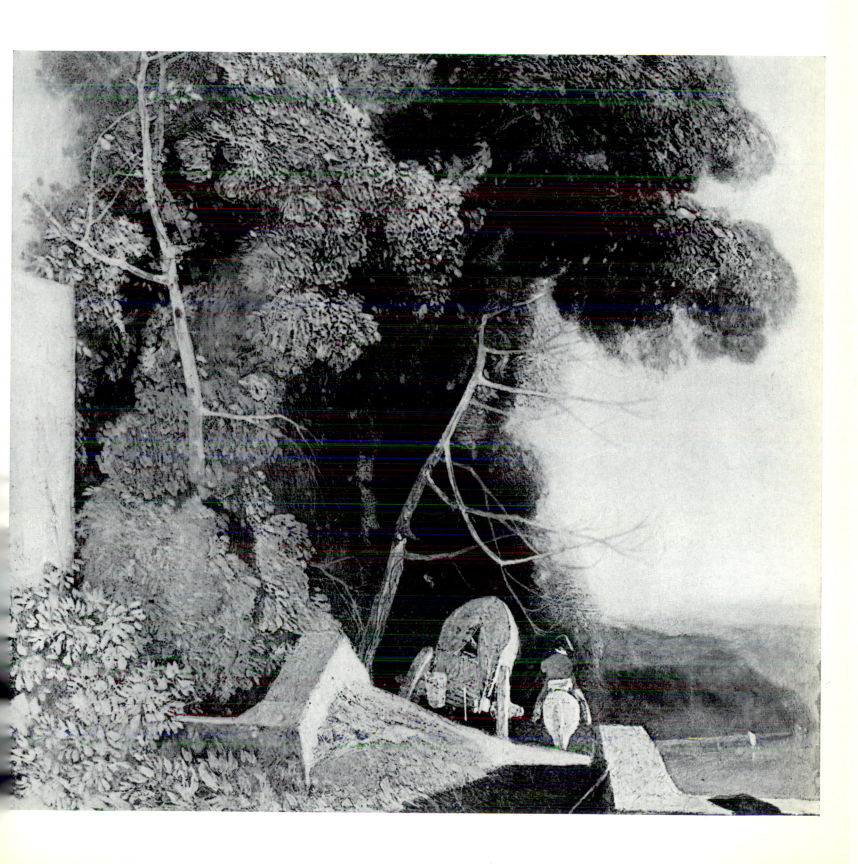

30. John Glover: *Borrowdale*. Watercolor, 16½ x 24 inches. Newcastle-upon-Tyne, Laing Art Gallery.

This imposing landscape, with its looming moutain, was painted in the Lake Country. The scrupulous craftsmanship, in which each leaf seems to have been painted individually, patiently and meticulously, reveals the extent to which the English painters were still bound to classical tradition, even if during this period innovators such as Turner and Constable were already working.

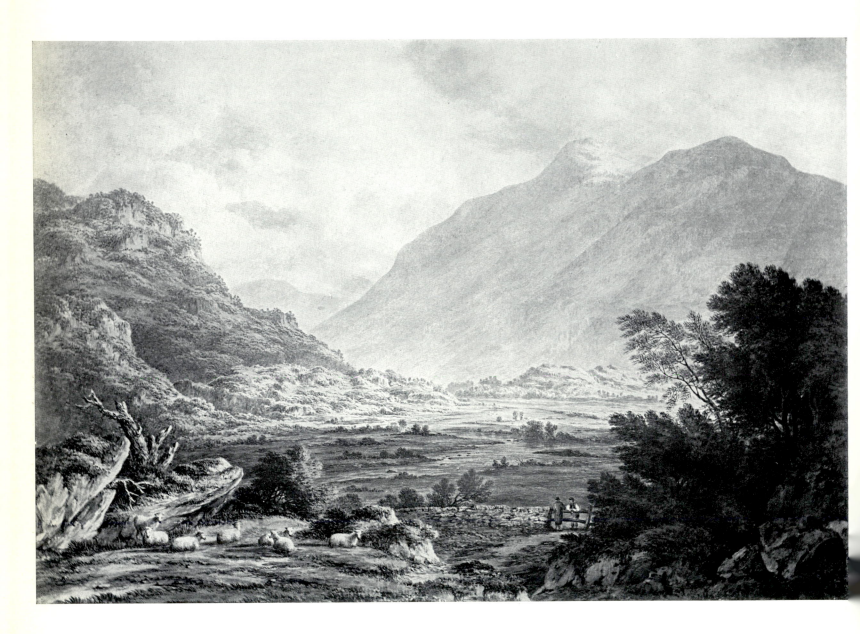

31. Thomas Barker of Bath: *Landscape Near Bath*. Oil on canvas, 31½ x 41⅝ inches. London, Tate Gallery.

Painted in the very early nineteenth century, after a trip to Rome around 1790, this landscape, with its broad composition and gilded, dense color in the manner of Gainsborough, is one of the several in this period that still retain an eighteenth-century vision of things.

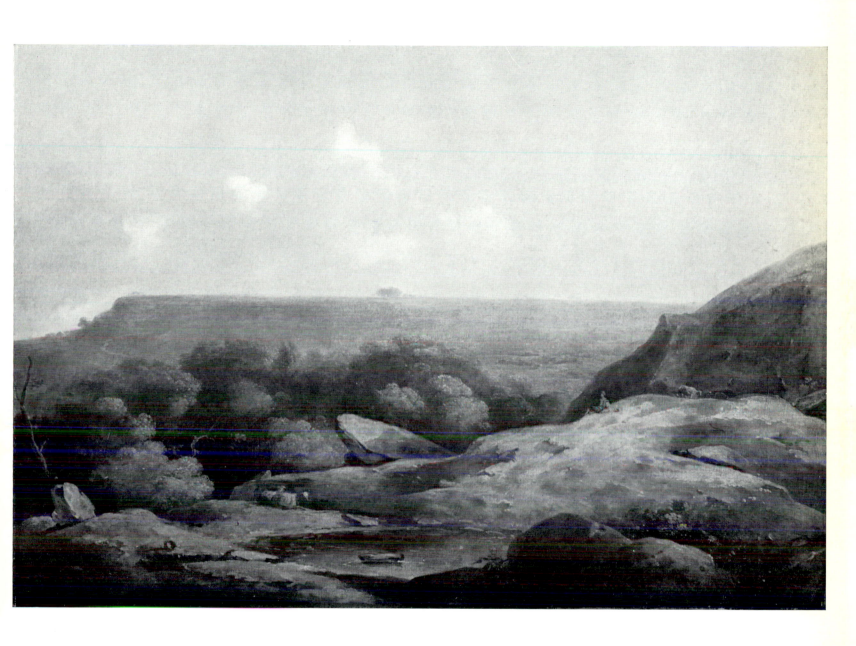

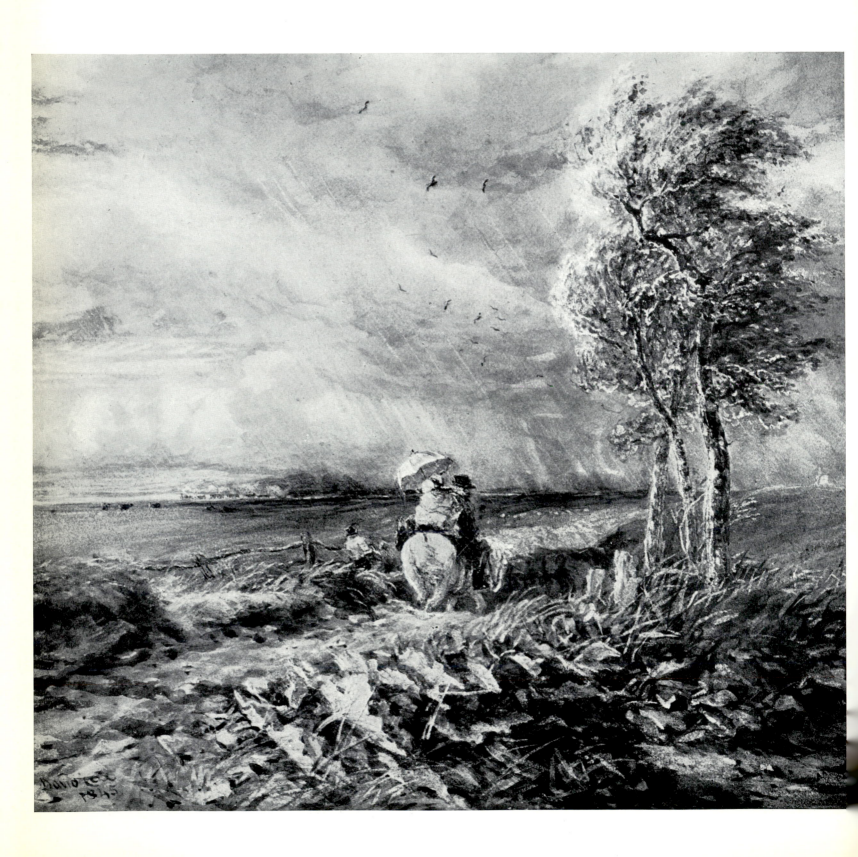

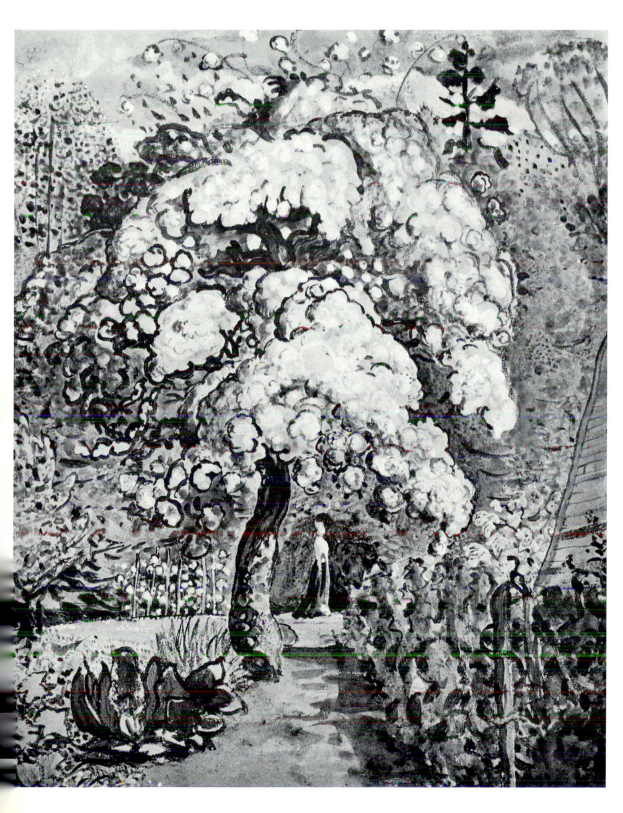

32. David Cox: *Sun, Wind, Rain*. 1845. Watercolor, 18¼ x 23¾ inches. Birmingham, City Museum and Art Gallery.

Cox was a member of the Old Watercolour Society founded in 1804 by John Varley, who had been his teacher. With an acute sense of color harmony, he painted many scenes of rain and storm, both in oil and in watercolor, with felicitous effects in spacious compositions.

33. Samuel Palmer: *Garden at Shoreham*. 1829. Watercolor and gouache, 11 x 8¾ inches. London, Victoria and Albert Museum.

In 1825 Palmer began painting the landscapes of Shoreham, a serene valley in Kent through which flows the Darent. Here he was inspired to do oils and watercolors distinguished for their fresh vigor and deep elegiac quality. His youthful works, like this one, are the most spontaneous and authentic.

34. John Martin: *Macbeth*. c. 1820. Oil on canvas, 20⅛ x 28 inches. Edinburgh, National Gallery of Scotland.

This is the small version of the much larger canvas Martin exhibited in 1820. Although he still relied on the classical ideal for his technique, as did many English painters of the time, his main tendency was to the theatrical and the grandiose. The visionary romanticism finds a parallel in the work of several German artists of the same period.

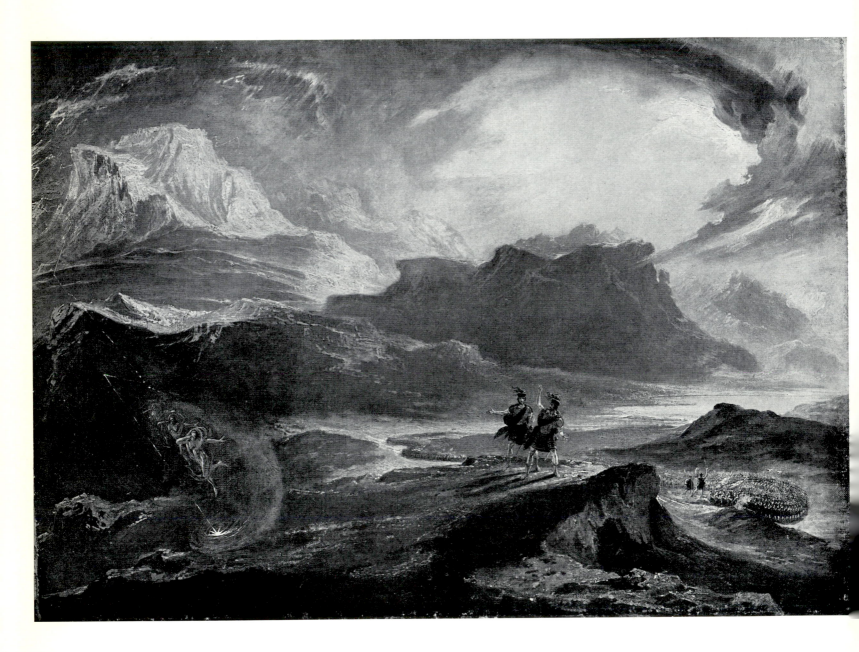

35. William Dyce: *Pegwell Bay, Kent.* 1859. Oil on canvas, 24¾ x 35 inches. London, Tate Gallery.
Representational fidelity, as we find it in several painters of this period who were part of or influenced by the Pre-Raphaelite movement, was the source of a number of suggestive paintings that, although lucid and detailed, aspired to a certain grandiosity, as in this example.

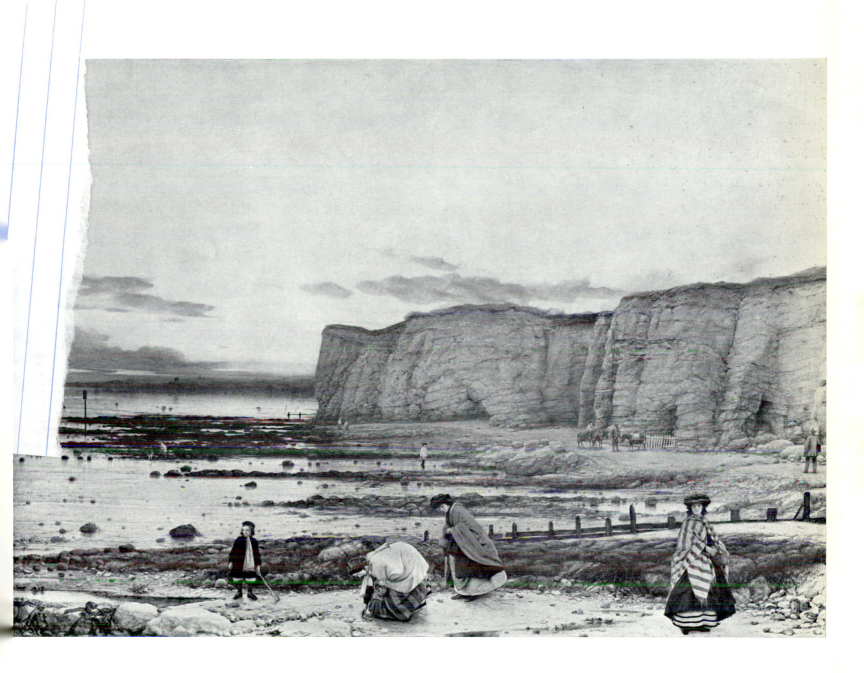

36. James A. McNeill Whistler: *Old Battersea Bridge: Nocturne—blue and gold.* c. 1865. Oil on canvas, $29\frac{1}{2}$ x $20\frac{1}{8}$ inches. London, Tate Gallery.

In this painting Whistler shows that he has assimilated impressionist techniques, but he treats the composition more imaginatively, as one can see in this nocturnal marine landscape dominated by the pylon of the bridge seen from below.

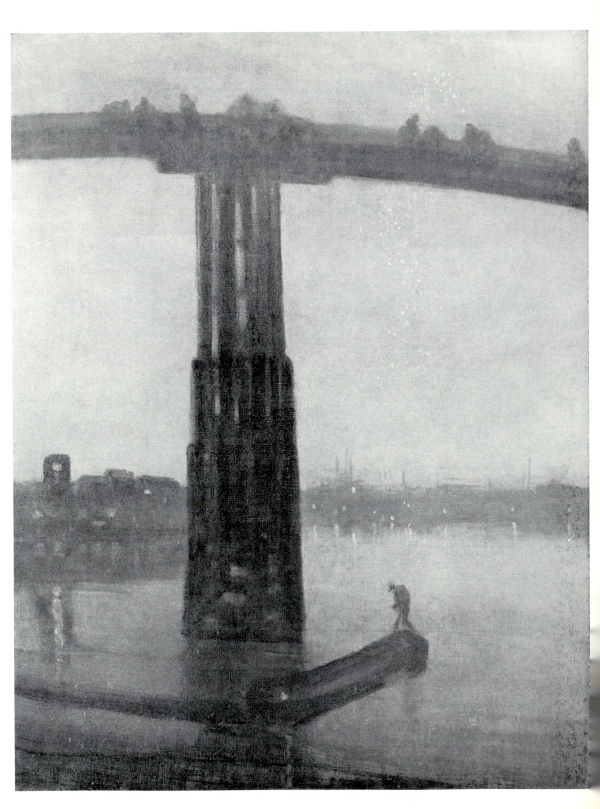

FRANCE

The little town of Verrières must be one of the prettiest in the Franche-Comté. Its white houses with their steep, red tile roofs spread across a hillside, the folds of which are outlined by clumps of thrifty chestnut trees. The Doubs flows a couple of hundred feet below the town's fortifications, built long ago by the Spaniards and now fallen into ruins.

Verrières is flanked on the north by a lofty mountain, one of the spurs of the Jura. As soon as it grows cold in October, the ragged peaks of Verra are covered with snow. A brook which drops from the mountain passes through Verrières before falling into the Doubs provides power for a number of sawmills; it is a simple industry and yields a certain prosperity for a fair number of the inhabitants, who are peasants rather than bourgeois. Still, the sawmills are not what has made this little town rich. The manufacture of so-called Mulhouse cotton prints is responsible for the general affluence that, since the fall of Napoleon, has resulted in new façades for almost all the houses of Verrières.

Scarcely inside the town, one is stunned by the racket of a roaring machine, frightful in its appearance. Twenty ponderous hammers, falling with a crash which makes the street shudder, are lifted for each new stroke by the power of a water wheel. Every one of these hammers makes, every day, I don't know how many thousand nails. The workmen are pretty, fresh-faced girls; they slip little slivers of iron into place beneath the sledge hammers, which promptly transform them into nails. A primitive factory like this provides one of those sights that most surprise the traveler as he enters for the first time the mountains separating France from Switzerland.

Red and Black, 1830. STENDHAL

The Lake of Bourget lies seven hundred feet above the Mediterranean, in a great hollow among the jagged peaks of the hills; it sparkles there, the bluest drop of water in the world. From the summit of the Cat's Tooth the lake below looks like a stray turquoise. This lovely sheet of water is about twenty-seven miles round, and in some places is nearly five hundred feet deep.

Under the cloudless sky, in your boat in the midst of the great expanse of water, with only the sound of the oars in your ears, only the vague outline of the hills on the horizon before you, you admire the glittering snows of the French Maurienne; you pass, now by masses of granite clad in the velvet of green turf or in low-growing shrubs, now by pleasant sloping meadows; there is always a wilderness on the one hand and fertile lands on the other, and both harmonies and dissonances compose a scene for you where everything is at once small and vast, and you feel yourself to be a poor onlooker at a great banquet. The configuration of the mountains brings about misleading optical conditions and illusions of perspective; a pine-tree a hundred feet in height looks to be a mere reed; wide valleys look as narrow as meadow paths. The lake is the only one where the confidences of heart and heart can be exchanged. There one can love; there one can meditate. Nowhere on earth will you find a closer understanding between the water, the sky, the mountains, and the fields. There is a balm there for all the agitations of life. The place keeps the secrets of sorrow to itself, the sorrow that grows less beneath its soothing influence; and to love, it gives a grave and meditative cast, deepening passion and purifying it. A kiss there becomes something great. But beyond all other things it is the lake for memories; it aids them by lending to them the hues of its own waves; it is a mirror in which everything is reflected.

The day after he arrived he climbed the Pic de Sancy, not without difficulty, and visited the higher valleys, the skyey nooks, undiscovered lakes, and peasants' huts about Mont

Dore, a country whose stern and wild features are now beginning to tempt the brushes of our artists, for sometimes wonderfully fresh and charming views are to be found there, affording a strong contrast to the frowning brows of those lonely hills.

Imagine for yourself an inverted cone of granite hollowed out on a large scale, a sort of basin with its sides divided up by queer winding paths. On one side lay level stretches with no growth upon them, a bluish uniform surface, over which the rays of the sun fell as upon a mirror; on the other lay cliffs split open by fissures and frowning ravines; great blocks of lava hung suspended from them, while the action of rain slowly prepared their impending fall; a few stunted trees, tormented by the wind, often crowned their summits; and here and there in some sheltered angle of their ramparts a clump of chestnut-trees grew tall as cedars, or some cavern in the yellowish rock showed the dark entrance into its depths, set about by flowers and brambles, decked by a little strip of green turf.

At the bottom of this cup, which perhaps had been the crater of an old-world volcano, lay a pool of water as pure and bright as a diamond. Granite boulders lay around the deep basin, and willows, mountain-ash trees, yellow-flag lilies, and numberless aromatic plants bloomed about it, in a realm of meadow as fresh as an English bowling-green. The fine soft grass was watered by the streams that trickled through the fissures in the cliffs; the soil was continually enriched by the deposits of loam which storms washed down from the heights above. The pool might be some three acres in extent; its shape was irregular, and the edges were scalloped like the hem of a dress; the meadow might be an acre or two acres in extent. The cliffs and the water approached and receded from each other; here and there, there was scarcely width enough for the cows to pass between them.

After a certain height the plant life ceased. Aloft in air the granite took upon itself the most fantastic shapes, and assumed those misty tints that give to high mountains a dim resemblance to clouds in the sky. The bare, bleak cliffs, with the fearful rents in their sides, pictures of wild and barren desolation, contrasted strongly with the pretty view of the valley; and so strange were the shapes they assumed, that one of the cliffs had been called "The Capuchin," because it was so like a monk. Sometimes these sharp-pointed peaks, these mighty masses of rock, and airy caverns were lighted up one by one, according to the direction of the sun or the caprices of the atmosphere; they caught gleams of gold, dyed themselves in purple, took a tint of glowing rose-colour, or turned dull and grey. Upon the heights a drama of colour was always to be seen, a play of ever-shifting iridescent hues like those on a pigeon's breast.

Oftentimes at sunrise or at sunset a ray of bright sunlight would penetrate between two sheer surfaces of lava, that might have been split apart by a hatchet, to the very depths of that pleasant little garden, where it would play in the waters of the pool, like a beam of golden light which gleams through the chinks of a shutter into a room in Spain, that has been carefully darkened for a siesta. When the sun rose above the old crater that some antediluvian revolution had filled with water, its rocky sides took warmer tones, the extinct volcano glowed again, and its sudden heat quickened the sprouting seeds and vegetation, gave colour to the flowers, and ripened the fruits of this forgotten corner of the earth.

The Wild Ass's Skin, 1831. HONORÉ DE BALZAC

But we are hardly in Normandy before our gaze, weary of the symmetry of Paris and its white walls, is welcomed by an ocean of greenery.

The sad grey plains remain towards Paris; the road enters a succession of valleys and high hills, whose tops, thick with trees, are outlined against the sky not without a certain boldness, bounding the horizon in a manner that gives play to the imagination — a novel pleasure indeed for the inhabitant of Paris.

As we advance, we perceive the sea to the right, between the trees with which the country is covered — the sea, without which no landscape can claim perfection.

If the eye, which the charm of distance awakens to the beauties of landscape, seeks for details, it discovers that every cluster of trees forms a kind of enclosure surrounded by walls of earth; these embankments, constructed regularly along the edge of all the fields, are crowned with a serried row of young elms.

The view I have described is precisely the one revealed on coming from Paris and approaching the sea, at two leagues from Carville.

In the direction of Paris, the first houses of the village, hidden amid apple trees, lie along the bottom of the valley; but at two hundred paces beyond the last ones, whose view stretches from the northwest towards the sea and Mont Saint-Michel, one crosses, on a brand-new bridge, over a pretty stream of clear water which has the sense to flow very rapidly, for everything has sense in Normandy and nothing is done without its *wherefore*, and often a wherefore very sharply calculated.

Lamiel, 1839-42. STENDHAL

Saint-Malo is nothing but a rock. Standing in former times in the middle of a salt-marsh, it became an island as a result of the tidal wave which, in 709, hollowed out the bay and placed Mont Saint-Michel in the midst of the waves. Today, the rock of Saint-Malo is connected to the mainland only by a causeway with the poetic name of Le Sillon, or the Furrow. Le Sillon is assailed on one side by the open sea and washed on the other side by the tide which turns round Saint-Malo to enter the port. A storm almost entirely destroyed it in 1730. At low tide, the port is dry for several hours, and on the north and east a beach of the finest sands is revealed. It is then possible to walk right round my father's home. Close at hand and in the distance are scattered rocks, forts and uninhabited islets: Fort Royal, La Conchée, Cézembre and Le Grand-Bé, where I am to be buried; without knowing, I chose well, for *bé*, in Breton, means *grave*.

At the end of Le Sillon, on which a calvary has been set up, there is a mound of sand at the edge of the open sea. This mound is called La Hoguette and is surmounted by an old gibbet: we contended with the birds for possession of the uprights, on which we used to play puss in the corner. But it was never without a kind of fear that we lingered in this spot.

There too are the Miels, dunes where sheep used to graze; on the right there are some meadows, lying at the foot of Paramé, the road to Saint-Servan, the new cemetery, a calvary, and some windmills on hillocks, like those which stand on Achilles's grave at the entrance to the Hellespont.

On certain days of the year, the people of the town and the countryside came together at fairs called assemblies, which were held on the islands and in the forts around Saint-Malo;

they went to these fairs on foot at low tide and in boats at high tide. The crowds of sailors and peasants; the covered wagons; the caravans of horses, donkeys and mules; the competition between the stallkeepers; the tents pitched on the shore; the processions of monks and confraternities winding their way through the crowd with their banners and crosses, the rowing-boats and sailing-boats coming and going; the ships coming into the port or anchoring in the roads; the artillery salvoes, the ringing of bells, all this combined to lend these gatherings noise, movement and variety.

Springtime in Brittany is sweeter than in the neighbourhood of Paris and comes three weeks earlier. The five birds which herald its appearance, the swallow, the oriole, the cuckoo, the quail and the nightingale, arrive with breezes which lodge in the bays of the Armorican peninsula. The ground is covered with daisies, pansies, jonquils, daffodils, hyacinths, buttercups and anemones like the patches of waste land around St. John Lateran and the Holy Rood of Jerusalem in Rome. The clearings are clothed in tall, elegant ferns; the fields of gorse and broom blaze with flowers which look like golden butterflies. The hedges, lined with a profusion of strawberries, raspberries and violets, are adorned with may blossom, honeysuckle, and brambles whose brown, curving shoots bear magnificent leaves and fruit. There are bees and birds everywhere; children come across a swarm or a nest at every step. In certain sheltered places, the myrtle and the rose-bay grow out in the open as in Greece; the fig ripens as in Provence; every apple-tree, with its carmine-coloured flowers, looks like a village bride's bouquet.

The sea which I was to meet with on so many coasts washed, at Brest, the tip of the Armorican Peninsula: beyond that prominent cape there lay nothing but a boundless ocean and unknown worlds; my imagination revelled in this infinity. Often, sitting on some mast that had been laid along the Quai de Recouvrance, I watched the movements of the crowd: shipwrights, sailors, soldiers, custom-house officers and convicts passed to and fro before me. Passengers embarked and disembarked, pilots conned their ships, carpenters squared blocks of wood, rope-makers lit fires under coppers which gave out clouds of smoke and the healthy smell of tar. Bales of merchandise and sacks of victuals were carried backwards and forwards; artillery trains were rolled from the sea to the magazines, from the magazines to the sea. Here, carts backed into the water to take on cargoes; there, garnets lifted loads, while cranes lowered stones and dredging-machines dug up alluvium. Forts repeated signals, launches came and went, vessels got under sail in the docks.

There is nothing more delightful than the countryside for some fifteen miles round Saint-Malo. The banks of the Rance, from the mouth of the river to Dinan, are enough in themselves to deserve the traveller's attention, forming as they do a constant medley of rocks and greenery, sandbanks and forests, creeks and hamlets, ancient manors of feudal Brittany and modern dwelling-houses of trading Brittany. The latter were built at a time when the merchants of Saint-Malo were so rich that on festive occasions they fricasseed piastres and flung them red-hot out of the windows. These houses are extremely luxurious. Bonnaban, the château of MM. de la Saudre, is partly built of marble brought from Genoa, and has a magnificence of which we have no idea in Paris. La Briantais, Le Bosq, Le Montmarin, La Balue and Le Colombier are or were adorned with orangeries, fountains and statues. Sometimes the gardens slope down to the water behind the arcade formed by a screen of lime-trees, through a colonnade of pine-trees, to the end of a lawn: seen across a bed of tulips, the sea displays its ships, its calms and its storms.

...On the banks of the Saône, a few miles upstream from Lyons, the little graceful town of Mâcon lies on the slopes of a gentle hill, surrounded by meadows and villages. Two bell towers of Gothic style, already ruined before the Revolution, and now on the verge of complete decay, meet the eye and command the attention of those who, en route to Provence or Italy, find themselves aboard one of the many steamboats that ply the river all day long. Below this old ruined temple for about half a mile, there are long rows of white houses and buildings where produce and merchandise of the South, together with the wines of Mâcon's merchants, are loaded and unloaded. The whole upper part of the town, which cannot be seen from the river, is abandoned to a silent calm. It could be compared to a Spanish town. In the summer, the grass grows from the pavements and the shadows of the tall walls of the old convents make the solitary, narrow roads look gloomy....

A boarding school, a hospital, many churches — some restored, others being used as storage space by the town's merchants — a large square, entirely surrounded by a row of tall linden trees, where children come to play and elderly people come to enjoy the sunshine, blind alleys crossing the wide streets, some charming houses looking on one side toward the town and on the other toward the wide fields of the green plains, five or six large palaces on the main square, almost always closed, which during the winter receive the oldest and most important families of the entire province, this is the description of the upper part of the town. It is the headquarters of what, of old, used to be called the nobility and the clergy. Today it is still the center of the magistrature and the wealthiest landowners of the town. And so it is everywhere, the laborers go down every morning to their jobs from the top of the nearby mountains, to return there at dusk to rest without participating in the life and the wealth of which they are the instruments.

At the corner of this large square, which at the time of the Revolution was an important stronghold and still now bears its name, there is a tall, imposing palace with very few windows. Its massive, sunburnt walls, blackened by the rain, hold together after some centuries with the help of large iron supports. A tall, wide door, with two steps in front of it, leads to a long vestibule, at the end of which, inundated by rays of sunshine coming in through a colossal window from the courtyard, shines the great staircase made of cut stone climbing, floor by floor, to the various awesome apartments.

...Leading away from the Saône, where it flows among green pastures, underneath the fertile hills of Mâcon, and heading toward this little town and the ruins of the old Abbey of Cluny (where Abelard died) is a mountain road, going up and down like the early waves of the high tide. At right and left are white houses surrounded by vineyards. Thinning out toward the steep slopes of the high mountains, they are now bare and unattended. There are rocky paths covered by a grayish grass and a few scattered herds that look like white dots. The mountain peaks are crowned by huge protruding rocks, corroded by time and by the fury of the winds and looking like ruins of some old dismantled castle. Following the winding road at the bottom of these hills, after about a two hours' walk from town, there is, on the left, a narrow path shaded by willow trees, going downhill through meadows toward a stream where one can hear the constant beating of a mill wheel.

This path, surrounded by canes, goes on a little further, following the stream which, when swollen by rain, overflows into it as if it were its natural bed. Then, one crosses a small bridge and, through a twisting, short path, one heads toward some houses with red brick roofs, higher up, on a small plateau. This is our village. A grey, pyramidal bell tower dominates seven or eight farm houses. A stoney road passes between these farm houses, leading finally to a door, somewhat taller and wider than the others, opening into a courtyard at the end of which hides my father's house....

Les Confidences, 1849.

ALPHONSE DE LAMARTINE

On June 6, 1832, at about eleven in the forenoon, the Luxembourg, solitary and depopulated, was delicious. The quincunxes and flower-beds sent balm and dazzlement into the light, and the branches, wild in the brilliancy of midday, seemed trying to embrace each other. There was in the sycamores a twittering of linnets, the sparrows were triumphal, and the woodpeckers crept along the chestnuts, gently tapping the holes in the bark. The flower-beds accepted the legitimate royalty of the lilies, for the most august of perfumes is that which issues from whiteness. The sharp odor of the carnations was inhaled, and the old rooks of Marie de Medicis made love on the lofty trees. The sun gilded, purpled, and illumined the tulips, which are nothing but all the varieties of flame made into flowers. All around the tulip-beds hummed the bees, the flashes of these fire-flowers. All was grace and gayety; even the coming shower, for that relapse, by which the lilies of the valley and honeysuckles would profit, had nothing alarming about it, and the swallows made the delicious menace of flying low. What was there drank in happiness; life had a pleasant perfume, and all this nature exhaled candor, help, assistance, paternity, caresses, and dawn. The thoughts that fell from heaven were as soft as a little child's hand that we kiss. The statues under the trees, nude and white, were robed in dresses of shadow shot with light: these goddesses were all ragged with sunshine, and rags hung from them on all sides. Around the great basin the earth was already so dry as to be parched, and there was a breeze sufficiently strong to create here and there small riots of dust. A few yellow leaves remaining from last autumn joyously pursued each other, and seemed to be sporting.

The abundance of light had something strangely re-assuring about it; life, sap, heat, and exhalations overflowed, and the immensity of the source could be felt beneath creation. In all these blasts penetrated with love, in this movement of reflections and gleams, in this prodigious expenditure of rays, and in this indefinite outpouring of fluid gold, the prodigality of the inexhaustible could be felt, and behind this splendor, as behind a curtain of flames, glimpses of God, that millionaire of the stars, could be caught. Thanks to the sand, there was not a speck of mud, and, thanks to the rain, there was not a grain of dust. The bouquets had just performed their ablutions, and all the velvets, all the satins, all the varnish, and all the gold, which issue from the earth in the shape of flowers, were irreproachable. This magnificence was free from stain, and the grand silence of happy nature filled the garden, — a heavenly silence, compatible with a thousand strains of music, the fondling tones from the nests, the buzzing of the swarms, and the palpitations of the wind. The whole harmony of the season was blended into a graceful whole, the entrances and exits of spring took place in the desired order, the lilacs were finishing and the jessamine beginning, a few flowers were behind and a few insects before their time, and the vanguard of the red butterflies of June fraternized with the rear-guard of the white butterflies of May. The plane trees were putting on a fresh skin, and the breeze formed undulations in the magnificent enormity of the chestnut-trees.

Les Misérables, 1862. VICTOR HUGO

And, with a look, she made him notice the Seine, with its two banks and the sky. Little clouds, violet, grey, and silver, were tumbling and playing about on the horizon, some of them with flashes of light just touching their crests, and seeming to produce an effect of sea-foam in the far-off sky. Out of these clouds rose the sky itself, infinite and blue, splendid, and already beginning to pale, as at the hour when the stars are lighting themselves up behind the day. Right above their heads hung two or three clouds, hovering over them, solid and motionless. A bright light was poured down upon the water,

sleeping here, twinkling there, lighting up the ripples of the river in the shadow of the boats, just touching here a mast, and there a rudder, catching as it passed the orange petticoat or the pink cap of a washer-woman.

The country and the outskirts and suburbs of the town all met on the two banks of the river. Long lines of poplars showed here and there between the detached houses, which marked the end of a town. One saw low cottages, hoardings, gardens, green shutters, wine-shops painted red, with acacias in front of their doors, old barrels lying on their side, and here and there blinding peeps of white walls; then there came the hard lines of factories built of brick, with their roofs of tiles or zinc, and their large call bells. Smoke rose straight out of the mouths of their chimneys, and its shadow fell upon the river like the shadow of a column. On one chimney was written "Tobacco." On a plaster wall one saw the words, "Doremus, called Labiche, boat-builder." Over a canal, blocked up with barges, a revolving bridge raised its two black arms into the air. Fishermen were casting and drawing in their lines, wheels were creaking, carts were coming and going. Towing-ropes were being dragged along over the earth, which was rusty, hardened, blackened, dyed every colour by the coal-dust, the residuum from mineral works, and by deposits from chemical factories. A vague, indeterminate smell of grease and sugar, mixed with the emanations from the water and the smell of tar, rose from the candle factories, the glue factories, the tanneries, the sugar refineries, which were scattered about on the quay amongst thin, dried-up grass. The noise of foundries and the screams of steamwhistles broke, at every moment, the silence of the river. It was at once a picture of Asnières, Saardam, and Puteaux, one of the Parisian landscapes of the banks of the Seine, such as Hervier loves to paint, which are dirty and bright, miserable and gay, populous and full of life, where Nature passes every now and then between the buildings and the factories, as a blade of grass passes between the fingers of a man.

Renée Mauperin, 1864. EDMOND AND JULES DE GONCOURT

Soon they were quite in the Bois de Vincennes.

Narrow beaten tracks, full of footprints, crossed one another in all directions over the trampled and hardened earth. In the spaces between these little paths, there stretched patches of grass, but grass that was crushed, dried up, yellow and dead, scattered about like litter, the straw-colored blades of which were entangled on all sides with brushwood amid the dull greenery of nettles. Here might be recognized one of those rural spots to which the great suburbs go to lounge on Sundays, and which remain like turf trampled by a crowd after a display of fireworks. Twisted, ill-grown trees stood at intervals, small elms with grey trunks, spotted with yellow leprosy, and lopped to the height of a man, sickly oaks eaten by caterpillars, and with only the lace-work of their leaves remaining. The verdure was paltry, wasted and scanty; the leafage in the air looked thin; the stunted, worn, and scorched foliation, merely speckled the sky with green. The flying dust of high roads covered the ground with grey. The whole had the wretchedness and leanness of a trampled and choked vegetation, the sorry look of verdure on the outskirts of a city, where nature seemed to be issuing from the pavement. No song in the branches, no insect on the beaten soil; the noise of the carts bewildered the birds; the organ suppressed the silence and quivering of the wood; the street passed humming through the landscape.

Germinie Lacerteux, 1865. EDMOND AND JULES DE GONCOURT

I used to rise very early; and one of my chief delights was to take a solitary walk every morning about eight o'clock, in the Luxembourg Nursery.

You never saw that nursery, I fancy. It was like some forgotten garden of the last century — a garden pretty as the gentle smile of an old lady. Thick hedges separated the straight narrow walks — walks that seemed strangely calm between their walls of foliage methodically clipped. The great shears of a gardener were incessantly busy preserving the faultless line of these leafy partitions; and here and there one saw flower beds, strips of velvety sod planted with young trees as regularly marshaled as college students on promenade, also little society knots of magnificent rosebushes, or regiments of fruit trees.

A whole corner of this ravishing grove was inhabited by bees. The straw hives, placed at regular distances upon plants by a scientific hand, opened to the sun their thimble-sized doors, and all along the walks you saw the buzzing golden flies, the veritable mistresses of that pacific domain, the true "promeneuses" of those quiet alley-corridors.

I used to go there nearly every morning. I would generally sit down upon a bench and read. Sometimes I would just let the book fall upon my knee, and give myself up to reverie, — while hearing about me the great murmur of Paris, — or abandon myself to enjoyment of the infinite repose of those antique elm-groves.

"The Minuet." GUY DE MAUPASSANT

I was infinitely fond of that country [Virelogne]. There are delicious corners in this world which have a sensual charm for the eyes. One loves them with a physical love. We folk whom nature attracts, keep certain tender recollections, often keen, for certain springs, certain woods, certain ponds, certain hills, which have touched us like happy events. Sometimes even memory returns toward a forest nook, or a bit of a river bank, or a blossoming orchard, seen only once, on some happy day, which has remained in our heart like those pictures of women seen in the street, on a spring morning, with a white, transparent costume, and which leave in our soul and flesh an unappeased, unforgettable desire, the sensation of having just missed happiness.

At Virelogne, I loved the whole region, sowed with little woods and traversed by brooks which ran through the soil like veins bringing blood to the earth.

We fished in them for crayfish, trout, and eels! Divine happiness! We could bathe in certain places and often found woodcock in the grass which grew on the banks of those little narrow streams.

"Mother Savage," 1870-71. GUY DE MAUPASSANT

...My great, my only, my overwhelming passion has been — for ten years — the Seine. Ah, that beautiful river, calm, varied, fetid, full of visions and garbage! I believe I have loved it so much because, if I am not mistaken, it has given me the sense of life. Ah, those strolls along the flowered banks, my friends the frogs, dreaming while their bellies were

cooling off on a leaf of a nymphaea, the water lilies, graceful and frail among the large thin blades of grass; all of a sudden, behind a willow tree, they would open before me a page of a Japanese album when the kingfisher would fly from me like a deep blue flame! How much have I loved all that, with an instinctive passion of the eye, a passion that would spread throughout my body in a profound and natural joy!

Many have memories of nights of love; mine are of the sunrise, through the fluctuating, gauzy morning fog, as white before dawn as dead creatures and then, as the first ray glides over the prairies, tinted in a ravishing pink; of the moon giving to the surface of the flowing water a silver shine that made all my dreams bloom.

And this — a symbol of eternal illusion — was born for me out of the rotting water, transporting to the sea all the filth of Paris....

"Mosca. Souvenirs d'un Canotier." GUY DE MAUPASSANT

[From Arles, 1888]

Arles doesn't seem to me any bigger than Breda or Mons.

Before getting to Tarascon I noticed a magnificent landscape of huge yellow rocks, piled up in the strangest and most imposing forms. In the little village between these rocks were rows of small round trees with olive-green or gray-green leaves, which I think were lemon trees.

But here in Arles the country seems flat. I have seen some splendid red stretches of soil planted with vines, with a background of mountains of the most delicate lilac. And the landscapes in the snow, with the summits white against a sky as luminous as the snow, were just like the winter landscapes that the Japanese have painted.

The "Vines" that I have just painted are green, purple and yellow, with violet bunches and branches in black and orange.

On the horizon are some gray willows, and the wine press a long, long way off, with a red roof, and the lilac silhouette of the distant town.

In the vineyard there are little figures of women with red parasols, and other little figures of men working at gathering grapes with their cart.

Over it is a blue sky, and the foreground is of gray gravel. This is a pendant to the garden with the clipped bush and the oleanders.

I think you will prefer these ten canvases to the batch I last sent, and I venture to hope to double the number in the autumn.

Day after day it grows richer and richer. And when the leaves start to fall — I do not know if this happens in the beginning of November here the way it does with us — when all the foliage is yellow, it will be amazing against the blue. Ziem has given us that splendor many a time already. Then a short winter, and after that we shall have got to the orchards in bloom again.

What Gauguin says about "Persian" painting is true. I don't believe that it would shock anybody in the Dieulafoi Museum, one might put it there without any difficulties. But, but, but... I myself do not belong to the world of the great, not even to any world at all... and... I prefer the Greeks and Japanese to the Persians and Egyptians. All the same, I do not mean to say that Gauguin is wrong in working in the Persian style.

But I should have to get used to it.

My dear Theo,
I am at last writing to you from Stes.-Maries on the shore of the Mediterranean. The Mediterranean has the colors of mackerel, changeable I mean. You don't always know if it is green or violet, you can't even say it's blue, because the next moment the changing light has taken on a tinge of pink or gray.

The shore here is sandy, neither cliffs nor rocks — like Holland without the dunes, and bluer.
You get better fried fish here than on the Seine. Only fish is not available every day, as the fishermen go off and sell it in Marseilles.

One night I went for a walk by the sea along the empty shore. It was not gay, but neither was it sad — it was — beautiful. The deep blue sky was flecked with clouds of a blue deeper than the fundamental blue of intense cobalt, and others of a clearer blue, like the blue whiteness of the Milky Way. In the blue depth the stars were sparkling, greenish, yellow, white, pink, more brilliant, more sparklingly gemlike than at home — even in Paris: opals you might call them, emeralds, lapis lazuli, rubies, sapphires. The sea was very deep ultramarine — the shore a sort of violet and faint russet as I saw it, and on the dunes (they are about seventeen feet high) some bushes Prussian blue.

I think you will like the falling leaves that I have done.
It is some poplar trunks in lilac cut by the frame where the leaves begin.
These tree trunks are lined like pillars along an avenue where there are rows of old Roman tombs of a blue lilac right and left. And then the soil is covered with a thick carpet of yellow and orange fallen leaves. And they are still falling like flakes of snow.
And in the avenue, little black figures of lovers. The upper part of the picture is a bright green meadow, and no sky, or almost none.
The second canvas is the same avenue but with an old fellow and a woman as fat and round as a ball.
But on Sunday if you had been with us, you would have seen a red vineyard, all red like red wine. In the distance it turned to yellow, and then a green sky with the sun, the earth after the rain violet, sparkling yellow here and there where it caught the reflection of the setting sun.

[From Saint-Rémy, 1889]

Outside the cicadas are singing fit to burst, a harsh screeching, ten times stronger than that of the crickets, and the scorched grass takes on lovely tones of old gold. And the beautiful towns of the South are in the same state as our dead towns along the Zuyder Zee that once were so bustling. Yet in the decline and decadence of things, the cicadas dear to the good Socrates abide. And here certainly they still sing in ancient Greek.

Unfortunately there are no vineyards here; but for that I should have done nothing else this autumn. There are plenty, but it would be necessary to go and stay in another village to do them.
On the other hand the olive trees are very characteristic, and I am struggling to catch them. They are old silver, sometimes with more blue in them, sometimes greenish, bronzed, fading, white above a soil which is yellow, pink, violet-tinted or orange, to dull red ocher. Very difficult though, very difficult. But that suits me and induces me to work wholly in gold or silver. And perhaps one day I shall do a personal impression of them like what the sunflowers were for the yellows.

From time to time there are moments when nature is superb, autumn effects glorious in color, green skies contrasting with foliage in yellows, oranges, greens, earth in all the

violets, heat-withered grass among which, however, the rains have given a last energy to certain plants, which again start putting forth little flowers of violet, pink, blue, yellow. Things that one is quite sad not to be able to reproduce.

And skies — like our skies in the North, but the colors of the sunsets and sunrises more varied and clearer. Like in a Jules Dupré or a Ziem.

I also have two views of the park and the asylum, where this place looked very pleasing. I tried to reconstruct the thing as it might have been, simplifying and accentuating the haughty, unchanging character of the pines and cedar clumps against the blue.

Anyway — if it should be that they remember me, which is a matter of indifference to me — there will be something in color to send to the Vingtistes. But I am indifferent to that. What I am not indifferent to is that a man who is very much my superior, Meunier, has painted the "Sclôneuses" of the Borinage and the shift going to the pits, and the factories, their red roofs and their black chimneys against a delicate gray sky — all things that I have dreamed of doing, feeling that it had not been done and that it ought to be painted. And still there is an infinity of subjects there for artists, and one ought to go down into the mine, and paint the light effects.

Nature is very beautiful here in autumn with the yellow leaves. I am only sorry that there aren't more vineyards here. I started to paint one a few hours away though. It happens that a big field becomes quite purple and red, as the Virginia creeper with us, and next to that a yellow square, and a little farther on a spot which is still green. All this under a sky of a beautiful blue, and violet rocks in the distance. Last year I had a better opportunity to paint that than now. I should have liked to add something like it to what I am sending you, but I'll owe you this for next year.

You will see from the self-portrait I add that though I saw Paris and other big cities for many years, I keep looking more or less like a peasant of Zundert, Toon, for instance, or Piet Prins, and sometimes I imagine I also feel and think like them, only the peasants are of more use in the world. Only when they have all the other things, they get a feeling, a desire for pictures, books, etc. In my estimation I consider myself certainly below the peasants.

Well, I am plowing on my canvases as they do on their fields.

Letters, 1888-89.

<div align="right">VINCENT VAN GOGH</div>

After two months of bitter cold, ice and snow, the city was steeped in a mournful, quivering thaw. From the far-spreading, leaden-hued heavens a thick mist fell like a mourning shroud. All the eastern portion of the city, the abodes of misery and toil, seemed submerged beneath ruddy steam, amid which the panting of workshops and factories could be divined; while westwards, towards the district of wealth and enjoyment, the fog broke and lightened, becoming but a fine and motionless veil of vapour. The curved line of the horizon could scarcely be divined, the expanse of houses which nothing bounded, appeared like a chaos of stone, studded with stagnant pools, which filled the hollows with pale steam, whilst against them the summits of the edifices, the house tops of the loftier streets, showed black like soot. It was a Paris of mystery, shrouded by clouds, buried as it were beneath the ashes of some disaster, already half-sunken in the suffering and shame of that which its immensity concealed.

...Tired out and distracted, Pierre raised his eyes as he reached the Place de l'Opéra. Where was he then? The heart of the great city seemed to beat on this spot, in that vast expanse

where met so many thorough-fares, as if from every point the blood of distant districts flowed thither along triumphal avenues. Right away to the horizon stretched the great gaps of the Avenue de l'Opéra, the Rue du Quatre-Septembre and the Rue de la Paix, still showing clearly in a final glimpse of daylight, but already starred with swarming sparks. The torrent of the Boulevard traffic poured across the Place, where clashed, too, all that from the neighbouring streets, with a constant turning and eddying which made the spot the most dangerous of whirlpools. In vain did the police seek to impose some little prudence, the stream of pedestrians still overflowed, wheels became entangled and horses reared amidst all the uproar of the human tide which was as loud, as incessant, as the tempest voice of an ocean. Then there was the detached mass of the opera-house slowly steeped in gloom, and rising huge and mysterious like a symbol, its lyre-bearing figure of Apollo, right aloft, showing a last reflection of daylight amid the livid sky. And all the windows of the house-fronts began to shine, gaiety sprang from those thousands of lamps which coruscated one by one, a universal longing for ease and free justification of each desire spread with the increasing darkness; whilst, at long intervals, the large globes of the electric lights shone as brightly as the moons of the city's cloudless nights.

...Thus the brothers sallied forth and entered the Bois by the Sablons gate, which was the nearest to them.

The last days of March had now come, and the trees were beginning to show some greenery, so soft and light, however, that one might have thought it was pale moss or delicate lace hanging between the stems and boughs. Although the sky remained of an ashen grey, the rain, after falling throughout the night and morning, had ceased; an exquisite freshness pervaded that wood now awakening to life once more, with its foliage dripping in the mild and peaceful atmosphere. The Mid-Lent rejoicings had apparently attracted the populace to the centre of Paris, for in the avenues one found only the fashionable folks of select days, the people of society who come thither when the multitude stays away. There were carriages and gentlemen on horseback; beautiful aristocratic ladies who had alighted from their broughams or landaus; and wet-nurses with streaming ribbons, who carried infants wearing the most costly lace. Of the middle-classes, however, one found only a few matrons living in the neighbourhood, who sat here and there on the benches busy with embroidery or watching their children play.

...They did not meet a living soul until they reached the outer boulevard. Here, however, no matter what the hour may be, life continues with scarcely a pause. No sooner are the wine shops, music and dancing halls closed, than vice and want, cast into the street, there resume their nocturnal existence. Thus the brothers came upon all the homeless ones: low prostitutes seeking a pallet, vagabonds stretched on the benches under the trees, rogues who prowled hither and thither on the lookout for a good stroke. Encouraged by their accomplice — night — all the mire and woe of Paris had returned to the surface. The empty roadway now belonged to the breadless, homeless starvelings, those for whom there was no place in the sunlight, the vague, swarming, despairing herd which is only espied at night-time.

...And as one boulevard after another was reached, the Boulevard Poissonnière, the Boulevard Bonne Nouvelle, the Boulevard St. Denis and so forth, as far as the Place de la République, there came fresh want and misery, more forsaken, and hungry ones, more and more of the human "waste" that is cast into the streets and the darkness. And, on the other hand, an army of street sweepers was now appearing to remove all the filth of the past four and twenty hours, in order that Paris, spruce already at sunrise, might not blush for having thrown up such a mass of dirt and loathsomeness in the course of a single day.

37. Pierre-Henri de Valenciennes: *The Tower of Paul III from the Convent of Ara Coeli.* c. 1786. Oil on paper on cardboard, $7\frac{5}{8}$ x $20\frac{5}{8}$ inches. Paris, Louvre.
During his long stay in Rome, the artist painted many views of the city, following a long tradition among both foreign and Italian painters of the seventeenth and eighteenth centuries. Another version of this view shows the tower at a different hour of the day.

38. Alexandre Hyacinthe Dunoy: *Naples from Capodimonte* (detail). 1813. Oil on canvas, 50 x $70\frac{1}{2}$ inches. Naples, Capodimonte Museum.
Here the artist is still bound to the pictorial modes of the eighteenth century, with a detailed rendering of the landscape and idealized golden light.

39. Achille-Etna Michallon: *Ideal Landscape Inspired by Frascati* (detail). 1822. Oil on canvas, 50 x $67\frac{3}{8}$ inches. Paris, Louvre.
When it was exhibited at the 1822 Paris Salon, this painting, notable for the then unusual softness of the colors, was acquired by Louis XVIII.

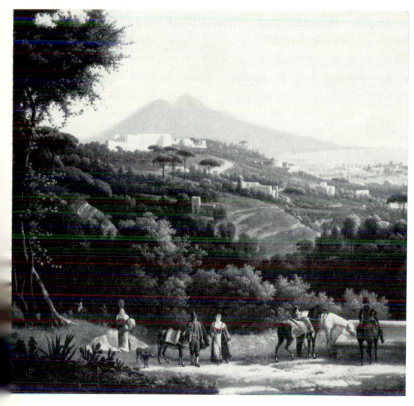

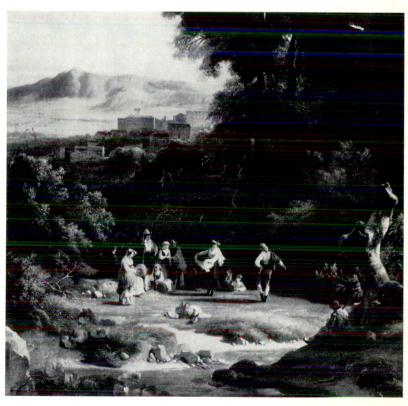

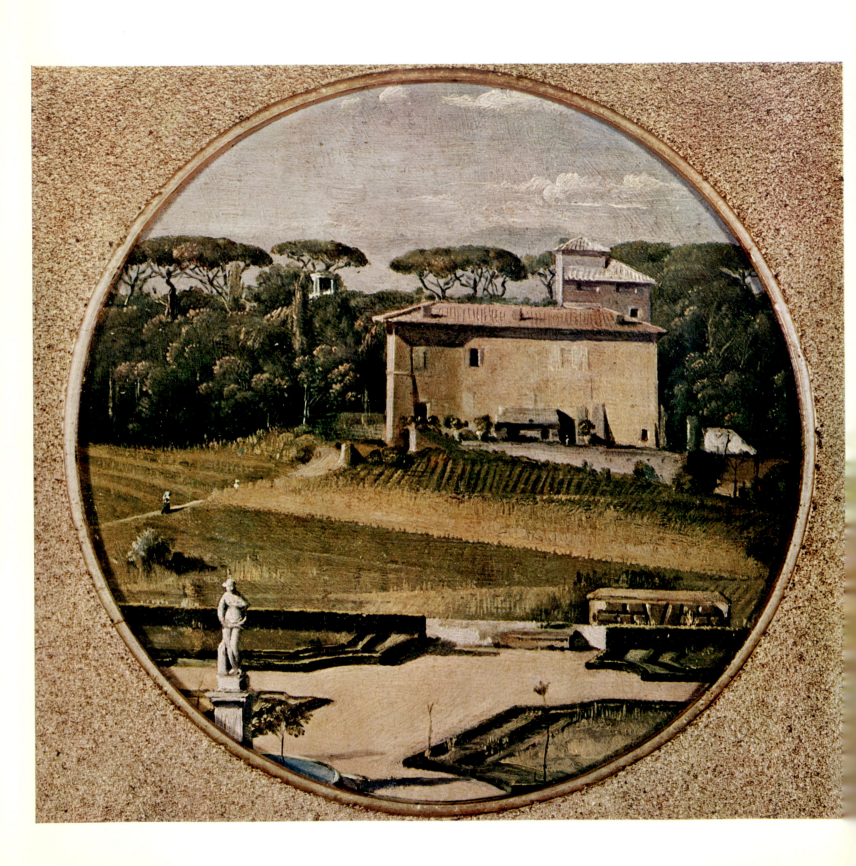

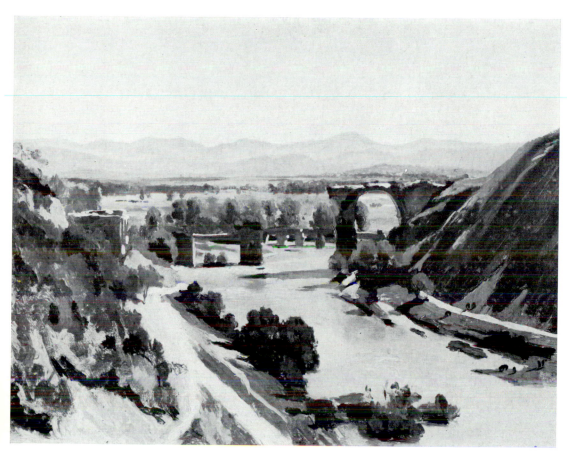

40. Jean-Auguste-Dominique Ingres: *Raphael's House in Rome*. 1806-1807. Oil on panel, 6¼ inches in diameter. Paris, Museum of Decorative Arts.

Ingres did only three Roman views, all of them round and all executed during the first few months of his long residence in that city. This tondo is striking not only for the beauty of the composition but also for the way the colors are steeped in light. Corot himself was not to achieve the same effect until some twenty years later. The house was in the park of Villa Borghese and was demolished in 1849.

41. Jean-Baptiste-Camille Corot: *The Bridge of Narni*. 1826. Oil on canvas board, 14⅛ x 18½ inches. Paris, Louvre.

The views he painted of Rome and the surrounding countryside were central to Corot's development. From a base that was still Poussin-like in feeling, he went on to achieve a painterly freshness, expressed by intense, luminous color and a broad sense of space. Both De Pisis and Morandi took this painting as a model in 1926, in homage to the French artist.

42. Jean-Baptiste-Camille Corot: *Bridge of the Castle Sant'Angelo*. 1826-27. Oil on canvas, 7⅞ x 14½ inches. San Francisco, Palace of the Legion of Honor.

Corot painted this during his first trip to Rome, and its composition is essentially the same as the one used by other visiting painters, for instance, Van Wittel, and it is quite possible Corot had him in mind. In this view, we can see that Corot was already stressing the mass of the various structures, as they are located in space and delineated by the light in an overall, soft golden-brown tone.

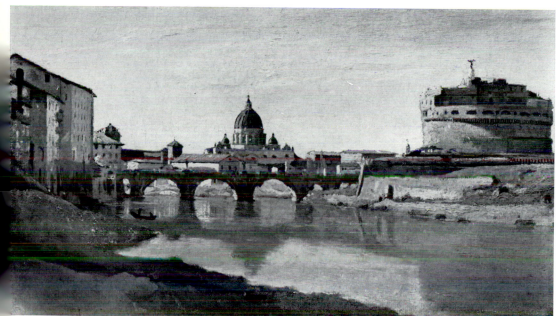

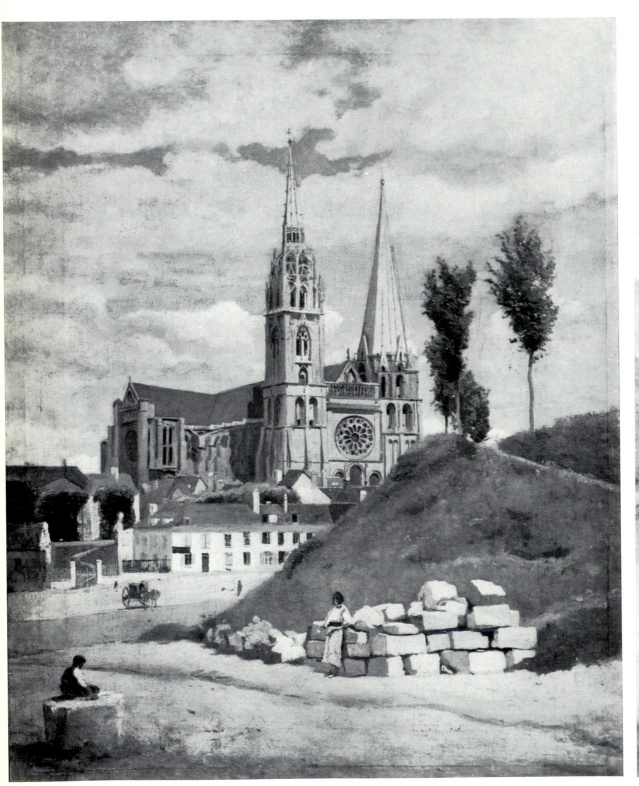

COROT

43. Jean-Baptiste-Camille Corot: *The Cathedral of Chartres*. 1830. Oil on canvas, 24⅜ x 19⅝ inches. Paris, Louvre.
Corot frequented the forest of Fontainebleau and other places in France to find the landscapes best attuned to his poetic sense. He travelled around Normandy and Burgundy especially. This view of Chartres is a masterpiece of pictorial unity, enlivened by vivid touches of color.

44. Jean-Baptiste-Camille Corot: *The Pond with the Overhanging Tree*. c. 1872. Oil on canvas, 16½ x 17⅜ inches. Reims, Musée des Beaux-Arts.
Corot cannot be considered an impressionist, but without doubt his vision of nature, expressed with loving, direct fidelity and an acute sense of the quiet play of light, is an anticipation of impressionism. In his last years Corot's sensibility tended toward the melancholy, and his palette was dominated by bluish and pearly greys with which he rendered the dying light of the woods and ponds.

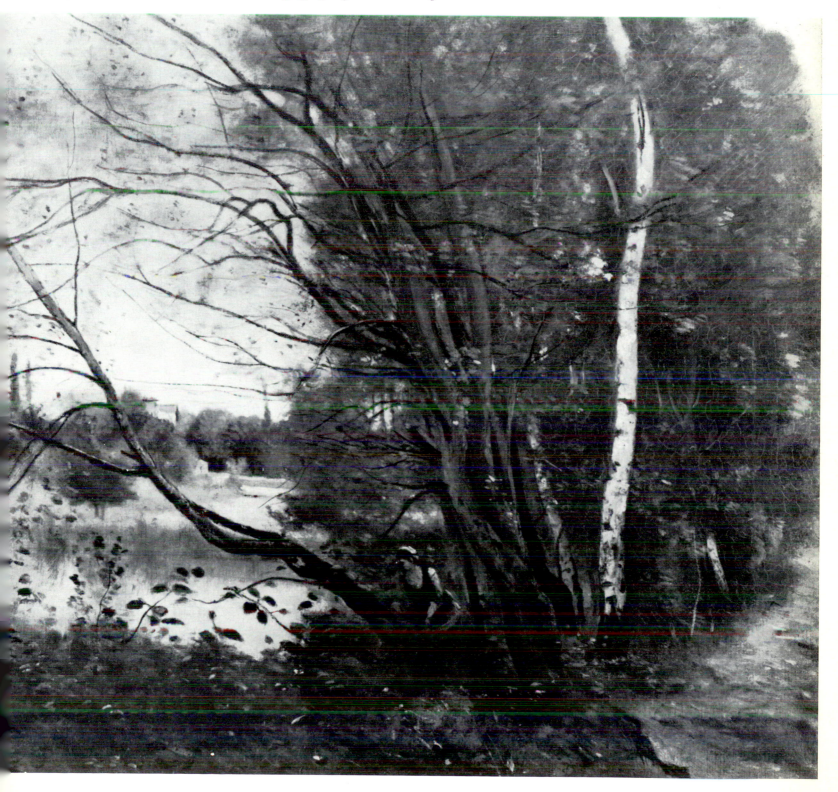

45. Jean-Baptiste-Camille Corot: *The Cathedral of Mantes*. 1865-70. Oil on canvas, 20⅛ x 12⅝ inches. Reims, Musée des Beaux-Arts.

The artist had already depicted the apse of the cathedral at Mantes. Two versions are in the Reims Museum: this vertical one, and another, horizontal, painted within a short time of each other. In both we see a pale sky, grey light and feathery leaves, with the church reflected in the river.

46. Jean-Baptiste-Camille Corot: *The Palace of the Popes at Avignon*. c. 1836. 13⅜ x 28¾ inches. London, National Gallery.

Corot's love of nature impelled him to take many trips through France and Italy. This landscape of Avignon was done shortly after his return from Italy. In a fine spatial synthesis, the imposing walls of the palace stand out against the horizon, and the distance is marked off by the enclosed areas of color formed by the trees and houses.

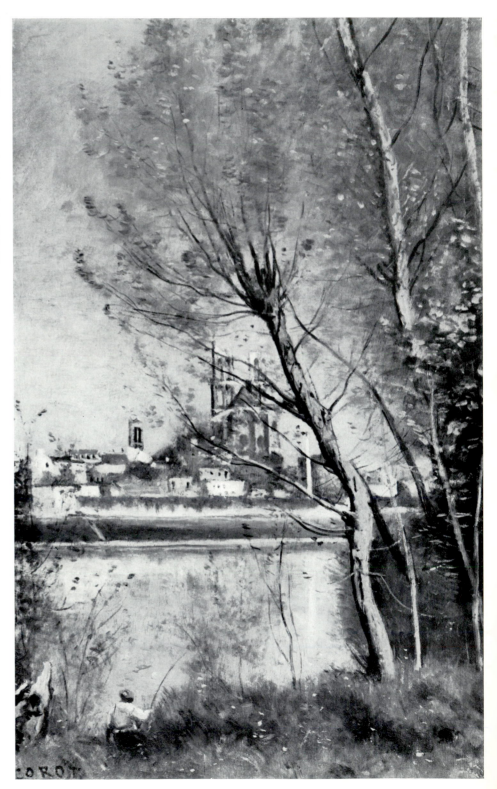

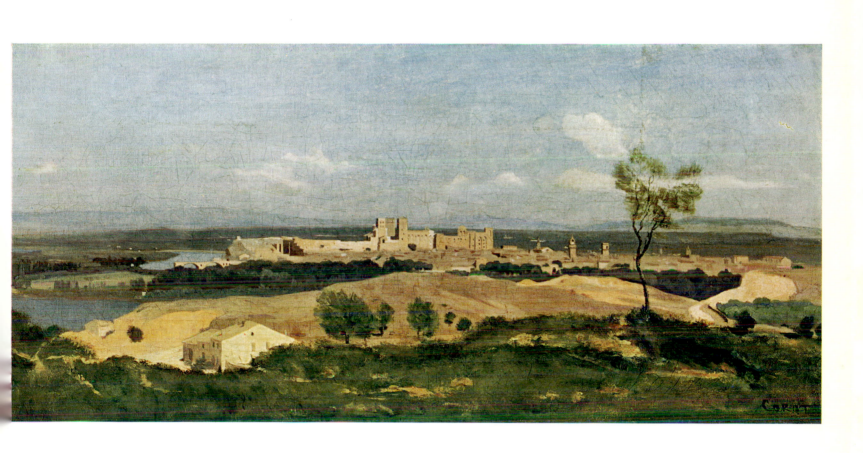

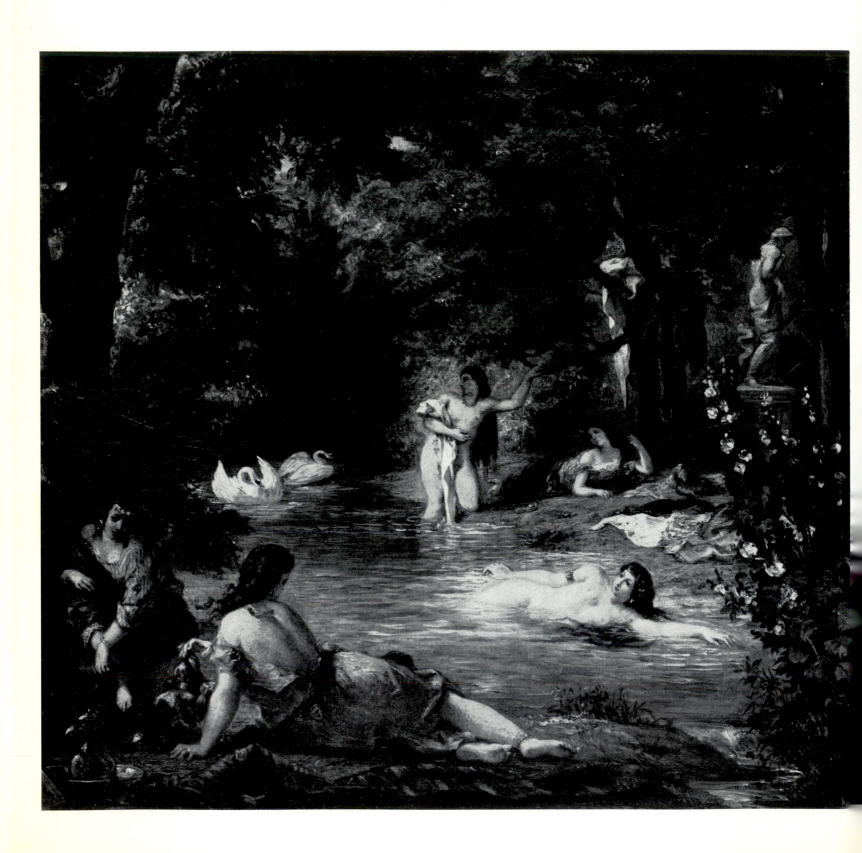

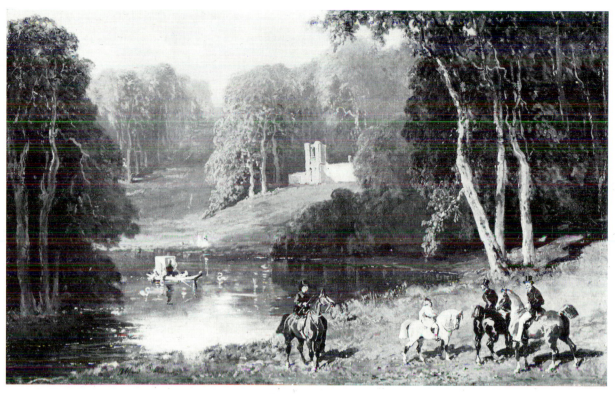

47. Eugène Delacroix: *Turkish Women Bathing*. 1854. Oil on canvas, $36\frac{1}{2}$ x 31 inches. Hartford, Connecticut, Wadsworth Atheneum.

Delacroix painted few landscapes, and always with figures, animals, still lifes. With his romantic taste for the exotic, the oriental, he depicted here in the thick of the forest a group of Turkish women bathing, as if he were evoking a modern Diana with her attendants.

48. Alfred De Dreux: *Knights and Amazons by the Lake of Pierrefonds*. c. 1859. Oil on canvas, $16\frac{7}{8}$ x $25\frac{5}{8}$ inches. Paris, Louvre.

While the Barbizon painters sought to find their feelings reflected in nature and thus were preparing the way for impressionism, here De Dreux was looking for a beautiful setting against which to pose his elegant riders.

49. Auguste Ravier: *The Tiber at Ostia, at Night*. 1840-43. Oil on canvas, $11\frac{3}{4}$ x $17\frac{1}{2}$ inches. Paris, Louvre.

After his training was completed in Paris, Ravier was encouraged by Corot to go to Italy. A withdrawn and lonely man, he was struck by the sadness of the Roman countryside, which he depicted in deep, vibrant tones.

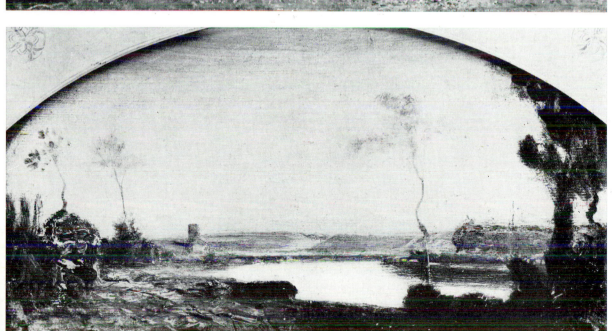

50. Théodore Rousseau: *The Pond*. 1849-55. Oil on panel, 10¼ x 14½ inches. Paris, Louvre.

The group of painters who made up the Barbizon School took their name from the village at the edge of the forest of Fontainebleau, where they had gone to live and work in order to paint directly from nature at different times of the day in an unspoiled setting. The countryside there became the mirror of their feelings, which tended toward the contemplative and the melancholy.

51. Jules Dupré: *Watering the Animals by the Great Oak*. 1850-55. Oil on canvas, 32¼ x 47¼ inches. Paris, Louvre.

Although the Barbizon group found inspiration around them, these painters were also attached to the vision of nature they found in the Dutch landscapists, especially Ruysdael. Their realism, however, is tempered by a solemn, almost religious sense of nature.

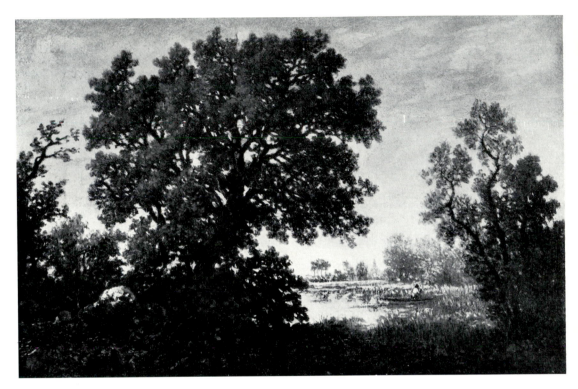

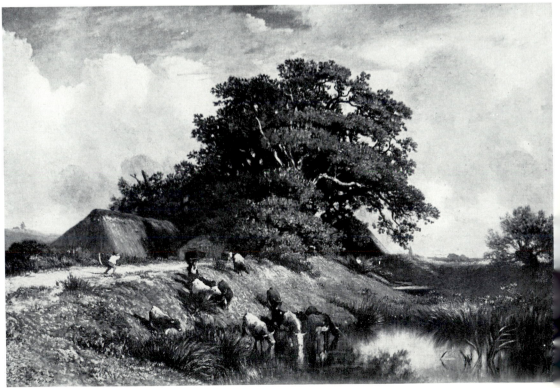

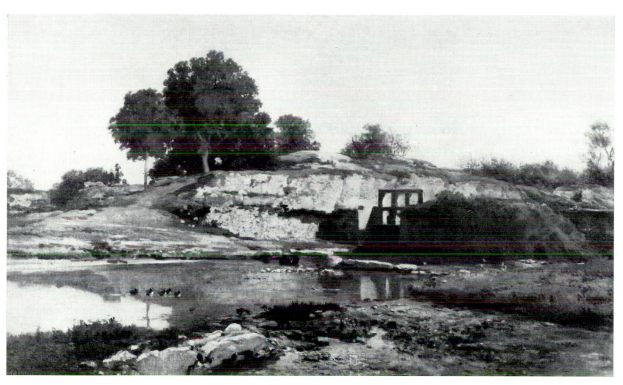

52. Charles Daubigny: *The Locks at Optevoz*. 1859. Oil on canvas, $19\frac{1}{8}$ x $28\frac{3}{4}$ inches. Paris, Louvre.

This is a replica of the painting now in the Museum of Rouen. At times the Barbizon painters depicted scenes outside the forest at Fontainebleau, but always chose unspoiled, rustic places. Daubigny painted these scenes with a peculiar and compelling silvery light.

53. Charles Daubigny: *Gobelle's Mill at Optevoz*. Oil on canvas, $22\frac{3}{8}$ x $36\frac{1}{4}$ inches. New York, Metropolitan Museum of Art.

Compared to his fellow painters at Barbizon, Daubigny had a deeper awareness of light, which he would express with still reflections at dusk, when the sky grows pale and the water of the ponds and brooks is lighted by silvery glints.

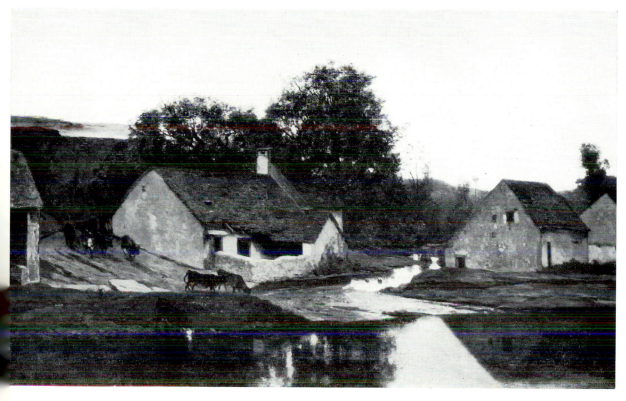

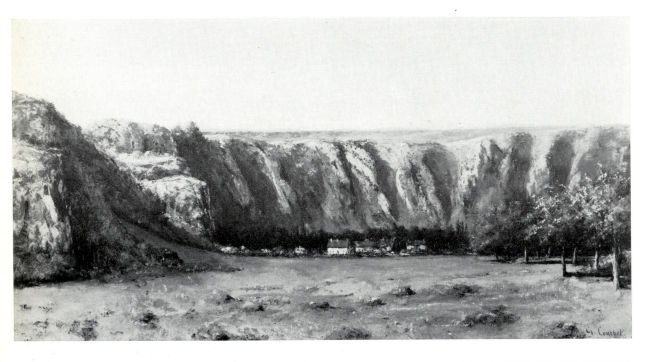

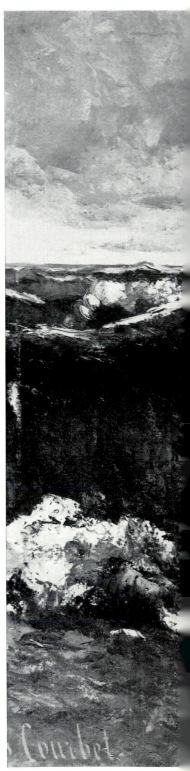

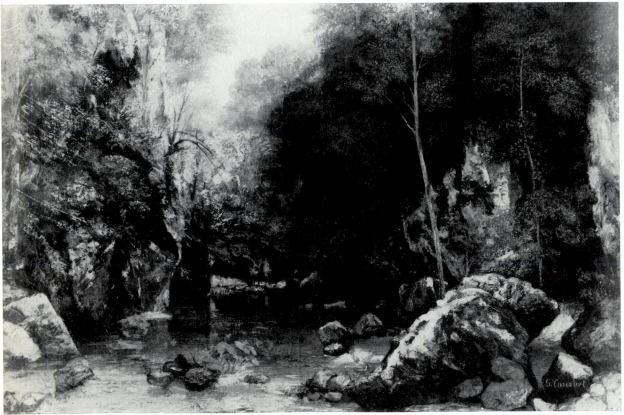

54. Gustave Courbet: *Ten O'Clock Crag*. 1855. Oil on canvas, 33⅝ x 63 inches. Paris, Louvre.
After a short romantic period, Courbet took to representing reality more directly; his explicit rendering of things made him the leading exponent of realism.

55. Gustave Courbet: *The Brook of the Black Well*. 1865. Oil on canvas, 37 x 51⅝ inches. Paris, Louvre.
This painting once belonged to Napoleon III, before being acquired by the Museum of Luxembourg in 1879. In keeping with his straightforward perception of nature and reality, Courbet's painting became profoundly objective.

56. Gustave Courbet: *The Wave*. 1870. Oil on canvas, 26⅜ x 42¼ inches. Bremen, Kunsthalle.
Courbet painted ocean waves a number of times. In the same year he painted this, he painted a similar view of the ocean entitled Stormy Sea *(now in the Louvre). The artist was especially fond of depicting subjects in which nature reveals its overwhelming primitive force.*

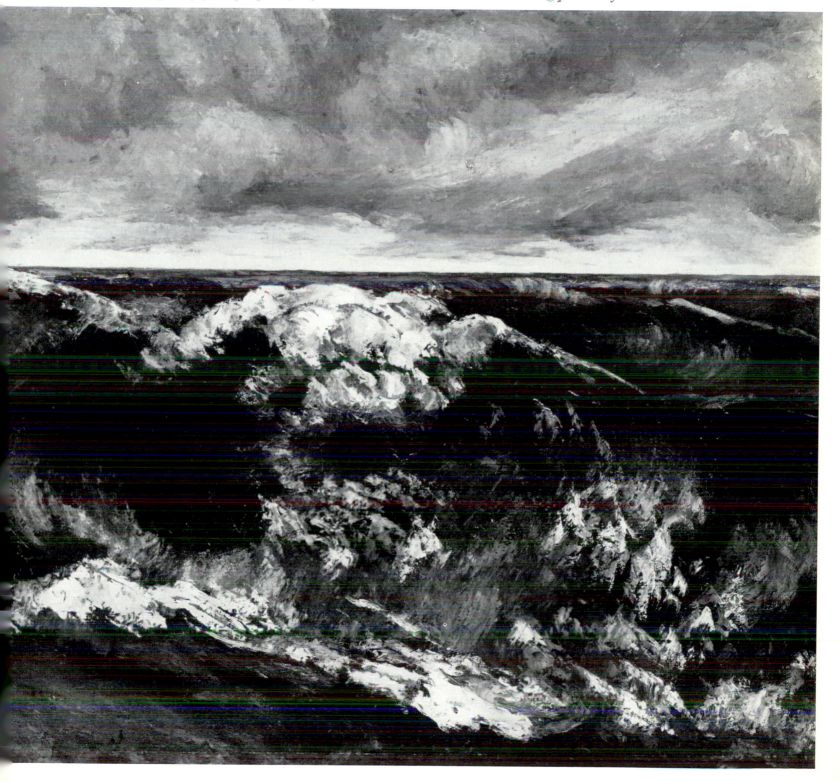

57. Gustave Courbet: *The Cliffs of Etretat after the Storm*. 1870. Oil on canvas, 52⅜ x 63¾ inches. Paris, Louvre.
Living for a time on the Normandy coast, Courbet would portray the different aspects of the shoreline. Here the rocky mass looms in the composition;
the boats are solidly objective, and the light picks out the volumes that confirm this concreteness. Later, when Monet painted this same rock, he chose to
capture its violet reflections and the dense, shimmering humidity of the atmosphere.

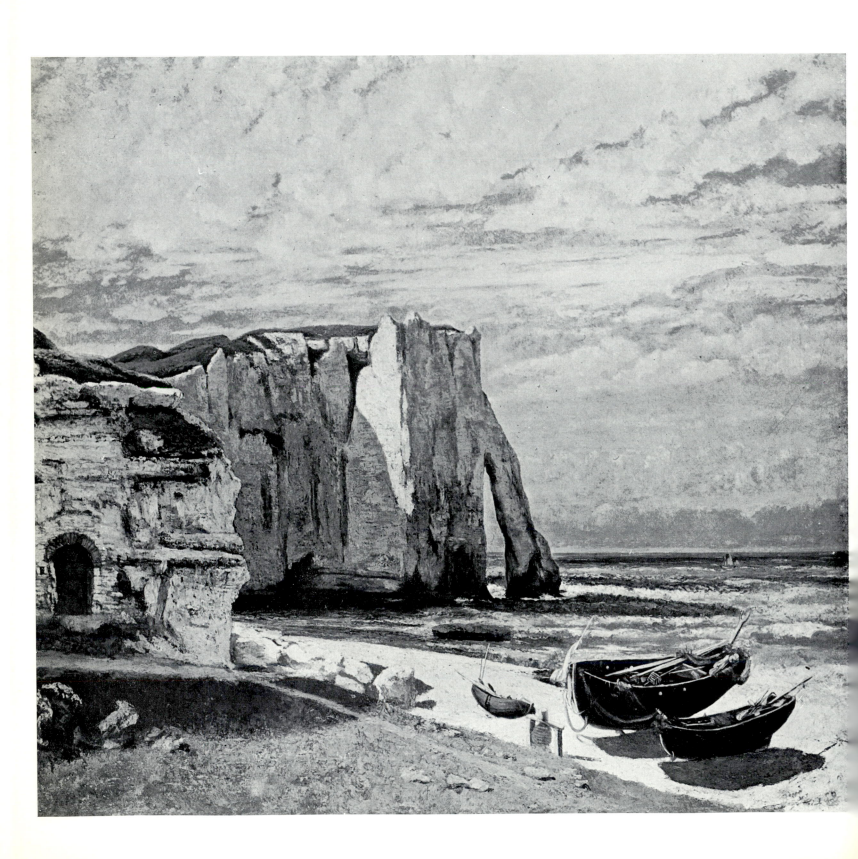

58. Jean-François Millet: *The Shepherdess*. 1850-55. Oil on canvas, 12¾ x 9⅞ inches. Paris, Louvre.
Drawn by the philosophy of the Barbizon painters, Millet joined them, but while his fellow painters portrayed nature in a contemplative mood, but always naturally, Millet, a very gifted artist, introduced an excessive pathos into his paintings.

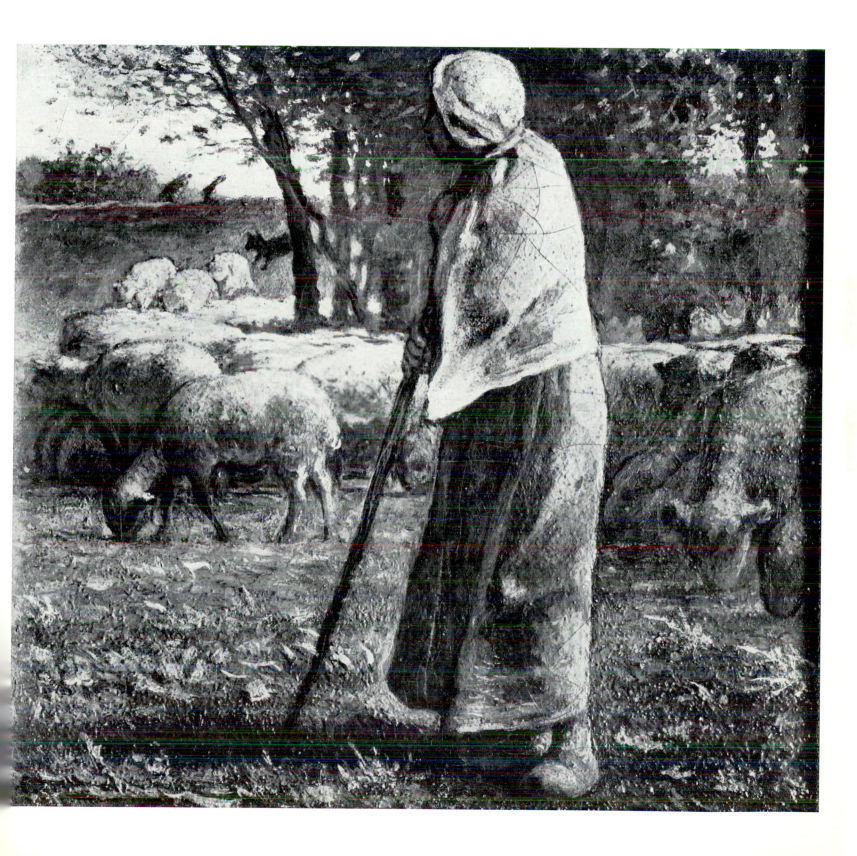

59. Théodore Rousseau: *Cows at the Pond*. 1852-55. Oil on panel, 8⅝ x 13⅜ inches. Paris, Louvre.

Toward dusk, a girl leads the cows to a pond, around them the twisted oaks and a heath. The vast sky and the solitude of the countryside are reminiscent of the Dutch landscapes of the seventeenth century, but here the handling is more realistic, even if the great silence conveys a definite mood.

60. Jean-François Millet: *The Church at Gréville*. 1871-74. Oil on canvas, 23⅝ x 28⅞ inches. Paris, Louvre.

The old church is rendered with the same colors we see in the rocks and the ground. The late light strikes it from the side, and the resulting cold and silvery highlights remind us of Daubigny's paintings. Lacking Millet's usual pathos, the painting's simplicity and strict visual quality make it a masterpiece.

61. Edouard Manet: *Le Déjeuner sur l'Herbe* (detail). 1862-63. Oil on canvas, entire painting 35¼ x 45⅝ inches. London, Courtauld Institute.

This is a preparatory study for the famous painting in the Louvre which Manet exhibited and which caused a great scandal at the 1863 Salon des Refusés. Even if the subject is derived from an engraving by Raimondi and from Titian's Fête Champêtre *(other critics attribute this painting to Giorgione), it is handled with a strictly modern sense of life, landscape and light.*

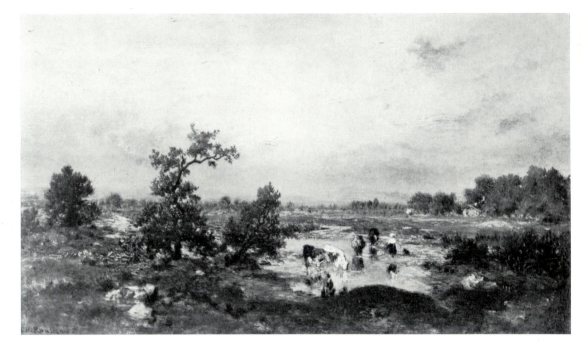

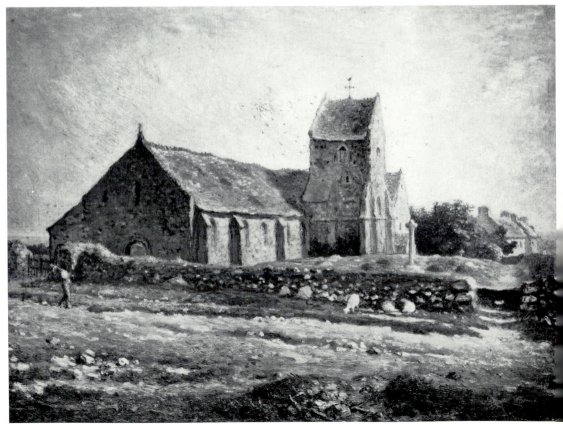

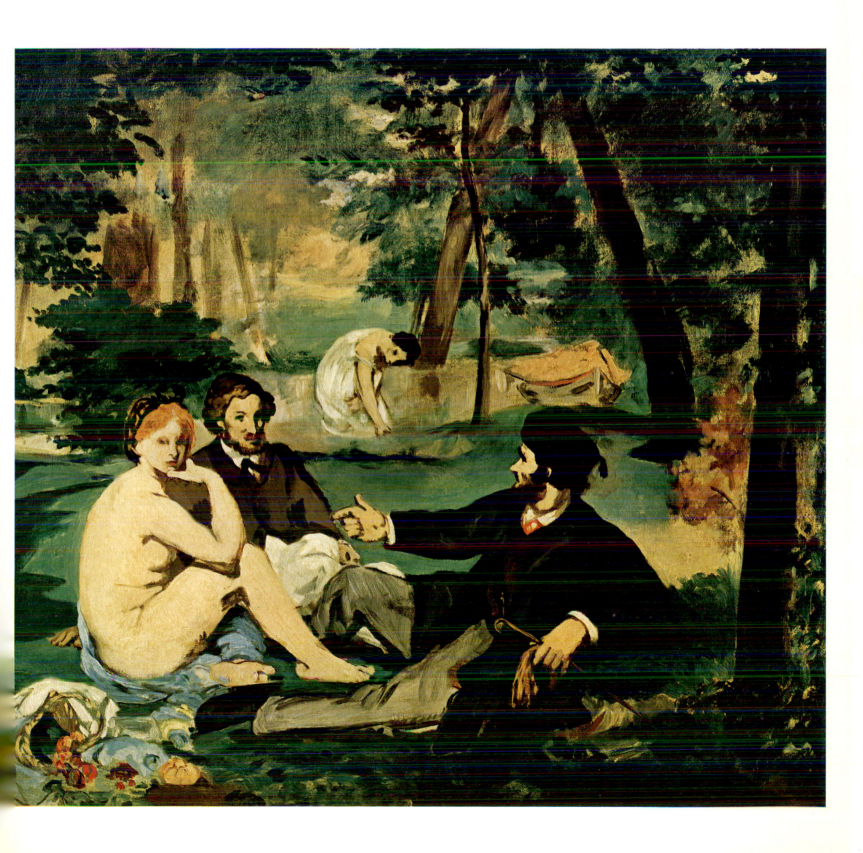

62. Eugène Boudin: *The Empress Eugénie on the Beach at Trouville*. 1865. Oil on canvas, 13½ x 22½ inches. Glasgow, Art Gallery and Museum.

Between Honfleur, Le Havre and Trouville, Boudin painted a number of beach scenes and scenes of daily life. Aware of the innovations made by Jongkind, especially the light, rapid impression, Boudin followed his example, but with a brighter palette. He was Claude Monet's teacher.

63. Eugène Boudin: *The Jetty at Deauville*. 1869. Oil on canvas, 9 x 12⅝ inches. Paris, Louvre.

In these small canvases, the artist captured the busy life on northern beaches with rapid brushwork and tasteful color. Impressionism here is interpreted joyously, with episodes narrated through images.

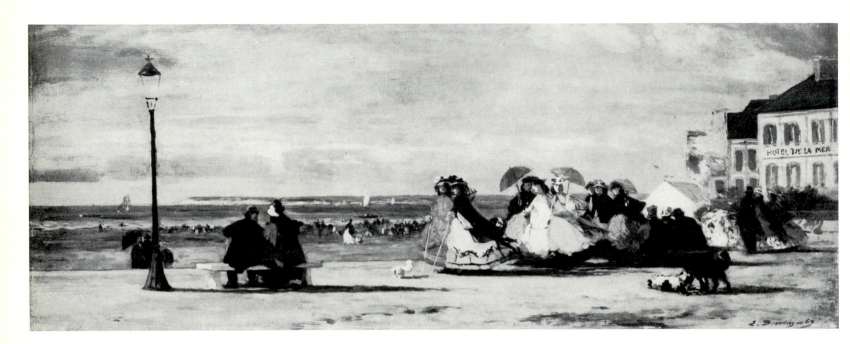

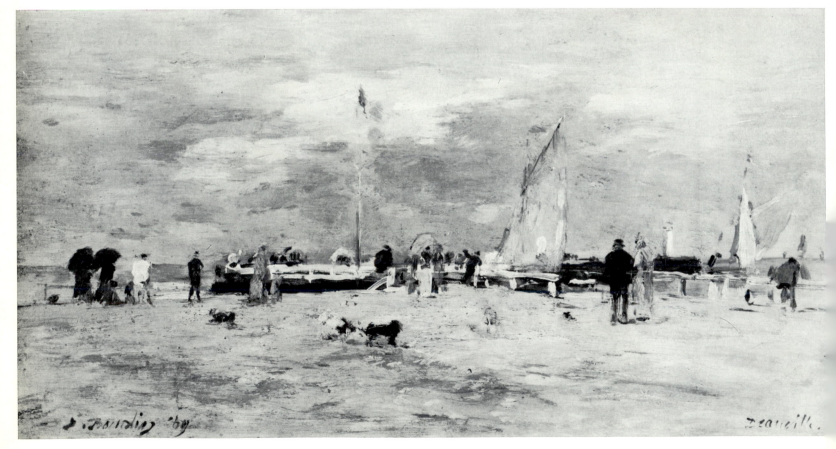

64. Claude Monet: *The Beach at Sainte-Adresse*. 1867. Oil on canvas, 31⅞ x 37¾ inches. Chicago, Art Institute.

With the realism of Courbet and the Barbizon painters as a model, and developing through a modern sensitivity a direct vision of reality and an imme-diate pictorial transposition, impressionism was born in Paris in 1863. Monet, more than Manet, who had made the first sallies, was to realize most completely its intention: to capture the transient moment with an equally rapid technique.

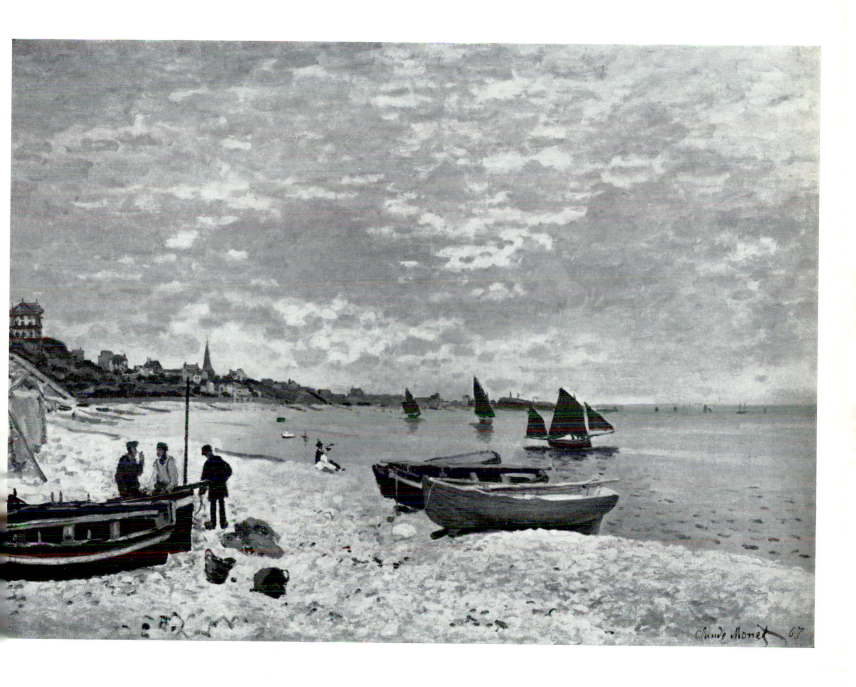

65. Claude Monet: *Quai du Louvre.* c. 1868. Oil on canvas, 25⅝ x 36⅝ inches. The Hague, Haags Gemeentemuseum.

Monet painted the activity along the Seine several times, and in his cultural makeup we find the perspective view as it had been developed by the eighteenth-century Venetians, the objective realism of Courbet and the light of the Dutch painters, but his painting was entirely new because the real world is captured on canvas with a glance, and the light emphasizes the pictorial rhythm rather than the details.

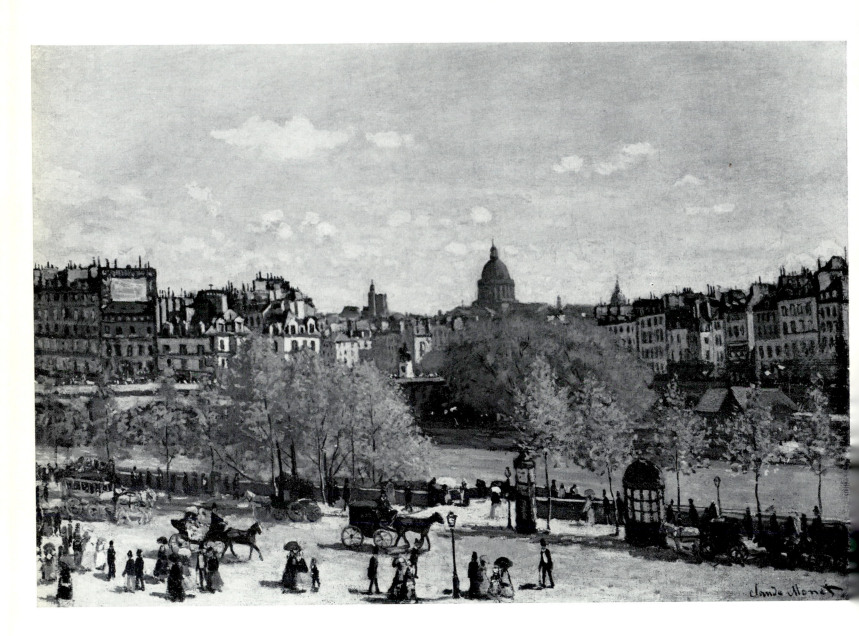

66. Claude Monet: *La Grenouillère*. 1869. Oil on canvas, 28¾ x 39 inches. New York, Metropolitan Museum of Art.

The joy of life as it is perceived in the immediacy of daily happenings and a fluid technique that could capture reflections and highlights prompted Monet to find his subjects along the Seine, where light and color and life seemed to be at their liveliest.

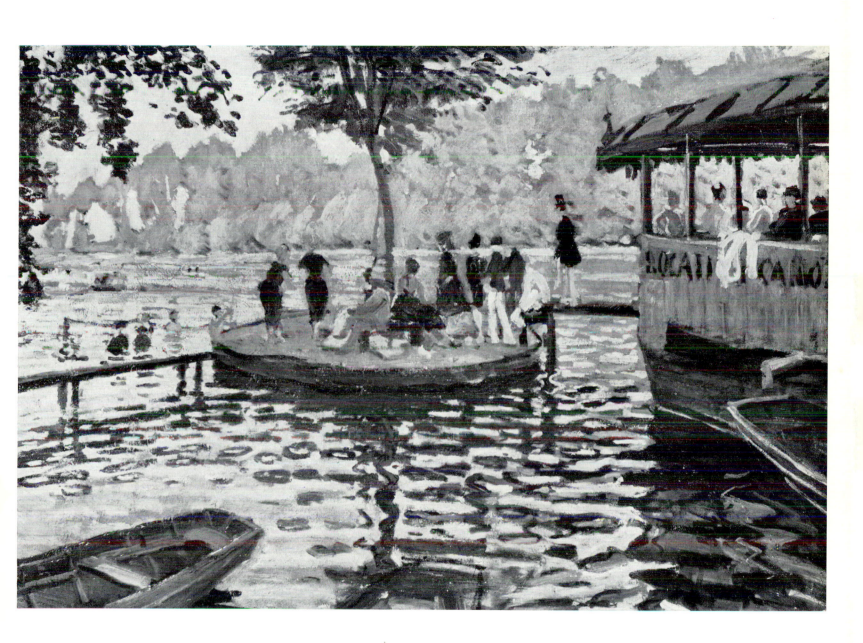

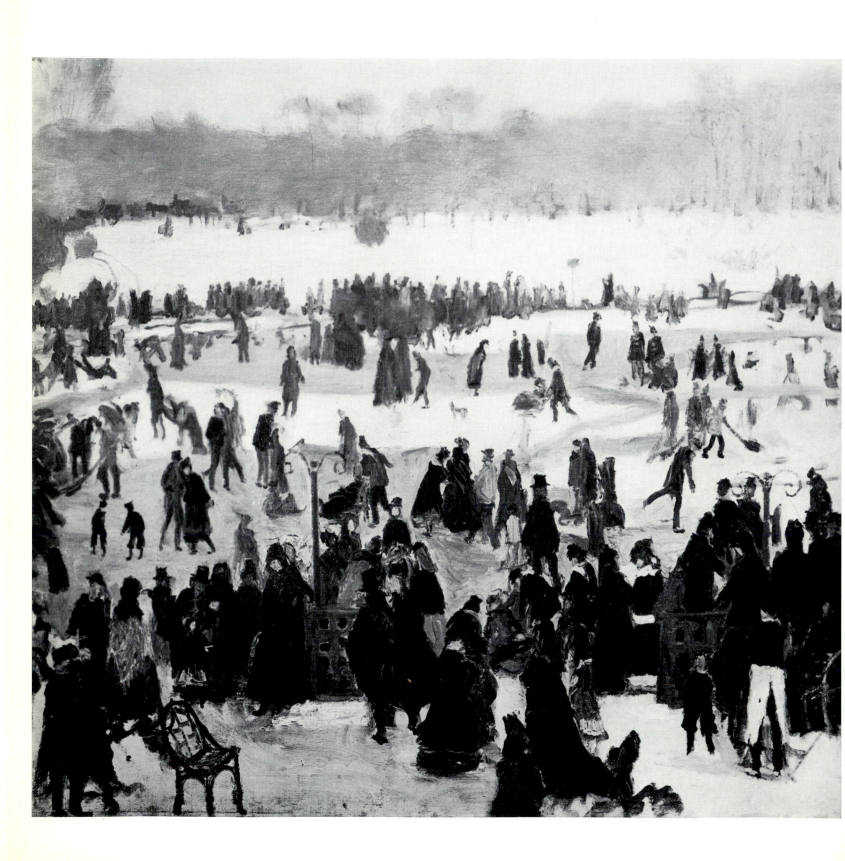

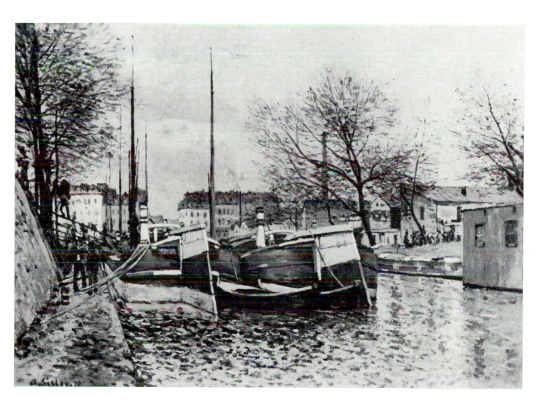

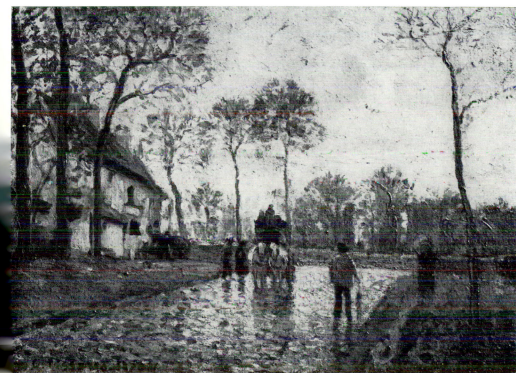

67. Pierre-Auguste Renoir: *Skaters at Long-champs in the Bois de Boulogne* (detail). 1868. Oil on canvas, entire painting 28⅜ x 35⅞ inches. Basel, Robert von Hirsch Collection.

Renoir, too, loved scenes of city life, the crowds that gathered to listen to concerts in the park or stroll along the Seine. With the quite beautiful effect of color against the white of the snow, Renoir captured the animation of the skaters, as Bruegel and Avercamp had in their time.

68. Alfred Sisley: *The Saint Martin Canal in Paris*. 1870. Oil on canvas, 21⅝ x 25⅝ inches. Winterthur, Oskar Reinhart Collection.

The years around 1870 were the most active for the impressionists. Everywhere they found themes which they could render into immediate, fresh images set against the rapid play of light, breaking into myriad touches of color.

69. Camille Pissarro: *The Coach at Louveciennes*. 1870. Oil on canvas, 10 x 14 inches. Paris, Louvre.

Pissarro lived in this town for some time, as did Sisley. Autumn here is slowly stripping the trees and the rain is scoring the earth; the air is dank and misty, brown and transparent at the same time. Pissarro uses this simple scene to record the changing season, and succeeds in dissolving the outlines of figures and objects in fluid areas of color.

70. Camille Pissarro: *Entering the Village of Voisins*. 1872. Oil on canvas, 18⅛ x 21⅝ inches. Paris, Louvre.

Pissarro and other impressionist painters chose to live in small villages, in order to be in touch with nature, of course, but we must realize that there were economic motives as well, because the public still did not understand the imaginative power of these paintings. In this painting, spring appears imminent, a mood the painter conveys with the clear light, the long morning shadows, the pale sky.

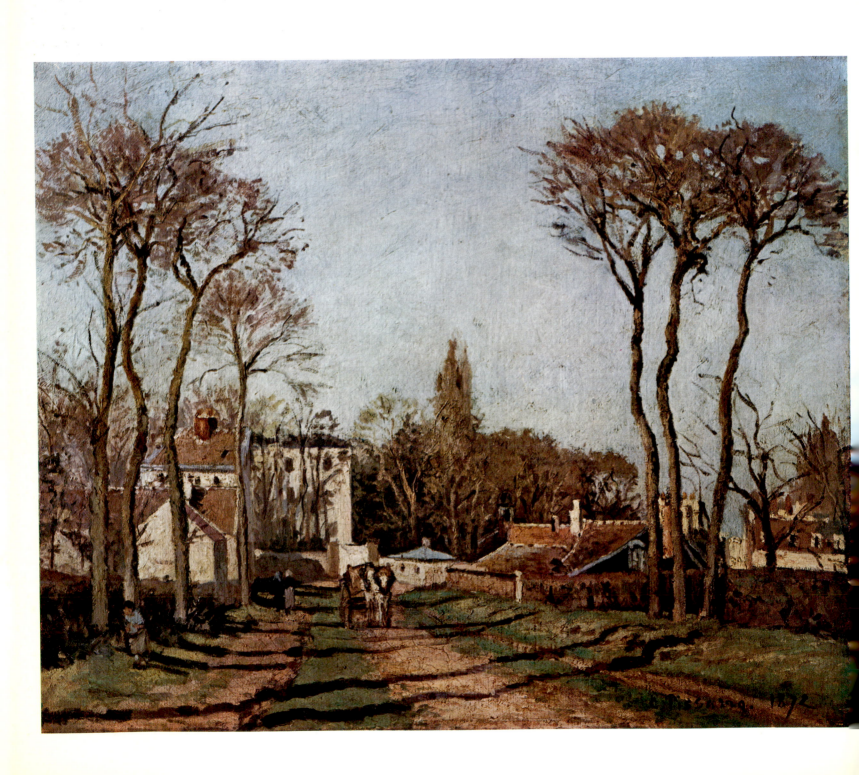

71. Edgar Degas: *Carriages at the Races*. 1870-73. Oil on canvas, 14⅛ x 29½ inches. Boston, Museum of Fine Arts.

Degas took part right from the start in the arguments over impressionism. But he had been trained in the museums and with classical Italian painting; he could not pursue an esthetic of transient light and color to the disadvantage of drawing and composition. With his own style, and with gemlike areas of color, he did, however, depict outdoor scenes: the streets of Paris and the horse races.

72. Claude Monet: *The Regatta at Argenteuil*. c. 1872. Oil on canvas, 18⅞ x 29½ inches. Paris, Louvre.

The painting was part of the 1864 Caillebot legacy, but was accepted by the Louvre only in 1929. The Seine at Argenteuil often saw impressionist painters at work, Monet especially, who did a number of paintings there between 1872 and 1875. He was avid in his attempts to capture the various aspects of the river, the lively reflections in the water, the numerous instances when color and atmosphere played against each other. This painting is one of the most famous of the impressionist masterpieces.

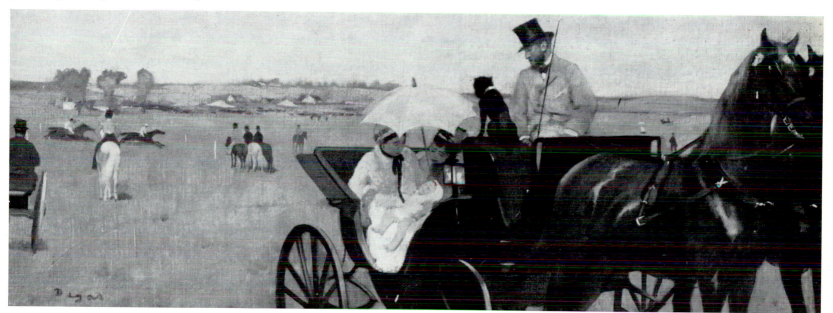

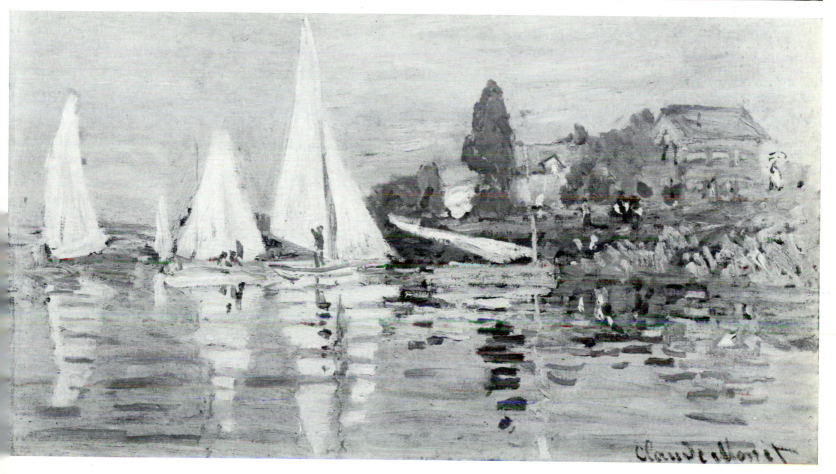

73. Pierre-Auguste Renoir: *The Seine at Argenteuil.* c. 1873. Oil on canvas, 18¼ x 25⅝ inches. Paris, Louvre.

Here we see the river and its unspoiled banks under the wide, cloud-filled sky. The village can be made out among the groves. The details of this river landscape dissolve in the vibrant areas of color. In fact, Renoir is seeking the most intense color effects amid the diffuse luminosity.

74. Claude Monet: *The Sea at Etretat.* 1883. Oil on canvas, 26 x 31⅞ inches. Paris, Louvre.

Monet returned to Etretat several times and painted it according to different artistic conceptions. In this version, we see that he has dissolved natural outlines into the washes of light and vibrant color. A comparison with Courbet's rendering of Etretat (plate 57) would be useful in order to see the profound differences between the two painters.

75. Alfred Sisley: *Ile Saint-Denis* (detail). 1872. Oil on canvas, entire painting 19⅞ x 25⅝ inches. Paris, Louvre.

Sisley, too, was attracted by the scenes on the Seine and there painted his subtly luminous, spacious, delicately highlighted "moments." This painting was formerly in the E. May Collection, where it formed a triptych with paintings by Pissarro and Monet done around the same time.

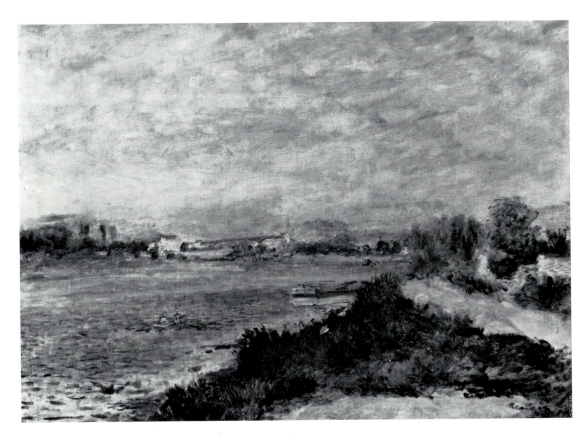

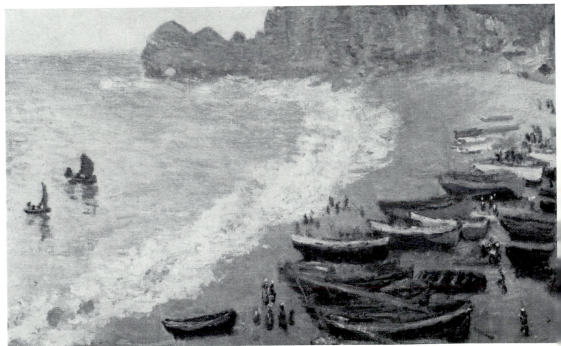

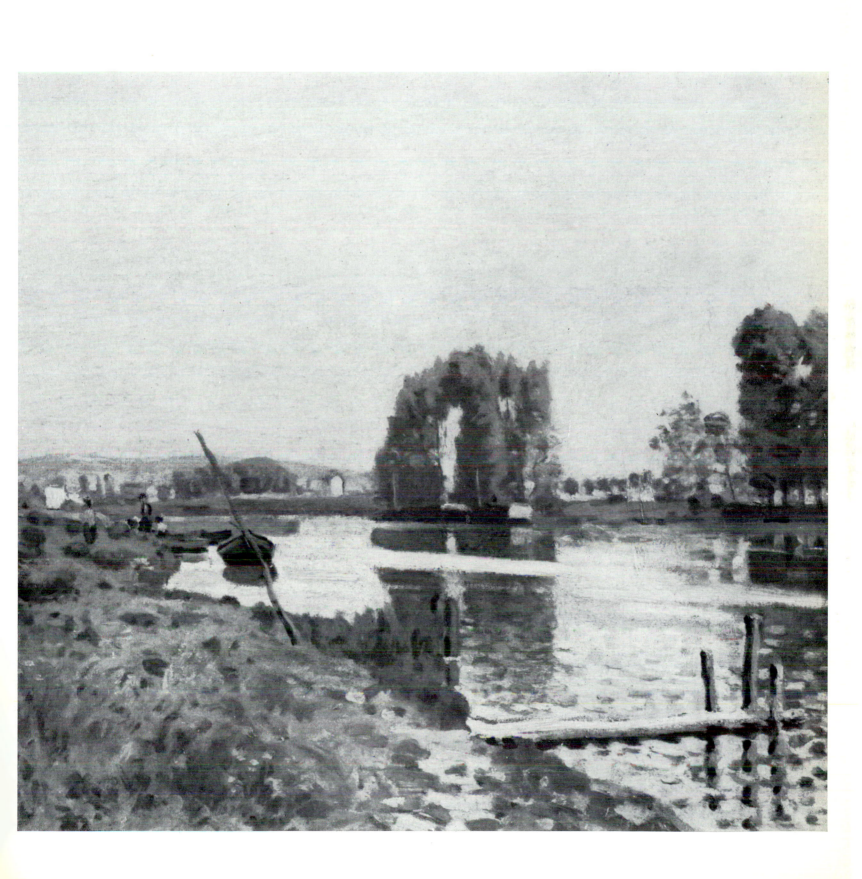

76. Paul Cézanne: *Dr. Gachet's House at Auvers-sur-Oise.* c. 1873. Oil on canvas, 18⅛ x 15 inches. Paris, Louvre.

The artist stayed at Dr. Gachet's house several times, as had Guillaumin and Pissarro. In 1890, the doctor welcomed Van Gogh there, shortly before he killed himself. Cézanne had been persuaded by Pissarro to use impressionist technique, and with it he produced a number of significant paintings. But he had difficulty accepting Monet's notions about the dynamics of light. We can always observe in Cézanne's paintings how he maintained the firmness and the solidity of volumes.

77. Alfred Sisley: *Louveciennes in Winter* (detail). 1874. Oil on canvas. Washington, Phillips Collection.

Sisley did quite a few paintings at Louveciennes in the company of Pissarro. He is aware of all effects of light and tries to render all of its many possibilities. But unlike Monet, who dissolved his volumes into a kind of powdered color, Sisley retained consistent tones even in the thinnest and most fragile washes.

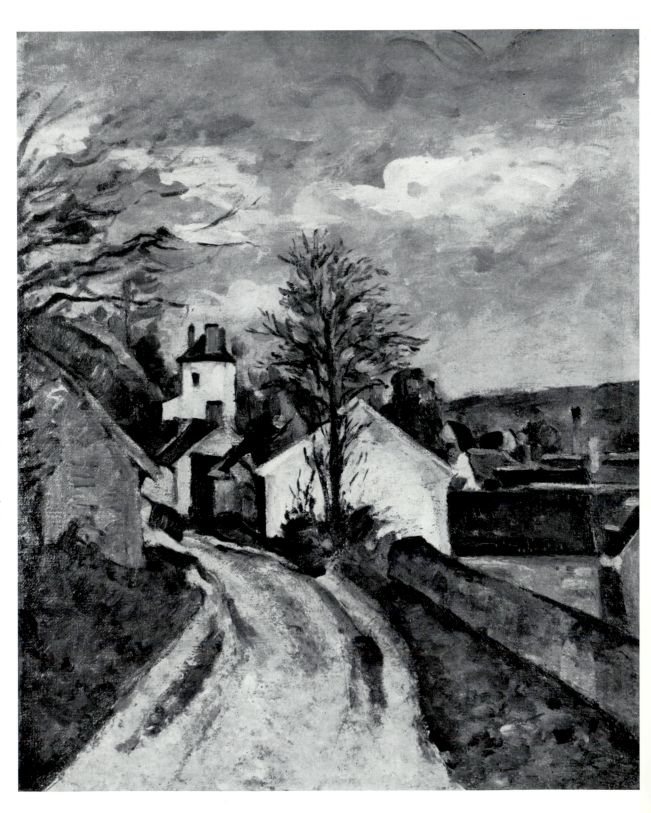

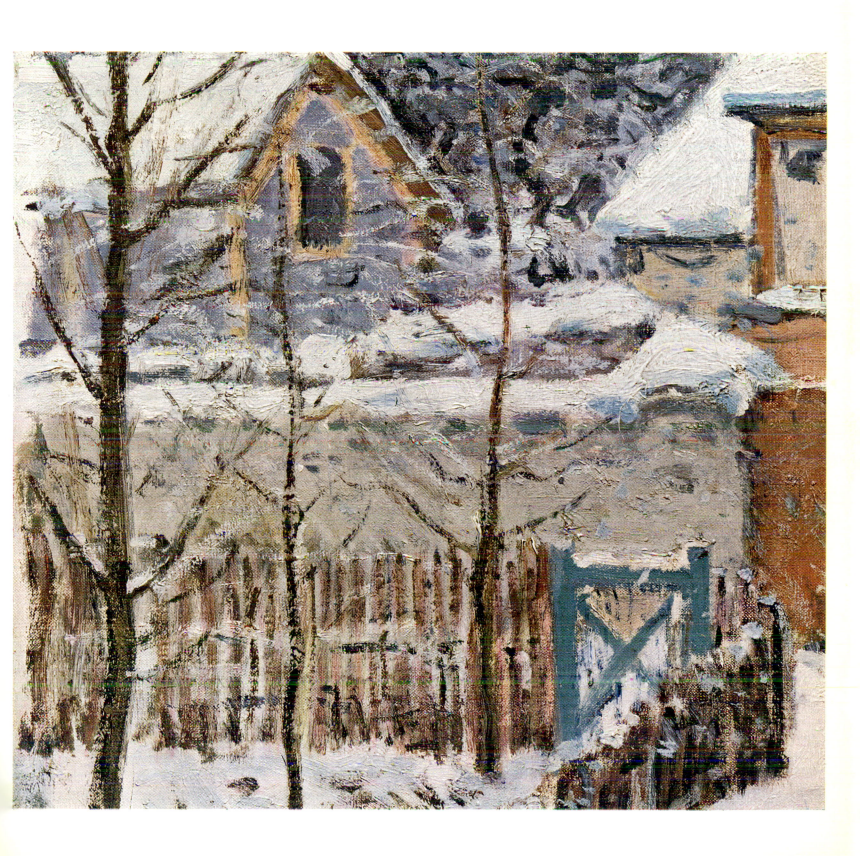

78. Alfred Sisley: *Louveciennes in Winter*. 1874. Oil on canvas, 21⅝ x 17¾ inches. Washington, Phillips Collection.
This is the whole of the painting of which a detail is shown in plate 77. Here we can better grasp the intimate scale Sisley was master of.

79. Paul Cézanne: *La Maison du Pendu*. 1873. Oil on canvas, 21⅝ x 26 inches. Paris, Louvre.
In 1873, the painter was staying at Auvers, not far from the Pontoise home of Pissarro, who introduced him to clear colors and painting tone on tone. Cézanne was persuaded at first to carry his realism toward more painterly solutions. This particular subject inspired him several times; this version is the most compact and tactile. Exhibited with the other impressionist paintings at Nadar's studio in 1874, it was the only one sold.

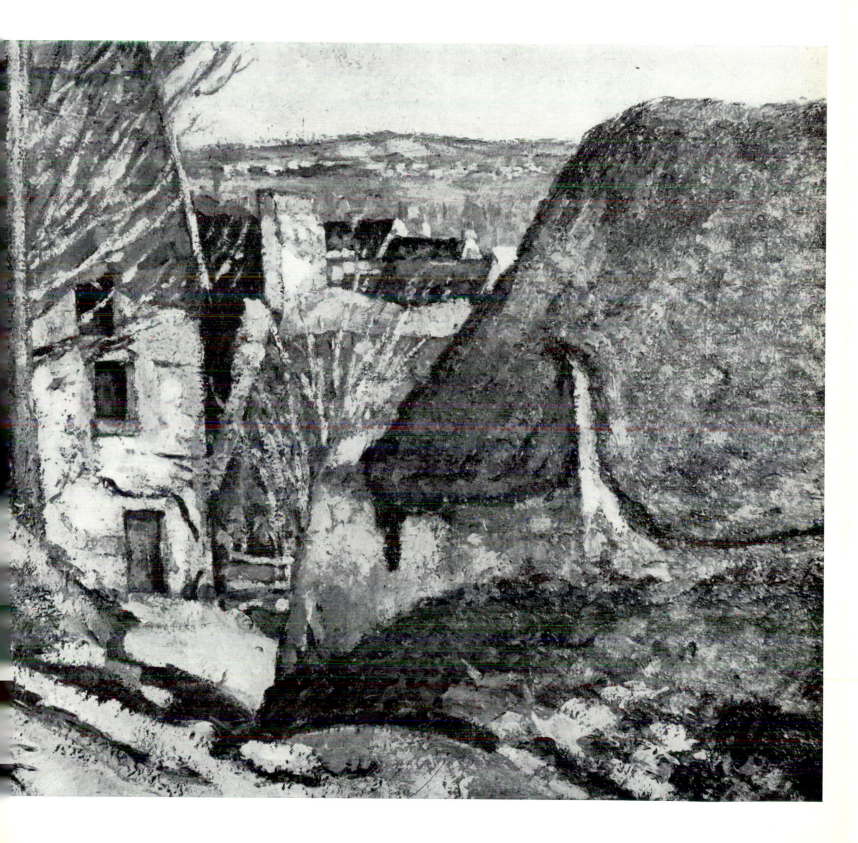

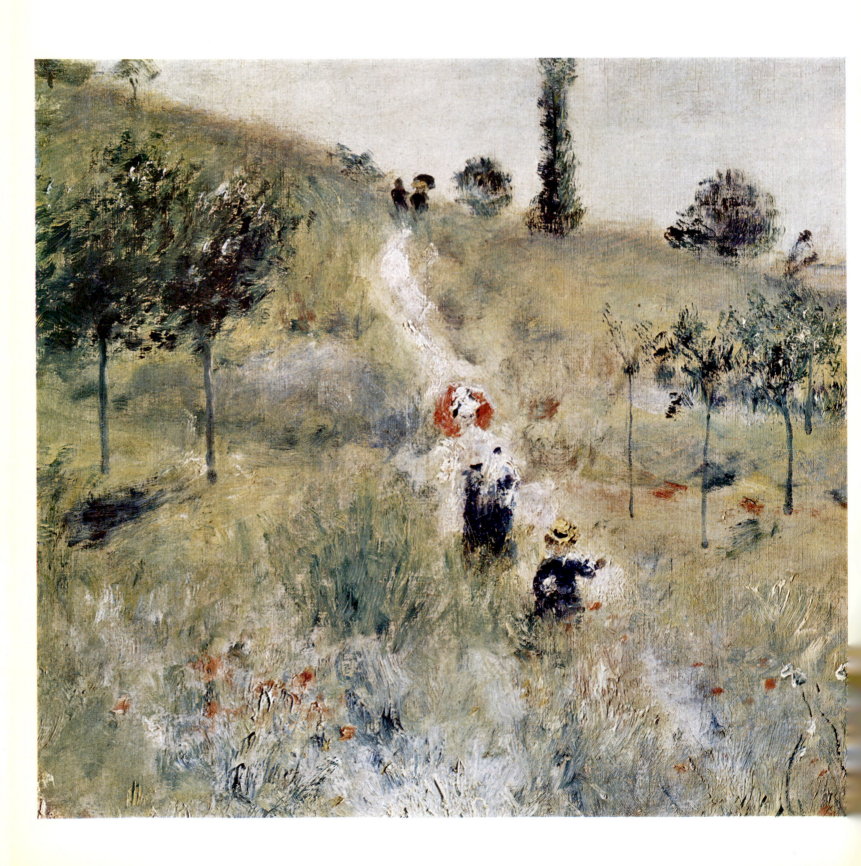

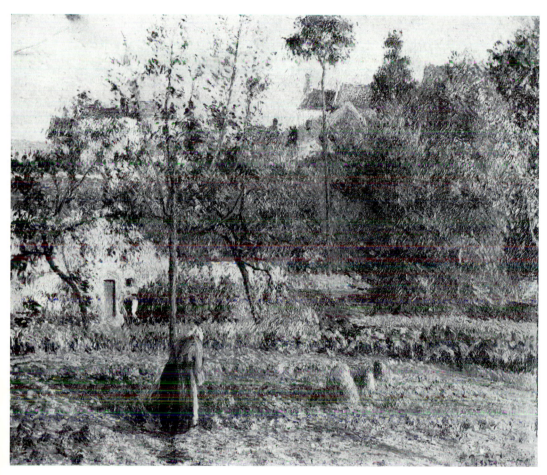

80. Pierre-Auguste Renoir: *Path Through the High Grass* (detail). 1876-78. Oil on canvas, entire painting $23\frac{1}{4}$ x $29\frac{1}{8}$ inches. Paris, Louvre.

This is one of the most famous masterpieces of impressionism. The scene is just outside Paris; summer has burst forth with all its intense light, and several figures, including the woman with the red parasol, are running down the flowering hillside. The felicity of the color, always a talent of Renoir's, can here be appreciated in all its splendor.

81. Camille Pissarro: *Garden at the Hermitage, Pontoise*. 1879. Oil on canvas, $21\frac{5}{8}$ x $26\frac{1}{8}$ inches. Paris, Louvre.

Living at Pontoise, as at Louveciennes and other small villages, enabled the painter to follow the variations in light and color during the different seasons. Thick brushstrokes of color shape the hedges, the grass, the leaves caught against the light on the branches, in a striking chromatic harmony.

82. Claude Monet: *Winter at Argenteuil*. 1878. Oil on canvas, $23\frac{1}{4}$ x $38\frac{5}{8}$ inches. Buffalo, Albright-Knox Art Gallery.

Monet, a brilliant painter of summer light, was always faithful to this town on the Seine where he painted so many scenes with sailboats under the triumphant summer sun; he would paint these scenes on cold winter days as well. With all the snow, mud, murky water and grey sky, he still manages to find splendid ash and violet tones.

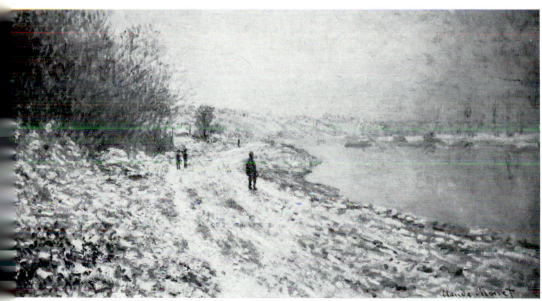

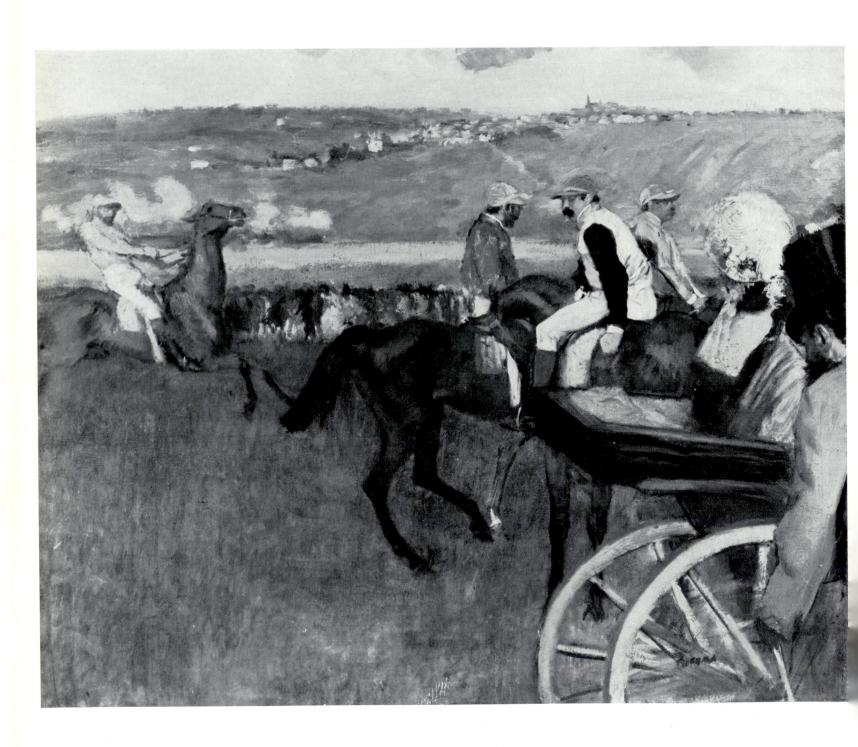

83. Edgar Degas: *At the Races: Jockeys by a Carriage*. 1877-80. Oil on canvas, 26 x 32¼ inches. Paris, Louvre.

This painting has an unusual composition characteristic of Degas: the figures appear in the foreground, but to the side, almost at the edge of the canvas. His fellow impressionists sought to capture the real world as its appearance changed with the light; Degas achieves the same immediacy by this dislocation of his figures, who seem to have suddenly come into view.

84. Vincent Van Gogh: *Montmartre*. 1886. Oil on canvas, 17⅜ x 13⅛ inches. Chicago, Art Institute.

His encounter with the impressionists the first time he went to Paris in 1886 brought a radical change to Van Gogh's painting. His background would not allow him to become a fully committed impressionist, but under their influence his palette brightened considerably, and he became more sensitive to the effects of light. But drawing was always the determining factor for him, and his brushstrokes constructed the forms rather than dissolving them in the luminous flow of color.

85. Paul Cézanne: *Mill Near Pontoise.* 1881. Oil on canvas, 29⅛ x 36¼ inches. Berlin, National Gallery.

The painting belonged to Père Tanguy, who sold paints and was well known to the impressionists, several of whom did his portrait. Impressionism fell into a crisis around 1880 when it became increasingly clear that the optical or retinal reaction to light, to which Monet was always loyal, brought a certain thinness and superficiality to painting by overstressing immediacy. In this painting, Cézanne reveals his resolve to achieve plasticity and to avoid dissolving his forms in light.

86. Paul Cézanne: *The Viaduct at L'Estaque*. 1882-85. Oil on canvas, 21¼ x 25⅝ inches. Helsinki, Museum.

He returned permanently to Provence around 1882 at the time when he had become completely disenchanted with impressionist technique. The solitary life he led at Aix, at L'Estaque and Gardanne, his methodical work habits, and the evolution of his thoughts led him to express his own vision. His style became more synthesizing each year, according to his intention "to do Poussin over, from nature."

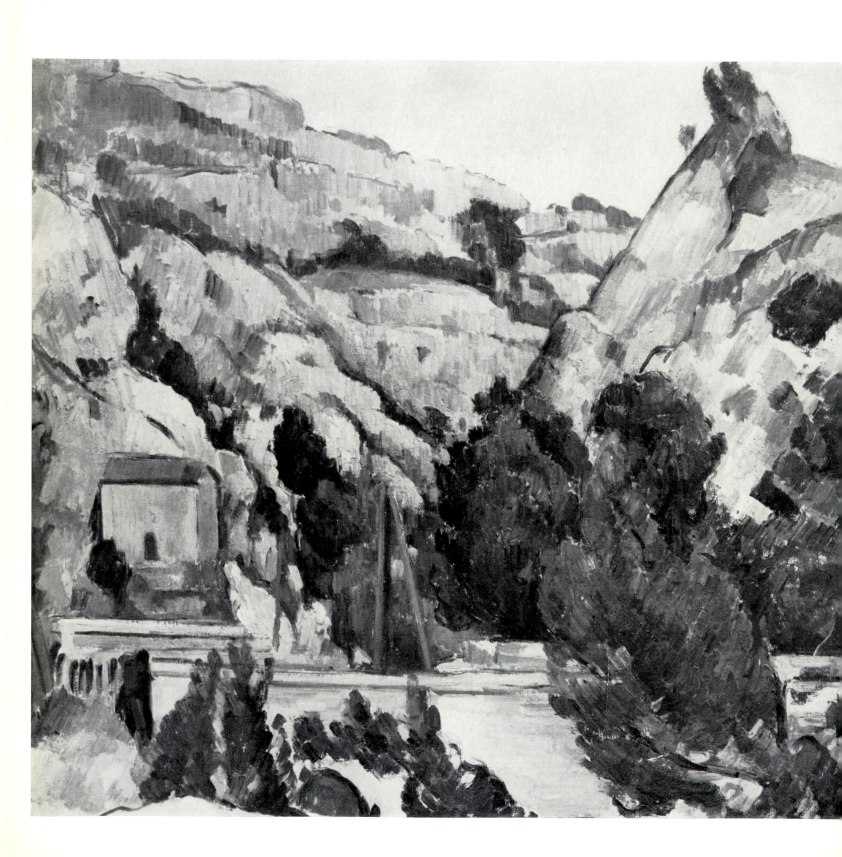

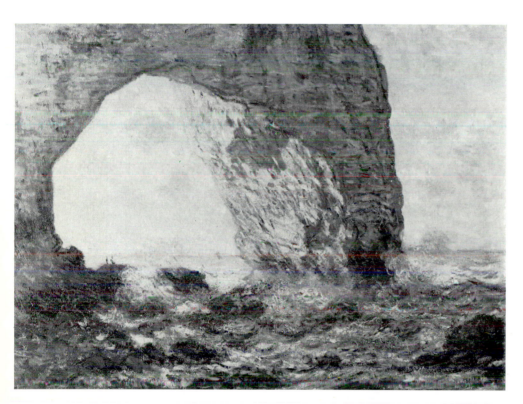

87. Paul Cézanne: *The Viaduct at L'Estaque*. 1882-85. Oil on canvas, 17⅜ x 20⅞ inches. Oberlin, Allen Memorial Art Museum, Oberlin College.

This painting once belonged to Ambroise Vollard, the art dealer who was the first to understand and defend Cézanne's work. The painter insistently returned to the same site to paint several versions until he was satisfied he had achieved the concise plasticity, in terms of strong volumes, he desired.

88. Claude Monet: *Cliff at Etretat*. 1886. Oil on canvas, 25⅝ x 31⅞ inches. New York, Metropolitan Museum of Art.

This is one of the many versions of the famous rock mass rising out of the sea that Monet painted. A comparison between this painting and the preceding one by Cézanne is very instructive: although both painters had started off with the same impressionist ideals, they arrived at entirely opposite positions, Cézanne concerned with closed, articulated forms, and Monet stubbornly continuing his pursuit of the effects of shifting light.

89. Pierre-Auguste Renoir: *The Bench in the Garden*. 1886. Oil on canvas, 21¼ x 25⅝ inches. Merion, Pennsylvania, Barnes Foundation.

Renoir also became dissatisfied with impressionism, which he considered too preoccupied with the external values of light. During a trip to Italy in 1881, he discovered Raphael and became enthusiastic about him. From that moment, Renoir's color becomes solider, his light less effulgent and his drawing crisper. This painting is dated 1886, when the artist was summering between Roche-Guyon and St. Briac, near Dinard.

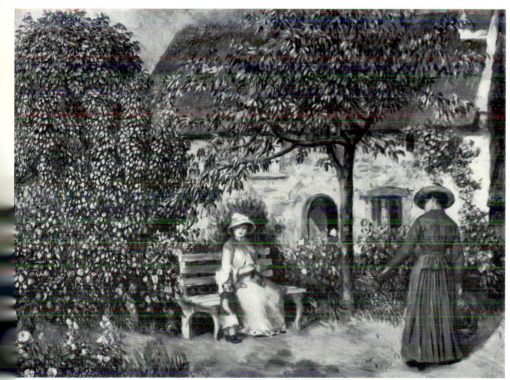

90. Paul Cézanne: *Mont Sainte-Victoire*. 1885-87. Oil on canvas, 21 ¼ x 25 ⅝ inches. Amsterdam, Stedelijk Museum.

Mont Sainte-Victoire, which dominates the country around Aix, attracted Cézanne's interest many times. His paintings of the landscape, done at different periods, seem almost to be a running account of his artistic evolution. The first versions go back to 1882-85. In 1906, he was still intent on painting the same mountain, but with quite different ideas.

91. Paul Cézanne: *Mont Sainte-Victoire*. 1904-1906. Oil on canvas, 23 ⅝ x 28 ¾ inches. Basel, Kunsthaus.

Caught from several points of view, the mountain becomes a kind of myth to the painter. It closes off the horizon with its characteristic cone; Cézanne observes it at different hours of the day, and the valley below, according to the intensity of the light, opens out as a great green space strewn with houses and groves of trees.

92. Paul Cézanne: *Mont Sainte-Victoire*. 1885-87. Oil on canvas, 26 ⅜ x 36 ¼ inches. London, Courtauld Institute.

The landscape here is expressed as a magnificent expanse, evocatively framed by the pine which opens its branches in the foreground. It is a quiet hour of the day, conveyed by the stupendous, cool greens and blues that shine in the clear airiness of the composition.

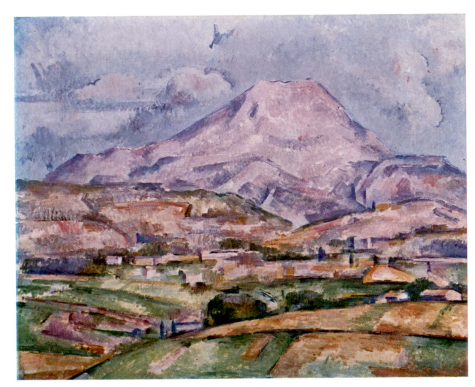

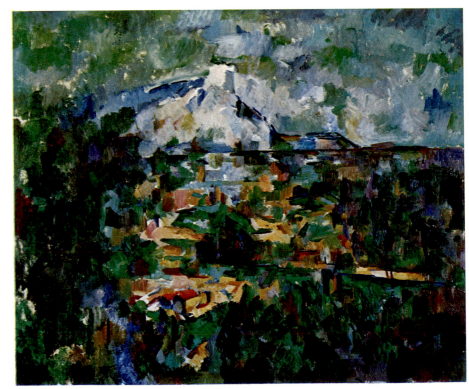

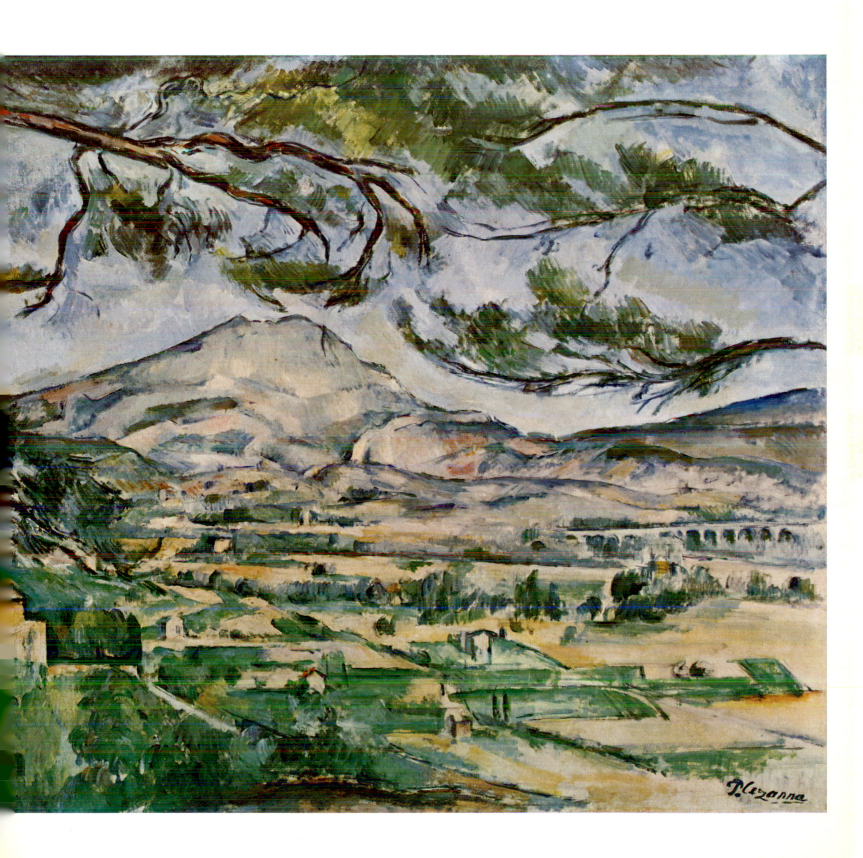

93. Paul Cézanne: *Mont Sainte-Victoire*. 1904-1906. Oil on canvas, 25⅝ x 31⅞ inches. Zurich, Kunsthaus.
When Cézanne painted Mont Sainte-Victoire in his last years, his evolution toward a geometric and synthetic style was complete. His search for closed forms moving in space had achieved a lyric quality that was far removed from naturalism. Paintings such as this were to fire the imagination of young painters, Braque and Picasso for instance, and to give rise to cubism.

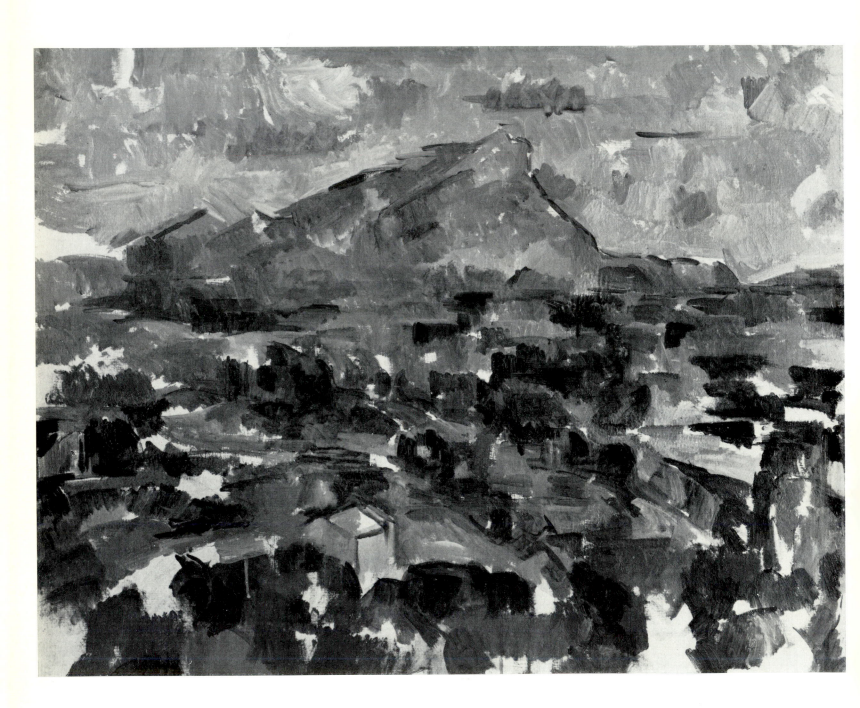

94. Pierre-Auguste Renoir: *Mont Sainte-Victoire*. 1889. Oil on canvas, 21⅝ x 29½ inches. Merion, Pennsylvania, Barnes Foundation.
Renoir was Cézanne's guest in January 1888 at the Jas de Bouffan, near Aix. He returned the next year and rented a house from Cézanne's brother-in-law for several months. Compelled by the dramatic mountain landscape, and certainly after he had seen Cézanne's paintings, Renoir painted the same scene several times, aiming at chromatic intensity brightened with reddish touches rather than at a formal synthesis.

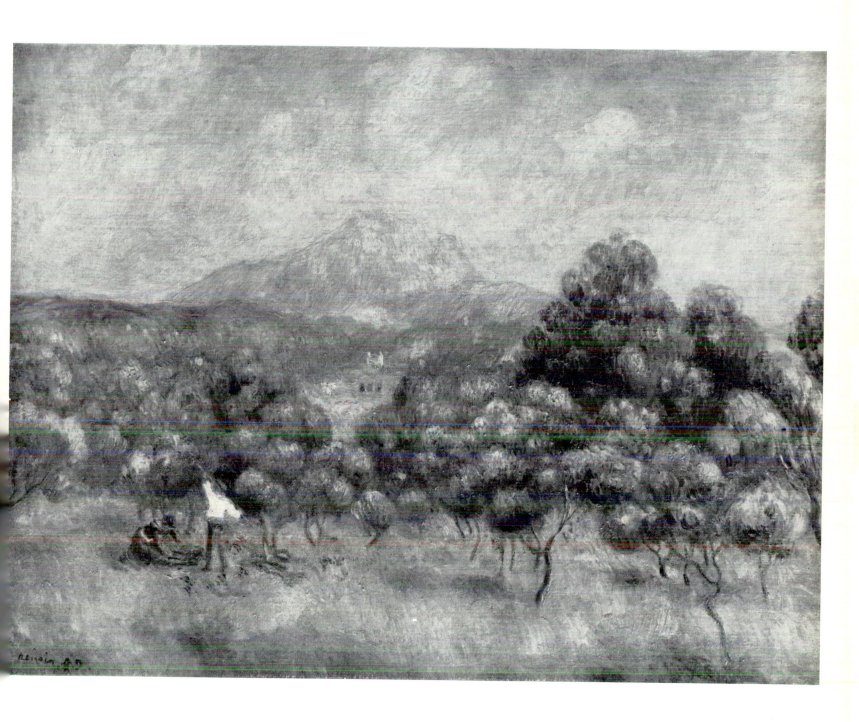

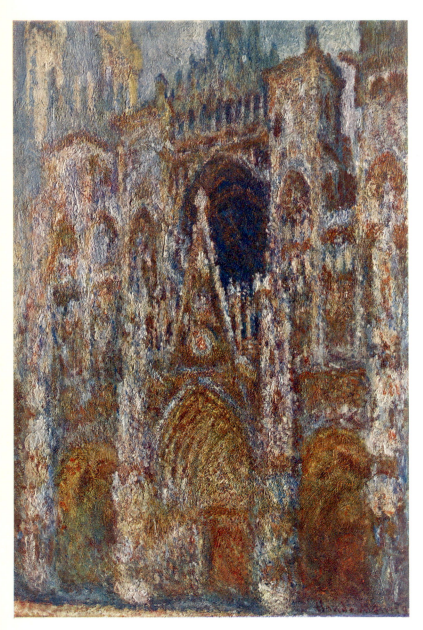
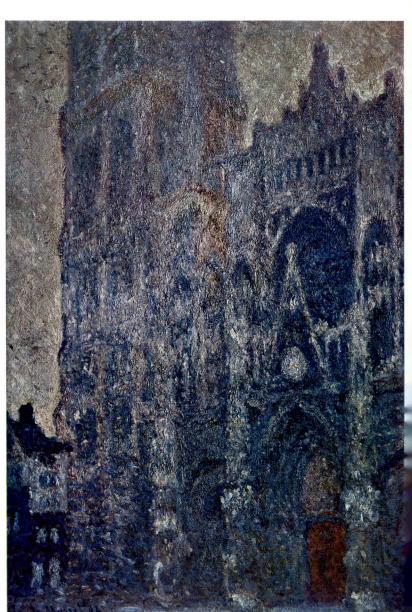

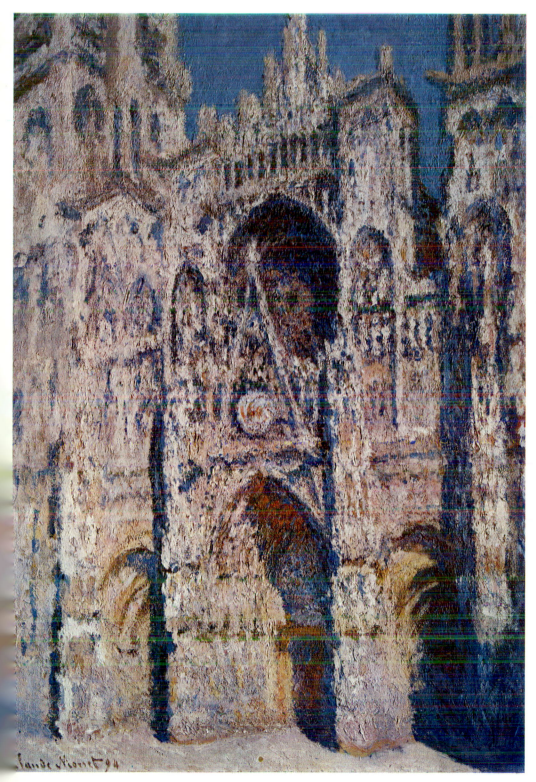

95. Claude Monet: *Rouen Cathedral, Morning.* 1894. Oil on canvas, 35⅞ x 24¾ inches. Paris, Louvre.

To prove his contention that light changes or determines the concreteness of a landscape, Monet used the same subject many times, depicting it at various times of the day. The series on the Rouen Cathedral, for instance, consists of about twenty paintings, and in order to paint them and to catch all the modulations of the light, he rented an apartment facing the cathedral.

96. Claude Monet: *Rouen Cathedral and the Albane Belfry, Morning.* 1894. Oil on canvas, 41¾ x 28¾ inches. Paris, Louvre.

The morning light whitens the ancient stones. Monet seemed to observe a principle of chromatic variations, much like Debussy's music; in fact, he subtitled the painting "White Harmony." Five paintings in this series were acquired by Count Isaac de Camondo, who gave them to the Louvre in 1904.

97. Claude Monet: *Rouen Cathedral and the Albane Belfry, Midday.* 1894. Oil on canvas, 42⅛ x 36¼ inches. Paris, Louvre.

The bright light washes the cathedral façade, and Monet subtitled this version "Blue and Gold Harmony." During this same period, he was also painting along the Thames. Later, in his garden at Giverny, he did the series of water lilies.

98. Claude Monet: *London, The Houses of Parliament*. 1904. Oil on canvas, 31⅞ x 36¼ inches. Paris, Louvre.

Between 1900 and 1904, Monet painted a number of landscapes of the Thames, devoting one series to Charing Cross Bridge, another to Waterloo Bridge, and a third, consisting of eleven canvases, to the Houses of Parliament. All thirty-seven of the Thames series were exhibited in Paris in 1904, with great success. In this painting, the tall form of Parliament rises in the bluish fog, and the sun gleaming from above strikes the river with orange reflections.

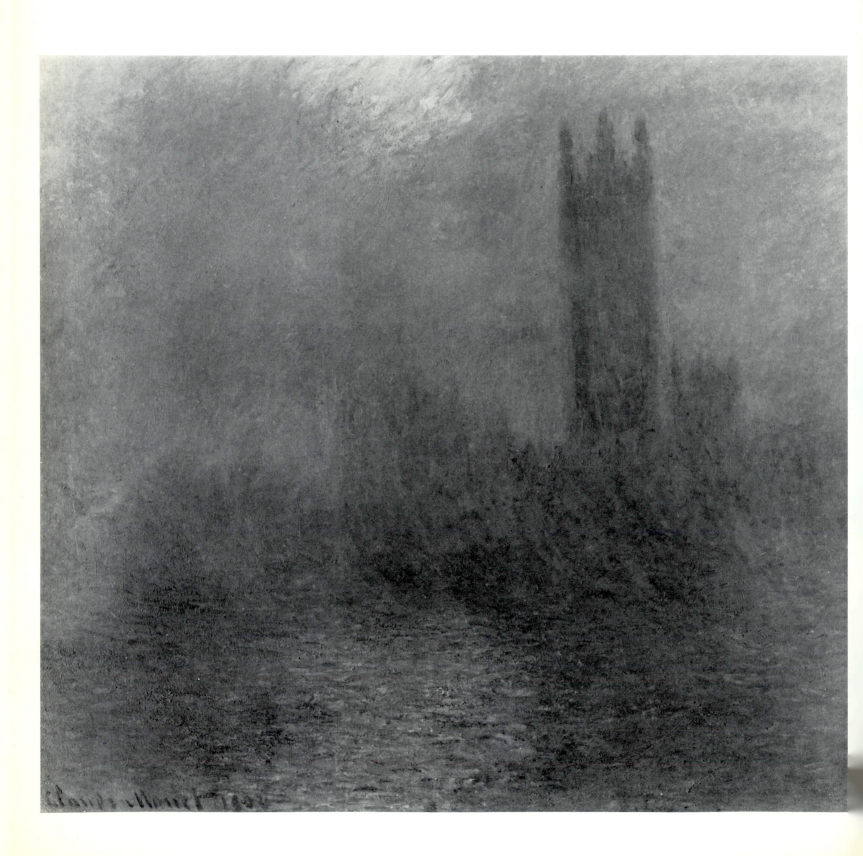

99. Claude Monet: *Venice: The Ducal Palace.* 1908. Oil on canvas, 31⅞ x 39⅝ inches. Brooklyn, The Brooklyn Museum.

When Monet arrived in Venice in 1908, he was struck by the color and light in the air of the city, and by the shifting reflections in the canals. Just as he had done with the Cathedral of Rouen, he treated the Ducal Palace as a mere pretext for the play of vibrant tones; the structure itself has practically no solidity.

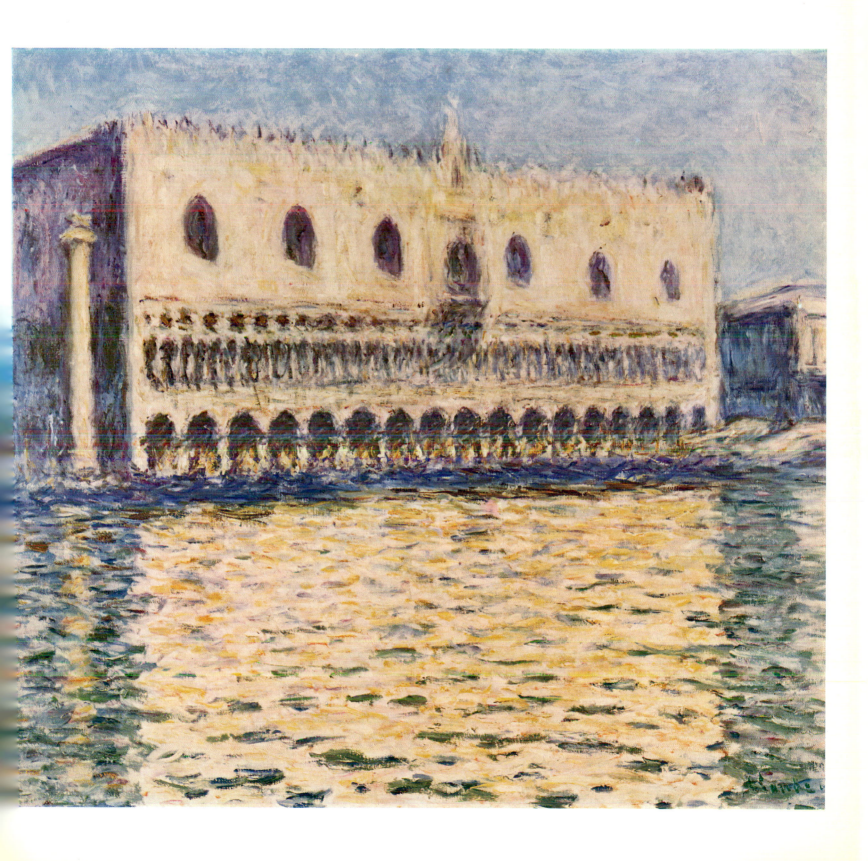

100. Georges Seurat: *Field of Poppies (La Luzerne, Saint-Denis)*. 1885-86. Oil on canvas, 25⅛ x 31⅞ inches. London, Courtauld Institute.

His work rejected by the 1884 Salon, Seurat joined with Signac and Redon to form a Salon des Indépendants to show the work of the neo-impressionists, whose interest in light was scientifically concentrated in the reaction of color when broken down into its component hues, as by a prism. This technique, essentially painting with dots and dabs of color next to one another, was called pointillism or divisionism.

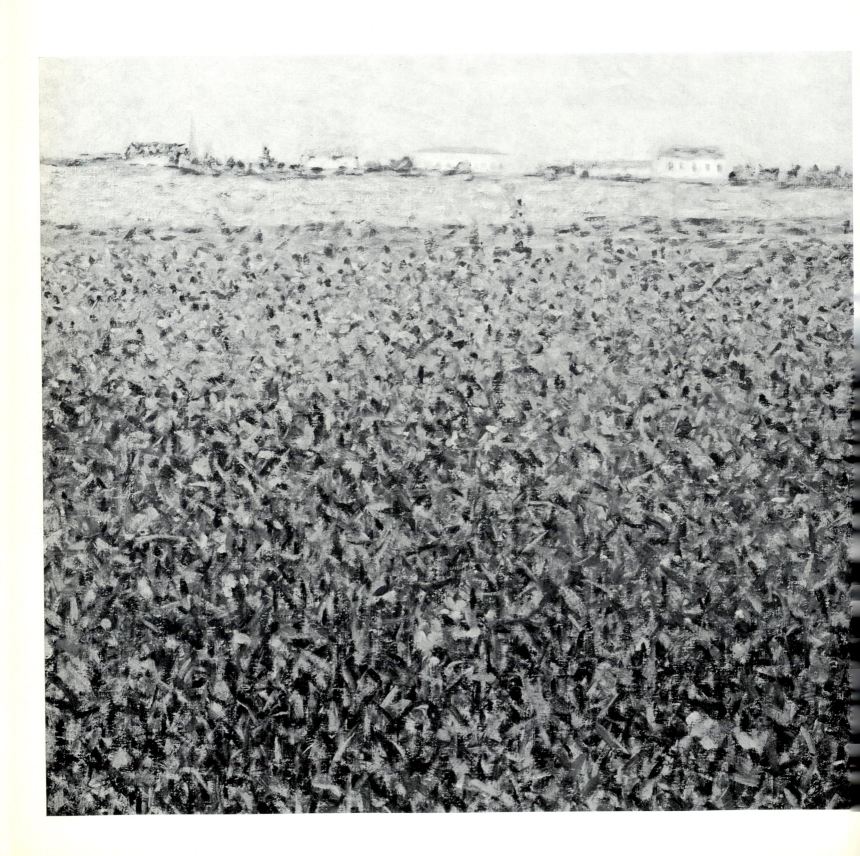

101. Georges Seurat: *Sunday Afternoon on the Island of La Grande Jatte*. Final study. 1884. Oil on canvas, 27¾ x 41 inches. New York, Metropolitan Museum of Art.

Before painting the large canvas that he was to show in Paris in 1886 (now in Chicago), Seurat did a number of studies at the Grande Jatte, even of small details, which he worked up in his studio, using the pointillist technique and clearly defined geometric forms.

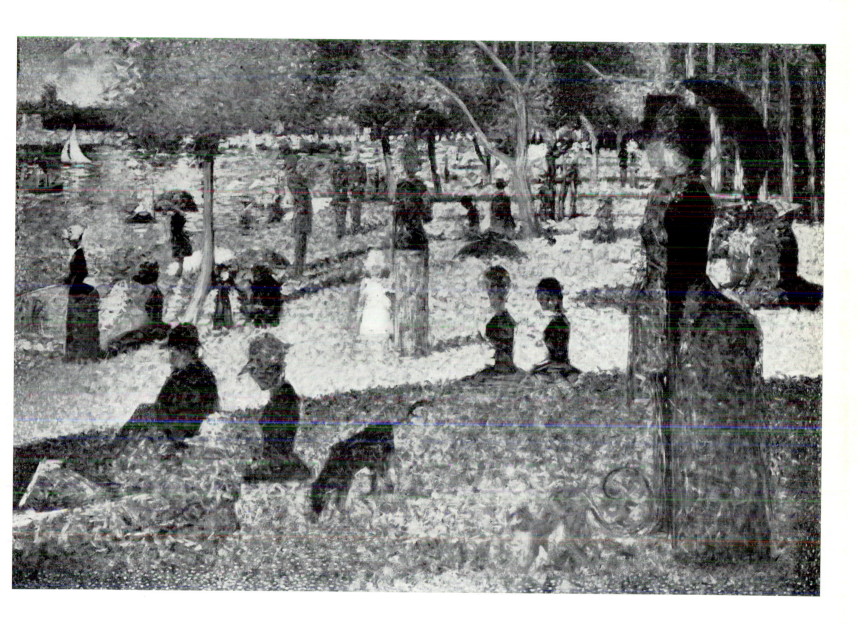

102. Georges Seurat: *Le Bec du Hoc, Grandcamp* (detail). 1885. Oil on canvas, 25⅜ x 32⅛ inches. London, Tate Gallery.
This painting was shown at the exhibition sponsored by the avant-garde group known as Les Vingt (The Twenty) *in Brussels in 1887. The great simplicity of this marine landscape enables Seurat to concentrate on the abstract combination of points of color to achieve maximum vibrancy, without much regard for representational accuracy.*

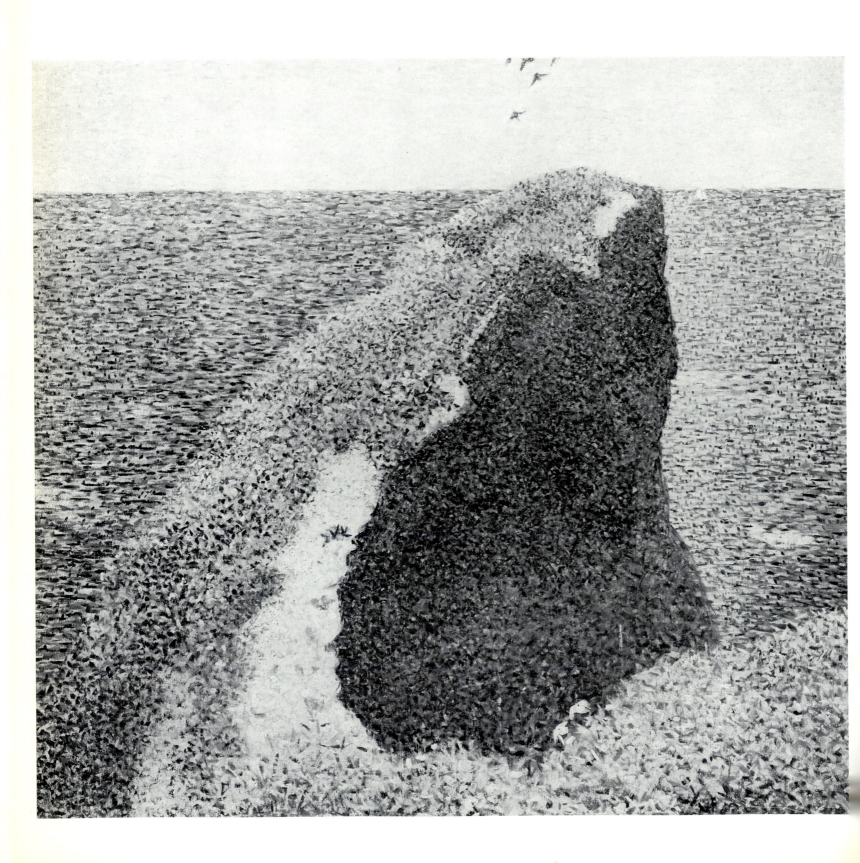

103. Georges Seurat: *The Bridge at Courbevoie*. 1886. Oil on canvas, 18¼ x 21⅝ inches. London, Courtauld Institute.
Although he was as profoundly interested in the phenomenon of light as Monet was, he avoided the loose, flowing manner of the impressionists in order to construct tight, distinct geometric compositions.

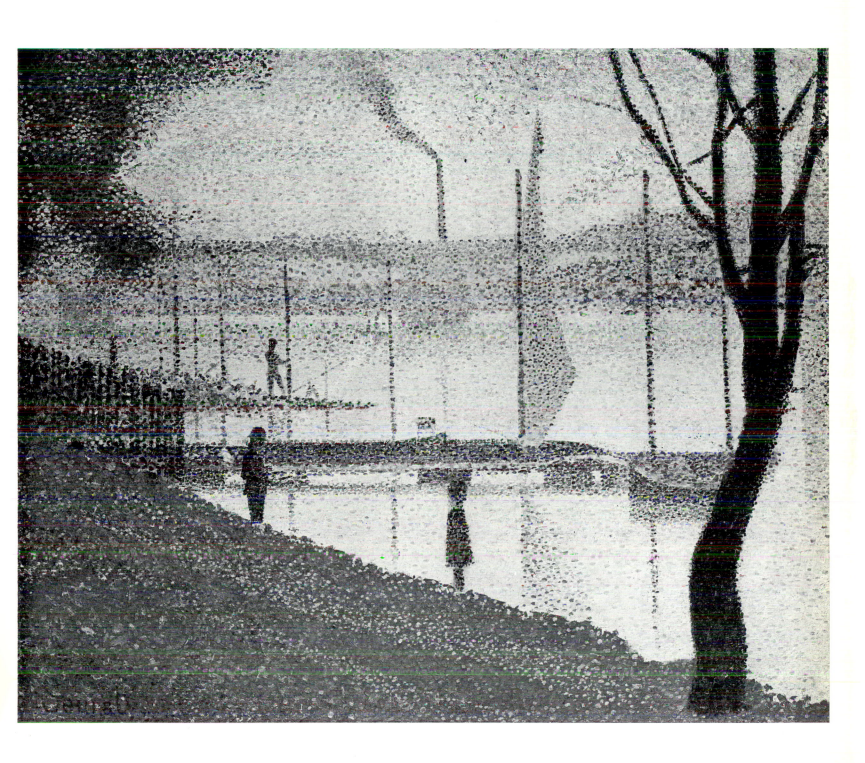

104. Paul Signac: *The Lighthouse at Port-Rieux*. 1888. Oil on canvas, 18⅛ x 25⅝ inches. Otterlo, Kröller-Müller Museum.
A close disciple of Seurat, he took part in the Salon des Indépendants, which launched neo-impressionism. Signac's pointillism is even more fastidious than Seurat's, and his canvases end by resembling mosaics.

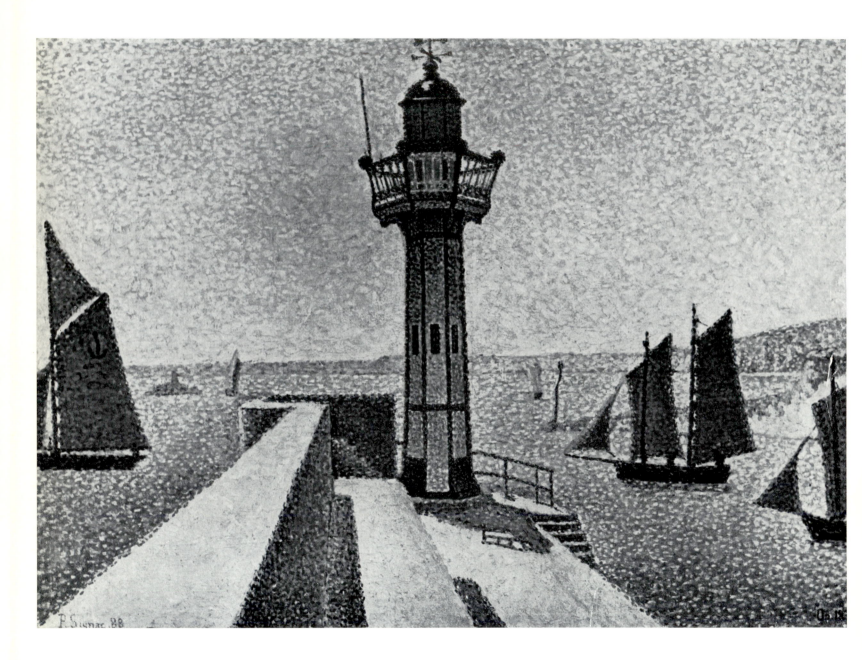

105. Camille Pissarro: *River, Early Morning, Rouen.* 1888. Oil on canvas, 44⅞ x 66½ inches. Philadelphia, Museum of Art, John G. Johnson Collection.

For a time Pissarro also practiced Seurat's pointillism. This painting was done at Rouen, on the island of Lacroix, on a foggy morning. His training as an impressionist enabled him to achieve delicate effects of shaded light.

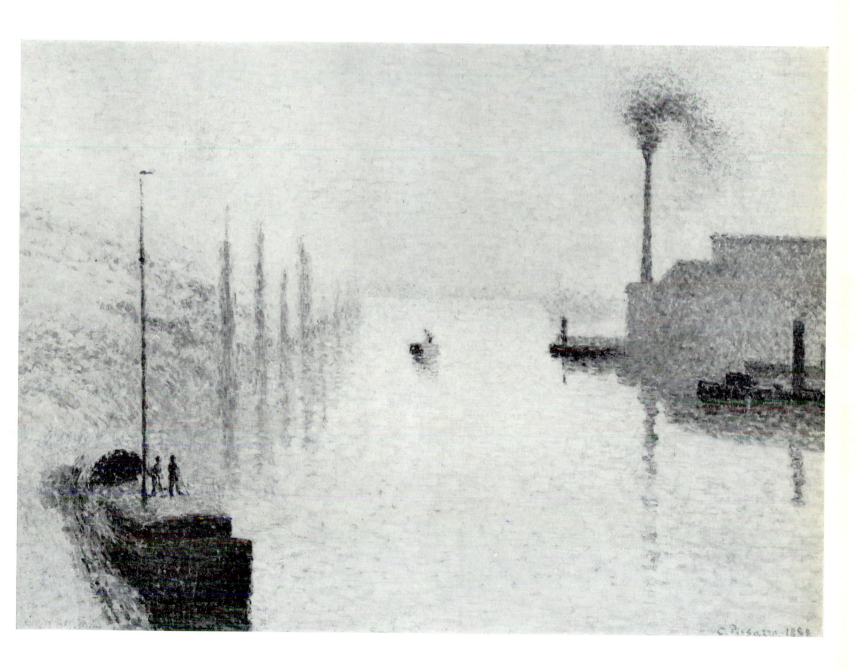

106. Paul Gauguin: *Brittany: Cows at the Stream*. 1885. Oil on canvas, 31½ x 25⅝ inches. Milan, Gallery of Modern Art, Grassi Collection.

Introduced to impressionism by Pissarro, Gauguin here begins to show signs of independence, painting more for visual pleasure in the range of colors rather than for visual fidelity to nature.

107. Paul Sérusier: *Landscape at the Bois d'Amour: The Talisman*. 1888. Oil on panel, 8⅝ x 10⅝ inches. Paris, private collection.

In 1888 Sérusier returned to Paris with a landscape painted on a small panel under Gauguin's guidance at Pont-Aven. The colors are an end in themselves and constitute a symbolical, not an actual, scene. This panel was seen by Bonnard, Denis, Vuillard and other painters at the Académie Julian. They called it their " Talisman," and it gave rise to the formation of a group called Les Nabis.

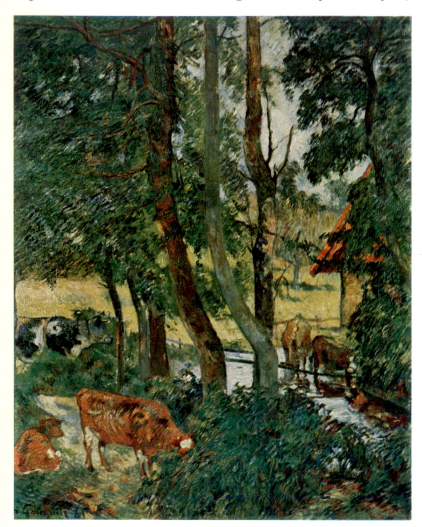

108. Maurice Denis: *The Muses, or The Sacred Wood.* 1893. Oil on canvas, 66⅛ x 53⅛ inches. Paris, Musée National d'Art Moderne.

The cultural background of this painting is quite complicated. Although the painter was born just when impressionism was at its height, he studied Poussin and Ingres and came under the influence of Gauguin when he was working at Pont-Aven. The symbolism of Gauguin and the spiritualism of Puvis de Chavannes are modified besides with the purism of the Italian primitives whom Denis admired. He was one of the founders, along with Bonnard, Vuillard, Sérusier and others, of the group known as Les Nabis. *The aim in this painting is clearly to achieve a stylized, elegant spirituality and decorativeness. From works such as this, Art Nouveau was shortly to develop.*

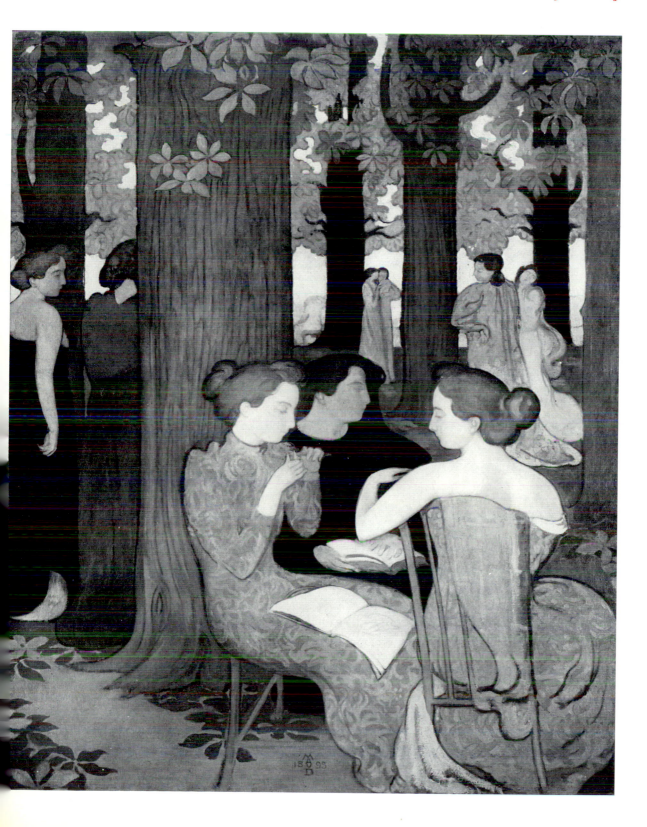

109. Paul Gauguin: *Les Alyscamps.* 1888. Oil on canvas, 35 x 28 ⅜ inches. Paris, Louvre.

In 1888 Gauguin went back to Pont-Aven before going to Arles to join Van Gogh. There he found other painters: Bernard, Laval, Sérusier. Although his nominal subjects were taken from the Breton landscape and peasant life, he does not treat them either realistically or impressionistically. His free choice of colors expresses his inner attitude toward reality.

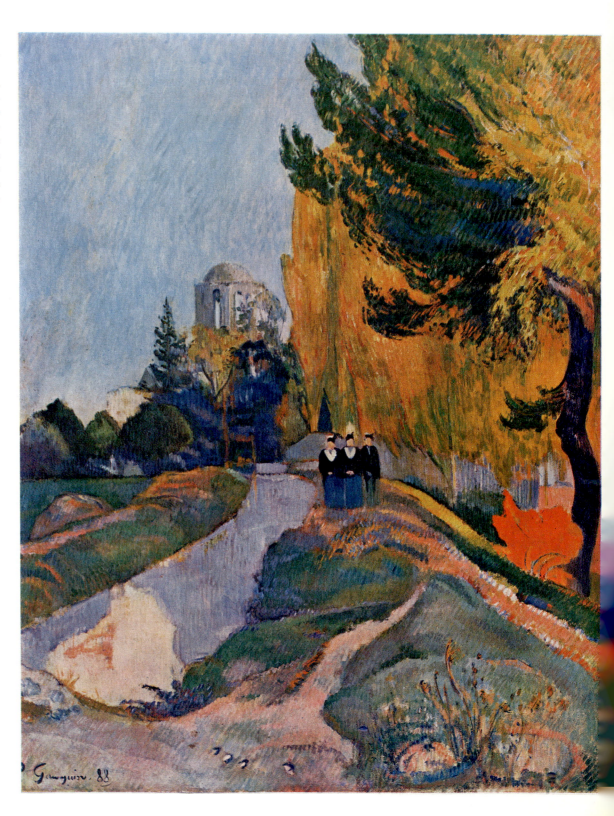

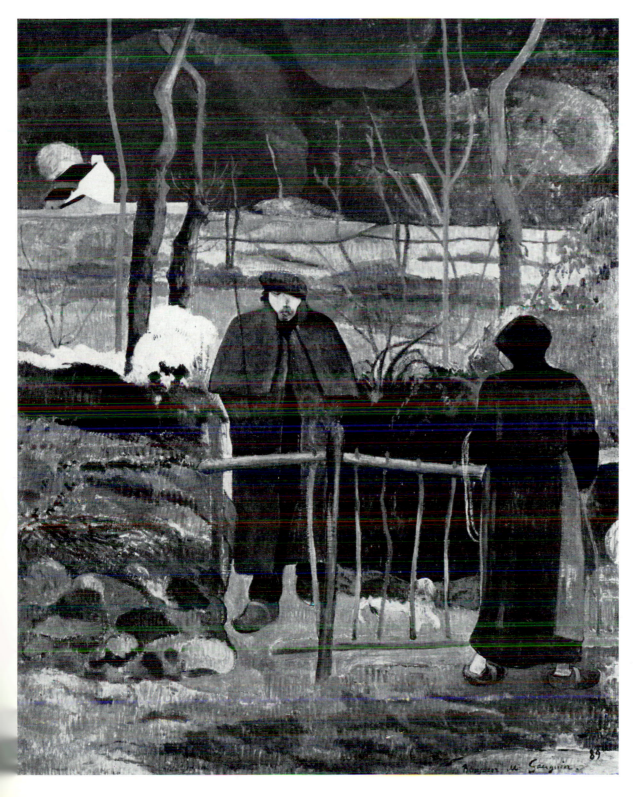

110. Paul Gauguin: *Bonjour, Monsieur Gauguin*. 1889. Oil on canvas, 36⅜ x 29⅛ inches. Prague, National Gallery.

The painter is here giving an answer to Courbet's Bonjour, Monsieur Courbet, *painted in 1854. Courbet's, however, was a direct, almost harsh realism, and his color the color of mortar, whereas Gauguin's is a symbolist anti-naturalism, with bright colors enclosed in black outlines, like stained-glass windows, the so-called "cloisonnisme."*

III. Vincent Van Gogh: *View of Arles*. (April 1889). Oil on canvas, 28⅜ x 36¼ inches. Munich, Neue Staatsgalerie.

This painting was done after the famous quarrel with Gauguin that led to Van Gogh's cutting off his own ear. He then went to Provence to convalesce, taking with him Seurat's ideas about dividing color into its pure components, but he applied them in his own way, more expressively and freely, using the commonest subjects (a chair, a pair of shoes) and reaching heights of chromatic lyricism.

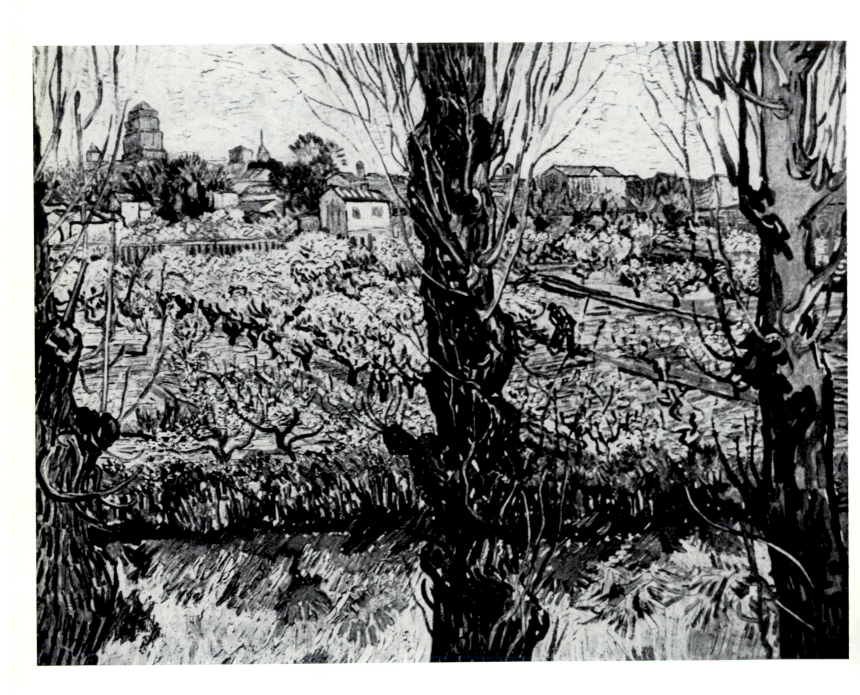

112. Vincent Van Gogh: *Summer Evening at Arles (Dusk)*. September 1888. Oil on canvas, 29⅛ x 35⅞ inches. Winterthur, Kunstmuseum (Emil Hahnloser Bequest).

The sun is setting behind the town, silhouetted in violet against the green sky; in the foreground is a yellow field with red flowers. His guest, Gauguin, had not yet arrived in Arles, but we can see that Van Gogh's style had already taken a definite turn: he uses pure color in a bold, expressive way, thus opening a chapter in the history of painting that was to have profound effects, the more immediate on the Fauves and the German Expressionists.

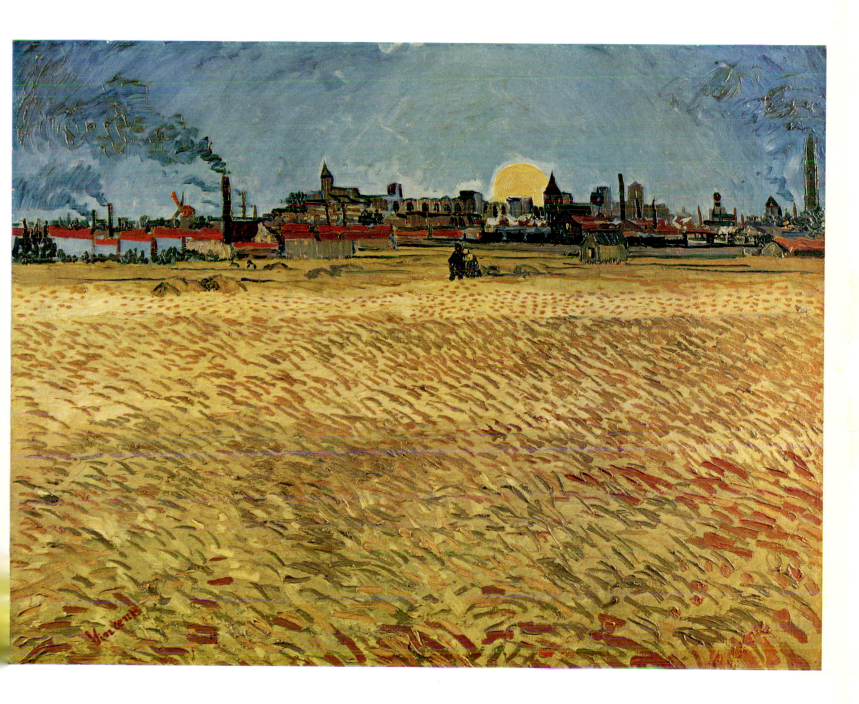

113. Vincent Van Gogh: *The Garden of the Hospital at Arles*. May 1889. Oil on canvas, 28¾ x 36¼ inches. Winterthur, Oskar Reinhart Collection.

After he had cut off his ear, Van Gogh was sent to the hospital in Arles, but was later transferred to the insane asylum of St. Rémy because the people of Arles were afraid of him. This painting represents the hospital garden. The combination of pure colors and bold design creates a highly expressive style.

114. Vincent Van Gogh: *The Church of Auvers-sur-Oise*. June 1890. Oil on canvas, 37 x 29⅛ inches. Paris, Louvre.

After he had been released from St. Rémy in 1890, he went to Paris to stay with his brother Théo, who, in the meanwhile, had married and had a child. Van Gogh realized he was imposing, and went to Auvers, to the house of Dr. Gachet, who had been hospitable to other painters. The village church inspired him, and he remembered he had started painting by depicting the church in Nuenen, in Holland. But this time the pure colors and marked contrasts give an entirely different feeling.

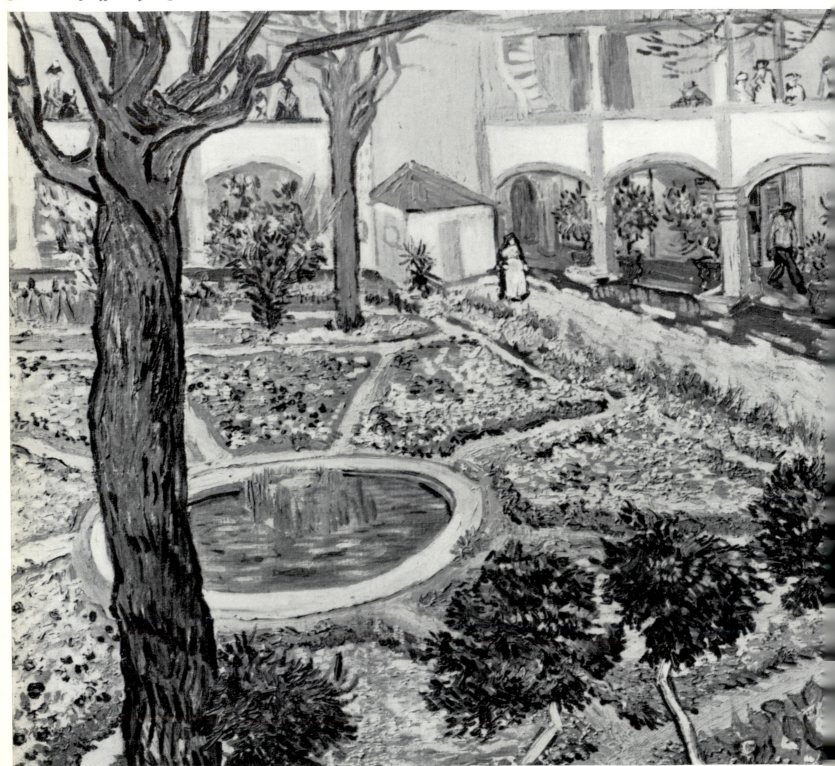

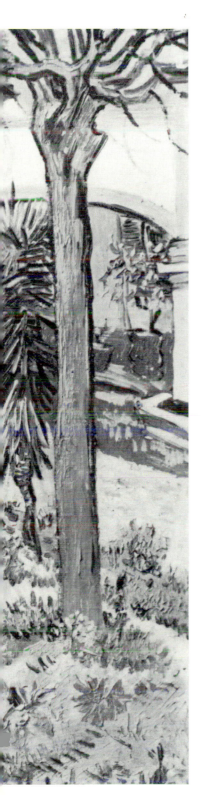
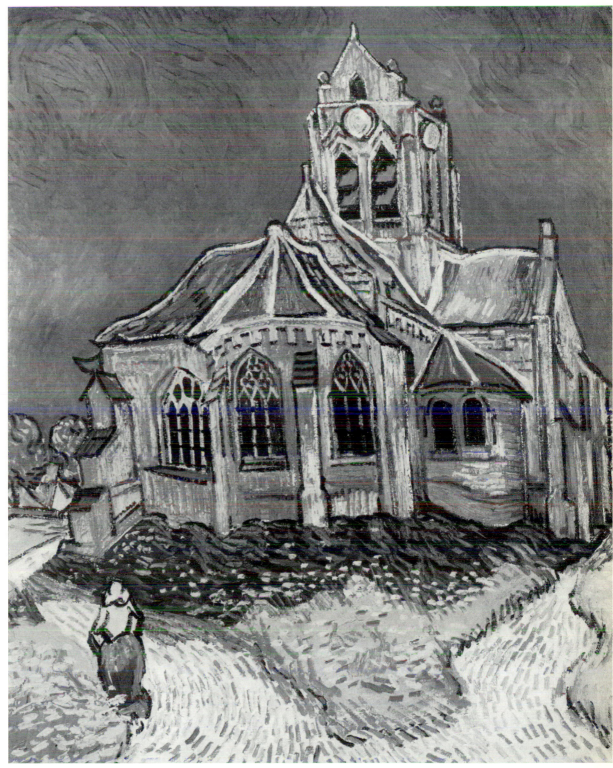

115. Vincent Van Gogh: *Landscape at Auvers in the Rain*. June 1890. Oil on canvas, 28⅜ x 35⅜ inches. Moscow, Pushkin Museum.
The bold, shifting perspective of the fields is cut in two by the road. The colors gleam, the brushwork is swirling or speckled. But in spite of all this show, there is a pervading melancholy.

116. Gustave Moreau: *The Triumph of Alexander the Great*. 1890. Oil on canvas, 61 x 61 inches. Paris, Moreau Museum.

By 1864, after a trip to Italy and becoming friends with Puvis de Chavannes, Moreau had begun painting quite differently from the impressionists. Inimical to naturalism and in keeping with the strange evolution romanticism had undergone in the hands of several English and German visionaries, Moreau creates an imaginary world that is at once precious, decadent and symbolistic, expressed in theatrical terms, with gigantic stage sets like this one, a fantastic oriental city built on the side of a cliff.

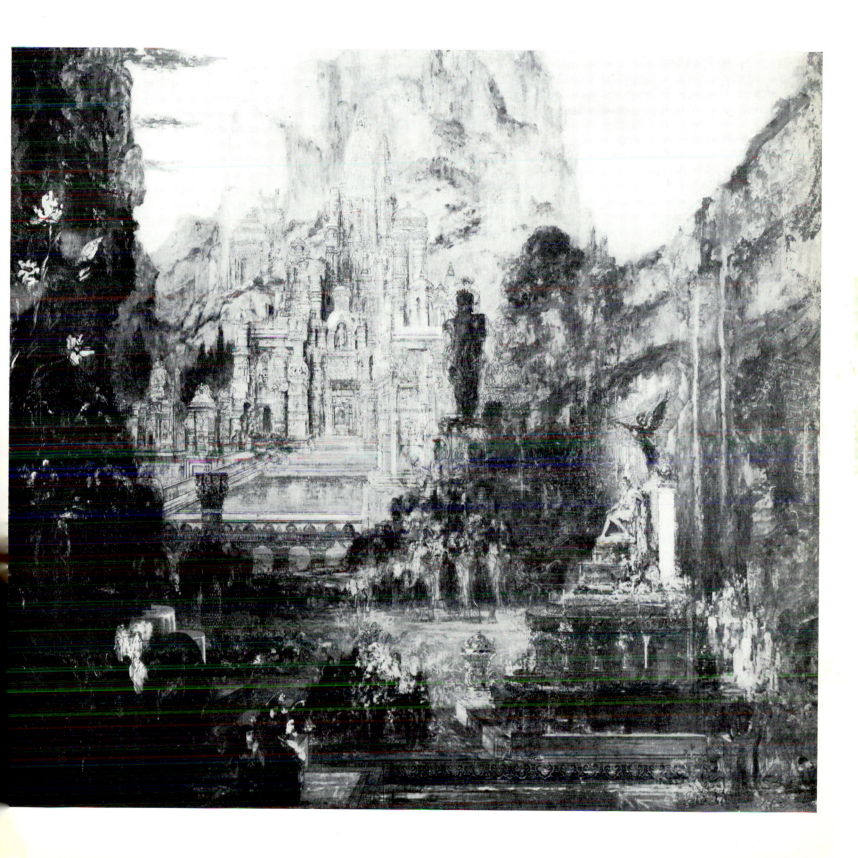

117. Odilon Redon: *Landscape at Peyrelebade*. 1880. Oil on cardboard, 17⅜ x 18¼ inches. Paris, Ari Redon Collection.

He spent his adolescence in a small village, Peyrelebade, in a lonely region of fields and woods, which may account for his hypersensitivity. Like Moreau, he was not attracted by the impressionism of his time. Although there is a semblance of representationalism in the detailed execution of landscapes and flowers, his paintings are permeated by a dream atmosphere shot through with strange colors and mysterious transformations.

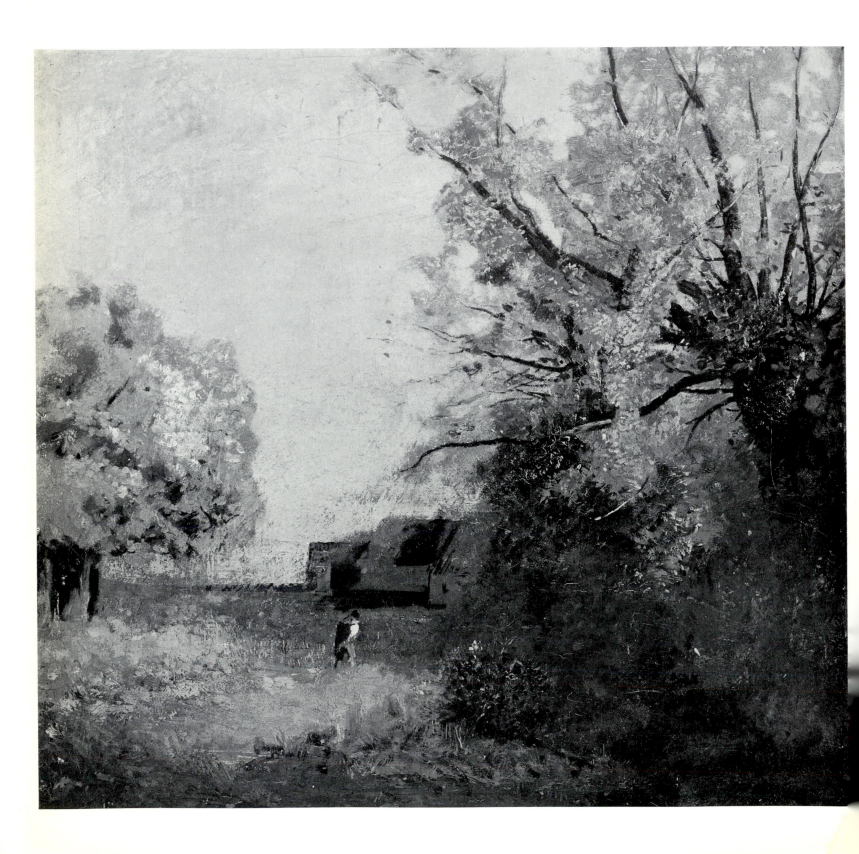

ITALY Just below the town the road descends into a ravine clothed with the most magnificent chestnut trees. It is the bed of a stream enclosed on each side by rocky walls, from which at first the eye seeks an outlet in vain. At length, however, a great picturesque bridge appears, crossing one of the head springs of the Sacco, and before us, on a high hill, lies the dark village of Cavi, built on terraces of black tufa, but girdled about with vineyards and gardens; and now also the Volscian Mountains come into sight.

In the market-place of Cavi stands a column, the actual, as well as heraldic, emblem of the Colonna, whose ancient fief this place is.

We had still three miles to ride across the mountain-side to reach Genazzano, our eyes all the time feasting on that enchanting valley of the Sacco. Before us, in the distance, Pagliano, the second in importance of the Colonna towns, was visible, with its white castle, and further still, in the haze on the horizon, old Anagni was coming forth, on its hilltop. Then the road descended suddenly into a charming region of hill and dale, which alternated in the happiest way, a picture of rural prosperity, with its grey olive groves, shady chestnuts, corn and maize fields and gardens, and everywhere the little dome-shaped elm trees; festooning them, dark masses of grape-vines. On the long rocky hills enclosing this picture Genazzano stands, a narrow, dark grey strip, just like the tufa rocks on which it is founded. The houses look as if they were marching in procession to the shrine of Santa Maria *del buon Consiglio*, the great sanctuary of the Latian Campagna, or else taking their way up to that beautiful baronial Colonna castle crowning the summit of the hill, the dutiful vassals of its lord.

A tower with battlements defends this little town. As soon as you enter it you see a rough fresco on the wall of a house depicting the sacred figure of the Madonna of Good Counsel borne up in the arms of angels, pilgrims drawing near to her reverently. Miserable streets lead to the Piazza Imperiale, the principal square. The houses are sufficiently uninviting, but an occasional semi-circular Gothic window, like some withered efflorescence surviving from the Middle Ages, charms us by its Moresque rosettes.

Anagni surprised me, accustomed as I had been to the dark streets and shabby houses of other Campagna towns. Here I rode in between rows of important-looking buildings and palaces, which bore every mark of the seventeenth-century luxury of Rome, and gave a certain well-to-do air to the whole town. Its modern aspect set me wondering; I failed to understand it until I had made myself better acquainted with the history of the place.

Presently I came to the principal square, a small quadrangle enclosed by modern dwelling-houses on one side, by palaces on two others, on the fourth by a low stone fence, or enclosure, from whence, as it lies on the slope of the hill, the valley of the Sacco is visible, and through it the Via Latina, winding up in graceful curves, from Valmontone. This ancient road does not touch Anagni, but goes on its way, skirting the foot of the hill, till it arrives at Ferentino and Frosinone, and the banks of the river Liris, which it reaches just below Ceprano. From this piazza the view is so fine that it may well enchant even those who have beheld the whole of Italy, from the Alps to the African and Ionian Seas. Just opposite rise the Volscian Mountains, their sunlit rocks clearly defined, the very windows in the towns set upon them being visible. These towns catch the eye in every direction as they succeed each other all along the slopes of Monte Fortino, the famous Segni, Gavignano, Rocca Gorga, and Scurgola. Then come Morolo, Sapini, and Patrica, behind which the tall, bold, pyramid of Monte Cacume stands out, blue and beautiful. In the distance peak after peak arises, then more towns — Ferentino behind a hill, Frosinone, whose fortress is still visible, Anara, Posi, Ceccano, and many other places can the eye discover. Towards Rome stretches out a vast plain, bounded by the heights of Palestrina, which may itself be seen in the far distance. The Latian Mountains come within our ken, and so the greater part of Latium can, without effort, be beheld from thence.

Turning out of this square, an entirely different view presents itself, and here we realise

the position of Anagni for the first time. The hill on the outer edge of which it is built joins on to the Serra, or springs out from that range, in the form of a sickle. The brown rocks lie bare and rugged all around as you look out on a wilderness from which Monte Acuto springs up hard by, a dark castle which takes its name from the precipice on which it stands.

Seeing what its position is, it is no wonder that Agnani became the favourite place of retreat, or summer abode, of so many Popes during the Middle Ages — a country town raised above the Campagna, its air so health-giving, while it is sheltered and protected by those rocks and walls.

Latian Summers, 1867-77. FERDINAND GREGOROVIUS

To disentangle and classify this human ant-heap would be a task as interesting as difficult. We have many descriptions of Neapolitan life, many painstaking and clever books, but even although we may have already read a thousand of them, we nevertheless stand bewildered in presence of the kaleidoscopic scene.

Let us rather frame a picture of life in Santa Lucia. I have already said that this quay, one of the most remarkable points of Naples, is the neutral centre where the upper and lower strata of population meet, and where the middle class has gained the ascendancy. The beautiful quay of insignificant length is enclosed on the left by the buildings of the palace, on the right by the picturesque Castel dell'Ovo. Almost in the middle of the great bend described by the bay, it stands open to the sea and here the gaze can range across the stretch of waters, because uninterrupted, as in the harbour, by any throng of shipping. This fact consequently attracts not only the traveller to such hotels as are situated in Santa Lucia, but also the middle class to the quay, for the sake of the incomparable spectacle to be seen in the evening and for other enjoyments.

I spent six weeks in Santa Lucia. Standing on the balcony of my room, the bay, Vesuvius, the white towns at its foot, the shores of Castellamare and Sorrento as far as the Cape of Minerva, and the rocky isle of Capri lay before my eyes. Every morning the bay itself awoke me as soon as the roseate lights of its placid waters streamed into my room, and every morning I watched the marvels of the sunrise and the colour splendour of mountains and sea, which now seemed to kindle and waken the immense city itself. Such is the site of Santa Lucia; but when the moon pours her magic light over mountains, sea and city, and the entire bay as far as the quay lies flooded in a broad stream of light she affords an even more magic spectacle. The black forest of masts in the harbour then hovers spectre-like in a white mist of silver, the slender tower of the lighthouse faintly flashes, boats glide like dark shadows dreamily across the shining levels, appear and disappear. On the horizon the beautiful rock of Capri rises phantom-like out of the night, and quite overpoweringly, like phantasmagoric photographs, shine the Somma, Vesuvius and the mountains of Castellamare and Sorrento. Who can sleep on such a night? We get into a boat and row across the phosphorescent waves, or join the populace on the quay and eat *frutti di mare*.

For here on the water's edge joyous life flows merrily on. The little stalls of the oyster-dealers stand in two rows. Santa Lucia is the centre for all the products of the sea — mussels and oysters of every kind lie here tastefully laid out on slanting shelves. Every stall is numbered and furnished with the name of its owner. The invitation to partake is incessant; the lights glitter; but the beautiful strange mussels and sea urchins, star-fish, corals, crabs with their curious forms and variegated shells attract our attention more than our appetite. The mysterious realm of the deep lies open to us; and so fairylike is the aspect of this miniature market of shell-fish as to suggest a marine Christmas fete; the sight moreover may be enjoyed every evening.

The view of the city, the bay, the mountains and islands changes with every turn of the road, with every hill and valley; we know not where to look, whether on the blue waters, over this amphitheatre of the city bathed in light, on the luxuriant gardens with their smiling villas, or the picturesque groups of pines, palms and cypresses. The traveller who remains unmoved by such a landscape must be as unimpressionable as a lump of lava. From the studios we turn to ascend the road, where rows of donkeys are always waiting for hire. But it is better to proceed on foot. Let us go on, and on our way take note of the succession of varying scenes. Attracting our attention in succession, we see the white walls of the Castle of S. Elmo surmounting yellow-brown rocks covered with cactus and aloe, and overgrown with climbing plants; the hollows filled with gardens; here an *osteria* smothered in vines; again, brown barren tufa rocks; a valley filled with lemon, tulip and pomegranate trees, breathing a perfume of narcotic sweetness; now a suburb with its industries; again open smiling hills, a sight of country houses; a ravine with cactus and palms; an unexpected glimpse of the city on the left, of the bay, of Capri; a hedge of pine trees, over which Vesuvius hovers bathed in tenderest violet. Again, a wild, rocky scene; gardens and fantastic-looking houses with open *loggie*; then a rural picture, shepherds driving their goats. A convent with its accompaniment of monks. Higher hills with pine trees — but ah! who can describe all these lovely scenes?

Having seen the three most beautiful sea-ports of Italy — Genoa, Naples and Palermo, rivals to one another in point of situation, I am able to compare them, and consider that Naples undoubtedly bears the palm. For what other town can boast so classic a natural amphitheatre, such a bay, a Vesuvius, such shores as Castellamare and Sorrento, and such lovely islands? The wealth of colour, the size and width of the picture are probably unequalled in the world; the dimensions are so vast the eye cannot grasp them; the work of man like that of nature seems to stretch into infinitude, and the beautiful scene to resolve itself into light and splendour. Looked at from near, it is impossible to embrace the whole of Naples in a glance; the picture divides itself into groups. To comprehend it in its entirety, we require a reduced point of view, to behold the perspective from one of the surrounding hills or from the sea, where the outlines of the city are lost and those of nature alone predominate.

Genoa and Palermo, on the other hand, present the aspect of a picture enclosed in the most magnificent of frames; Genoa with its palaces and country houses rising on the hills, resembling an amphitheatre; Palermo stretching out in the most luxuriant of valleys and surrounded by mountains of sculpturesque outline, which project a short way into the sea, on one side in Cape Pellegrino, on the other in the promontory of Zaffarano, forms a picture enchanting both in colour and outline. At Naples all is vastness, all bathed in such light and infinitude that the senses are carried away and no repose is allowed to the distracted eye. From whatever spot we may choose to view the city — S. Elmo, Camaldoli or Vesuvius itself — and these are the most elevated points from which to survey the wondrous panorama — Naples everywhere presents itself as a shapeless mass; landscape and sea are everywhere predominant. The crowd of houses which has arisen around the bay produces no architectural impression, but rather the feeling of unlimited extent and that life has monopolised undue proportions in this Elysian scene. Situation and view are here sufficient for man. It would seem as if in admiration of such splendour, he had folded his hands and abandoned the attempt to compete with nature in works of grandeur. Nothing predominates amid this sea of houses; the flat roofs stretch endlessly on; so many platforms from which the spectator may rejoice in the view; a few cupolas of churches, and these small and inconspicuous; scarcely anywhere a tower to interrupt the monotony of the horizon. Incomparably more beautiful is Constantinople, whose cupolas soar over the many ramifications of the city, and whose countless slender minarets, towering above cypresses and pines, bestow a strange charm on the picture.

The architectural uniformity, indeed utter unimportance, of Naples has always seemed to

me entirely essential to the conception of the city. It so completely reflects the history of the country, the instability and change of its transitory dynasties, the inorganic character, the incapacity of the people for any task in the history of civilisation or culture, their passivity and enjoyment of the present, their utter sensuousness and universal desire for amusement. History has never left any impress, and consequently the city itself is in the last degree devoid of form and monument. Neither the character of the dynasties, nor that of the people has ever found expression in great monuments; and monuments are the embodiments of phases of civilisation, outward manifestations of the inner being, of the living ideas, which have once ruled or which still rule.

...One Sunday, early in the morning, in magnificent weather, we went to Sorrento by boat and from there we headed for Capri. The sea was no less calm than the sky; the lines of the landscape disappeared in a vague and indefinite light at the horizon. Capri however, appeared in front of us, majestic, grave, rocky, severe, with its wild mountains, its sheer reddish rocks of a calcareous formation. On a peak could be seen the ruin of an old brownish castle. Here and there were remains of military batteries and the open mouths of cannons, solitary, abandoned, almost totally covered by the yellow flowered broom; rough reefs and rocks surrounded by sea falcons and local birds "used to the sun" as Aeschylus used to say; down below, caverns, grottoes, dark and mysterious; on the top of the hill a pleasant looking small town with its white houses, tall walls and a church cupola; still further below, on the narrow strip of the beach, a small fishing port, and a row of boats pulled up on the beach.

...All was silence and peace; one could see only a fisherman, two boys swimming near a rock, two young maidens on the beach and all around severe looking rocks. I had reached a solitude, both savage and romantic. From that point of the marina, a steep and arduous path climbed among walled gardens to the small town. In those gardens carved out of the heart of the rock, were grapes, olive and citrus trees, but vegetation was poor, especially to the eye of someone coming from the prolific Campania. Even the trees in Capri look like hermits. One enters the town through a wooden bridge and an old door, with a lonely look, and it seems that peace reigns and that human needs can be ignored. Some inhabitants, in festive clothes, were chatting while sitting on the steps of the Church. Many children were cheerfully playing on the little piazza, in front of the temple and it looked as though built just for their games. The houses, small, with terraced roofs, all seemed to have a grape vine growing up their walls. A narrow street, never touched by a vehicle, took us to the hostel of Don Michele Pagano in front of which grew a stupendous palm. Even there, we seemed to be arriving at an hermitage, a retreat, turned into a rest place for pilgrims.

...At the bottom of the hill, lies one of the most romantic spots of the island, the Marina Piccola, a small beach, with South exposure, among rocks, whose boulders, tumbled down to the sea, give it a peninsular shape. There are two solitary fishermen's houses, nearly carved out of the rocks. In that spot the beach can hardly accommodate two boats. While sitting there, one could think oneself alone in the world. The Bay of Naples, its beaches, its islands, its sails, have disappeared, as if they did not exist. The eye wanders over the immensity of the sea, in the direction of Sicily and, further on, of Africa. One sees only water, and fantasy may travel equally to Palermo, Cagliari or Carthage. There are only bare rocks and deserted reefs all around and caves that open on the shore on both sides. To the right is Capo Marcellino, a gigantic steep rock protruding into the sea; to the left, indented and lacy, like an old castle, Capo Tragara, and near it, the Faraglioni, gigantic rocks, inaccessible, more than one hundred feet high, soaring from the sea like pyramids from the desert, of a conic shape, one smooth and the other fantastically notched and bizarre. Their shadow extends to the sea giving it a melancholy look. Further on, in one of the rocks, the arch of a cave reveals an entry for boats, while at their summit, some undistinguished bushes and wild plants swing, beaten by the wind.

I beheld the sublime landscape of Syracuse for the first time as the sun was setting, and the whole country from the Ionian Sea to the mountains of Hybla lay bathed in that deep glow that can only be produced by a Sicilian sky. Not even on the summit of Etna, when the entire island, three seas and the coast of Italy lay shimmering in light before me, was I so profoundly impressed as I was by the evening silence on this vast plain of the dead at Syracuse. The spectacles afforded by nature make less appeal to the imagination than do those of history; the former awake no memories, and it is by memory that the mind is invigorated and animated.

I had arrived from the ancient Leontium (Lentini), the birthplace of the sophist Gorgias, had travelled by the Catania road, past the peninsula of Magnesi, the ancient Thapsus, and along by the harbour of Trogilus (Lo Stentino). There, stretching immediately in front of this basin, rises a lofty plateau about 200 feet in height of bare limestone rock, descending precipitously on all sides; an imposing triangle, the acute angle of which stretches landwards as far as the hill of Euryalus, and whose base sinks towards the sea. On this wide and lofty plain stood ancient Syracuse; the city, however, then extended as far as the island of Ortygia, which was united to the coast by an embankment.

Having ascended the plateau, I beheld the vast territory of the city, the island with the wretched modern town, at its sides the two harbours and behind Cape Plemmyrium; a solemn, majestic landscape, which in grandeur is perhaps surpassed by none other in the world except the Roman Campagna! Inland it is bounded by the imposing outlines of the mountains of Hybla, at its feet lies the Ionian Sea, once alive with fleets and the scene of naval battles, than which the history of England scarcely records any greater. The silver-grey olive trees sparsely scattered over the brown earth alone enliven this classic solitude. As far as the eye can see, it is furrowed from end to end by the traces of past centuries and the footprints of countless generations and resembles some huge battlefield of history. For miles around not a living thing save hawks, perched on the yellow stone or seeking for prey. No less rocky and arid than the plateau looks Cape Plemmyrium opposite, between which and Ortygia is the entrance to the harbour, once barred to Nicias by the Syracusans with vessels and chains. The whole beautifully curving line of coast is entirely lifeless; where the wreath of luxurious gardens and villas stretched in far-off times, scarcely a shed or the solitary house of a fisherman is to be seen. Everywhere desertion, or flat marsh-land and bare yellow masses of stone; only there, where the Anapus flows into the harbour, reeds and poplars mark the course of the stream, the site of the Fountain of Cyane and the marsh of Syraca, from which the city originally derived its name.

I thus drove to the island city, my gaze constantly riveted on the countless tombs excavated in the rocky ground on each side of the way, and by the quarries which here and there stood forth in the most curious disorder. Some cultivation begins in front of the little harbour; a few vineyards and gardens, where was once produced the celebrated nectar of Syracuse, which gladdened the heart of Gelo, Hiero and Pindar. A single column standing opposite the island is all that the glance discovers of the ruins; this column stands like the genius of death in this plain of tombs and mocks at the traveller, before whose mind hovers the vision of the city, that great and celebrated Syracuse that is said once to have numbered more than a million inhabitants.

Siciliana, 1867-77. FERDINAND GREGOROVIUS

I have already said that Naples resembles the Orient, and I do not believe I am mistaken. The buildings, the narrow, filthy streets, the vegetation in the center of the city and in the suburbs, the custom of living in the streets, the noisy poor in rags and tatters surround-

ing us constantly, in short, many things give you the illusion of being in a dream and in Cairo or Alexandria, with fellahs, donkeys and the like, the only difference being the language. In fact, there you would be pestered for "baksheesh" and here they fleece you for a penny. Although its costumes are less varied, a Neapolitan crowd, in certain points of the city at specific hours, strongly recalls the tangled, knotted and ever-growing swarm of people which streams across the Sultana Valide Bridge as described by De Amicis in his *Constantinople*.

Let us, however, leave aside comparisons and see Naples as it really is. Let us lose ourselves in this labyrinth, this human ant hill. Let us plunge into this contagious gayety, into this feverish vitality. Let us allow ourselves to be pulled into this dizzying whirlpool which attracts and yet overwhelms our senses by constant and excessive excitement. The first impression received in visiting Naples is that of a city in festival. All that noise, screaming, vehicles, people crowding the streets, at first make you think that it must all be due to some extraordinary event: a demonstration, a riot, or something similar. Turn your eyes upward, myriads of windows and balconies, curtains swinging in the sun, and leaves and flowers and among them, people, just to confirm your illusion. Cries, screams, whip-cracks deafen you, the light blinds you, your brain begins to feel dizzy and you gulp air. You feel drawn into becoming part of the enthusiastic demonstration, to applaud, to cry "Evvive" — but for what? What is there before your eyes is nothing exceptional or extraordinary. All is perfectly calm; no deep political passion is stirring in these people. They all mind their business and talk about normal things; it is just a day like any other. It is Naples' life in its perfect normality, nothing more.

What a strange place this is! What a bizarre blending of the most beautiful and the most horrendous, the excellent and the worst, the appealing and the nauseating. The spirit feels as if the eyes were constantly opening and shutting, darkness and light, light and darkness. Next to the very elegant lady a group of poor people with dirty rags; garbage and dirt underfoot and an emerald sky above you. On one side a cool and beautiful seascape, on the other, pale faces of the poorest people crowding around the opening of their cave-like dwelling. Down there, a group of impeccable dandies crowd around the fragrant basket of a flower girl, and next to them a bunch of little urchins in their shirts wallow in the garbage. Here a scented wave of orange blossom enraptures you, two steps further, the stench of fried fish offends your nostrils; the sad song of a maiden from a flowered balcony charms you, the potent braying of an ass crashes your eardrums. I could go on and on.

The extraordinary, dazzling variety of what hits the eye of a newcomer to this city is such, that it could be believed that the people got together and decided not to do the same things in the same manner. The spirit of a primitive independence is the absolute ruler; everyone does what he wants and what suits his fancy, without worrying about being ridiculous or a nuisance to others. The policeman is almost powerless in such a hullabaloo. The blacksmith moves his forge to the middle of the streets and so do all the other craftsmen. The tenants of the "bassi" or ground floors driven out by the darkness and the bad air of their dwellings, spread themselves out in the street with their furniture, their cats, dogs, donkeys, chickens, sheep and there they all stay, chatting, scratching, working, sleeping, eating, digesting and so on…. From morning till night, therefore, the whole city takes on the look of an immense junkshop.

In some streets the sky is almost hidden by masses of laundry hung up to dry and blow in the air on ropes that go from one side of the street to the other. They drip and snap in the wind as if they too were happy to see themselves finally clean and in the light of the sun. In other streets, circulation is sometimes blocked by all sorts of obstructions, yet, by zig-zagging, one manages to go through, go on, and laugh. Nobody grumbles and nobody complains. Nobody is reprimanded, nobody pays attention to complaints because they are all doing the same.

Sometimes we imagined we were taking a long journey to the Kingdom of Cathay or to the Republic of Samarkand but we had some great obstacles to overcome. We had to imagine that bushes were a forest, an embankment a mountain, gutters substituted for rivers and streams. Then we would encourage each other with brave gestures or, looking around cautiously, we would consult in low voices, subdued, breathing hard. Deciding once to test the ground, we went down, through brambles and duck ponds, screaming and jumping at breakneck speeds, as if possessed by the devil. The obstacles were not insurmountable. It was not seldom, however, that the girl's clothing was torn or damaged or that her feet got wet while splashing about in the water with her light shoes. As for me, my jacket was used to thorns and I could have stayed in the water for a hundred years, like an oak, before the dampness would get through the hardened soles of my feet. While she was drying herself and tidying up, I would start comforting her — for she would be sulky over such mishaps — and to avoid her crying or scratching me, I would make her laugh and carry her over my shoulders while jumping, at the same time, over bumps and streams. I was as robust as a little bull and I was delighted when she abandoned herself on my neck with her face and hands, in order to laugh more heartily. I felt that I had the strength, notwithstanding such a load, to reach, if not quite to Cathay or Samarkand, most certainly farther than Fossalta. The first hours of the afternoon were spent in such a manner. Then we began to widen our range, away from the immediate neighborhood of the castle, to become familiar with the roads, paths and the far away places. The meadows of the valley, where we had been on our first trips, sloped westward toward a beautiful stream of water winding through the plain under the great shadows of poplars, alders and willow trees, lazily, like a pretty country girl who had time on her hands or did not care to work. Down there, the birds chirped constantly and the grass grew thick and very tall like a carpet in the private quarters of a lady. There were bushy labyrinths of thorny brambles and fragrant shrubs which seemed to furnish the shadiest shelter and the softest seats for children's games or amorous conversations. The murmur of the water created a harmonious silence and doubled the magic of our fresh, bell-like voices. When we sat down on the greenest and fullest piece of turf, a green frog ran away to the edge of a nearby shrub and turned to look at us from there, as if it were on the verge of asking something or spying upon our business. For such pleasant pauses, we chose almost invariably a bank where the river is wider. There, after winding in capricious and murmuring twists and turns, it flows straight for a good stretch, quietly and silently, like a silly girl who had all of a sudden become a nun. The gentle slope calmed the river's flow and Pisana used to say that, just like her, the water was tired of running around and one should imitate her and sit down.

...The new horizons which were opening for my soul gave it a shelter against the persistence of the first vexations of childhood. I would rest in the great bosom of nature. Its beauty would take my mind off my anger and gloominess. The vast countryside where I was then running was quite different from the useless garden and fish pond that I had enjoyed so much between the ages of six and eight. If Pisana left me in the middle of the road to tease other boys, or if she ran away towards the fields hoping that in the meantime some visitors had come to the castle, I did not make a fool of myself by running after her, shrugging my shoulders and showing my sulkiness. I would instead go to soothe my suffering in the coolness of the meadows or on the river bank. There were new projects and new wonders with each step. I discovered a place where the water was almost as wide as a lake, clear and silvery as a mirror. The beautiful tresses of water weeds mingled in it, as if caressed by a magic breeze. Pebbles shone at the bottom, white and polished like pearls that had accidentally fallen out of their shells. Geese and ducks flopped their wings on the water and, after a momentary splash, struck out with their legs, taking on a tranquil and graceful formation, like a fleet under sail. It was a delight to see them advance, retreat, turn. The transparency of the water was only disturbed by a light ripple that would die on the bank in an even softer caress. All around, there were thick, century-old trees on which

wild vines were weaving the most extravagant green draperies. The vine would crown the top of an elm tree, then abandon itself to the sturdier support of an oak and, embracing this tree all around, it would fall over it in graceful garlands. On it went, from branch to branch, from tree to tree, as if dancing. Its black, minute berries invited the starlings to a picnic, along with the pigeons fighting to get their fair share. Where the lake became a brook, there were two or three mills. Their wheels seemed to run after each other, splashing water, like silly girls. I used to stay there long hours, watching them and throwing pebbles in the waterfalls to see them bounce and then fall again to disappear under the whirling round of the wheel. From the mills one could hear the noise of the millstones, the millers singing, children screaming, and always the squeaking of the chain over the hearth while the polenta was being stirred. I knew this because the smoke coming out of the chimney always preceded the occurrence of this new, strident note in the universal concert. In front of the mills, there was a constant coming and going of sacks and flour-covered figures. Women from nearby villages came and chatted with the women of the mills while their grain was being ground. Meanwhile, the little donkeys, freed from their loads, greedily enjoyed the bran mash prepared as a treat for them on the occasion of the trips to the mills. When they finished, they started to bray, merrily stretching ears and legs. The miller's dog barked and ran around them with playful assaults and defenses. I tell you, it was indeed a very lively scene and I couldn't think of anything better. I only knew of life what I had been told by Martino, Maestro Germano and Marchetto. From then on, I started to look with my own eyes, to reason and learn with my own mind, to find out what work and reward meant, to recognize the various chores of women, peasants, millers and donkeys. Such things kept me busy and amused and I would go to Fratta with my head turned toward the clouds, admiring the beautiful changing colors within them.

My walks became longer and longer and I deserted more daringly the Parish School and the custody of Fulgenzio. When I went on horseback with Marchetto, I was too young to retain in my memory what I saw, and when I grew older and bigger, he did not dare put me on the packhorse which was too old with wisdom to be strong on its legs. So, everything seemed new and surprising, not just the mills and millers, but the fishermen, their nets, the farmers, the plough, the shepherds, goats and sheep, all, all were a source of delight and surprise. Finally, one day I thought I was losing my mind, so marvelous and unbelievable were the things I saw. I want to tell them, as perhaps it was that walk that made me a believer forever in the simple and poetic religion of nature. It consoled me later for human wickedness with the sweet, unfailing serenity of its joys.

Confessions of an Octogenarian, 1867. IPPOLITO NIEVO

That branch of the lake of Como which extends southwards between two unbroken chains of mountains, and is all gulfs and bays as the mountains advance and recede, narrows down at one point, between a promontory on one side and a wide shore on the other, into the form of a river; and the bridge which links the two banks seems to emphasize this transformation even more, and to mark the point at which the lake ends and the Adda begins, only to become a lake once more where the banks draw farther apart again, letting the water broaden out and expand into new creeks and bays. The country bordering the lake, formed by the deposits of three great torrents, is backed by two neighbouring mountains, one called San Martino, and the other, in the Lombard dialect, the *Resegone*, from its saw-like row of peaks; so that on first seeing it — looking northwards, for instance, from the ramparts of Milan — one can pick it out at once, on the name alone, from the vast and lengthy range

of other mountains of obscurer name and more ordinary form. For a considerable stretch the country rises slowly and continuously; then it breaks up into little cliffs and valleys and level and rugged tracts, following the shape of the mountains and the erosion of the water. The shore itself, intersected by the beds of torrents, is almost entirely gravel and flint; the rest is fields and vineyards, and scattered farms, villages, and towns, with here and there a wood extending right on up the mountain-side. Lecco, which is the largest of these towns and gives its name to the district, lies on the lakeside not far from the bridge, and is even apt to find itself partly in the lake when this is high; it is a big town nowadays, well on the way to becoming a city. At the time of the events which we are about to describe, this township was already of some importance; it was fortified, and so had the honour of housing a commandant. It also had the advantage of a permanent garrison of Spanish soldiers, who taught modesty to the wives and daughters of the town, tickled up the shoulders of an occasional husband and father, and, towards the end of summer, never failed to scatter themselves among the vineyards, to thin out the grapes and lighten the labours of the vintage for the peasants. Paths and tracks used to run — and still do — from one to another of these villages, from the mountain heights to the lakeside, and from one precipice to the other. Sometimes they run steep, sometimes level, and often drop suddenly and bury themselves between two walls, from which, when one looks up, only a patch of sky and some mountain peak can be discerned. Sometimes they come out on open terraces; thence the eye ranges over prospects of varying extent, always full of interest and always changing, as each point of vantage takes in different aspects of the vast landscape, and as one part or the other is foreshortened, or stands out, or disappears. One can see a piece here, another there, and then again a long stretch of that great varied sheet of water; on this side the lake is shut in at one end and almost lost among the ins and outs and groupings of the mountains, then spreads out again between more mountains, unfolding one by one, and reflected upside down in the water with the villages on the shores; on the other side is more river, then lake, then river again, losing itself in a shining coil among the mountains, which follow it, getting smaller and smaller until they too are almost merged in the horizon. The very spot from which so many different views can be seen has views of its own on every side. The hillside on which you walk unfolds its cliffs and pinnacles above and around you, each standing out on its own and changing at every step, turning what had just seemed a single ridge into a whole series of ridges, and showing on a height something that a moment before had seemed down on the shore; the quiet and cosy character of these hillsides pleasantly tempers the wildness around, and is a foil for the grandeur of the rest of the landscape.

The bailiffs there must be out hunting for him! The orders that must have gone round to ransack inns and villages and roads for him! Then he thought that, after all, there were only two bailiffs who knew him, and that he did not wear his name written on his forehead. But various stories he had heard came back to him of fugitives found and caught by strange coincidences, recognized by their gait, or their suspicious air, or some other unforeseen signs; all this plunged him into gloom. Although the clock was striking twenty-four as he left Gorgonzola and the approaching darkness was lessening those dangers all the time, yet it was with reluctance that he took to the main road: and he determined to turn into the first lane that seemed to lead towards the part he was so anxious to reach. At first he met an occasional passer-by; but, full as he was of those ugly apprehensions, he had not the heart to accost any of them to ask the way. — Six miles, that man said — he thought — if it becomes eight or ten by going out of my way, the legs that did the others will do those too. I'm certainly not going towards Milan; so I must be going towards the Adda. If I go walking on and on, sooner or later I'll get there. The Adda has a good loud voice, and I shan't need to ask the way any longer, when I'm near it. If there is any boat to cross by, I'll cross at once; if not, I'll stop in a field or in a tree, like the sparrows, till morning. Better up a tree than in a prison-cell. —

Quite soon he saw a small lane opening off to the left, and turned into it. If he had come across anyone at that hour he would not have had so many scruples about asking to be shown the way; but not a living soul was to be seen or heard. So he went on wherever the road led him, thinking, — Me raise the devil! Me want to murder all the gentry!

Trudge, trudge, trudge. The cultivated land now merged into moorland strewn with fern and broom. This seemed to him, if not an absolute indication, at least some sort of argument for a river being near, and he started off by a path that ran through it. After a few steps he stopped to listen: but still in vain. The irksomeness of the journey was intensified by the wildness of the spot, by there not being in sight a mulberry, or a vine, or any other sign of human cultivation, which had been a kind of company for him. On he went, in spite of this, and to beguile or quieten fancies which were beginning to beset his mind — the vestiges of tales told him as a child — he began as he walked along to recite the prayers for the dead.

Gradually he found himself getting into higher undergrowth of thorn, scrub-oak, and brambles. On he walked, quickening his pace more from impatience than desire, and began to see an odd tree or two scattered among the bushes; and still farther along the same path, he realized that he was entering a wood. He felt a certain aversion to plunging into it, but overcame it and pushed on; but the deeper he plunged in, the more his aversion grew, the more everything unnerved him. The trees he could just discern seemed like strange, deformed monsters; he was alarmed by the shadow of the gently swaying tree-tops, quivering on the path, lit up here and there by the moon; the very rustling of the dry leaves stirred or trampled by his feet had something hateful to his ear. His legs had a kind of urge, an impulse to run, and at the same time seemed barely able to support him. He felt the night breeze stinging his brow and cheeks; more sharply and bitterly he felt it piercing between his clothes and his bare flesh, and penetrating into the very marrow of his bruised, exhausted bones, quenching the last spark of his energy. At one moment the repugnance, the vague horror with which his mind had been battling for some time seemed suddenly about to overwhelm him. He nearly succumbed altogether; but terrified by his own terror more than by anything else, he summoned his former spirits to his aid and bade them hold firm. Thus momentarily reinvigorated, he stopped short to take thought, and decided to get out of there at once by the path he had come, return straight to the last village he had passed, get back among human beings again, and seek some shelter, even at an inn. As he stood still there, the rustling of his feet in the leaves hushed, and all quiet around him, he began to hear a sound — a murmur — a murmur of running water. He strained his ears — now he was sure of it. "It's the Adda!" he exclaimed. It was like finding a friend, a brother, a saviour. His weariness almost disappeared; he felt his pulse beat again, the blood course freely and warmly through his veins once more, his confidence return, and most of his uncertainty and dejection disappear. Without hesitation now he plunged deeper and deeper into the wood towards the friendly sound.

In a few moments he reached the edge of the flat ground and the brink of a high bank; and peering down through the bushes that covered the whole slope, he saw the gleam of running water. Then raising his eyes, he saw a vast plain stretching out from the opposite bank, scattered with villages, and beyond them hills on one of which was a big whitish splodge which, he thought, must be a town — Bergamo for sure. He went a little way down the slope, and, pushing aside and parting the brushwood with his hands and arms, looked down to see if there was any boat stirring on the river, and listened for the splashing of oars. But he saw and heard nothing. Had it been anything smaller than the Adda, Renzo would have gone straight down and tried to ford it; but he well knew that the Adda was not a river to be treated so lightly.

So he then began to consider, very calmly, what the best thing was to do. To climb up into a tree and stay there waiting for the dawn for perhaps another six hours, in that breeze and that frosty air, was more than enough to numb him in good earnest. To walk up and

down for the whole of that time, apart from being very little use against the rigours of the night, was also asking too much of those poor legs of his, which had already done more than their duty. He remembered having seen in a field near the heath one of those straw-thatched cabins made of logs and wattle plastered with clay, which the peasants around Milan use to deposit their harvest in the summer, and shelter at night to watch over it. At other seasons of the year they are deserted. He quickly marked this out for his lodging, and retracing his steps along the path, passed the wood, the bushes, and the heath once more, and went towards the cabin. A worm-eaten door half off its hinges, without key or chain, blocked the entrance. Renzo opened it and went in. He saw a wicker hurdle swung in the air like a hammock and propped up on cleft branches, but did not bother to get up into it. On the ground he saw some straw; and thought that a little nap would taste very sweet even there.

The sky held promise of a fine day. Away in a corner the moon, rayless and pale, stood out even so against the vast background of greyish-blue, which way down towards the east was merging gently into a rosy yellow. Farther down still, right on the horizon, stretched a few clouds in long, uneven layers of blue and brown, the lowest of them tipped beneath with a streak almost of flame, which was gradually becoming sharper and more vivid. To the south other clouds, piled up in light and fleecy masses, were glowing with a thousand nameless colours: that Lombard sky which is so lovely — when the day *is* lovely — so radiant, so peaceful. Had Renzo been there for pleasure he would certainly have looked up and admired that dawn, which was so different from the one he was used to seeing in his own mountains. But his attention was on the path, and he was walking with long strides, to warm himself up and to arrive quickly.

The Betrothed, 1840. ALESSANDRO MANZONI

...Demetrio occupied three small rooms on the top floor of an old house on the via San Clemente. To reach them, there was a dark, small, winding staircase, as in a bell tower.
Once up there, one achieved the reward of air and a sweeping view over the roofs. A small railing guided you to a little outside balcony. Since the day the new landlord had come to live in the house, it was covered by a young Virginia creeper, planted in a barrel.
During the good season, some beanstalks grew green and wound around the ironwork, opening their beautiful white, red and purple cuplike flowers and sending their tendrils to caress the walls. From some beams, thick bunches of carnations rained down over the roof below. More than the flowers, however, Demetrio loved plants, the simple plants garbed only in green — *tredescanzie*, like the flowing hair of a beautiful woman; thin, elongated ferns; the velvety softness of moss; the unruliness of ivy; and even rosemary and hard-leafed salad greens. In short, he loved green in all its modest and rich variety, that blessed green that seems to be meant for soothing the soul and the body.
Born as he was in the midst of the meadows of Lombardy, descended from people who for ages were accustomed to working in the grass, he had in his blood a fantastic instinct for the green and silent in nature. He knew, he understood its most mysterious voices. It was this great craving for grass that made him grow a sample of that nature, of which he dreamed nearly every night, in three or four wooden crates on the sunburnt tile roof.
When he wished to get a breath of fresh air, he went to spend a Sunday at the Cascine Boazze, a few miles out of Porta Romana, near the bell tower of Chiaravalle, a classic place for green,

for damp meadows, for long, wide spaces stretching on and on, of an emerald-green grass-covered land sunk among rows of silvery willows and tremulous poplars.

...The three windows and the railing overlooked a deep, narrow courtyard, similar to a tower, the end of which could not be seen. Looking straight ahead, the eye caught an extensive view over a multitude of large roofs, smaller roofs, overlayered, crowded one on top of the other, and all of a uniform, burned color. There were a great many garrets, protruding attics, openings, chimneys of all shapes and colors with open, yawning black mouths, some of them topped with iron hats shaped like helmets, fencing masks, bonnets and umbrellas — a crowd of all shapes, in other words, that in the twilight and in nights of full moon seemed to be posing, coming to life.
It was already the second Sunday of Lent, and the season, blessed by a beautiful month of March, was coming in gaily, arm-in-arm with spring.
The sun shone live and festive through the three tiny windows. The fresh morning breeze ran up the tiled roofs and a small green bunch of elder peeked from some balcony or terrace up high.

...The sound of his voice brought him back to things and thoughts of this world. He would get up, straighten with his hands his head and cramped legs, look around the room and then he would take his hat and out he would go, away, to dry up his melancholy in the air and the sun of Piazza Castello, to look for a healthy and honest distraction in the tents at Tivoli where the great marvels of the universe were shown. The plants were dressed up in early green. On the edge of the avenues, still damp and cool, tender grass was growing, bringing pleasure to the heart, as if that touch of green — creeping into the sterile amphitheater of a great city all dust and stones — were a reminder of the good mother nature which grows right out of fortress walls. Against the glaring background of Piazza d'Armi, the Arch of Peace stood silhouetted with its black horses against the white marble. Behind it, one could see the snow-capped tips of the distant Alpine foothills and Monte Rosa. The latter, on clear, dry days, shows itself to the Milanesi like a vague, rather confused symbol of a better world.
Demetrio enjoyed watching the circling horses, maneuvering in front of the Castle, and listening to the legends told by the circus people, and to the clairvoyants selling the good fortune that they themselves do not possess....

...While crossing the old Lazzaretto bridge from which the city offers itself once more to the eyes of the traveller, with its ample roads and white buildings — the lights were already shining in the homes and shops — he greeted it with a sigh. Then the train, accelerating, reached the low country-side in the damp and thick darkness of the night. With its muffled shaking, it stimulated the tumultuous flow of thoughts. It was not an unknown countryside. On the contrary, these were the very same meadows where he was born and raised as a boy. After the fourth or fifth gatehouse, even in the dark, he began to recognize the old farm of the Pianellis, and further on, San Donato. Through a dark bunch of poplars, he saw the long, low farmhouse where, once, a rustic Demetrio used to come out wearing clogs and pants rolled up to his knees. In a low spot, hidden by a wall surmounted by a triangular roof, lay for twenty-five years now, a woman, a good woman, who had also uselessly worked for the well-being of her people. "Ciao, mamma...," said a voice that an irritated and deaf Demetrio did not wish to hear. A bit further on, the train would pass a pond, on the edge of which stands the stupendous Abbey of Chiaravalle. There it was, almost rising from the purple water, with its black, solemn construction, the machinery of the bell tower imprinted like a shadow in the dark air. Over there, outlined by some reddish lights, stood the solid mass of the Cascine, the royal palace of Signor Paolino.

118. Giacinto Gigante: *Marketplace at Castellammare*. Oil on canvas, 15⅜ x 22 inches. Sorrento, Museo Correale.
The market is being held along the shore, just a few steps from the water, thronged with figures, horses, carts, barrels and stalls. This slice of life is in direct contrast to the norms of neoclassicism then dominant throughout Italy.

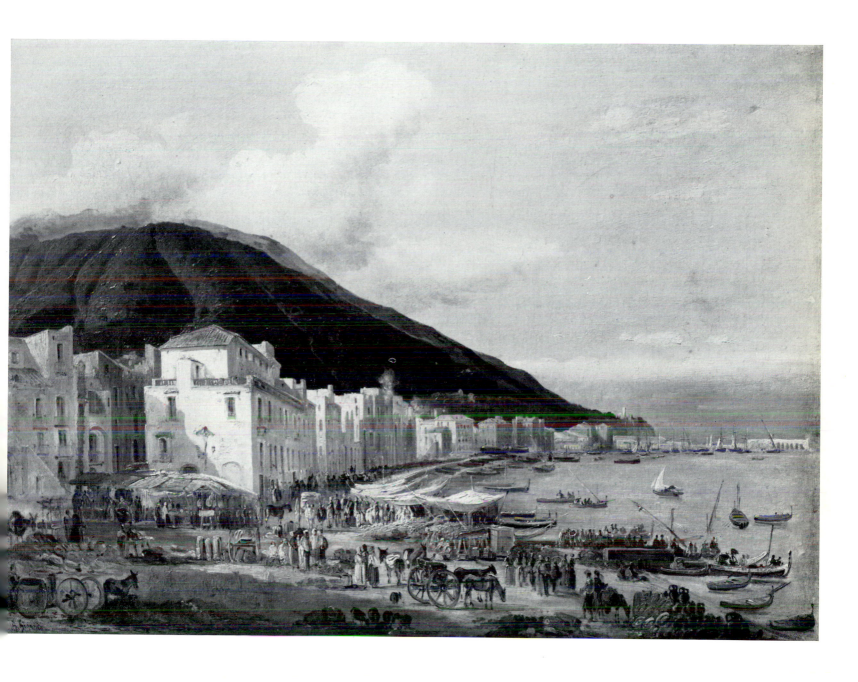

119. Giacinto Gigante: *Dusk at Pozzuoli*. 1847. Oil on canvas, 10¼ x 15⅜ inches. Milan, Giacomo and Ida Jucker Collection.
Neapolitan landscape painting followed the lines laid down by Dutch and Venetian landscape artists. In fact, the Dutch painter Pitloo was called to direct the Naples Academy in the early nineteenth century.

120. Filippo Palizzi: *Herd of Buffalo*. 1847. Oil on canvas, 11⅜ x 25⅜ inches. Piacenza, Ricci Oddi Gallery.
Although a realist painter, Palizzi used eighteenth-century color in a modern key, thereby obtaining broad, luminous effects.

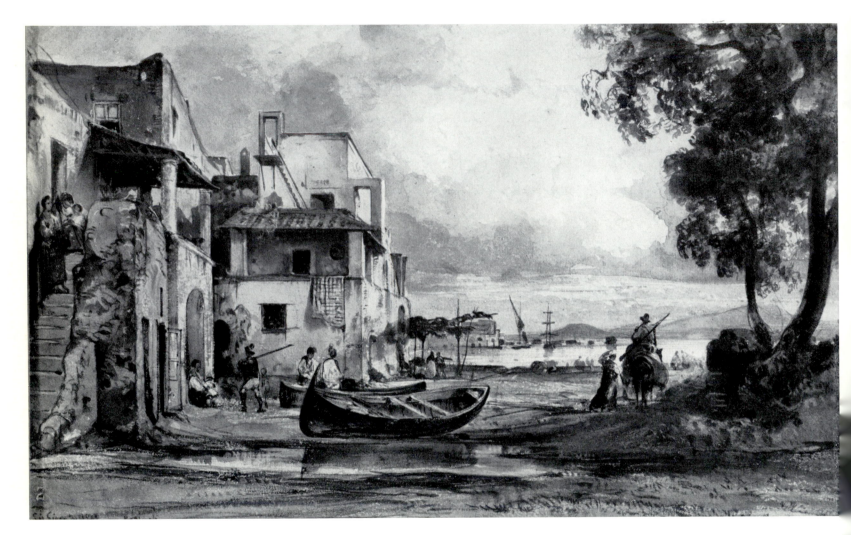

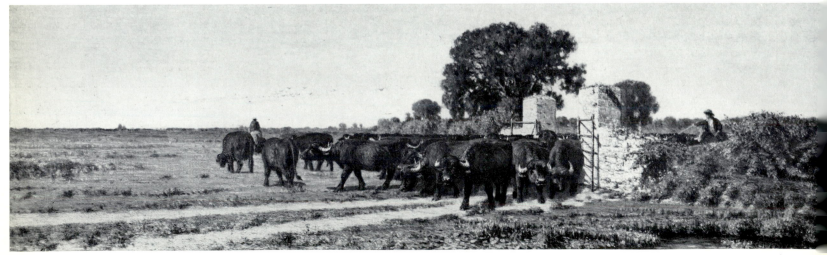

121. Marco De Gregorio: *Archways*. Oil on canvas, 21⅝ x 30¾ inches. Florence, Gallery of Modern Art.
The unfortunately short-lived "Resina School" was a forerunner in Italy of realist painting executed directly from nature.

122. Federico Rossano: *Road on Vesuvius* (detail). 1875. Oil on canvas, entire painting 22⅜ x 41¾ inches. Naples, Capodimonte Museum.
A disciple of Neapolitan landscape painting, Rossano here attempts a contrast between bright light and intense colors in a pastoral theme.

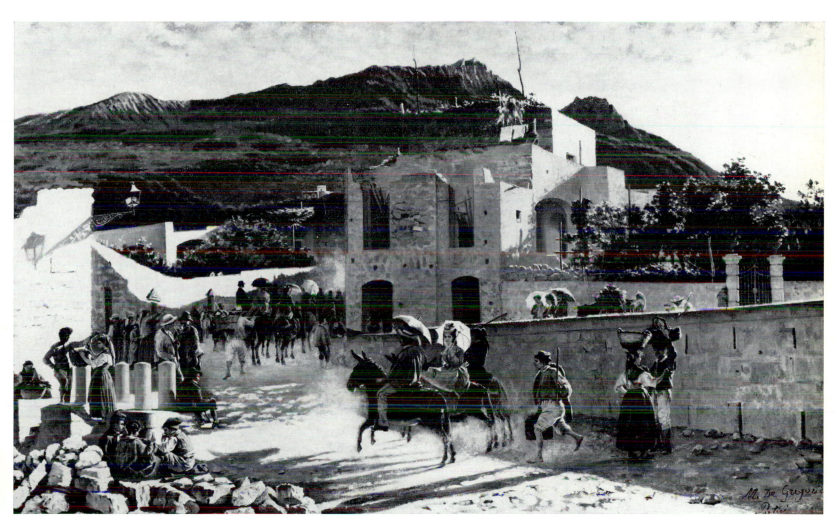

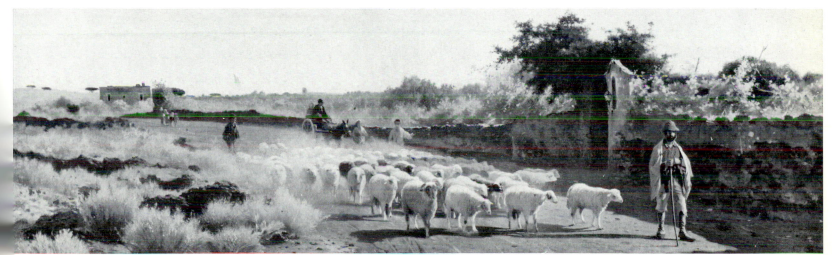

123. Giuseppe De Nittis: *Westminster Bridge* (detail). c. 1877. Oil on canvas, entire painting 30¾ x 52 inches. Barletta, Civic Museum, De Nittis Gallery.

This Italian painter, who arrived in Paris in 1868, lived through the opening phase of impressionism and was inspired by it in his landscapes. This view of London and the Houses of Parliament, for instance, is a study of the dissolution of color into light.

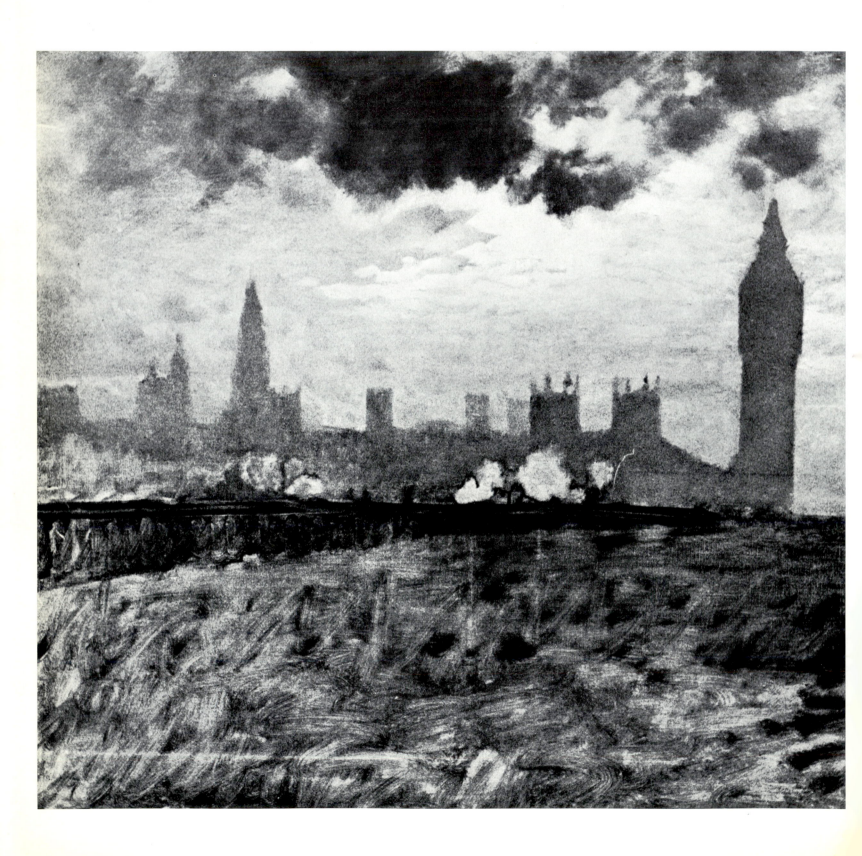

124. Giuseppe De Nittis: *The Ofantino River* (detail). 1866. Oil on canvas, entire painting 23⅝ x 39¾ inches. Milan, Enrico Piceni Collection.

The painter did this landscape of Apulia when he was in Florence and had already met the Macchiaioli painters, who admired his limpid rendering of the landscape and his gemlike colors set in spacious, light-filled compositions.

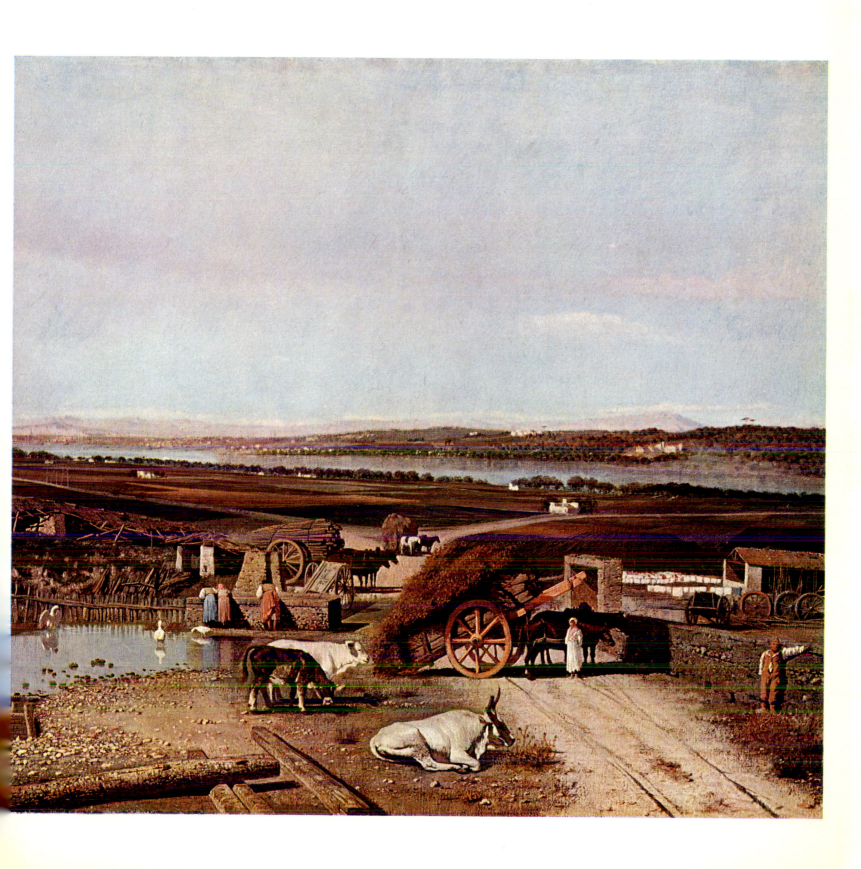

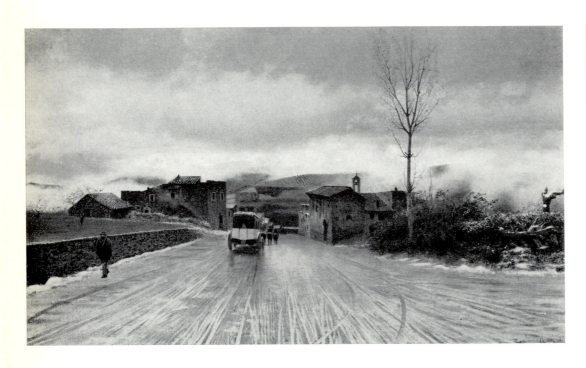

125. Giuseppe De Nittis: *Crossing the Apennines*. 1867. Oil on canvas, 16½ x 30¾ inches. Naples, Capodimonte Museum.
This is another example of the paintings De Nittis did during the years he was in touch with the Macchiaioli. *The greys and the foggy atmosphere are extremely well handled.*

126. Giuseppe De Nittis: *London, The National Gallery*. 1876. Oil on canvas, 27½ x 41⅜ inches. Paris, Petit Palais.
The perspective angle of this view of London is reminiscent of the Italian veduta, *but the fluid color and the bustling figures obviously derive from the impressionist way of conveying life in the open. The clarity of the line and the light in this painting explains why Degas insisted De Nittis be included in the First Impressionist Exhibition at Nadar's in 1874, despite Renoir's objections.*

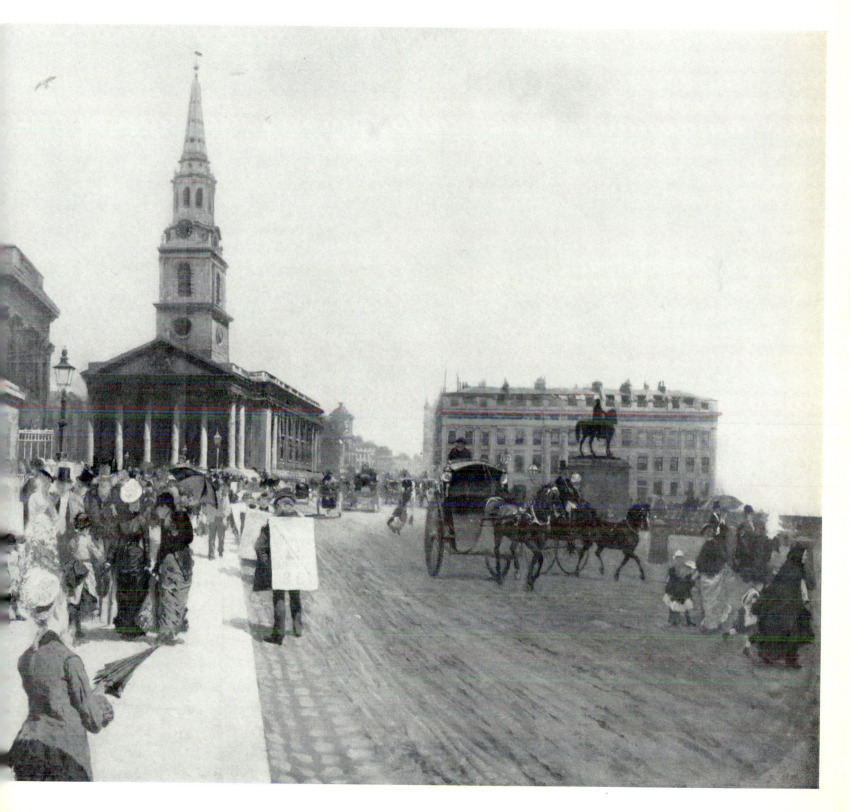

127. Giuseppe De Nittis: *Paris, Place des Pyramides*. 1876. Oil on canvas, $27\frac{1}{2}$ x $41\frac{3}{8}$ inches. Milan, Gallery of Modern Art.

His rendering of the immediacy of a daily scene and the particular hour of the day does not prevent this artist from maintaining a clear sense of space, defined outlines and solid color.

128. Giuseppe De Nittis: *Along the Ofanto River*. Oil on canvas, $16\frac{1}{2}$ x $25\frac{5}{8}$ inches. Barletta, Civic Museum, De Nittis Gallery.

If this is a landscape of Apulia, as the Barletta Museum and the critic Enrico Piceni claim, then it was painted with a different technique from the other views of the Ofanto; that is, here we can see traces of impressionist influence.

129. Luigi Basiletti: *View of Lake Iseo*. Oil on canvas, $29\frac{1}{8}$ x $40\frac{1}{8}$ inches. Brescia, Pinacoteca Tosio Martinengo.

The brief period the artist spent in Rome left a neoclassical mark on his style, which he overcame once he returned to his own region. In this painting we can still see the hard, enamelled colors in the classical taste, but the silver light already tends to soften the total effect.

130. Giovanni Migliara: *Porta Nuova, Milan.* 1815. Oil on canvas, 18½ x 24⅜ inches. Milan, Museum of Milan.

In Milan the tradition of perspective views continued well into the nineteenth century. Although Migliara was careful to observe the rules of neoclassical decorum, he still succeeded in bringing out realistic moments as had the Dutch painters who worked in Rome during the preceding century. Here the Porta Nuova is seen from within the city; beyond stretches open country right to the mountains of Brianza.

131. Giovanni Migliara: *The Bridge of the Trophy, The Pavian Canal at Porta Ticinese.* Watercolor, 14⅛ x 10⅝ inches. Milan, Museum of Milan.

The Trofeo, or memorial, seen at the right was put up by Giacomo da Novi in 1605 in honor of the Spanish governor, Count de Fuentes, who was instrumental in starting work on the Pavia Canal. The Trofeo was removed in 1865. In the background can be seen the Arch by Cagnola erected after 1804 for the First Consul Napoleon.

132. Angelo Inganni: *Milan, La Scala.* c. 1845. Oil on canvas, 31⅞ x 39⅜ inches. Milan, La Scala Theater Museum.

The painting shows what the Contrada del Giardino looked like before it became Via Manzoni and the houses to the left and in front of the opera house were torn down to make room for the open square.

133. Giuseppe Canella: *Corsia dei Servi, Milan.* 1838. Oil on canvas, 25½ x 32⅝ inches. Milan, Museum of Milan.

The name of this street came from the church of the Servites that used to be there.

134. Giuseppe Canella: *Paris, Rue de Rivoli* (detail). 1826. Oil on canvas, Paris, Musée Carnavalet.

Canella dedicated himself to landscape painting right from the beginning and was esteemed throughout Europe. In 1823 he went to Paris and began painting views of the city, much appreciated by the Duke of Orléans, of which this is one.

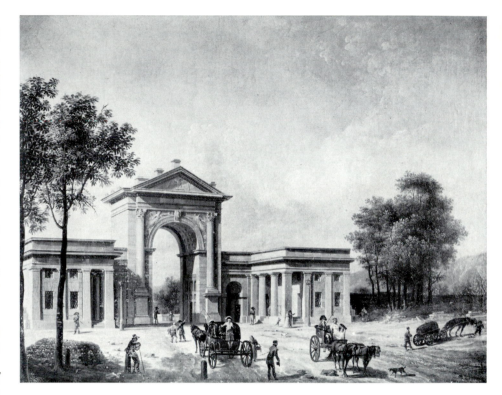

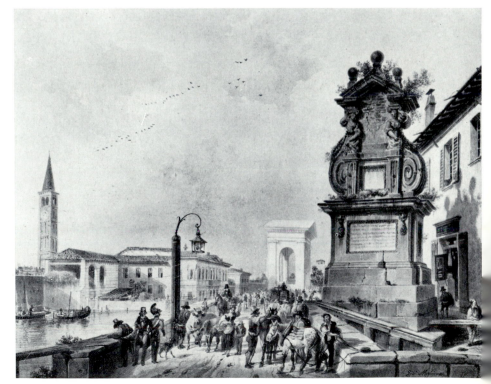

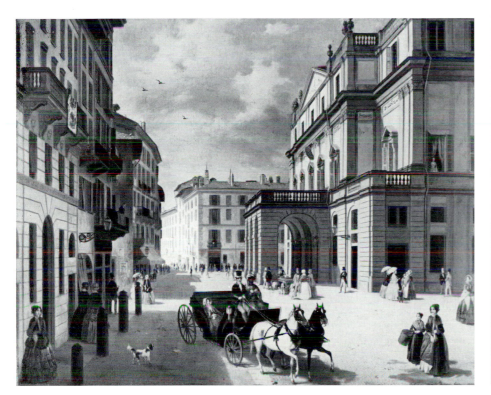

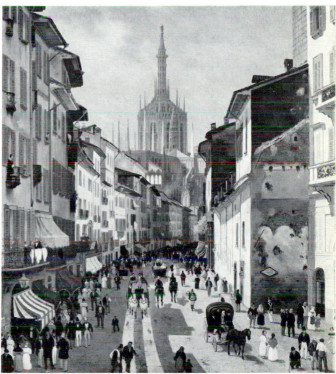

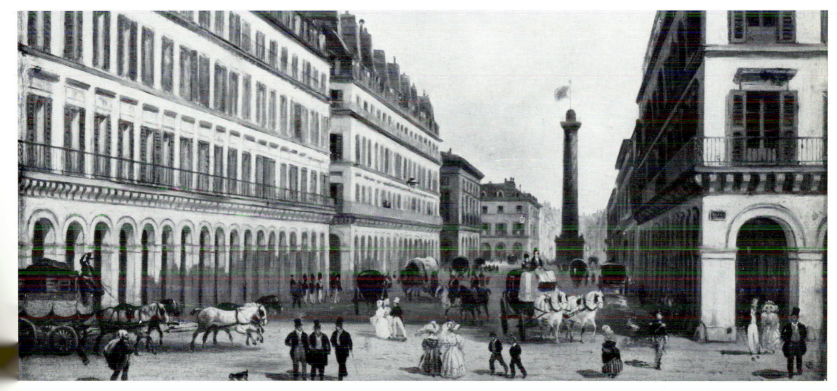

135. Giovanni Carnovali, called Il Piccio: *Along the Brembo*. 1846-1848. Oil on canvas, 17¾ x 24 inches. Piacenza, Ricci Oddi Gallery. *Among the many painters in Milan who declared themselves romantics simply because they painted characters without the usual Roman togas, Carnovali was the only true romantic for his sensitive perception of nature, which he saw as the mirror of his feelings.*

136. Giovanni Carnovali, called Il Piccio: *Landscape with Trees*. 1846. Oil on canvas, 24¾ x 39⅜ inches. Milan, Gallery of Modern Art. *This landscape also, of the few Carnovali painted, was inspired by the region around Bergamo. The diffuse light aids in conveying a soulful mood.*

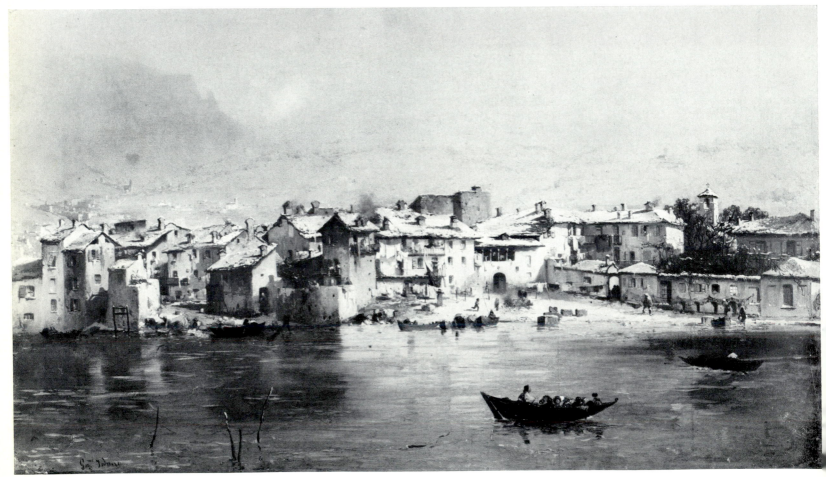

137. Gerolamo Induno: *Pescarenico*. 1862. Oil on canvas, 18⅛ x 31½ inches. Turin, Gallery of Modern Art.
This small town on the river Adda, just at its source on Lake Lecco, was made famous by the nineteenth-century novelist Manzoni, who used it as a setting for many of the scenes in The Betrothed.

138. Giovanni Carnovali, called Il Piccio: *Landscape with Trees* (detail). 1846. Oil on canvas, Milan, Gallery of Modern Art.
Broad horizons and imposing trees set against a light-filled sky were always favorite motifs with romantic painters and poets, who found their spiritual need to unite with the universe best expressed by space and luminosity.

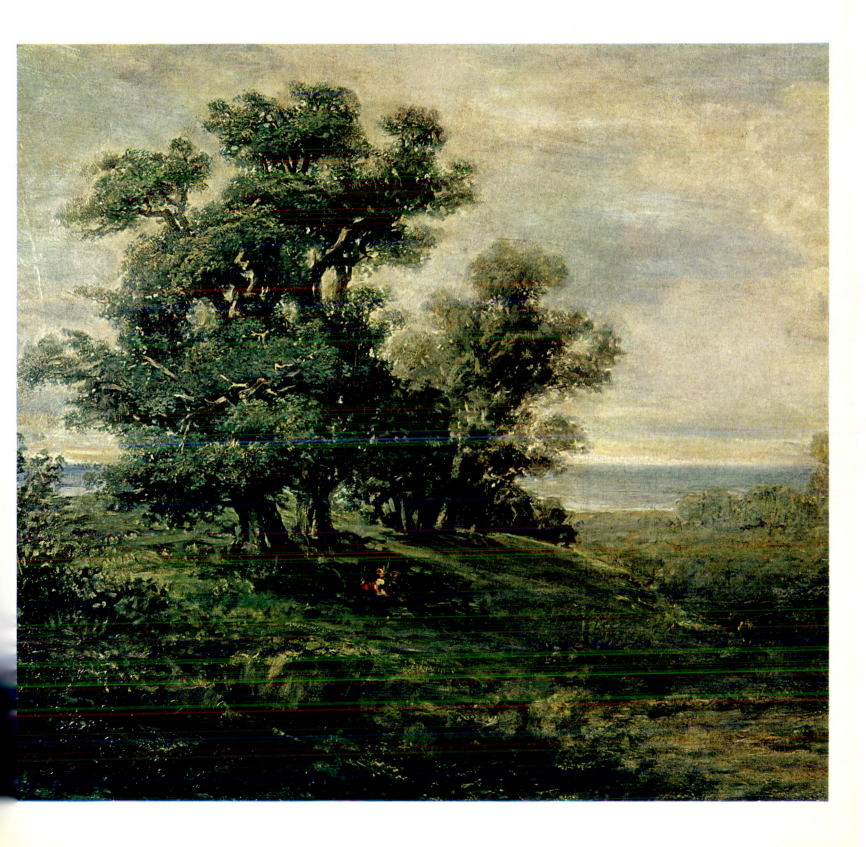

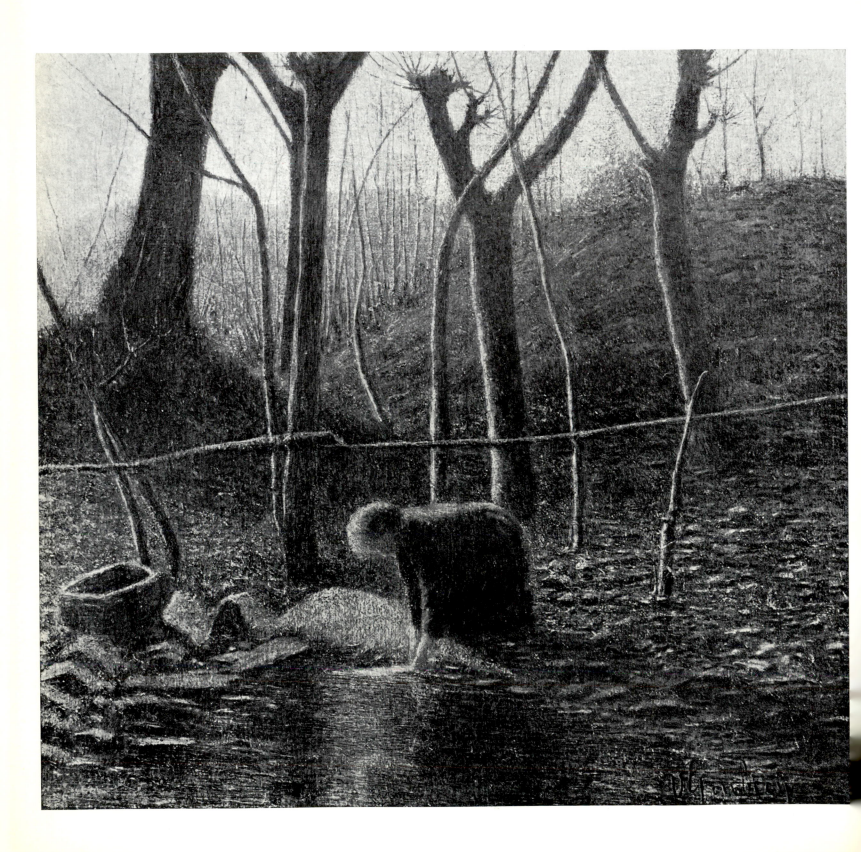

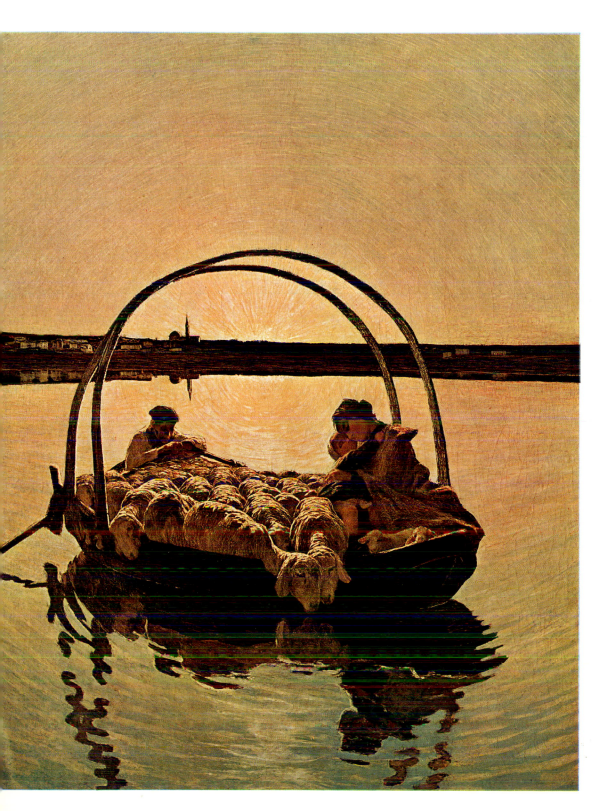

139. Vittore Grubicy de Dragon: *At the Warm Spring* (detail). Oil on canvas, entire painting 15½ x 18½ inches. Milan, Gallery of Modern Art.

A painter and art dealer, he was a friend and adviser to Segantini, whom he persuaded to become a pointillist. His own painting was a variation of divisionism, his color being rubbed rather than dabbed, with a strong propensity for the pathetic.

140. Giovanni Segantini: *Ave Maria on Board*. 1882-1886. Oil on canvas, 35⅞ x 46⅞ inches. St. Gallen, Christian Fischbacher Collection.

Segantini painted this famous scene on the shores of Lake Pusiano; the town of the same name can be seen in the background. He was already a pointillist when he did this painting.

141. Giovanni Segantini: *At the Hitching Post.* 1886. Oil on canvas, 66⅛ x 145¼ inches. Rome, National Gallery of Modern Art.
This large canvas, which won a prize in Vienna, was the last in Segantini's naturalist period. We see how the painter conveys a solemn sense of the land-scape and of life as well by the contrast in scale between the foreground and the vastness of nature behind it.

142. Giovanni Segantini: *Haymowing.* 1889-1899. Oil on canvas, 58⅝ x 53⅛ inches. St. Moritz, Segantini Museum.
In this work, Segantini's esteem for Millet is evident. But Segantini takes the counterpoint between light and color even further than Millet by accentuat-ing each brushstroke. The painting was begun during the time he was in Savognino and completed ten years later at the Maloja.

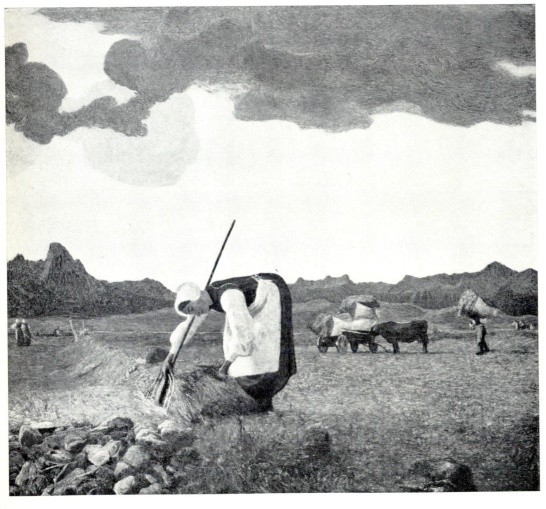

143. Vittore Grubicy de Dragon: *Winter Sun* (detail). c. 1901. Pastel, 15 x 23¼ inches. Milan, Wally Toscanini Collection.
Despite the rather small size of the canvas, this painting achieves a sense of grandeur. Through composition and color the artist was able to capture the effect of sunset on a snow-covered mountain.

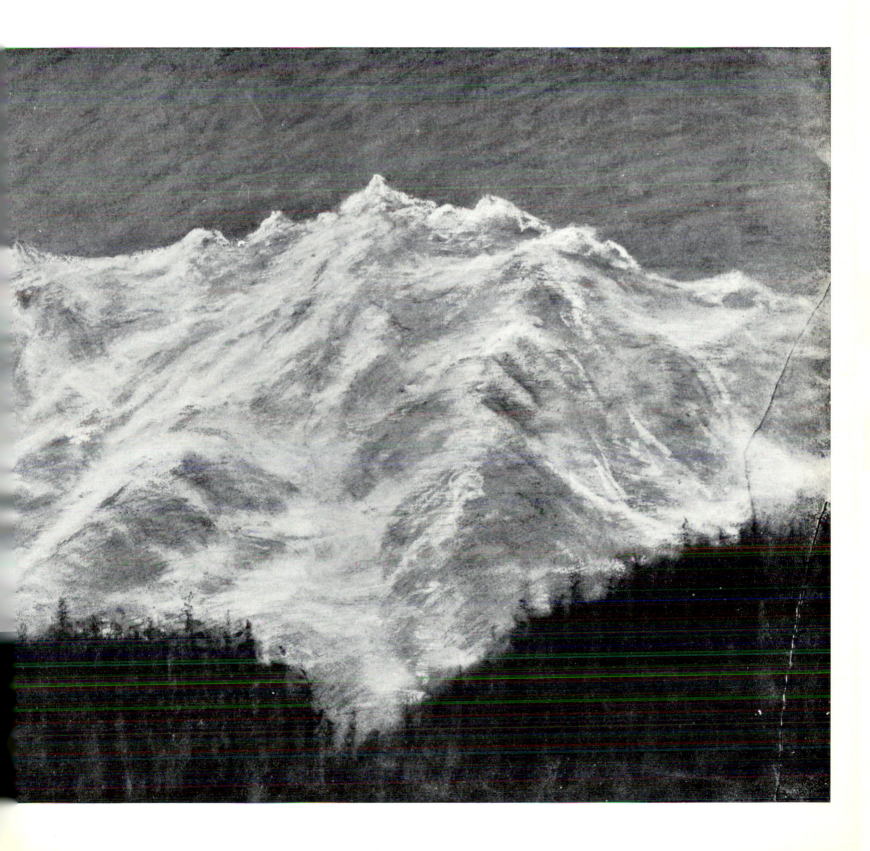

144. Giovanni Segantini: *Savognino in the Snow* (detail). Oil on canvas, entire painting 13⅝ x 19½ inches. Milan, Maria Ramazzotti dell'Acqua Collection.

Around 1886 Segantini left the valleys of Brianza and went up into the mountains. Savognino was his first stop, and there he developed his pointillist technique in order to render the crystalline transparency of the air and the refraction of color on the snow.

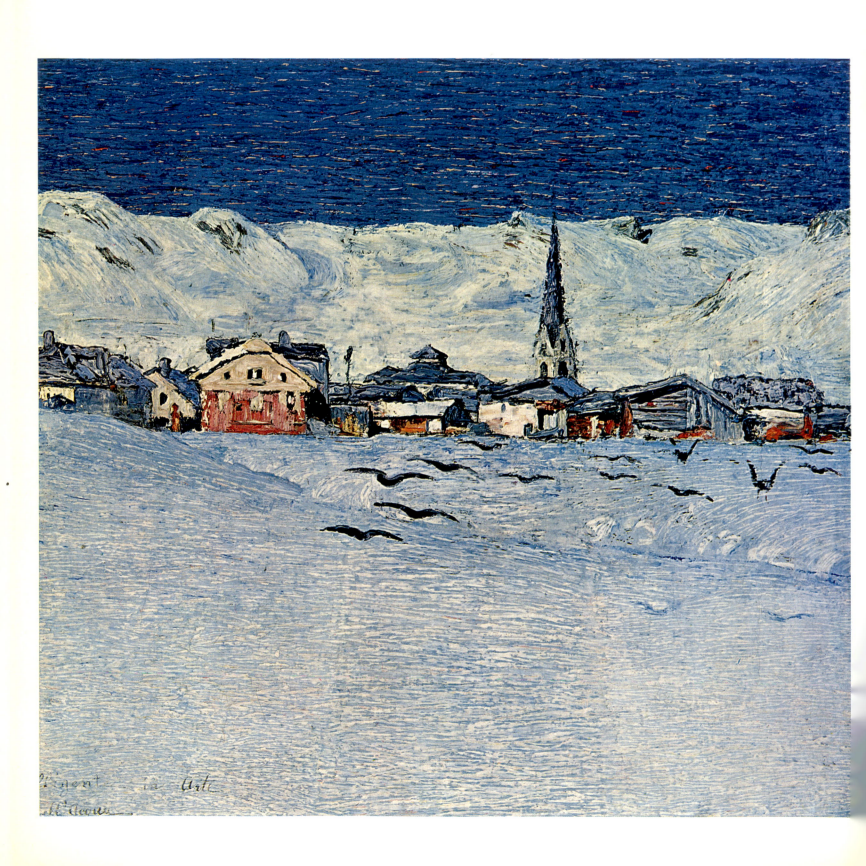

145. Giovanni Segantini: *Return from the Woods* (detail). 1890. Oil on canvas, entire painting 25⅛ x 37 inches. St. Gallen, Christian Fischbacher Collection.

The snow-covered landscape between Savognino and the Maloja, and the clear, silent days, often moved Segantini to capture the immense tranquillity of the region. Against this stillness he would set, as we see here, a scene of human labor that unmistakably conveys a sense of resignation.

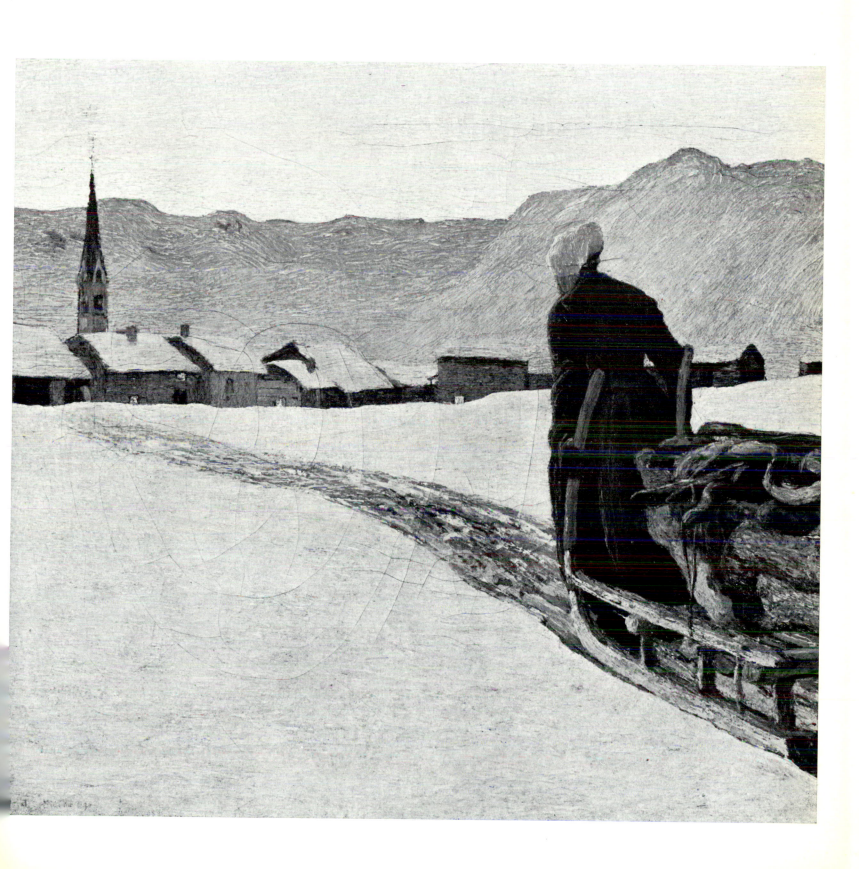

146. Giovanni Segantini: *Grazing in Springtime*. 1896. Oil on canvas, 38⅝ x 61 inches. Milan, Brera Gallery.
The snows have just melted and the cattle have come out to graze. The period the artist spent on the Maloja is marked by symbolical painting, as Segantini strove to represent his almost religious conception of nature. Divisionism is applied systematically in this painting, resulting in intense naturalism.

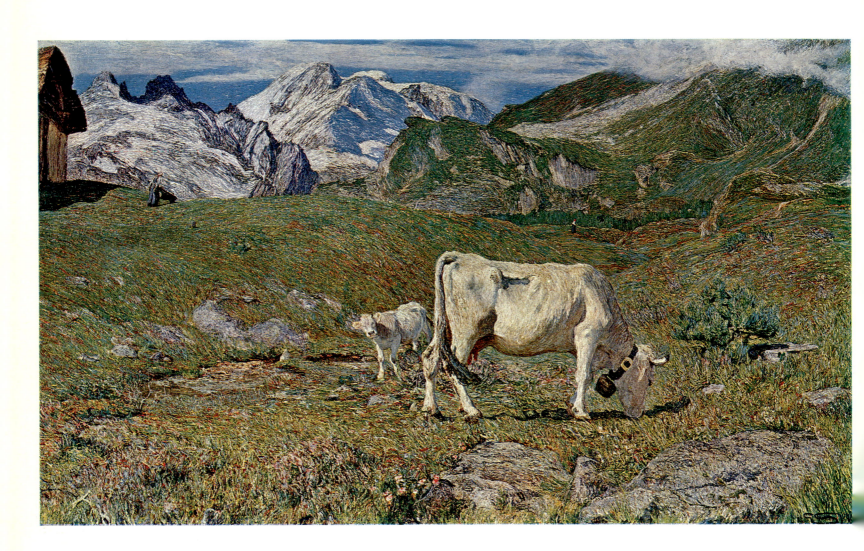

147. Giovanni Segantini: *The Triptych of the Alps, Death.* 1896-1899. Oil on canvas, 74¾ x 126 inches. St. Moritz, Segantini Museum.
In order to finish this triptych that was to express the artist's idea of nature and human existence, Segantini spent a number of weeks among the high valleys of the Schafberg. The horse and sleigh wait to bear a casket down to the valley below, the event being witnessed by the tall peaks illuminated by the sun.

148. Emilio Gola: *Canal in Milan.* Oil on canvas, 26¾ x 33⅞ inches. Milan, Picture Gallery of the Edison Corporation.
The barge canals in Milan were covered over in 1930 within the city limits, but they are still open at Porta Ticinese, where there are moorings, visible in this painting.

149. Mosè Bianchi: *Snowfall in Milan.* c. 1885. Oil on canvas, 15¾ x 19⅝ inches. Milan, Gallery of Modern Art.
As Milan's economic development created the need for new suburbs, the neoclassical elegance for which the central city is noted had to give way to rapidly constructed and practical buildings.

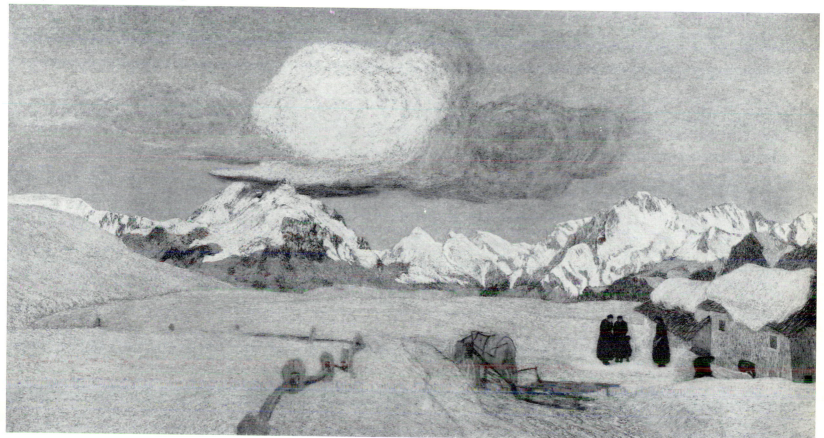

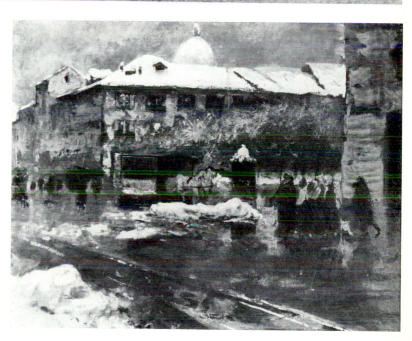

150. Cesare Tallone: *Upper Bergamo*. Oil on panel, 14½ x 18⅞ inches. Milan, Ventura Gregorini Collection.

After he became a professor at the Brera Academy in Milan, Tallone painted many views of Bergamo and the surrounding area. The thick, brilliant color renders admirably the plasticity of the town set against the heavy sky.

151. Ippolito Caffi: *Paris, Boulevard Saint-Denis.* c. 1855. Oil on canvas, 12¼ x 20⅛ inches. Venice, Ca' Pesaro.

In Venice, he was a disciple of the vedutisti. *He went to Rome in 1832 and probably met Corot there. A restless man, he frequently travelled around Italy and other countries in Europe, and his work met with success even in Paris. He died at sea during a battle off the island of Lissa, near Yugoslavia.*

152. Guglielmo Ciardi: *Capri.* 1866. Oil on canvas, 16½ x 30⅛ inches. Rome, National Gallery of Modern Art.

Famous as a painter of the lagoon and the region around Venice, Ciardi sometimes tried his hand at depicting other places, as in this landscape of Capri.

153. Ippolito Caffi: *The Pincio in the Morning* (detail). 1846. Oil on canvas, 9⅞ x 16⅞ inches. Venice, Ca' Pesaro.

Because of the quality of the sunlight he was able to capture, Caffi's Roman views have a brightness and a golden tone about them. At left we see the obelisk and the church of Trinità dei Monti.

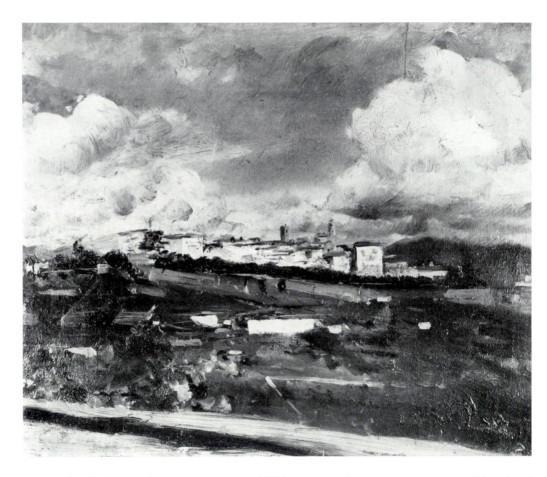

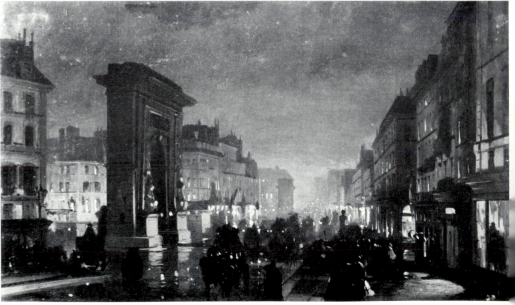

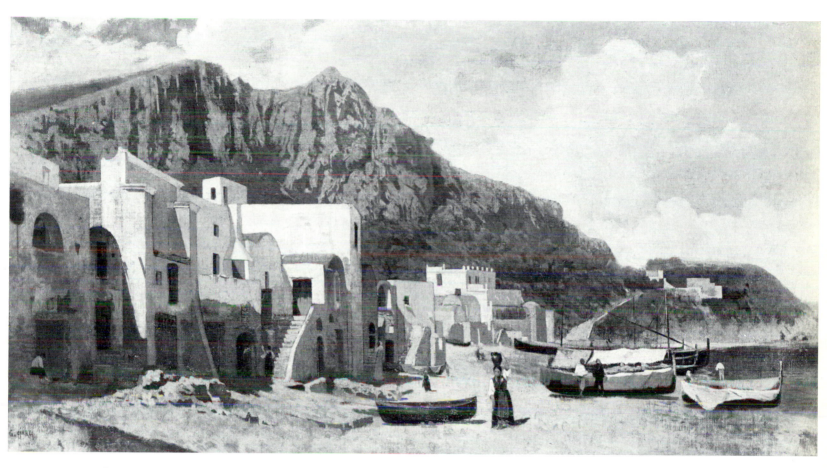

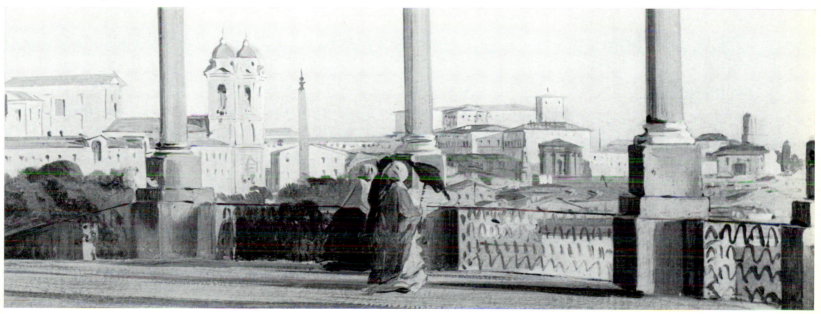

154. Federico Zandomeneghi: *Place d'Anvers, Paris* (detail). 1880. Oil on canvas, entire painting 40⅛ x 53½ inches. Piacenza, Ricci Oddi Gallery.

A friend of many impressionists, he participated in their exhibitions and in the critical debates about painting out of doors. In this painting we can see in the contrast between color and light that the artist already sensed the problems that were to lead to the crisis in impressionism around 1880.

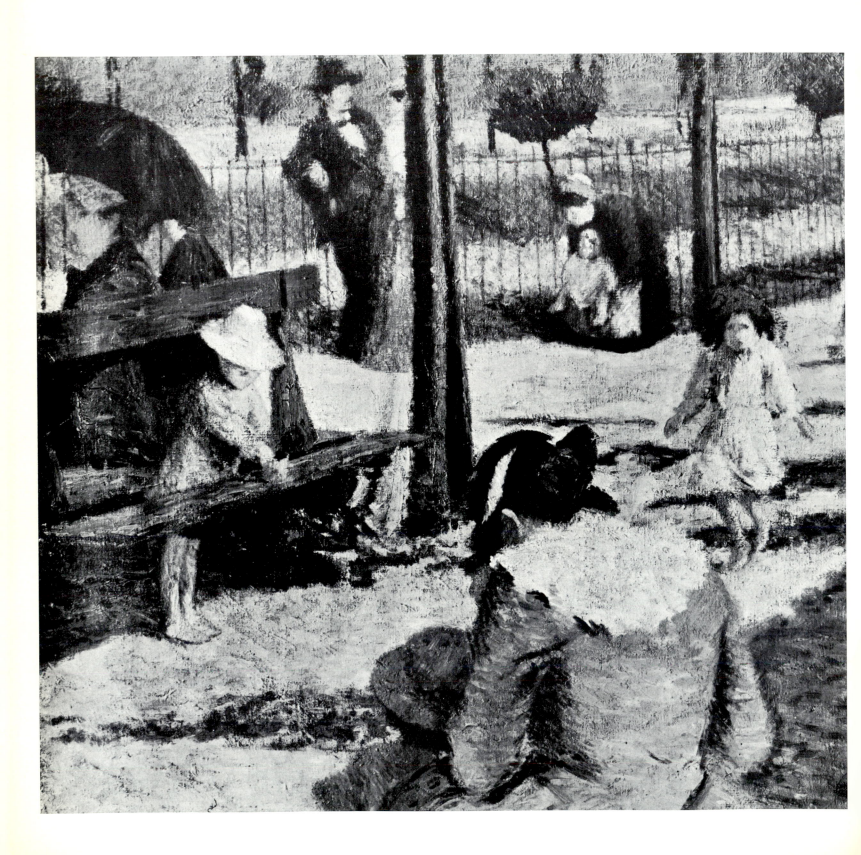

155. Federico Zandomeneghi: *Place du Tertre, Paris* (detail). 1880. Oil on canvas, entire painting 18⅛ x 15⅝ inches. Milan, Gaetano Giussani Collection.
In this painting as well, the painter pays great attention to the effects of color and to certain contrasts in city life.

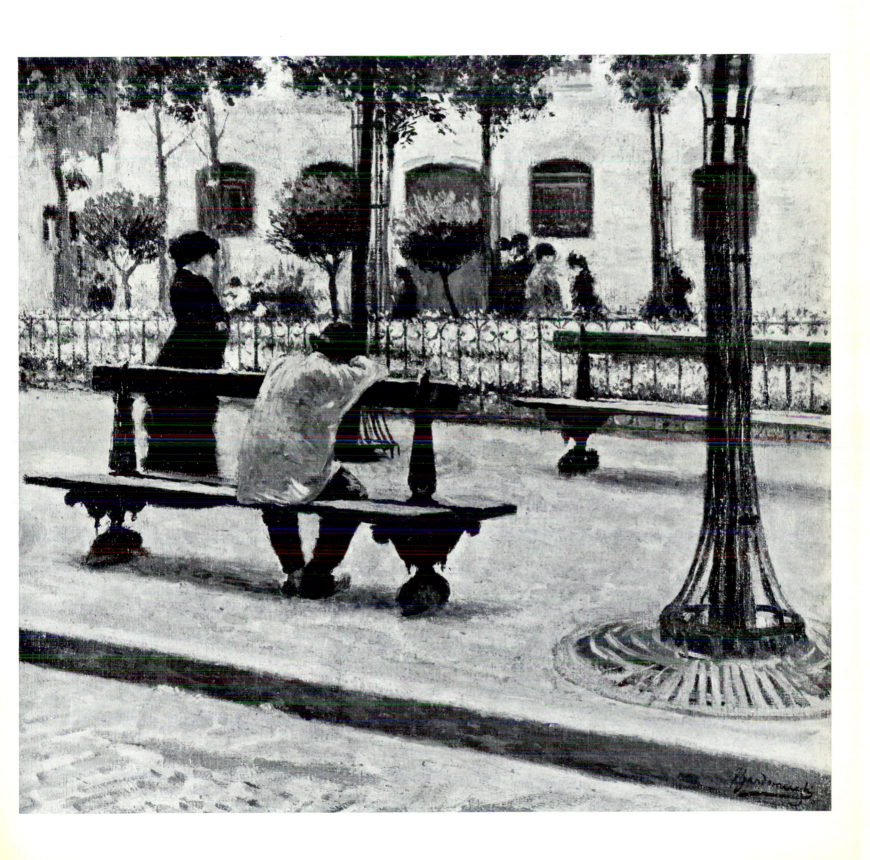

156. Giovanni Costa: *Dusk on the Arno*. c. 1861. Oil on panel, 8⅞ x 17⅜ inches. Milan, Giacomo and Ida Jucker Collection.
He was the first painter to induce Fattori to paint from nature directly. Here his color is intense; the representational elements serve to frame the chromatic play.

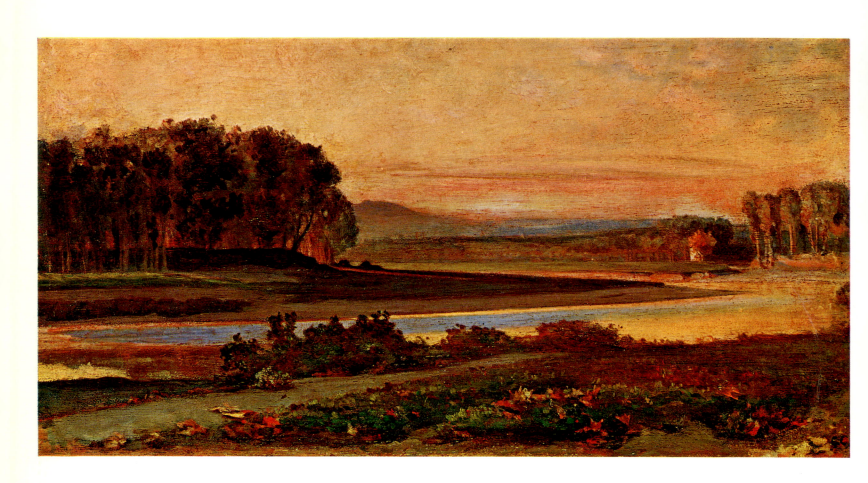

157. Giuseppe Abbati: *The Mugnone River by the Cure*. 1865. Oil on panel, 9 x 13⅛ inches. Milan, Giacomo and Ida Jucker Collection. *The Mugnone is the other river that flows near Florence, through the public park known as Le Cascine. The solid color of each defined area is typical of the Macchiaiolo style.*

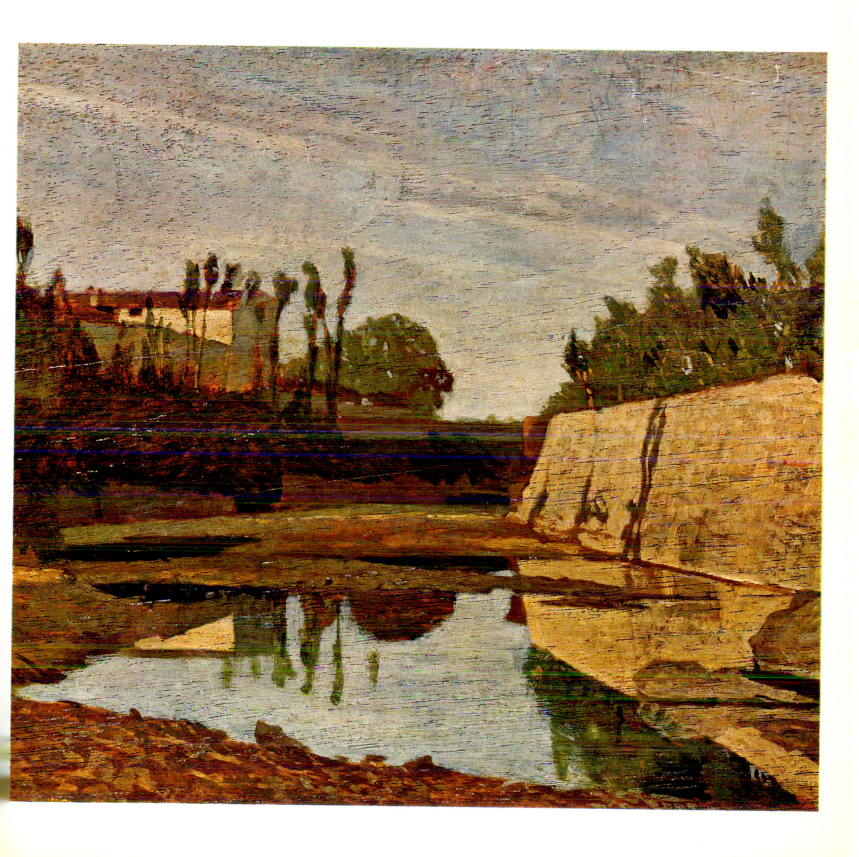

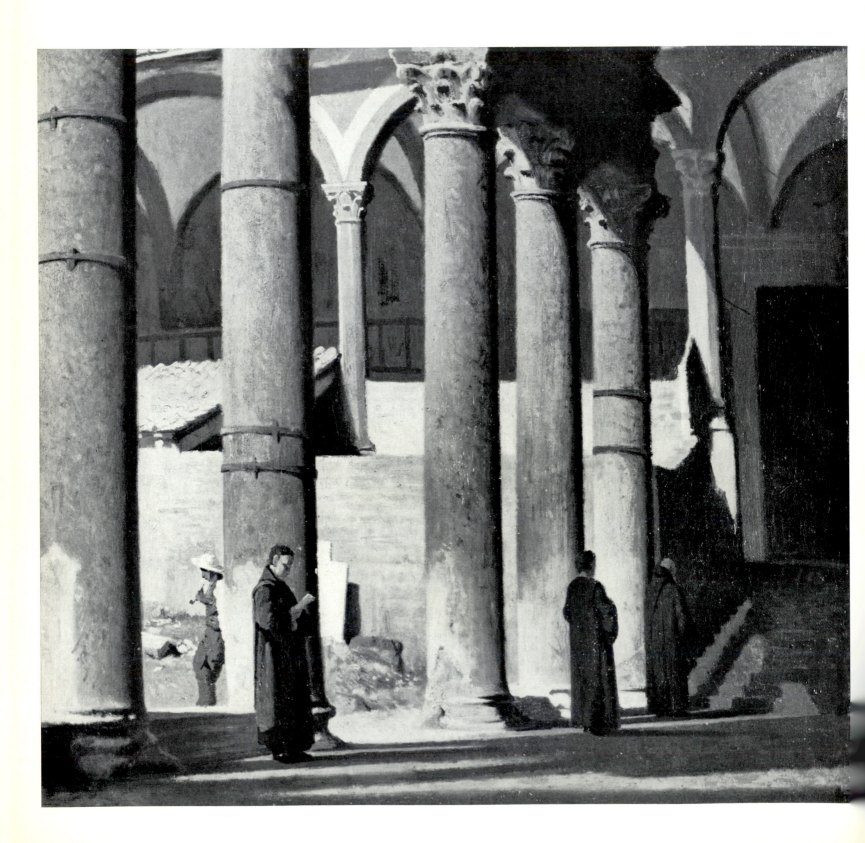

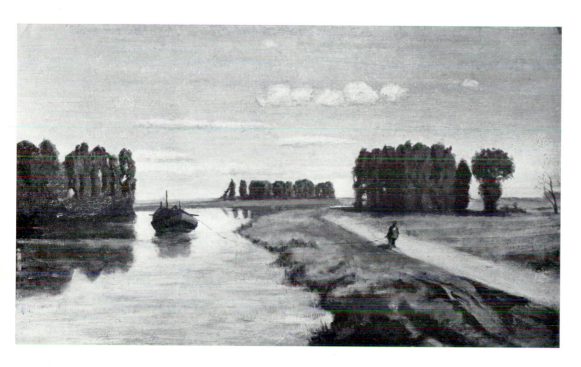

158. Giuseppe Abbati: *The Cloister of Santa Croce* (detail). c. 1862. Oil on canvas, entire painting 18½ x 28⅞ inches. Milan, Giacomo and Ida Jucker Collection.

The Macchiaiolo rebellion against academic methods had just begun in Florence when this painting was done. The representation of an everyday scene, with special attention to the immediacy of light, did not prevent Abbati from respecting the perspective rigor of the Florentine painters of the Quattrocento.

159. Serafino De Tivoli: *The Arno by the Cascine.* c. 1863. Oil on panel, 8⅝ x 14⅛ inches. Milan, Giacomo and Ida Jucker Collection.

The Arno flows through Florence past the park called Le Cascine and descends to the plain and its mouth just beyond Pisa.

160. Serafino De Tivoli: *The Old Fish Pond at Bougival.* c. 1864. Oil on canvas, 35¼ x 45⅝ inches. Leghorn, Alvaro Angiolini Collection.

De Tivoli had been in Paris for the Universal Exposition in 1855 and brought back to Florence news of what the Barbizon painters were accomplishing. This painting was done during his second visit to Paris, around 1864. We can see the influence of the impressionist painters who were just then beginning to create a stir with the work of Monet and Manet.

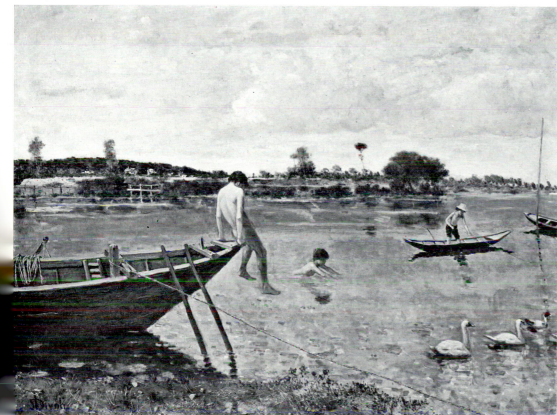

Serafino De Tivoli: *The Old Fish Pond at Bougival* (detail). c. 1864. Oil on canvas. Leghorn, Alvaro Angiolini Collection.
This detail reveals the impressionist influences more clearly, both in the fluid handling of light and in the more transparent use of color.

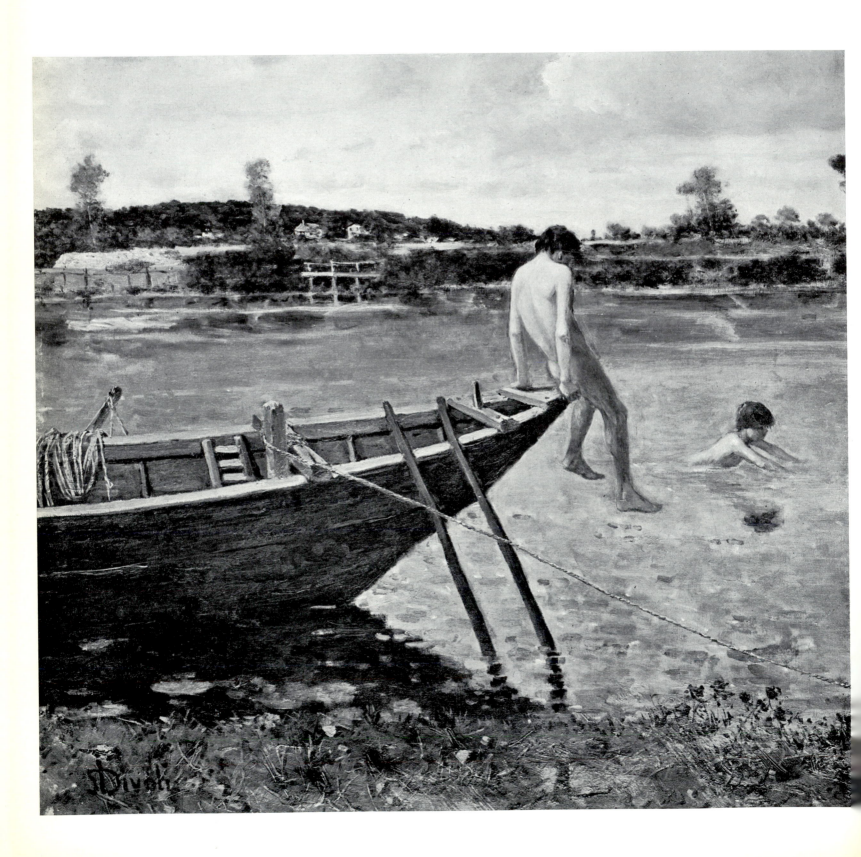

162. Raffaello Sernesi: *Lake Trasimeno.* c. 1865. Oil on canvas, 12¼ x 32¼ inches. Milan, Giacomo and Ida Jucker Collection.
Here Sernesi pauses by the blue waters of Lake Trasimeno, emphasizing the depth of the view by placing the large trees in the foreground.

163. Raffaello Sernesi: *Castiglioncello.* c. 1865. Oil on canvas, 5⅛ x 9⅜ inches. Piacenza, Ricci Oddi Gallery.
Castiglioncello, in the Maremma region, was a favorite haunt of the Macchiaioli, especially Fattori, because of the defined volumes to be found in the landscape, and the special clarity of the light by the coast.

164. Raffaello Sernesi: *Castiglioncello* (detail). c. 1865. Oil on canvas, Piacenza, Ricci Oddi Gallery.
Detail, the left side of the preceding painting.

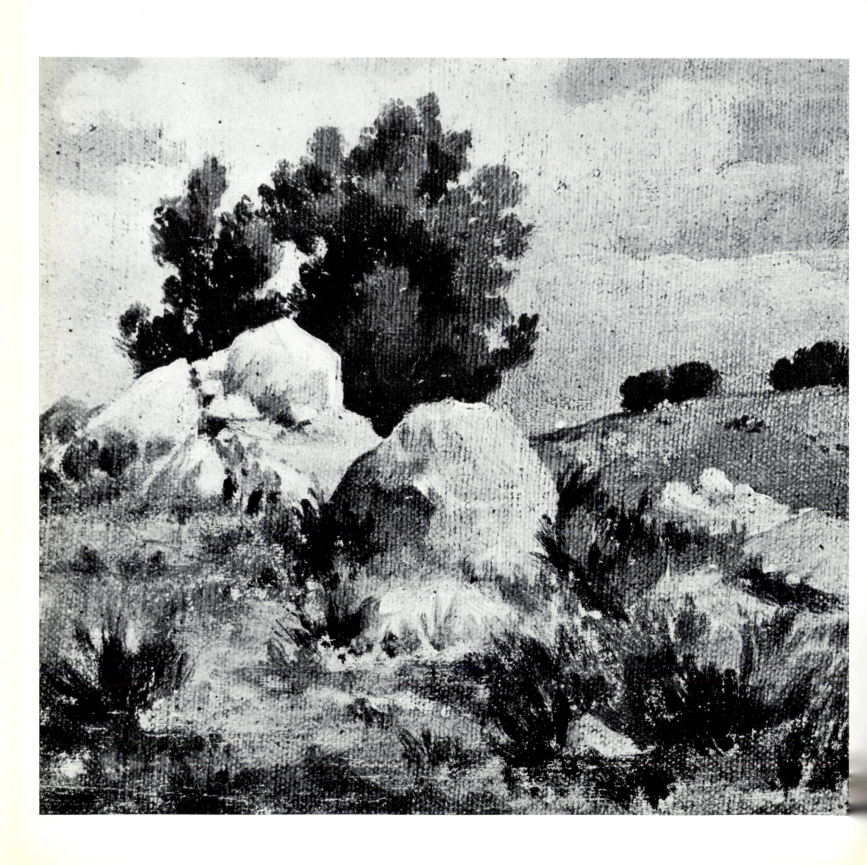

165. Raffaello Sernesi: *Hills around Florence*. 1865. Oil on panel, 5¾ x 7¼ inches. Florence, Gallery of Modern Art.
The small dimensions of this panel suggest it was painted on a cigar-box cover, as Fattori also used to do. On the left we can make out the cupola of the Duomo and Giotto's campanile.

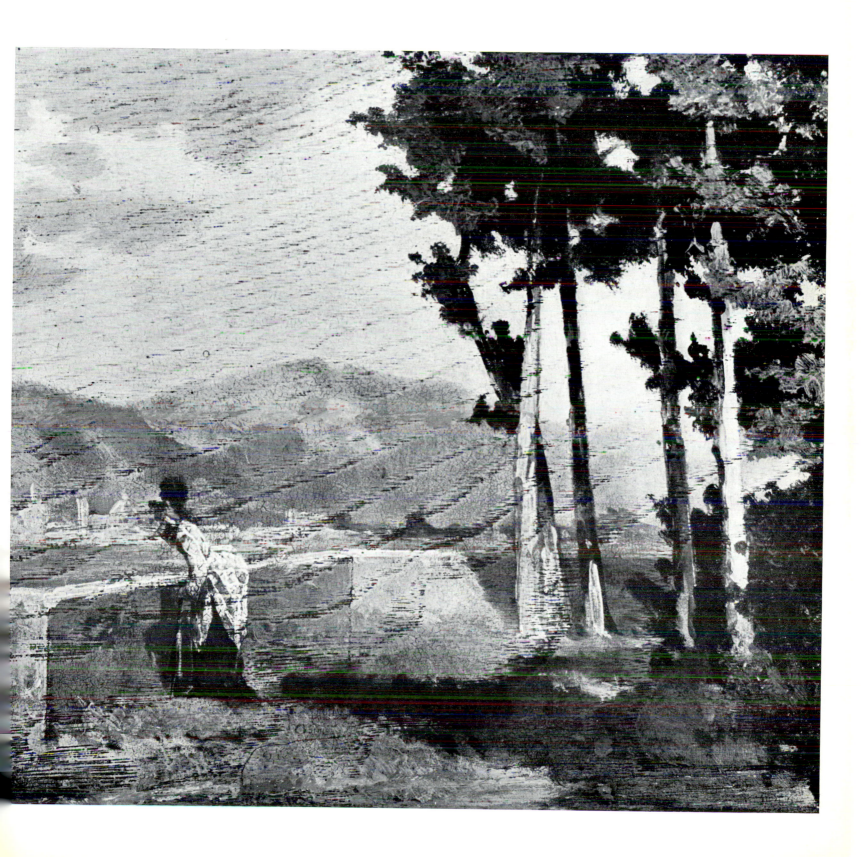

166. Odoardo Borrani: *Sand Diggers on the Mugnone* (detail). 1880. Oil on canvas, entire painting 55½ x 44⅛ inches. Florence, Gallery of Modern Art.
The sand diggers are making their way down to the riverbank with their sieves and shovels. The light reflected on the water creates unusual effects of transparency.

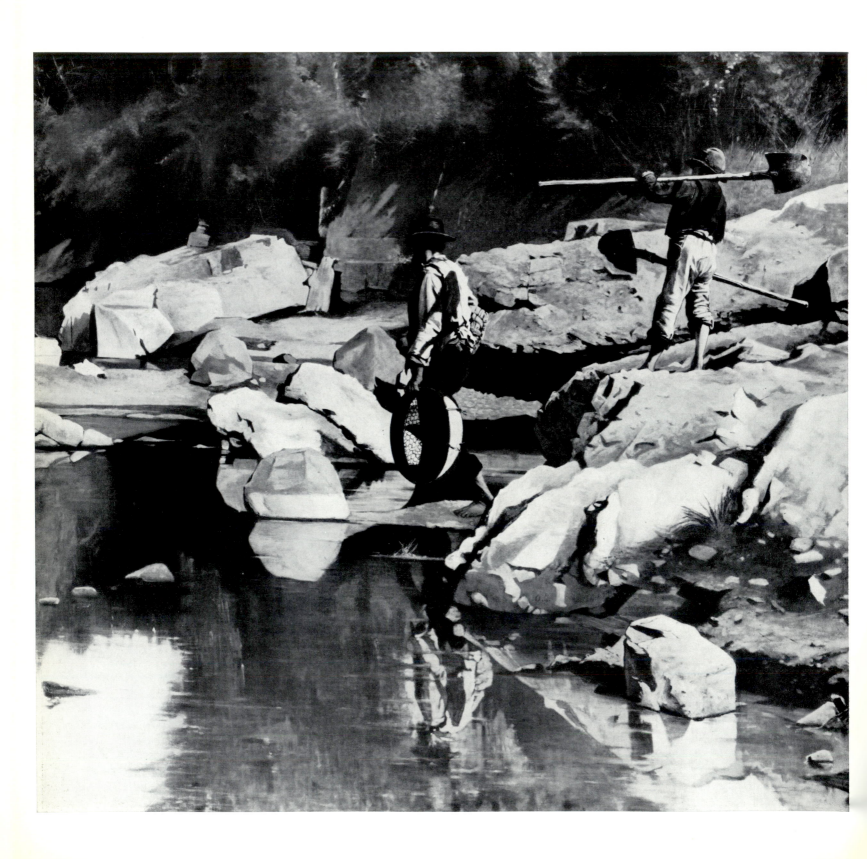

167. Silvestro Lega: *The Arbor* (detail). 1868. Oil on canvas. Milan, Brera Gallery.
Of the Macchiaioli, Lega continued the technique the longest, but when he finally started using newer techniques, he achieved such notable immediacy and luminosity that he frequently outdid his contemporaries.

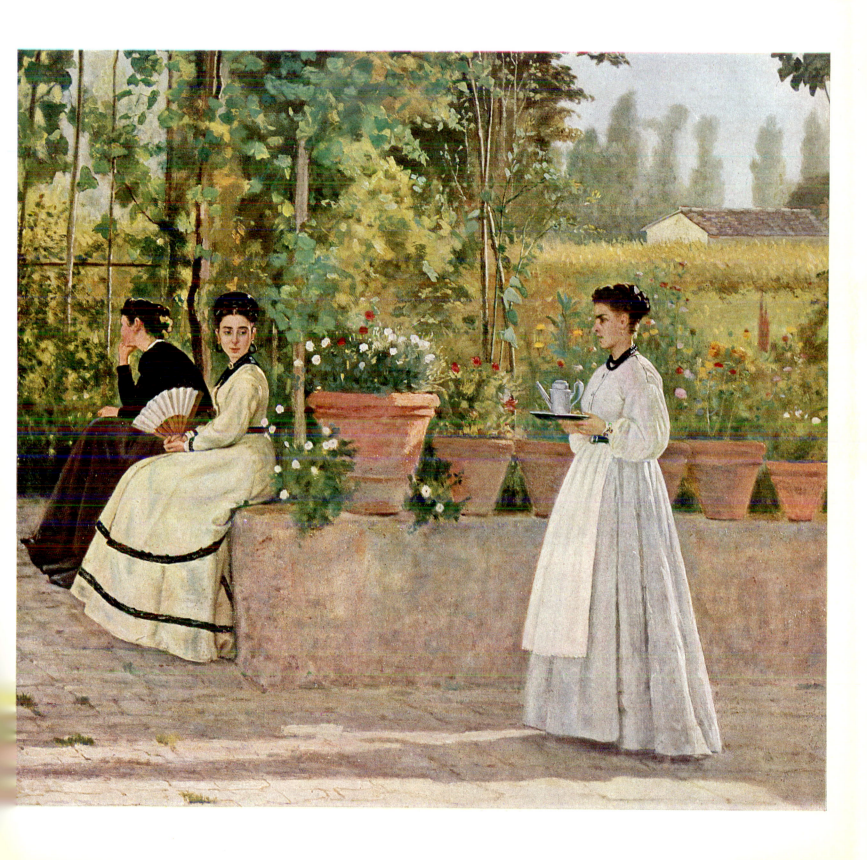

168. Silvestro Lega: *The Arbor*. 1868. Oil on canvas, 29⅛ x 36⅝ inches. Milan, Brera Gallery.

The realism of this moment in the afternoon becomes intimate and felt only because of the painter's perceptiveness in handling genre scenes.

169. Silvestro Lega: *Farmhouse and Haystacks*. c. 1885. Oil on panel, 7½ x 13¾ inches. Milan, Giacomo and Ida Jucker Collection.

After 1880 Lega's gentle, intimate handling of his subjects and the crystalline light of his Macchiaiolo paintings gave way to such vivid color that at times, in the harsh light he adopted, it seems violent. The mood of his paintings became more dramatic.

170, 171. Silvestro Lega: *The Visit to the Villa*. 1864 (sketch). Oil on panel, 5⅛ x 13 inches. Florence, Gallery of Modern Art.

In the late afternoon the women sit chatting quietly. Beyond lies the Tuscan countryside, with its felicitous, muted colors.

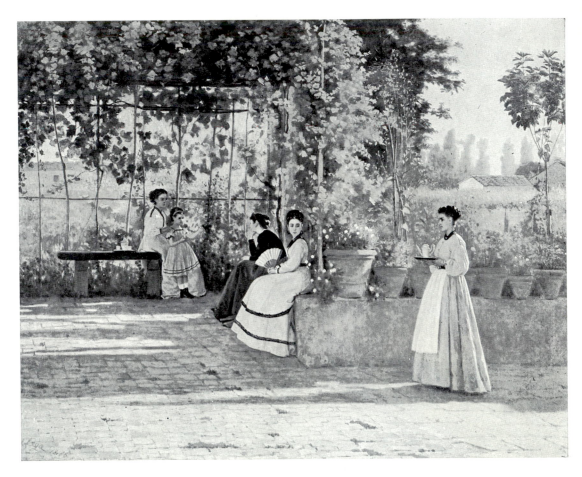

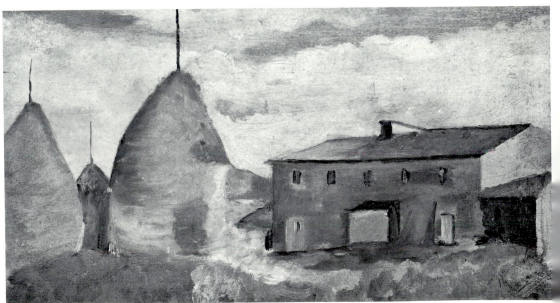

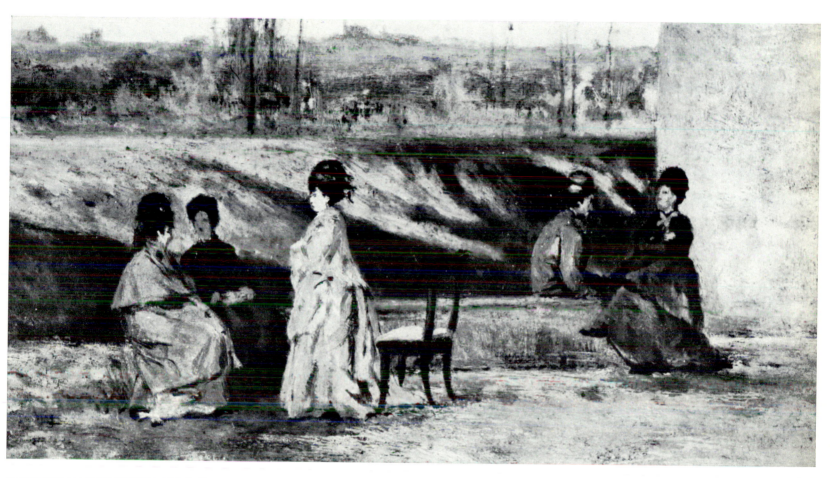

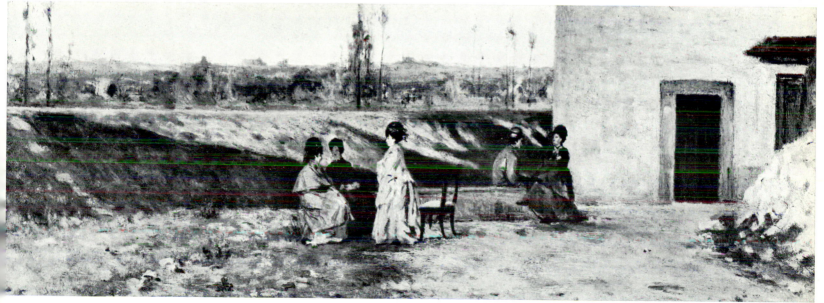

172. Silvestro Lega: *Farmhouse and Haystacks* (detail). c. 1885. Oil on panel. Milan, Giacomo and Ida Jucker Collection.
Detail of plate 169, the right side. After his Macchiaiolo period, Lega brought a more subjective, dramatic, modern vision of landscape to his painting, to the point where he seems to anticipate the Tuscan landscapes Rosai was to paint.

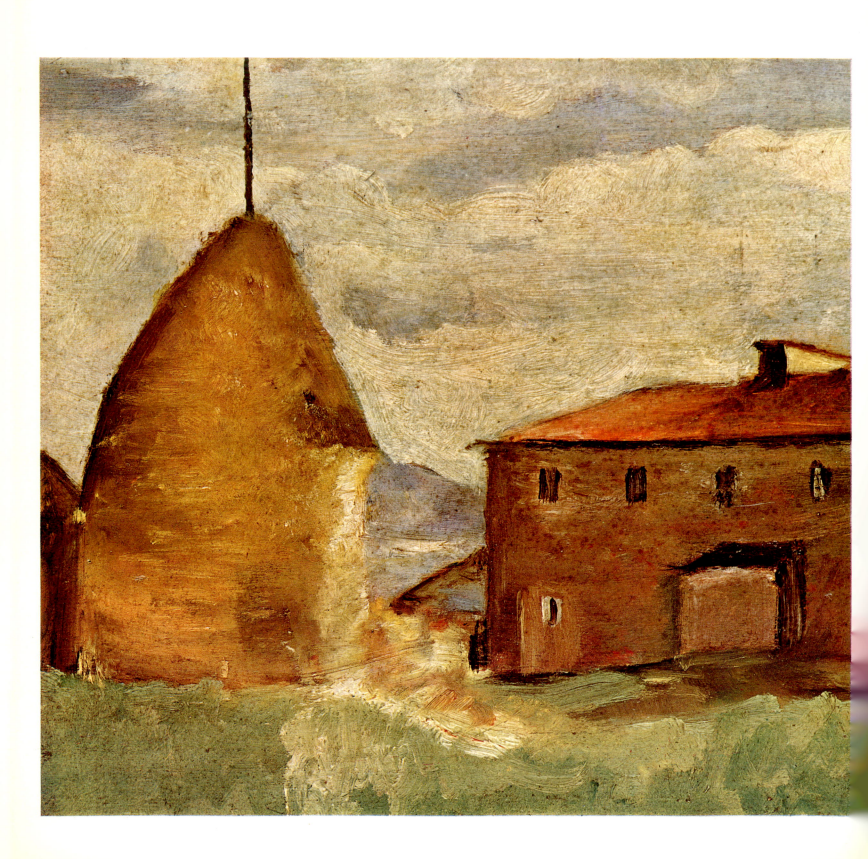

173. Telemaco Signorini: *Road to La Capponcina* (detail). 1875-1878. Oil on cardboard, entire painting $11\frac{3}{8}$ x $6\frac{1}{2}$ inches. Milan, Giacomo and Ida Jucker Collection.

Macchiaiolo *painting, of which Signorini was one of the prime exponents, began gradually to turn to a more fluid rendering of volumes after 1875.*

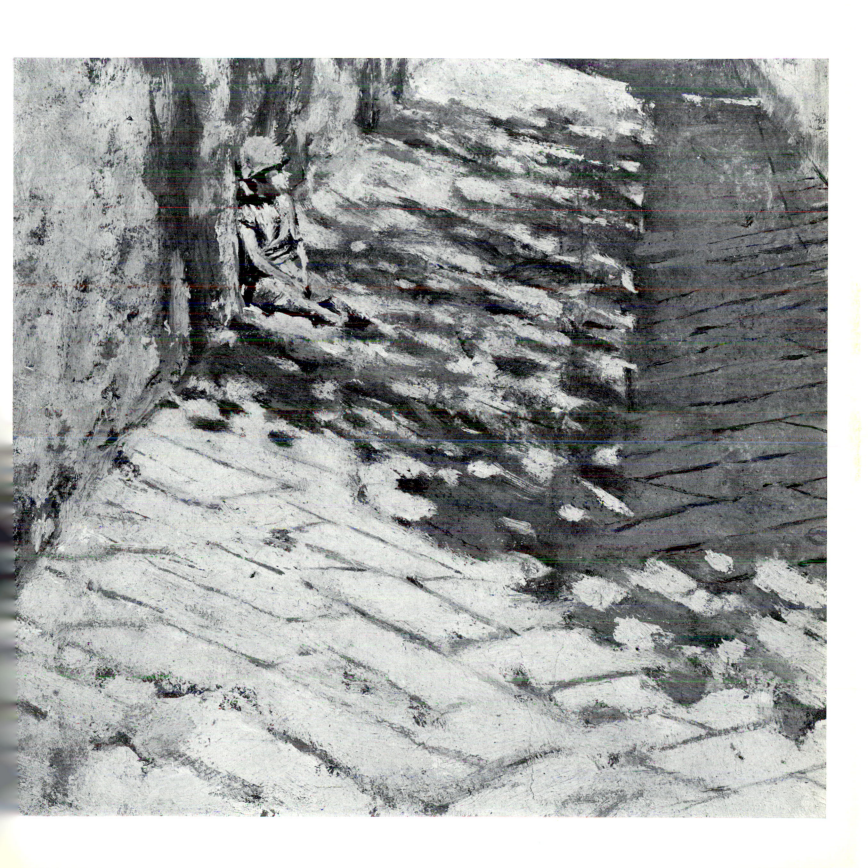

174. Telemaco Signorini: *The Square in Settignano*. c. 1880. Oil on canvas, 14⅛ x 19⅝ inches. Crema, Stramezzi Collection.

One of the basic principles of Macchiaiolo painting was verisimilitude. Here we can see the artist went so far as to letter the signs. Light and shadow are the major components of this still, hot mid-afternoon scene.

175. Telemaco Signorini: *Florence, Via Scialoja*. c. 1875. Oil on canvas, 9⅞ x 13¾ inches. Milan, Amedeo Cocchi Collection.

Light divides the composition into two areas, but the shadow is azure and delicate, the brushwork much more fluid.

176. Telemaco Signorini: *The Square in Settignano* (detail). c. 1880. Oil on canvas. Crema, Stramezzi Collection.

Detail of plate 174, left side. The division between light and shadow is defined, but the brushwork is broken up, looser.

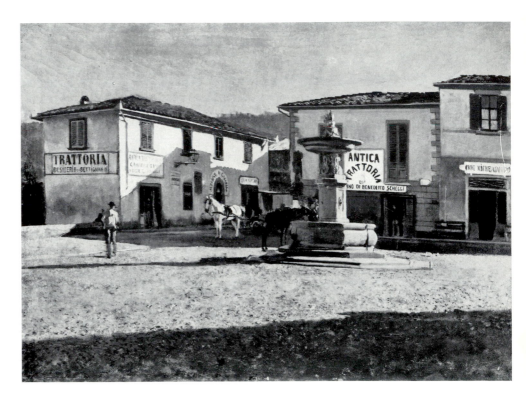

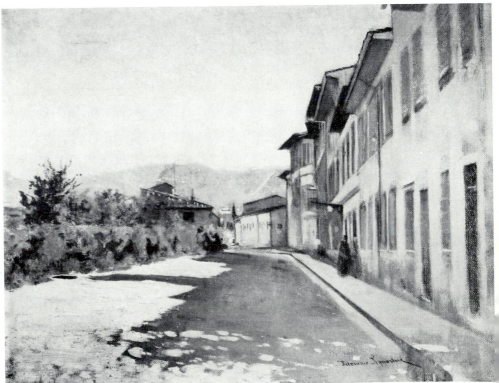

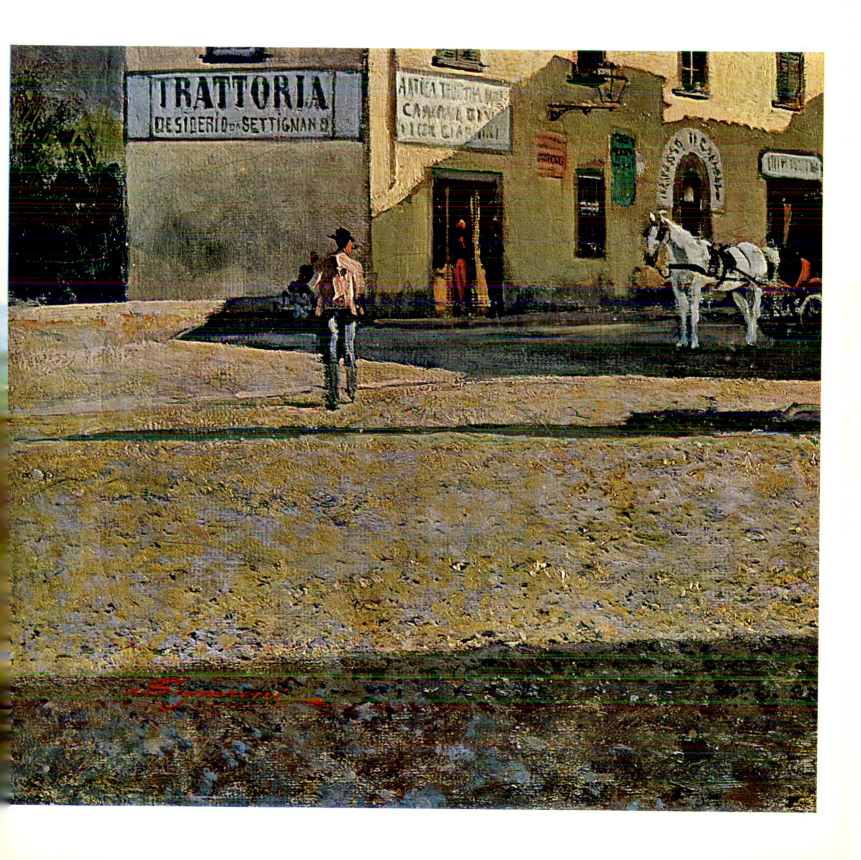

177. Telemaco Signorini: *A Street in Edinburgh*. c. 1881. Oil on canvas, 12¼ x 38¾ inches. Milan, Giacomo and Ida Jucker Collection.
After 1880 Signorini left Florence for Scotland, and we know of several views he did of Edinburgh. In these paintings, the artist accentuated the realistic touches; his Macchiaiolo period was definitely over.

178. Telemaco Signorini: *End of August*. c. 1880. Oil on canvas, 22⅞ x 25⅛ inches. Florence, Gallery of Modern Art.
This is probably a view of the Sienese landscape toward the south. The color relationships, which obviously have reference to the impressionists, are extremely felicitous. The sensitive modulations in the color extend the feeling of space in this landscape.

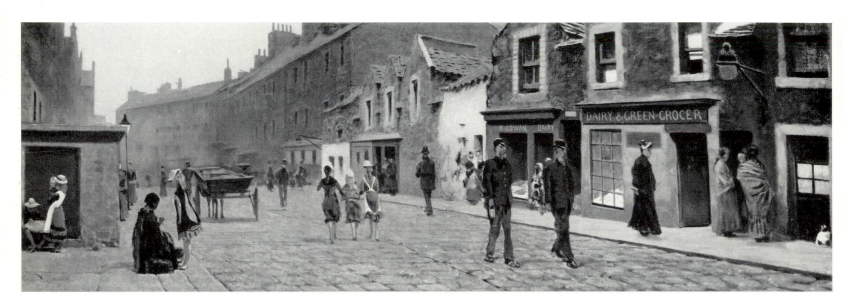

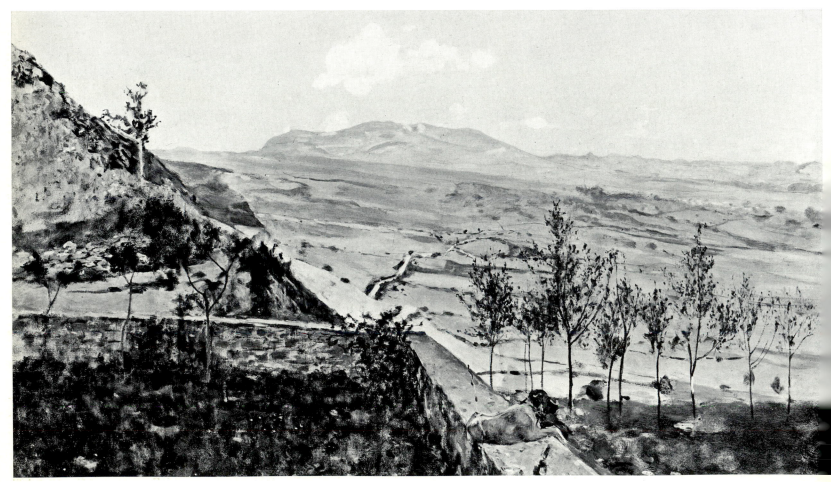

179. Giovanni Fattori: *Water Carriers of Leghorn*. 1865. Oil on canvas, 15 x 47 inches. Leghorn, Alvaro Angiolini Collection.
This is one of the masterpieces of Macchiaiolo *painting: the broad horizon, the solid plasticity of the two women, the gemlike color, the stupendous harmony between drawing and chromatic value rank this painting among the most compelling of the period.*

180. Giovanni Fattori: *Water Carriers of Leghorn* (detail). 1865. Oil on canvas. Leghorn, Alvaro Angiolini Collection.
Detail of plate 179, showing the two water carriers. Figures such as these, rendered in the typical Macchiaiolo *manner, were derived from the studies Fattori made from the paintings of Fra Filippo Lippi.*

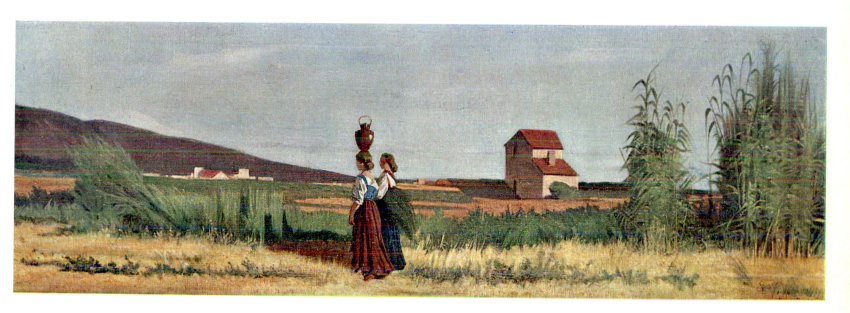

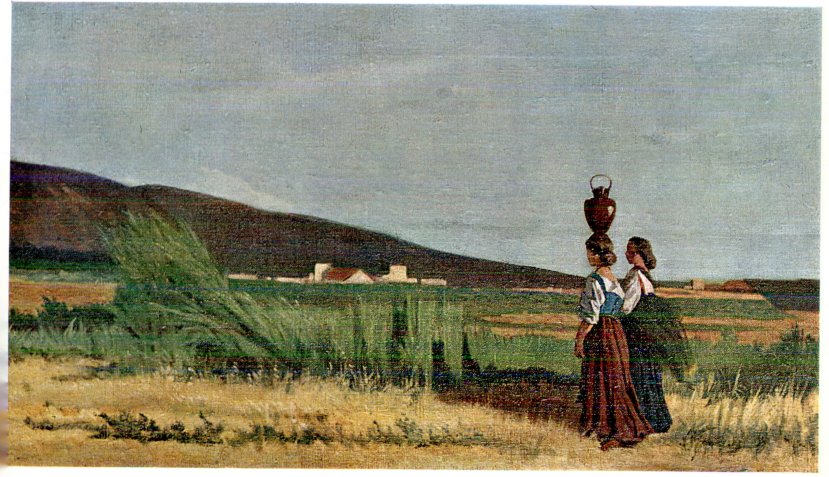

181. Giovanni Fattori: *Signora Martelli at Castiglioncello* (detail). 1865-1868. Oil on panel, entire painting 7⅞ x 13¾ inches. Leghorn, Civic Museum.

The woman we see here was the wife of Diego Martelli, an art critic and a patron of the Macchiaioli, who later went to Paris and became an astute critic of the impressionists. The figure in the shadows is put in relief by the play of light through the trees.

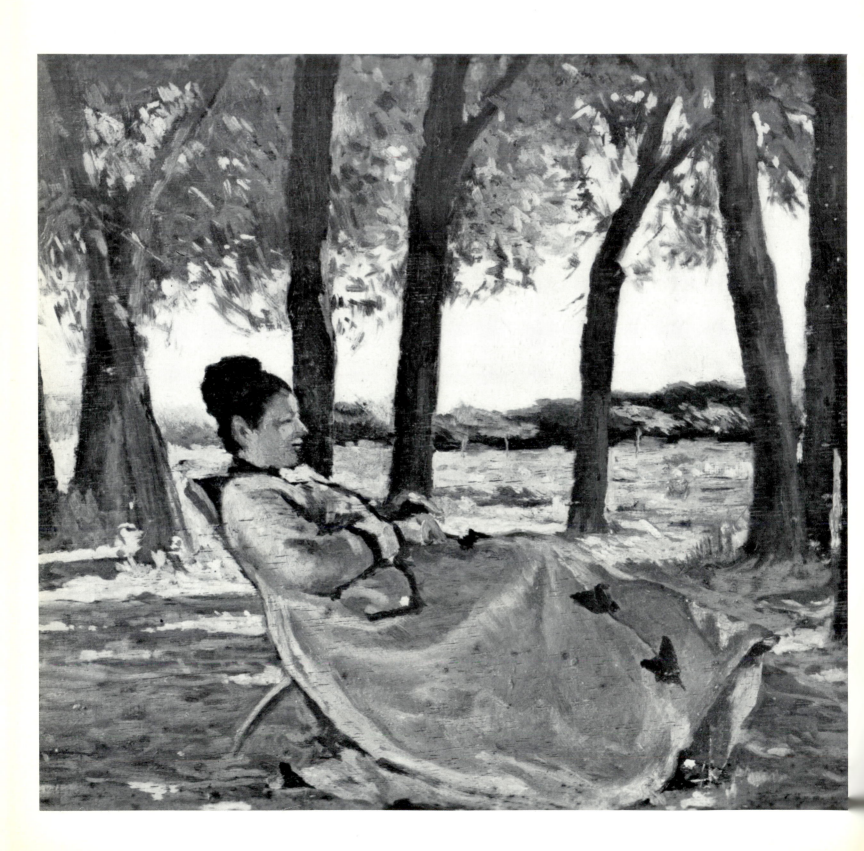

182. Giovanni Fattori: *Southwesterly Gale.* 1875. Oil on canvas, 10⅞ x 26 inches. Florence, Gallery of Modern Art.
The wind blows inland from the sea, almost uprooting the trees. This is an example of how Fattori interpreted nature dramatically in this period.

183. Giovanni Fattori: *Plain with Horses and Soldiers.* Oil on canvas, 8⅝ x 24 inches. Naples, Capodimonte Museum.
The painting achieves a certain intensity because of its unusual horizontal extension, a quadrangle of countryside. In a number of other paintings Fattori took advantage of a similar low, broad horizon to achieve an effect of infinite space.

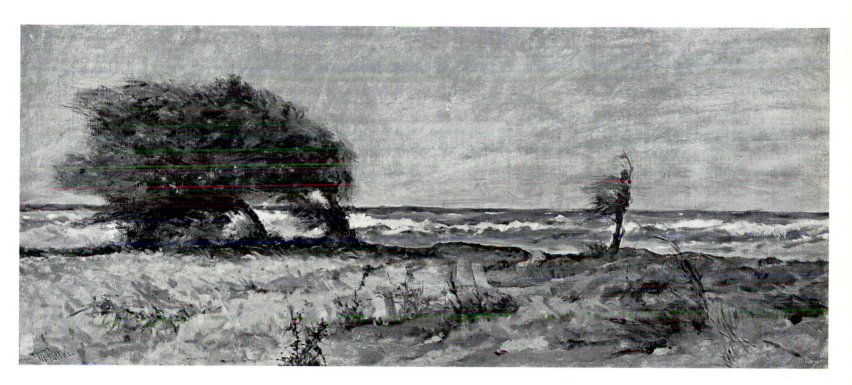

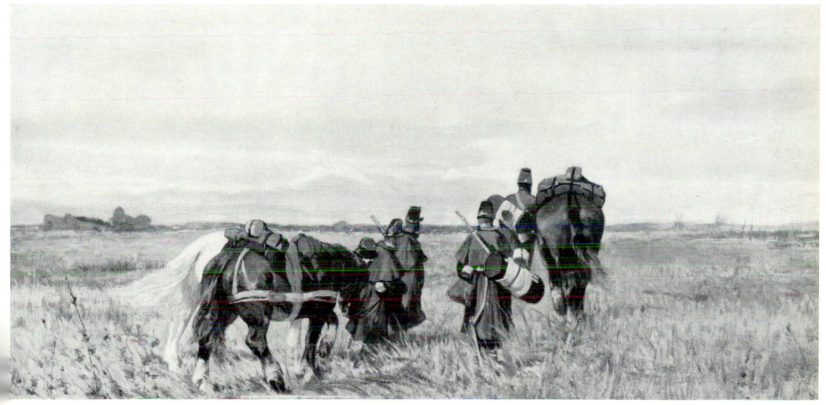

184. Giovanni Fattori: *Southwesterly Gale* (detail). 1875. Oil on canvas. Florence, Gallery of Modern Art.
This view was probably painted at Castiglioncello, where Fattori was fond of going, even after his friend Martelli, who had a house there, had gone to Paris.

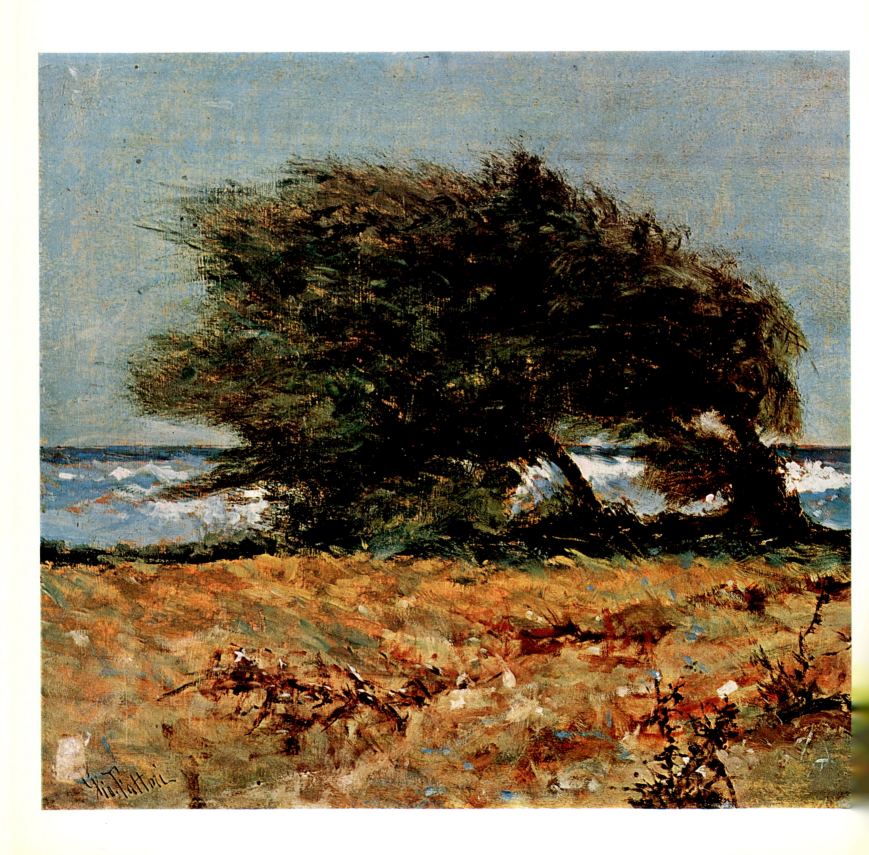

185. Giovanni Fattori: *Roman Countryside*. c. 1885. Oil on canvas, 32⅝ x 68⅛ inches. Leghorn, Civic Museum.
For Fattori also the Macchiaiolo style was outmoded by 1880. His works in this period aim at a dramatic realism embodying the human condition.

186. Giovanni Fattori: *Oxen Grazing*. c. 1890. Oil on canvas, 10⅝ x 20½ inches. Florence, Gallery of Modern Art.
Fattori directed his realism to dramatizing existence. What was once a serene and reflective nature in Macchiaioli paintings now becomes livid and sickly, with harsh silhouettes against a menacing sky.

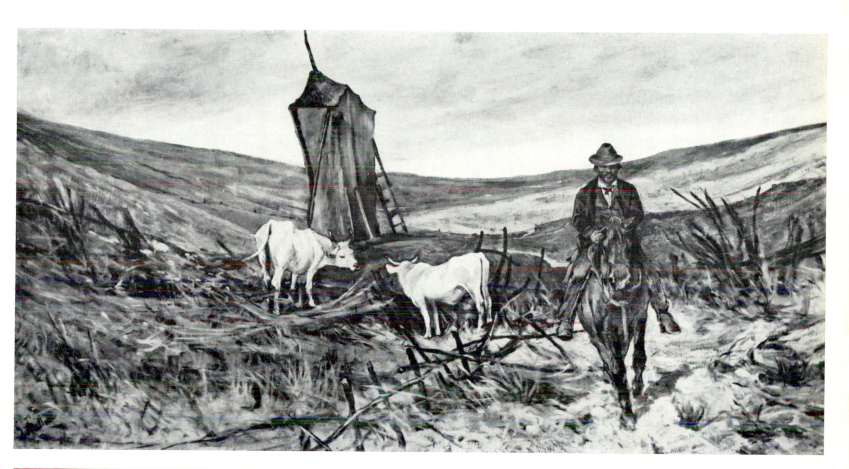

187, 188. Giovanni Fattori: *La Rotonda Palmieri*. 1866. Oil on panel, 5⅛ x 14⅛ inches. Florence, Gallery of Modern Art.
La Rotonda *was a sheltered observation point near a bathing establishment called Palmieri's. In this small panel we can see the definition of the Macchiaioli style that resolves the color-light problem in the close juxtaposition of forms. This painting is an exceptionally brilliant example and a masterpiece of Florentine impressionism.*

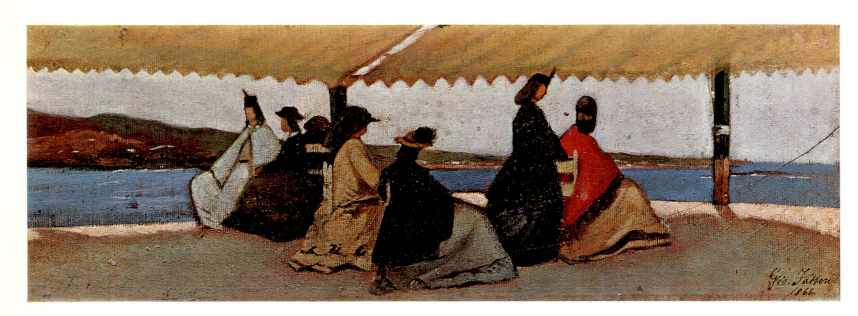

189. Massimo d'Azeglio: *An Italian Vendetta*. 1835. Oil on canvas, 68⅞ x 88⅝ inches. Milan, Gallery of Modern Art.
Death is here set against a stormy sky and shattered trees, a visual metaphor that is patently romantic.

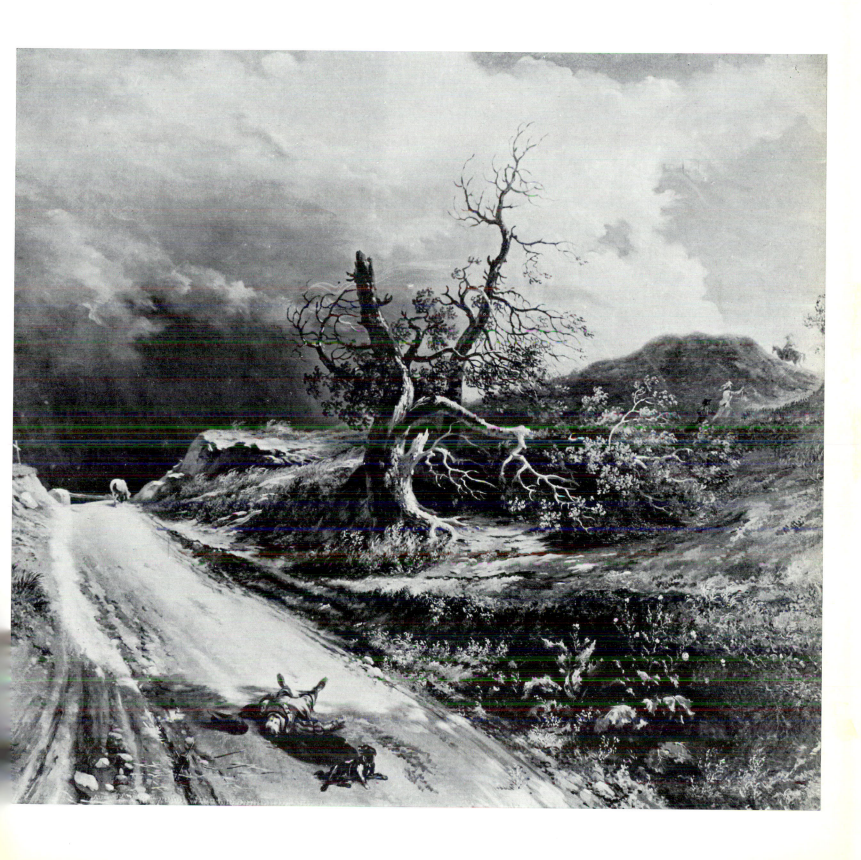

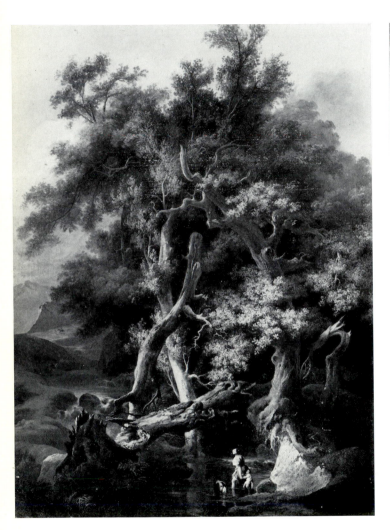
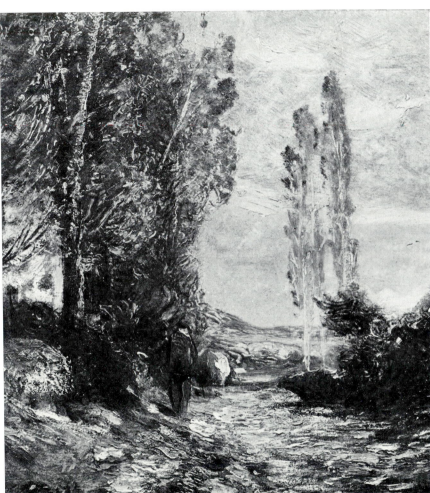

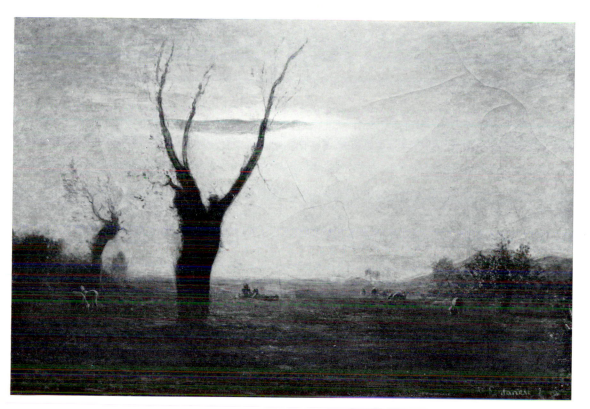

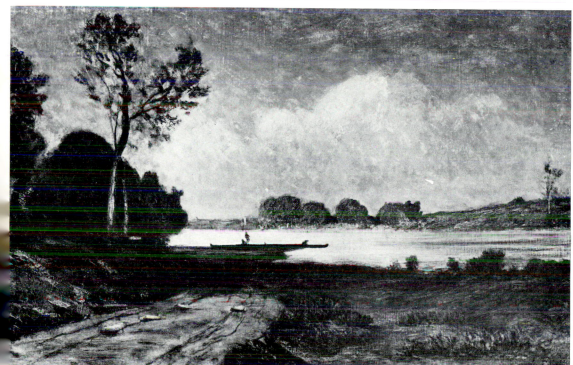

190. Cesare Della Chiesa di Benevello: *Forest*. 1840. Oil on canvas, 78 x 57½ inches. Turin, Gallery of Modern Art.

The composition with twisted and leafy trees was derived from Dutch and English landscapes, but the feeling behind it is clearly romantic.

191. Antonio Fontanesi: *The Poplars*. c. 1868-1870. Oil on cardboard, 12⅝ x 9⅝ inches. Piacenza, Ricci Oddi Gallery.

Fontanesi's loving study of Corot's works led him to treat nature in a somewhat melancholy vein. The free handling of color in this painting already anticipates the innovations of the impressionists.

192. Antonio Fontanesi: *April*. 1872. Oil on canvas, 66⅛ x 100 inches. Turin, Gallery of Modern Art.

This is one of the most famous of Fontanesi's paintings. The landscape is treated powerfully, simply, realistically, a direct parallel with the painter's own intense nature.

193. Antonio Fontanesi: *On the Banks of the Po near Turin*. Oil on canvas, 21⅝ x 33⅞ inches. Piacenza, Ricci Oddi Gallery.

This spacious landscape, the broad sky filling out the perspective suggested by the clump of trees on the left, permits the painter to present us with a solemn view of a river flowing slowly to the sea.

194. Enrico Reycend: *From the Hills around Turin*. 1906. Oil on canvas, 30¼ x 47¼ inches. Turin, Gallery of Modern Art.

On the left the cupola of the church of the Capucines; the city articulates by degrees across the plain. At the right we can make out the tower and the point of the Mole Antonelliana.

195. Enrico Reycend: *Square with Trees, Houses and Bell Tower*. 1885-1890. Oil on cardboard, 13 x 9⅝ inches. Turin, Gallery of Modern Art.

Autumnal bleakness among the barren trees. Reycend depicts a real scene, but treats it with a painterliness worthy of the impressionists.

196. Lorenzo Delleani: *Flowering Heath*. 1880. Oil on panel, 9 x 12⅝ inches. Turin, Gallery of Modern Art.

Fields, meadows and groves are the painter's favorite themes since they enable him to exercise his full range as colorist.

197. Giuseppe Pellizza da Volpedo: *The Clump of Briars* (detail). Oil on canvas, entire painting 28¾ x 36¼ inches. Piacenza, Ricci Oddi Gallery.

The countryside around Voghera provided a number of scenes for the painter's brush. He concentrated mostly on the thick vegetation, as if with that dense mass he could express a pervading melancholy.

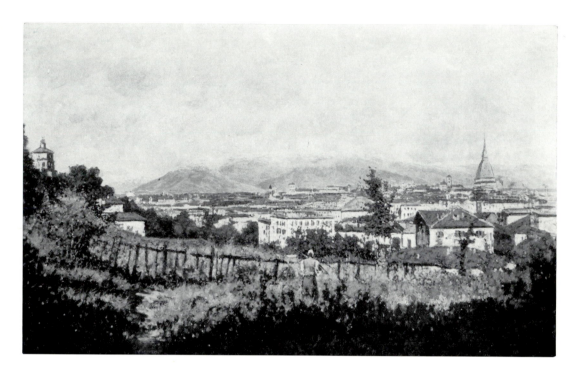

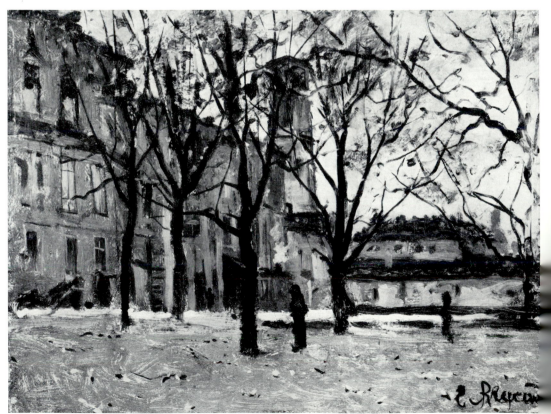

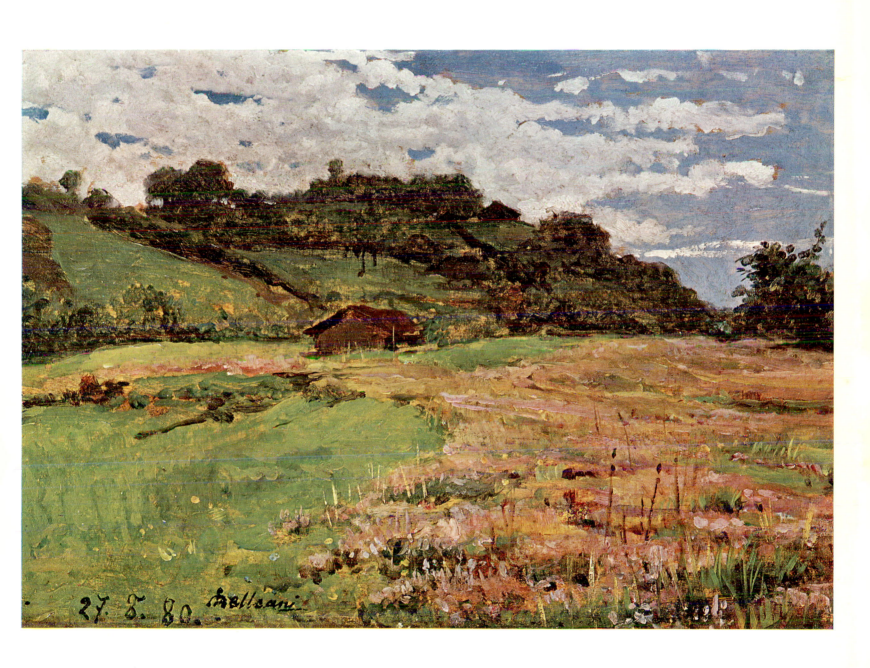

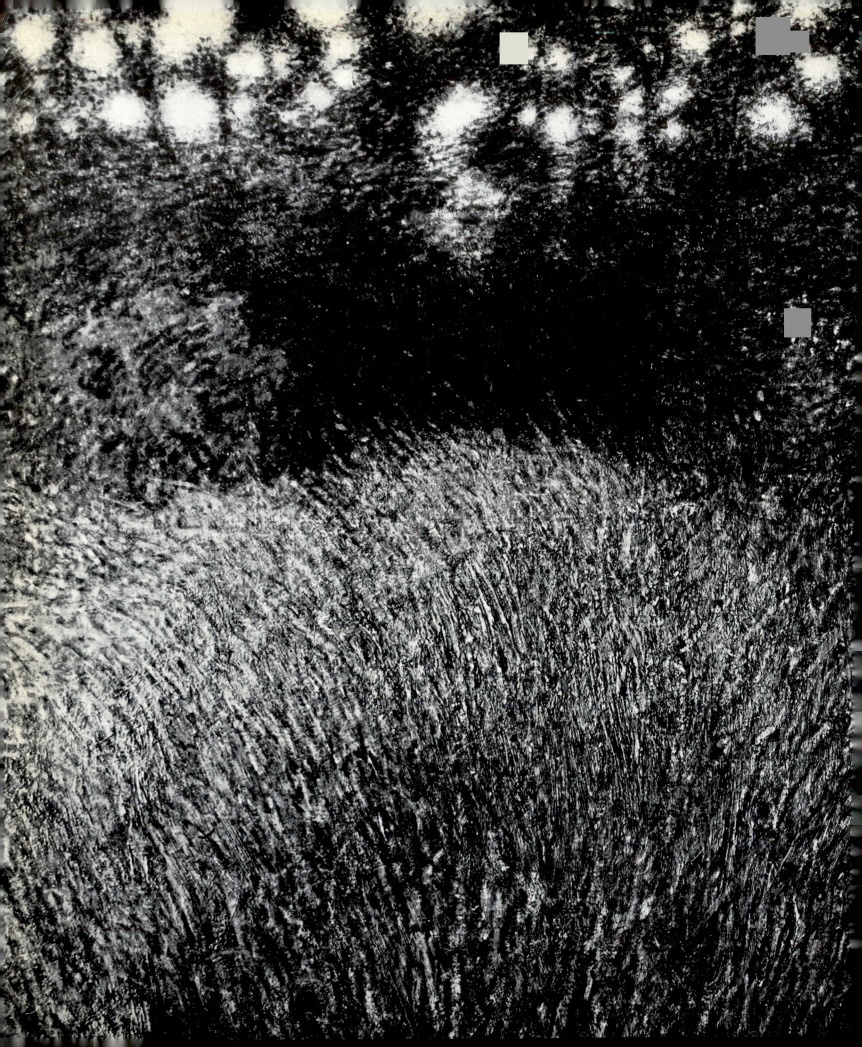

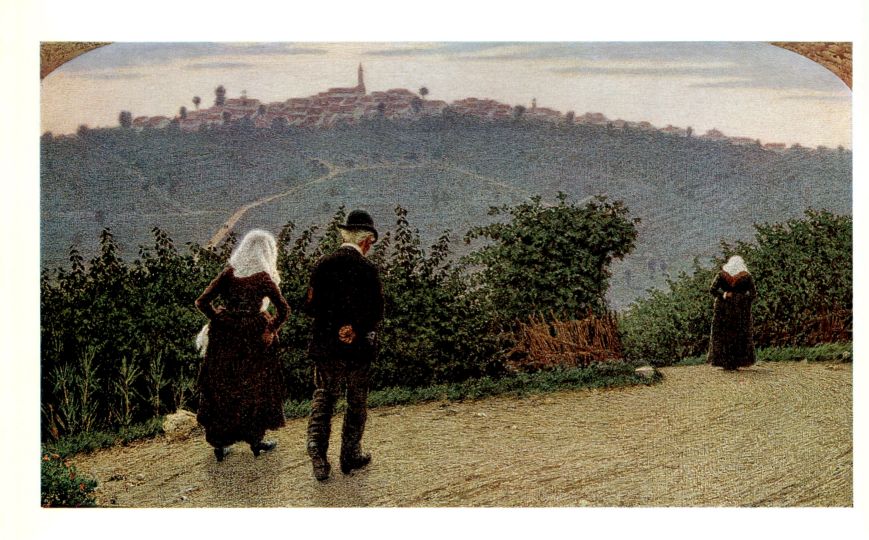

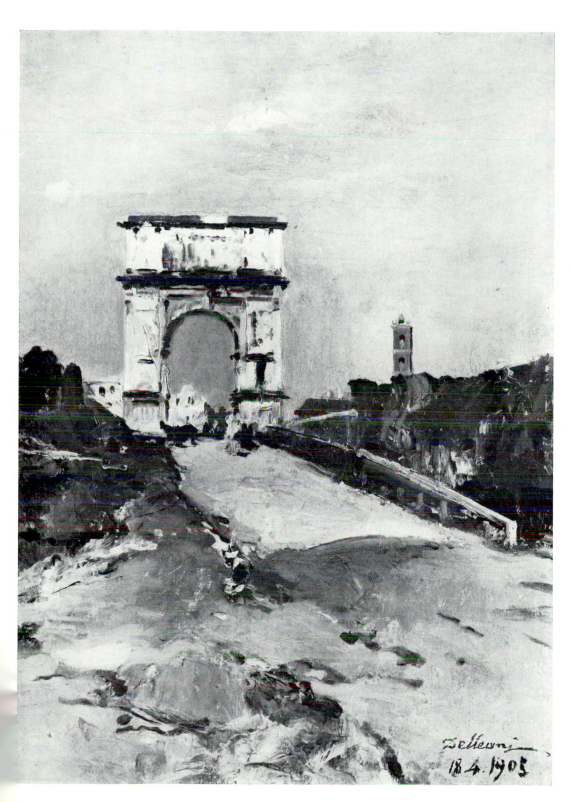

198. Angelo Morbelli: *Sunday Dawn*. 1915. Oil on canvas, 30¾ x 52 inches. Piacenza, Ricci Oddi Gallery.

This is a landscape of the Po Valley beyond Pavia. The artist uses a pointillist technique to render the luminosity of dawn. The azure-violet tone is the result of a quite subtle painterly intuition.

199. Lorenzo Delleani: *Arch of Titus, Rome*. 1905. Oil on panel, 17½ x 12⅝ inches. Piacenza, Ricci Oddi Gallery.

The scene seems to have been taken in at a glance and rendered in thick, rapid brushstrokes. Delleani is less preoccupied with detail in this painting than he usually is, in order to achieve the marvelous play of rich color.

200. Giuseppe Pellizza da Volpedo: *The Mirror of Life*. 1895-1898. Oil on canvas, 35⅜ x 78¾ inches. Turin, Gallery of Modern Art.
The horizontal morning light emphasizes the spaciousness of the composition. Despite the compelling beauty of this late autumn scene, the title indicates the pessimism the artist had begun to feel.

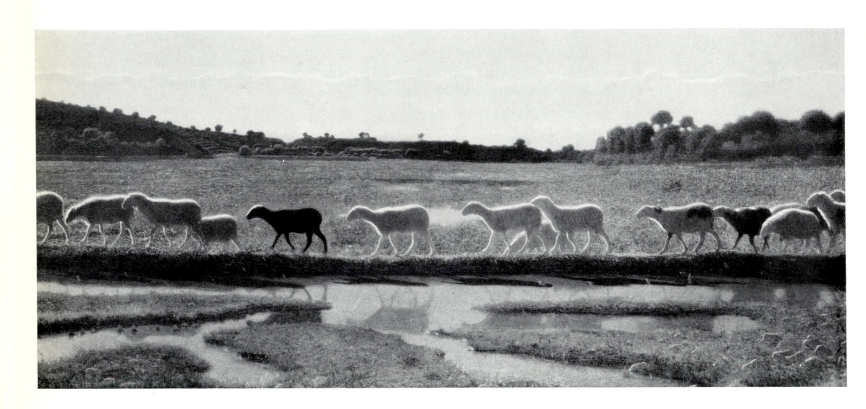

201. Giuseppe Pellizza da Volpedo: *Clothes in the Sun*. 1905. Oil on canvas, 33⅛ x 50¾ inches. Milan, Sacerdoti Gallery.

The painting is unfinished, but even in its present state it is very expressive, with its pure complementary colors applied in the divisionist manner, more imaginary than natural, achieving a modernity that can be compared with the work of the Fauves.

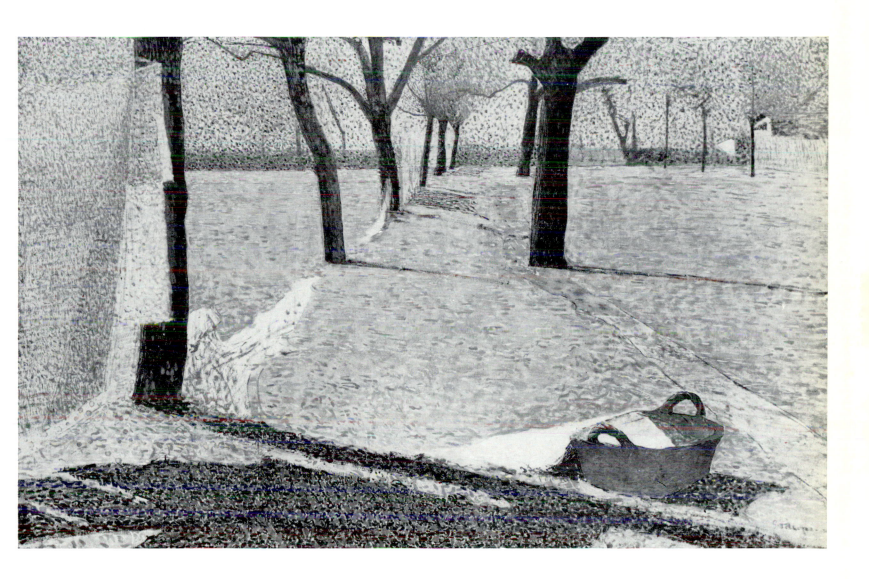

202. Carlo Fornara: *Alpine Church*. 1910. Oil on panel, 15½ x 19½ inches. Milan, Giacomo and Ida Jucker Collection.

Fornara used a variation of pointillism to capture the immediacy of the natural world, its light and the splendor of its colors. He painted all his landscapes in Val Vigezzo, the area in northern Italy where he was born.

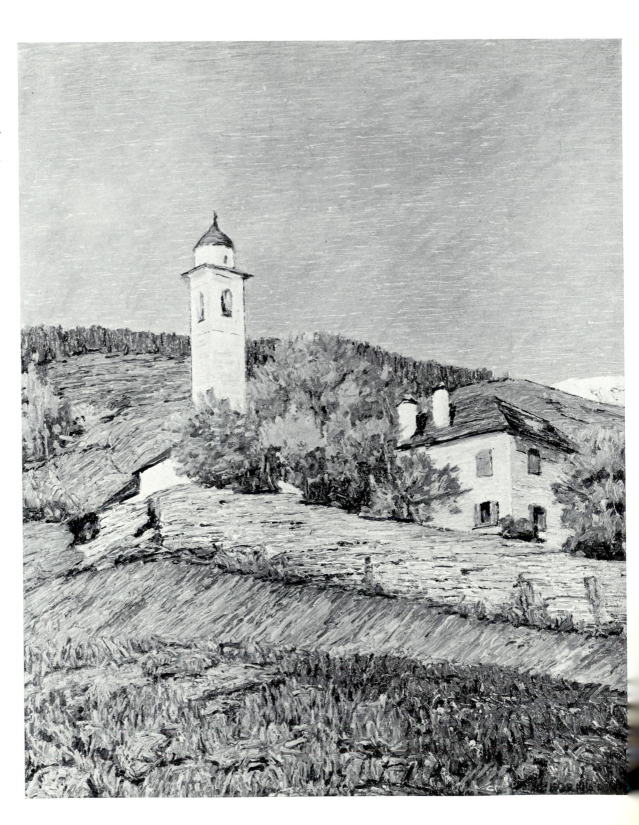

AUSTRIA GERMANY

At first it continued uphill through shrubbery and deciduous trees, then it leveled out. He had emerged from the thicket, and only majestic maples now stood around him on a dark greensward, looking almost as if they had been planted in a deliberate order and pattern. It was obvious that there had once been a good driveway here, but it was all long neglected and choked with stunted shrubs. Victor walked on across this strange park of maple trees. After passing through a further tract of bushes he came to a very curious place. It was like an orchard of small fruit trees, many of them shriveled and dead. But the grass under these trees had at its center the round stone parapet of a well, and scattered all over it among the tree trunks stood gray stone dwarfs with bagpipes, lyres, clarinets, and all sorts of musical instruments in their hands.

The mountains, the beautiful mountains which he had admired so much as he approached, were turning blacker and blacker and throwing sinister patches of shadow onto the lake, on which the pale gold of the evening light still lay and even glittered now and then in the dark reflections of the peaks. And everything around him grew stranger and stranger as night enfolded it. On the water the faint gold and the black dross stirred and often intermingled, which meant that a slight breeze must be blowing. Although Victor's eyes were accustomed only to the bright, beautiful impressions of day, he found himself staring in fascination at this gradual ebbing of color, this envelopment of everything in night and silence.

Across the water stood the Grisel, with all its rocky clefts sparkling and glittering, and although at night it had seemed to be the highest mountain there, still higher ones were now standing around it which he had not seen in the darkness: now they shone down at him soft and blue, and there were patches of snow on them in many places, diving like white swans into the clefts. Everything glistened and shimmered, tall trees stood in front of the house covered with such moisture as he had never seen before, the grass was dripping, huge shadows fell everywhere, and the whole spectacle was repeated once more in the lake, which lay there swept clean of every trace of mist, a pure mirror of water.

"The Recluse," 1845. ADALBERT STIFTER

I wandered on the whole day, and the slanting rays of the sun were shining through the trees when at last I came out into a little grassy valley set around by mountains and full of red and blue flowers; overhead scores of butterflies were fluttering to and fro in the glow of evening.
So solitary was it here that the world seemed to be hundreds of miles away. The crickets chirped, and lying in the long grass on the other side of the valley, a shepherd played a mournful air on his pipe, filling the heart with sadness.

I walked briskly onwards, for darkness was closing in. The birds, which had still been singing loudly as the last rays of evening sunshine gleamed through the wood, were suddenly quiet, and I almost began to feel frightened in the midst of the eerie rustling of the trees. Then I heard the sound of dogs barking in the distance. I quickened my pace. The forest grew lighter, and through the last few trees I saw an open space where a group of children were playing noisily around a tall linden tree. There was also an inn there, in front of which a party of peasants were sitting round a table, playing cards and smoking; near the door on the other side a number of young lads and girls, the latter with their arms wrapped in their aprons, sat chatting to each other in the cool of the evening.

The farther we went, the wilder and more desolate the country became, and when all of a sudden the moon shone out from behind the crags and trees, the scene presented a grim

and gruesome aspect. The narrow, rocky passes forced us to go slowly, and the monotonous rattle of the wheels echoed loudly against the stony slopes as though we were driving into a huge tomb. From invisible waterfalls in the depths of the forest came a continuous roar, and owls cried in the distance: 'Follow, follow!'

Memoirs of a Good-for-Nothing, 1826. JOSEPH VON EICHENDORFF

The town of *Göttingen*, celebrated for its sausages and University, belongs to the King of Hanover, and contains nine hundred and ninety-nine dwellings, divers churches, a lying-in-asylum, an observatory, a prison, a library, and a "council-cellar," where the beer is excellent. The stream which flows by the town is termed the *Leine*, and is used in summer for bathing, its waters being very cold, and in more than one place so broad, that Luder was obliged to take quite a run ere he could leap across. The town itself is beautiful, and pleases most when looked at — backwards. It must be very ancient for I well remember that five years ago, when I was there matriculated, (and shortly after "summoned,") it had already the same grey, old-fashioned, wise look, and was fully furnished with beggars, beadles, diss*art*ations, tea-parties with a little dancing, washer-women, compendiums, roasted pigeons, Guelphic orders, professors, ordinary and extraordinary, pipe-heads, court-counsellors, and law-counsellors. Many even assert that at the time of the great migration of races, every German tribe left a badly corrected proof of its existence in the town, in the person of one of its members, and that from these descended all the Vandals, Frisians, Suabians, Teutons, Saxons, where, separately distinguished by the color of their caps and pipe-tassels, they may be seen straying singly or in hordes along the Weender-street. They still fight their battles on the bloody arena of the *Rasenmill*, *Ritschenkrug* and *Bovden*, still preserve the mode of life peculiar to their savage ancestors, and are still governed partly by their *Duces*, whom they call "chief-cocks," and partly by their primevally ancient law-book, known as the "Comment," which fully deserves a place among the *legibus barbarorum*.

The hills here became steeper, the fir-woods waved below like a green sea, and white clouds above, sailed along over the blue sky. The wildness of the region was, however, tamed by its uniformity and the simplicity of its elements. Nature, like a true poet, abhors abrupt transitions. Clouds — however fantastically formed they may at times appear — still have a white, or at least, a subdued hue, harmoniously corresponding with the blue heaven and the green earth; so that all the colours of a landscape blend into each other like soft music, and every glance at such a natural picture, tranquillizes and re-assures the soul. The late Hoffman would have painted the clouds spotted and checquered. And like a great poet, Nature knows how to produce the greatest effects with the most limited means. There she has only a sun, trees and flowers, water and love. Of course, if the latter be lacking in the heart of the observer, the whole will, in all probability, present but a poor appearance, the sun will be so and so many miles in diameter, the trees are for fire-wood, the flowers are classified according to their stamens, and the water is wet.

I was soon welcomed by a grove of stately firs, for whom I, in every respect, entertain the most reverential regard. For these trees, of which I speak, have not found growing to be such an easy business, and during the days of their youth it fared hard with them. The mountain is here sprinkled with a great number of blocks of granite, and most of the trees are obliged either to twine their roots over the stones, or split them in two, that they may thus with trouble get at a little earth to nourish them. Here and there stones lie, on each other, forming as it were a gate, and over all grow the trees, their naked roots twining down over the wild portals, and first reaching the ground at its base, so that they appear to be growing in the air. And yet they have forced their way up to that startling height, and grown

into one with the rocks, they stand more securely than their easy comrades, who are rooted in the tame forest soil of the level country.

Most beautiful were the golden sun-rays shooting through the dark green of the firs. The roots of the trees formed a natural stairway, and everywhere my feet encountered swelling beds of moss, for the stones are here covered foot-deep, as if with light-green velvet cushions. Everywhere a pleasant freshness and the dreamy murmur of streams. Here and there we see water rippling silver-clear amid the rocks, washing the bare roots and fibres of trees. Bend down to the current and listen, and you may hear at the same time the mysterious history of the growth of the plants, and the quiet pulsations of the heart of the mountain. In many places, the water jets strongly up, amid rocks and roots, forming little cascades. It is pleasant to sit in such places. All murmurs and rustles so sweetly and strangely, the birds carol broken strains of love-longing, the trees whisper like a thousand girls, odd flowers peep up like a thousand maidens' eyes, stretching out to us their curious, broad, droll-pointed leaves, the sunrays flash here and there in sport, the soft-souled herds are telling their green legends, all seems enchanted, and becomes more secret and confidential....

The lower we descended, the more delightfully did subterranean waters ripple around us; only here and there they peeped out amid rocks and bushes, appearing to be reconnoitring if they might yet come to light, until at last one little spring jumped forth boldly. Then followed the usual show — the bravest one makes a beginning, and then the great multitude of hesitaters, suddenly inspired with courage, rush forth to join the first. A multitude of springs now leaped in haste from their ambush, united with the leader, and finally formed quite an important brook, which with its innumerable water-falls and beautiful windings ripples adown the valley. This is now the Ilse — the sweet, pleasant Ilse. She flows through the blest Ilse-vale, on whose sides the mountains gradually rise higher and higher, being clad even to their base with beech-trees, oaks, and the usual shrubs, the firs and other needle-covered evergreens having disappeared. For that variety of trees prevails upon the "Lower Harz," as the east side of the Brocken is called in contradistinction to the west side or Upper Harz, being really much higher and better adapted to the growth of evergreens.

No pen can describe the merriment, simplicity and gentleness with which the Ilse leaps or glides amid the wildly piled rocks which rise in her path, so that the water strangely whizzes or foams in one place amid rifted rocks, and in another wells through a thousand crannies, as if from a giant watering-pot, and then in collected stream trips away over the pebbles like a merry maiden. Yes, — the old legend is true, the Ilse is a princess, who laughing in beauty, runs adown the mountain. How her white foam-garment gleams in the sun-shine! How her silvered scarf flutters in the breeze! How her diamonds flash! The high beech-tree gazes down on her like a grave father secretly smiling at the capricious self-will of a darling child, the white birch-trees nod their heads around like delighted aunts, the proud oak looks on like a not over-pleased uncle, as though he must pay for all the fine weather; the birds in the air sing their share in their joy, the flowers on the bank whisper, "Oh, take us with thee! take us with thee! dear sister!' 'but the wild maiden may not be withheld, and she leaps onward, and suddenly seizes the dreaming poet, and there streams over me a flower-rain of ringing gleams and flashing tones....

Pictures of Travel, 1824-31.

HEINRICH HEINE

The number and extent of forests indicate a civilization yet recent: the ancient soil of the South is almost unfurnished of its trees, and the sun darts its perpendicular rays on the earth which has been laid bare by man. Germany still affords some traces of uninhabited nature. From the Alps to the sea, between the Rhine and the Danube, you behold a land covered with oaks and firs, intersected by rivers of an imposing beauty, and by mountains

of a most picturesque aspect; but vast heaths and sands, roads often neglected, a severe climate at first fill the mind with gloom; nor is it till after some time that it discovers what may attach us to such a country.

The south of Germany is highly cultivated; yet in the most delightful districts of this country there is always something of seriousness which calls the imagination rather to thoughts of labor than of pleasure, rather to the virtues of the inhabitants than to the charms of the nature.

The ruins of castles which are seen on the heights of the mountains, houses built of mud, narrow windows, the snow which during winter covers the plains as far as the eye can reach, make a painful impression on the mind. An indescribable silence in nature and in the people, at first oppresses the heart. It seems as if time moved more slowly there than elsewhere, as if vegetation made not a more rapid progress in the earth than ideas in the heads of men, and as if the regular furrows of the laborer were there traced upon a dull soil. Nevertheless, when we have overcome these first unreflecting sensations, the country and its inhabitants offer to the observation something at once interesting and poetical; we feel that gentle souls and tender imaginations have embellished these fields. The high-roads are planted with fruit-trees for the refreshment of the traveller. The landscapes which surround the Rhine are everywhere magnificent. This river may be called the tutelary genius of Germany; its waves are pure, rapid and majestic like the life of a hero of antiquity. The Danube is divided into many branches; the streams of the Elbe and Spree are disturbed too easily by the tempest; the Rhine alone is unchangeable. The countries through which it flows appear at once of a character so grave and so diversified, so fruitful and so solitary, that one would be tempted to believe that they owe their cultivation to the genius of the river, and that man is as nothing to them. Its tide, as it flows along, relates the high deeds of the days of old, and the shade of Arminius seems still to wonder on its precipitous banks. The monuments of Gothic antiquity only are remarkable in Germany; these monuments recall the ages of chivalry; in almost every town a public museum preserves the relics of those days. One would say that the inhabitants of the North, Conquerors of the world, when they quitted Germany left behind memorials of themselves under different forms, and that the whole land resembles the residence of some great people long since left vacant by its possessors. In most of the arsenal of German towns, we meet with figures of knights in painted wood, clad in their armor; the helmet, the buckler, the cuisses, the spurs, — all is according to ancient custom; and we walk along these standing dead, whose uplifted arms seem ready to strike their adversaries, who also hold their lances in rest. This motionless image of actions, formerly so lively, causes a painful impression. It is thus that, long after earthquakes, the bodies of men have been discovered still fixed in the same attitudes, in the action of the same thoughts that occupied them at the instant when they were swallowed up.

...the gardens are almost as beautiful in some parts of Germany as in England: the luxury of gardens always implies a love of the country. In England, simple mansions are often built in the middle of the most magnificent parks. The proprietor neglects his dwelling to attend to the ornaments of nature. This magnificence and simplicity united do not, it is true, exist in the same degree in Germany; yet in spite of the want of wealth and the pride of feudal dignity, there is everywhere to be remarked a certain love of the beautiful which, sooner or later, must be followed by taste and elegance, of which it is the only real source. Often, in the midst of the superb gardens of the German princes are placed Aeolian harps close by grottoes encircled with flowers that the wind may waft the sound and the perfume together. The imagination of the northern people thus endeavors to create for itself a sort of Italy; and, during the brilliant days of a short-lived summer, it sometimes attains the deception it seeks.

203. Rudolf von Alt: *Vienna, Cathedral of St. Stephen*. 1832. Oil on canvas, 18⅛ x 22⅝ inches. Vienna, Oesterreichische Galerie.
Around 1830, on the example set by Waldmüller, Austrian landscape painting became more concerned with nature. In this painting, however, we see that the taste for views in the manner of Bellotto, who had been at the court of Maria Theresa in 1759, was still dominant.

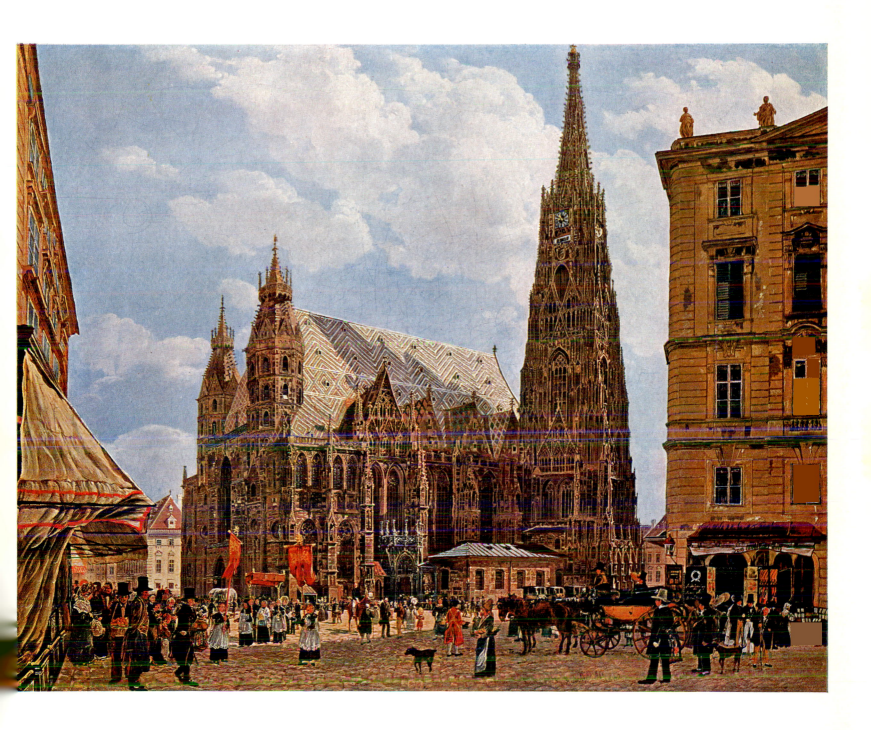

204. Matthias Rudolf Thoma: *Landscape and View of Vienna*. 1834. Oil on canvas, 13⅜ x 12⅝ inches. Vienna, Oesterreichische Galerie.

Although Austrian painting had turned to the natural world and left behind mythological and pastoral scenes in the first decades of the century, it was still taken with certain neoclassical modes, especially the minute and punctilious representation of the subject. This painting, however, reveals the beginning of a new attitude toward nature that will have important results.

205. Ludwig Ferdinand Schnorr von Carolsfeld: *Mont Blanc Seen from Chamonix*. Oil on canvas, 9⅜ x 16½ inches. Vienna, Oesterreichische Galerie.

This landscape is still somewhat conventional, with its glossy surface and careful details intended to display the artist's draftsmanship. But the white mass of the glacier touched by a rosy light indicates a fresher, more perceptive approach to nature.

206. Ferdinand Georg Waldmüller: *Landscape with Oak Tree*. 1849. Oil on canvas, 27½ x 36¼ inches. Vienna, Oesterreichische Galerie.

At the time of Metternich the first form of naturalism that emerged was called "Alt Wien," and its major exponent was Waldmüller. He brought to his painting his eighteenth-century training and a taste for Dutch landscape painting. A certain hyperbole in his style is reminiscent of baroque grandeur, but he was essentially sensitive to nature. His style opened the way to realism, and he encouraged the movement.

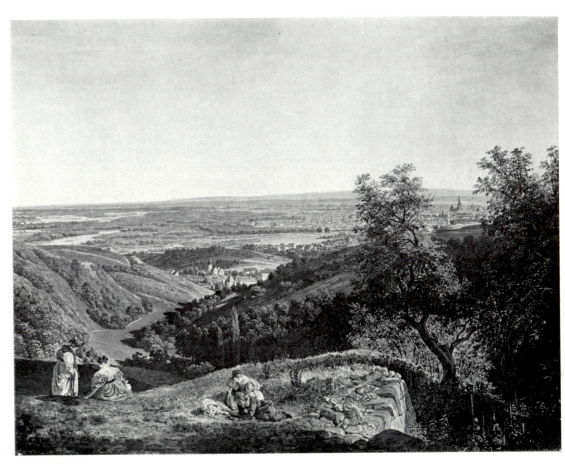

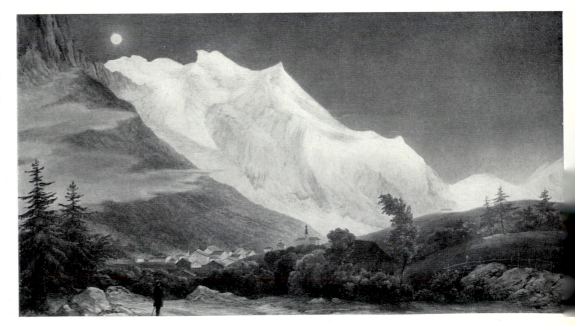

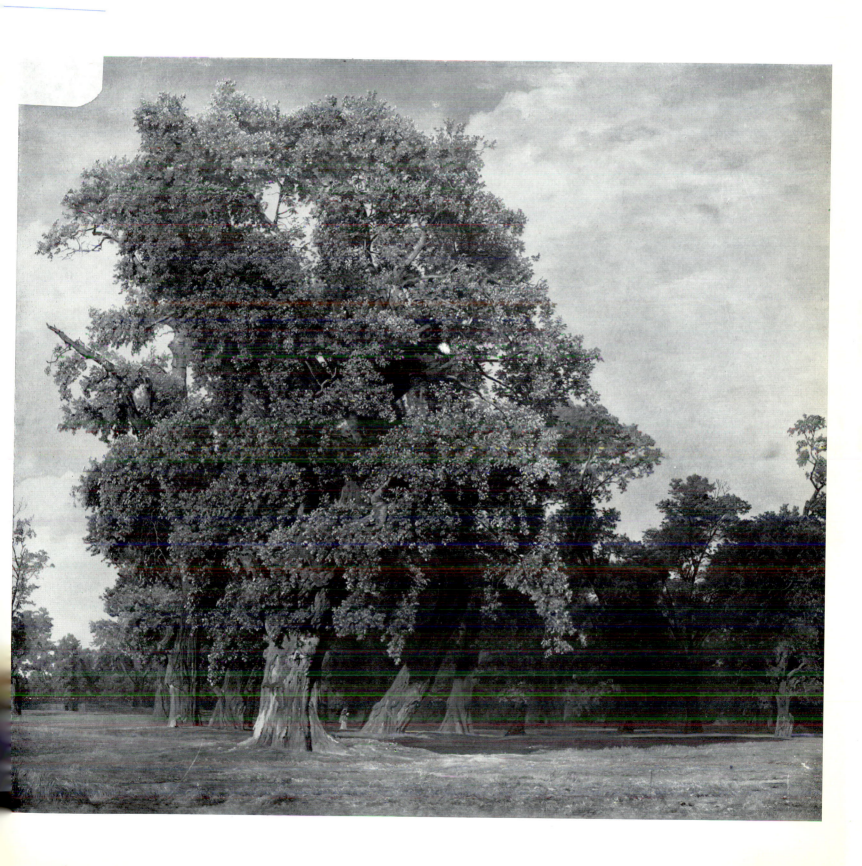

207. Joseph Anton Koch: *Apollo and the Thessalian Shepherds*. c. 1835. Oil on canvas, 30⅞ x 47 inches. Copenhagen, Thorvaldsens Museum.

Koch was able to realize his ideals after he went to Italy. His classicism is not derived from ancient Greece and Rome, but from the Florentine and Umbrian painters of the Quattrocento, ranging from Beato Angelico to Fra Filippo Lippi and Perugino. His surfaces are highly finished, his technique cold and intellectual, his subjects animated by a nostalgia for a lost world that he, like his peers the Nazarenes, was under the illusion of being able to recapture in painting.

208. Karl Schuch: *Trees at Purkersdorf*. 1872. Oil on canvas, 32⅝ x 39¾ inches. Vienna, Oesterreichische Galerie.

Schuch was noted for his virtuoso, monumental still lifes, but he also painted landscapes that were influenced by Leibl's group in Munich, and through them, by the French impressionists. Here we see light playing on the trees and on the openings, creating bright areas of color. The painter here shows more feeling toward nature.

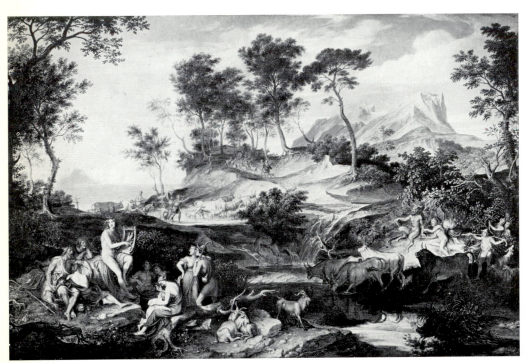

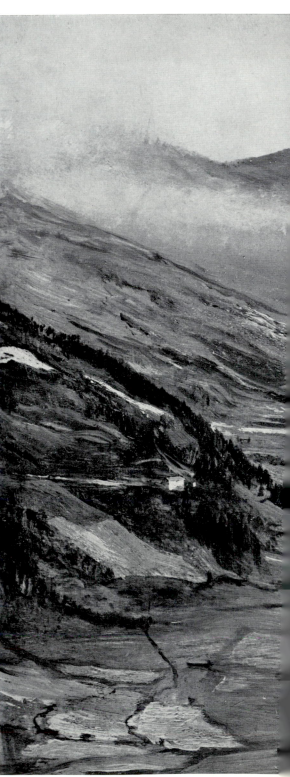

209. Anton Romako: *The Valley of Gastein*. Second version. 1877. Oil on canvas, 10¼ x 12⅜ inches. Vienna, Oesterreichische Galerie.
This vast mountain landscape can be considered as still belonging to the romantic period. The vision here, however, is more perceptive, the eye keener in picking out the pictorial values that show traces of impressionist fluidity. The artist did a number of paintings in this valley.

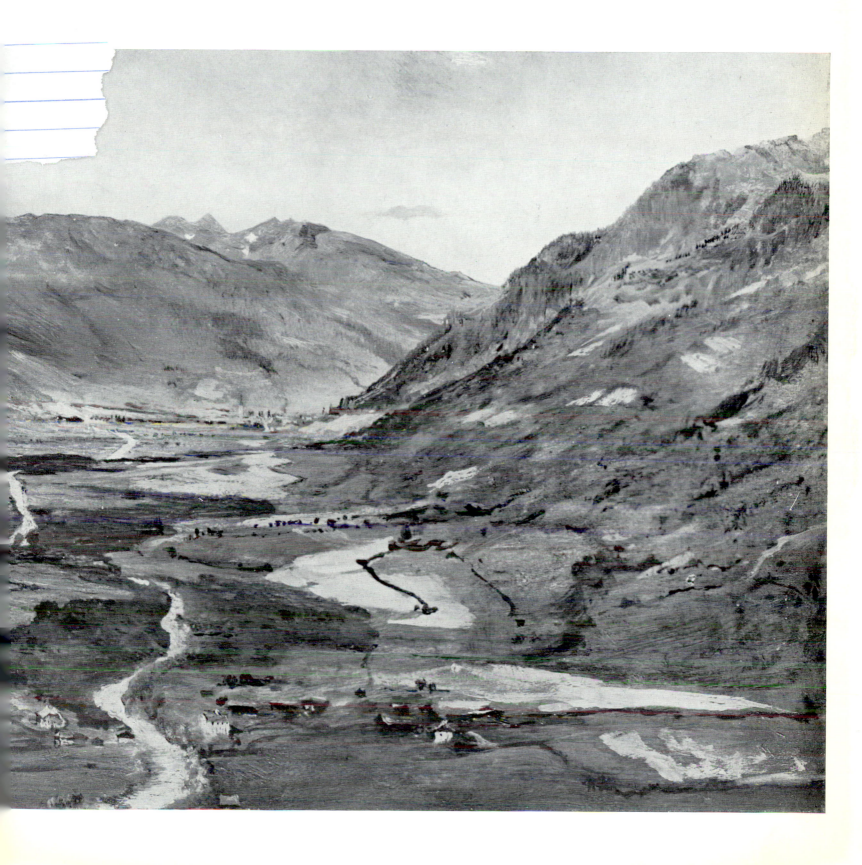

210. Theodor von Hörmann: *View of Prague*. 1890. Oil on canvas, $23\frac{5}{8}$ x $28\frac{3}{4}$ inches. Vienna, Oesterreichische Galerie.

French impressionism had spread throughout Europe and become the school of painting that best represented the artistic sensibility of the age-that is, of the second half of the nineteenth century. Von Hörmann reveals in this painting the unquestionable influence of Pissarro.

211. Carl Moll: *Marketplace in Vienna*. 1894. Oil on canvas, $33\frac{7}{8}$ x $46\frac{7}{8}$ inches. Vienna, Oesterreichische Galerie.

This painter also can be numbered among those influenced by the spread of impressionism. The intense play of light, the exact but not finicky realism and his sense of color above all, show to what extent Moll came close to Monet's style in his views of the Paris quays done around 1875.

212. Gustav Klimt: *Flowering Field*. c. 1905. Oil on canvas, $43\frac{1}{4}$ x $43\frac{1}{4}$ inches. Vienna, Oesterreichische Galerie.

Toward the end of the century, a movement arose in Europe in reaction against the pervading naturalism, which recalled art to imagination and to the autonomy of expressive means, a movement known variously as decadentism or symbolism. Klimt, who had realist beginnings, soon became one of the major exponents of European symbolism, an elegant, disquieting, subtly capable artist whose painting provided a basis for art nouveau *and a main source of Kandinsky's abstractionism.*

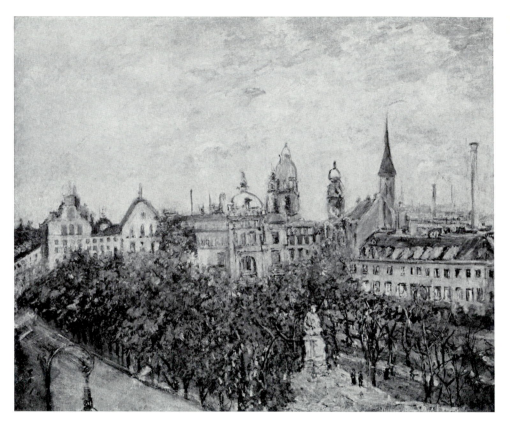

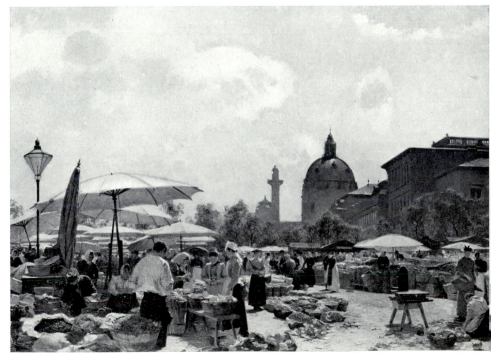

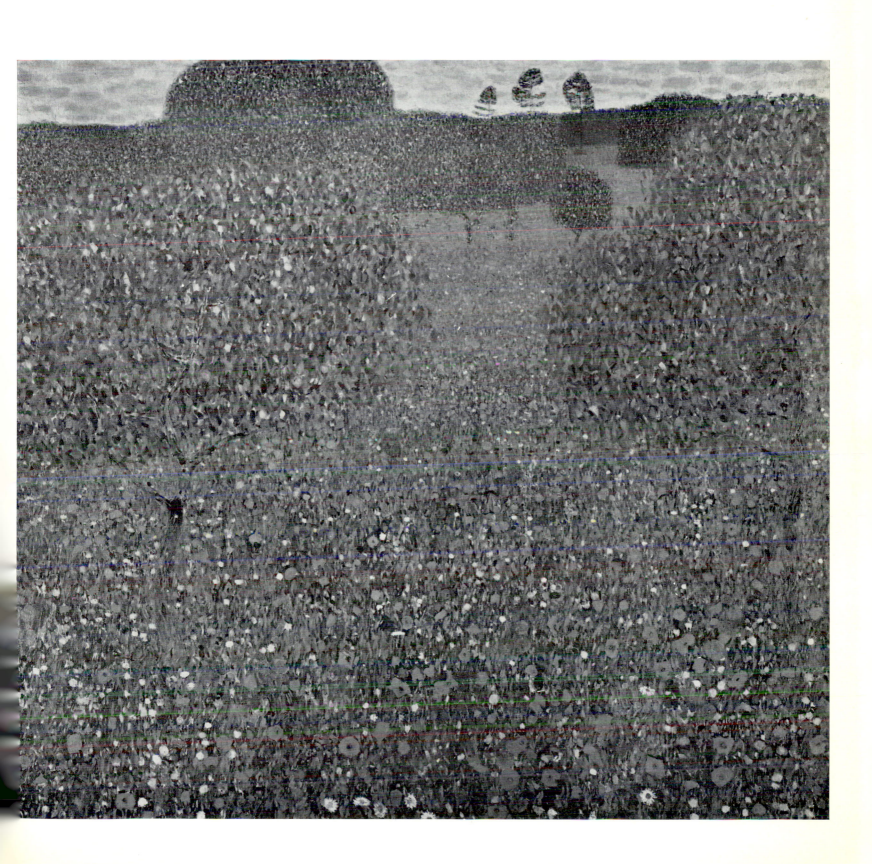

213. Emil Jacob Schindler: *The Pond in the Woods*. 1881. Oil on canvas, 24 x 37⅝ inches. Vienna, Oesterreichische Galerie.
The work of the Barbizon School, especially that of Rousseau and Daubigny, suggested this landscape to Schindler. The place is still unspoiled, but the artist's elegiacal interpretation is marred by traces of melancholy.

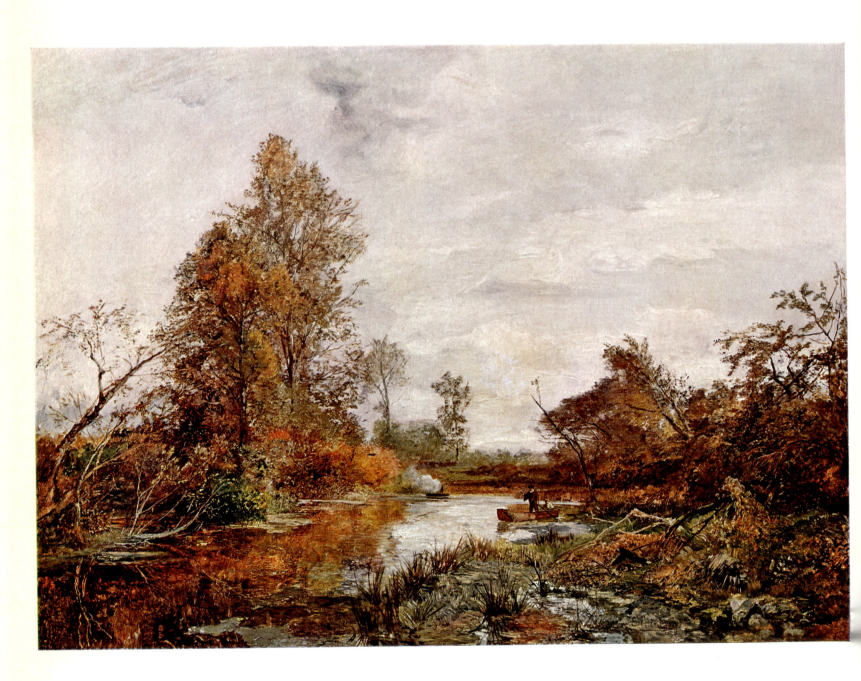

214. Caspar David Friedrich: *Trees by Moonlight.* 1820. Oil on canvas, 7⅝ x 10 inches. Cologne. Wallraf-Richartz Museum.

At times the artist's profound romanticism manifested itself in visionary, strange landscapes shot through with anxiety; at others he would lose himself in the contemplation of certain striking aspects of nature, as in this painting of carefully drawn, twisting trees silhouetted by the moonlit night.

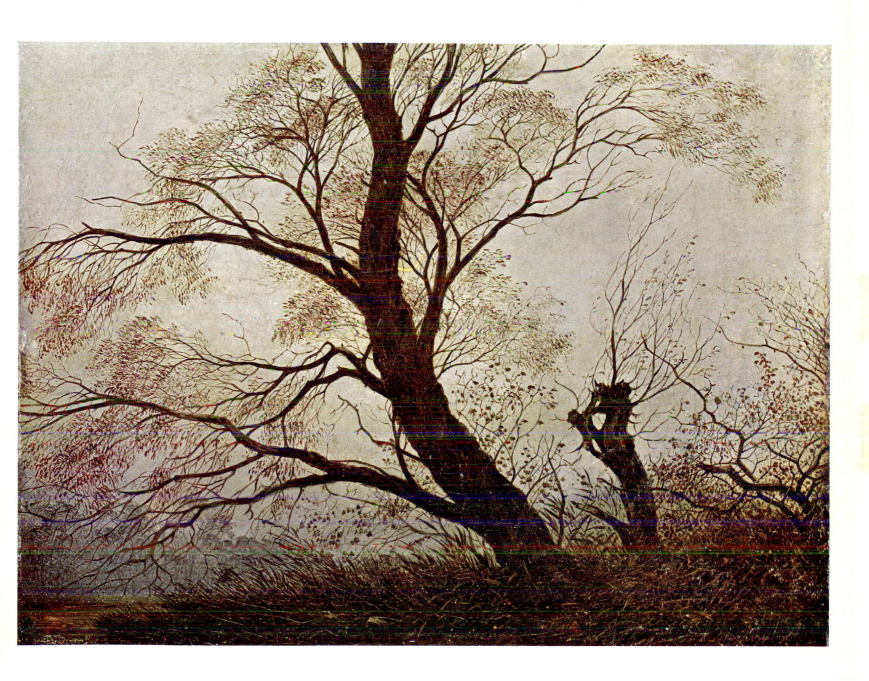

215. Caspar David Friedrich: *Summer*. 1808. Oil on canvas, 28⅛ x 40¾ inches. Munich, Neue Pinakothek.

In this painting we can clearly discern Friedrich's eighteenth-century, neoclassical training: the broad horizon, the landscape opening out into immense space but formally enclosed by the cupola of the sky, the entire image meticulously drawn. But it is precisely this minuteness that was to be the basic quality of his later, highly introspective painting that seems so modern now, and so striking for its anticipation of symbolism, a visionary tradition that was typically German, going back as far as Grünewald and Schongauer.

216. Caspar David Friedrich: *Monastery Cemetery in the Snow*. 1819. Oil on canvas, 47⅝ x 66⅞ inches. Berlin, Nationalgalerie.

Accentuating the romantic strain in his background and the visionary tendencies in his melancholy nature, the artist began around 1910 to depict a gothic vision of his world that not only relates him to the German tradition of "theological painters" from Grünewald to Bosch, but also enables him to express a new, anxious, almost ineffable feeling.

217. Philipp Hackert: *Capri*. 1792. Oil on canvas, 19¼ x 24 inches. Caserta, Royal Palace.

Naples has always claimed the attention of artists from every part of the world for the beauty of its landscape, the intense light of the sky and its superb collections of ancient art. In this painting the artist reveals certain grand and still wild aspects of the isle of Capri.

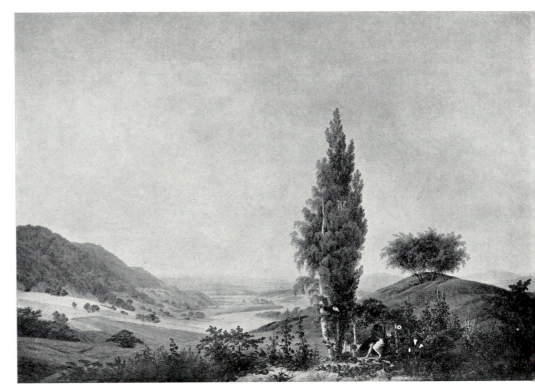

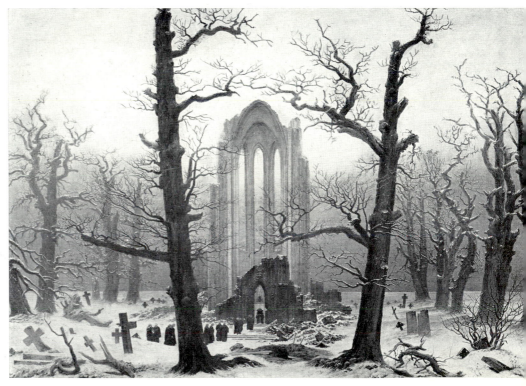

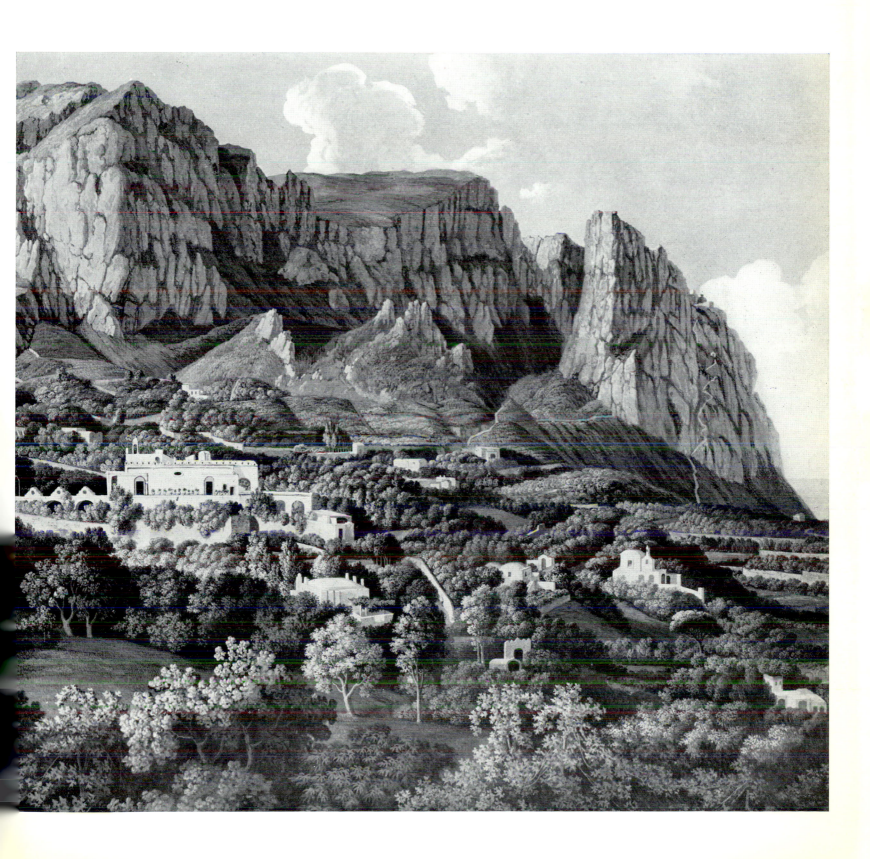

218. Karl Friedrich Schinkel: *The Tall Spires of the Cathedral*. 1813. Oil on canvas, 36⅞ x 49½ inches. Munich, Neue Pinakothek.

Without touching the depths of Friedrich's disquieting romanticism, Schinkel imitates his minute handling of detail, almost as if under a magnifying lens. Here we see how he has counterposed the theatrically lighted, cloud-banked sky against the lacy turrets and spires of the cathedral, in a view that seems unreal despite the relentless realism of each scrupulous detail.

219. Eduard Gärtner: *Bridge in Berlin*. 1842. Oil on canvas, 15⅛ x 24⅞ inches. Munich, Neue Pinakothek.

The stage-set composition of this painting, with the buildings on each side acting as flats, the various planes (the transparency of the water, the reflected bridge, the actual bridge and the limitless prospect seen through its arches) and the almost documentary quality of each element, recall Bellotto's view of Verona with a bridge, now in the Dresden Pinakothek.

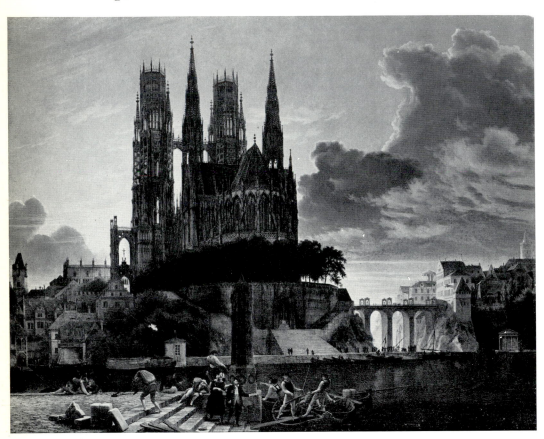

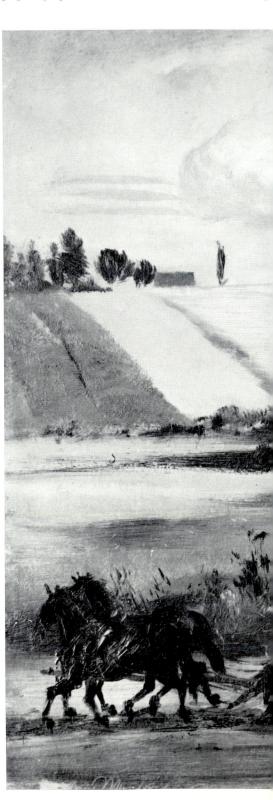

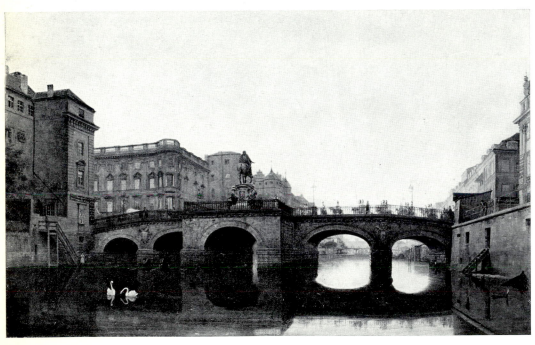

220. Adolf von Menzel: *Storm over the Tempelhofer.* 1846. Oil on cardboard, 12⅜ x 18⅛ inches. Cologne, Wallraf-Richartz Museum.
In this painting romanticism blends with the spirit of realism: the signs of the storm reflect feelings, while the representational urge tries to show natural phenomena as they are.

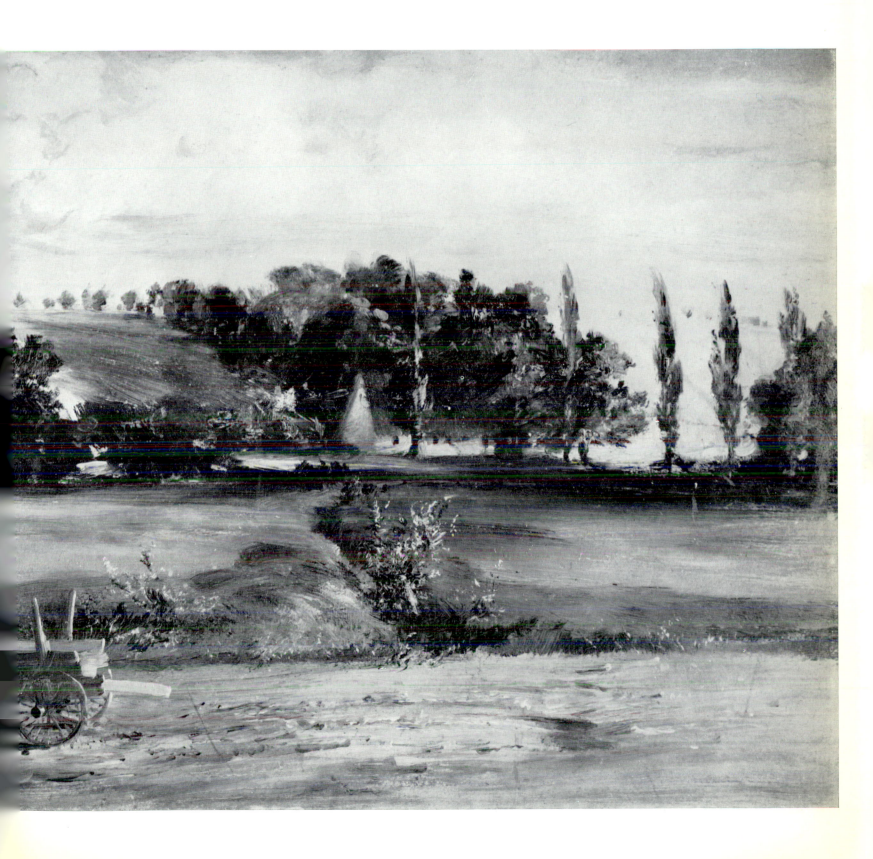

221. Anselm Feuerbach: *Landscape with Waterfall*. 1865. Oil on canvas, 29½ x 24⅜ inches. Munich, Schackgalerie.

At this point realism still dominates German art, despite the lively debates over impressionism in Paris. If anything, we can detect the romantic spirit of these paintings in the choice of subjects, which were usually wild, primitive forest haunts, the unspoiled places these artists venerated with almost pantheistic intensity.

222. Franz von Lenbach: *The Alhambra*. Oil on canvas, 28⅝ x 36 inches. Munich, Schackgalerie.

This view is still handled realistically. But the neutral objectivity of the scene is transformed by the pervading mood the artist has created by accentuating the tower motif, making it seem something magical or fabulous.

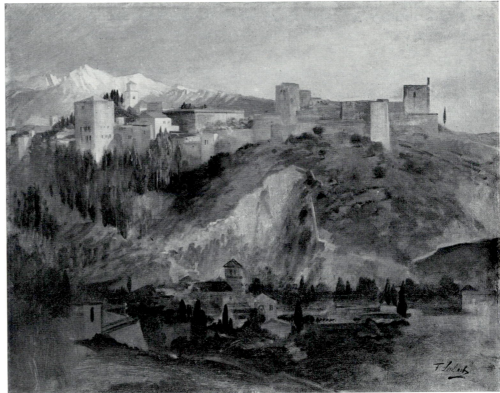

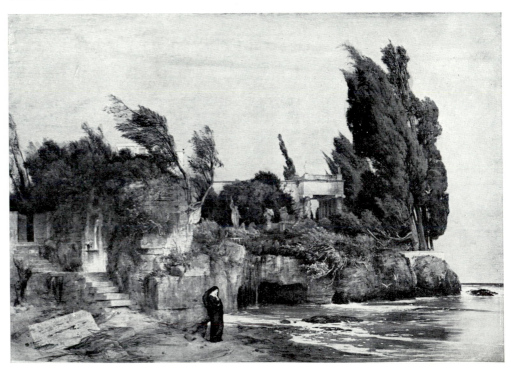

223. Arnold Böcklin: *Villa by the Sea*. 1865. Oil on canvas, 48⅝ x 68½ inches. Munich, Schackgalerie.

Friedrich's visionary romanticism certainly had an influence on Böcklin's symbolist painting: the foreboding silences, the moonlit nights, the secret places. And yet the world each artist expressed is different: Friedrich's was gothic, Böcklin's literary, decadent, esoteric, which he realized in the places, the figures, the ruins and the classical myths intended to convey a state of enchantment, the anxious expectation of something extraordinary. Around 1910 De Chirico was to derive his metaphysical painting from Böcklin's.

224. Hans Thoma: *Landscape with River*. 1875. Oil on canvas, 33⅝ x 49 inches. Munich, Neue Pinakothek.

Thoma handles the problem of light as the impressionists had—with sensitive fidelity. The sunburst through the scattered clouds creates an interesting play of light on the plain, while the river flows placidly on.

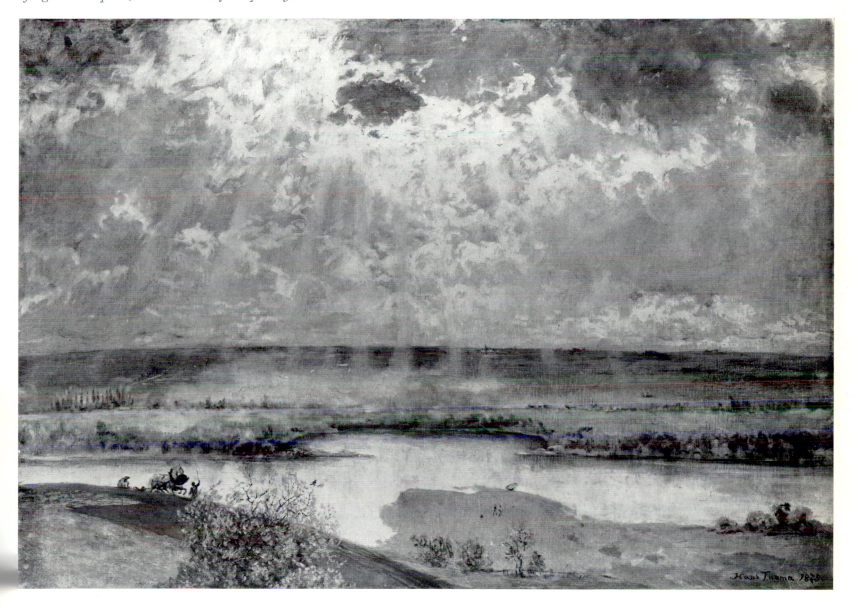

225. Lovis Corinth: *Holiday in Hamburg*. 1911. Oil on canvas, 27½ x 35⅝ inches. Cologne, Wallraf-Richartz Museum.
The shifting, color-laden play of light the impressionists had exploited in their paintings is here taken even further by Corinth's vivacious sense of color. Kokoschka's expressionist landscapes come out of these brilliant forays.

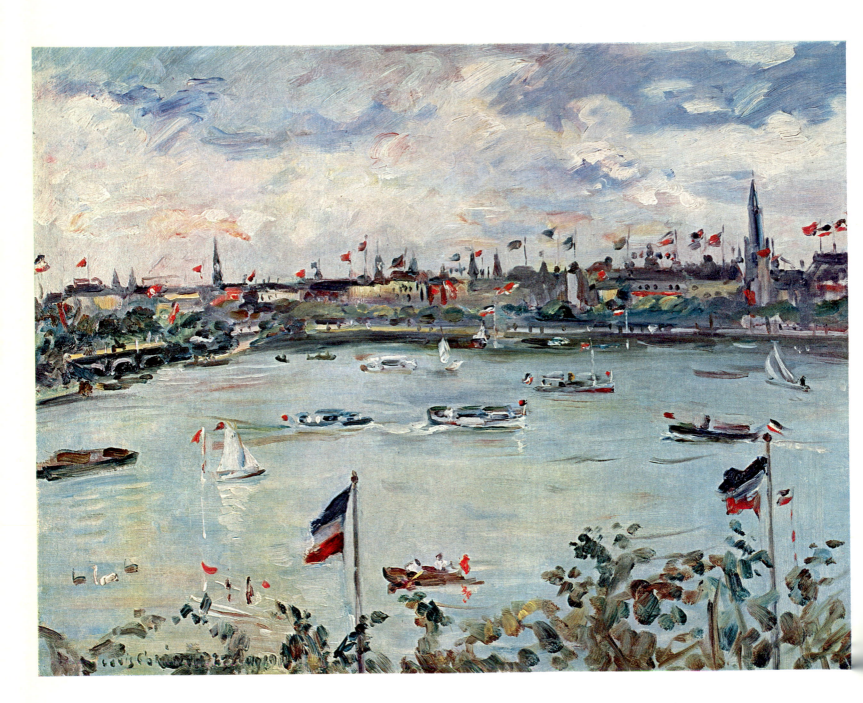

BELGIUM
HOLLAND
DENMARK
NORWAY
RUSSIA

Dear Theo,

Sunday morning

I just received your very welcome letter, and as I want to take some rest today, I'm answering it at once. Many thanks for it and for the enclosure, and for the things you tell me. And many thanks for your description of that scene with the workmen in Montmartre, which I found very interesting, as you describe the colors too, so that I can see it. I am glad you are reading the book about Gavarni. I thought it very interesting, and it made me love him twice as much.

Paris and its surroundings may be beautiful, but we have nothing to complain of here either.

This week I painted something which I think would give you the impression of Scheveningen as we saw it when we walked there together: a large study of sand, sea and sky — a big sky of delicate gray and warm white, with a single little spot of soft blue gleaming through — the sand and the sea, light — so that the whole becomes blond, but animated by the characteristically and strikingly colorful figures and fishing smacks, which are full of tone. The subject of the sketch is a fishing smack with its anchor being weighed. The horses are ready to be hitched to the boat and then to draw it into the water. Enclosed is a little sketch of it.

It was a hard job. I wish I had painted it on a panel or on canvas. I tried to get more color into it, namely depth and firmness of color. How curious it is that you and I often seem to have the same thoughts. Last night, for instance, I came home from the wood with a study, and I had been deeply absorbed in that question of depth of color for the whole week, and especially then. And I should have liked to have talked it over with you, especially with reference to the study I made; and look here, in this morning's letter you accidentally speak of having been struck in Montmartre by the strong, vivid colors, which were nevertheless harmonious.

I do not know if it was exactly the same thing that struck us both, but I know well that you would certainly have felt what struck me so particularly, and probably you would have seen it in the same way too. I begin by sending you a little sketch of the subject and will tell you what it was about.

The wood is becoming quite autumnal — there are effects of color which I very rarely find painted in Dutch pictures.

In the woods, yesterday toward evening, I was busy painting a rather sloping ground covered with dry, moldered beech leaves. This ground was light and dark reddish-brown, made more so by the shadows of trees casting more or less dark streaks over it, sometimes half blotted out. The problem was — and I found it very difficult — to get the depth of color, the enormous force and solidity of that ground — and while painting it I perceived for the very first time how much light there still was in that dusk — to keep that light and at the same time the glow and depth of that rich color.

For you cannot imagine any carpet as splendid as that deep brownish-red in the glow of an autumn evening sun, tempered by the trees.

From that ground young beech trees spring up which catch light on one side and are brilliant green there; the shadowy sides of those stems are a warm, deep black-green. Behind those saplings, behind that brownish-red soil, is a sky very delicate, bluish-gray, warm, hardly blue, all aglow — and against it all is a hazy border of green and a network of little stems and yellowish leaves. A few figures of wood gatherers are wandering around like dark masses of mysterious shadows. The white cap of a woman bending to reach a dry branch stands out suddenly against the deep red-brown of the ground. A skirt catches the light — a shadow is cast — a dark silhouette of a man appears above the underbrush. A white bonnet, a cap, a shoulder, the bust of a woman molds itself against the sky. Those figures are large and full of poetry — in the twilight of that deep shadowy tone they appear as enormous terracottas being modeled in a studio.

I describe nature to you; how far I rendered the effect in my sketch, I do not know myself; but I do know that I was struck by the harmony of green, red, black, yellow, blue, brown, gray. It was very like De Groux, an effect like that sketch of "Le départ du conscrit," for instance, formerly in the Ducal Palace.

It was hard to paint. I used for the ground one and a half large tubes of white — yet that ground is very dark — more red, yellow, brown ocher, black, sienna, bister, and the result is a reddish-brown, but one that varies from bister to deep wine-red, and even a pale blond ruddiness. Then there is still the moss on the ground, and a border of fresh grass, which catches light and sparkles brightly, and is very difficult to get. There you have at last a sketch which I maintain has some significance, and which expresses something, no matter what may be said about it.

While painting it, I said to myself, I must not go away before there is something of an autumn evening in it, something mysterious, something serious. But as this effect does not last, I had to paint quickly. The figures were put in at once with a few strong strokes of a firm brush.

It struck me how sturdily those little stems were rooted in the ground. I began painting them with a brush, but because the surface was already so heavily covered, a brush stroke was lost in it — then I squeezed the roots and trunks in from the tube, and modeled it a little with the brush. Yes — now they stand there rising from the ground, strongly rooted in it.

In a certain way I am glad I have not *learned* painting, because then I might have *learned* to pass by such effects as this. Now I say, No this is just what I want — if it is impossible, it is impossible; I will try it, though I do not know how it ought to be done. *I do not know myself* how I paint it. I sit down with a white board before the spot that strikes me, I look at what is before my eyes, I say to myself, That white board must become something; I come back dissatisfied — I put it away, and when I have rested a little, I go and look at it with a kind of fear. Then I am still dissatisfied, because I still have that splendid scene too clearly in my mind to be satisfied with what I made of it. But I find in my work an echo of what struck me, after all. I see that nature has told me something, has spoken to me, and that I have put it down in shorthand. In my shorthand there may be words that cannot be deciphered, there may be mistakes or gaps, but there is something of what wood or beach or figure has told me in it, and it is not the tame or conventional language derived from a studied manner or a system rather from nature itself.

Enclosed another little sketch made in the dunes. Small bushes are standing there, the leaves of which are white on one side and dark green on the other, and are constantly rustling and glittering. In the background, dark trees.

You see I am absorbed in painting with all my strength; I am absorbed in color — until now I have restrained myself, and I an not sorry for it. If I had not drawn so much, I should not be able to catch the feeling of and get hold of a figure that looks like an unfinished terracotta. But now I feel myself on the open sea — the painting must be continued with all the strength I can give it.

When I paint on panel or canvas, the expenses increase again. Everything is so expensive, the colors are also expensive and are so soon gone. Well, all painters have those difficulties. We must see what can be done. I know for sure that I have an instinct for color, and that it will come to me more and more, that painting is in the very marrow of my bones. Doubly and twice doubly I appreciate your helping me so faithfully and substantially. I think of you so often. I want my work to become firm, serious, manly, and for you also to get satisfaction from it as soon as possible.

One thing I want to call your attention to, as being of importance. Would it be possible to get colors, panels, brushes, etc., *wholesale*? Now I have to pay the retail price. Have you any connection with Paillard or some such person? If so, I think it would be very much cheaper to buy white, ocher, sienna, for instance, wholesale, and then we could arrange

about the money. It would of course be much cheaper. Think it over. Good painting does not depend on using much color, but in order to paint a ground forcefully, or to keep a sky clear, one must sometimes not spare the tube.

Sometimes the subject requires delicate painting, sometimes the material, the nature of the things themselves requires thick painting. Mauve, who paints very soberly in comparison to J. Maris, and even more so in comparison to Millet or Jules Dupré, has cigar boxes full of empty tubes in the corners of his studio; they are as numerous as the empty bottles in the corners of rooms after a dinner or soirée, as Zola describes it for instance.

Well, if there can be a little extra this month, it will be delightful. If not, that will be all right, too. I shall work as hard as I can. You inquire about my health, but how is yours? I am inclined to believe that my remedy would be yours also — to be in the open air, to paint. I am well, but I still feel it when I am tired. However, it is getting better instead of worse. I think it a good thing that I live as frugally as possible, but painting is my special remedy. I sincerely hope that you are having good luck and that you will find even more. A warm handshake in thought and believe me,

Yours sincerely, Vincent

You see there is a blond, tender effect in the sketch of the dunes, and in the wood there is a more gloomy, serious tone. I am glad both exist in life.

Dear Theo, Saturday evening

I want to write you a few more impressions of Antwerp.

This morning I took a most satisfactory walk in the pouring rain, the object of this excursion being to get my things at the customhouse; the various dockyards and warehouses on the quays are splendid.

I have walked along the docks and the quays several times already, in all directions. Especially when one comes from the sand and the heath and the quiet of a peasant village, and has been in none but quiet surroundings for a long time, the contrast is curious. It is an unfathomable confusion. One of de Goncourt's saying was: "Japonaiserie forever." Well, those docks are a famous Japonaiserie, fantastic, peculiar, unheard of — at least one can take this view of it.

I should like to walk there with you, just to know whether we see alike. One could make everything there, city views — figures of the most varied character — the ships as the principal things, with water and sky a delicate gray — but above all — Japonaiserie. I mean, the figures are always in action, one sees them in the queerest surroundings, everything fantastic, and at all moments interesting contrasts present themselves.

A white horse in the mud, in a corner where heaps of merchandise are lying covered with oilcloth — against the old smoky black walls of the warehouse. Quite simple, but an effect of Black and White.

Through the window of a very elegant English bar, one will look out on the dirtiest mud, and on a ship from which, for instance, attractive merchandise like hides and buffalo horns is being unloaded by hideous dock hands or exotic sailors; a very dainty, very fair young English girl is standing at the window looking at it, or at something else. The interior with the figure altogether in tone, and for light — the silvery sky above that mud, and the buffalo horns, again a series of rather sharp contrasts. There will be Flemish sailors, with almost exaggeratedly healthy faces, with broad shoulders, strong and plump, and thoroughly Antwerp folk, eating mussels, or drinking beer, and all this will happen with a lot of noise and bustle — by way of contrast — a tiny figure in black with her little hands pressed against

her body comes stealing noiselessly along the gray walls. Framed by raven-black hair — a small oval face, brown? orange-yellow? I don't know. For a moment she lifts her eyelids, and looks with a slanting glance out of a pair of jet black eyes. It is a Chinese girl, mysterious, quiet like a mouse — small, bedbug-like in character. What a contrast to that group of Flemish mussel eaters.

Another contrast — one passes through a very narrow street, between tremendously high houses, warehouses, and sheds.

But down below in the street pubs for all nationalities with masculine and feminine individuals to match, shops selling eatables, seamen's clothes, glaringly colorful and crowded. That street is long, every moment one sees something striking. Now and again there is a noise, intenser than anywhere else, when a quarrel is going on; for instance, there you are walking, looking about, and suddenly there is a loud cheering and all kinds of shouting. In broad daylight a sailor is being thrown out of a brothel by the girls, and pursued by a furious fellow and a string of prostitutes, of whom he seems rather afraid — at least I saw him scramble over a heap of sacks and disappear through a warehouse window. Now, when one has had enough of all this tumult — at the end of the landing stages where the Harwich and Havre steamers are moored — with the city behind one, one sees nothing in front, absolutely nothing but an infinite expanse of flat, half-inundated fields, awfully dreary and wet, waving dry rushes, mud, the river with a single little black boat, the water in the foreground gray, the sky, foggy and cold, gray — still like a desert.

As to the general view of the harbor or a dock — at one moment it is more tangled and fantastic than a thorn hedge, so confused that one finds no rest for the eye, and gets giddy, is forced by the whirling of colors and lines to look first here, then there, without being able, even by looking for a long time at one point, to distinguish one thing from another. But when one stands on a spot where one has a vague plot as foreground, then one sees the most beautiful quiet lines, and the effects which Mols, for instance, often paints.

Dear Theo, [The Hague, 1883]

One of the causes of my sometimes thinking of moving might be eliminated in another way. Yesterday and the day before I have been strolling around the neighborhood of Loosduinen. I walked from the village to the beach, and found lots of cornfields there, not so beautiful as those in Brabant, but there must be reapers, sowers and gleaners, all those things which I have missed this year, which was the reason for my occasionally feeling the need of a change.

I do not know whether you have seen that region. I had never been there before. I painted a study there on the beach. There are some sea dikes or moles, piers, jetties, and very picturesque ones too, made of weather-beaten stones and wicker work. I sat down on one of them and painted the rising tide till it came so near I had to move my things in a hurry. Between the village and the beach are bushes of a deep bronzed green, tangled by the sea wind, and so striking that more than once one thinks, Oh, now that's *the* "Buisson" by Ruysdael. A streetcar is running there now, so it is within easy reach when one has equipment or wet studies to carry home.

This is a scratch of the path to the beach.

My thoughts were with you all during the walk.

I know you will agree with me that the dunes around The Hague and Scheveningen have lost much of their typical character in the last ten years, and are getting another, more frivolous aspect, more and more each year.

Going back, not only ten, but thirty, even forty or fifty years, one comes to the period when they began to paint the dunes, etc., in their true character. At that time things were more Ruysdael-like than now.

If one wants to see things with a Daubigny, a Corot atmosphere, one must go farther, where the soil is almost untrodden by bathing guests, etc. Undoubtedly Scheveningen is very beautiful, but nature is no longer untouched there; however, that same untouched quality of nature struck me enormously during that walk I told you about.

This will give you an idea of the pier.

Rarely has silence, has nature alone impressed me in such a way recently. These very spots where nothing is left of what one calls civilization, where all that is definitely left behind, these very spots are those one needs to get calmed down.

But I would have liked to have you with me, because I think you would have had the same impression of being in surroundings such as I imagine Scheveningen must have been at the time when the first Daubignys appeared, and I found those surroundings full of a strong, stimulating vigor inducing one to undertake some manly work.

When you come, it will perhaps be fun to go there together, with no civilization around us, only a poor rickety shell cart on the white road; and for the rest, shrubs that look, every one of them, like *the* "Buisson" by Ruysdael. The landscape itself very simple, flat: stretches of ragged dune soil, hardly undulating.

I think if we were together on that spot, it would put you and me into a mood such that we would not hesitate about the work, but feel decisive about what we have to do. Was it a chance harmony of my rather gloomy mood with those surroundings, or shall I find the same impressions there again in the future? I don't know, but when I again feel the need to forget the present and to think of the time when the great revolution in art began, of which Millet, Daubigny, Breton, Troyon, Corot are the leaders, I will go to that same spot once more.

I wish you could see it; perhaps when you come we might take a stroll there together — the streetcar brings one to Loosduinen in a moment, it even goes as far as Naaldwijk now. Those level grounds behind Loosduinen are exactly like Michel — and the lonely beach too. Though, after our last letters, I think less about the future than about the present, I still hope that when you come we shall decide that I shall make a number of small water colors for you, and perhaps some small oil paintings, just as an experiment.

If I could only manage to have money enough to carry on my painting vigorously this year.

That walk, all by myself, far away in the dunes, has quieted me by making me feel as if I had not been alone, but had had a talk with one of the old painters from the time when Daubigny was beginning.

I shouldn't be surprised if you also remembered that spot once you had walked there. While writing this letter, I have started a water color of that bush; I painted a study of the other thing — the jetty — so at all events I have a souvenir of the walk, which I can show you when you come. And if you like, we can take a walk there together.

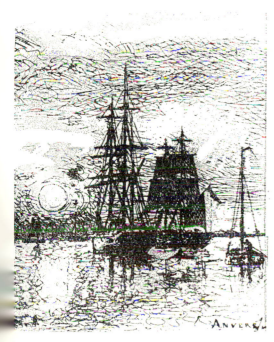

Dear Theo, [N. Amsterdam]

This once I write to you from the very remotest part of Drenthe, where I came after an endless expedition on a barge through the moors. I see no possibility of describing the country as it ought to be done; words fail me, but imagine the banks of the canal as miles and miles of Michels or Th. Rousseaus, Van Goyens or Ph. de Konincks.

Level planes or strips of different color, getting narrower and narrower as they approach the horizon. Accentuated here and there by a peat shed or small farm, or a few meager birches, poplars, oaks, — heaps of peat everywhere, and one constantly meets barges with peat or bulrushes from the marshes. Here and there lean cows, delicate of color, often sheep — pigs. The figures which now and then appear on the plain are generally of an impressive character; sometimes they have an exquisite charm. I drew, for instance, a woman in the barge with crape around her golden head-plates because she was in mourning, and afterward a mother with a baby; the latter had a purple shawl over her head. There are a lot of Ostade types among them: physiognomies reminding one of pigs or crows, but now and then a little figure that is like a lily among thorns.

Well, I am very pleased with this excursion, for I am full of what I have seen. This evening the heath was inexpressibly beautiful. In one of the Boetzel Albums there is a Daubigny which gives exactly that effect. The sky was of an indescribably delicate lilac white, no fleecy clouds, for they were more compact and covered the whole sky, but dashes of more or less vivid lilac, gray, white, a single rent which the blue gleamed through. Then a glaring red streak at the horizon, below which the very dark stretch of brown moor, and standing out against the brilliant red streak, a number of low-roofed little sheds.

In the evening this moor often shows effects which the English call "weird" and "quaint." Fantastic silhouettes of Don Quixote-like mills or curious giants of drawbridges stand out against the vibrating evening sky. In the evening such a village, with the reflections of lighted windows in the water or in the mud puddles, sometimes looks extremely friendly.

Before I left Hoogeveen, I painted a few studies there, including one of a large moss-roofed farm. For I had had Furnée send colors, as I thought the same as you wrote in your letter, that by getting absorbed in my work, and quite losing myself in it, my mood would change, and it has greatly improved already.

But at times — like those moments when you think of going to America — I think of enlisting in the East Indian army; but those moments when one is overwhelmed by things are miserable and gloomy, and I could wish you might see those silent moors, which I see here from my window, for such a thing is soothing, and inspires more faith, resignation, steady work. I drew several studies in the barge, but I stayed here awhile to paint some more. I am quite near Zweeloo, where Liebermann, among others, has been; and besides there is a place here where you still find large, very old sod huts which haven't even a partition between the stable and the living room. First of all I intend to visit that place one of these days.

But what tranquillity, what expanse, what calmness in this landscape — one feels it only when there are miles and miles of Michels between oneself and the ordinary world. I cannot give you a permanent address yet, as I do not know exactly where I shall be the next few days, but by October 12 *I shall be in Hoogeveen*, and if you send your letter at the usual time *to the same address*, I shall find it there, on the 12th, in Hoogeveen.

The place where I am now is New Amsterdam.

Father sent me a money order for 10 guilders, which, along with the money from you, enables me to paint a little now.

I intend to settle at the inn where I am now for a long time, provided that from there I can easily reach the district with the large old sod huts, as I should have better light and more space there. As to that picture by that Englishman you mention, with the lean cat and the small coffin; though he got his first inspiration in that dark room, he would hardly have been able to paint it in that same spot, for if one works in too dark a room, the work usually becomes too light, so that when one brings it into the light, all the shadows are too weak. I just had that experience when I used the barn to paint an open door and a glimpse of the little garden. Well, what I wanted to say is that there will be a chance to remove that obstacle too, for here I can get a room with good light that can be heated in winter.

Well, boy, if you do not think any more about America, nor I of Harderwijk, I hope things will take care of themselves. I admit your explanation for C. M.'s silence may be right, but sometimes one can purposely be careless. On the back of the page you will find a few scratches. I write in haste, it is already late.

How I wish we could walk here together, and paint together. I think the country would charm and convince you. Adieu, I hope you are well and are having some luck. I have been thinking of you continually during this excursion. With a handshake,

Yours sincerely, Vincent

Dear brother,

I must just tell you about a trip to Zweeloo, the village where Liebermann stayed a long while, and where he made studies for his picture at the last Salon, the one with the poor washerwomen. Where Ter Meulen and Jules Bakhuyzen have also been a long time. Imagine a trip across the heath at three o'clock in the morning, in an open cart (I went with the landlord, who had to go to the market in Assen), along a road, or "diek" as they call it here, which had been banked up with mud instead of sand. It was even more curious than going by barge. At the first glimpse of dawn, when everywhere the cocks began to crow near the cottages scattered all over the heath and the few cottages we passed — surrounded by thin poplars whose yellow leaves one could hear drop to earth — an old stumpy tower in a churchyard, with earthen wall and beech hedge — the level landscapes of heath or cornfields — it, all, all, all became exactly like the most beautiful Corots. A quietness, a mystery, a peace, as only he has painted it.

But when we arrived at Zweeloo at six o'clock in the morning, it was still quite dark; I saw the real Corots even earlier in the morning.

The entrance to the village was splendid; Enormous mossy roofs of houses, stables, sheep-folds, barns.

The broad-fronted houses here stand between oak trees of a splendid bronze. In the moss are tones of gold green; in the ground, tones of reddish, or bluish or yellowish dark lilac gray; in the green of the cornfields, tones of inexpressible purity; on the wet trunks, tones of black, contrasting with the golden rain of whirling, clustering autumn leaves — hanging in loose tufts, as if they had been blown there, and with the sky glimmering through them — from the poplars, the birches, the lime and apple trees.

The sky smooth and clear, luminous, not white but a lilac which can hardly be deciphered, white shimmering with red, blue and yellow in which everything is reflected, and which one feels everywhere above one, which is vaporous and merges into the thin mist below — harmonizing everything in a gamut of delicate gray. I didn't find a single painter in Zweeloo, however, and people said *none* ever came *in winter*.

I, on the contrary, hope to be there *just* this winter.

As there were no painters, I decided not to wait for my landlord's return, but to walk back, and to make some drawings on the way. So I began a sketch of that little apple orchard, of which Liebermann made his large picture. And then I walked back along the road we had driven over early in the morning.

For the moment the whole country around Zweeloo is entirely covered — as far as the eye can see — with young corn, the very, very tenderest green I know.

With a sky over it of a delicate lilac-white, which gives an effect — I don't think it can be painted, but which is for me the keynote that one must know in order to understand the keynotes of other effects.

A black patch of earth — flat — infinite — a clear sky of delicate lilac-white. The young corn sprouts from that earth, it is almost moldy-looking with that corn. That's what the good fertile parts of Drenthe are basically; the whole in a hazy atmosphere. Think of *Brion's* "Le dernier jour de la création"; yesterday it seemed to me that I understood the meaning of that picture.

The poor soil of Drenthe is just the same — but the black earth is even blacker still — like soot — not lilac-black like the furrows, and drearily covered with ever-rotting heather and peat. I see that everywhere, the incidentals on the infinite background: on the moors, the peat sheds; in the fertile parts, the very primitive gigantic structures of farms and sheep-folds, with low, very low little walls and enormous mossy roofs. Oak trees all around them. When one has walked through that country for hours and hours, one feels that there is really nothing but that infinite earth — that green mold of corn or heather, that infinite sky. Horses and men seem no larger than fleas. One is not aware of anything, be it ever so large in itself; one only knows that there is earth and sky. However, in one's quality of a little speck noticing other little specks — leaving the infinite apart — one finds every little speck to be a Millet.

I passed a little old church exactly, exactly "The Church at Gréville" in Millet's little picture in the Luxembourg; instead of the little peasant with his spade in that picture, there was here a shepherd with a flock of sheep walking along the hedge. There was not a glimpse of the true sea in the background, but only of the sea of young corn, the sea of furrows instead of the sea of waves.

The effect produced was the same. Then I saw plowers, very busy — a sandcart, a shepherd, road menders, dungcarts. In a little roadside inn I drew an old woman at the spinning wheel, a dark little silhouette out of a fairy tale — a dark little silhouette against a light window, through which one saw the clear sky. and a small path through the delicate green, and a few geese pecking at grass.

And then when twilight fell — imagine the quiet, the peace of it all! Imagine then a little avenue of high poplars with autumn leaves, imagine a wide muddy road, all black mud, with an infinite heath to the right and an endless heath to the left, a few black triangular silhouettes of sod-built huts, through the little windows of which shines the red light of the little fire, with a few pools of dirty yellowish water that reflect the sky, and in which trunks lie rotting; imagine that swamp in the evening twilight, with a white sky over it, everywhere the contrast of black and white. And in that swamp a rough figure — the shepherd — a heap of oval masses, half wool, half mud, jostling each other, pushing each other — the flock. You see them coming — you find yourself in the midst of them — you turn around and follow them. Slowly and reluctantly they trudge along the muddy road. However, the farm looms in the distance — a few mossy roofs and piles of straw and peat between the poplars.

The sheepfold is again like the silhouette of a triangle — dark. The door is wide open like the entrance to a dark cave. Through the chinks of the boards behind it gleams the light of the sky. The whole caravan of masses of wool and mud disappear into that cave — the shepherd and a woman with a lantern shut the doors behind them.

That coming home of the flock in the twilight was the finale of the symphony I heard yesterday.

That day passed like a dream, all day I was so absorbed in that poignant music that I literally forgot even food and drink — I had taken a piece of brown bread and a cup of coffee in the little inn where I drew the spinning wheel. The day was over, and from dawn till twilight, or rather from one night till the other, I had lost myself in that symphony.

I came home, and sitting by the fire, I felt I was hungry, yes, very hungry. But now you see how it is here. One is feeling exactly as if one had been to an exhibition of the Cent chef-d'oeuvres, for instance; what does one bring home from such a day? Only a number of rough sketches. Yet there is another thing one brings home — a calm ardor for work. Do write soon, today it is Friday, but your letter has not yet arrived; I am longing to get

it. It also takes some time to get it changed, as I have to go to Hoogeveen for it, and then return here. We do not know how things will go, otherwise I should say, *now* the simplest thing would be perhaps to send the money *once* a month. At all events, write soon. With a handshake.

Yours sincerely, Vincent

Letters, 1876-1889.

VINCENT VAN GOGH

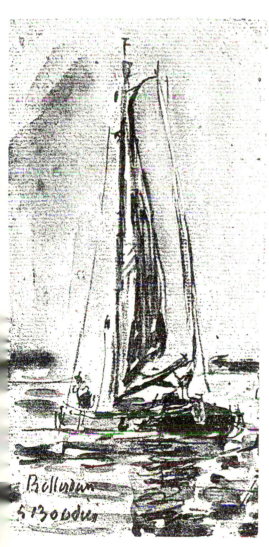

One cold December day a beggar came wandering up the slopes of Broby. He was dressed in the most miserable rags, and his shoes were so worn that the cold snow wet his feet. Löven is a long, narrow lake in Värmland, intersected in several places by long narrow sounds. In the north it stretches up to the Finn forests, in the south down to the lake Väner. There are many parishes along its shores, but the parish of Bro is the largest and richest. It occupies a large part of the shores of the lake both on the east and west sides; but on the west side are the biggest estates, such as Ekeby and Björne, known far and wide for their wealth and beauty, and Broby, with its large village and inn, its court-house, sherrif's-house, vicarage, and market-place.
Broby lies on a steep slope. The beggar had come past the inn, which lies at the foot of the hill, and was struggling up towards the vicarage, which is on the hill-top.

The plain is as long as the lake; but it is no easy matter to find any space between the hills and mountains, all the way from the valley of the basin at the northern end of the lake, where it first ventures to expand, up to the shore of Vänern where it leisurely comes to rest. There is no doubt that the plain would rather follow the shore of the lake in spite of its length; but the mountains give it no peace. The mountains are mighty granite walls, covered with woods, with many ravines, which are difficult to cross, rich in moss and lichen, — in those old days the home of many wild animals and birds.
Half way up the long line of hills, there are numerous low-lying swamps or tarns with their dark water. Here and there is a charcoal kiln or an open patch where timber and wood have been cut, or a burnt clearing; and these all show that there is work going on in the mountains. But usually the mountains are lighthearted and rest in peace. They are content to watch the lights and shadows play over their slopes.
The plain, which is upright and prosperous and loves work, wages perpetual war with these mountains, in a friendly spirit, however.
"It is quite enough," the plain says to the mountains; "if you set up your walls around me, that is safety enough for me."
But the mountains will not listen. They send out long rows of hills and barren table-lands right down to the lake. They raise magnificent outlook towers on every promontory; and so seldom do they leave the shores of the lake, that only in a few places the plain can descend to the soft sands of the wide shore.

It knows how in the light of midday they sink down towards the horizon, and are low and a dim light-blue; and in the morning or evening light they raise their venerable peaks, clear blue as the sky at the zenith.
Sometimes the light falls on them so sharply that they look green or dark-blue, and each separate fir-tree, each path and cleft, is visible for many miles.

There are places where the mountains draw back and allow the plain to come forward and gaze at the lake. But when it sees the lake either hissing and spitting in fury like a wild-cat, or covered with that cold mist which comes when the seasprite is busy with brewing or washing; then it agrees that the mountains were right, and draws back to its narrow prison again.

Men have cultivated the beautiful plain from time immemorial, and have built much there. Factories and mills were erected wherever streams with foaming waterfalls rushed down the slopes to the shore. On the bright, open places, where the plain reaches to the lake, churches and parsonages were built; but along the edges of the valley, half-way up the slope, on stony ground, where grain would not grow, there are farmhouses and officers' quarters, and here and there a manor.

The Story of Gösta Berling, 1890-1891. SELMA LAGERLÖF

Mistress Rigitze Grubbe, relict of the late lamented Hans Ulrik Gyldenlöve, owned a house on the corner of Östergade and Pilestraede. At that time, Östergade was a fairly aristocratic residence section. Members of the Trolle, Sehested, Rosencrantz, and Krag families lived there; Joachim Gersdorf was Mistress Rigitze's neighbor, and one or two foreign ministers usually had lodgings in Carl van Mandern's new red mansion. Only one side of the street was the home of fashion, however; on the other side, Nikolaj Church was flanked by low houses, where dwelt artisans, shopkeepers, and shipmasters. There were also one or two taverns.

On a Sunday morning, early in September, Marie Grubbe stood looking out of the dormer window in Mistress Rigitze's house. Not a vehicle in sight! Nothing but staid footsteps, and now and then the long-drawn cry of the oyster-monger. The sunlight, quivering over roofs and pavements, threw sharp, black, almost rectangular shadows. The distance swam in a faint bluish heat mist.

Flakes of orange-colored light shot up from the sea-gray fog-bank in the horizon, and lit the sky overhead with a mild, rose-golden flame that widened and widened, grew fainter and fainter, until it met a long, slender cloud, caught its waving edge, and fired it with a glowing, burning radiance. Violet and pale pink, the reflection from the sunrise clouds fell over the beaches of Kallebodstrand. The dew sparkled in the tall grass of the western rampart; the air was alive and quivering with the twitter of sparrows in the gardens and on the roofs. Thin strips of delicate mist floated over the orchards, and the heavy, fruit-laden branches of the trees bent slowly under the breezes from the Sound.

In the afternoon of the same day, a fitful wind blew through the streets of the city, whirling up clouds of dust, whittlings, and bits of straw, and carrying them hither and thither. It tore the tiles from the roofs, drove the smoke down the chimneys, and wrought sad havoc with the tradesmen's signs. The long, dull-blue pennants of the dyers were flung out on the breeze and fell down again in spirals that tightened around their quivering staffs. The turners' spinning-wheels rocked and swayed; hairy tails flapped over the doors of the furriers, and the resplendent glass suns of the glaziers swung in a restless glitter that vied with the polished basins of the barber-surgeons.

Maria Grubbe. JENS PETER JACOBSEN

Steamboats moved slowly forty years ago. It took us a long time to reach Nizhni-Novgorod, and I well remember those first days, drenched with beauty.

The weather was fine, and from morning to night I was up on deck with my grandmother, floating there beneath the bright sky, between the banks of the Volga embroidered with the golden silk of autumn. The rust-coloured boat with a barge in tow moved lazily against the current, nosing its way with a gentle slapping of paddles through the grey-blue water. The barge was grey and resembled a water bug. The sun stole imperceptibly above the Volga; every hour brought something new — everything about us changed. The green hills were folds in the rich raiment of the earth. Towns and villages seemed made of gingerbread as they passed in the distance; golden autumn leaves floated on the water.

Very early one Saturday morning I went into Petrovna's garden to catch bullfinches. Some time passed, but the proud, red-breasted creatures would not enter my snare. Vaunting their beauty, they would step importantly over the silver snow crust, or fly into the bushes, where they would sway on the hoar-covered branches like bright flowers among blue sparkles of snow dust. All this was too lovely to allow of my feeling disappointment in the hunt. In general I was not a very impassioned hunter: I always took greater pleasure in the process than in the result. I was most interested in observing and meditating on the lives of the birds.

What could be more pleasant than to sit alone at the edge of a snowy field and listen to the chirping of the birds in the crystal silence of a winter's day, while somewhere far away in the distance sounded the bells of a passing troika — that melancholy lark of the Russian winter.

Childhood.

<div align="right">MAXIM GORKY</div>

How intoxicating, how magnificent is a summer day in Little Russia! How luxuriously warm the hours when midday glitters in stillness and sultry heat and the blue fathomless ocean arching like a voluptuous cupola over the plain seems to be slumbering, bathed in languor, clasping the fair earth and holding it close in its ethereal embrace! Upon it, not a cloud; in the plain, not a sound. Everything might be dead; only above in the heavenly depths a lark is trilling and from the airy heights the silvery notes drop down upon adoring earth, and from time to time the cry of a gull or the ringing note of a quail sounds in the steppe. The towering oaks stand, idle and apathetic, like aimless wayfarers, and the dazzling gleams of sunshine light up picturesque masses of leaves, casting on to others a shadow black as night, only flecked with gold when the wind blows. The insects of the air flit like sparks of emerald, topaz and ruby about the gay kitchen gardens, topped by stately sunflowers. Grey haystacks and golden sheaves of corn are ranged like tents on the plain and stray over its immensity. The broad branches of cherries, of plums, apples and pears bent under their load of fruit, the sky, with its pure mirror — the river in its green proudly erect frame... how full of voluptuousness and languor is the Little Russian summer! Such was the splendour of a day in the hot August of eighteen hundred... eighteen hundred... yes, it will be thirty years ago, while the road eight miles beyond the village of Sorotchintsy bustled with people hurrying to the fair from all the farms, far and near. From early morning waggons full of fish and salt had trailed in an endless chain along the road. Mountains of pots wrapped in hay moved along slowly, as though weary of being shut up in the dark; only here and there a brightly painted tureen or crock boastfully peeped out from behind the hurdle that held the high pile on the waggon, and attracted longing glances from the devotees of such luxury. Many of the passers-by looked enviously at the tall potter,

the owner of these treasures, who walked slowly behind his goods, carefully wrapping his flaunting and coquettish crocks in the detestable hay.

Evenings on a Farm near Dikanka, 1831-32. NICOLAI GOGOL

After that there was a silence.

Meanwhile a broad limitless plain intercepted by a chain of hills, unrolled before the eyes of the wayfarers. These hills peep and rise one behind the other until they attain an elevation which, stretching to the right of the road as far as the horizon, flows into the lilac atmosphere. You go on and on, and never can see where this horizon begins or where it ends.

The sun has already made its appearance behind the town and slowly, without any fuss, has begun its day's work. At first, a long way ahead where the sky is divided from the earth near the tumuli and the wind-mill — which from a distance looks like a little dwarf waving his arms — a broad bright yellow streak of light crept across the earth; in a few moments the light of that streak had come a little nearer, had crept to the right and acquired possession of the hills. Something warm touched Egorooshka's back, a streak, and suddenly all the wide steppe cast aside the penumbra of dawn, smiled, and began to sparkle with dew. The reaped corn, the high grass, the wart-wort, the wild hemp, all a rusty brown and half dead from the summer heat, now bathed in dew and caressed by the sun, revived, ready to flower again. An Arctic petrel flew across the road with a cheerful cry, the Siberian marmots called to each other in the grass; far away to the left somewhere, a peewit wailed; a covey of partridges, startled by the britchka rose up and with their soft "trrr" flew away to the hills; grasshoppers, crickets, field-mice and mole-rats struck up their squeaking monotonous music in the grass.

But after a short lapse of time the dew evaporated, the air lost its freshness and the misguided steppe reassumed its languishing July appearance. The grass drooped, and the sounds of life died away. The brown-green, sunburned hills, the lilac distance with its tints as restful as shade, the plain with its misty limits, and the inverted-looking sky — for in the steppes, where there are no forests or high mountains, the sky seems fearfully deep and pellucid — at this moment appeared limitless and torpid with grief.

How suffocating and depressing! The britchka speeds along and Egorooshka sees all the while the same thing: sky, plain, hills, The sounds in the grass have subsided, the petrel has flown away, there are no partridges to be seen. Tired of doing nothing, the rooks fly over the withered grass; they all resemble one another, and render the steppe even more uniform.

A kite with a flowing movement of his wings floats in the air, then suddenly stops, as if it recollected the nuisance of existing. Then, shaking his wings, darts off like an arrow across the steppe, and no one knows why he is flying, nor what he wants. In the distance the windmill is waving its fans.

About mid-day the britchka turned off the road to the right, went a little distance at a foot's pace, and then came to a standstill. Egorooshka heard a soft, very soothing murmur and felt something cool and velvety on his face like some other kind of air. From a hillock, made by nature cementing some immense and monstrous stones together, ran a narrow stream of water through a pipe of hemlock, placed there by some unknown benefactor. The stream was clear, playfully splashed to the ground, glistened in the sun, and, roaring gently as if it imagined itself a strong and boisterous brook, flowed swiftly somewhere to the left.

"The Steppe," 1888. ANTON CHEKHOV

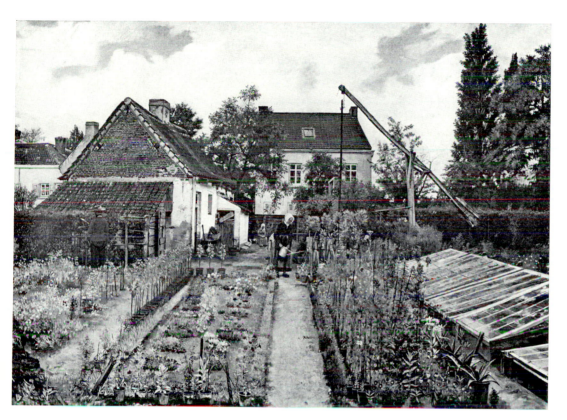

226. Henri de Brakeleer: *Horticulturist's Garden*. 1864. Oil on canvas, 33⅛ x 45¼ inches. Antwerp, Musée Royal des Beaux-Arts.

The son and nephew of painters, he had training in the arts from his family. His straightforward, sometimes heavy-handed naturalism was expressed in everyday, simple scenes: the interiors of houses, the gardens and the usual still lifes.

227. Willem Vogels: *The Pond*. Oil on canvas, 39¾ x 58⅝ inches. Antwerp, Musée Royal des Beaux-Arts.

The painting was acquired by the Museum in 1922. The cultural base of Vogel's style was the direct naturalism of the Barbizon School. But the artist was also aware of the achievements the impressionists had made, adding his own sadness, which we feel in the greys and the twilights he was fond of.

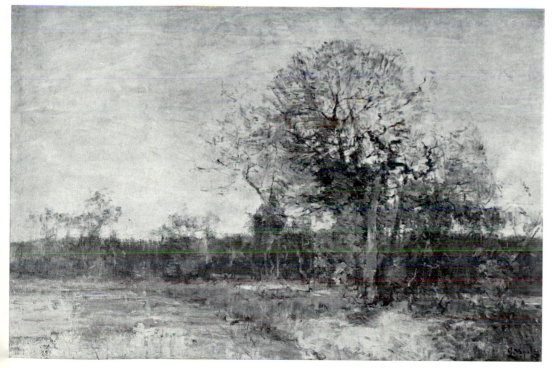

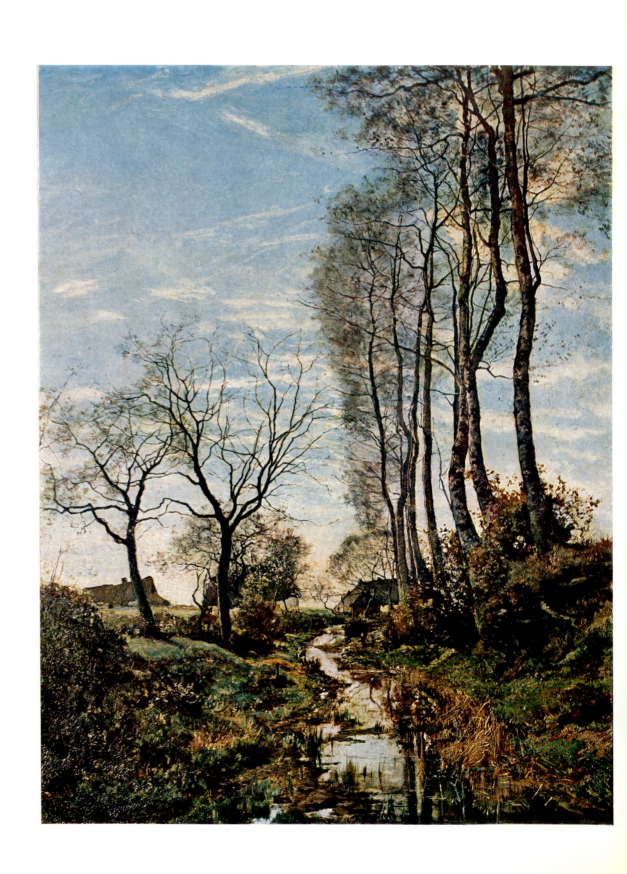

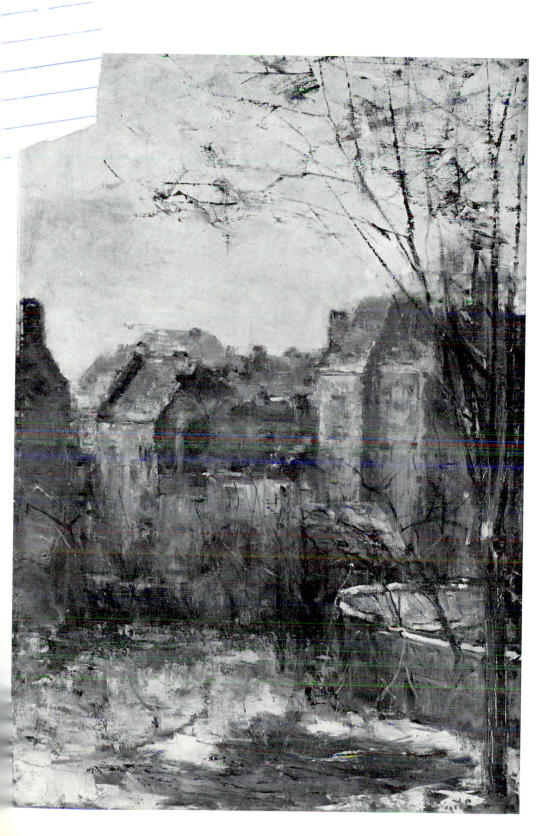

228. Hippolyte Boulanger: *The Valley of Josafat*. Oil on canvas, 43¼ x 33½ inches. Antwerp, Musée Royal des Beaux-Arts.

A sensitive observer of the landscapes in the Flemish lowlands, he was inspired by Daubigny, whose presence we feel in the silvery light, in the glinting reflections in the water, and in the etched drawing of the barren trees.

229. Willem Vogels: *My Garden*. Oil on canvas, 33⅛ x 22 inches. Antwerp, Musée Royal des Beaux-Arts.

Just as in the preceding painting, here the bleak, ashen winter atmosphere prevails over the lively color the impressionists used in their skies, including Pissarro's colorful winter scenes. These overcast landscapes correspond to the conception of life as being without consolation. Vogels is nonetheless to be considered among the most powerful naturalist painters in Belgian art.

230. Henry Evenepoel: *The Fair at Les Invalides*. Oil on canvas, 25⅛ x 36¼ inches. Antwerp, Musée Royal des Beaux-Arts.

If we find impressionist influences in his early paintings, the artist was still attempting to give more body to his color, and a different kind of expressiveness, more in the direction of Van Gogh.

231. James Ensor: *Grey Shore*. 1880. Oil on canvas, 23¼ x 29⅛ inches. Antwerp, Musée Royal des Beaux-Arts.

Ensor too, like Van Gogh, had his dark period, using thick color impasted directly on the canvas, as if to render the three-dimensionality of nature. Later his palette burst out in the now famous gaudy scarlet reds.

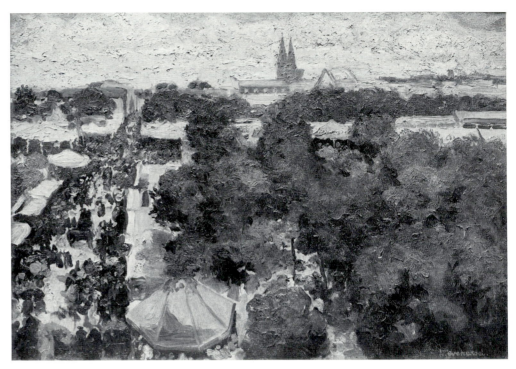

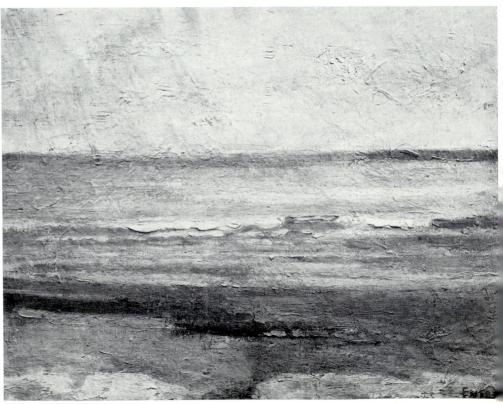

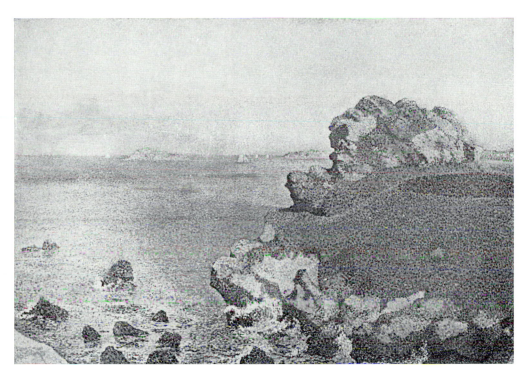

232. Théo van Rysselberghe: *Reef, near Roscoff, Brittany (Point Perkiridec)*. 1889. Oil on canvas, 26¾ x 41¾ inches. Otterlo, Rijksmuseum Kröller-Müller.

He travelled a great deal around Europe, and was much sought after by the French and Belgian high bourgeoisie. In 1898, in part out of admiration for the divisionists, especially Signac, he moved to Paris. His pointillism achieved certain effects of strong violet shading.

233. Isidoor Verheyden: *Pilgrimage in Campine*. Oil on canvas, 51⅝ x 66½ inches. Antwerp, Musée Royal des Beaux-Arts.

The somewhat coarse realism of this artist was expressed by bright, gaudy colors that convey the festive quality of peasant life.

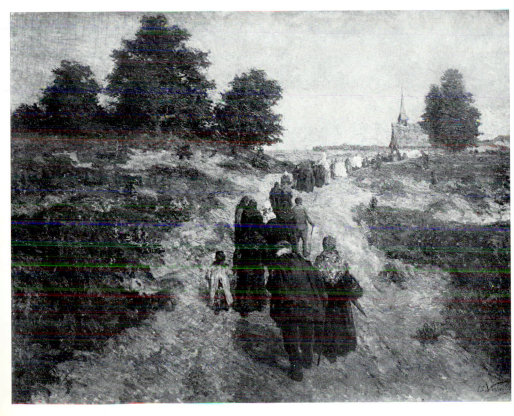

234. Henri van de Velde: *Woman at the Window*. Oil on canvas, 43¾ x 49¼ inches. Antwerp, Musée Royal des Beaux-Arts.
Where Van Rysselberghe's pointillism expressed itself in broad marine landscapes and beach scenes teeming with social life and in elegant portraits where his color could have full range, Van de Velde's was more concerned with delineating plastic volumes, arranged very deliberately in rigid compositions.

235. James Ensor: *Port of Ostend*. 1890. Oil on canvas, 22⅞ x 29⅛ inches. Antwerp, Musée Royal des Beaux Arts.
The great procession of Christ's Entry into Brussels, painted in 1889, marks the end of the color experiments Ensor began after 1886. These experiments were his declaration of independence from the rather dreary naturalistic and proletarian themes so pervasive in the art of the Low Countries, as he sought expression more than description in his use of color. From then on, Ensor was to use intense colors, as in this landscape, where the red of the ships and the houses along the dock virtually leaps out.

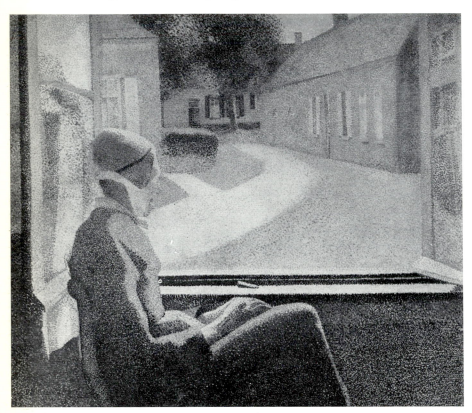

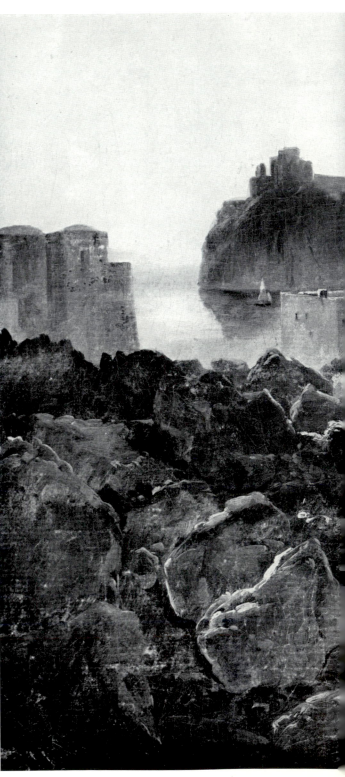

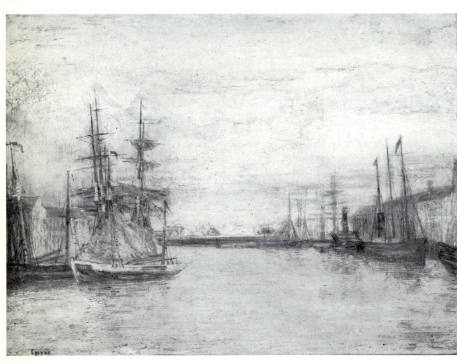

236. Anton Sminck Pitloo: *View of Ischia*. Oil on canvas, 13¾ x 18½ inches. Naples, Capodimonte Museum.
After he had studied painting in Paris he went to Rome in 1805, and like so many of his compatriots, dedicated himself to painting views. He was later called to the Naples Academy, an important event not only in his own career, but for the development of Neapolitan painting as well. He did not possess a great talent, but he set an example of observing nature directly and with feeling, thus giving rise to the Resina School.

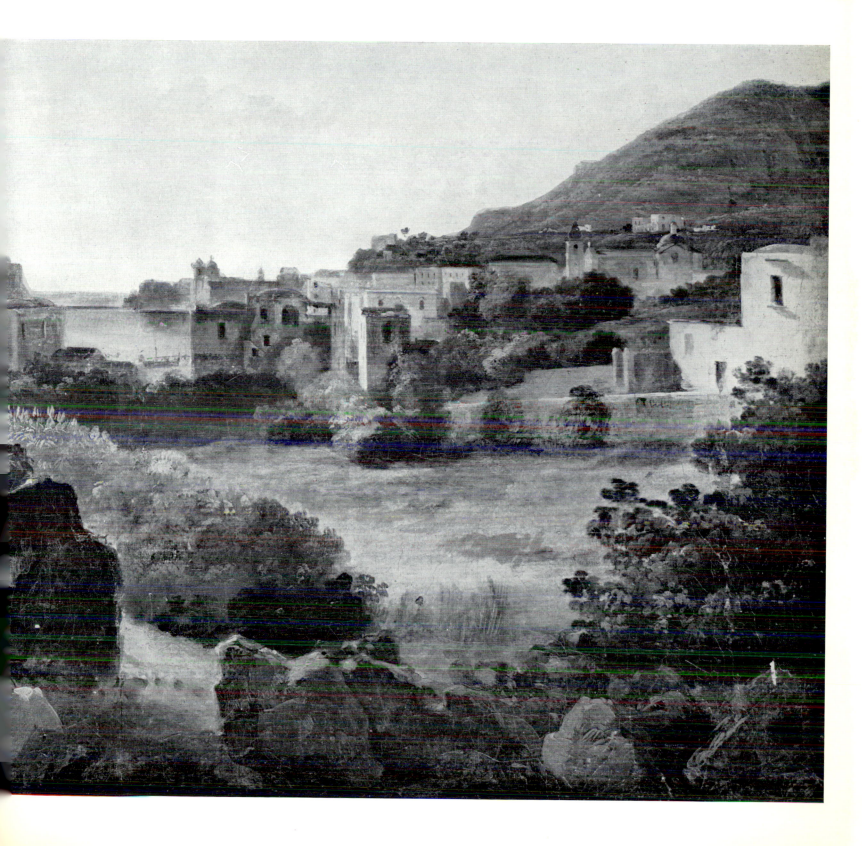

237. Johannes Weissenbruch: *View of the Church of St. Denis at Liège*. Oil on canvas, 37⅜ x 30¼ inches. Amsterdam, Rijksmuseum.

Meticulous representation of details, the taste for old stone and perspectives delineated by light, the precise contrasts between light and shadow are all signs of the influence on Weissenbruch of the Dutch painters of the seventeenth century.

238. Johannes Weissenbruch: *Old Gate at Leerdam*. Oil on canvas, 30¼ x 41 inches. Amsterdam, Rijksmuseum.

This painting was acquired at an exhibition in 1870. Untouched by the new currents in French art which were spreading throughout Europe, the artist remained faithful to the traditions of the landscape painters of his own country, with the soft color and light of Vermeer.

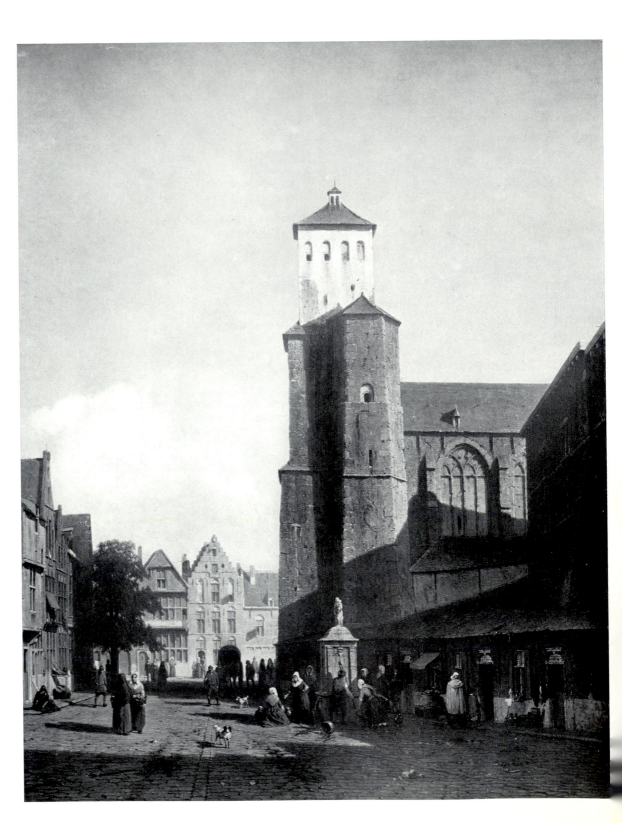

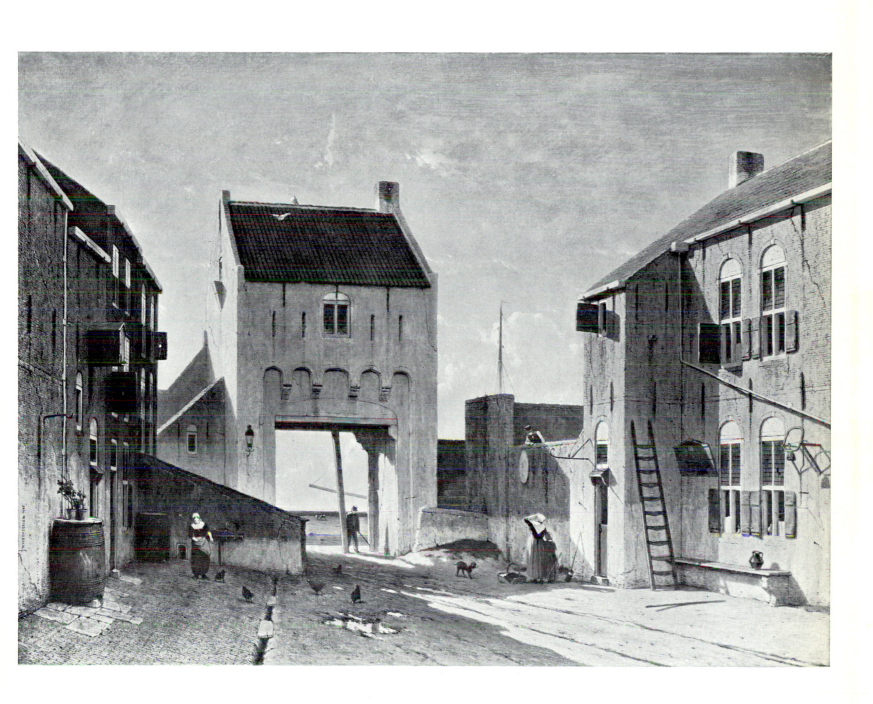

239. Wijnand Jan Joseph Nujen: *Ruins*. 1836. Oil on canvas, 39 x 55¾ inches. Amsterdam, Rijksmuseum.

Although he did not paint for long, he was none- theless instrumental in introducing a definite roman- tic vein into traditional Dutch realism, not only by his preference for depicting ruins and stormy skies but also by his dark colors.

240. Johan Barthold Jongkind: *Canal at Delft*. 1844. Oil on panel, 9¼ x 12⅜ inches. The Hague, Haags Gemeentemuseum.

Jongkind's landscapes follow the glorious tradition of Dutch realism, but his acute sense of light values, expressed in rapid, sensitive brushwork, was very meaningful for the impressionists, especially Monet.

241. Johan Barthold Jongkind: *The Castle of Miheung*. 1878. Oil on canvas, 15¾ x 25⅝ in- ches. The Hague, Haags Gemeentemuseum.

His encounter with the works of Bonington and Corot modified his realistic style, the light, the water, the atmosphere becoming more transparent. To heighten this transparency, he often used water- color.

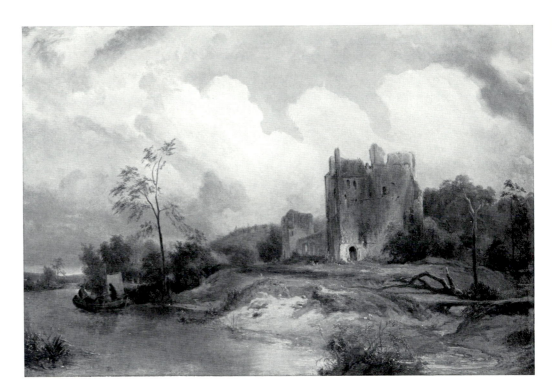

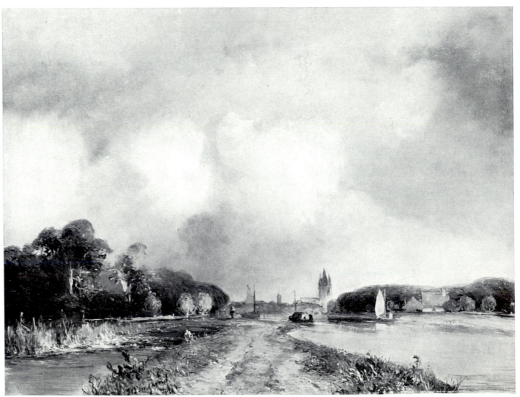

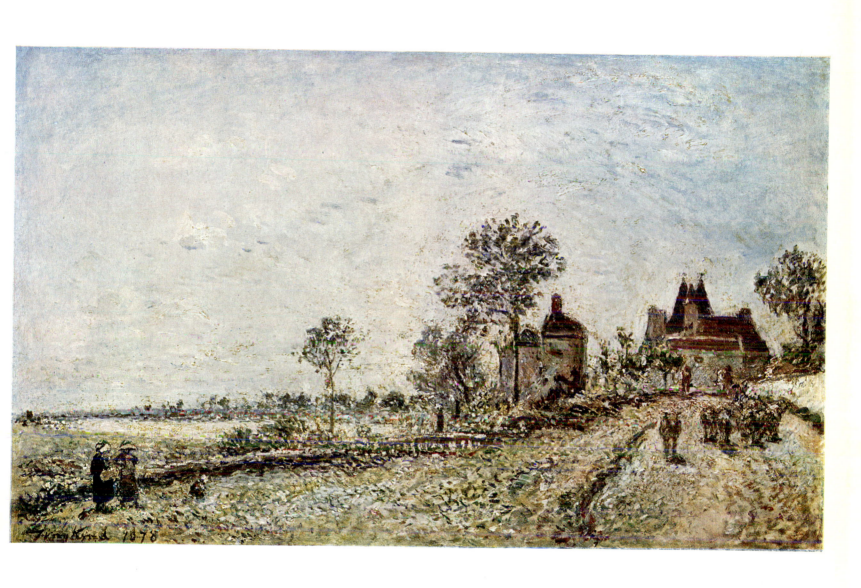

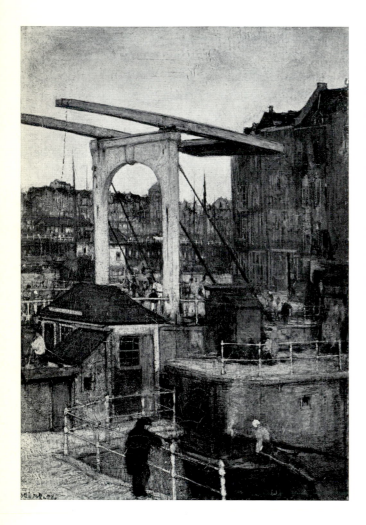

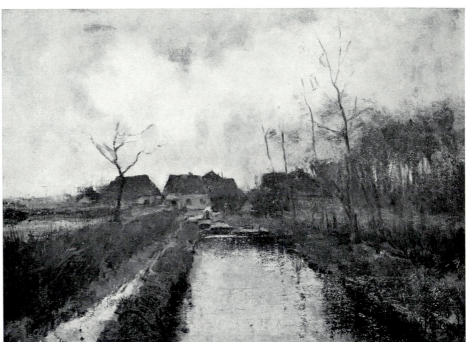

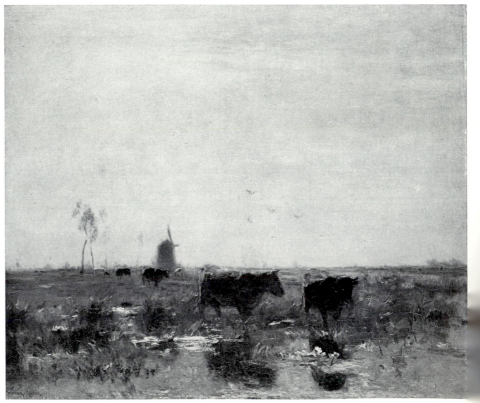

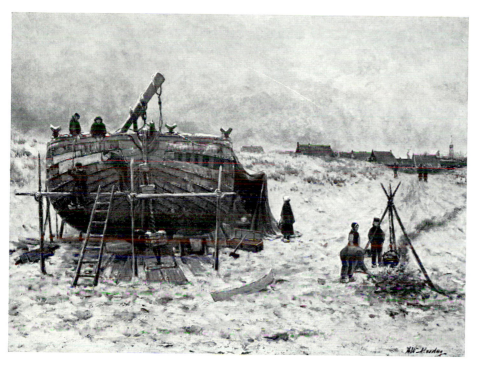

242. Matthijs Maris: *Souvenir of Amsterdam*. 1871. Oil on panel, 18⅛ x 13¾ inches. Amsterdam, Rijksmuseum.

This is a very constructed view of an old quarter of Amsterdam, with bridges, canals, barges, sailboats and houses facing the water. The realism in this painting is quite vigorous, even in the scrupulous details. The brown tones convey the sad splendor of autumn in Holland.

243. Anton Mauve: *House on the Canal*. Oil on canvas, 14⅛ x 19¼ inches. Amsterdam, Rijksmuseum.

The naturalism of the Barbizon School, expressed in views of the countryside, trees and canals, with houses that seem barely to emerge from the earth, is picked up by Mauve in subdued tones of grey and pale greens.

244. Willem Maris: *Meadow with Cows*. c. 1892. Oil on canvas, 34¼ x 43⅛ inches. Amsterdam, Rijksmuseum.

On the flat stretch of field, among the ponds and wagon roads lined by a few trees, an old windmill raises its sails. The very nature of the landscape, the almost constant greyness in the sky and the light convey a deep sense of a bleak world, severe and melancholy.

245. Hendrik Willem Mesdag: *Landscape with Boat*. Oil on canvas, 31⅛ x 39 inches. The Hague, Mesdag Museum.

Drawn up by the dunes, the boat is being overhauled for spring. On the tripod at right, tar is being heated over the fire. The artist's realism is frank and uninhibited, his color thick and somber, as the winter scene demands.

246. Jan Toorop: *Flower Garden near Oedstgeest*. 1885. Oil on canvas, 25⅞ x 30¼ inches. The Hague, Haags Gemeentemuseum.

Toorop was one of the founders of the group known as Les Vingt *in Brussels, and one of the first painters to accept Seurat's pointillism. His own pointillism is close and fine. The symbolist tendencies in his painting take him beyond naturalism in the search — through intense color — for somewhat complicated, precious, decorative effects.*

247. Jens Juel: *View of the Little Belt at Hindsgavl.* c. 1800. Oil on canvas, $16\frac{1}{2}$ x $24\frac{1}{2}$ inches. Copenhagen, Thorvaldsens Museum.

The landscape is taken up by two azure areas, the water and the sky, bordered by shores of pale greens and soft ochres, and by the trees, their branches and leaves etched one by one against the background. The tradition here still belongs to the eighteenth century and neoclassicism, but the artist betrays a finer feeling in his observation of nature, a feeling that can be considered romantic.

248. Pierre Chauvin: *The Garden of Villa Falconieri at Frascati.* 1810. Oil on canvas, $24\frac{3}{8}$ x $29\frac{3}{8}$ inches. Thorvaldsens Museum.

A tour of Italy was a basic element in the artistic training of northern painters, who preferred Rome and sometimes remained there for several years, especially since the Danish sculptor Thorvaldsen, who lived there, provided them support. In this landscape the grounds of the famous villa are seen with a sensitive eye and rendered with a fresh sense of color.

249. John Christian Clausen Dahl: *Mountain Landscape with Waterfall, Norway.* 1821. Oil on canvas, $38\frac{1}{8}$ x $53\frac{3}{4}$ inches. Copenhagen, Thorvaldsens Museum.

The romantic spirit of nature as a primordial force moves through this landscape, which might be considered theatrical but is nonetheless authentic in its content and extremely well painted. Dahl, a Norwegian, thinks of nature as a vital, positive reality and depicts it with a frank directness.

250. Johann Christian Reinhardt: *Italian Landscape with Hunter*. 1835. Oil on canvas, 17⅝ x 23⅝ inches. Copenhagen, Thorvaldsens Museum.

As much as there may be "heroic" elements in this landscape in the manner of Claude Lorrain, such as the imposing rock masses and the gnarled oaks, the general mood is one of utter serenity. The painter obviously was able to overcome the conventions in which he was trained to convey the charm of the place and the spacious luminosity.

251. Joseph Steingrübel: *View of Florence*. 1834. Oil on canvas, 17⅛ x 21¼ inches. Copenhagen, Thorvaldsens Museum.

The composition and the setting are still handled here in the eighteenth-century manner, in keeping with the tradition of the northern painters who began the genre of the Italian view. In the foreground some peasants are playing at bowls, while a monk begs alms. Beyond the umbrella pines, we can make out the principal buildings of Florence: the cupola of the cathedral, Palazzo Vecchio, Orsanmichele, Giotto's campanile and the rooftops of the houses along the Arno.

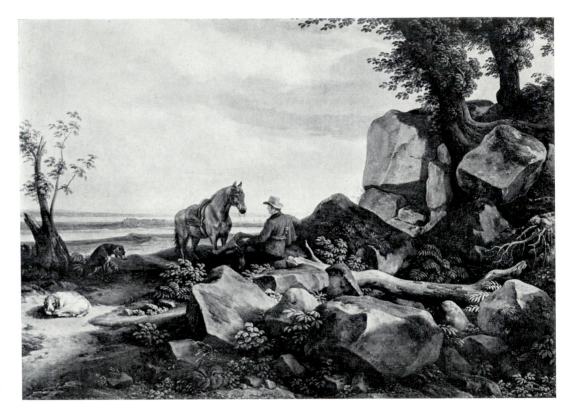

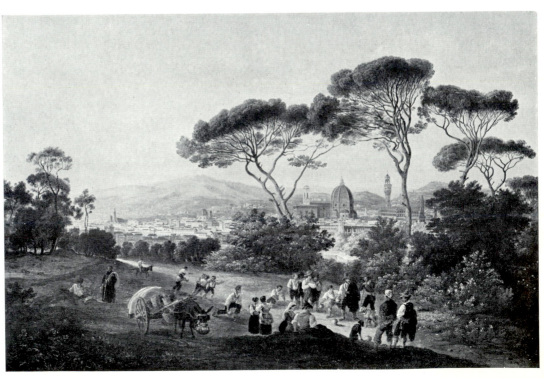

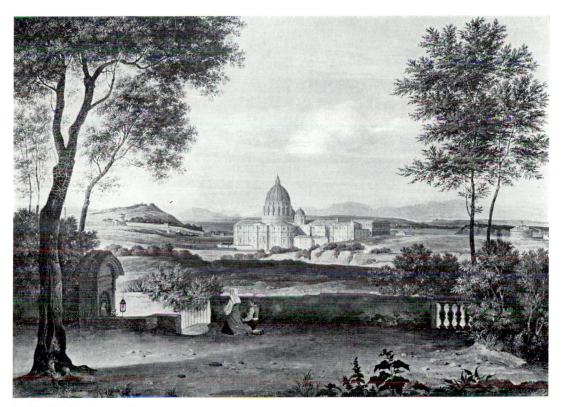

252. Heinrich Reinhold: *View of St. Peter's from the Park of Villa Doria Pamphili.* 1823. Oil on canvas, 14¼ x 19 inches. Copenhagen, Thorvaldsens Museum.

The artist does not betray any particular emotion in the face of this monumental view of St. Peter's, which he renders with lucid and necessary details. If anything, his feelings are absorbed in the effort to portray an ideal vision that tends to be classicizing and static.

253. Johan Thomas Lundbye: *Landscape near Arreso, with a View of the Dunes of Tisvilde.* 1838. Oil on canvas, 19 x 37¼ inches. Copenhagen, Thorvaldsens Museum.

Focused as if under a lens, somewhat reminiscent of certain English views by Canaletto, this landscape, with its dense clouds, its play of color, its sensitivity to silent space, indicates that naturalism had finally penetrated northern painting, opening it to greater awareness of feeling.

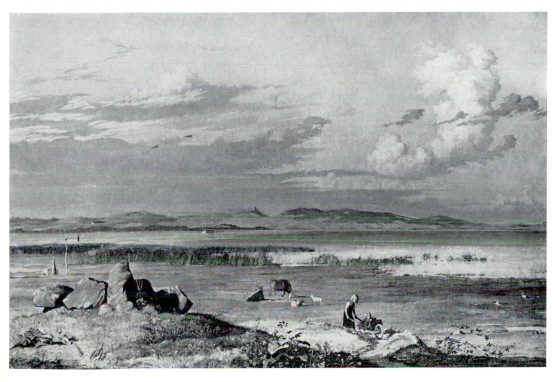

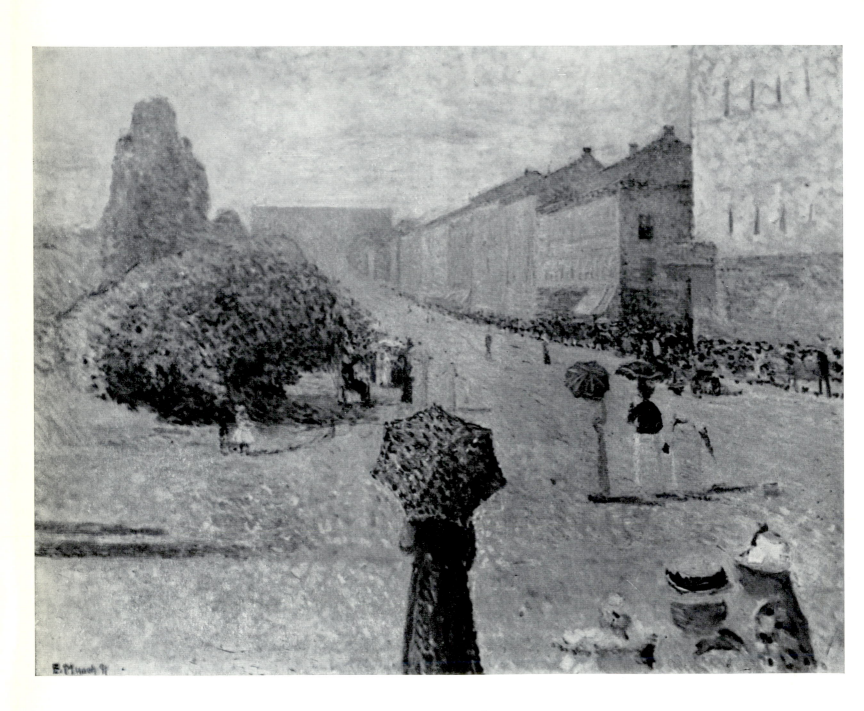

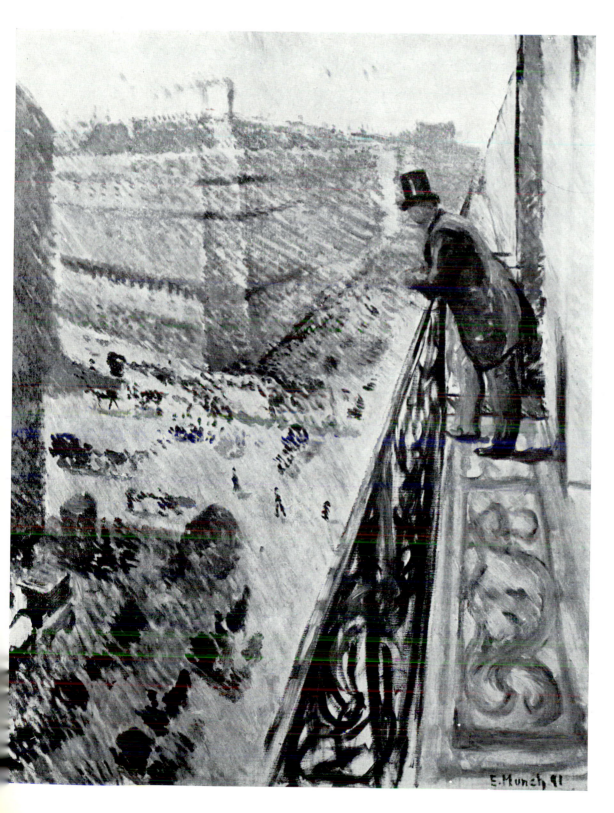

254. Edvard Munch: *A Spring Day in Karl Johann Street*. 1891. Oil on canvas, 49⅞ x 31½ inches. Bergen, Billedgalleri.

During his trips to Paris, Munch became influenced by the divisionists, by Pissarro more than Seurat, as we can see from his use of light, which remains impressionistic. Spring here has burst forth, but an uneasiness pervades the brilliant scene, suggested by the large empty areas and the violet tones.

255. Edvard Munch: *Rue Lafayette*. 1891. Oil on canvas, 36¼ x 28¾ inches. Oslo, National Gallery.

Light here streams down on the long prospect of the street, turning everything into highlights. The passersby and the carriages themselves are gleams of color. Monet and Pissarro had used this technique, but Munch has taken it to the point of nervous fragmentation.

256. Alexis Savrasov: *The Crows Have Arrived*. 1871. Oil on canvas, 24⅜ x 19⅛ inches. Moscow, Tretjakov Gallery.

Savrasov can be considered the founder of modern Russian landscape painting. His romantic temperament led him to depict the isolated provinces, their characteristic scenes and light, becoming the most important interpreter of his time of life in the country during the long, bleak winters.

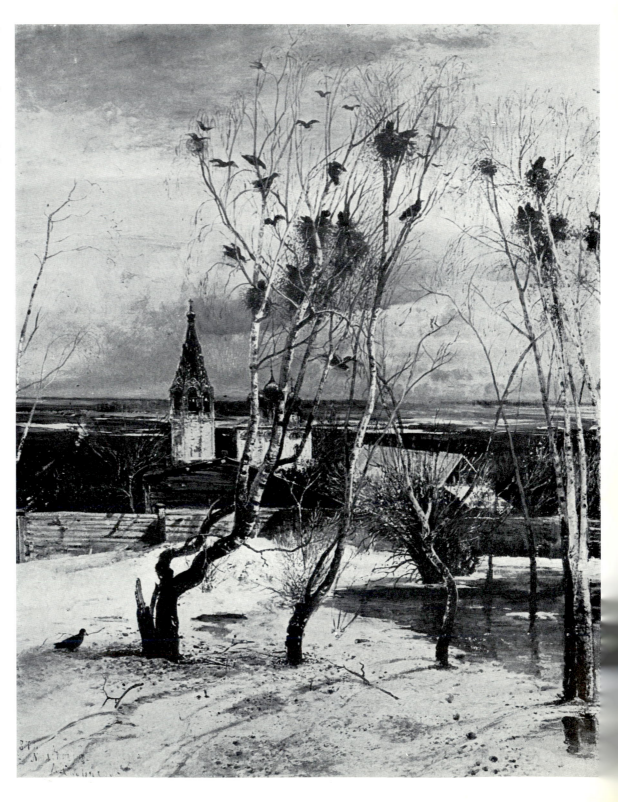

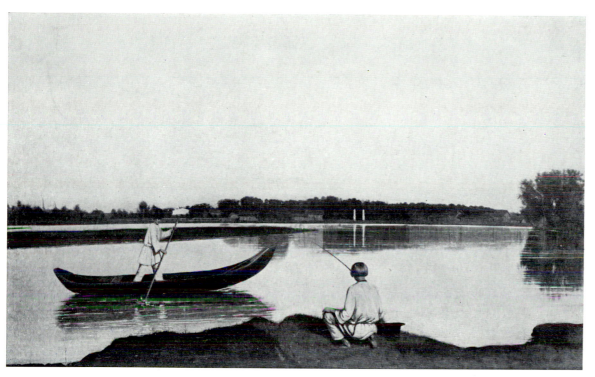

257. Gregor Soroka: *Fishermen*. Oil on canvas, 26 ¾ x 40 ⅛ inches. Leningrad, Russian Museum.

The realism of this landscape is rendered in grey lights that seem to transfix the scene, to capture a moment, thus revealing a deeply felt romantic inclination in the artist.

258. Vasili Vasilievich Vereschagin: *Kirgiz Tents on the River*. 1869-70. Oil on canvas, 11 x 16 ⅛ inches. Moscow, Tretjakov Gallery.

After having taught for years at the St. Petersburg Academy, he refused to be named professor and went instead to Paris to perfect his painting and learn about French art. He was more interested in the realists than in the impressionists, and with Meissonier's work as an influence, became famous in Russia as a painter of battle scenes. He travelled about Russia a great deal to depict the various regions and peoples. This scene is part of a series he painted in Turkestan between 1869 and 1873.

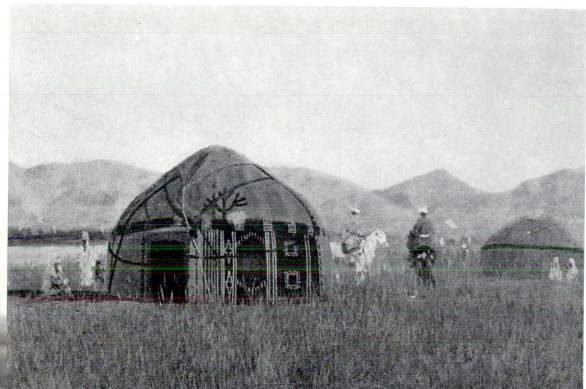

259. Vasili Ivanovich Surikov: *Winter in Moscow*. 1887. Oil on canvas, 10¼ x 13¾ inches. Moscow, Tretjakov Gallery.
A realist painter, he successfully dedicated himself to the historical genre, taking his subjects from episodes in Russian history. He was a capable portraitist as well, and a landscape painter, as we can see in this winter scene where his concern for his subject gives way to his sober and compelling interpretation.

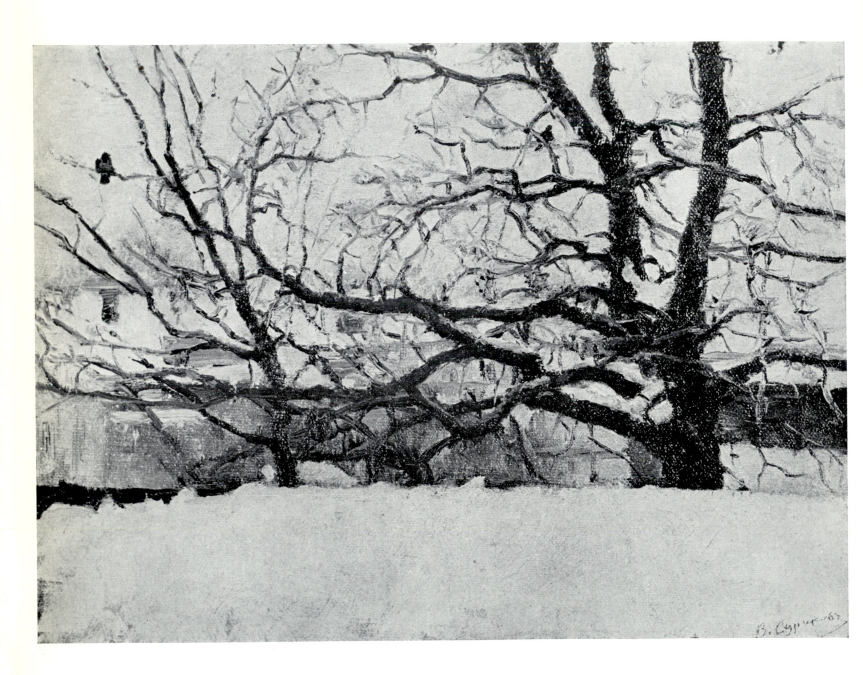

260. Isaak Levitan: *Tolling of the Evening Bells*. 1892. Oil on canvas, 34¼ x 42⅜ inches. Moscow, Tretjakov Gallery.
He studied under Savrasov and used the same technique to render the Russian landscape, its stillness and profound sadness.

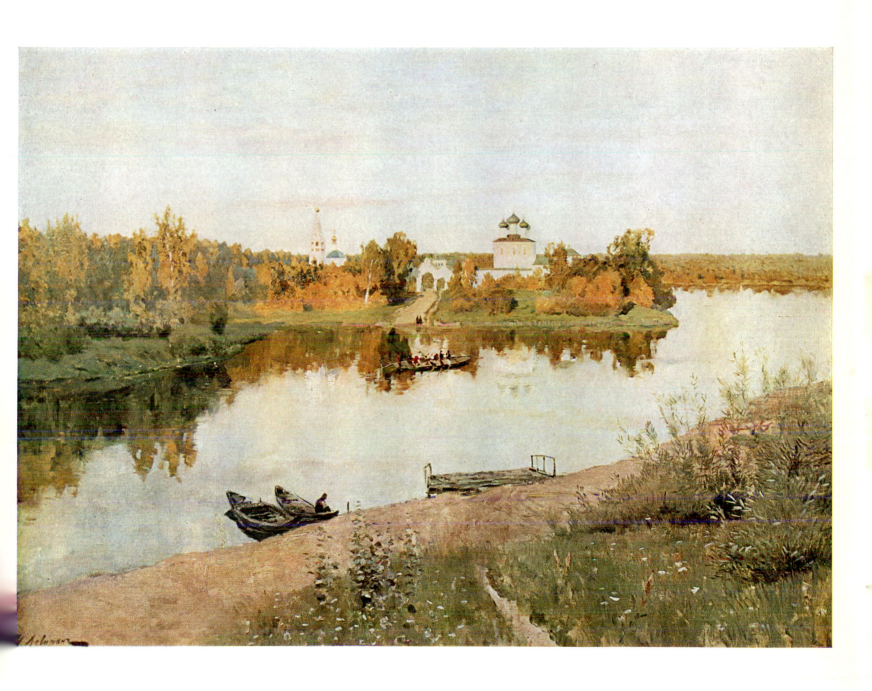

261. Isaak Levitan: *Eternal Peace*. 1894. Oil on canvas, 59 x 81½ inches. Moscow, Tretjakov Gallery.

In 1898 he became professor in the landscape atelier at the School of Painting, Sculpture and Architecture, where he had studied with Savrasov.
riverscape, its immense space seen with Chekhovian detachment, is an apt metaphor for the idea of eternal silence that inspired the artist.

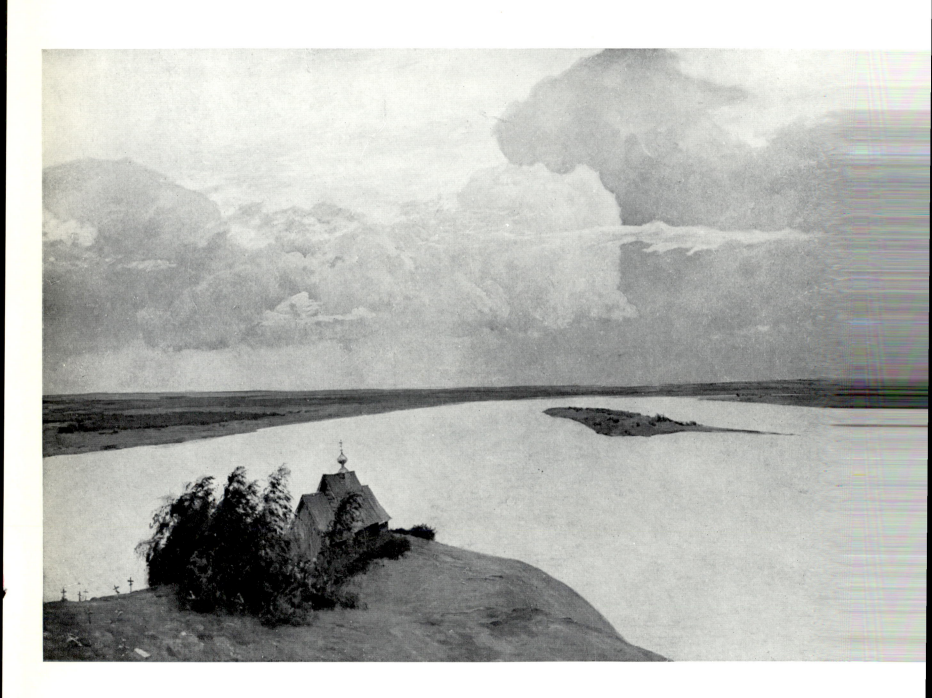

THE UNITED STATES

When the travellers reached the verge of the precipice, they saw at a glance the truth of the scout's declaration, and the admirable foresight with which he had led them to their commanding station.

The mountain on which they stood, elevated, perhaps, a thousand feet in the air, was a high cone that rose a little in advance of that range which stretches for miles along the western shores of the lake, until meeting its sister piles, beyond the water, it ran off towards the Canadas in confused and broken masses of rock, thinly sprinkled with evergreens. Immediately at the feet of the party, the southern shore of the Horican swept in a broad semicircle, from mountain to mountain, marking a wide strand, that soon rose into an uneven and somewhat elevated plain. To the north, stretched the limpid and, as it appeared from that dizzy height, the narrow sheet of the "holy lake," indented with numberless bays, embellished by fantastic headlands, and dotted with countless islands. At the distance of a few leagues, the bed of the waters became lost among mountains, or was wrapped in the masses of vapor that came slowly rolling along their bosom, before a light morning air. But a narrow opening between the crests of the hills pointed out the passage by which they found their way still further north, to spread their pure and ample sheets again, before pouring out their tribute into the distant Champlain. To the south stretched the defile, or rather broken plain, so often mentioned. For several miles in this direction, the mountains appeared reluctant to yield their dominion, but within reach of the eye they diverged, and finally melted into thelev el and sandy lands, across which we have accompanied our adventurers in their double journey. Along both ranges of hills, which bounded the opposite sides of the lake and valley, clouds of light vapor were rising in spiral wreaths from the uninhabited woods, looking like the smokes of hidden cottages; or rolled lazily down the declivities, to mingle with the fogs of the lower land. A single, solitary, snow-white cloud floated above the valley, and marked the spot beneath which lay the silent pool of the "bloody pond."

The Last of the Mohicans, 1826.

J. FENIMORE COOPER

Thine eyes shall see the light of distant skies;
 Yet, Cole! thy heart shall bear to Europe's strand
 A living image of our own bright land,
Such as upon thy glorious canvas lies;
Lone lakes — savannas where the bison roves —
 Rocks rich with summer garlands — solemn streams —
 Skies, where the desert eagle wheels and screams —
Spring bloom and autumn blaze of boundless groves,
Fair scenes shall greet thee where thou goest — fair,
 But different — everywhere the trace of men,
 Paths, homes, graves, ruins, from the lowest glen
To where life shrinks from the fierce Alpine air,
 Gaze on them, till the tears shall dim thy sight,
 But keep that earlier, wilder image bright.

"To Cole, the Painter, Departing for Europe," 1829.

WILLIAM CULLEN BRYANT

...To speak truly, few adult persons can see nature. Most persons do not see the sun. At least they have a very superficial seeing. The sun illuminates only the eye of the man, but shines into the eye and the heart of the child. The lover of nature is he whose inward and outward senses are still truly adjusted to each other; who has retained the spirit of infancy even into the era of manhood. His intercourse with heaven and earth becomes part of his daily food.

In the presence of nature a wild delight runs through the man, in spite of real sorrows. Nature says — he is my creature, and maugre all his impertinent griefs, he shall be glad with me. Not the sun or the summer alone, but every hour and season yields its tribute of delight; for every hour and change corresponds to and authorizes a different state of the mind, from breathless noon to grimmest midnight. Nature is a setting that fits equally well a comic or a mourning piece. In good health, the air is a cordial of incredible virtue. Crossing a bare common, in snow puddles, at twilight, under a clouded sky, without having in my thoughts any occurrence of special good fortune, I have enjoyed a perfect exhilaration. I am glad to the brink of fear. In the woods, too, a man casts off his years, as the snake his slough, and at what period soever of life is always a child. In the woods is perpetual youth. Within these plantations of God, a decorum and sanctity reign, a perennial festival is dressed, and the guest sees not how he should tire of them in a thousand years. In the woods, we return to reason and faith. There I feel that nothing can befall me in life — no disgrace, no calamity (leaving me my eyes), which nature cannot repair. Standing on the bare ground — my head bathed by the blithe air, and uplifted into infinite space — all mean egotism vanishes. I become a transparent eyeball; I am nothing; I see all; the currents of the Universal Being circulate through me; I am part or parcel of God....

Nature, 1836. RALPH WALDO EMERSON

Monday, October 18th [1841]
There has been a succession of days which were cold and bright in the forenoon, and gray, sullen, and chill towards night. The woods have now taken a soberer tint than they wore at my last date. Many of the shrubs which looked brightest a little while ago are now wholly bare of leaves. The oaks have generally a russet-brown shade, although some of them are still green, as are likewise other scattered trees in the forests. The bright yellow and the rich scarlet are no more to be seen. Scarcely any of them will now bear a close examination; for this shows them to be rugged, wilted, and of faded, frost-bitten hue; but at a distance, and in the mass, and enlivened by the sun, they have still somewhat of the varied splendor which distinguished them a week ago. It is wonderful what a difference the sunshine makes; it is like varnish, bringing out the hidden veins in a piece of rich wood. In the cold, gray atmosphere, such as that of most of our afternoons now, the landscape lies dark, — brown, and in a much deeper shadow than if it were clothed in green. But, perchance, a gleam of sun falls on a certain spot of distant shrubbery or woodland, and we see it brighten with many hues, standing forth prominently from the dimness around it. The sunlight gradually spreads, and the whole sombre scene is changed to a motley picture, — the sun bringing out many shades of color, and converting its gloom to an almost laughing cheerfulness. At such times I almost doubt whether the foliage has lost any of its brilliancy. But the clouds intercept the sun again, and lo! old Autumn appears, clad in his cloak of russet-brown. Beautiful now, while the general landscape lies in shadow, looks the summit of a distant hill (say a mile off), with the sunshine brightening the trees that cover it. It is noticeable that the outlines of hills, and the whole bulk of them at the distance of several miles, become stronger, denser, and more substantial in this autumn atmosphere and in these autumnal tints than in summer. Then they looked blue, misty, and dim. Now they show their great humpbacks more plainly, as if they had drawn nearer to us.

Passages from the American Note-Books, 1841. NATHANIEL HAWTHORNE

September 1st. [1838]
Last evening, during a walk, Greylock and the whole of Saddleback were at first imbued with a mild, half-sunshiny tinge, then grew almost black, — a huge, dark mass lying on

the back of the earth and encumbering it. Stretching up from behind the black mountain, over a third or more of the sky, there was a heavy, sombre blue heap or ledge of clouds, looking almost as solid as rocks. The volumes of which it was composed were perceptible by translucent lines and fissures; but the mass, as a whole, seemed as solid, bulky, and ponderous in the cloud-world as the mountain was on earth. The mountain and cloud together had an indescribably stern and majestic aspect. Beneath this heavy cloud, there was a fleet or flock of light, vapory mists, flitting in middle air; and these were tinted, from the vanished sun, with the most gorgeous and living purple that can be conceived, — a fringe upon the stern blue. In the opposite quarter of the heavens, a rose-light was reflected, whence I know not, which colored the clouds around the moon, then well above the horizon, so that the nearly round and silver moon appeared strangely among roseate clouds, — sometimes half obscured by them.

Passages from the American Note-Books, 1838. NATHANIEL HAWTHORNE

Oct. 7, 1857.
Halfway up Fair Haven Hill, I am surprised for the thousandth time by the beauty of the landscape, and sit down by the orchard wall to behold it at my leisure. It is always incredibly fair, but ordinarily we are mere objects in it, and not witnesses of it. I see through the bright October air a valley, some two miles across, extending southwest and northeast, with a broad, yellow meadow tinged with brown at the bottom, and a blue river winding slowly through it northward, with a regular edging of low bushes of the same color with the meadow. Skirting the meadow are straggling lines, and occasionally large masses, one quarter of a mile wide, of brilliant scarlet and yellow and crimson trees, backed by green forests and green and russet fields and hills, and on the hills around shoot up a million scarlet and orange and yellow and crimson fires. Here and there amid the trees, often beneath the largest and most graceful of them, are white or gray houses. Beyond stretches a forest, wreath upon wreath, and between each two wreaths I know lies a similar vale, and far beyond all, on the verge of the horizon, rise half a dozen dark blue mountain summits....

The Journal of Henry David Thoreau. HENRY DAVID THOREAU

As I sat on the high bank at the east end of Walden this afternoon at five o'clock, I saw by a peculiar intention of the eye, a very striking, sub-aqueous rainbow-like phenomenon. A passer-by might have noticed the reflections of those bright-tinted shrubs along the high shore on the sunny side, but unless on the alert for such effects he would have failed to perceive the full beauty of the phenomenon. Those brilliant shrubs, from three to a dozen feet in height, were all reflected, dimly so far as the details of leaves, etc., were concerned, but brightly as to color, and of course in the order in which they stood, scarlet, yellow, green, etc.; but there being a slight ripple on the surface, these reflections were not true to the height of their substances, only as to color, breadth of base, and order, but were extended downward with mathematical perpendicularity three or four times too far for the height of the substances, forming sharp pyramids of the several colors gradually reduced to mere dusky points. The effect of this prolongation was a very agreeable softening and blending of the colors, especially when a small bush of one bright tint stood directly before another of a contrary and equally bright tint. It was just as if you were to brush firmly aside with your hand or a brush a fresh hue of paint or so many lumps of friable colored powders. There was accordingly a sort of belt, as wide as the height of the hill, extending downward along the whole north or sunny side of the pond, composed of exceedingly short and narrow inverted pyramids of the most brilliant colors intermixed. I have seen similar inverted pyramids in the old drawings of tattooing about the waists of the aborigines of this country. Walden, like an Indian maiden, wears this broad, rainbow-like belt of brilliant-colored points

or cones round her waist in October. The colors seem to be reflected and re-reflected from ripple to ripple, losing brightness each time by the softest possible gradation, and tapering towards the beholder.

The Journal of Henry David Thoreau. HENRY DAVID THOREAU

Shot gold, maroon and violet, dazzling silver, emerald, fawn,
The earth's whole amplitude and Nature's multiform power consign'd for once to colors;
The light, the general air possess'd by them — colors till now unknown,
No limit, confine — not the Western sky alone — the high meridian — North, South, all,
Pure luminous color fighting the silent shadows to the last.

"A Prairie Sunset," 1888. WALT WHITMAN

I jot this mem. in a wild scene of woods and hills, where we have come to visit a waterfall. I never saw finer or more copious hemlocks, many of them large, some old and hoary. Such a sentiment to them, secretive, shaggy — what I call weather-beaten and let-alone — a rich underlay of ferns, yew sprouts and mosses, beginning to be spotted with the early summer wild-flowers. Enveloping all, the monotone and liquid gurgle from the hoarse impetuous copious fall — the greenish-tawny, darkly transparent waters, plunging with velocity down the rocks, with patches of milk-white foam — a stream of hurrying amber, thirty feet wide, risen far back in the hills and woods, now rushing with volume — every hundred rods a fall, and sometimes three or four in that distance. A primitive forest, druidical, solitary and savage — not ten visitors a year — broken rocks everywhere — shade overhead, thick underfoot with leaves — a just palpable wild and delicate aroma.

"An Ulster County Waterfall," from *Specimen Days*, 1879. WALT WHITMAN

> The years are many since, at first,
> For dreamed-of wonders all athirst,
> I saw on Winnipesaukee fall
> The shadow of the mountain wall....
>
> Still, when the sun of summer burns,
> My longing for the hills returns;
> And northward, leaving at my back
> The warm vale of the Merrimac,
> I go to meet the winds of morn,
> Blown down the hill-gaps, mountain-born,
> Breathe scent of pines, and satisfy
> The hunger of a lowland eye.
>
> Again I see the day decline
> Along a ridged horizon line;
> Touching the hill-tops, as a nun
> Her beaded rosary, sinks the sun.
> One lake lies golden, which shall soon
> Be silver in the rising moon;
> And one, the crimson of the skies
> And mountain purple multiplies....

"A Summer Pilgrimage," 1883. JOHN GREENLEAF WHITTIER

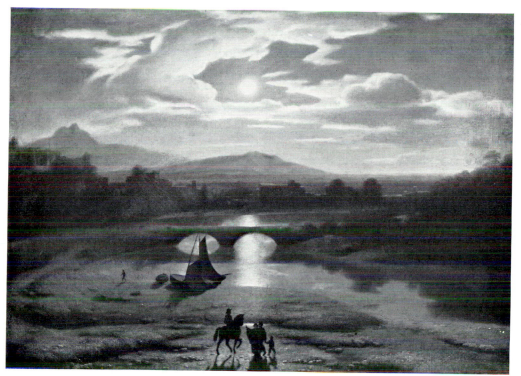

262. Washington Allston: *Moonlit Landscape.*
1819. Oil on canvas, 24 x 35 inches. Boston,
Museum of Fine Arts. Gift of Dr. W.S. Bigelow.

*Glasslike water, absolute stillness and luminous
moonlight convey a poetic mood of reverie characteristic
of the tranquil romanticism of Allston's late works.
Rendering of light effects was a major preoccupation of
nineteenth-century American landscape painters.*

263. Edward Hicks: *Niagara Falls.* ca. 1835.
Oil on wood, 37¾ x 44½ inches. Williamsburg,
Virginia, Abby Aldrich Rockefeller Folk Art
Collection.

*For Hicks as for other nineteenth-century American
painters, Niagara Falls was the greatest example of
the sublime in nature, an expression of God's power.
Characteristically, he chose to paint the Falls from a
print after a painting by John Vanderlyn even though
he had visited the site himself.*

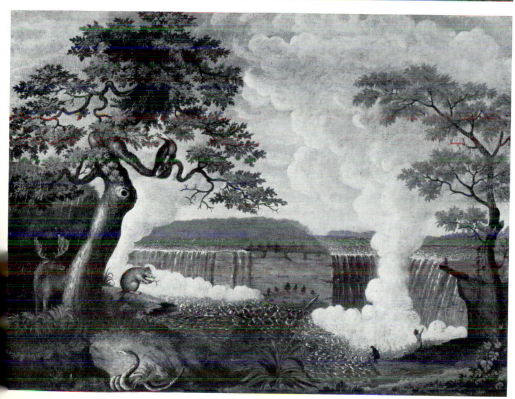

264. Thomas Doughty: *In Nature's Wonderland*. 1835. Oil on canvas, 24 ¼ x 30 inches. Detroit, Detroit Institute of Arts.

The viewer joins the small figure in the painting in his contemplation of the wonders of nature. Though often less interested in topographical representation than in a generalized pastoral effect, Doughty here captures the grandeur of a particular place and the idyllic atmosphere pervading the scene.

265. Alvan Fisher: *Sugar Loaf Mountain*. 1821. Oil on canvas, 25 ½ x 33 inches. Boston, Boston Museum of Fine Arts, M. and M. Karolik Collection.

Through the use of minute figures dwarfed by an immense landscape, the artist expresses the overwhelming magnitude of nature. This striking contrast in scale, combined with the hazy mist of the background, produces a romantic feeling characteristic of early American landscape painting.

266. Asher B. Durand: *Kindred Spirits*. 1849. Oil on canvas, 46 x 36 inches. New York, New York Public Library.

Commissioned as a gift to William Cullen Bryant in gratitude for his eulogy of Thomas Cole, the painting symbolizes the sensitivity to the beauties of nature shared by the poet and the painter. Contrasts of the meticulous foreground detail with the hazy distance and the smallness of the men with the immensity of nature are the sources of the picture's drama.

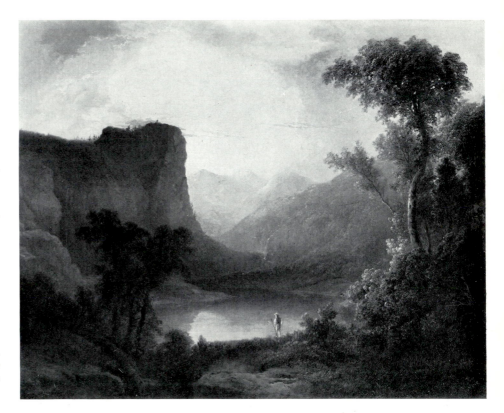

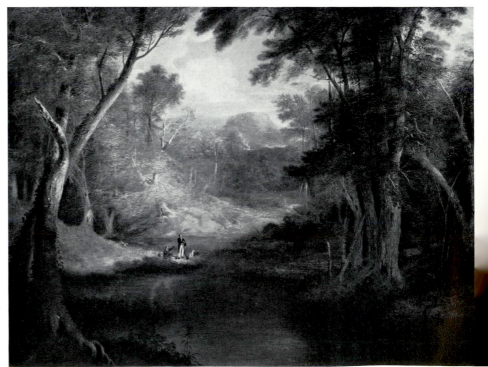

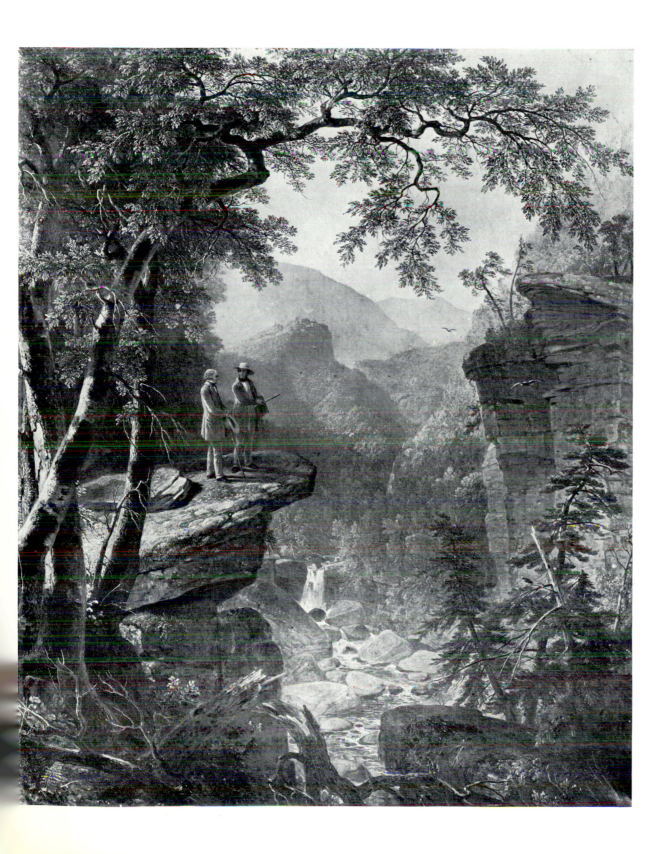

267. Thomas Cole: *The Course of Empire: Desolation*. 1836. Oil on canvas, 39½ x 61 inches. New York, The New-York Historical Society. *The scene is set at twilight in early autumn in this last canvas of an allegorical series expressing successive changes in nature and in the maturation of man. Ivy overgrowing the ruins of civilization and elegiac, emanating light produce a sense of nostalgia and awareness of the transience of human creations.*

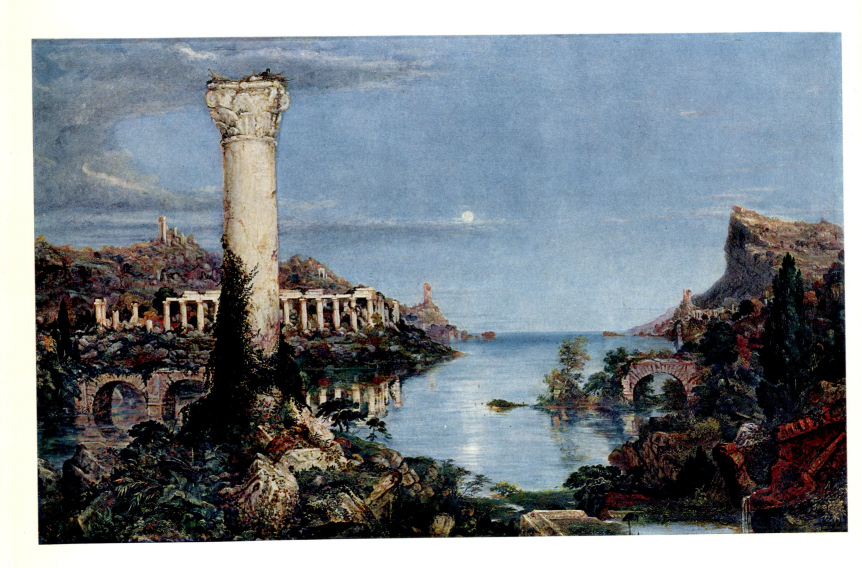

268. Fitz Hugh Lane: *Ships in Ice Off Ten Pound Island, Gloucester*. 1850's. Oil on canvas, 12 x 19¾ inches. Boston, Museum of Fine Arts, M. and M. Karolik Collection.

The intense recording of observed detail combines with classic distribution of forms and consciousness of light as a poetic, radiating substance to produce balance between the real and the ideal. The sense of stopped time, effected through the utmost compositional control and effacement of stroke, is basic to the American luminist vision.

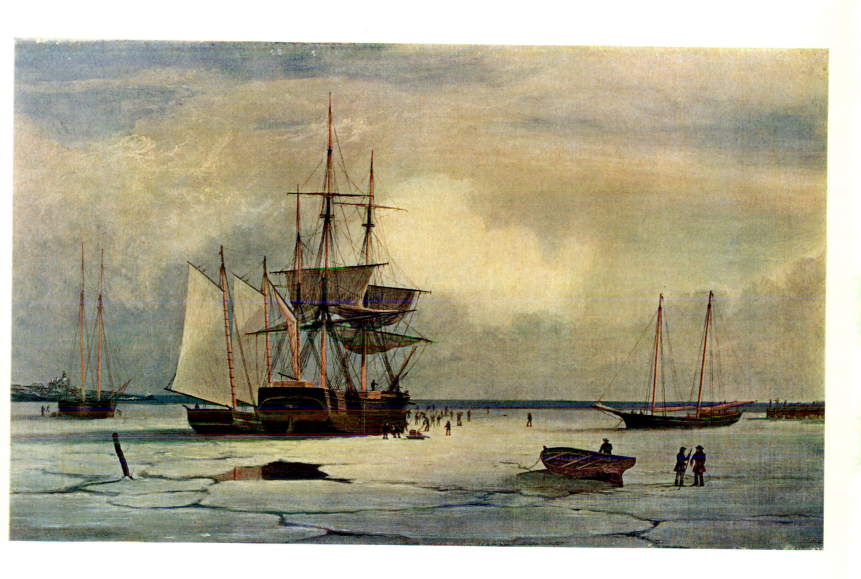

269. William Sidney Mount: *Long Island Farmhouses.*
c. 1854-1859. Oil on canvas, 21⅞ x 29⅞ inches. New
York, Metropolitan Museum of Art. Gift of Louise
F. Wickham in memory of her father, William H.
Wickham, 1928.

*Painted from his "portable studio," the picture is unusual
in Mount's work for the primacy of landscape over genre
elements. The artist has accurately conveyed the atmosphere
of the day and the typical appearance of his surroundings.*

270. George Caleb Bingham: *Landscape with Fisher-
man.* c. 1850. Oil on canvas, 24¾ x 30 inches. St.
Louis, Missouri Historical Society.

*Typical of Bingham's landscapes of the early fifties, the
scenes is a pleasing but formulaic arrangement of rocks,
foliage and water rather than a topographical recording.
Subtly rendered light, shadow and atmospheric effects rein-
force the tranquil mood.*

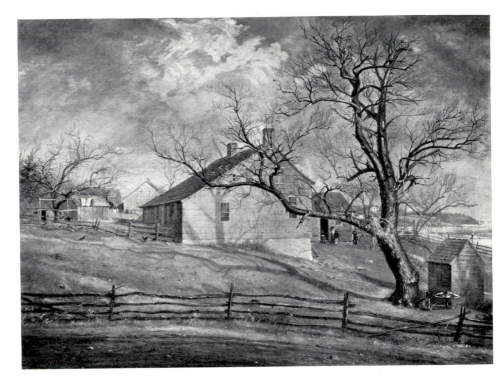

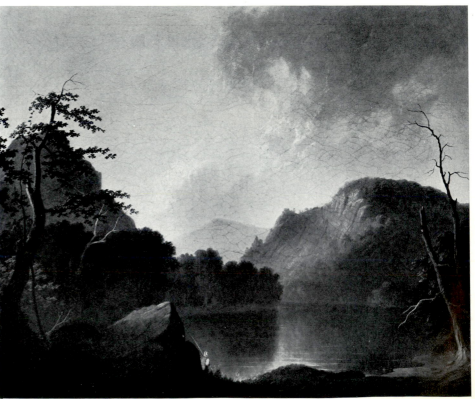

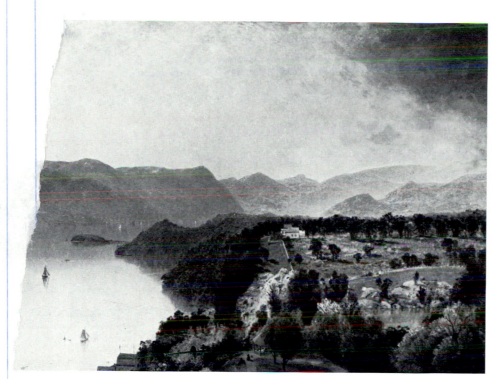

271. John Frederick Kensett: *View from West Point*. 1863. Oil on canvas, 20 x 34 inches. New York, The New-York Historical Society.

Careful observation of natural phenomena produces a masterly treatment of hazy atmosphere and shimmering water in glowing color. The sense of stopped time — an eternal moment — as well as the long horizontal format, links Kensett with the luminists, Heade and Lane.

272. George Henry Durrie: *Returning to the Farm*. 1861. Oil on canvas, 25 x 36 inches. New York, The New-York Historical Society.

The artist's great interest in weather conditions is expressed in notes in his Diary *on the beauties of the winter landscape. Here he captures a winter day in the New England countryside with subtle harmony of color and exquisite finish.*

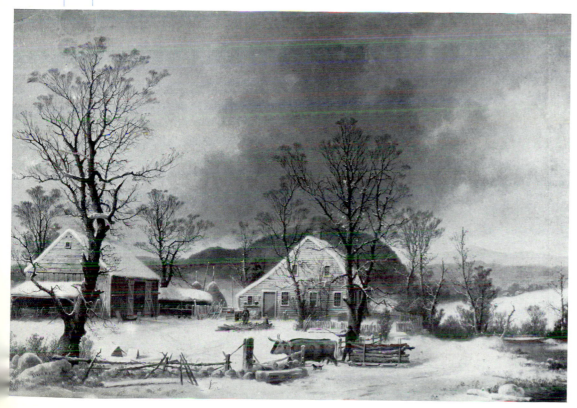

273. Martin Johnson Heade: *Approaching Storm: Beach Near Newport.* 1860's. Oil on canvas, 28 x 58¼ inches. Boston, Museum of Fine Arts, M. and M. Karolik Collection.

Heade records the appearance and mood of rock, sea and atmosphere, but, through infinitesmal observation and detail, carries realism into the realm of the surreal. The painting exemplifies the American luminist vision in its classic structure, negation of stroke and radiating, emanating light.

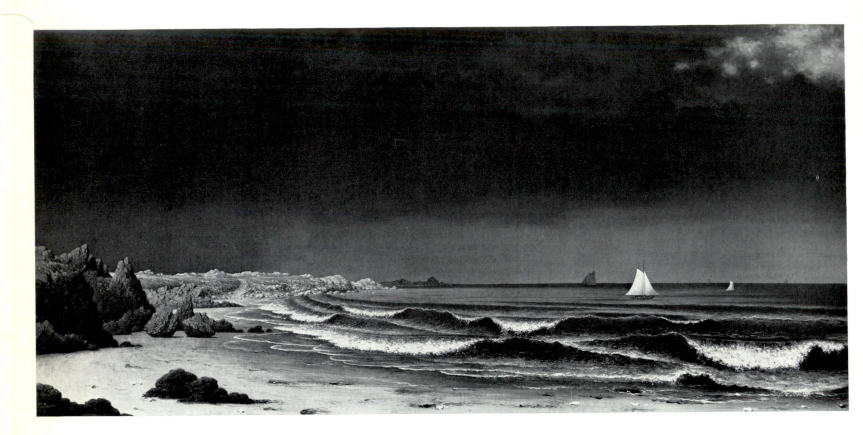

274. Sanford Robinson Gifford: *In the Wilderness*. 1861. Oil on canvas, 30 x 54 inches. Toledo, Ohio, Toledo Museum of Art.
The ethereal delicacy of all-enveloping, luminous, diffused light dematerializes forms and conveys a sense of eternal stillness. This landscape is an early example of Gifford's mature and characteristic style.

275. Worthington Whittredge: *Camp Meeting*. 1874. Oil on canvas, 16 x 40 11/16 inches. New York, Metropolitan Museum of Art. Lazarus Fund, 1913.
Although he depicted what must have been a common rural activity, the painter was more interested in the effect of light and shadow in sky, stream and trees. The measured distribution of forms and contrasts of scale establish a sense of poetic tranquillity, characteristic of Whittredge at his best.

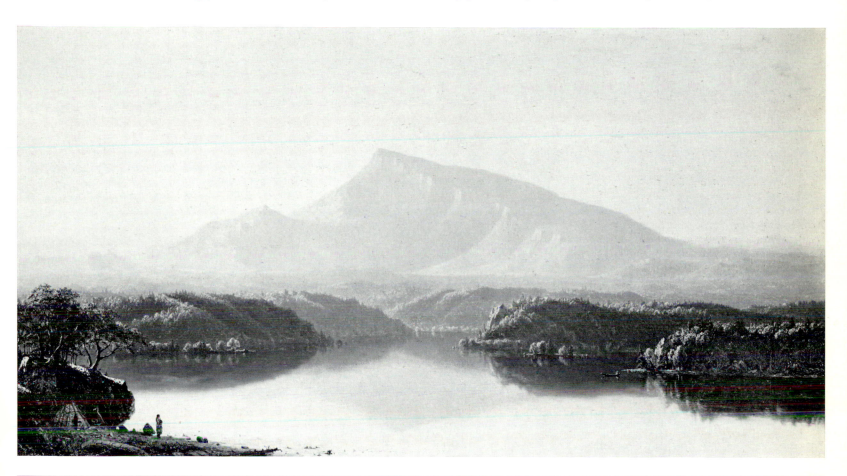

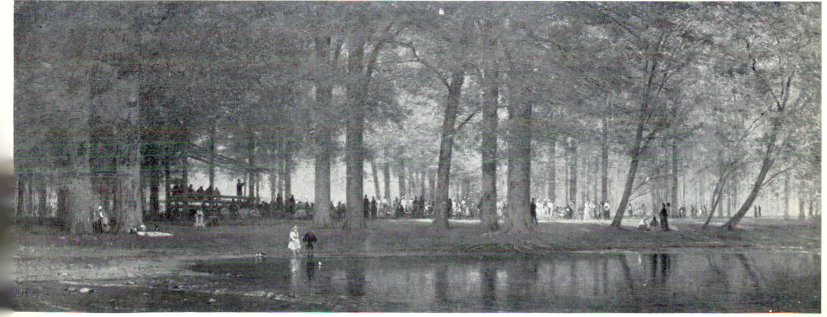

276. Jasper F. Cropsey: *Autumn on the Hudson River*. 1860. Oil on canvas, 60 x 108 inches. Washington, D.C., National Gallery of Art. Gift of the Avalon Foundation.

A panoramic view of the vicinity of Storm King mountain, the picture is impressive for its immense size and remarkable accumulation of accurately rendered details. His most ambitious work to that date, it was enthusiastically greeted by the English public who marveled as much at the stunning colors of the American autumn as at Cropsey's ability to capture the scene.

277. George Inness: *Lackawanna Valley*. 1855. Oil on canvas, 34 x 50 inches. Washington, D.C., National Gallery of Art. Gift of Mrs. Huttleston Rogers.

In painting this commissioned advertisement for the Delaware, Lackawanna and Western Railroad, the artist has concentrated less on the roundhouse, train and tracks than on the sweep of green fields and glowing, hazy atmosphere. Although he retains the panoramic vision of the Hudson River tradition, he displays a new technical ease and unity gained from contact with Barbizon paintings.

278. Frederick Edwin Church: *Sunrise off the Maine Coast*. 1863. Oil on canvas, 37 x 47 inches. Hartford, Connecticut, The Wadsworth Atheneum.

The spectator is brought into immediate confrontation with the rugged New England coast, the crashing water, and the glowing sun obscured by clouds. Lacking the melodramatic overtones of many of his larger works, the scene conveys pure cosmic vitality and force.

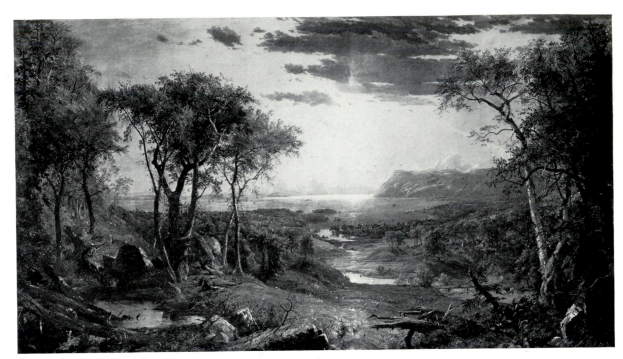

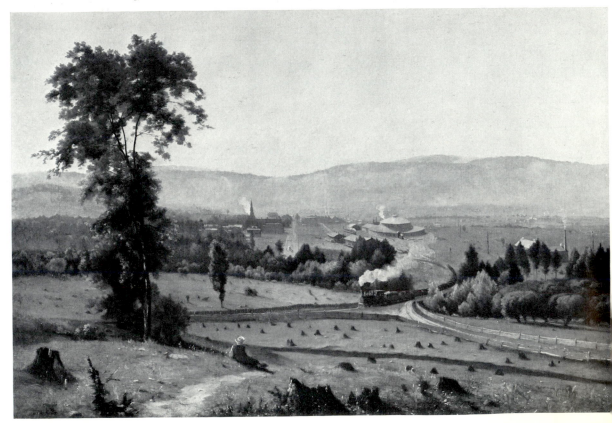

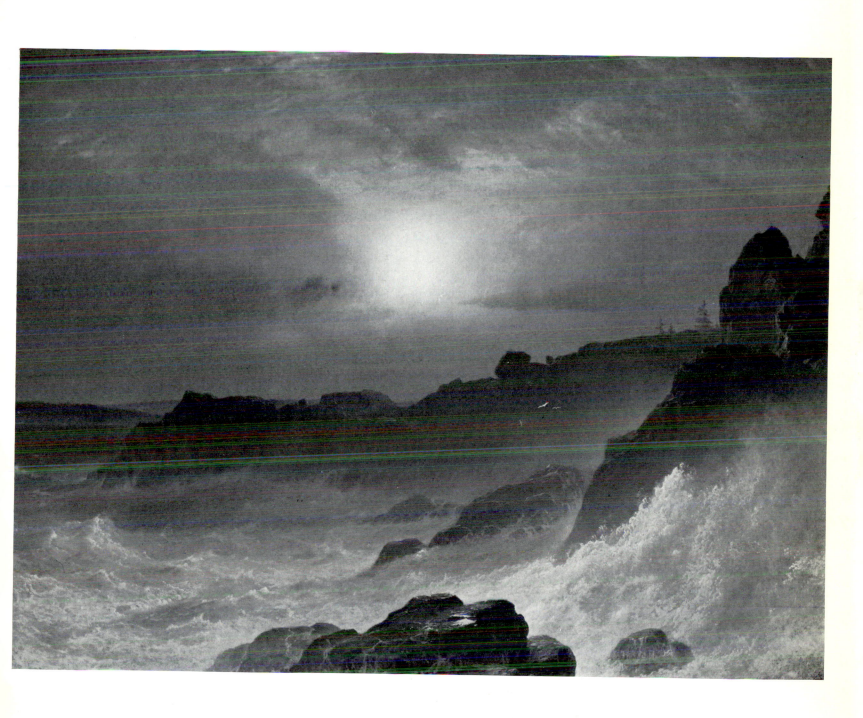

279. Thomas Eakins: *Sailboats Racing on the Delaware.* 1874. Oil on canvas, 24⅛ x 36⅛ inches. Philadelphia, Philadelphia Museum of Art. *Rarely preoccupied by landscape for its own sake, Eakins used a sailing scene to demonstrate meticulous draftsmanship and mastery in the arrangement of compositional elements. Deliberate mathematical construction and harshly brilliant sunlight eternalize the moment, denying motion despite the breeze.*

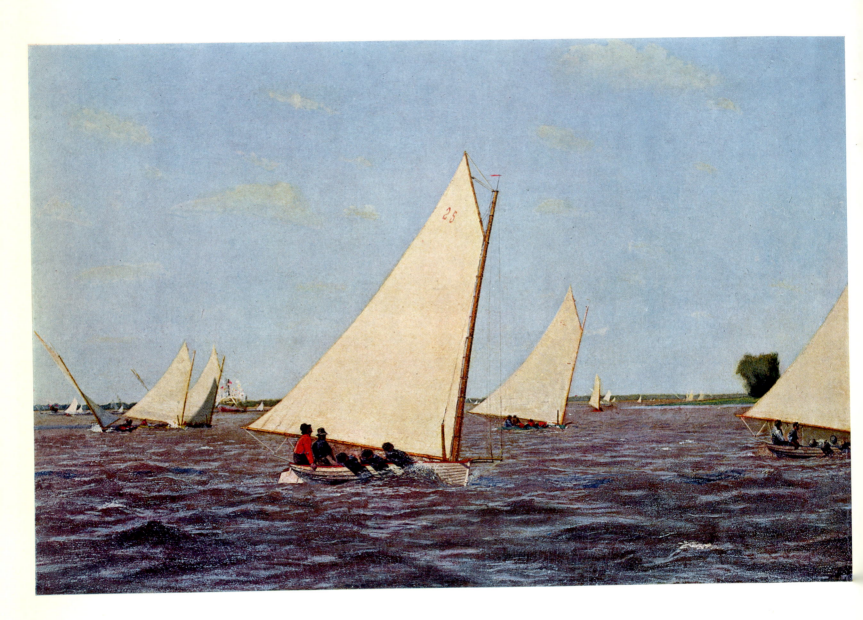

280. John Henry Twachtman: *Niagara in Winter*. 1890's. Oil on canvas, 30 x 25 inches. New Britain, Connecticut, New Britain Museum of American Art.

Unlike earlier American artists, he sought no expression of romantic sublimity in depicting the Falls. Bringing the spectator close to the swirling foam, he conveyed his enjoyment of the play of light over moving water and created a visual symphony of close tonalities of blue and white.

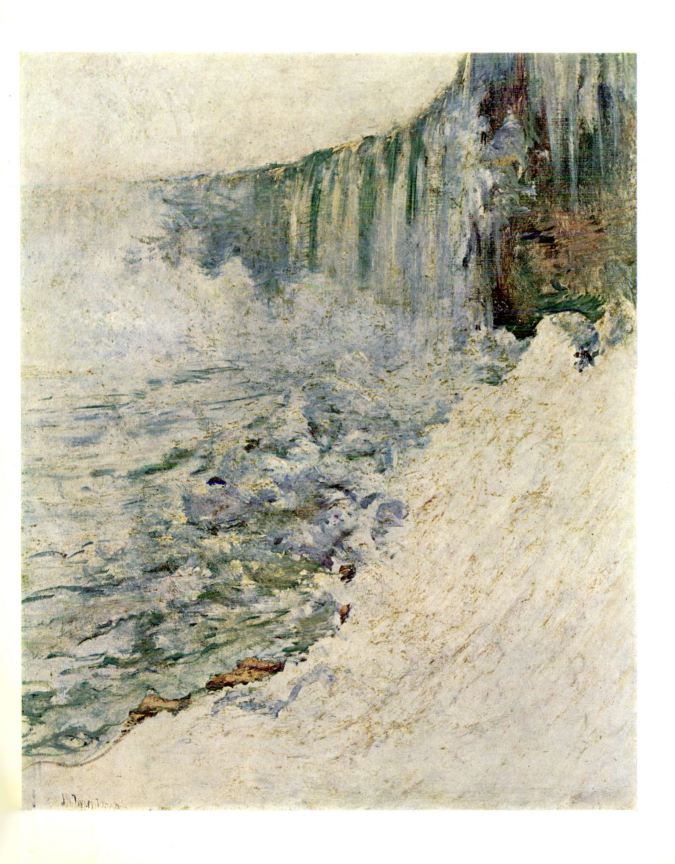

281. Albert Bierstadt: *The Rocky Mountains*. 1863. Oil on canvas, 73¼ x 120¾ inches. New York, Metropolitan Museum of Art. Rogers Fund, 1907.

Based on sketches made in the Nebraska Territory in the summer of 1859, this panorama of the western slopes of the Rockies helped establish Bierstadt's popularity. The minutely recorded details of Indian life in the shaded foreground contrast with the immensity and glowing, opalescent color of the mountain backdrop.

282. John La Farge: *Bridle Path, Tahiti*. c. 1890. Watercolor (gouache), 29½ x 33 inches. Cambridge, Massachusetts, Fogg Art Museum. Gift of Edward D. Bettens to the Louise E. Bettens Fund.

His early interest in the accurate rendering of light and air was reinforced by the brilliant atmosphere of the South Seas. His impressive abilities as a colorist are evident in the splendid, rich hues of this Tahitian scene.

283. Winslow Homer: *Early Morning After a Storm at Sea*. 1902. Oil on canvas, 30½ x 50 inches. Cleveland, Ohio, Cleveland Museum of Art. Gift of J.H. Wade.

The narrative element is gone from Homer's late and most successful sea scenes, and the sea exists in and of itself. Through tactile handling of viscous paint, reminiscent of Courbet. the artist expressed the force of the water, no less weighty or solid than the rock, and the overwhelming power of the sea.

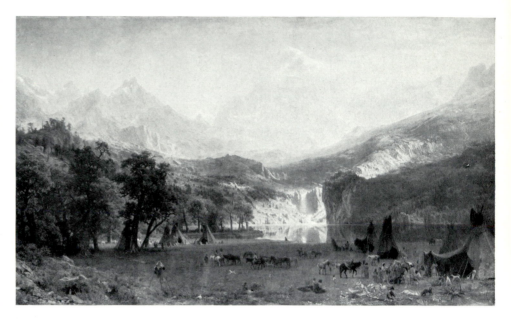

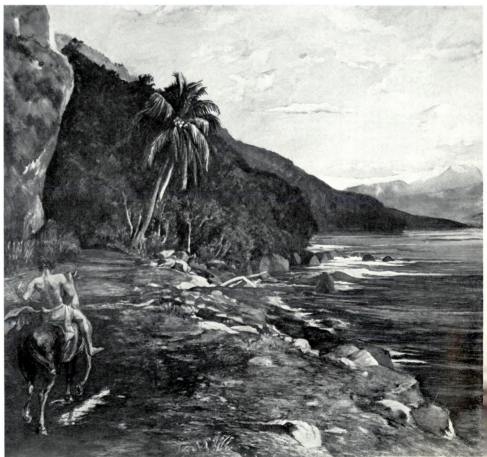

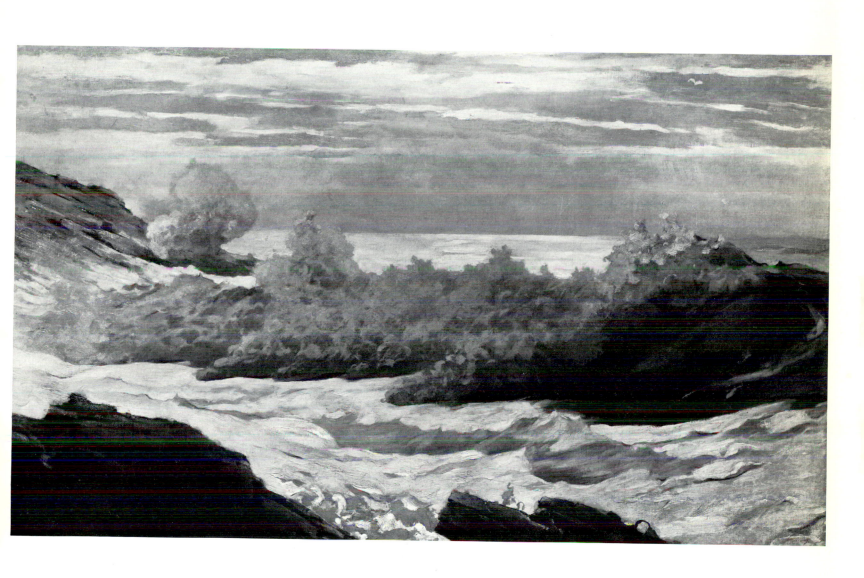

284. Albert Pinkham Ryder: *Moonlit Cove*. n.d. Oil on canvas, 14⅛ x 17⅛ inches. Washington, D.C., The Phillips Collection.

One of Ryder's most abstract works, the painting achieves its impact through rhythmic correlations of expressive shapes. Through constant nurturing of paint and a search for simplicity of contour, the artist has distilled the elements of boat, rock, cloud and shadow into images of cosmic power.

285. Ralph Albert Blakelock: *Moonlight*. n.d. Oil on canvas, 27¼ x 32¼ inches. Brooklyn, N.Y., The Brooklyn Museum.

Dark trees, delicately silhouetted against blue-white moonlight and Indian motifs to evoke a memory of America's primitive past, are this romantic painter's obsessive images. The lyric quality of light and expression of the mystery of the wilderness raise his art above the level of scenic or ethnographic recording.

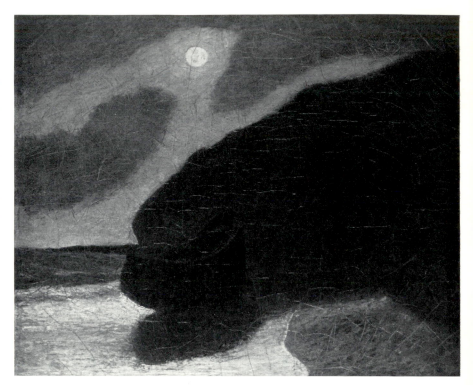

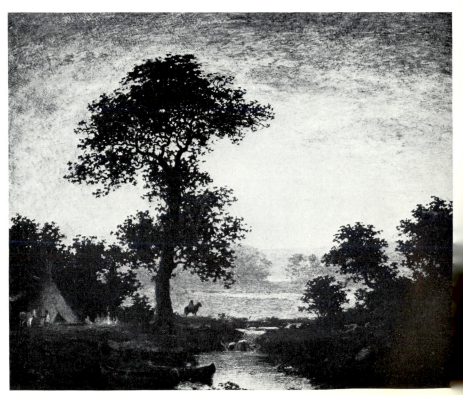

BIOGRAPHIES

These notes are intended to provide basic information on the life and training of each artist and an indication of his place in the history of art, without claiming to be critical biographies.

GIUSEPPE ABBATI (Naples 1836 - Florence 1868)

His father, a painter who had gone to live in Naples, started him on his career. He went to Venice where he attended the Academy and remained until 1852. On his return to Naples, he dedicated himself to painting decorative frescoes. He lost an eye fighting on the side of Garibaldi. In 1861 he went to Florence to participate in the National Exposition; his two paintings won some appreciation, and he began frequenting the Caffè Michelangelo and the *Macchiaioli* painters. He was persuaded by their ideas about painting outdoors, and began painting landscapes. Out of spiritual affinity, he associated with Lega, Sernesi and Borrani, and together they formed the Pergentina School, named after the locality where they habitually worked. The melancholy nature of Abbati's vision led to a style that was contained, even severe, in its precise drawing, somewhat cold in tone, but with a perfect blend of light and chiaroscuro. In 1886, he joined Garibaldi again on his way to Trento, and in 1868 was back in Florence. While a guest of Diego Martelli at Castiglioncello in the Maremma, where almost all the *Macchiaioli* visited from time to time, he was bitten by a rabid dog and died.

WASHINGTON ALLSTON (Georgetown, South Carolina 1779 - Cambridgeport, Massachusetts 1843)

Allston attended Harvard University before going to England to study art in 1801. The coloristic technique he learned in London was strengthened by study of Rubens, Titian, Poussin and Claude Lorrain in the Louvre in 1803. It was further reinforced by contact with Venetian paintings in Italy from 1804 to 1808. Three years in Boston were followed by a second trip to England, where he remained until 1818.
He was America's first full-scale romantic artist. Two characteristic trends of romanticism prevail in his art. The first, an interest in grandiose themes of mystery and fear, often historical or biblical, was intensified by contact with Benjamin West and Henry Fuseli during his early years in England. The second — imaginative reverie upon nature, solitude and contemplation — finds its fullest expression in his late works. These show affinities with the writings of his friend Samuel Taylor Coleridge.
Through his study of the painterly traditions of England and Italy, Allston brought a genuinely coloristic style to American art as early as 1805. He expanded the range of artistic subject matter to include history, landscape, marine and genre, in addition to the portrait painting which had dominated eighteenth-century American art.
His pictures were intended not only as images for the eye but as objects for contemplation by the mind. His ideal and introspective style found no immediate following among the next generation of American painters. However, the literary works of Nathaniel Hawthorne and Henry Wadsworth Longfellow exhibit definite parallels. He is the first representative of an important undercurrent in American art, that of dreamy and mysterious spirituality.

RUDOLF VON ALT (Vienna 1812-1905)

At first his father Jacob's student, he went on to study at the Academy of Fine Arts in Vienna. He took several trips to Italy, Switzerland, Belgium and through other parts of Austria which provided him material for his precise observation of landscapes and views. He had exhibitions at Munich, Vienna, Berlin, Dresden, Paris. He won recognition and prizes at Berlin and Vienna and became a member of both academies. His refined ability to paint views earned him a commission from the Austrian government to depict the major monuments of Europe. Besides his paintings, his watercolors are notable, and he also did many drawings, lithographs and etchings. Among his works are some excellent views of Vienna, including *View of Vienna from the South*, 1840; views of the *Royal Castle at Brussels; The Guardroom in the Royal Castle at Salzburg* (Vienna, Imperial Museum); *Stairway of the Giants in the Palace of the Doges, Venice; The Port of Palermo* (Vienna, Imperial Museum).

THOMAS BARKER (Pontypool 1769 - Bath 1847)

His father was a painter and specialized in portraying animals. Thomas learned the elements of painting from him. With the help of a carriage-maker, he went to Rome in 1789. Three years later he returned to Bath, the master of a very precise and minute technique which enabled him to achieve some fine results in classical landscapes and Arcadian genre scenes. Gradually he imbued his paintings with the golden and intense manner of Gainsborough. His works were accepted by the Royal Academy and by the British Institution in London.

LUIGI BASILETTI (Brescia 1780-1859)

He first studied with a local Brescian painter, Santo Cattaneo, and then attended the Academy in Bologna. He went on to finish his training in Rome and there met Canova. He returned to Brescia as a neoclassicist, but his eye for color enabled him to avoid the tyranny of that style in the landscapes he painted of the Brescian countryside. He did portraits as well, and his altarpieces can be found in many churches of the city and the province. He made many drawings during his trips, and left an album of them, *Ricordi* (Souvenirs), now in the Brescia Art Museum. A cultured man with refined tastes, he taught at the University and was instrumental in excavating the Roman ruins around Brescia. He was a sage adviser to Count Tosio in acquiring works of art which later became the city's art collection.

MOSE BIANCHI (Monza 1840 - 1904)

His father, a painter, refused to allow him to study art until he was sixteen, when he entered the Brera in Milan. After participating in Garibaldi's campaign, he went back to the Brera in 1859, and studied under Giuseppe Bertini; one of his classmates was Tranquillo Cremona. Under Bertini's guidance he became a historical painter and had already achieved his first success by 1863, with a manner reminiscent of Tiepolo's. A year later his first genre painting appeared, executed romantically with rather superficial and literary pretensions. In order to achieve certain effects with bright spots of color, he neglected formal composition. This happened after his trips to Venice and Paris under the auspices of the Brera, when he had an opportunity to study the bravura style of Meissonier and Fortuny, which he attempted to reproduce in his decoration of villas and altarpieces and in many portrayals of folk life. His pictorial sense did not always compensate for the confusing narrative baggage in his works. His best paintings remain the "impressions" of Milan in the fog and snow that he did in 1890, in which the scenes of working-class life in the new sections of the city are depicted with sincerity — their success due in large part to the soft greys and browns he used in place of his usually showy colors. He painted portraits also, and in his last years, the country around Lake Maggiore.

ALBERT BIERSTADT (Solingen, Germany 1830 - New York 1902)

Though brought to New Bedford, Massachusetts, as an infant and educated there, he returned to Düsseldorf in 1853 to study under Lessing and Achenbach. His interest in landscape, evident in paintings shown even before his return to Germany, was reinforced by summer sketching trips along the rivers and in the mountains of Europe. Returning to America in 1857, he sought scenic subjects in the White Mountains and in the Far West, where he first went in the spring of 1858. By 1860, he was showing Rocky Mountain subjects as well as European and New England scenes at the National Academy of Design. The western subjects brought him immense popularity, and by 1866 he was at the peak of his career. He travelled extensively in America and Europe, gathering sketches from which immense and costly canvases were commissioned. By the early eighties, however, his grandiose scenes had begun to fall in public favor as more intimate interpretations of nature gained ascendancy as a result of French influence.
The quality of Bierstadt's paintings resides less in the monumentality of their size or themes than in the luminous, enveloping, emanating light which, in glasslike rocks and glistening shadows, conveys a sense of the mood of nature. This attention to the expressive quality of light and the recording of atmosphere were major preoccupations of his generation of American artists.

GEORGE CALEB BINGHAM (Augusta County, Virginia 1811 - Kansas City, Missouri 1879)

At the age of eight he moved with his family to the frontier town of Franklin, Missouri, where, after an apprenticeship to a cabinetmaker, he trained himself as a portrait painter. By 1835, he had established a studio in St. Louis and was painting portraits in and around Missouri. Although he had some formal training in Philadelphia in 1838, he was most affected by instruction books and engravings after the old masters. If, as one biographer suggests, he visited New York in 1838, he may have seen works by William Sidney Mount that inspired him to take up genre painting. His first recorded genre scene was exhibited in that year, but he continued to work primarily as a portrait painter in Missouri and in Washington, D.C., from 1840 to 1844. Stimulated by genre paintings seen during his stay in the East, aware of developing interest in genre through engravings after European masters, and encouraged by the Art Union, Bingham increasingly chose to paint frontier scenes. His depictions of rural and town life along the Mississippi and Missouri rivers are simple narratives, geometrically constructed, with great attention to light and air effects. His landscapes are as consciously composed as his genre subjects, combining Cole's ideal interpretation and Durand's careful observation of nature. In Germany from 1856 to 1859, under the influence of the Düsseldorf School, he replaced breadth of technique and atmospheric effect with hard, polished surfaces and careful detail. Portraiture, never abandoned even when he was at his height as a genre painter, and politics in Missouri were major interests of his last two decades.

RALPH ALBERT BLAKELOCK (New York 1847 - near Elizabethtown, New York 1919)

With Albert Ryder the leading romantic landscape painter of his generation, Blakelock was completely self-taught. Close study of nature and insistence on the literal recording of details relate his early landscapes to those of the Hudson River School. They lack grandiosity, however, and show a hint of the melancholy which dominates his later works. Though an admirer of the old masters, he never went abroad, being content to study photographs of their works. His three-year trip to the Far West, begun in 1869, made a lasting impression. Less interested in the scenic than in the poetic effect of primeval forests and Indian life, he expressed the mystery and penetrating solitude of the American wilderness in his art. As he interpreted and reinterpreted the haunting stillness of the forests, seen often by twilight or moonlight, he produced increasingly romantic, symbolic, unnaturalistic works. His technical methods, like those of Ryder, were erratic. Victim of the contemporary taste for naturalism and literalism in painting, he enjoyed little popularity until after 1900, by which time frustration had brought about mental collapse.

In his sentiment for nature and his emphasis on the rich effect of color and pigment, he is related to the Barbizon School. His art, however, is the product of a personal sensibility, an individual reaction to the American landscape.

ARNOLD BÖCKLIN (Basel 1827 - San Domenico di Fiesole 1901)

A student of Schirmer at Düsseldorf and, in 1848, of Alex at Geneva, he made many productive trips to Paris and Basel to study art, and remained in Basel until 1850. His stay in Italy, mostly in Rome from 1850 to 1857, gave a typical cast to his historical paintings. Under the influence of ancient and Renaissance works, and of the painters Gaspard Dughet and Franz Dreher, his landscape paintings became romantic and unreal. He returned to Switzerland in 1857, but after meeting with little success in Basel, went on to Munich, where his painting *Pan Among the Reeds* (1859) met with the approval of Count Schack, who purchased several of Böcklin's paintings.

He was named professor at the Weimar Academy, but in 1862 returned to Rome. His visits to Naples and Pompeii inspired several paintings, including two versions of *The Villa by the Sea*. His style has a strange, magical diffuseness about it. After he finished some frescoes in Basel in 1866 — including those in the Museum — he worked in Munich for four years. Returning to Italy again, he stayed in Florence from 1874 until 1884, surrounded by students and disciples. There he executed some of his most intense works, such as the several versions of *The Isle of the Dead*, in which his imagination achieved subtle and poetic pathos.

A friend of writers and poets, including Keller, whom he had met in Zurich in 1884, Böck-

lin became interested in certain literary perversities of the Decadents. Steeped in melancholy and fantasy, with strong literary tendencies, his work greatly impressed the young De Chirico, whose metaphysical style was influenced by it.

RICHARD PARKES BONINGTON (Arnold 1802 - London 1828)

In 1817, at the age of fifteen, he went with his family to live in Calais, and being already fond of art took watercolor lessons from the painter Louis Francia. But he realized that the center of art was Paris and was barely seventeen when he ran away from home to that city, so that he could study the great paintings in the museums.

In 1820 he went to study with Gros, an historical painter but a good craftsman. In 1822 he exhibited at the Paris Salon. The following year he travelled to the northern seacoast of France to paint immense landscapes and fishing scenes. In 1825 he went to England for a few months, then to Italy. He had seen Venice, Florence, Bologna and Pisa when he realized he had tuberculosis. He returned to London and died shortly thereafter. Despite the fact that his brief life did not permit full realization of his talent, the paintings he left — revealing an intense luminous transparency and a fine awareness of the natural world — testify to his genius as a poet-painter.

ODOARDO BORRANI (Pisa 1834 - Florence 1905)

He studied in Florence under Bezzuoli and Pollastrini, whose academic style was opposed to the style of the *Macchiaioli*, with whom he soon became associated. His first exhibited works show a definite realist tendency. He frequented the Caffè Michelangelo, the haunt of the rebel artists, and became friends with the young *Macchiaioli* painters Sernesi, Lega and Abbati, with whom he formed the so-called Pergentina School. In 1859 he went off to war. After his return he went with Sernesi up into the mountains near Pistoia to paint the landscape there. He exhibited at the first National Exhibition in Florence in 1861. His representational painting succeeds in preserving a certain primitive quality, a neatness and a chaste pictorial style derived from the works of Paolo Uccello and Filippo Lippi. In the following years, however, he used light — especially chiaroscuro effects — to attenuate this severity. Although there is a somewhat frigid tone about some of his paintings, there are many others in which his technique is so candid and clear that they can be judged among the best by the *Macchiaioli* group. With Lega he opened an art gallery in the Palazzo Ferroni in Florence, but it failed, and Borrani was ruined. He was forced to give private painting lessons after that, and he also painted ceramics for the Doccia factory.

LOUIS - EUGÈNE BOUDIN (Honfleur 1824 - Deauville 1898)

His painting, which seems to be fairly facile — that is, a spontaneous expression of his imagination — is, in reality, the product of a close study of Isabey, the Barbizon School, Courbet's realism and Corot's subtle and soft luminosity. Boudin was also a careful observer of the Dutchman Jongkind; like him, he concentrated on representing the effects of light and atmosphere along the coast and the furthest reaches of the sky. Monet spent some time with him at Le Havre, and from him acquired the sense of space one can attain by the sea. Boudin was especially fond of beach scenes, which he captured with his small animated figures, sailboats, flying flags and shifting reflections. After 1865 he in turn was influenced by his former pupil Monet, and participated in the First Impressionist Exhibition in 1874. But he preferred life in the country and returned to his Normandy villages and beaches.

HIPPOLYTE BOULANGER (Tournai 1837 - Brussels 1874)

After an unhappy childhood and difficulty in getting started, Boulanger was forced to work as a decorator. But with the help of a friend, he was able to go to live at Tervuren, near Brussels, where the forest of Soignes attracted Belgian painters just as the forest of Fontainebleau had attracted the French "realists." Considered a master of natural representation, he preferred to call himself a "pupil in the school of Tervuren." Working in this natural

environment, and influenced by the Barbizon painters and by Courbet, he was able to paint more freely than was permitted by the academic formulas then prevailing in official Belgian art circles. He was especially interested in capturing the variations in light in the different seasons, thus approaching — at least in intent — the Impressionists. Among his notable paintings are several landscapes of the Ardennes forest, such as the *View of Dinant*, 1870 (Brussels, Royal Museum of Fine Arts), considered by some his finest work. The works, however, which best indicate his free inspiration in the presence of nature are the views of the woods and the surrounding area at Tervuren, executed in the years just before his early death. In 1872, he showed at the Brussels Salon and received a gold medal. He participated in the Paris Salons of 1873 and 1874. His dedication to painting *en plein air*, although linked to the Flemish tradition, made a strong impression on young Belgian painters. He did some engraving as well, being a contributor to the *Uylenspiegel*.

HENRI DE BRAKELEER (Antwerp 1840-1888)

Studying with his father Ferdinand, an historical painter, but even more with his uncle, Henri Leys, he acquired a thorough knowledge of traditional techniques, executing genre scenes with typical characters in the detailed realism passed on by generations of Dutch painters from masters such as Nicolas Maes and Gabriel Metsu. The objective and patient reconstruction of details is evident right from the start in Brakeleer's work. His paintings of interiors, with their warm reddish tonalities and ample perspectives, give evidence of the care with which he painted the textures of things. He sought out different places in the old part of Antwerp for his views, usually choosing windows as his point of observation. He would change studios often in order to study light from various locations; the poet Verhaeren nicknamed him "the painter in the window." He stopped painting for three years and in 1883, when he began again, he was no longer interested in the detailed work he had done before. His landscapes now reflected the impressionist current and the new ideas that had come into Belgium and had led to the formation of *Les Vingt*. We can see these results best in the collection of his paintings in the Royal Museum in Brussels. The break between *The Geographer* and *Woman of the People*, one of his last works, is considerable. The compactness of the former is replaced by a sketchiness in which the form is broken by the free brushwork and by thick, crude whites, reds and squirts of green, which have been compared to Van Gogh's early work.

IPPOLITO CAFFI (Belluno 1809 - Isle of Lissa 1866)

He took evening lessons from Federici in Belluno and then went to work in a cousin's studio, finally attending the Academy in Venice. In 1832, he was able to join his cousin in Rome. Like other painters of the time, he participated in the struggle for Italian unity, and turned the situation to advantage by painting battle scenes. But his reputation is based mainly on the views he painted of Venice and Rome, much in the spirit of the Venetian *vedutisti*, with special attention to perspective and warm light, even if his colors appear somewhat enamelled. He travelled a great deal, from Athens to Constantinople, Naples to Paris. He was in Greece in 1843; in 1847 he took a balloon flight with the Frenchman Arhan; in 1848 the Austrians took him prisoner during the battle of Visco. He went back to Paris in 1855, where his views of the city and his illustrations of news stories aroused notable interest. His landscapes showed more sensitivity and amplitude than they had before. He fought in the naval battle off Lissa (Yugoslavia) in 1886 and went down with his ship.

GIUSEPPE CANELLA (Verona 1788 - Florence 1847)

He was self-educated and followed in his father's footsteps, becoming a decorator and then a set designer. He left Verona and travelled around Europe, finally settling in Paris for ten years, where he painted views in the Venetian manner but with a flair for daily events. In 1830 he went to Milan, and Ferdinand I of Austria named him to the Brera Academy. He taught in Venice also but he preferred Milan. His paintings are spacious and airy, with a certain stage-prop monumentality about them. To his admiration for the Venetian painters he added an appreciation of the seventeenth-century Dutch landscapists whose works he saw during his trips north. He was inspired by them to paint from nature, in a somewhat

static manner because of his fussy precision, but he had a fine sense of light and color tone. The figures that bustle around in his paintings are more than character types, and so we can say Canella's art is a tasteful marriage between the genre scene and the panoramic view.

GIOVANNI CARNOVALI, called IL PICCIO (Montegrino Luino 1804 - Cremona 1873)

Son of a mason who had moved to Bergamo, and called *Il Piccio* ("Shorty") because of his height, Carnovali began at the age of nine to study under Diotti at the Carrara Academy. He was the only truly romantic painter among the Italians, an artist who could depict nature spontaneously and warmly, without regard to polemics or fashion. If anything, he continued in the Venetian tradition, from Titian to Tiepolo and Guardi, with abundant light and thick, rubbed color. He was a solitary man, somewhat eccentric, but in genuine communion with nature. He did several portraits, but painted historical scenes and landscapes as well, revealing with his sensitive technique and bright atmosphere the breadth of his elegiac feeling. He went to Rome on foot in 1831, and on his way back he stopped in Parma to study Caravaggio's works. In 1845 he took a walking trip to Switzerland and France with his friend the painter Trecourt. He went back to Rome in 1848, and pushed on as far as Naples. He made drawings on immense sheets of paper wherever he went, to record his gentle, somewhat sensual response to the life around him. He lived in Milan, Pavia and Cremona, among a limited circle of friends. His travels, his sudden absences from beloved places and the long periods he spent on walking trips gave him ample opportunity to commune with nature. It seems he loved a girl, but she died before he could let her know, and one night unexpectedly he came upon her funeral. The shock was so great that he remained faithful to her memory for the rest of his life. He became ill while swimming in the Po and drowned.

PAUL CÉZANNE (Aix-en-Provence 1839-1906)

The son of a rich merchant, Cézanne was sent to private school at Aix, where he met Emile Zola. He became interested in painting and attended the School of Fine Arts in his town; he copied the old paintings in the museums and churches of Provence, including several works from the Italian Renaissance, spreading dense color in a low key on the canvas with a palette knife in preference to a brush. In 1862 he went to Paris and attended the Académie Suisse where he met Pissarro and Guillaumin. He studied the paintings of Delacroix and Courbet, later he frequented the Café Guerbois, met Manet and was influenced by him. From Aix, his father, a hard and authoritarian man, continued to control him closely, but despite the tension, Cézanne was unable to break away. He was obliged to make frequent trips to Aix, he lived with his model in secret, not daring to marry or to reveal the existence of their child out of fear of his father. He lived at Auvers-sur-Oise from 1872 to 1874, and there met Dr. Gachet, whose portrait he painted. He frequently visited Pissarro, who was staying at Pontoise, and was persuaded by him to paint according to impressionist tenets: out of doors, with clear, fluid color, division of tones, attention to natural light. At Auvers, he painted *La Maison du Pendu*, now in the Louvre. The painting was shown at the First Impressionist Exhibition, and was the only one sold, the buyer being Count Doria. He took part in all the impressionist exhibitions until 1877. In 1882 he was invited to exhibit at the Paris Salon. In the same year, he went to live permanently at Aix-en-Provence, isolated, stubbornly pursuing the idea of synthesizing form and color which led him to break from impressionism. Light in his paintings no longer derives from the fluidity of color, but becomes embodied in plastic form. He was aware that high-keyed luminosity disperses formal values, and although he greatly admired Monet, he said Monet's painting was a problem above all of the eye, whereas he wanted to make it a problem of a strong and analytic style. Significantly, he added that he wanted to "do Poussin over again, from nature."
He worked at his technique relentlessly, coming back again and again to his paintings, and wearing his subjects out with endless posing. When he was painting the portrait of Vollard the dealer, who had become interested in his work, Cézanne said after more than a hundred sittings that the shirt-front did not displease him. The themes of his paintings are the landscapes around L'Estaque, and Mont Sainte-Victoire, a cone that dominates the plain of Aix. The mountain was painted many times by Cézanne, and indeed by comparing the various versions over the years, we get a clear idea of the evolution of Cézanne's

technique toward a solid, monumental, powerfully concise vision, which, said Cézanne, can be achieved only by dealing with nature by means of the cylinder and the sphere. On this fundamental principle is based the work of several young artists at the beginning of the new century, among whom are Braque and Picasso. Thus cubism was born. Cézanne's great labors, which he calls "my struggle with the Angel," were taken as a model by Zola for his novel *L'Oeuvre*, in which he recounts an artist's failure. As a result, Cézanne broke off their friendship. In 1895 Vollard dedicated a show to him in Paris. Up to his death, probably brought about by his refusal to leave off painting even in a violent storm, Cézanne continued to pursue, with ever more intensely articulated results, his idea of painting based on form-color and geometric composition.

PIERRE ATHANASE CHAUVIN (Paris 1774 - Rome 1832)

Chauvin made studies of classical works, and exhibited in Paris from 1793 to 1831. In 1802 he took the customary trip to Italy, and to Rome two years later. With the support of Prince Talleyrand in 1806 he was able to continue painting.
His landscapes are carefully delineated, and achieve notable levels of descriptive merit. The episodes and views he paints still employ neoclassical mythology but begin to show signs of romanticism.
Memorable among these are the several landscapes of St. Cloud, where he worked, as well as some of Paris and Angers. In Rome he became a friend of Thorvaldsen, and the Danish sculptor acquired some of Chauvin's most limpid landscapes, including *The Garden of Villa Falconieri at Frascati*, 1810 (Copenhagen, Thorvaldsens Museum); the same subdued but clear light is present in *The Garden of Villa d'Este*, Tivoli, 1811, and in *The View of Grottaferrata* (Copenhagen, Thorvaldsens Museum). He gained a reputation for being a fine and faithful reporter in his impartial handling of views from nature.
He received commissions from tourists and important art lovers visiting Italy, among whom was Metternich in 1819. In the same year, he executed *The Entrance of King Charles VIII* (now at the Palace of Fontainebleau) for the King of France. He was a friend of Ingres, who did a portrait of him and his wife (Bayonne, Bonnat Collection). He was named to the Academy of St. Luke in 1813, a member of the Institute in 1827, and to the Legion of Honor in 1828.

FREDERICK EDWIN CHURCH (Hartford, Connecticut 1826 - New York 1900)

Encouraged by his parents in his choice of painting as a profession, he studied drawing and color in Hartford until 1844 when he entered Thomas Cole's studio in Catskill, New York, for two years. He adopted Cole's conception of heroic landscape, carefully observed and meticulously rendered, and painted a number of mountain and coast scenes. In 1853, inspired by the writings of Alexander von Humboldt, he began a series of journeys to South America, the Arctic, the Caribbean and the Mediterranean. His immense depictions of the geological wonders of the world, echoing the transcendentalist's sense of awe before the vastness of nature, were enthusiastically received. A central figure of the Hudson River School, Church expressed in his heroic landscapes the national pride of the era of Manifest Destiny. By the mid-sixties, he had become the recognized leader of the American landscape school. However, a change of taste, a desire for sentiment and mood rather than drama or realism in landscape, occurred by the 1870's. Church responded by abandoning the epic in favor of the pensive, basing his effects on glowing, radiant light. The last two decades of his life were unproductive.

GUGLIELMO CIARDI (Venice 1842 - Quinto di Treviso 1917)

At the age of eighteen he entered the Academy in Venice, and in 1866 was already exhibiting some landscapes of great promise. In 1868 he went to Florence to the studio of Telemaco Signorini, with an introduction from Zandomeneghi.
The *Macchiaioli* environment awakened him to new possibilities, and caused him to break away from academic procedures. He became involved with the painters influenced by the Barbizon School, in Rome and Naples with Palizzi and other painters of the same bent, and between 1869 and 1875 he painted many small oils on wood in much the same spirit

as the work of Fattori and Lega. After 1870 he left Italy, but by this time his artistic habits were ingrained, and no matter how much he tried realist techniques, the Venetian tradition of luminous color always won out. He painted Venice and the Lagoon, and the country around Treviso with broad, green horizons. The painting *Messi d'Oro* (1883), which won for him gold medals at Nice and Berlin in 1886, was one of these landscapes. From 1894 until his death he taught at the Academy in Venice.

THOMAS COLE (Bolton-le-Moor, Lancashire, England 1801 - Catskill, New York 1848)

After training in England as a calico designer and wood engraver, he migrated to the United States with his family in 1818, settling in Steubenville, Ohio, the following year. Encouraged by a visiting portraitist, he decided to become an artist, starting as an itinerant portrait, miniature, scene and ornamental painter. When he moved to Pennsylvania with his family in 1823, he worked for his father in the manufacture of floor cloths and spent his spare time sketching landscapes. He studied briefly at the Pennsylvania Academy and began exhibiting landscapes in 1824. The proceeds from the sale of three pictures in New York in 1825 made possible his first trip to the Catskills. Works produced there attracted the attention of other artists and marked the beginning of his artistic success. In 1826 he participated in the founding of the National Academy of Design and moved to Catskill, New York, his permanent home. With the help of a patron, he made his first trip abroad in 1829, living for two years in London and visiting Italy.

Anxious to express allegorical and moral ideas in his paintings, he infused his landscapes with literary and historical associations. He produced several major allegorical landscape series, from *The Course of Empire*, commissioned in 1833, to *The Cross and the World*, unfinished at his death. More natural landscapes, which he regarded as means of attracting public approval and earning a living, were inspired by American scenery and by Italian sites revisited in 1841-42.

Never intentionally a realist, he transformed even the most topographical views into poetic images through the use of symbolic props and romantic light. The conflict between his desire to elevate landscape to the ideal level of history painting and his public's chauvinistic taste for depictions of the natural glories of the American continent produced in Cole frustration with his own time and place. Though his followers in the Hudson River School still felt the poetic element in nature, they abandoned romantic fervor and responded to the American desire for factual recording of natural forms.

JOHN CONSTABLE (East Bergholt, Suffolk 1776 - London 1837)

According to his own statement, Constable decided to become a painter in order to record the beauty of natural places. His family was well off, thanks to their several flour mills, and his father did not want his son to become an artist. Nonetheless, Constable enrolled at the Royal Academy of London. He was drawn to the art of Rubens, Ruysdael and Claude Lorrain, which had a great influence in his formation. He made several copies of Girtin's watercolors and Ruysdael's paintings as technical exercises; among English painters he devoted special attention to Gainsborough and Turner. His first landscapes show marked signs of this training, with a classical quality and traces of Flemish realism. In 1802 he had his first exhibition at the Royal Academy, and one of the differences between him and Turner was immediately evident: Constable preferred serene landscapes to Turner's stormy ones. For this reason, he worked for a long time in the pleasant areas around Suffolk, Salisbury and Hampstead; his familiarity with these places enabled him to paint with confident sincerity. In 1809 he fell in love with Mary Bicknell, but her family was wealthy and he could not marry her until after her parents died. He became a friend of the Archdeacon John Fisher, a nephew of the Bishop of Salisbury, who gave him moral support. From 1817 on, he painted a large landscape every year to be shown at the Royal Academy, where he was admitted as an associate in 1819, and as a full member only later, in 1828. In 1824 he participated in the Paris Salon and won his first international success, and the esteem of Delacroix, Troyon and other painters of the Barbizon School. He never wanted to leave England, which so delighted his eye. He became one of the most sensitive and penetrating of the naturalists, as he devoted more and more attention to the vast luminosity of the sky and the shimmering transparency of the atmosphere. In 1824 he went to live at Brighton to paint the marine landscape there. His wife died in 1828, leaving seven

children. He was called upon to give a series of lectures at the Royal Institution and then at the Royal Academy. In his later years, his technique is more nervous, in consonance with his more passionate, freer vision of the world.

LOVIS CORINTH (Tapian, Prussia 1859 - Zandvoort, The Netherlands 1925)

He studied at the Königsberg Academy from 1876 to 1880 and then at the Munich Academy from 1880 to 1884. After a brief period in Antwerp, he went to Paris in 1884, as a student of Bouguereau. Then he returned to Königsberg, remaining there until 1891 when he went to Munich (until 1902). He moved on to Berlin and became a supporter of the *Sezession* movement along with Liebermann and Slevogt. His early studies of Rubens and Hals inspired him to the sensual naturalism of the portraits and mythical scenes of his first period. We can detect impressionism's influence in the works he did between 1880 and 1890, which were marked by strong color contrasts and thick impastos, and by disturbing images. His style already betrays a psychological dimension that will be of interest to the future expressionists. He also painted sacred themes. In 1911 he underwent a severe physical and emotional crisis which precipitated profound changes in his painting. The work of the expressionists, the ferment caused by the Blaue Reiter group (Kandinsky, among others) with whom Corinth associated for a time, and the paintings by Kokoschka shown in Berlin (1910), all led him to break with his former style and give rein to a fresh visionary impetus, with more vivid color and freer movement, both in his large still lifes and in the landscapes, especially the ones he painted at his summer residence in Urech (Bavaria) from 1918 on. The hallucinatory portraits of this period approach expressionism. He left drawings, watercolors, lithographs and critical and literary writings as well.

JEAN-BAPTISTE CAMILLE COROT (Paris 1796-1875)

The young Michallon advised him to do historical landscapes and urged him to go to Italy. Rather than taking examinations for the Prix de Rome, he went to Italy with his family's support. He arrived in Rome in December 1825, after having journeyed through Switzerland. Following the advice that many artists, including Valenciennes, had given him, he did numerous paintings and drawings directly from nature, seeking out lonely and suggestive places in Sabina, the Alban Hills, Tivoli and even such far-removed places as Subiaco. In 1827, he submitted his *Bridge at Narni* to the Paris Salon. His Valenciennes-like manner gives way to heavier brushwork and a keener sensitivity to the effects of light and the particularities of each location, which he realizes on canvas with golden yellows and ochres. In 1828 he went as far as Naples, Capri and Ischia, leaving at the end of the summer for Paris by way of Venice. He did not remain long in Paris because he wanted to find open country and forests that would offer rich variations in color, and so he went to Fontainebleau, and from there he made trips from time to time to Normandy and Brittany. Once he had overcome the hold Poussin's neoclassicism had on his style, he went on to paint subtler landscapes taken directly from nature, composed within strict intellectual limits that assured tonal harmony, yet left room for the painter's feelings. At this point, Corot succeeded in striking a balance between the demands of composition and the lyrical intensity, yet serene intimacy, of his inspiration. In 1834 he returned to Italy in the company of the painter Grandjean, this time lingering on the west coast and then passing through Volterra. During this period, under the Italian light, his colors became finer, with extremely delicate half-tones that nonetheless achieve body and compactness in his rendering of space. In 1843, he travelled through Italy again, sojourning in the Roman countryside and in the Alban Hills. The Italian landscape left an indelible impression on Corot, even in his typically French scenes such as the *Cathedral of Chartres* (1830) or the *Cathedral of Mantes* (about 1865). In his last years, the misty greys of the air and subdued transparencies of the ponds, the autumnal trees and leaves create a new kind of poetic landscape, pervaded by a sad quiet. We could not really call him an impressionist, even in these late works, but his naturalistic treatment of landscapes immersed in light certainly contributed to the impressionists' understanding of their own intentions.

GIOVANNI COSTA, called NINO (Rome 1826 - Marina di Pisa 1903)

He studied under Camuccini, Coghetti, Agricola and Podesti, all good painters but limited by their academicism. His break with them was inevitable, especially because of his critical nature. From 1848 on, he left off painting several times to fight for Italian unification. In 1859 he went to Florence and urged his ideas about painting in the open from nature, without academic rules, on the *Macchiaioli*, especially Fattori. He travelled to Paris in 1862, and from there to London the next year, thence to Fontainebleau where he associated with Corot. In 1870 he came back to Rome. "Only reality is right," he affirmed. His painting gradually developed from an early scrupulous and minute representationalism to a broader, rustic yet sober treatment, aiming always at concision, incisiveness and subdued lighting.

JOHN SELL COTMAN (Norwich 1782 - London 1842)

The young Cotman went to London in 1798 to find more opportunities to study painting. He met with good fortune: in 1800, at the age of eighteen, he had a show at the Royal Academy, proving to be a talented painter who loved rich impasto and imposing theatrical dimensions. He travelled throughout Britain in his early years, and when he returned to Norwich in 1806, he became one of the most influential of the artists belonging to the school founded by John Crome, and in fact was called upon to teach drawing. In 1812, he went to Yarmouth as guest of his patron Dawson Turner. He crossed the Channel several times between 1817 and 1820. After about fifteen years in Norwich, he moved to London in 1834 because he had been named professor of drawing at King's College, and there spent the last years of his life.

GUSTAVE COURBET (Ornans 1819 - La Tour de Peilz, Switzerland 1877)

A seminarian at Ornans, he later attended the royal school at Besançon where he met the painter Flajoulot, who had studied under David. His family wanted him to be a lawyer, but the young Courbet was more interested in philosophy and art. His earliest paintings had much of Gros and Géricault about them, but with more distinct representationalism. When his work was first shown at the Paris Salon, he won both praise and condemnation for the frankness of his style, which was even defined as crude and brutal. Thus began his struggle in both criticism and painting to sponsor and realize the new social ideals of the time. His painting was intimately related to his revolutionary political ideas, and in fact he associated with Proudhon and Leroux, both radical intellectuals and political leaders. The works he showed in 1848 had a clearly revolutionary stamp, and the year after, he painted the large canvas entitled *Burial at Ornans*, which became a kind of manifesto for realist art, along with *The Stone Breakers*, destroyed in World War II. With his social realism, he wanted to give support to the radical ideal of transforming the world and saving man. In the following years appear works of fundamental importance, such as *The Threshers* and *The Painter in His Studio*, a large canvas painted between 1853 and 1855, in which he depicted friends and admirers and embodied many of his ideas. Napoleon III tried to commission paintings from him, but Courbet refused so as not to compromise his ideals. In 1855, he also refused to show at the Universal Exposition, preferring to build a booth nearby on the Pont de l'Alma for his own exhibit. Opposed to official shows as he was, he nonetheless met with success in his exhibitions in the provinces. He felt nature as an objective entity present in the concreteness of everyday life. He depicted the Normandy cliffs that were later to attract the impressionists, the forests and stands of oak, the heavy swells of the sea and the flight of deer and roebucks at the approach of hunters. When the Commune took power in Paris after the 1870 insurrection, he was named commissioner of fine arts. After the restoration, he was convicted of having participated in destroying the column in the Place Vendôme. In truth, however, he had already resigned as commissioner when the column was taken down. He was imprisoned for six months and his goods seized to pay the damages.
He retired to Switzerland in 1873, and resumed painting in a subdued naturalist manner, his realist crudeness now tempered by an almost pantheistic feeling in which there are traces of melancholy.

334

EDGAR DEGAS (Hilaire-Germain-Edgar Degas) (Paris 1834-1917)

His father, a banker with interests in Naples and an art lover, would take him as young boy to visit museums. He could have studied law, but decided on art, and frequented the studio of Louis Lamothe, a follower of Ingres. In 1855, he was admitted to the Ecole des Beaux-Arts, where he met Fantin-Latour and Bonnat. But he was impatient with academic discipline and went travelling, especially in Italy where he spent the four years from 1856 to 1860 in Naples, Rome and Florence, copying Renaissance masters and drawing from nature. His painting in this period, of which the *Bellini Family* is the most significant example, is identifiable for its careful drawing and gemlike colors. He would say that a painter had to have "the intelligence and love of Mantegna along with the *brio* and colors of Veronese." In Florence he came in touch with the *Macchiaioli* and painted historical scenes and portraits. The paintings he sent to the Paris Salons appeared to be strictly traditional, but actually his composition was quite new, with figures seeming to enter from the side or, as in the paintings he did of racetracks, with figures seemingly in motion. His inquiring nature led him to frequent the Café Guerbois, where the impressionists used to gather; but in the end, his ideas were quite different from those, say, of Monet. Whereas the impressionists were concerned with the phenomena of light and its transience, Degas was concerned with body movement, which he always tried to capture at its most intense and characteristic moment: jockeys racing, trotters, ballerinas, crowds in the street — a dynamic impressionism, one might say, rather than an atmospheric one. In 1874 he exhibited at the First Impressionist Exhibition, and continued to do so every year except 1882, but he was a special case among the impressionists because painting outdoors was not a basic principle with him. He travelled widely, including a trip to the United States; he was in New Orleans for a year, 1872-73. His mastery of drawing made him especially aware of the linearity of Japanese art. At a certain point he preferred to use pastels for greater freedom and rapidity in catching the arc of a gesture, the fleeting trace of a foot, the vaporosity of tulle. After 1886, he broke away from the impressionists, and emphasized his differences in both technique and artistic purpose. In the series of women at their bath or at their toilette, he achieved a powerful definition of the human body in various positions and from daring angles, with color that no longer pretended to be natural, but expressed the warmth of those rooms, the perfume of those bodies and the filtered light from those curtains. This new pictorial way of looking at things caught the interest of Toulouse-Lautrec and later, Bonnard. Degas lived out his last years in Paris, and died almost blind.

MARCO DE GREGORIO (Resina, Naples 1829-1876)

Landscape painting, particularly the realist current, inspired a group of painters in Naples in 1863 to form the Portici School, known also as the Resina School. Its major exponents were Giuseppe De Nittis, Federico Rossano and Marco De Gregorio. They were especially influenced by the *Macchiaiolo* painter Adriano Cecioni, who had come to Naples from Florence. Their artistic motives were very much those of the Pergentina painters, Sernesi, Abbati, Lega; that is, love of actual things, tonal relationship among colors, clear, defined composition, unobtrusive sentiment. The Portici School (or Resina School) did not last long; Cecioni returned to Florence in 1867, and De Nittis joined him shortly afterwards before going on to Paris. In contrast to the showy colors of the Neapolitan painters, the Portici group preferred more intimate and refined tonalities. It was probably at De Nittis' behest that the Paris dealer Goupil took an interest in the two painters of the group who had remained in Italy. De Gregorio's vision is more severe and sober, and his tone, if not very resonant, is intensely sensitive. There is a certain archaic quality in his choice of subjects.

EUGÈNE DELACROIX (Charenton 1798 - Paris 1863)

Although his father is described as having been foreign minister under the Directory and prefect under Napoleon, it seems Delacroix was Talleyrand's son. He studied painting with Guérin and through him met Géricault, for whom he felt immediate admiration. In 1822 his first important painting, *Dante and Virgil Crossing the Styx*, was well received at the Paris Salon. Although it is essentially an historical painting with academic characteristics, there is a new spirit about it, a response to the classical theme it depicts. A well-educated man with a fine critical sense, Delacroix began to write his *Diary* that year, and kept at it the

rest of his life, noting the cultural currents of the times and his own romantic ideas. At Bonington's suggestion, he made a trip to London and met the English landscapists, being especially drawn to Constable. In 1824 he was so moved by the tragedy of Greece that he painted the *Massacre of Chios*, which put him in the forefront of romantic artists. His color and monumental composition are taken principally from baroque and Venetian painters. The insurrections of 1830 inspired him to depict *Liberty Leading the People*, showing the commanding figure of a young woman carrying the tricolor over the barricades. In 1832 he went to Morocco, which proved to be a rich source of subjects for him, making him the leading exponent of exotic scenes. *The Women of Algiers* is the most important painting of this period, during which he illustrated the whole panoply of Berber warriors, desert scenes, flying cloaks and colorful turbans. *Women of Algiers* depicts an Arab interior, with inlaid woods, carpets, perfumes; the color conveys the sensual atmosphere, and the light heightens the effect of indolent young female bodies. Delacroix's romanticism, however, does not lead him away from form, and in a certain sense we can speak of the classical spirit in his art which he got from Gros and Prud'hon and from his visits to museums. In 1833 he began to do large commissions for the government, including frescoes in the Chamber of Deputies; toward the end of his life he was busy decorating Saint-Sulpice with a vigor and flair reminiscent of Tintoretto. Baudelaire praised the works he exhibited at the 1848 Salon because he considered him his counterpart in art. Delacroix was a close friend of writers and musicians, Chopin and George Sand in particular. He had a number of opponents as well, among whom was Ingres, who vainly tried to prevent him from being nominated to the Institute. As subjects, he was particularly fond of storm scenes, horses and tigers in combat, battles and hunts. His large canvases tend to be overwhelming, but his smaller ones put his romantic ideals in clearer focus. Toward the end, afflicted by illness, he withdrew from his active social life among intellectuals, and spent his time in the country at Champrosay or in his Paris studio, which was transformed into a museum after his death.

CESARE DELLA CHIESA DI BENEVELLO (Turin 1788-1853)

Although self-educated, he was a painter of some talent and a generous patron. He founded the Society for the Promotion of the Fine Arts in Turin and became its first president. His theatrical feeling for landscape owed much to the eighteenth century and derived mainly from the Dutch and English. He was very active in promoting cultural exchanges, as well as a variety of public events to support art and artists. When lithography was introduced to Turin, he took to it enthusiastically and encouraged other artists to do the same.

LORENZO DELLEANI (Pollone, Biella 1840 - Turin 1908)

A student at the Albertine Academy in Turin, he was at first an ardent romantic, executing historical scenes and recounting events in the lives of famous people such as Canaletto and Doge Veniero. With his painting *Regatta at Venice*, he was successfully received at the 1878 Salon by the same public that rejected the work of the impressionists. About 1880, he changed his genre and dedicated himself to landscape painting, revealing a lively imagination and a feeling for striking color. He was a rapid painter, and his smaller panels took shape quickly and with good results. He went to Holland in 1883 and was impressed enough by traditional Dutch landscape painting and by Rembrandt to use richer colors and fresh insight. At times he let himself be carried away by light or tonal effects, or too fleshy color, and was not always a judicious artist. His best paintings are those in which the vibrant visual feeling is realized concretely.

MAURICE DENIS (Granville 1870 - Paris 1943)

He attended the Académie Julian in Paris to study painting, and there he met Vuillard, Bonnard and Sérusier. Sérusier had returned from Pont-Aven in Brittany in 1888 with the famous panel called "the talisman" on which he had painted the landscape *Bois d'Amour* according to Gauguin's instructions. On the basis of the fresh pictorial insights in this landscape, Denis and his friends put into practice a new esthetic which combined Gauguin's synthesizing style and the literary ideas of the Symbolists, thus rejecting naturalism and

impressionism. They contended that although painting used life and nature as starting points, it transcended them by spiritualizing reality, or at least intellectualizing it by proper detachment and contemplation, or by the use of imaginative symbolism. The intentions of the group, known as *Les Nabis*, are best indicated in Denis' own words, written in 1890: "...a painting, before being a horse in battle, a nude woman or an anecdote, is essentially a flat surface covered with colors arranged in a certain order." This was obviously a declaration against representationalism and for subjective art. On this principle, pushing it to its extremes, the whole of modern art has been based. Denis had great esteem for Cézanne and visited him, along with Emile Bernard, at Aix; later he dedicated a painting to him, *Homage to Cézanne*. In 1895 he left for Italy; in 1897 he returned there in the company of André Gide. He became religious and studied the Italian mystics. Abandoning the tenets of *Les Nabis*, he began to paint religious subjects, such as *The Annunciation* (1913), in the *art nouveau* manner.

GIUSEPPE DE NITTIS (Barletta 1846 - St. Germain-en-Laye, Paris 1884)

He studied at the Academy in Naples, but was sent away as a disciplinary measure. At his first exhibition in 1864, his painting *The Approaching Storm* caught the attention of Cecioni, a painter on scholarship in Naples from the Florence Academy. With Rossano, De Gregorio and Raffaele Belliazzi, he formed the Resina School, which Morelli ironically called the Republic of Portici. He went to Florence in 1867, but stayed there only a few months, returning to Naples and then going to France. Because of the insurrection in Paris in 1870, he returned home, but was back in Paris two years later. His success began in 1873 at the Paris Salon, with his painting *Road to Brindisi*, which interested Degas, who asked De Nittis to exhibit with the impressionists. De Nittis did, in fact, participate in the First Impressionist Exhibition of 1874.

He spent the following year in London, where his light and airy Paris views had a good reception.

His association with the impressionists was a productive one for his painting, which took on a transparent fluidity that was particularly compelling when he used pastels. The critic Claretie wrote that "he understood Paris better than the Parisians did." Dealers and collectors bought up his works at such a rate that his fellow painters became envious. During his Paris period, he had a preference for shaded colors and pearl greys, which best expressed his *intimiste* attitude. Then he realized he ought to brighten his palette, and wrote to Cecioni saying so, but he did not change the *sfumato*, causing some Italian critics, Banti for instance, to speak of his "sickly" painting, and causing even Cecioni to say, rather too severely, that his art was merely chic.

Like Degas, De Nittis looked to Japanese art for the secret of open space; and his shimmering fluidity can be attributed to the impressionists. His drawing, although light enough, no longer suggested volume but concentrated on the outline, a vestige from his Naples efforts and the influence of the *Macchiaioli*. His style is distinctive, even if somewhat elegant and not lacking in facilely pleasant qualities. Undoubtedly one of the most gifted artists in the Europe of his times, De Nittis died of a stroke.

SERAFINO DE TIVOLI (Leghorn 1826 - Florence 1892)

At first he studied landscape painting, then enlisted in Garibaldi's army in 1848. After that, he took part in discussions with the *Macchiaioli* who gathered at Caffè Michelangelo in Florence, and became a proponent of painting directly from nature. In 1855 he went to Paris with Altamura to follow more closely the critical battle raging around Courbet and brought a report back to Florence, along with an appraisal of the Barbizon group. He went to live in London in 1864, and remained there several years, but we know little about him during this period. In 1873 he went to Paris, and became interested in what the impressionists were doing. Some evidence of their influence can be seen in his work, but for the most part his drawing remained strong, and his color bright and hard, a reflection of both Corot and the leanness of the Florentine Quattrocento.

THOMAS DOUGHTY (Philadelphia 1793 - New York 1856)

Trained as a craftsman and stimulated by a night-school course in drawing, Doughty decided to become a professional painter in 1820. Of a generation whose artists were primarily

interested in portraiture, he turned instead to landscape, painting, at first, topographical views of gentlemen's estates. Through the 1820's and 1830's, he worked in Philadelphia and Boston. His quiet pastoral views of the rivers and mountains of the eastern seaboard were reproduced and widely circulated. He himself lithographed many of his own paintings for the *Cabinet of Natural History and American Rural Sports*, a periodical which he published with his brother from 1830 to 1834.

Favorable reviews encouraged him to go to England in 1837, where he remained two years, exhibiting at the British Institution. From 1841 until his death, he resided in New York and participated in the artistic life of the city. He was an active supporter of the American Art Union, an organization which distributed the paintings of Doughty and others by lottery throughout the country. During a second trip to Europe in the mid-1840's, he produced idealized views of the countryside in England, Ireland and France. Though often inspired by naturalistic observation, he developed a stock formula for depicting an atmospheric, idyllic view which he repeated with many variations. Standard elements of his landscapes are a unique silvery tone and tiny figures enjoying immense vistas. One of the first American painters to devote himself exclusively to landscape, Doughty is considered an important forerunner of the Hudson River School.

ALEXANDRE HYACINTHE DUNOY (Paris 1757 - Lyons 1841)

His first appearance as a painter, it seems, was at the Salon of Youth, held in Paris in 1781. His growing success among artists and art lovers enabled him to show regularly at the Paris Salons from 1791 to 1833. Under the patronage of the King of Naples, Joachim Murat, he went to live in Italy for several years; some dated paintings prove he was in Naples in 1813-14 for certain. He was a careful painter especially concerned with the fineness of detail in his landscapes, which appears to be an almost iconographical problem with him. He tried his hand at historical painting, as in *The Meeting of Napoleon and Pius VII at Fontainebleau.*

JULES DUPRÉ (Nantes 1811 - Isle-Adam 1889)

His father was a manufacturer of porcelain ware, and the young Dupré began by decorating his father's products, until he went to Paris and there became interested in painting. The works of two Dutch landscapists, Ruysdael and Van Goyen, turned his attention to that genre, and visiting London he was similarly impressed by Turner and Constable. He was successful at the Paris Salon in 1831, but having become friends with Théodore Rousseau, he joined him at Barbizon. He was moved by the same ideals; he, too, felt nature as the mirror of a moral life. He was a more nervous painter than Rousseau, preferring more decided contrasts in his chiaroscuro, and for this reason would paint at late sunset when the dying light mingles with the mists rising from the ground.

ASHER B. DURAND (Maplewood, New Jersey 1796-1886)

In his boyhood, he assisted his craftsman father and developed an interest in engraving that was reinforced during an apprenticeship to a steel engraver, Peter Maverick, beginning in 1812. He became Maverick's partner in 1817. Durand established a printing firm with his brother Cyrus in 1824. His reproductions of history, genre and landscape paintings, published in gift books and manuals, established his reputation as America's leading engraver. He was an active member of the most vital artistic and literary circles of contemporary New York. Growth of his early interest in painting resulted in his abandoning engraving in 1836. At first, he concentrated on portraits and figure pieces, but soon turned to landscape, exhibiting scenes in considerable numbers after 1837. His fundamental method of painting landscape was formed by the time of his trip to Europe in 1840-41. He advocated study of nature first, encouraging American artists to seek material in their native land rather than in foreign locales or in the work of other artists. Although some of his landscapes, especially his early and his more ambitious scenes, show reminiscences of the formulae of Thomas Cole and Claude Lorrain, direct and realistic treatment generally prevails. His training in engraving and practice of painting out-of-doors made him a meticulous workman and a careful observer. His crisp and immediate natural images were typical of and influential upon the mature Hudson River School.

GEORGE HENRY DURRIE (New Haven, Connecticut 1820-1863)

After two years of study with Nathaniel Jocelyn, a New Haven artist, Durrie worked as an itinerant portraitist in Connecticut and New Jersey through the 1840's. During this time he began painting and exhibiting winter scenes. By 1847 he had developed the characteristic style of his most memorable works. This style, in which he chronicled the social history of contemporary New England farm life, is based on crisp, linear painting, skillful handling of snow effects and sensitive attention to winter atmosphere. By about 1850 he had abandoned the brightly colored, stiffly drawn portraits of his early career and devoted all his attention to rural landscape. Some of his paintings of the 1850's, in which figures play an important role, suggest contact with the works of William Sidney Mount. After 1857 the landscape becomes dominant and the figures less prominent. In the 1860's Currier and Ives and other printmakers reproduced a number of his paintings. These prints won wide circulation and immense popularity.

While his contemporaries in landscape painting functioned within the limits of traditional academic training, emphasizing pure landscape and shunning winter scenes, Durrie, in an idiomatic and personal style, produced works which have unusual sociological significance and great beauty.

WILLIAM DYCE (Aberdeen 1806 - Streatham 1864)

His family wanted him to be a doctor, but he preferred studying theology and painting on his own until he was given permission at eighteen to study at the Royal Academy in London. As was customary among artists then, he visited Italy twice, in 1825 and again in 1827. His religious tendencies and his esthetic interests brought him in touch with the group of German painters in Rome known as the Nazarenes, and from this association derived his detailed style and bright, hard colors. Although attracted to nature, he transformed it on canvas in this refined style, achieving a kind of ideal grandeur. In 1830 he moved to Edinburgh and entered the Royal Scottish Academy. From there he went to London in 1837 and the next year was named director of the School of Drawing. Received by the Royal Academy in 1844, he became a full member in 1848 and was commissioned to decorate the House of Lords.

THOMAS EAKINS (Philadelphia 1844-1916)

Instruction in drawing at the Pennsylvania Academy and anatomy lessons at Jefferson Medical School were the foundation for Eakins' study of art in Europe from 1866 to 1870. He acquired a solid training in academic technique in Gérôme's *Beaux-Arts atelier* and an appreciation for the factual character-studies of Velázquez, seen on a trip to Spain.

His original technique combined French academic devotion to solid form with Spanish freedom in the rendering of warm light and atmosphere. Truth to reality, the keynote of his mature works, is evident in his mathematically constructed rural scenes and in the uncompromisingly objective portraits of family and friends which dominate his work after the mid-1880's. Science, as it could contribute to his art, was a constant interest. He used the camera to analyze locomotion and investigated perspective and anatomy.

Basing his instruction on the nude and encouraging his students to paint in full color without preliminary drawing, he began teaching life classes at the Pennsylvania Academy in 1877. By 1882, when he became its president, the school had gained a reputation as the most progressive in the country. After his forced resignation in 1886, he simultaneously taught at various schools in New York, Washington and Philadelphia. Adverse criticism and obscurity marked his career until about 1900. Since that time he has been recognized as one of America's greatest realists and the forerunner of major twentieth-century movements.

JAMES ENSOR (Ostend 1860-1949)

His father was English, his mother Belgian; until his death he lived and worked in his native city. After his studies in Ostend, he went to Brussels in 1877, where he joined a group of socialist university students. He returned to Ostend in 1880. His early paintings,

from 1879 to about 1883, show an effort to modify the compact Flemish realism he was heir to with broader rendering, perhaps with some impressionist influences at work.

His vision of bourgeois life is crushing. Already in his *Woman in Blue* (dated 1881, Brussels, Royal Museum of Fine Arts) and especially in his *Still Life with Fans* (1881, Brussels, Boogaerts Collection) we see a nervous, rough application of color. In 1883 he began to paint in sombre tones, full of disquieting omens. In 1884, he joined *Les Vingt* and participated in their first shows with paintings permeated with Bosch and Bruegel and the symbolists and with no trace of the sun-laden style of the impressionists. Ensor seems to have wanted to satirize existence bitterly and to have been fascinated with the sense of death. "Masques" and "skeletons" begin appearing in his paintings and fill the excellent etchings he did between 1884 and 1887. Toward 1888 his colors get brighter and more biting, reaching subdued visionary levels. But the same light accentuated to the extreme engulfs his busy *Carnival on the Beach* (1887, Brussels, Museum of Fine Arts), which was a prelude to his daring *Entry of Christ into Brussels* (1888, Antwerp, Museum), a *kermesse* of thick, garish colors on grotesque masks, expressionist in advance of expressionism. As a result of the uproar the painting caused, Ensor was ejected from *Les Vingt*. Even his bourgeois interiors become horror-laden and satirical.

In 1894, he had his first one-man show in Brussels; in 1898, in Paris. His best work, to be judged side by side with Van Gogh's and Gauguin's, was done by the early 1900's; after that his paintings become cold and cursory. He was discovered in 1905 by the collector François Frank, who supported him. Verhaeren dedicated a book to him in 1908; his work was recognized and became popular; in 1910 he had a show in Rotterdam, and in 1914 the first monograph about him appeared in Germany.

HENRI JACQUES ÉDOUARD EVENEPOEL (Nice 1872 - Paris 1899)

In Brussels he attended the drawing school of Saint-Josse-Ten-Noode, under Blanc Garin, but his training was mostly at the École des Beaux-Arts in Paris, where he was first a pupil of Galland, then of Gustave Moreau. A fellow student of Matisse and Rouault, he became interested in the works of the impressionists. He participated for the first time in the Salon des Artistes Français in 1894, and in 1895 in the Salon de la Société Nationale. Although his earlier paintings repeat traditional naturalist concerns, they attempt a Degas-like incisiveness.

If his portraits tend to be solid and realistic, his freer works — from 1895 to 1899 — give us an idea of his talent and his sense of the play of color under light. Scenes equally distant in feeling from the sure freedom of Manet, the lucid projections of Degas and the elegance of Whistler are evidence of his verve. Ochre and deep blue tones stand out among the attenuated areas, with flattenings in the manner of Toulouse-Lautrec. Brighter light floods the paintings he did after his trip to Algeria, where he spent the winter of 1897 because of illness, in the interior, at Blidah. Not far from Renoir in nuance and feeling for his subject, he did a number of children's faces. He wrote in a letter: "We must paint only out of love for what we are doing, and only what we love with our hearts is commendable; each brushstroke must be guided by our sensibility." He did a number of engravings and lithographs and illustrated the tales of Edgar Allan Poe. A retrospective exhibition took place at the Venice Biennale in 1928.

GIOVANNI FATTORI (Leghorn 1825 - Florence 1908)

He attended the Academy in Florence from 1846, studying under Bezzuoli, but had to leave because of financial hardship. At first he painted historical subjects, but later he began to draw and paint from nature, in the streets, in the country, wherever he happened to be. Returning to Florence after the insurrections of 1848-49, he took to drawing and painting horses and soldiers on maneuvers or at leisure. He frequented the Caffè Michelangelo, took part in the discussions led by Signorini, and exchanged letters and opinions with Nino Costa, who urged him to paint things as they are and not to listen to the academics. For about ten years, he could not manage to find his own style. In 1861, he won a contest for the best battle scene with his *Italian Camp after the Battle of Magenta*, the first of his mature paintings. He did many military scenes, but he overcame the banality of illustration art inherent in this kind of subject by capturing the naked, exhausting reality of war and avoiding empty heroics. His first major portrait was of his cousin Argia, a frank, open portrayal, and another, of his

Stepdaughter, a superb piece of painting for its incisive formal qualities and chalky whites. He came late to the "*macchia*"; that is, the Florentine impressionism that used small, defined areas of color to render an integrated, mosaic-like whole. Fattori dedicated himself intensely to this technique, without limiting himself to predetermined procedures, and achieved some of the most notable results of all the *Macchiaioli*. During this period, he considers nature a concrete reality, majestic and hospitable in its still intact primordial state. He would always paint in the open, concentrating on small subjects that he would depict on wooden cigar-box covers. In 1869 he was named to teach at the Academy, but only later, in 1886, was he given tenure as professor of landscape painting. He took a trip to Paris in 1875 and met Meissonier, the famous painter of battles, who was "adjusted and successful" compared to the provincial Fattori. While in Paris, Fattori took special interest in Manet's paintings. Other great war paintings of Fattori's are *The Assault on the Madonna della Scoperta* (1868) and the *Battle Formation at Custoza* (1880). In between these rather disparate subjects, nature and war, he painted small panels of the Maremma region, and genre scenes of city and country life, as, for instance, the jewel of his *macchia* technique, *La Rotonda Palmieri* (1866).

After 1880, he seems to have had a change of heart, and in any case was beset by financial and family troubles that cast a melancholy tone over his work. He painted the Roman countryside and the herds, a malarial, wild, hard landscape inhospitable to man.

ANSELM FEUERBACH (Speyer 1829 - Venice 1880)

The son of an archeologist, raised in a cultured environment, he pursued classical studies at Freiburg. But his penchant for art led him to take courses at the Academy in Düsseldorf under Schadow, Schirmer and Sohn from 1845 to 1848. Rethel also contributed to the young man's training, especially in the direction of neoclassicism, but Feuerbach's interest in Rubens and the Venetians influenced him toward a romantic interpretation of history and myth.

From 1848 to 1850, he was in Munich, where he associated with Karl Rhals, who was an exponent of the French taste. At Antwerp in 1850-51, he studied the old Flemish masters; a year later, in Paris, he was interested in Courbet, but saw him through a classicizing filter. And in fact, during his second stay in Paris, he associated with Couture and appreciated Delaroche. The formal component can be seen even in the numerous series of portraits he did at the time; the sitters are very solemn, but at times immersed in a delicate luminosity. At other times, he achieved a greater freedom and a more authentic feeling for landscape. He went to Karlsruhe in 1854, but returned to Italy the next year, and deepened his sense of light and color in Venice; he made a copy of Titian's *Ascension* and went to Florence and studied Raphael and Michelangelo. During his stay in Rome, 1857-72, he was surrounded by pupils and followers.

In Count von Schack he found an assiduous collector and patron, for whom he painted literary and historical subjects. Named professor at the Vienna Academy in 1873, he decorated the rooms of the Academy with the *Fall of the Titans* (the oil sketches are now in the Munich Art Gallery). Other works are in the Palace of Justice in Nuremberg.

ALVAN FISHER (Needham, Massachusetts 1792 - Dedham, Massachusetts 1863)

Tired of clerking in a country store and eager to become an artist, Fisher apprenticed himself in 1812 to John Penniman, a Boston painter. He began as a portraitist, but soon turned to rural genre and animal scenes. In 1815 he took up landscape painting as a profession. Notes in his early sketchbooks indicate that he tried to paint out of doors, directly from nature. At the same time, he found it necessary to seek instruction from drawing books and engravings after the European masters. His views of New England landscapes, sometimes real and sometimes half imaginary, show affinities with paintings by such artists as Cuyp, Ruysdael, Berchem and Gainsborough. During the mid-1820's, he travelled through the South painting portraits of racehorses which recall in subject matter the works of Landseer. In 1825 he visited England, France, Italy and Switzerland. He studied briefly in Paris, copying in the Louvre. Upon his return to the United States, he settled permanently in Boston. Exhibitions there and in New York and Philadelphia often included his works. A successful and respected painter, Fisher exemplified the American artist of his generation who borrowed European subjects, compositions and techniques to supplement his own limited experience. Yet he conveyed the American feeling of awe before the grandeur of nature.

ANTONIO FONTANESI (Reggio Emilia 1818 - Turin 1882)

He studied with Minghetti in the art school of his town, but family necessity compelled him to take up decorating private houses with perspective paintings, flowers and medallions. In 1847 he rushed to Turin to volunteer in the struggle for Italian unification. Later he was forced to take refuge at Lugano, where he gave painting lessons. In 1850, he moved to Geneva and began to sell his watercolor and pastel landscapes in the manner of Calame. He stayed there until 1865, travelling to Paris and the provinces, and frequently to Italy. In 1855, he was present in Paris at the critical debates over Courbet's realism, and he became interested in the Barbizon group. In 1859 he returned to Italy for the unification struggle, and then was back in Geneva.

In 1861, he had exhibitions in Paris and Florence, where he came into contact with the *Macchiaioli*. His interest turned to the paintings of Ravier, Corot and Troyon, with particular attention to Rembrandt. He was exposed to Turner in London during his trip there in 1865; in the same year he set up a studio in Florence and stayed there until 1867. He was called to teach at the Albertine in Turin in 1869; at the time he was the best-informed Italian artist about artistic developments in the rest of Europe. And yet his themes and his manner continued in his own way, with progressive refinement and increasing lyricism. His landscapes depict the flatlands and woods where rivers run, with broad skies and puffy clouds. At first serene and elegiac, his paintings became permeated with a melancholy yearning, and the light as well as the umber density of his colors further reveal his malaise, but at the same time, because of his strong realist attitude, never lapse into pathos. He was an outstanding example to the Piedmont artists who came after him, because his landscape paintings were international in tone. In 1875 he accepted an invitation to teach at the Art School in Tokyo, but three years later he had to return to Turin because of illness, and he taught there at the Albertine until his death.

CARLO FORNARA (Prestinone, Val Vigezza 1871-1968)

The son of poor mountaineers, he began his painting career between 1884 and 1889 under the guidance of Cavalli, who had returned to Val Vigezza from France, where he had been an assistant to Delacroix. Fornara left for Paris to study the impressionists, and became enthusiastic over Cézanne's work. He made his debut in Milan in 1891, the year critical debates had begun over divisionism, which was practiced in Italy by Segantini, Grubicy and Previati. He remained within the Lombard tradition of heavy impasto until 1897, when Segantini, recognizing his talent, asked Fornara to join him. Fornara took to Segantini's technique, to his pronounced realism, to his feeling for nature, but rejected his symbolic and literary themes. Returning to Prestinone in Val Vigezza, he painted landscapes of his valley during the different seasons of the year, and scenes of mountain life. He was a dedicated divisionist, but always in relation to reality, and with warm, binding color, a reflection of his interest in what Cézanne had done, and in certain insights into color Van Gogh had had. After 1921, his divisionism changed into a looser and more spontaneous vision of things, but he remained constant to his themes, and detached from the upheavals in the artistic life of Milan and Turin.

CASPAR DAVID FRIEDRICH (Greifswald 1774 - Dresden 1840)

He dedicated himself to art with the help and advice of the architect J. G. Quistrop and attended the Copenhagen Academy from 1794 to 1798. But the most important part of his formation took place in Dresden, where he entered the circle of romantic writers and artists that included Otto Runge, L. Tieck, Novalis, Schlegel. The early sepia drawings and watercolors he exhibited in 1805 at Weimar already reveal an original romantic attitude, expressed by subjective, even imaginary motifs that are sometimes lugubrious. This vision of things became the singular characteristic of the school of Dresden, in a quite different direction from the allegorizing of the Hamburg School. Friedrich purposely never went to Italy; he preferred working in his native town, in Pomerania, along the North Sea coast, or on the island of Rügen. His visionary style, admired by Goethe, was intimate and refined, with an almost fantastic sharpness about it, and Goethe, whom he had met in 1810, acquired several of his works. His oil paintings, which he began to do in 1807, were understood only by a limited circle of connoisseurs. There is a subtle simplification of color arrangement in

them, and unique angles of observation that render his landscapes unreal. His choice of subjects and his composition were radically alien to the rhetoric of academic works. The mountain scenes he painted on the Riesengebirge or on the shore at Greifswald are hard to find now, since most of them were destroyed in various ways, including the fire that burned down the Crystal Palace in Munich in 1831. Memorable are *Woman in the Sun*, 1807 (Essen, Folkwang Museum); *The Sinking of the Hope*, 1808 (Hamburg, Kunsthalle); *Sea-cliffs*, 1812 (Vienna, Nineteenth-Century Gallery); the absorbing *White Rocks on the Isle of Rügen*, 1818 (Winterthur, Reinhart Collection); *Two Men Contemplating the Moon*, 1819 (Dresden, Gemäldegalerie); *Dioramic View of an Autumn Landscape near Dresden*, 1820 (Berlin, formerly Gurlitt Collection); *Woman at the Window*, 1818-20 (Berlin, Nationalgalerie). In 1817 he became a member of the Dresden Academy and in 1824 a professor. His painting was known to only a few, but although he died alone and poor, his spirit remained an influence in German and Nordic art.

THOMAS GAINSBOROUGH (Sudbury, Suffolk 1727 - London 1788)

His father, a dry goods merchant, sent him to London in 1740 to study painting. Young Thomas frequented the painters Gravelot and Francis Hayman, and adopted the techniques of Flemish painting. He married in 1746 and two years later returned to Sudbury; in 1750 he moved to Ipswich and began painting portraits. In 1759 he went to Bath, where he remained until 1774, making a reputation for himself as a portrait painter in the manner of Van Dyck. He began exhibiting in London in 1761, and was among the founding members of the Royal Academy in 1768, but after various disagreements with the directors, he left it in 1784. He had gone to live in London in 1774, and around 1780 began painting Giorgionesque "fantasies" and landscapes, in which Flemish and Venetian influences blend. Even though Gainsborough was deeply immersed in the culture and outlook of his time, he had a modern awareness of landscape and how to render it with greater sensitivity, well in advance of either Turner or Constable, who, in fact, looked to his work as an evolutionary step ahead in painting.

EDUARD JOHANN PHILIP GÄRTNER (Berlin 1801-77)

He studied with Friedrich W. Müller at Kassel, and precociously dedicated himself to painting. After working in a porcelain factory in Berlin from 1814 to 1821, he went to work and study with the set designer K. Gropius and took courses at the Academy as well. He became known through the exhibits of his oils and watercolors at the Academy; in 1822, he exhibited views of Berlin and of the Castle of Marienburg. Supported by a royal grant, he went to Paris in 1825 and refined his technique under the landscapist F. E. Bertin; around this time he did the small *View of Pont St.-Michel with Notre Dame* (Breslau, Royal Palace). His fame in his own country stems from his almost documentary views of Berlin, whose orderliness and perspective clarity remind us of Canaletto's work. From 1830 on, he felt the need to paint more thematically, even though his work continued to be predominantly illustrational. He participated in the annual exhibitions in Berlin. Among his most famous works are the *Panorama of Berlin* in six parts, painted in 1834-35 (St. Petersburg, Winter Palace); a series of views of Königsberg, Breslau, Prague, and Vienna, among which is *The Hospital Chapel* (Vienna, Fr. Schutz Collection). Between 1837 and 1839 he was in Russia working on a commission from Czar Nicholas entitled *Panorama of Moscow from the Kremlin*, in three parts. In 1833, he had become a member of the Berlin Academy, and the museums of Berlin still contain the major part of his work, including watercolors and lithographs.

PAUL GAUGUIN (Paris 1848 - Atuana, Marquesas Islands 1903)

On his mother's side he was of Spanish-Peruvian descent, and he spent his childhood in Peru. Eager to travel, he became a seaman, but in 1871 landed in Europe and became a stockbroker. He married a Danish girl from a rich family, and they had four children. Of a restless and independent nature, he began painting as a pastime. He met Pissarro, who introduced him to his impressionist colleagues; Gauguin's paintings around 1875 are in fact impressionist in technique and inspiration. Gauguin did not hesitate to break with his family and his comfortable life to accept the risks and the sacrifices of being an artist, and

a very non-conformist one at that. Anxious to find different stylistic solutions, and to real-ize color through sensation rather than impression, he left Paris for Pont-Aven in Brittany in 1886, but accepted his friend Laval's invitation to go to Martinique the next year. There he found what he was looking for, luxuriant nature and violent tropical colors. When he returned to Pont-Aven, he began to paint with pure color, outlining his forms in black, much in the same way stained glass is outlined in lead, and filling them in with color according to the requirements of the composition rather than according to nature, the aim being to arouse in the viewer a profound sense of primitive vitality. This method of outlining in black came to be known as *cloisonnisme*. At Pont-Aven he associated with Emile Bernard and Sérusier. In 1888 he accepted Van Gogh's invitation to come to Arles, but after a few weeks of bitter quarreling, he went back to Paris, and stayed with a friend, Emile Schuffenecker, another former broker who had left the stockmarket to become a painter. Gauguin's new technique, like the innovations of the impressionists before him, was not well received by the press or the public. Only a few men of letters, like Mallarmé, and the young painters at the Académie Julian, were aware of the really new import and the imaginative impetus of symbolist painting. Degas was very happy to acquire *La Belle Angèle*, the portrait of the woman in whose pension Gauguin stayed at Pont-Aven. Still restless for new horizons and unspoiled nature, anxious to shed the complications of civilization, Gauguin departed for Tahiti in 1891. Out of money, he returned to Paris in 1893, and although he lived in Brittany and continued to paint the landscapes and the life of the province, he did so with the luxuriant colors of more exotic places. His friend, the writer Daniel de Monfreid, helped him leave for Tahiti in 1895, and Gauguin never returned to France. After his death, Victor Segalen found on an easel in his hut a snow-covered landscape of Brittany which Gauguin had painted in 1894 at Le Pouldu just before his departure for Tahiti. The painting is now in the Musée du Jeu de Paume in Paris.

SANFORD ROBINSON GIFFORD (Greenfield, Saratoga County, New York 1823 - New York 1880)

An artistic older brother and a collection of engravings at home led Gifford naturally to an interest in art. After two years at Brown University, he briefly studied figure drawing and perspective in New York, simultaneously painting portraits. A sketching trip to the Catskills in 1846 stimulated his affection for outdoor life and persuaded him to turn to landscape painting. His early scenes reveal a debt to the work of Thomas Cole but show an effort to render light in a fresh and natural way.
During two years spent in England, France and Italy in the mid-1850's, he painted European subjects and independently studied European art. He was especially attracted to works of Turner and of the Barbizon School. By the end of his stay, his earlier preoccupation with the recording of light had developed into a personal luminist style. This is marked by great attention to hazy atmosphere and diffused, opalescent sunlight. It is evident in his paintings of the wilderness and seashore through the 1860's and 1870's.
Restless and in search of subject matter, Gifford went abroad again in 1859 and, after serving in the Civil War, spent two years in the Mediterranean area. In the 1870's he made two trips to the West, going as far as California and Alaska. Companions on his travels included fellow landscape painters Worthington Whittredge and John Frederick Kensett.

GIACINTO GIGANTE (Naples 1806-1876)

His first training came from his father Gaetano, he too a painter; he then went on to study with W. Huber, a Swiss, and accompanied Pitloo on his painting trips outdoors. He became involved with the group known as the Posillipo school, and was soon their most gifted exponent. These *vedutisti* were somewhat pedantic, but nonetheless enthusiastic, painters from nature, which saved them from the frigid idealizing of neoclassicism. Gigante was taken on as a clerk in the printing and tax office of the Kingdom of Naples, and travelled widely in the area. In 1830, he published a series of lithographic *Views of Naples* and the surrounding area. When he was in Sicily in 1846 with the czar and czarina of Russia, he did another album with *Views of the Island*. The King of Naples named him court painter and drawing teacher to his children. To help him with his landscape studies, the king en-couraged him to take trips throughout the kingdom to gather observations and historical material. In addition to these almost documentary activities, he did have imaginative mo-

ments and immediate painterly insights into light and atmospheric transparencies which one critic defined as a "silver impressionism" (E. Cecchi, 1926).

In 1863 he painted an impression of the *Chapel of San Gennaro* thronged with a lively crowd. His knowing and sure capabilities with watercolor permitted him to capture the transient effects of light on color. He practically never left the Kingdom of Naples, even after the unification of Italy.

JOHN GLOVER (Houghton on the Hill 1767 - Laucenston, Tasmania 1849)

Impelled by a natural vocation for art, he studied painting on his own, especially examples in the classical taste, which led him to prefer finished paintings, grandiose in size, but detailed in execution, although in England there were already two such important innovators as Turner and Constable. In 1794 he went to Lichfield and taught painting there. In 1795 he exhibited at the Royal Academy for the first time, and his modest success induced him to move to London, where he actually arrived in 1805. He was a member of the Old Water Colour Society, which consisted of a talented and demanding group of watercolorists, and became its president. Curious about landscapes in other parts of the world, he travelled to Switzerland and Italy and finally in 1831 to Australia, where he settled.

EMILIO GOLA (Milan 1851-1923)

Of a noble family, Gola earned a degree in engineering, but preferred painting. A lively temperament and quick sensibility, but without the melancholy strain of the *Scapigliati* (a nineteenth-century avant-garde movement of rebellious writers and painters in Milan), enabled him to render landscapes, portraits and figures with verve and with a tendency toward verism that was not rigid. His brushwork is spontaneous, rapid, fluid. He went to England and Holland, and then to Paris to get to know Manet's work. His own style remained within Lombard impressionism, with strong chiaroscuro and a certain excess of palette. But his impetuosity produced some rather compelling results in tonalities and coloring that later painters found suggestive.

If impressionism tends to break up light, Gola's tends to thicken it, with an effect of singular plasticity released in dense vibrations of color. In 1889 he exhibited the *Portrait of His Mother* in Paris, and in 1892 won the gold medal at the Munich Exposition with the same painting. In 1915 he participated in the San Francisco Exposition, and was one of the first, along with Segantini, to be nominated for the Carnegie Prize in Pittsburgh.

VITTORE GRUBICY DE DRAGON (Milan 1851-1920)

He was very influential in the cultural life of Milan during the last decades of the nineteenth century. A critic, and with his brother Alberto an art dealer, he was active in contemporary art, and an intelligent student of the new currents then developing in the Low Countries and in Paris. He began to paint late, when he was nearly thirty, and was self-taught. He achieved particularly good results in luminous landscapes, with cloud-laden skies and distant light. His technique was too personal to be called orthodox divisionism, but with fine atmospheric effects and vibrancy it does have almost an attenuated fragility about it. He took special interest in Segantini, and became his adviser and dealer, introducing him to Millet and acquainting him with French divisionism. In fact, he came brilliantly to the defense of all the divisionists when Segantini showed his *Two Mothers* and Previati his *Motherhood* at the Brera exhibition in 1891. In his last years he lived withdrawn.

PHILIPP HACKERT (Prenzlau 1737 - San Piero di Careggi 1807)

He practiced with his father's guidance, copying portraits and landscapes by famous artists. He continued his studies at the Berlin Academy, and later travelled through Germany, Norway and France, painting landscapes and decorating. In Normandy he did many drawings from nature, and then went to Paris with his brother Johann, also a painter, and both met with success there. In 1768 along with their brother Georg, an engraver, they arrived

in Rome. Philipp painted landscapes and decorations in private homes, and a series of paintings for Catherine of Russia on the episodes of the Russo-Turkish war. In 1770 he took his first trip to Naples and the surrounding area to do some views of Vesuvius for Lord Hamilton and several small pictures for Lady Hamilton. Then to Sicily in 1778 and North Italy and Switzerland the year after. He returned to Naples in 1782 to paint a view of the Royal Palace at Caserta for the king; the court received his precise, detailed style with favor. In 1789, he was named court painter and did a number of royal portraits. It was during this time that Hackert arranged to have the Farnese collection moved to Naples. Goethe visited him and they became friends. Despite a certain coldness in his style, his fame spread. He decorated several rooms of the Royal Palace at Caserta. Because of the French occupation in 1799, he left Naples for Tuscany, where he spent his last days.

MARTIN JOHNSON HEADE (Lumberville, Pennsylvania 1819 - St. Augustine, Florida 1904)

His inclination toward art was apparent early, and he received instructon in portirait painting from Thomas Hicks and encouragement from his parents. Sent abroad for further study in 1837, he spent some three years in Italy, France and England. By 1843 he was established as a portrait painter in New York. He began to turn increasing attention to landscape and in the next two decades travelled widely, recording American scenes. The turning point in his career occurred in 1863 when his passion for travel and naturalist's interests led him to Brazil to paint pictures for a book on hummingbirds. The publication was abandoned because of various technical difficulties, and Heade sold the paintings in England in 1865. Extensive travels in South and Central America, the Caribbean and the Far West highlighted the next twenty years. In 1885 he settled permanently in St. Augustine. Living in a period of growing scientific awareness, he was an untiring seeker after truth in nature. His hummingbird and flower paintings testify to his abilities as scientific observer and master of technique. While he sought ornithological and botanical accuracy in these works, his lush landscape backgrounds reveal a romantic bent which consistently modified his realism. In his pure landscapes and marines, his peculiar and personal recording of atmosphere and mood transforms literal scenes into tranquil, subjective impressions.

EDWARD HICKS (Bucks County, Pennsylvania 1780-1849)

He is probably the best-known nineteenth-century American primitive painter. He was untutored in art except as a maker and painter of carriages and coaches, and unpracticed except as a painter of furniture, fire boards, tavern signs and street markers. Combining the life of the artisan with that of a preacher in the Society of Friends, he aimed to express honesty and intensity of vision and religious sincerity. His most famous works are the fifty or more versions of *The Peaceable Kingdom*, executed between 1820 and the end of his life. These paintings, based on the theme from Isaiah, reveal his religious interests and his artistic inclinations. They depend, as do most of his works, on prints after paintings by other artists for their general composition and details.
However much he relied on black-and-white prints, his superb sense of color produced impressively original works. His early artisan's training is apparent in the fine technique and excellent state of preservation of his paintings.
Combining innocence with artistic knowledge based on tradition, Hicks is akin to the great European primitives, an earlier American equivalent of Henri Rousseau.

WINSLOW HOMER (Boston 1836 - Prout's Neck, Maine 1910)

Winslow Homer, who was to become the master of several media, was trained as a lithographer in Boston in the mid-1850's. In 1857, he began an eighteen-year career as a freelance illustrator, producing drawings to be reproduced as wood engravings in *Harper's Weekly* and other magazines. In 1859, he moved to New York and studied briefly in a drawing school in Brooklyn and at the National Academy of Design. As *Harper's* correspondent, he recorded Civil War scenes, showing more interest in the everyday life of the troops than in their battles. By 1864 he had begun painting the rural scenes which dominate

his work in oil and watercolor through the 1870's. A visit to Paris in 1866-67, when two paintings by him were placed on view at the Universal Exposition, had little effect upon his art. In the late sixties, parallels between his subjects and methods and those of the impressionists are striking, but there is no evidence of contact or influence. He spent 1881 and 1882 at Tynemouth, on the English coast, and began painting the sea scenes for which he is most noted. His affection for the sea and his desire for solitude led him to settle permanently in Prout's Neck, Maine, in 1883. He made numerous trips to the Adirondacks, to Canada and to Florida and the Caribbean. Forest, mountains and sea, the elements of nature least affected by man, were his favorite themes. Genre interest gradually subsided in his paintings and land and sea alone became heroic images.

One of the most individualistic and purely American artists, he, like Whitman in poetry, interpreted the American landscape and spirit in a personal, vital and native way.

THEODOR VON HÖRMANN (Imst, Tyrol 1840 - Graz 1895)

As an officer in the Austrian army he fought in the Italian campaigns of 1859 and 1866, and against Prussia. About 1870 he attended the Academy of Fine Arts in Vienna as a student of E. Von Lichtenfels and A. Feuerbach. For several years he taught drawing and fencing at St. Pölten's Military School. In Paris in 1886, he studied with Raphael Collin, at the same time paying careful attention to French realism and impressionism, which came to figure in his own late style, also because of Schindler's influence. During his stay in France, he worked in Brittany and at Barbizon. Returning to Austria, he lived and worked primarily at Dachau, with visits to Znaim, Prague, Vienna and the surrounding area. He exhibited his landscapes with figures in Vienna in 1874, paintings that are clearly inspired by a love for nature as it is; for instance, *The Harvester's Holiday* (Belvedere, Vienna) and other vigorously realized subjects now in the Ferdinandeum at Innsbruck, and in art museums of Vienna and Brünn. In his last paintings he used a range of much stronger and brighter colors, reflecting the new tendencies in European painting: *Morning near Lunenburg* and *View of Prague* (Belvedere, Vienna), *Night Skating Party* (Belvedere, Vienna). After his death his paintings came to be appreciated — the result of several retrospective exhibitions, especially the one held in Vienna in 1895.

GEROLAMO INDUNO (Milan 1827-1890)

He took lessons at the Brera with Sabatelli, an historical painter, but just when he began to be successful with his lively narrative scenes, he abandoned his brushes to take up arms in the insurrection of 1848. A few months later he had to flee with his brother Domenico (also a painter) to Switzerland. He went to Florence in 1849, and on to Rome to fight with General Medici. He displayed great valor and was saved by some monks who hid him when he was seriously wounded. He finally reached Milan, only to go off again to the Crimean campaign as part of the Piedmont expedition. He fought by Garibaldi's side as an officer for the whole 1859 campaign. From these adventurous expeditions he managed to bring back a number of sketches, from which he did several paintings with notable success, even if they frequently lapse into sentimentality and illustrational art, or rather, they were successful because of this. When pressed by economic necessity, he did not hesitate to decorate houses and villas and paint stage sets. Induno revealed a fine hand at drawing and a sense of color when his scenes of farewell, battle, or middle-class life were adequately controlled by genuine imagination. We must judge on the basis of these better paintings from among the large number he executed. Especially when he does landscapes from nature and obeys his first instinct in rendering what he sees, his style is much more straightforward and attractive for the brilliance and rightness of his highlights and tones.

ANGELO INGANNI (Brescia 1807 - Gussago 1880)

He learned the elements of art from his father and his brother Francesco, both painters. His genre paintings of military life, executed while he was in the service, are still well known. His portrait of Marshal Radetzky won him his discharge and he remained in Milan to study at the Brera with Hayez. He was also an able *vedutista*, and after Migliara's death in 1837, assumed his place in the public's favor; several of his paintings, scenes of Milan particularly

and of the province, were exhibited in Vienna and Paris. His views have admirable perspectives, which he fills with crowds of character types. His rendering is, however, very uneven in quality because he lingered too long over certain narrative elements, or conceded too much to his clients' whims. Carlo Porta, the poet, has been suggested as the source for Inganni's minor characters, and this may be so, but the painter certainly lacked Porta's graphic concision. He had an observant eye and a rapid touch, so that his paintings are dependable documentaries of nineteenth-century Milan. When he can sustain his inspiration with disciplined technique, his work achieves some fine moments. His observations of the real world — the street scenes, lights at night, the harsh whites of winter — enabled him to hurdle the problems of both neoclassical rigidity and romantic feathering. He did frescoes and paintings for churches, too, and in the parish church of Gussago, he left a *Deposition* signed: "Angelo Inganni popularly known as a painter of perspectives."

JEAN-AUGUSTE-DOMINIQUE INGRES (Montauban 1780 - Paris 1867)

The son of the sculptor and musician Joseph Jean Marie, Ingres inherited a vocation for the arts and began studying at Toulouse with Jean Briant. In 1797, he entered David's studio. He soon distinguished himself and won the Prix de Rome in 1801 with *The Ambassadors of Agamemnon*. He finally went to Rome in 1806, after having supported himself in Paris painting portraits, notably the inflated portraits of Napoleon, or the more sincere and memorable ones of the Rivière family. He was a fellow at the French Academy in Rome until 1810, and decided to stay on in the city to continue doing portraits of the large foreign colony. King Murat had him come to Naples to paint the portraits of the royal family. It was during his stay at the Academy that he painted the three famous *tondi*, Raphael's house and other views of Villa Borghese, although he ordinarily did not paint landscapes. In 1820, he accepted an invitation to stay in Florence from his friend the sculptor Lorenzo Bartolini, and remained there four years. In 1824 he returned to Paris, and that same year his painting, *The Vow of Louis XIII*, met with considerable success at the Salon. He returned to the French Academy in Rome in 1835, this time as director. Evenings at the Ingres home became famous for the concerts held there. He returned to Paris permanently in 1841. His enthusiasm for Raphael after his earlier interest in ancient Greek and Roman art led him to refine his painting technique and his drawing even further. He dominated the Paris art scene for years, in direct opposition to Delacroix and, later, Courbet. He had tremendous successes but also harsh criticism, for instance of his *Odalisque*, who had, someone counted, more vertebrae than were natural, as if Ingres were a scientist and not an imaginative artist, as free in his fantasy as El Greco or Parmigianino. Classical in training and draftsmanship, Ingres reveals, nonetheless, numerous romantic qualities in his work. At his death, the contents of his studio were willed to his native city.

GEORGE INNESS (near Newburgh, New York 1825 - Bridge-of-Allan, Scotland 1894)

He took lessons in drawing and painting and worked for a map-engraving firm during his youth in New York and Newark. By 1846 he had abandoned engraving, taken up landscape painting, established a studio and begun exhibiting. In his early works, he combined classical landscape prototypes derived from Claude, Poussin and Hobbema with the naturalism and meticulous detail of the contemporary Hudson River School. He had travelled in Europe in 1847 and 1850-52, but his visit to Paris in 1854-55 had the most profound effect on his art. His growing conviction that smallness of detail was unsatisfactory to express his own conception of nature was reinforced by contact with the Barbizon painters. He abandoned meticulous recording in favor of painterly expression of light and atmosphere. He aimed to arouse emotions, to convey the "subjective mystery of nature." By the early 1860's, he had mastered the lyrical, poetic style for which he became famous. In the next decades his technique became increasingly free until, by the eighties, he had achieved a personal impressionism. From 1855 on, he lived and worked in a number of towns in the northeast. He spent 1870-72 working in Italy and 1873-74 in France. In the mid-eighties, he travelled extensively, going as far as Cuba and Mexico City; in the early nineties, he visited Florida and the Far West. He died while on a trip to Europe.
Coming out of the Hudson River School tradition, Inness was instrumental in the formation of later nineteenth-century appreciation of an intimate, suggestive interpretation of nature.

JOHAN BARTHOLD JONGKIND (Lattrop, Holland 1819 - Grenoble 1891)

In 1845, he met Eugène Isabey in Paris and started frequenting his studio. With the help of the dealer Père Martin, he was able to live and paint. He showed at the 1855 Paris Exposition, and his style, which, as the years went on, revealed an amazing freedom in the handling of both light and color, especially after 1860, greatly influenced the impressionists. Monet claimed his eye had had a thorough education from Jongkind. Baudelaire admired the engravings on exhibit at Cadart's in Paris in 1862. Jongkind took part in the *Salon des Refusés* in 1863. A talented painter of marine landscapes, he shows faultless perception of light and color vibrancy in his renderings of such scenes — a type highly prized by Flemish tradition. His views of Paris and the coasts of Brittany and Holland won him the esteem of critics and avant-garde artists in France, including Manet, who expressed his admiration for him during his trip to Holland in 1872. Poverty and alcohol ruined his life; Monet wrote in 1862 that Jongkind was dying for the sake of art, and that his friends were taking up a collection for him. But his will to work revived in 1863 and he did drawings, etchings, and paintings at Honfleur. Later, he found in Madame Fesser, a drawing teacher, a companion who brought order to his life and went with him in 1878 on his travels to Belgium, Lake Geneva, Normandy, Provence, the Dauphiné, and Côte St. André, and to Isère, between Lyons and Grenoble, where he settled in 1880. Quite striking, transparent watercolors follow, along with the paintings: *At the Chuzeau, in the Snow*, 1880; *Banks of the Isère at Grenoble*, 1883; *The Seine at Argenteuil*, 1889 (all in the Camondo Collection, Louvre, Paris). An imaginative perception of landscape can be found in the two versions of the *Apse of Notre Dame in Paris*, one done in 1863 (Roger Marx Collection), the other in 1864 (Paris, Cachin-Signac Collection). He would not paint in oils directly from nature, but in his studio he would work up sketches he had made on the scene, with a rather precise visual memory of the whole subject.

JENS JUEL (Gamborg Figen 1745 - Copenhagen 1802)

The illegitimate son of Elisabeth Wilh Juel, servant of a Wedelsborg nobleman, Juel was sent to study with Johann Gehrmann in Hamburg, because he had shown an early talent for painting. He observed the work of the Dutch painters (especially Aert van der Neer), which guided his first landscapes, for instance, *View of Hamburg*, 1764 (Hamburg, Kunsthalle), portraits, still lifes and genre scenes. In 1765 he went to Copenhagen, where he won several prizes. In 1767 he received a gold medal for *The Anointing of David*; in 1771 for *The Triumph of Mordecai*, both subjects, as can be seen from the titles, from the Bible. But his specialty and his best work is to be found in portraits: *His Sister Anna*, 1765; *Self-Portrait*, 1765 (Copenhagen, Ny Carlsberg Glyptotek); *King Christian VIII*, 1772 (Palace of Rosenborg); *Portrait of His Wife Caroline*, 1770 (Frederiksborg Museum).
He took long study trips to Holland, Rome and Paris in the years 1772 to 1779, which served to perfect his composition and handling of color. His later portraits have distinctly more psychological insight, such as the one of the Swedish sculptor J. T. Sergel, now in the National Museum in Stockholm. In 1773 he came in touch with the painter N. Abildgaard and did his portrait (Frederiksborg Museum) and painted the Nano Bajocco, a local Roman character. While in Paris, in 1776 he painted the portrait of the engraver J. F. Clemens (Frederiksborg Museum) that brought him success in France and Switzerland. In 1799 he went to live in the Castle of Charlottensborg and became the director of the Academy of Fine Arts. Among his last works figure delicate sketches of children in the garden, drawings, pastels, miniatures and family portraits, all scenes of contained elegance in the French manner, done with a light hand. Particularly graceful and narrative are his landscapes, which he painted from an eighteenth-century point of view, but expressed with a new feeling for nature that comes through the enamel brightness of the color.

JOHN FREDERICK KENSETT (Cheshire, Connecticut 1816 - New York 1872)

The son of an English engraver, he worked until 1840 in that trade in various shops in New Haven, New York and Albany. He exhibited his first landscape painting in 1838, but was convinced that he needed contact with European tradition and training to fulfill

his artistic ambitions. In 1840, he went abroad with Asher B. Durand and two other landscape painters whom he had met in New York. During the seven years he remained in Europe, he studied and sketched in Paris and its environs, in the English countryside, along the Rhine, in Switzerland and in Italy.

Upon his return, he established a studio in New York and, through the 1840's, spent summers painting in the Catskills, Adirondacks, Green Mountains and other northeastern locales. In the following decades, he sought subject matter as far west as Colorado and Montana and revisited the British and Italian countryside. He exhibited regularly at the National Academy of Design and the Art Union. An important organizational figure in the New York art world and a leader of the Hudson River School, he gained wide popularity for his lyrical portrayals of the American countryside. His work as a whole reveals consistency and lack of stylistic development. Undramatic and straightforward, his paintings depict the exact atmosphere, light, color and detail of nature as he observed it.

GUSTAV KLIMT (Baumgarten 1862 - Vienna 1918)

From his father, a Bohemian engraver, he got his first stimulus for art, and then went on to Vienna to take courses in applied art under Berger, and studied also with Hans Makart. Among his early works are decorative panels, executed in collaboration with his brother and another painter named Matsch, for the theaters of Karlovy-Vary and Carlsbad, and for the Museum of Art History in Vienna. After his brother Ernst died, Klimt underwent a crisis which kept him from painting steadily in the years 1892-97, but nonetheless in 1895, he did the rather dramatic and symbolic *Music*. In 1897 he founded the *Sezession* of Vienna with J. M. Olbrich, and became its president. The ceiling decorations for the University of Vienna, which he did in 1903 (now destroyed) using the allegories of *Law*, *Philosophy* and *Medicine*, caused a furor. He broke with the secessionist group in 1904 and travelled to Berlin, Brussels and London. His symbolism is a supreme admixture, with precious subjects and designs, that comes to be one of the most important manifestations of *art nouveau*. Writhing lines, bright, hard colors, and decorative motifs of all sorts compose his painting, which achieves superb moments. Bits and pieces from Gustav Mahler and from Von Hofmannsthal are part of his cultural equipment. In 1910 he did a wall mosaic for the dining room of Palais Stoclet, built by J. Hoffmann in Brussels. A refined eroticism pervades his graphic art, and there are exceptional prints by him in collections in London, Vienna and Bremen. His formal design has had a profound influence on Austrian and European decorative art. In 1911 his paintings were shown in the Austrian Pavilion of the Venice Biennale, and he was awarded a gold medal. In 1917 he was named an honorary member of the Vienna and Munich academies.

JOSEPH ANTON KOCH (Obergibeln, Tyrol 1768 - Rome 1839)

From a humble family, he managed to study with artists in Stuttgart and Augsburg with the help of influential persons. His success came early because of his draftsmanship; in 1788-89 he won several prizes. He painted decorations and for a time did caricatures. But in 1791, having done studies from nature along the Upper Rhine, he became enthusiastic about landscape painting, and his trip to Italy, made possible by the Englishman Nott, only increased his enthusiasm. In Rome in 1795, he became friends with Carsten and worked in his studio on landscapes and nudes. His association with Reinhardt made him aware of the classicizing appeal of ancient art, and besides he became friends with the neoclassical sculptor Thorvaldsen. His work was inspired by themes from the greatest writers, such as Ossian, Dante, Homer, Shakespeare, and so on. Sales of several paintings and a number of commissions from German art lovers and writers in 1803-04 considerably improved his financial condition. Esteemed by Canova and Lethier, he met with success in Italy and abroad. He did engravings and paintings of biblical subjects, using for the most part the Roman countryside as background. He had an exhibition in Munich in 1814, winning a prize for his *Sacrifice of Noah* (Copenhagen, Thorvaldsens Museum). Among his idealized scenes are *The Rape of Hylas*, 1834; *Apollo and the Thessalian Shepherds*, 1834 (Copenhagen, Thorvaldsens Museum).

JOHN LA FARGE (New York 1835 - Providence 1910)

The son of prosperous French emigrés, he was aware from childhood of the artistic and literary heritage of Europe. Informal instruction in art and a liberal college education were followed in 1856 by a trip to Paris, where he met prominent members of French literary and artistic circles. Although he studied briefly in the studio of Couture and examined paintings in continental galleries, he did not consider adopting art as a profession until his return home. In 1859 he entered the Newport studio of William Morris Hunt, another former pupil of Couture, who had adopted the theories of Jean-François Millet. Although interested in Millet's attitudes, La Farge wished to do studies from nature without formulas, to record the exact time of day and conditions of light. By the early sixties, he, like many of his European counterparts, had begun to seek guidance and inspiration in the optical studies of Chevreul and in Japanese color prints. Through the sixties and early seventies he produced numerous landscapes, flower still lifes, informal portraits and figure studies. The commission to decorate Trinity Church, Boston, in 1876, and experiments in making stained glass, commencing in 1877, directed his attention to decoration. Major mural commissions and an enormous glass production occupied his mature career.
With his friend Henry Adams he travelled to Japan in 1886 and to the South Seas in 1890-91. The watercolors inspired by these trips are among his most delightful and popular works.
He was as prolific a critic as he was a painter. The sheer breadth and richness of his scope mark him as a major influence on late-nineteenth-century American art and taste.

FITZ HUGH LANE (Gloucester, Massachusetts 1804-1865)

An intimate knowledge of the sea was fundamental to Lane's character and art. At an early age he sketched and painted in the seaport village of his birth, but received no formal artistic training until he moved to Boston in the early 1830's. There he was apprenticed to a lithographer and produced views and portraits of buildings and ships in both oil and print. In 1845 he and a partner started their own lithographic firm, which issued many of Lane's most successful and popular prints. A confident draftsman and assured painter in oils by his return to Gloucester in 1848, he entered a period of prolific production of fine marines and landscapes. Despite the crippling effects of a childhood illness, he travelled extensively along the Atlantic coast. Numerous sketches were transformed in the studio into canvases which effectively combine meticulous detail and unified atmosphere.
An exemplary American luminist, he produced compositions in which extreme geometric control, superb technique, subtle tonal gradations, and lucid, emanating light fix moments in time for all eternity. His ability to effect a profound blend of the real and the ideal, the observed and the conceptual, makes Lane a unique and central figure in nineteenth-century American landscape painting.

SILVESTRO LEGA (Modigliana 1826 - Florence 1895)

He studied in Florence with Pollastrini and Mussini, and out of loyalty to these teachers, he was at first resentful toward the noisy and argumentative *Macchiaioli* painters who gathered in the Caffè Michelangelo. In 1848 he fought in the battle of Curtatone, and on his return from war studied with Ciseri. His early training emphasized drawing skill and a tendency toward clear, straightforward colors. Gradually he was persuaded to move toward the *macchia* technique, and indeed he brought a rather exquisite and subtle handling to it. Of the whole group he was especially attached to Sernesi, Abbati and Borrani, along with whom he gave more life to *macchiaiolismo*, making it less representational and more painterly. As the years went on, his brushwork became freer, more fluid, and had more body. Particularly successful are his scenes of pergolas and gardens, of riverbanks and women quietly conversing. After 1870, family troubles darkened his outlook, his paintings became coarser, with more obvious contrasts. With Borrani he tried running a gallery in Florence, but the venture was a complete failure. Embittered, he returned to his native town in the Apennines, and his painting shows his disillusionment. In 1885 he returned to Florence and

went to live in the mountains between Leghorn and Pisa; although ill, he took to painting landscapes and peasant scenes. His portraits of peasant women are executed with thick, brusque strokes that seem to indicate his anguish. His technique prefigures Rosai's later more rustic and primordial landscapes. Lega's last years were spent in extreme poverty, and he died penniless in the hospital in Florence.

FRANZ SERAPH VON LENBACH (Schrobenhausen, Bavaria 1836 - Munich 1904)

At his father's wish, he took courses at the School of Arts and Crafts at Landshut from 1847 to 1852, then entered the Polytechnic at Augsburg. His training in art began in 1857 under Piloty at the Munich Academy. His first successful painting was entitled *Peasants Taking Shelter from the Storm* (Kaiser Friedrich Museum, Magdeburg). His trip to Rome between 1858 and 1859 with Piloty proved useful. From 1860 on, his erudite manner becomes accentuated, his portraits being especially incisive, for instance *Doctor Schanzenbach*, 1860 (Neue Pinakothek, Munich). Named professor at Weimar, he left his post shortly thereafter to go to Rome in 1863-64; there he made copies of famous paintings for various clients, including Count Schack. In 1867, while in Spain, he made copies of Titian and Velázquez. He became a renowned portrait painter, an acute interpreter of the temper of the new German empire and soon its most sought-after "official" portraitist. He had the confidence of Bismarck, whom he portrayed in several poses and various uniforms, and of Kaiser Wilhelm I and of Pope Leo XIII. Lenbach combined shrewd psychological insight with a noble pose to produce portraits of many famous people, including Wagner, Theodor Mommsen, the singer Barbi, Gladstone and the Prince of Hohenlohe. Named member of the Berlin Academy in 1883 and of the Antwerp Academy in 1891, he won many recognitions and awards. A number of his works are exhibited in the Lenbach Gallery in Munich, in his former house.

ISAAK ILICH LEVITAN (Lithuania 1860 - Moscow 1900)

He studied at the School of Painting, Sculpture and Architecture in Moscow, especially with Savrasov and later, Polyanov.
After 1880, he became one of the Wandering Artists (*Peredvizhniki*). He exhibited *Evening in the Fields at Planting Time* in 1883. He admired the landscape paintings of Venetsianov and Savrasov, which were already freer in subject matter, even if there was a noticeable streak of romanticism in them. He achieved an immediate sense of concreteness in his realistic views, especially after his trips into the interior, in the Crimea, around 1886.
His art matured after his trip to Paris in 1889 when he had the opportunity to see the works of the Barbizon painters and Corot at the Universal Exposition. His themes are more agile and airy after 1890: *Eternal Peace*, 1893-94, considered the most typical of this period; *Golden Autumn*, 1895, and *March*, 1897 (Moscow, Tretjakov Gallery), in which the transparent, vibrant light hints at impressionism. He later dedicated himself to drawing and watercolors; his watercolors done in 1892 are especially noteworthy.
Levitan is one of the most important exponents of Russian realism, and one of its finest artists.
In 1898 he began teaching in the Moscow art schools and encouraged an *intimiste* style. He exhibited at the shows organized by the review *Mir Iskusstva*.

JOHAN THOMAS LUNDBYE (Kallundborg 1818 - Flensburg 1848)

He began his studies with J. Lund, then went to the Copenhagen Academy to study with Eckersberg. He was molded by the archeologist Thomsen and the art historian Hoyen. He became interested in nature by painting in the Danish countryside with P. C. Skovgaard. His earliest period, between 1836 and 1837, was spent in painting portraits of friends and family. But around 1840 — partly owing to his study of the Dutch seventeenth-century painters — he preferred to do animals and landscapes. Among his early works, especially important are the *View of Arreso*, 1840, and *Marine Landscape*, 1842 (both in Copenhagen, Ny Carlsberg Glyptotek). He carried out the decorations in Aggersborg's house, in collaboration with Skovgaard and Kobke. He came under the influence of German romanticism. In 1845-46 he won a scholarship which permitted him to go to Italy, where he did many

paintings of the Roman countryside. From there, he went to Holland for a year, 1847-48. He distinguished himself as the most realistic of the Danish animal painters, and treated genre scenes and landscapes with vigor. The Hirschsprung Collection in Copenhagen has six hundred drawings by Lundbye. His last paintings are outstanding for their dramatic, darker quality. His drawing style was incisive; he also did drawings to illustrate children's fairy tales.

ÉDOUARD MANET (Paris 1832-1883)

His father was a judge, but did not disapprove of his son's becoming an artist. Manet entered Couture's studio in 1849, but, soon discontented, he went off on his own to copy the masters in the museums and to travel abroad. In 1853, he went to Italy, Germany and Holland. The first painting he exhibited in Paris, after the scandal caused by the Salon's refusal to show some of the younger artists, was the *Déjeuner sur l'Herbe* in 1863. Napoleon III himself had to intervene for these rejected artists rebelling against the academicism of the Ecole des Beaux-Arts by authorizing a *Salon des Refusés*. Used to Delacroix and Ingres, and not thoroughly convinced by Courbet's realism, Parisians turned against the work of these painters, which they considered too realistic, too everyday and too disrespectful of traditional classical and literary themes. Besides, they considered the craftsmanship slipshod, the execution too hasty. Manet's *Déjeuner*, taken from a print by Raimondi and from the Giorgione-Titian *Concert*, was at the center of the controversy, and so the younger artists gathered around Manet and he became the leader in the new art movement. In 1865, his trip to Spain enabled him to study Velázquez and Murillo more closely, with a profound impact on his own style. That same year, his *Olympia* caused another uproar when it was exhibited. In 1867 he set up his own exhibition in Paris in a hut, directly across from where Courbet's paintings were being shown. The rebellious painters began to gather at the Café Guerbois along with naturalist writers, and here they worked out the ideas which came to be the basis of impressionism; that is, a determination to fulfill the implications of romantic *and* realist painting by transcribing immediate impression, and identifying the eye, feeling and craft as one instantaneous response to reality. Among these young artists, who were labeled "impressionists" belittlingly, were Monet, Pissarro, Cézanne, Renoir, Sisley, Berthe Morisot. Although supposedly their leader, Manet never wanted to exhibit as part of the group, not even at the First Impressionist Exhibition at Nadar's in 1874 (which turned out to be a disaster) that was so important in introducing the new group to Paris. Monet, who was consistent with impressionist principles and painted in the open air, had a notable influence on Manet, although the latter did not share Monet's methods and worked on his own. He retired to Bellevue in 1880 because of illness, then to Versailles in 1881, and to Rueil in 1882.

MATTHIJS MARIS (The Hague 1839 - London 1917)

A little younger than his brother Jacob and older than Willem, he started drawing quite early; some extant studies by him were done at the age of thirteen. As a student with the marine landscapist Louis Meijer at The Hague, he was given a scholarship by the queen. He joined his brother Jacob at Antwerp in 1855 and remained there until 1858, studying at the Academy with N. de Keyser. He worked with his brother and Alma Tadema in the same studio. Back at The Hague in 1859, he went on a trip with Jacob to Germany and Switzerland, where he became familiar with the works of the medieval masters and of some romantic painters too, such as Schwind, Kaulbach, Rethel. In Paris from 1865 to 1867 and later, he comes into contact with the work of Corot, Jongkind and Hébert. His landscape painting is romantic, intimate, touched by mysticism. A symbolist vein runs through all his work. A few years later, after his military service during the Franco-Prussian War, and his participation in the 1872 and 1873 Paris Salons, he went to London and accepted a commission to do decorations, especially on stained glass, from Daniel Cattier. He had a preference for literary and historical-legendary subjects, drawn from Shakespeare as translated into the Pre-Raphaelite terms of Burne-Jones predominantly, but refined in Maris' handling. He did a number of nature paintings and etchings that are marked by quite subtle and precise drawing in a dreamlike atmosphere (views of *Lausanne, Neuchâtel, Fribourg*, etc.).

WILLEM MARIS (The Hague 1844-1910)

The son of a printer in The Hague, he was the youngest of the three brothers whose painting left such an important mark on The Hague School. He lived and worked almost all his life in Holland. Encouraged by his brothers Jacob and Matthijs, he began sketching landscapes and animals from nature while still in his teens. He took short trips through the Rhineland in 1866; another trip, this time to Norway ten years later, was very useful in allowing him to study landscapes and genre scenes by several able Nordic painters. But the Dutch countryside remained his favorite theme, which he depicted with subdued naturalism and at times a veiled atmosphere. He has sometimes been compared to Corot, although his painting is much more romantic. He exhibited at The Hague in 1863. In 1889 he won a silver medal at the Paris International Exposition; in 1900 he was a member of the awards jury and his own paintings were exhibited non-competitively. Many of his genre scenes are in Dutch museums, among others *Summer Richness* (Civic Museum, Amsterdam); *A Warm Day* (Art Museum, The Hague); *Calves, Landscape with Cattle* (Mesdag Museum, The Hague).

JOHN MARTIN (Haydon Bridge 1789 - Douglas, Isle of Man 1854)

His first painting teacher, at Newcastle, was an Italian, Bonifacio Musso, and so we can readily understand the classical line present throughout his painting. But his art gradually moved toward imaginary themes that were grandiose and fantastical and with a definite unreal quality that ranks him among the visionary romantics, of whom the best at that time were the Germans. In 1806 he moved to London, and the Royal Academy accepted his paintings from 1812 on. His *Belshazzar's Feast* achieved great success in 1821, again an example of how his romantic imagination was fired by classical and historical materials. It is readily understandable, therefore, why he undertook to illustrate Milton's *Paradise Lost* in 1827.

ANTON MAUVE (Zaandam 1838 - Arnhem 1888)

His father, a Protestant minister in Arnhem, wanted his son to become a painter, and so he started drawing and painting at an early age. His first teacher was P. F. van Os, a well-known animal painter in Haarlem. From 1856 to 1859 he was with Willem Maris and J. W. Bilders at Oosterbeck. In 1865 he went to work in Amsterdam. Committed to realist painting, he endowed his scenes with a contemplative mood. From 1878, he worked and lived in the village of Laren, where several painters had already gathered, and which came to be considered Holland's Barbizon. His rural scenes, veiled in tones of grey and blue, became famous. Millet's influence is quite noticeable in several works, or as some scholars have pointed out, Corot's. Among his best things are views of the beach and dunes at Scheveningen. These paintings distinguished him among the group of painters in The Hague School, which he founded along with the Maris brothers and Mesdag. His wife, Jet Catentus, was a cousin of Vincent Van Gogh, to whom Mauve gave valuable advice, especially as to oil painting techniques. Van Gogh was his rather difficult student for a year (1881-82) at The Hague. Mauve worked also at Drenthe, in the same desolate countryside Van Gogh went to in 1883. In his drawings and watercolors, he achieved a fine tone and *sfumato*.

ADOLF FRIEDRICH ERDMANN MENZEL (Breslau 1815 - Berlin 1905)

He dedicated himself to lithography in his father's printing shop, and soon became well known, mostly for his series of prints on the *Life of Frederick the Great*, taken from Kügler (1840-42) and drawn with remarkable vigor. His work is quite important in the development of German engraving. But especially noteworthy are several of his early paintings for their objectivity and airy sobriety. In this, Blechen was his predecessor, but Menzel's painting opened the way to impressionism among the Berlin painters. In 1845-51 he did a series of lithographs on the uniforms of Frederick's army (*Die Armee Friedrichs des Grossen in ihrer Uniformierung*); the same year, however, he painted the luminous *Room with Balcony* in the Nationalgalerie in Berlin. He illustrated Lange's *The Old Prussian Army* in 1852; in 1877, Kleist's *The Cracked Pitcher*. His oil paintings on historical subjects reveal a talent for effects of light, e.g., *The Round Table of Frederick II at Sans Souci*, 1850 (Nationalgalerie,

Berlin). In 1851, he did the clean, solid *Portrait of a Woman* (Reinhart Collection, Winterthur). In his crowded genre scenes, always courtly in character, a vigorous realism sometimes makes itself felt, as in *Frederick II in the Battle of Hochkirck*, 1858 (Royal Palace, Berlin). His trip to Paris in 1867 renewed his interest in urban scenes and a looser technique, as in *A Sunday at the Tuileries* (Nationalgalerie, Berlin) and *In the Luxembourg Gardens* (Tretjakov Gallery, Moscow). He was named crown professor, and was a member of various academies: Berlin (1853), Vienna, Munich, Dresden, Brussels; he was publicly recognized not only in his own country but in others as well. The Berlin Academy honored him in 1885 with a comprehensive exhibition of his works.

HENDRIK WILLEM MESDAG (Groningen 1831 - The Hague 1915)

A bank clerk until he was thirty-five, he was always interested in painting and took lessons from Willem Roelofs. From 1867 on, he paints in a personal manner, preferring marine landscapes, beach scenes with fishermen, foggy or storm-tossed seas. The emotional mood conveyed by the perturbed atmosphere gives a disquieting aspect to an otherwise traditional Flemish and Dutch landscape theme. By 1870 he was fairly well known. In touch with the Maris brothers and Alma Tadema, he came to appreciate the works of the Barbizon painters. He exhibited at the Paris Salons from 1870 to 1871, winning recognitions and citations, including the Legion of Honor. His painting *Evening at Scheveningen* (1872) was very successful. He showed intermittently until 1889. He was founder of an artistic association called *Pulchri Studio*. Also an important collector, with his wife, the painter Sientje van Houten, he gave the nucleus of the collection of the Gallery of Modern Art, which is today the Mesdag Museum in The Hague. The Museum also has many of his own works, including *The Beach at Scheveningen*, *The Port of Vlissengen*, and *Stormy Sea*.

ACHILLE-ETNA MICHALLON (Paris 1796-1822)

His father Claude was a sculptor, and he urged his son to study painting; his teachers included Valenciennes, Bertin, Dunoy. At the age of sixteen he had already won second prize at the Paris Salon. In 1817 he was the first to win the prize established by Valenciennes at the Ecole des Beaux-Arts for historical landscape painting, and was thus able to go to Rome, where he lived until 1821. Trained in the heroic landscape manner of Poussin, he painted imaginary views, even if the details were taken from reality. The king purchased a view of Frascati that was exhibited at the 1822 Salon, now in the Louvre. The academy professors, however, were critical of his free compositions and considered his paintings facile. The young Corot was an admirer of his; Michallon gave him advice and encouraged him to go to Italy. The great possibilities Michallon's talents gave signs of were cut short by his early death, at the age of twenty-six.

GIOVANNI MIGLIARA (Alessandria 1785 - Milan 1837)

He studied with Albertolli, a famous decorative artist of his time, and with Bernardino Galliani, an able fresco painter, with whom he collaborated in painting the scenery for the Carcano Theater in Milan in 1804. From these masters Migliara learned his skill as a miniaturist, set designer, decorator and landscape painter. In 1806 he entered La Scala as set designer but had to leave four years later because of ill health. He dedicated himself to painting, and after 1820 his works were in demand among the rich families of Milan. In 1828, the Prince de Caraman-Chimay offered him a thousand gold francs (a high figure for the time) for a painting requested by the Prince of de Beaufremont. He had commissions from Maria Christina of Savoy, Maria Louisa of Parma, Leopold II of Tuscany, Carl Albert and Metternich. He travelled frequently in search of new sights to paint, and his views, even in that predominantly neoclassical age, preserved such a Canaletto-like quality that some of his most beautiful ones were thought to be by Canaletto's nephew, Bellotto. Among the Lombard landscapists of the early nineteenth century, Migliara stands out for his careful perspective drawing, his sense of color, his bright golden light and the openness of his compositions. Despite certain virtuoso effects which were probably a result of his training as a miniaturist and decorator, his paintings are marked by a fresh spontaneity and bright touches of color, even in his most documentary efforts.

JEAN-FRANÇOIS MILLET (Gruchy 1814 - Barbizon 1875)

His family were farmers, and Millet worked in the fields until he was twenty. Attracted by art, he took lessons from a painter of the David school, but when his father died, he had to leave off painting to tend the farm. He began studying painting again in 1837 and won a scholarship to Paris, where he worked in Delaroche's studio. At first he was compelled to do mythological scenes, but finally was able to turn to his own style, romantic landscape painting, which gradually moved toward realism with scenes from the peasant life he knew so well. In 1849 he joined the painters at Barbizon. In the years following, a highly senti-mental and pathetic note crept into his peasant scenes. He was able to maintain, nonetheless, a strong realistic tone in his full-bodied paintings. In 1857, he painted *The Gleaners* and then *The Angelus*, which was too sentimental for the artist's own good, although quite popular. His style is similar to Courbet's, only more concrete and harder, nor did Millet lapse into the same late ambiguities. During the war in 1860, he withdrew to Cherbourg, where he painted several marine landscapes. In his last years the government commissioned him to do some decorations for the Pantheon, but he died before he could finish them.

CARL MOLL (Vienna 1861-1945)

He attended the Academy of Fine Arts in Vienna, and studied with C. Griepenkerl and Emil Schindler, whose widow he later married. Schindler's influence on Moll was notable: he published a monograph on Schindler in 1930 and carried on his style, although using more vibrant color and emphasizing a post-impressionist quality in his landscapes and still lifes. He was among the dissatisfied artists who started the Vienna *Sezession* in 1897, but left it to join Gustav Klimt's group. His energetic nature led him to participate in public debates and exhibitions that had considerable effect on Vienna's cultural life. He showed at the *Sezession* exhibitions from 1901 to 1908. His works appeared in the review *Deutsche Kunst und Dekoration* from 1899-1900 to 1917, and in *Ver Sacrum*, 1900, 1903. His southern Austrian landscapes are characterized by bright splashes of color, and distinct literariness: *The Ruins of Schönbrunn* (Vienna, Belvedere), *Winter Sun* (Munich, Neue Pinakothek). Within the frame of *art nouveau* and *Sezession* values then dominant in Vienna (the 1890's and early 1900's), Moll's work in graphics and painting was independent; a striking example is *The Artist in His Studio* (1906). He participated in the Paris Salon and won a medal at the 1900 Inter-national Exposition.

CLAUDE MONET (Paris 1840 - Giverny 1926)

At Le Havre, where he spent his boyhood, he met Boudin, who started him painting out of doors. In 1859 he went to Paris and attended the Atelier Suisse, where he met Pissarro; a year later, at Le Havre, he came to know Jongkind. These friendships sprang up because of common convictions about art and meant, for Monet, a fundamental preparation for the naturalism he was to develop into impressionism, so central to French art of the nine-teenth century, and the culmination of the realist esthetic. In 1862 he attended the Atelier Gleyre and met the young painters who were to join him in the impressionist movement: Renoir, Sisley, Bazille. The uproar created by the "*refusés*" at the 1863 Salon served to unite them around Manet, and shortly afterwards they began meeting at the Café Guerbois. At the 1865 Salon, Monet exhibited his version of *Le Déjeuner sur l'Herbe*, which he had painted outdoors, while Manet's had been done in a studio. Monet worked on the founda-tion of Courbet's realism and Boudin's and Jongkind's teachings during these years, moving steadily toward clear color and the transcription of impressions from nature. At the out-break of war in 1870, he and Pissarro went to London and had the opportunity to study and admire Turner, especially his handling of color dissolved in brilliant atmosphere. Upon Monet's return to France, he went to live for six years, from 1873 to 1878, at Argenteuil, on the Seine, and painted the riverscape, with the light reflecting color on the water and into the air. Canoeing and regattas are his major theme in this period, enabling Monet to articulate the basic principles of impressionism; that is, the harmony between the world's concreteness and its beauty and man's intelligence which can devise a technique to render it instantly, as it takes place, with the implicit philosophic notion that there does exist an existential joy, which of course Monet's light-hearted subjects tended to exemplify. At the first exhibition the photographer Nadar gave for the impressionists in 1874, Monet showed

a scene of a foggy morning on the Thames entitled *An Impression, Sunrise*. Press and public were hostile to the exhibition and to the new style, even though it corresponded in so many ways to the cultural climate of the time, and the title of Monet's painting gave rise to the derisive definition of the group as "impressionists," but the painters and writers who shared those ideas were only too happy to claim the name. Between 1878 and 1883, Monet lived at Vétheuil and his painting began subordinating subject matter to the play of light and color. In 1883 he retired to Giverny, among the gardens and pools where he grew water lilies.

Monet went to Italy three times, first in December 1883 with Renoir to visit the Italian Riviera as far as Genoa. The next year, between January and March, he went to Bordighera alone, and was profoundly influenced by the Mediterranean light, which caused him to accentuate the intensity and fusion of his colors. In 1908 he arrived in Venice, and remarked that he regretted not having seen it when he was young and "was willing to dare any audacity." From 1890 on, his paintings become studies of the variations in light and color at different times of day on the same subject, including his famous "cathedrals," "sheaves of wheat" and, from his garden, the "water lilies." In fact, the subject becomes a mere support for the vibrant color and shimmering light of his later works. The naturalism of his painting now becomes a retinal transcription - often fantastic - of effects of light and color. The paintings of Venice are typical, as are the cathedrals and water lilies, of this new tendency; the water of the canals takes up most of the canvas, and we see the buildings reflected in it with the most incredible, scintillating refractions. The birth of cubism, inspired in large measure by Cézanne's style, put Monet in the shade, as if he had become obsolete in some way, but in the years following, abstract impressionism and the irrational currents in modern painting, which place color before form, came to dominate the scene, proving the strong ties between many modern European and American painters and Monet's late works.

GUSTAVE MOREAU (Paris 1826-1898)

Born to a middle-class family, his father an architect, he first received a classical education, then attended the Ecole des Beaux-Arts as a student of the painter Picot. He was in Italy for three years, met Degas and probably the *Macchiaioli* painters, and had the opportunity to admire at first hand the works of the Renaissance masters, especially Mantegna and Carpaccio. The classicism, predominantly architectural and archeological, that he found in Mantegna united in his sensibility with the romantic training he had had in Paris from Chassériau and Delacroix to produce an idealized and indeed novelistic style that is precious and symbolic. He borrowed from the Pre-Raphaelites as well, to enrich his imagery with allusions to other cultures and periods. In this sense, his images are artificial, but they are shaped from an extremely complex pastiche of literature, spiritualism, and music. Moreau never accepted realism or impressionism, and worked apart from any current, spinning exotic and visionary fantasies that at times took on the appearance of a stage set. But in an age when reality and nature seemed to be the basic models for art, Moreau reasserted the creative power of the imagination and placed it in the service of a highly refined estheticism. We find in it, true, magic elements juxtaposed with classical elements, esoteric meanings next to cultural bric-a-brac, but we must credit him with penetrating beyond visible reality. Symbolist and Decadent writers like Huysmans were drawn to his work, and found in it a mine of images to be transposed into words. He was named a professor at the Ecole des Beaux-Arts in 1892, and taught Rouault, Matisse, Marquet, Dufy, and also Braque — students, obviously, of a temperament much different from his — whom he encouraged to pursue their own talents, and thereby he won their esteem. At his death, his studio was turned into a museum, an extraordinary collection of *fin-de-siècle* taste and culture. Its first custodian was Rouault.

WILLIAM SIDNEY MOUNT (Setauket, Long Island 1807-1868)

He was born and grew up in Stony Brook, Long Island, and spent the greater part of his life in the same vicinity. He went to New York in 1824 as an apprentice in his brother's sign-painting firm and entered the newly founded art school of the National Academy of Design two years later. He first tried historical painting, then devoted himself to portraiture. By 1830 he had begun painting the genre subjects for which he is best remembered. In 1836 he returned to his Long Island home, finding there the subject matter which had the great-

est appeal for him and his patrons. Though encouraged by friends to go abroad, he preferred to remain at home, making only brief trips to New York and to the Catskills.

Greatly interested in the effects of atmosphere and light, he painted the landscape settings of many of his genre scenes in the open air. By 1852, he had designed a portable studio in which he could paint outdoors without regard to the weather, thereby avoiding a "studio look" in his paintings.

He showed works at the National Academy of Design every year from 1828 until his death. Widely circulated reproductions of his works increased his contemporary reputation.

One of the most important American realist painters, he relied far less on artistic precedents than on careful observation of the life and the countryside around him.

EDVARD MUNCH (Loten 1863 - Elkey, Oslo 1944)

At first enrolled at the School of Arts and Crafts in Oslo, he later entered the studio of Christian Krohg. He exhibited in Oslo for the first time in 1883, and was derided by the critics and public alike. His paintings executed between 1881 and 1883 are minutely detailed interiors and landscapes that recall Scandinavian realism. With the help of a scholarship he went to Paris in 1885, and his works in the next three years (for instance, *At the Tivoli*, Oslo, Munch Museum) have a Degas flavor. In 1889, he held his first one-man show in the student center in Oslo.

In the autumn of the same year, he returned to Paris and entered Bonnat's studio, but was more attracted to the work of Seurat, Van Gogh, Gauguin, Toulouse-Lautrec, and under their influence began the series of paintings called *The Frieze of Life*, in which he tried to express "living beings who breathe and feel and love." The tragic sense of life, felt by Munch so deeply because of his own family's misfortunes, permeates his spectral figures and gradually dominates his vision. After his show at the Art Nouveau Gallery in Paris, Strindberg wrote a very favorable criticism in the *Revue Blanche* in 1896, recognizing affinities with his own playwriting in the painter's work. We can already see in the compositions done in 1893-94 the livid phantom images, bound and shrouded, that become his hallmark.

Symbolist influence can also be found in his graphic works; the first were done in Berlin in 1893-94, such as: *Death and the Girl*, which he had painted in oil the year before, now in the Munch Museum; *The Sick Child*, 1894, taken from the painting done in 1885-86, now in the National Gallery in Oslo. A friend of Mallarmé, Strindberg and other writers, he designed the sets for Ibsen's *Peer Gynt* in 1896, and drew the illustrations for Baudelaire's *Les Fleurs du Mal* in 1897. The works he showed in Oslo and Berlin the same year, 1892, scandalized the public but at the same time put him on the European scene with his powerful representation of life, love and death that prefigures expressionism.

At this point, his paintings take on a harsh, bright coloring, as in his famous *Girls on the Bridge*, 1901 (Oslo, National Gallery). Then follow his personal exhibitions in various European capitals: Berlin, 1902; Cologne, 1912; Zurich, 1922; Paris Exposition, 1937. We see in the numerous portraits, family scenes, and landscapes of this period a terrible burden of anxiety, revealing an obsession with psychology more than artistic or formal concerns. In 1906-07 he was commissioned by Reinhardt to design sets for his Berlin productions of *Revenants* and *Hedda Gabler*. Throughout his last years, he continued making prints that have disquieting and powerful effects.

He returned to Norway in 1909, and stayed until 1916, working on the mural decorations for the lecture hall at the University of Oslo. In the same grandiose manner, this time with clearer colors, he decorated a farmhouse near Oslo in 1921-22.

During his last years, retired to Elkey, he took up earlier themes, expressed with continuing anxiety.

WIJNAND JAN JOSEPH NUJEN (The Hague 1813-1839)

He was able to paint for only a few years, but his work was an admirable continuation of the Dutch landscape-painting tradition, and a fresh contribution to it. His paintings, drawings and etchings are vividly romantic expressions of the places he visited, such as *Brittany Landscape*, 1833 (London, private collection), or of marine landscapes of his own country. At The Hague, he studied with Andreas Schelfhout, and married his daughter. At about sixteen, he was already participating in group shows in his own city and at Ghent, where

he met with success with his *Winter Scene in Amsterdam* in 1838. We can find a clear objectivity yet a deep perception of emotional values in his scenes, such as *Ruins* (Rijksmuseum, Amsterdam); *Stormy Embarkation* (Dordrecht, Civic Museum); *The Old Mill* (Civic Museum, The Hague). His drawings and watercolors are noteworthy; several excellent examples are in the Grez Collection in Brussels. Although his life was short, the works he left rank him among the best of the Dutch romantic painters.

FILIPPO PALIZZI (Vasto 1818 - Naples 1899)

Born into a family of painters in the Abruzzi, he went to Naples in 1832 to study at the Academy under Camillo Guerra and Costanzo Angelini. But he was drawn to Giuseppe Bonolis's studio where he could work without academic strictures. He soon distinguished himself for his talent with color and his capacity to observe reality.

In 1839 he painted *Cows and Other Animals* (Gallery of Modern Art, Rome) which became the focal point of Neapolitan realism, with Palizzi himself and Domenico Morelli as its primary exponents. He won a prize in 1838, even though his painting was completely opposed to the academic tradition. His landscapes, and his animal pictures especially, were painted with scrupulous representationalism yet with a certain fine broadness in handling light and color that can be related to the main current of seventeenth-century Neapolitan realism. Two of his paintings exhibited in 1845 prompted Morelli to comment that they were "the revelation of a style of painting different from any other because of its genuine truthfulness, something no school could claim."

Palizzi grasped the issues at stake in the romantic painting of the Barbizon School even though he himself never took up their program. In 1867 he exhibited his *Animals Leaving Noah's Ark* and other paintings in Paris, and met with great success.

SAMUEL PALMER (Newington 1805 - Redhill 1881)

A very precocious artist, he had his first exhibition at the Royal Academy when he was only fourteen. He was self-trained and of an imaginative bent, and was particularly susceptible to the attraction of William Blake, whom he met when he, Palmer, was nineteen. The literary, biblical and legendary themes, however, that Blake had handled with his peculiar symbolic and fanciful transformations, Palmer replaced with scenes from everyday life, thereby creating a striking disjunction between theme and manner. He moved to Shoreham, near Kent, in 1827 and stayed there eight years, forming a group of young artists. He travelled much around England, then in 1837 married the daughter of his colleague John Linnell; he and his wife went to Italy, where they remained two years. An excellent watercolorist, he was accepted by The Old Water Colour Society in 1854, and from then on dedicated himself to watercolors and etchings.

GIUSEPPE PELLIZZA DA VOLPEDO (Volpedo 1868-1907)

He studied with Bertini at the Brera and later with Cesare Tallone at the Carrara Academy in Bergamo, and finally in Florence between 1893 and 1895. His craftsmanship was superb, and his inspiration came mainly from his felt participation in the sufferings of the peasants and emigrants. Although a close observer of reality, he avoided an out-and-out realistic style; his images are intensely calm, yet convey inner turbulence. His first success came in 1892 in Genoa. There he met Nomellini, who encouraged him to adopt the divisionist theories Nomellini had learned in Milan, accompanied by Grubicy and Previati and observing Segantini's work. Pellizza began at that point to reconcile his thematic concern for the proletariat and the new directions in painting. He occupied a special place among the divisionists with his very lyrical style: Segantini was the most brilliant painter of the group, Previati the most theoretical, Morbelli the most precise and Pellizza the finest colorist. His painting is an attempt to share the burden of the poor, and his *intimiste* scenes sometimes touch a note of peculiar religiosity. His humanitarian ideals led him at times to include symbolic and allegorical figures in his paintings, but his craftsmanship spared him from literary excesses. Bitter disillusionment and the death of his young wife drove him to suicide.

CAMILLE PISSARRO (St. Thomas, Danish Antilles 1830 - Paris 1903)

He went to Paris the first time between 1842 and 1847 to finish his study of painting and then went to Venezuela with his friend, the painter Fritze Melbye. Returning to Paris in 1855, he attended the Académie Suisse, where he met Monet. His early work was inspired by Delacroix, Courbet and Corot, but he became more and more influenced by Monet, and exhibited his works in 1863 with the *"refusés"* from the regular Paris Salon, which however accepted his works in the years following. He moved to Pontoise in 1865 and then to Louveciennes, where he lived for a time with Sisley. At the outbreak of war in 1870, he went to England with Monet. He participated in all the impressionist shows, and was frequently called on to resolve differences among the group. He had returned to Pontoise, where Cézanne joined him and was persuaded by him to become an impressionist. Pissarro was a lively man but malleable, and his style underwent several modifications as he met painters with stronger ideas than his. His painting always has something ingenuous and rough about it, but nonetheless a genuineness. He was among the group that showed at the first impressionist exhibition presented by the photographer Nadar in 1874. His paintings more frequently included scenes of country life than cityscapes. In 1884, while at Eragny, he came under the influence of Seurat's neo-impressionist ideas, and joined the divisionists in their 1886 and 1888 shows, but he later returned to his own more congenial style.

ANTON SMINCK PITLOO (Arnhem 1791 - Naples 1837)

His early training was with J. van Ameron, one of the foremost teachers at the School of Fine Arts in Arnhem, who was noted for his handling of washes in watercolor landscapes. After three years of study in Paris (1808-11) under Bertin, he spent three years in Rome, and his views underwent a somewhat rigid classicizing under the influence of the neoclassical ideas then current, as, for instance, in *Ruins, View of St. George* (Amsterdam, Rijksmuseum). In 1816 he went to Naples; as a result his rather delicate and shimmering tonalities opened up to a broader luminosity. In 1824, the king appointed him to teach landscape painting at the Naples Academy. Although partly influenced by the works of other landscape painters then in Naples, Pitloo was more interested in genre scenes, views and marine landscapes. His students were susceptible to his ideas; among them were the group who later formed the so-called Resina School: Gigante, Carelli, Vianelli. But after 1830, the situation changed, and he took to more realistic painting under the influence of his former pupils. On a limited scale, he brought more general European ideas to Neapolitan art. Among his major works are *Landscape with Pines, The Temples at Paestum, Marine Landscape at Naples, View of Ischia* (Naples, Capodimonte Museum); many of his drawings and etchings are in private Dutch and Belgian collections and in various museums.

FRANÇOIS-AUGUSTE RAVIER (Lyons 1814 - Morestel, Bère 1895)

Sent to Paris by his family in 1832 to study law, he soon left the university to pursue painting. He was self-trained, and he painted views of Paris and the surrounding countryside in the same way he had painted his native city. During one of his trips to the Auvergne, he met Corot and esteemed him for the rest of his life. He travelled to Italy several times, and in 1840 stayed for more than a year; in 1843 he returned and joined Corot. His thick impastos and heavy rubbed color, the striated brushwork alternating highlights and streaks of color convey a deep and marked romanticism. His realistic subjects are little more than pretexts for expressing his strong emotionalism and his unusual, bright orchestration of colors. Contrary to what his tour of Italy might be expected to have taught him, he was especially taken with lonely, abandoned, thicketed places in the Roman countryside and the wild flatlands at the mouth of the Tiber. His deep sensibility, and his way of using impasto to capture the thick layers of air and the brightness of light left a profound mark on Antonio Fontanesi, who knew and admired him. Ravier returned to France and settled at Morestel, his eyesight gradually dimming, some say because he had looked at the sun too long.

ODILON REDON (Bordeaux 1840 - Paris 1916)

After trying to enroll in the Ecole des Beaux-Arts to study architecture, he decided to pursue painting and entered Gérôme's studio. Having grown up in open country amid the loneliness of untilled fields, Redon infused his painting with fantastical and somewhat mysterious themes. He was a close friend for a time of the expert engraver Bresdin, who led him to an enthusiastic appreciation of Rembrandt. Although preferring to work alone, he repeatedly tried to meet Courbet and Corot. Fantin-Latour urged him to do lithographs, and in them Redon found the medium best adapted to his images of a dream life. He met Gauguin in 1886 and they became fast friends. In 1889 Gauguin asked Redon where he might go to get away from civilization, and it seemed he would choose the Isle of Bourbon where Redon's wife had some property that her description had made sound very attractive. Redon was among the thirty people Daniel de Monfreid had to inform about the forthcoming exhibition of Gauguin's works, and again in 1901 his name appears among the subscribers who were to purchase and donate Gauguin's painting *Whence we come...* to the Luxembourg Museum. In 1903 he began to paint Gauguin's portrait from memory, in profile with a background of leaves and flowers, that is almost an evocation of his dead friend. Redon discovers that reality has many faces and undergoes many disturbing metamorphoses; he peers at it closely, into hidden crevices and dense undergrowths, among microscopic beings and stellar dust. A strange, unknown kind of life overwhelms the familiar world and our sense of things, and a fantastic symbiosis takes place, reinforced by the intensely fine color he used. The universe multiplies under Redon's brush, and our sense of being disintegrates into swarming metamorphoses that break down outlines and forms. His paintings are a spinning of dreams, expressed with subtle mastery of color and drawing.

JOHAN CHRISTIAN REINHARDT (Hof 1761 - Rome 1847)

After an early attempt at studying theology at the University of Leipzig, he took up the study of painting with Oeser; in 1783, at Dresden, he learned engraving from Klengel. In 1785, he became friends with Friedrich Schiller, and then associated himself with the Duke of Meininger, for whom he worked. In 1789, he went to Rome, where at first he preferred doing simple, subdued landscapes, with strong but balanced traces of Dutch and German influence in the incisiveness of his etchings. In 1792 he did some prints for a Nuremberg publisher. Among his first Italian landscapes are *The Garden of Villa Borghese* and *Forest*, 1793 (Copenhagen, Thorvaldsen Museum). In 1795 he enters the cultural circle of the Dane, Carstens, and becomes friends with Koch. His painting undergoes a radical change; abandoning his former naturalism, he takes to doing mythical, heroic scenes reminiscent of Poussin, such as his *Heroic Landscape*, 1813 (Copenhagen, Thorvaldsen Museum). But his painting always maintains a certain romantic pathos, with a special sensitivity in the handling of light. Among his engravings is *The Storm*, 1800. Various drawings and watercolors by him are in the Nationalgalerie, Berlin and in the museum in Darmstadt and Dresden. Among his later Roman landscapes are *Ponte Lupo, near Tivoli*, 1823; *Roman Countryside*, 1823 (Copenhagen, Thorvaldsen Museum); *Imaginary Landscape with Love and Psyche*, 1828 (Leipzig, Museum), in which he picks out the details but envelops the pensive figures in a dream light. In the four years between 1825 and 1829, he designed landscape panels for Villa Massimi (now in Berlin). In 1826, he took part in the debate about theories of art between critics and artists of the German colony in Rome. He painted four large views of Rome for Ludwig I in 1829-35 that are now in the Munich Pinakothek.

HEINRICH REINHOLD (Gera 1788 - Rome 1825)

Son of the portrait painter Johann Friedrich Reinhold, brother of the landscapists Friedrich Philipp and Gustav, he completed his studies at the Dresden Academy and in Vienna from 1807 to 1809. At the end of the year, he went to Paris and became active in printmaking as well, doing several noteworthy plates for *Napoleon's Campaigns* on a commission from the Baron Denon. Around 1816, he began painting landscapes that show the influence of the Viennese romantic painters and the ideas of the Nazarenes, the German group working in Rome. He handled his landscapes with bright, enamel-like colors and allegorical intentions. He envisioned things so clearly and simply that sometimes his paintings are models of lucidity; as, for instance, his *Landscape* (Hannover, Landesmuseum). He did several Alpine

landscapes, especially while he was travelling in the area around Schneeberg in 1817. He went to Italy in 1819, and there met Koch and Richter and became a friend of Thorvaldsen, who did a portrait bust of him in 1825 (the original model in Copenhagen, a bronze copy on Reinhold's tomb in the Protestant Cemetery in Rome). Several of his Tuscan landscapes and many of those of Olevano, which he did between 1821 and 1824, rendered in an idealized light and gemlike colors, were obviously the products of loving care. In 1823, he did a number of landscapes on biblical themes: *Landscape with the Good Samaritan*, *Hagar and Ishmael*, and also *View of the Park of Villa Doria Pamphili* and the unfinished *Isle of Capri*, all of which are in the Thorvaldsen Museum in Copenhagen.

PIERRE-AUGUSTE RENOIR (Limoges 1841 - Cagnes 1918)

He began painting on porcelain at the Sèvres Manufactory, and this craft aroused his interest in art. He enrolled at the Ecole des Beaux-Arts, in Gleyre's atelier, in 1862 and there met Monet, Sisley and Bazille. To break with academic tradition and the norms of historical painting, heroic landscapes and the *tutto finito* (museum-finish paintings), Gleyre's students determined to paint outdoors and so went to the forest of Fontainebleau to work. After the uproar caused by Manet's *Déjeuner sur l'Herbe* at the 1863 Salon, Renoir began exhibiting at all the Paris Salons from 1864 on. Among the impressionists, Renoir is distinguished for his instinctive painterly handling of natural scenes, crowds and middle-class interiors, with sunny, flowing colors, and a naive yet deliberate sensuality that reminds us of Delacroix. In 1874, he participated in the first impressionist exhibition given by the photographer Nadar, but he was not bound to the group and, in fact, was often absent from their shows in order to participate in the official Salons. His association with Monet was close, and because of him he was led to a rapid, notational, visual rendering that can be called a poem on the joy of life. In the fall of 1881, he travelled through Italy, and painted Richard Wagner's portrait in Palermo. From there he went to Marseilles and to L'Estaque as Cézanne's guest. During his Italian trip he not only painted and drew, but also was an assiduous observer and museum-goer, giving special attention to the paintings discovered at Pompeii, and to the works of Raphael and Veronese. Surrounded by the brilliant Mediterranean sun, he came to the realization that painting impressions is limited to itself as a technique, and thus began his evolution toward more solid forms, within which his flowing color takes on more intensity and structural function. Around 1890, he stopped painting scenes from daily life and turned to monumental nudes and portraits. In 1889 he had started going to the south of France more often, as had Cézanne, and had acquired the house on the hillside among the olive trees at Cagnes-sur-Mer on the Côte d'Azur. There he went to live permanently in 1906. His last years were burdened with illness, notably crippling arthritis, but even though he was forced to move about in a wheelchair and to paint with the brushes tied to his hands, he never stopped painting.

ENRICO REYCEND (Turin 1855-1928)

He studied under Ghisolfi, then at the Albertine in Turin, where he came under the influence of Delleani and Fontanesi. During a brief trip to Milan, he was impressed by Carcano's work and consequently became a realist. He began showing in 1873 in Turin. When he went to Paris, his work won Corot's admiration. His paintings, all of them landscapes, became progressively more impressionistic, with an acute sensitivity to things as they are, and an awareness of the variations in light that was essentially comparable to Sisley's. Later his brushwork became firmer and more regular as he, along with other post-impressionists, moved away from the original tenets of impressionism and toward the use of more solid areas of color. In fact, in his later paintings there are divisionist effects. His shows were successful: Milan 1895, Turin 1896, Venice 1897, but toward the end his inspiration began to run out and apart from the bright color, his later paintings lack imaginative vitality.

ANTON ROMAKO (Atzgersdorf, Vienna 1832 - Döbling, Vienna 1889)

He attended the Vienna Academy from 1847, a pupil of Karl Rahls; then in 1849 he studied with W. Kaulbach, and in Venice with Karl Werner. He arrived in Rome in 1857 and married Sofie Köbel, the architect's daughter. Esteemed among the German artists living in

Rome, he was a friend of Litsz, Feuerbach, Jos von Kopf, all of whom visited him in his villa on Monte Mario. In 1874 he left Rome, burdened with family and financial difficulties and sickness. Moving to Döbling, near Vienna, he took only occasional brief trips to Paris and Rome, and worked without recognition. His paintings were appreciated only later, in the early 1900's, especially after the exhibition at Miethke's in 1905. An eclectic artist, he combined romantic and realist modes in his landscapes. He was named a Knight of the Legion of Honor in 1882.

FEDERICO ROSSANO (Naples 1835-1912)

He studied for a time at the Academy with Giacinto Gigante and Gennaro Ruo, but decided to pursue his training on his own in a realist vein. Joining Giuseppe De Nittis, who had been expelled from the Academy for disciplinary reasons, he also associated with Marco De Gregorio and other painters in forming the Portici School in 1863; they were all keenly interested in the *Macchiaioli* painters in Florence, who were also anti-academic. That same year the king purchased a painting of his entitled *Wheat Field*. De Nittis had left Naples and De Gregorio had died, so Rossano, too, left Portici for Paris. His informal training enabled him to accept impressionism without prejudice; his painting became fluid and full of light. He did views of Paris in delicate washes, conveying a vague sense of melancholy. When he returned to Naples, he was given a professorship in painting and remained faithful to his ideals to the end.

THÉODORE ROUSSEAU (Paris 1812 - Barbizon 1867)

The son of a tailor, he showed signs of talent quite early. He frequented the studios of Charles Rémond and Guillon Lethières, but essentially taught himself by painting outdoors, in a landscape style reminiscent of Claude Lorrain, with eighteenth-century attention to detail. Constable's paintings, which he saw at the 1832 Paris Salon, encouraged him to look at nature with more freedom and feeling. At that point, despite the objections of the academics, he began to paint more broadly and romantically, but with an accurate perception of reality that brings his painting close to the realist movement that was shortly to become so important. The Salon juries were unable to understand or accept Rousseau's innovations, and after several rejections, he decided to leave Paris for Barbizon, a village at the edge of the Fontainebleau forest where he had already been inspired to do several paintings which became famous years later, and where Corot had already settled down to paint. Amid the still wild environment of these woods and ponds, he was able to pursue his idea of landscape painting, solemn yet personal, with an underlying melancholy. Other painters followed his example — Troyon, Daubigny, Dupré, Millet — and thus was formed the Barbizon School, of which he was the most eminent exponent. Finally, at the 1855 exhibition of his works held in Paris, he won the recognition of both the public and the critics.

ALBERT PINKHAM RYDER (New Bedford, Massachusetts 1847 - Elmhurst, Long Island 1917)

Before moving to New York in 1870, Ryder had begun painting landscapes without any regular instruction. Although he studied briefly at the National Academy of Design, he appears to have profited more from the informal teaching of William E. Marshall, a portrait painter and engraver. His early landscapes, often including figures and animals, are more naturalistic than his later, more subjective renderings of nature.
He exhibited occasionally at the National Academy of Design and participated in the founding of the Society of American Artists in 1877. Although he made several trips abroad between that year and 1896, he appears to have gained more from the sea voyages than from any contact with the art of Europe.
His most important works, begun in the eighties and worked and reworked for many years, were products of intense introspection rather than literal descriptions of nature. Biblical, classical and literary themes were transformed into highly personal conceptions. Nature, especially the sea, was interpreted freely, simplified to essentials to express ideas and emotions in a purely plastic way.
A visionary whose pictorial images are more akin to dream than to observed reality, Ryder

is the culminating figure in nineteenth-century American romanticism. In his search for evocative imagery and his expression of mystery and sentiment, he may be linked with twentieth-century surrealists and painters of images of the inner reality of the mind.

ALEXIS KONDRAT'EVICH SAVRASOV (Moscow 1830-1897)

The son of a family of small merchants, he studied at the Institute of Painting, Sculpture and Architecture in Moscow, under Rabus, from 1848 to 1850. He joined the group of "Wandering Artists" who went from town to town painting local scenes, and is considered the forerunner of Levitan, Seroff and others in landscape painting.
His early landscapes are academic, but he later achieved much broader interpretations of the Russian scene, with its stormy skies and snow-covered and desolate fields. Among his earlier works we cite *A View of the Kremlin in a Storm*, 1851, and *View of Oraniebaum*, 1854 (Moscow, Tretjakov Gallery) for which he was awarded the title of academician.
We find more light and breadth in works such as *The Storm*, 1873 (Moscow, Tretjakov Gallery); *The Overflowing of the Volga* (Leningrad, Russian Museum), and especially in the painting considered his best, *The Crows Have Come*, 1871 (Moscow, Tretjakov Gallery), in which we can feel the tension of the symbolic bare trees silhouetted against the distant steppe. His drawings are spare, concise, penetrating. He would paint outdoors, directly from nature, modifying his romantic tendencies with the strict realism of his technique, as in *Country Road*, 1873, and *Rainbow*, 1875. He was named director of the Institute of Painting, Sculpture and Architecture in Moscow, and influenced many of the young students.

KARL FRIEDRICH SCHINKEL (Neuruppin 1781 - Berlin 1841)

While he was attending the Academy of Architecture in Berlin, he became familiar with the work of the architects David and Friedrich Gilly, whose projects managed to be original even within the strict frame of neoclassicism. Schinkel's training was solid and direct, based on his observation of classical, renaissance and medieval structures, especially during his trip south to Italy in 1803-04. From then to about 1811, he concentrated on painting, drawing and engraving, especially scrupulous views of monuments and ruins. His landscapes were more romantic in tone, although within a measured pace reminiscent of Claude Lorrain. He also did illustrations of architectural works in lithographs and etchings. He had important architectural commissions after 1811, and was architect of the crown until 1838, designing buildings that left an indelible mark on Prussian architecture.
In Berlin he designed public buildings that demonstrate the development of neoclassical forms toward even more imposing solemnity, such as the quarters for the Royal Guards, 1816, while his Berlin Theater, 1818-21, was done in the Greek Ionic manner. He revealed a strongly romantic side in his Gothic Revival structures, such as the War Monument in Kreuzberg, 1818. His private houses had a more integrated design, such as W. von Humbold's country house at Tegel, 1822-24. He was active in rebuilding churches, with both neoclassical and Gothic Revival motifs; a typical example is the church of St. Nicholas in Potsdam, 1830-37. He built the castles of Babelsberg and Glienicke. Travelling through Italy, France and England, he even left drawings for a projected vestibule for the British Museum. His interest in public buildings and in the functional architecture that was made possible and necessary by industrialization led him in his later work to more sober designs, such as his project for a warehouse and for the Academy library, 1837. His design for Otto of Wittelsbach's palace on the Acropolis of Athens in 1834 was imposing, as was his design for a castle for the Czar in the Crimea.

GIOVANNI SEGANTINI (Arco 1858 - Schafberg, Switzerland 1899)

Abandoned by his father, he was raised by an aunt, but in an attempt to run away, he nearly starved and was saved by a peasant who set him to tending animals. He began drawing fields and animals. Returning to Milan, he studied with the painter Tettamanzi and attended the courses at the Brera. In 1878 he exhibited his *Chorus of St. Anthony*, and the Grubicy brothers, who were art critics and dealers, took an interest in him, encouraging his talent, educating him in the developments in European art and introducing him to the works of Millet, Mauve and Mesdag, among others. In 1881 he began his search for unspoiled land-

scapes by painting at higher and higher levels in the Alps. Until 1886, he worked in the Brianza region, where he painted *At the Hitching Post*, which won him a gold medal at Vienna. He painted the *Ave Maria on Board* at Lake Pusiano. From 1886 to 1894, he painted at Savognino in the mountains, and here he did his famous paintings of the shepherdess, cattle and the humble life of the mountaineers. His artistic gifts and his humanitarian ideals combined to make him one of the major European realist painters. To accentuate his rendering of reality, on the advice of the Grubicys he began using a divisionist technique for the tactile and almost three-dimensional effects he obtained. He felt, as he himself said, "a sweet melancholy" in the presence of nature. In 1886, he went up the Maloja, in the Engadine Valley, to be closer to unspoiled nature and the long winter silence. His idealism, encompassing painting, nature and humanity, rapidly led him to allegory, expressed with a divisionism correct in theory, but with undulant brushwork that was to become so important in *art nouveau*. At certain times, his symbolism becomes complex, philosophical, and so although his technique was always brilliant, his visual rhetoric was a bit heavy-handed. He died of peritonitis on the Schafberg, in the Engadine.

RAFFAELLO SERNESI (Florence 1838 - Bolzano 1866)

He came from a family of modest means, and learned to draw under Antonio Ciseri. This served him in engraving prints and medals, one of which he did for Garibaldi. From the very beginning he was a follower of the *Macchiaioli* painters, particularly Lega, Abbati and Borrani, with whom he would go painting among the groves of Pergentina. In 1861 several of his paintings were shown at the National Exposition in Florence. With Borrani he went up into the Apennines around Pistoia to paint those silent landscapes. His paintings are distinguished for their clean color and firm drawing. He felt the intensity of space and the tonality of color, which he used in carefully delineated areas to create an idyllic effect, a profound elegy. He joined Garibaldi's forces in 1866, and died as a result of battle wounds.

PAUL SÉRUSIER (Paris 1864 - Morlaix 1927)

He studied painting at the Académie Julian in Paris with such fellow students as Vuillard, Bonnard, Maurice Denis, Roussel, Ranson. He was not only a gifted painter but an essayist on esthetic questions as well. When he met Gauguin in 1888 at Pont-Aven in Brittany, he became enthusiastic about his ideas on painting. Practically under Gauguin's instructions, he painted the *Bois d'Amour* on a panel made from a cigar-box cover, which he brought to Paris to show his friends. They called it their "talisman" because it meant freedom from strict representationalism and a key to the ratiocinated, sometimes esoteric symbolist art they were to develop. On the basis of the ideas in the single panel, they were inspired to form the group called Les Nabis, from the Hebrew word for prophet. The group was encouraged by the Natanson brothers, who were the founders of the *Revue Blanche*, and thus arose a close collaboration between the painters and the writers of the review. Sérusier collected his theories on painting and art in a book entitled *ABC de la Peinture*, published in 1921.

GEORGES PIERRE SEURAT (Paris 1859-1891)

At the Ecole des Beaux-Arts he studied under Lehmann, who was a rather conventional disciple of Ingres. He studied and often copied the works of Delacroix, Raphael and Holbein, already a sign of his preference for finished painting, defined forms, classical harmony and drawing. At the same time, he was pursuing his interest in optical effects and the behavior of color under different light, arriving finally at the theory that if colors are divided into their pure components, and these complementary colors are applied next to each other in small dabs or points, the effect in the viewer's eye, which will recompose the colors at a proper distance, will be of greater vibrancy. In the drawings he did before painting, interestingly enough, he handles charcoal with much the same effect, the powdery fragments rendering the softness and transparency of the air, and suggesting figures and forms by a denser dust, within an extremely balanced and formal composition. Divisionism, also referred to as pointillism, precludes the possibility of capturing impressions rapidly and so, along with Renoir's problems with form, and Cézanne's return to geometry,

brought impressionism to a crisis, even though impressionism has always remained the high point of nineteenth-century French art. Along with the technique of impressionism, gone was its celebration of the joy that color, light and life *en plein air* can bring. Divisionism was cerebral, scientific, almost abstract, even if Seurat still succeeded in expressing fresh relationships and striking a balance between calculated design and creative spontaneity. He would do oil sketches and drawings outdoors and use them as cartoons for the finished canvases he did in his studio.

In 1884, he submitted his first pointillist painting, the *Bathers at Asnières (La Baignade)* to the Salon. In this painting, the figures are arranged in a landscape lighted abstractly, the compositional rhythm as rigorous and integrated as in a painting by Piero della Francesca. It was rejected. He then decided, along with Signac and Odilon Redon, to start La Société des Artistes Indépendants, which organized its own exhibitions beginning in 1886. The division of color permitted Seurat to break away from the naturalistic rendering of surfaces; his vertical and somewhat rigid silhouettes, the sinuosity of his outlines and of the compositional elements in his paintings and his abstract handling of light are the key factors in his importance to the young artists who were just then beginning to find expressive means other than realism, and his importance to the rise of symbolism. The whole symbolist tendency, sometimes worldly and sometimes esoteric, owes everything to Seurat's formal experiments. The decorativeness in the works of Les Nabis, for instance, is traceable to Seurat. The cubists, around 1910, take to Seurat's faceted forms and crystal light. Divisionism spread fairly quickly to several European countries, varying in motifs and techniques in the framework of the different national cultures. When Seurat died after a brief illness, he had sold only two paintings in his lifetime.

PAUL SIGNAC (Paris 1863-1935)

His training came mainly from the impressionists, especially Monet, but he took up Seurat's divisionism immediately and became the president of the Société des Artistes Indépendants, which they had founded together in 1884. This new group of painters, who were soon joined by Cross and Luce and gradually by several impressionist painters such as Pissarro, whom Signac met at Guillaumin's house in 1885, were seeking to exalt one great impressionist discovery above all others: light, by the division of color. But the technique would not allow them to paint outdoors in the light, and their studied compositions and programmatic methods were precisely the opposite of the impressionist intention — that is, to capture the transient moment. These new esthetic principles were defined, even if so different from impressionism, as neo-impressionism. Signac was an especially dedicated practitioner of divisionism; his canvas became a kind of mosaic, in which the color tesserae took on more and more autonomy as the years went on. And with this autonomy came a complete break with naturalist conceptions of light and verisimilitude, paving the way for the color experiments the Fauves were to carry to total anti-naturalism in the early 1900's. He travelled a great deal, from Venice to Istanbul to Provence, making watercolor sketches of the places he saw, which he developed into paintings in his Paris studio.

TELEMACO SIGNORINI (Florence 1835-1901)

His father, a modest painter and copier at the Uffizi, started him off in painting, but he was soon involved in political conspiracies. He was brighter and more curious than his fellow artists who gathered at the Caffè Michelangelo in Florence, and led the attack against academicism and historical painting, especially after Serafino De Tivoli reported what was going on in Paris in 1855. In 1856 he went to Venice with D'Ancona and there was reaffirmed in his notion that a painter had to paint outdoors directly from nature. Signorini was the most ardent exponent of the *Macchiaioli*, and a tireless traveller in search of new scenes to paint. Some have tried to compare the *Macchiaioli* with the impressionists, or even to rate them as forerunners, but neither is valid. The two movements, although parallel, are not comparable. The *macchia* (meaning "spot") technique had in the first place a sense of structure and volume that clearly indicated the *Macchiaioli* fidelity to the Florentine painting tradition, while impressionism frequently sacrificed structure and form in order to achieve transparent light and color effects. During his travels — to Paris, London, Edinburgh — Signorini's formal rigor begins to give way to a more direct observation of reality, even a verist directness, we could say, at times with pedantic results, but at others with

quite powerful ones. Around 1880 he became more and more interested in social problems and in his canvases began depicting the life of the proletariat in the ghettos and knitting mills, hospitals and bordellos. He published a volume of memoirs as a *Macchiaiolo* in 1893, in which his critical sense was still acute. In his last years his usually harsh paintings were sometimes relieved by the serene marine landscapes he did while at Riomaggiore along the Italian coast near Genoa.

ALFRED SISLEY (Paris 1839 - Moret-sur-Loire 1899)

His parents were English, but lived in Paris. In 1862, he entered Gleyre's studio at the Ecole des Beaux-Arts, and there met Monet and Renoir, with whom he became fast friends because of their common ideas on art. The three of them would go to the forest at Fontainebleau to paint directly from nature. His first models were Corot and Courbet, then he became interested in Daubigny. In 1866 he went to Marlotte, then in 1867 to Honfleur, then to Bougival and Louveciennes where he joined Pissarro. He came under the influence of Monet's impressionism, which we can see in the paintings Sisley did at Voisins and Marly. The views of the flood at Pont-Marly he did at this time are famous.
Sisley's impressionism is characterized by soft colors and muted chromatic relationships. He took part in the First Impressionist Exhibition in 1874. He went to England in 1875, and then to Sèvres, where he remained until 1879. That year the Paris Salon rejected his paintings, but he joined the other impressionists in their own group show. His life was difficult; beset by financial problems, his paintings less successful than his fellow impressionists', he was largely ignored despite the exhibition Durand-Ruel dedicated to him in 1883. In 1894 he went to Rouen, and in 1897 back to England for a brief time. He never succeeded in obtaining the French citizenship he so wanted. Just when his work was beginning to meet with success, thanks to the writings of Gustave Geffroy, he died.

GREGOR SOROKA (1823-1864)

He was in the service of rich gentlemen until 1861, but he was also learning how to paint from Alexei Venetsianov and was his best pupil in the ten-year period from 1840 to 1850. Gifted with acute psychological perception, he painted strong and revealing portraits; for instance, among those he did after 1840 are *E. Milioukova* and *A. Pozdeev* (Moscow, Russian National Museum). From his teacher he acquired a tendency toward balanced genre scenes, well-lighted interiors with an *intimiste* character, as in *Cabinet aux Isles*, 1844 (Leningrad, Russian National Museum), in which he picks out the objects in delineated perspective. But Soroka's narrative gifts come out in his landscapes, several of which are excellent. Around 1840, he painted *The Fishermen* (Leningrad, Russian National Museum), a defined expanse, almost eighteenth-century in feeling, of a broad river landscape. Considered the most lyrical landscapist after Venetsianov, he had a tragic life. After his emancipation from servitude in 1861, he took part in a peasant revolt and was sentenced to corporal punishment. He hanged himself before the sentence could be carried out.

JAMES STARK (Norwich 1794 - London 1859)

He entered Crome's studio when he was seventeen and from him acquired a taste for Dutch landscape painting, but also learned to paint directly from nature, developing his own naturalistic yet somewhat mythical style. He exhibited for the first time in 1809 at the Norwich Society, then went to London in 1814 to study at the Royal Academy. He went back to Norwich five years later and became prominent among the painters belonging to the school his teacher, Crome, had started, becoming its president in 1830. Soon after, he returned to London where he remained until 1840, when he moved to Windsor.

JOSEPH STEINGRÜBEL (Augsburg 1804-1838)

He studied art with his father, and the engraver J. Simpert, then went on to the Munich Academy of Fine Arts from 1834 to 1837. Dedicating himself to landscape painting, he

made a trip through Switzerland and Italy to do studies. He was in Florence and Rome between 1834 and 1835, and met the German and Danish artists who gathered around Thorvaldsen. His dry and classicizing manner can be seen in his *View of Florence* (1834) or in the *View of Peschici*, of the same year, now in the Thorvaldsen Museum, Copenhagen. He made very incisive drawings of the places he visited, which he used to paint from. Many of these drawings are now in the Munich Civic Museum, Maillinger Collection. Several of his lithographs exemplify the unusual precision of his technique. He made engravings of many works of the Dutch masters, particularly Ostade, Ruysdael, Van de Velde.

VASILI SURIKOV (Krasnojarsk 1848 - Moscow 1916)

Along with Ilya Repin, he is considered one of the greatest masters of Russian realism in the second half of the nineteenth century. Linked with the intellectuals seeking social reforms, he was one of the most active of the "Wandering Artists" (*Peredvizhniki*) who went around Russia to educate the people in the national, social and moral significance of art rather than its esthetic value. Several of his paintings figure among the most programmatic of the Russian realist school, as *The Morning of Streltsy's Execution*, 1881 (Moscow, Tretjakov Gallery), which was exhibited with great success. We see the soldiers of the Czarina Sofia, Peter the Great's sister, being led to their death, while the menacing figure of the czar looks on. Rather heavy-handed and sometimes theatrical, Surikov's realism was put at the service of his social ideals, and although his paintings represent dramatic situations, his technique always remained academic. We find strong color contrasts in his masterpiece *Boyarina Morozova*, 1887 (Moscow, Tretjakov Gallery). Generally his landscape backgrounds are not detailed; old Moscow serves as a mere backdrop to episodes of injustice in ancient and contemporary Russian history. *Mensikov in Exile*, 1883 (Moscow, Tretjakov Gallery), like several other paintings of Surikov, describes a scene of pathetic realism. He continued his idealistic verism to the end of his life, but with flagging energy.

CESARE TALLONE (Savona 1853 - Milan 1919)

He began his apprenticeship by drawing in a craftsman's shop at Alessandria, and then went to the Brera in Milan to study historical painting under Bertini. With a painting in this genre he achieved his first success in Rome in 1883 and the next year in Turin. By 1885 he was known abroad as well, and was called to the Carrara Academy in Bergamo as drawing master, remaining there for fourteen years. In 1899 he succeeded Bertini at the Brera, and many modern Italian painters, including Carrà, received their training from him. Original and determined, he took his concept of composition and brilliant color from traditional painting and enhanced them with nineteenth-century impastos and chiaroscuros. He painted landscapes, still lifes and genre scenes, but he had a special mastery of the bourgeois portrait, which he rendered realistically, using color to achieve tactile body throughout the portrait, from the fabrics to the flesh of the face. His rapid, vigorous, sure brushwork enlivens what otherwise might have been a gallery of embalmed characters.

HANS THOMA (Bernau, Black Forest 1839 - Karlsruhe 1924)

He began with drawing and lithography and was appreciated by several art lovers. From 1859, he studied painting at the Karlsruhe Academy and then was Schirmer's student at Düsseldorf. His trip to Paris in 1868 enabled him to see the works of the Barbizon painters and Courbet at first hand. In 1870 he established himself in Munich and painted genre scenes, portraits and still lifes, modifying his romantic tendencies with a subdued realism and firm light. The solidity of his color and his precise observation place his early paintings among the most straightforward manifestations of German realism. His landscapes became subdued, more accurately perceived. His first exhibition in Munich in 1871 brought him to the public's attention. During his trip to Italy in 1874, his views become diffused with greater luminosity, as seen in *Villa Borghese* and *Animals in the Roman Countryside* (Mannheim, Kunsthalle). In 1876 he went to live in Frankfurt, and became the president of the Artists' Association there. In his succeeding exhibitions, in Munich and Berlin, he won recognition and awards for his work. In 1890, he was named honorary member of the Munich Academy,

and in 1899 he was called to teach at the Karlsruhe Academy; later he was named director of its Gallery, which now houses his works. His later work bears strong traces of the old German masters, Altdorfer, Cranach, but of symbolism as well, approaching the work of Von Marées and Böcklin.

JAN TOOROP (Poerworedjo, Java 1858 - The Hague 1928)

His parents sent him to The Hague in 1873 to learn a trade; in 1879 he was taking evening courses at the Polytechnic School in Delft; a year later he enrolled at the Amsterdam Academy, where he studied painting for two years. In 1882 he went to live in Brussels and studied with Portaels at the Academy. Marrying in England, he became interested in William Morris's work in applied art. His early paintings and prints bear the mark of social realism, as did so much Dutch art of the time. Around 1885, he began associating with avant-garde writers and artists in Brussels. Although he continued living in The Hague, he kept in touch with Ensor, Maeterlinck, Verhaeren and Destrée, and was invited to participate in the exhibition set up by *Les Vingt*. Until about 1890, his painting was still influenced by impressionism and divisionism, but Toorop's more typical style is densely linear, expressing a symbolic world made up of oriental, Javanese and *art nouveau* motifs. His exotic, imaginative refinements can also be seen in his drawings, posters, engravings and watercolors, such as *The Return to Himself*, 1893, and one of his most famous works, *The Three Brides*, 1892 (Otterlo, Rijksmuseum Kröller-Müller). Closed lines compose his phantasmal images in *A Dead Nun Mourned by Two Women*, 1893, and grotesque allusions his *The Rodents*. He was awarded a medal at the 1900 Paris International Exposition. In 1905 he was converted to Catholicism and began painting religious themes in the isolation of the religious center at Nijmegen (1909-1916).

JOSEPH MALLORD WILLIAM TURNER (London 1775 - Chelsea 1851)

His father was a barber and would sell the drawings his son made from books and magazines to his customers. Turner was nine when a brewer asked him to color several engravings. At fourteen he began studying at the Royal Academy. During his first years as a painter (by 1793 he already had set up a studio), his father helped him; his mother had died insane. After producing many architectural and typographical drawings, which were much in demand then, and many copies of famous paintings, he began doing watercolors with Thomas Girtin. His pictorial spontaneity proved a great asset. In 1797 he showed his first oil painting at the Royal Academy, and by 1802 had already been admitted to the Academy. Influenced by Poussin's classicism, he began to paint and engrave landscapes, and the same year he went to Paris and to Switzerland, where the mountains made a particular impression on him. In 1817 he travelled through Belgium and Holland and along the Rhine, all the while painting a great deal. In 1819 his trip to Rome was the occasion for many drawings; later he returned to Italy four times, visiting the major places. His father died in 1829, leaving Turner disconsolate and withdrawn, which gave rise to some talk of his being mad, but Ruskin denied it. When he went to live at Chelsea, along the Thames, he assumed the name of Booth so he could work undisturbed. If in 1833 he painted a view of Venice according to Canaletto's method of rendering views, then we can see how he was prepared two years later to bring that same method to more startling elaboration in his *Burning of Parliament*, painted from the actual scene, in which light bursts into shimmering colors, transparencies and highlights. His painting becomes progressively more fluid, dissolved; although he always worked from nature, light, atmosphere and vibrant color begin to dominate his forms in scenes of fog, rain and storm, and thus Turner's art becomes a basic text for the evolution of painting toward impressionism. After a period of ill health he died, leaving his works to the nation and the poor. He was buried in St. Paul's in London, near the tomb of Sir Joshua Reynolds.

JOHN HENRY TWACHTMAN (Cincinnati 1853 - Gloucester, Massachusetts 1902)

Having been introduced to the use of paints by his father, a window-shade painter, he enrolled in the evening school of the Ohio Mechanics' Institute in 1868 and in the McMicken School of Design, also in his native city, in 1871.

Successive influences from Munich and Paris mark major phases in his mature work. He was encouraged by Frank Duveneck, recently returned from Germany, to go abroad and enter the Royal Academy of Fine Arts in Munich in 1875. Between that year and 1883, a period marked by intervals of teaching at home in Cincinnati, in New York, and in Italy and Holland, his works reveal the somber tonalities, loaded brush, and broad stroke of the Munich School.

In France from 1884 to 1887, he studied at the Académie Julian and, what was more important, came under the influence of the younger school of French artists. His appreciation of light was awakened, and he abandoned the bituminous Munich palette in favor of the cooler hues of the open air. Upon his return to the United States, his interest in impressionist ideas was reinforced by contact with Theodore Robinson, who had studied with Monet at Giverny. Twachtman lightened his palette even more and selectively adopted certain impressionist attitudes and techniques.

A characteristically American impressionist, he never sacrificed the integrity of the subject to the depiction of light and color. His lyrical, delicate renderings of little glimpses of nature are expressions of an unmistakable personal style.

PIERRE-HENRI DE VALENCIENNES (Toulouse 1750 - Paris 1819)

He studied at the Royal Academy of Art in Toulouse, but his interest in landscape painting led him to take walking trips across France, reaching as far south as Provence and even into Spain. In 1769 he made his first visit to Italy, and later he met Hubert Robert in Touraine. The forests of Compiègne, Marly and Fontainebleau were among his favorite landscape subjects. We also know he went to England and Germany, but we do not know when. In 1777 he arrived in Rome and in 1779 went as far as Naples and Sicily, making numerous studies and sketches during the trip. After three years in Paris he returned to Rome in 1782, and was especially impressed by Panini's Roman views. After that he went on a six-year trip to Greece and the Middle East. In 1787 he exhibited three views of Italy at the Royal Academy and showed two other Italian subjects the same year at the Paris Salon. He exhibited regularly at the Salons, and in 1791 was granted a studio at the Louvre. In 1800 he published a treatise on perspective much appreciated by painters of the time, and in 1812 was named professor of perspective at the Ecole des Beaux-Arts. He was instrumental in the establishment of a prize for historical landscape painting, which was awarded every year until 1863. This coveted prize was won the first time by the young and unfortunate painter Michallon in 1817. A learned man, Valenciennes read Greek and Latin, knew Italian, German and English literature well, and was frequently asked for his advice by other painters. Corot never forgot his urging him to paint from nature and with utter simplicity. And Valenciennes' own paintings, with their serene composition and soft light, and his way of treating the Italian landscape not as an archeological set piece, but as a living reality, were exemplary to the young Corot.

HENRI VAN DE VELDE (Antwerp 1863 - Zurich 1957)

While he was studying at the Antwerp Academy from 1882 to 1884, he took an interest in Millet and his humanitarian ideals, which also attracted a fellow student, Vincent Van Gogh. In 1884-85, he was in Carolus Duran's studio, but as he came in touch with the avant-garde "symbolist" circles, and met Seurat and Signac, he began using divisionist technique. Along with Van Rysselberghe, he was behind the formation of *Les Vingt* in Belgium, and exhibited with them in 1889. But he had already joined Antwerp socialist circles in 1886 and in the magazines *Als ich kan* and *Van Nu en Straks* published illustrations that are graphic arabesques, clear indications of the important role he was to have in the *art nouveau* movement. After 1890, he went through a traumatic period provoked by a reading of Ruskin and Morris on the relationship of art to life. From Campine where he was working, he sent a collage tapestry to the 1893 exhibition of *Les Vingt*, and in 1894 surprised the public with his lecture on "Clearing Away Art," which he gave at the Libre Esthétique, extolling the virtues of applied art. That same year he married Marie Sèthe and built his house, Bloemenwerf, at Uccle. He began applying the "new style" to room decoration and furniture design for Bing the antique dealer, and his objects aroused considerable interest at the Paris Maison Moderne in 1895, and at the Dresden Exposition in 1897. Workshops at Uccle began manu-

facturing his objects and furniture, and in 1899 he was in Berlin designing interiors. In 1900 he was commissioned to redo the Folkwang Museum in Haagen.

In 1902, he was called to Weimar as art consultant and there began a "Seminar on the Arts and Crafts." From his lectures and from his travels to Greece and Egypt (1903), he arrived at the idea of the New Style (1907) as a "living tradition." Logic and ethics, intuition and reason combine in this new esthetic outlook to make the work of the architect and designer meaningful; Van de Velde's formulations were to be the basis for the later Bauhaus movement. In 1914 he built the Werkbund Theater in Cologne (now destroyed). Leaving Germany at the beginning of the First World War, he went to live in Switzerland. In 1921 he was asked to design the Rijksmuseum at Otterlo, which was begun in 1937 and finished in 1954. In 1925 he became the director of the Higher Institute of the Decorative Arts in Brussels, which had been established for him. In his later projects (Rest Home, Hannover, 1928; the transatlantic liner *Prince Baudouin*, 1930-32; Library of the University of Ghent, 1934), he tended to strike a balance between the plasticity of *art nouveau* and the functional structuralism developed by Le Corbusier and Walter Gropius. He lived his last years at Oberägeri, near Zurich.

VINCENT VAN GOGH (Groot Zundert, Brabant 1853 - Auvers-sur-Oise 1890)

His father was a Protestant minister, and Vincent, after trying his hand at various studies and occupations, and after having spent time drawing the peasants and the sere landscapes of Brabant, decided to become a missionary. After a rather cursory preparation in theology, he went off as a missionary among the Belgian miners in Borinage. It was then that his passionate correspondence with his brother Théo began; Théo was to prove his most understanding and generous supporter throughout his turbulent life. Vincent threw himself into his work as missionary to the point of sharing the hardships and deprivations of the miners, and his superiors, disapproving of his "undignified" behavior, dismissed him. He was a tutor for a time in an English school, but then while living in Antwerp and Amsterdam, he finally found his true vocation as a painter. His early dark style, derived from the painting of Israels and Mauve, from Daumier's lithographs as well as from the naturalist novels of Zola, ended around 1885 with the long series of peasant faces, from which he painted *The Potato Eaters*, the last work in this period. He came to know the gaudy paintings of Monticelli, and his brother, who worked for the art dealer Goupil, wrote to him about the new impressionists, and so Van Gogh decided to go to Paris in 1886. There he discovered city life and brighter, lighter colors. But more than just middle-class places, he frequented the Butte in Montmartre, then still an area of vegetable gardens, the Moulin de la Galette and working-class bistros. He changed his painting after he saw what the impressionists were trying to do, and after 1886, he began using pointillist technique to heighten the light and color intensity in his paintings. But the exciting life Paris offered, and the constant debate raging over artistic questions, unnerved him, and so he went to live in Provence, at Arles. Here the dazzling Mediterranean sun and intense colors excited his imagination and drove him to simplify his composition and drawing in order to work unfettered with pure color. The elementary forms are not suffused with light as in Monet's impressionist paintings, but are filled in with a color "sensation"; that is, no longer the eye's impression but the imagination's. He paints the landscapes around Arles, the yellow house, the café at night, the postman Roulin and his family, the Zouave, the fields, the cypresses, his bedroom, the chair and the shoes, all with the same lyric, excited colors. He invites Gauguin, who has a hard time of it between Paris and Brittany, to come to stay with him at Arles, and work with him in a kind of co-operative *atelier du Midi*. Gauguin accepted, but they were soon at odds over technique and intention. Their relationship reached such an embittered pitch that Van Gogh tried to injure Gauguin. Remorseful and beside himself with rage, Van Gogh mutilated part of his ear. He was confined to the St. Rémy asylum, but continued to paint and draw, and to confide in his brother Théo in letters that have become a singular record, not only of Van Gogh's development, but also of the state of the arts at that time. In the spring of 1890 he returned to Paris to stay with Théo, who in the meanwhile had married and fathered a son. Van Gogh then went off to Auvers-sur-Oise, where Dr. Gachet treated him, and Van Gogh painted his portrait. His nervous condition, his frustration with what he considered the inadequacy of his talent, and his continual struggle with philosophical and moral values inarticulable in his art, finally drove him to suicide. He shot himself in a field, and was buried at Auvers-sur-Oise. Théo died shortly after and, in accordance with his last wishes, was buried next to his brother.

THÉO VAN RYSSELBERGHE (Ghent 1862 - St. Claire, Var 1926)

Born into a family of architects, he studied at the Ghent Academy under Théodore Canneel. From 1879, he was at the Brussels Academy studying under the portrait painter Herbo and also with Portaels. A scholarship permitted him to visit Spain and Morocco, in the company of Dario de Regoyos and Franz Charlet. When he returned to Brussels, he met Octave Maus, H. van de Velde, A. W. Finch, Ensor and others with whom he formed the avant-garde group known as *Les Vingt* (1884) to bring fresh ideas to their national art. He was the most enterprising and energetic of the group, always in search of new talents to introduce at their annual shows. After painting mainly impressionistic works in the *intimiste* vein, he was very much angered when he first saw Seurat's *Grande Jatte* at the 1886 exhibition in Paris, although his companion, Verhaeren, wrote back enthusiastically about it. But he invited Seurat to the exhibition held by *Les Vingt* in Brussels the next year. In the months following, because of his friendship with Cross and Signac, who were present at the 1888 exhibition of *Les Vingt*, and their exchange of letters about painting, he adopts the *pointilliste* technique, mainly with landscapes and figures. With his propensity for Whistler's delicacy, he painted with small points of color at first, but in 1889 he varied his technique, using small points for details and larger dabs for backgrounds. And it must be added that while he was painting in systematic divisionism, of which he was the foremost Belgian practitioner, he was turning out rather naturalistic works as well.

With Finch and Regoyos, he associated with the French *Indépendants* in 1890 and took part in their Paris show in 1891. Octave Mirbeau commented on the atmosphere, the feminine grace, the clear elegance of Van Rysselberghe's art. Associating with Henri van de Velde around 1895, he started designing furniture, jewelry and posters for La Libre Esthétique (Fourth Salon, 1897, Musée des Beaux-Arts, Ixelles) and doing illustrations and typographical layouts. After living for a time in Paris in 1898, he moved to Provence. In 1902-1903 he collaborated with Victor Horta in the *art nouveau* decoration of the Hotel Solvay in Brussels.

JOHN VARLEY (London 1778-1842)

He started out as apprentice to a silversmith and then began studying drawing, with successful results. His paintings interested Dr. Monro, who became his patron. At the age of twenty, he showed a drawing at the Royal Academy, and in 1804 was among the founders of the Old Water Colour Society, which came to have a prominent place in the artistic life of England. Varley's fame as a drawing master grew, and among his young students we find the names of artists who were to become important in the years following, such as Cox, Fielding, De Wint, Linnell, Palmer. His style was picturesque and romantic, somewhat formal in certain instances, but brightened by his able handling of color. He was especially fond of depicting the mountainous landscapes of Wales. In his later years, his obsession with palm-reading and astrology contributed to his decline, and he died impoverished.

VASILI VASILIEVICH VERESHCHAGIN (Cherepovka, Novgorod 1842 - Port Arthur 1904)

After attending the Academy of Fine Arts in St. Petersburg until 1863, he went to Paris to study with Gérôme, and then travelled in Russia and Europe. Impelled by a documentary interest in the places he visited, he put together a volume entitled *Notes, Memories, Sketches*, which he published in St. Petersburg in 1883. After painting a number of landscapes, he embraced the realistic, social ideology of the anti-academic Russian artists in the years between 1863 and 1870 and joined the group known as the "Wandering Artists" (1870). His contribution lay mainly in his scenes of war, which were intended as pacifist documents. He died aboard the warship *Petropavlovsk* in the Russo-Japanese War. A famous example of his didactic painting is *The Apotheosis of War*, which he exhibited in 1874 and which was acquired by the collector Tretjakov for his gallery. The subject of the painting, a pile of skulls rotting in the sun, summarizes the themes of the pictorial cycle on Turkestan (1869-73). His depiction of various episodes in the Russo-Turkish War, in which he participated, is ambitious in scope (painted in 1878-79). In 1874 he refused to be named professor. In 1880 he painted the striking series against capital punishment, *English Death Sentence in*

India, Execution in Rome, Execution in Russia. Vereshchagin's art is powerful because its biting social protest overcomes its frequent theatricality. Another notable cycle on war is his depiction of Napoleon's Russian campaign, painted in 1889-90.

ISIDOOR VERHEYDEN (Antwerp 1846 - Brussels 1905)

A student of Quinaux and Portaels in Brussels, and related to Van den Eeckeoudt, he settled in that city and associated with realist artists. He painted in the country, and his folk scenes are marked by rich colors and unaffected representation, as in *Pilgrimage in Campine* (Antwerp, Museum); *Old Lindens in Campine* (Liège, Museum). Several of his subjects approach in feeling those of Meunier, of whom he did a portrait (Brussels, Musées Royaux des Beaux-Arts). He had shows in his own country and abroad, winning prizes and medals in Philadelphia and at the Paris International Exposition in 1889. His style was vigorously realistic in its portrayal of peasant life, and its underlying severity is evidence of the profound relationship between art and its moral roots. He was influenced by symbolism and *art nouveau*, especially in his last works, as we see in his portrait of King Leopold II (1901).

WILLEM VOGELS (Brussels 1836 - Ixelles 1896)

Self-educated, he started as a decorative painter in Ixelles, a suburb of Brussels. He had his first show of landscape paintings in 1880, when he also declared his debt to the "master" of Tervuren, Boulanger, and to Louis Artan, both Belgian exponents of the naturalism developed by the Barbizon School. Like Artan, he preferred stormy landscapes and became a sensitive interpreter of the natural scene. In 1883 he was among the founders of *Les Vingt* and exhibited regularly with them; especially close to Ensor, he nonetheless retained the modulations we find in Daubigny, a member of the Barbizon School, rather than the brighter colors of the impressionists. His early paintings were descriptive and representational, but later his instinct for color responded to the chromatic richness of the French artists exhibiting with *Les Vingt*, and his paintings became more luminous and vibrant, tending toward the greys, browns, and moss greens of the Flemish landscape. Moist colors are woven in among veiled transparencies, achieving a phantasmal effect at times. He was neglected by critics and collectors for a long time because of his impulsive "impressionistic" landscape painting, which was considered the first rupture in the Belgian cultural milieu. He also took part in the exhibitions at the Libre Esthétique.

JOHANNES WEISSENBRUCH (The Hague 1822-1880)

A brother of the painter Frederick Hendrik and a cousin of the landscape painter Jan Hendrik (1824-1904), who had been in touch with Van Gogh at The Hague, he had studied at The Hague Academy under Salomon L. Verveer, a landscape and genre painter. Weissenbruch became much sought after for his city views: scenes of The Hague, Amersfoort, Nijmegen, and so on. With precise yet delicate handling of the atmosphere, he could evoke a nature full of feeling, as we can see in *The Church of St. Denis at Liège, Old Street in Batavia, Port of Leerdam, Portrait of the Marine Landscapist L. Meijer* (Rijksmuseum, Amsterdam); *Church Square* (Mesdag Museum, The Hague). In these paintings we can observe the profound influence of several seventeenth-century Dutch painters to whom he was devoted, such as Vermeer, De Hooch, Saenredam. He attempted to translate their lyrical realism into modern terms, with notable results, even if we are sometimes aware of a definite museumlike quality. He brought his gifts as a sensitive observer of nature to his lithographs and engravings. His works have been shown in several group exhibitions of Dutch nineteenth-century painting in the last thirty years or so.

JAMES ABBOTT McNEILL WHISTLER (Lowell, Massachusetts 1834 - London 1903)

His family was of Irish extraction; Whistler was still a boy when he went to St. Petersburg with his father, who had obtained a post as engineer for the Russian railroads. In 1851 he returned to the United States to attend West Point; failing in his studies, he was assigned as cartographer in the Navy because of his able draftsmanship. Discharged in 1854, he went

to Paris the following year to study painting. He spent his time there copying at the Louvre, working at the Académie Gleyre, and becoming friends with artists such as Fantin-Latour, Degas, Courbet. He also frequented the Café Guerbois where impressionist painters gathered, and there he met Baudelaire and Manet. His early paintings were influenced by Courbet's realism, which freed him from literary and academic concerns, and it was Courbet himself who encouraged him in 1863 to paint *A Girl in White*, which was refused by the same Salon that rejected Manet's *Déjeuner sur l'Herbe*. In the space of a few years he took to the fluid, bright color the impressionists were using and, like Degas, was attracted by the unusual sense of open space that Japanese painters conveyed. Meanwhile he had settled in London, and had exhibited his works at the Royal Academy for the first time in 1860. In a now famous letter to Fantin-Latour in 1867, he rejected Courbet's realism and began to paint with his own unique inspiration, an openly exotic, esthetic purism that caused him to be criticized fiercely by Ruskin. He took frequent trips to Venice, Holland and Belgium. From 1878 on he lived in Chelsea, but his life was marred by his frequent diatribes and by the chilly reception given him by London artistic circles.

WORTHINGTON WHITTREDGE (Springfield, Ohio 1820 - Summit, New Jersey 1910)

Motivated by the wish to become an artist, he apprenticed himself to a Cincinnati house painter in 1837. Like many other American artists, he learned the rudiments of the craft by painting banners, signs and fire engines. Experiments in portraiture were abandoned in favor of landscape painting, to which he was drawn by his love of the outdoors. By 1846 he had begun showing landscapes at the National Academy of Design and had received encouragement from Durand. With several commissions for pictures to be done in Europe, he went abroad in 1854, remaining nearly ten years. He enjoyed contact with American and European artists, sketching trips on the Continent and study in Düsseldorf, Florence and Rome. By the time of his return to New York, however, he had come to doubt the desirability of extended European study, feeling that it might compromise the distinctive quality of an American artist's work. Seeking to reconcile his European experiences with his desire to depict the native scene, he travelled widely in search of subjects. He visited sites in the Catskills, in the Rockies and on the Atlantic coast, producing landscapes of every type. He preferred simple, homely subjects to grandiose vistas and aimed for faithful delineation of local scenery in the manner of Durand.

FEDERICO ZANDOMENEGHI (Venice 1841 - Paris 1917)

His father, a sculptor, began his training, but his son took issue with his father's ideas quite early. He participated in the Sicilian campaign with Garibaldi in 1860, and two years later was in Florence, a friend of the *Macchiaioli*, who were rebelling against academic art and discovering the esthetic value of painting in the open, directly from nature and popular life. He returned to Venice, and in 1874 went to Paris to visit the annual Salon, where he saw the work of the impressionists, to whom he felt immediately attracted because he found his own aspirations expressed in their paintings. He was never to leave Paris after that.
He became a friend and companion to the impressionists, and to the writers and dealers in their milieu, especially with Degas. Zandomeneghi's painting was, however, concerned with intimate scenes and daily events, and was expressed with more flowing, warmer color. The dealer Durand-Ruel took an interest in him and assured him a modest living. Two other Italian painters were trying their fortune in Paris at the time: Boldini and De Nittis. Zandomeneghi exhibited with the impressionists in 1879, 1880, 1881 and 1886, and in 1889 won an award at the Paris Salon. He was always aware of his debt to the impressionists, but his painting is distinguished by his own conception of his subjects and by his loyalty to the Venetian tradition of light and glowing color. He kept pace with the evolution in painting, and in 1886 we find him using the pointillist technique, which he modified with livelier color and freer brushwork at the suggestion of Degas and Toulouse-Lautrec. He never contributed any startling innovations to painting, but continued to express himself in a style and in images that can best be termed reserved, contained. Whenever his great gift for capturing a sense of intimacy could find witty episodes of ordinary life to portray, he could achieve remarkable psychological and pictorial effects. A one-man exhibition set up for him at the Venice Biennale in 1914 had little success. A posthumous show in Milan in 1922 was better received.

LITERARY SOURCES

Austen, J., *Persuasion* (1770-72). New York: E.P. Dutton and Co., Inc., 1950, pp. 81-2.

Balzac, de, H., *La peau de chagrin* (1831). Eng. ed., *The Wild Ass's Skin*; London: Everyman's Library, Dent, 1967, pp. 212, 219, 220, 221.

Bryant, W.C., "To Cole, the Painter, Departing for Europe" (1829), from *William Cullen Bryant, Poems... collected and arranged by the author*. New York: D. Appleton & Co., 1871, p. 144.

Chateaubriand, de, F.R., *Mémoires d'outre-tombe* (1848). Eng. ed., *The Memoirs of Chateaubriand*; New York: Alfred A. Knopf, Inc., 1961, pp. 14, 15, 20, 28, 51, 101.

Chekhov, A., *The Steppe and Other Stories* (1888). Eng. ed., F.A. Stokes Co., 1916, pp. 7, 8, 13.

Cooper, J.F., *The Last of the Mohicans, or A Narrative of 1757* (1826). Boston and New York: Houghton Mifflin Co., 1898, pp. 160-61.

De Marchi, E., *Demetrio Pianelli* (1890). Milan (translation).

De Quincey, T., *Confessions of an English Opium-Eater* (1856). London: J.M. Dent & Sons, Ltd.; New York: E.P. Dutton and Co., Inc., last reprinted 1960, pp. 74, 75, 76, 98, 99, 123, 124, 125.

Dickens, C., *Oliver Twist* (1837). London: Oxford University Press, 1966, pp. 184, 381, 382.

Eichendorff, von, J., *Memoirs of a Good-for-Nothing* (1826). Eng. ed., London: Calder and Boyars, 1966, pp. 43, 44, 63, 64.

Eliot, G., *The Mill on the Floss* (1860). New York: Harcourt, Brace & World (published in Great Britain), 1962, pp. 9, 10, 44, 45, 119, 291.

Emerson, R.W., *Nature* (1836), from *Nature, Addresses, and Lectures*. New and rev. ed., Boston: Houghton Mifflin Co., 1888.

Fucini, R., *Napoli a Occhio Nudo* (Naples Through a Naked Eye) (1878). Florence (translation).

Gissing, G., *Born in Exile* (1892). London (?): Thomas Nelson & Sons, 1913 (?), pp. 158, 159, 173, 174, 224.

Gogol, N., *Evenings on a Farm near Dikanka* (1831-32). Eng. ed., London: Chatto & Windus Ltd., 1926, pp. 11, 12.

Goncourt, de, E. and J., *Renée Mauperin* (1864). Eng. ed., New York: Boni and Liveright, Inc., 1919, pp. 5, 6.

Goncourt, de, E. and J., *Germinie Lacerteux* (1865). Eng. ed., New York: Alfred A. Knopf, Inc., 1922, pp. 232, 233, 323, 324.

Gorky, M., *Childhood*. Moscow: Foreign Languages Publishing House, 1950, pp. 24, 276, 277.

Gregorovius, F., *Latian Summers* (1867-77). Eng. ed., London: Junior Army Navy Stores, 1903, pp. 68, 69, 70, 124, 125, 126.

Gregorovius, F., *Siciliana* (1867-77). Eng. ed., London: G. Bell and Sons, Ltd., 1914, pp. 76, 77, 78, 81, 82, 83, 84, 85, 253, 254, 255.

Hardy, T., *The Return of the Native* (1878). New York: The Book League of America, 1928, pp. 3, 4, 5, 6, 7, 8, 14, 258, 259.

Hawthorne, N., *Passages from the American Note-Books* (1841). Boston and New York: Houghton Mifflin Co., 1888, pp. 267-68, 188.

Heine, H., *Reisebilder* (1824-31). Eng. ed., *Pictures of Travel*; Philadelphia: Frederick Leypoldt, 1863, pp. 50, 57, 58, 80, 81, 97, 98.

Hugo, V., *Les Misérables* (Book of Jean Valjean) (1862). Eng. ed., New York: Heritage Press, 1938, pp. 51, 52.

Jacobsen, J.P., *Maria Grubbe*. Eng. ed., New York: The American Scandinavian Foundation, 1962, pp. 18, 41, 47, 48.

Lagerlöf, S., *The Story of Gösta Berling* (1890-91). Eng. ed., Stockholm: Fritzes Kungl. Hovbok Handel, 1962, pp. 22, 38, 39.

Lamartine, de, A., *Les Confidences* (1849). Italian ed., Milan: Sonzogno, pp. 19, 20, 48, 49 (translation).

Manzoni, A., *I Promessi Sposi* (1840). Eng. ed., *The Betrothed*; New York: E.P. Dutton and Co., Inc., 1951, pp. 1, 2, 258, 259, 261, 262, 263, 265.

Maupassant, de, G., "Mother Savage," from *The Complete Short Stories*. New York: Hanover House, 1955, p. 910.

Maupassant, de, G., "The Minuet," from *The Adventures of W. Schnaffs and Other Stories*. Japan: Hokuseido Press, 1931, pp. 122-23.

Maupassant, de, G., "Mosca. Souvenirs d'un Canotier," from *L'Inutile Beauté*. Paris, 1890 (translation).

Moore, G., *Esther Waters* (1894). New York: Liveright Publishing Corp., 1942, pp. 310-11, 322.

Nievo, I., *Le Confessioni di un Ottuagenario* (Confessions of an Octogenarian) (1867). Milan. (translation).

Ruskin, J., *The Crown of Wild Olive* (1870). New York: John Wiley & Sons, Inc., 1874, pp. 5, 6, 7, 8.

Staël, de, Madame, *De l'Allemagne* (1830). Eng. ed., *Germany*; Boston: Houghton Mifflin Co., 1882, pp. 27-8.

Stendhal (Henri Beyle), *Le rouge et le noir* (1830). Eng. ed., *Red and Black*; New York: W. W. Norton and Co., Inc., 1969, pp. 1, 2.

Stendhal (Henri Beyle), *Lamiel* (1839-42). Eng. ed., Norfolk, Conn: James Laughlin, 1952, pp. 24-5.

Stifter, A., "The Recluse," from *Limestone and Other Stories* (1845). Eng. ed., Harcourt, Brace & World, 1968, pp. 203, 204, 206, 207, 218.

Thoreau, H.D., *Autumn*, from *The Journal of Henry David Thoreau* (1857). Ed. by H.G.O. Blake. Boston and New York: Houghton Mifflin Co., 1892, pp. 80, 82-3.

Van Gogh, V., *The Complete Letters*. Greenwich, Conn.: New York Graphic Society Ltd., 1958, Vol. II, pp. 62, 63, 100, 101, 220, 226; Vol. III, p. 525.

Whitman, W., "A Prairie Sunset," (1888) from *Sands at Seventy (First Annex; Leaves of Grass)*. New York and London: D. Appleton & Co., 1917, Vol. II, p. 317.

Whittier, J.G. "A Summer Pilgrimage," (1883) from *Poems Subjective and Reminiscent: Religious Poems*. Boston and New York: Houghton Mifflin Co., 1891, pp. 86-7.

Wilde, O., *De Profundis* (1905). New York: Vintage Books, 1964, pp. 158, 159.

Zola, E., *Paris* (1897). Eng. ed., Toronto: George N. Morang, 1898, pp. 1, 2, 142, 385, 589, 591.

BIBLIOGRAPHY

On the painters of the nineteenth century and on certain periods and movements the number of studies and publications is immense. We cite, therefore, the works that were consulted by the author with particular reference to landscape.

W. Dunlap, *History of the Rise and Progress of the Arts of Design in the United States*. New York, 1834; Boston, 1918; New York, 1965.

C. Baudelaire, *Curiosités esthétiques*. Paris, 1868.

G. Lanoë - T. Brice, *Histoire de l'école française de paysage depuis le Poussin jusqu'à Millet*. Paris, 1901.

E. Michel, *Les maîtres du paysage*. Paris, 1906.

U. Thieme - F. Becker, *Allgemeines Lexikon der bildenden Künstler von der Antike bis zur Gegenwart*. Leipzig, 1907-1950.

H. Lapauze, *Ingres, sa vie, son oeuvre*. Paris, 1911.

L. Rosenthal, *Du romanticisme au réalisme*. Paris, 1914.

C. Chassé, *Gauguin et le groupe de Pont-Aven*. Paris, 1921.

G. Jean-Aubry, *Eugène Boudin d'après des documents inédits*. Paris, 1922. Eng. ed., *Eugène Boudin*, rev. by R. Schmit, Greenwich, Conn., 1969.

H.A. Schmid, *Arnold Böcklin*. Munich, 1922.

G. Geffroy, *Claude Monet, sa vie, son oeuvre*. Paris, 1924.

H. Lapauze, *Histoire de l'Académie de France à Rome*. Paris, 1924.

E. Cecchi, *Pittura italiana dell'Ottocento*. Rome, 1926.

L. Hourticq, E. Dacier, G. Wildenstein, R. Bouyer, P. Jamot, G. Brière, *Le paysage français de Poussin à Corot à l'exposition du Petit Palais*. Preface by E. Bricox, Paris, 1926.

J.B. De La Faille, *L'oeuvre de Vincent Van Gogh*. Paris-Brussels, 1928.

H. Focillon, *La Peinture aux XIX et XX siècle*. Paris, 1928.

E. Somaré, *Storia della pittura italiana dell'800*. Milan, 1928.

H.M. Cundall, *A History of British Water Colour Painting*. London, 1929.

U. Ojetti, *La pittura italiana dell'800*. Milan-Rome, 1929.

R. Schneider, *L'art français au XIX siècle*. Paris, 1929.

P. Colin, *La peinture belge depuis 1830*. Brussels, 1930.

L. Justi, *Von Runge bis Thoma*. Berlin, 1932.

Les artistes français en Italie de Poussin à Renoir. Catalog of the exhibition at the Musée des Arts Décoratifs, Paris, 1934.

P. de Nolhac, *Peintres français en Italie*. Paris, 1934.

S. Ortolani, *La scuola di Posillipo*. Rome, 1934.

L. Venturi, *Cézanne, son art, son oeuvre*. Paris, 1936.

R. Huyghe, *La peinture française, XVIII et XIX siècle*. Paris, 1937.

L. Venturi, *Les Archives de l'Impressionnisme*. Paris-New York, 1939.

A. Shirley, *Bonington*. London, 1940.

T. Antal, "Géricault: Reflections on Classicism and Romanticism," in *The Burlington Magazine*. London, 1940-41.

M. Bernardi, *Ottocento piemontese*. Turin, 1946.

J. Rewald, *The History of Impressionism*. New York, 1946, 1955; rev. ed. 1961.

C. Chassé, *Le mouvement symboliste dans l'art du XIX siècle*. Paris, 1947.

A. Dragone. *I paesisti piemontesi dell'800*. Milan, 1947.

J.L. Vaudoyer, *Paysages d'Italie*. Catalog of the exhibition at the Galerie Charpentier, Paris, 1947.

S.J. Key, *John Constable, His Life and Work*. London, 1948.

J.L. Vaudoyer, *Les Impressionnistes de Manet à Cézanne*. Paris, 1948.

P. Courthion, *Courbet raconté par lui-même et par ses amis*. Geneva, 1948-50.

J.I.H. Baur, "Trends in American Painting, 1815-1865," *M. and M. Karolik Collection of American Paintings*, 1815 to 1865. Boston, 1949.

K. Clark, *Landscape into Art*. London, 1949.

H. von Einem, *Caspar David Friedrich*. Berlin, 1950.

P. Gay, *Jean-François Millet (1814-1875)*. Paris, 1950.

Germain Bazin, *Corot*. Paris, 1951.

C. Clare, *J.M.W. Turner, His Life and Work*. London, 1951.

G. Colmjon, *The Hague School*. Rijswijk, 1951.

F. Elgar, *Ingres*. Paris, 1951.

T. Natanson, *Le Bonnard que je propose*. Geneva, 1951.

M. Raynal, *Le XIX siècle. De Goya à Gauguin*. Geneva, 1951.

C. Roger-Marx, *Le paysage français de Corot à nos jours*. Paris, 1952.

M. Valsecchi, *Giovanni Carnovali detto Il Piccio*. Catalog of the exhibition, Bergamo-Varese, 1952.

Germain Bazin, *L'époque impressionniste*. Paris, 1953.

D. Durbé, *Giovanni Fattori*. Catalog of the exhibition, Leghorn, 1953.

V. Fiala, *Die russische realistische Malerei des 19. Jahrhunderts*. Prague, 1953.

L. Vitali, *Lettere dei macchiaioli*. Turin, 1953.

A. Ottino Della Chiesa, *Pittori lombardi del secondo Ottocento*. Catalog of the exhibition, Como, 1954.

A. Humbert, *Les Nabis et leur époque*. Geneva, 1954.

M. Drucker, *Renoir*. Paris, 1955.

E. Piceni, *De Nittis*. Milan, 1955.

F. Russoli, *Pierre Bonnard*. Catalog of the exhibition, Milan, 1955.

A. Antal, *Fuseli Studies*. London, 1956.

P. Buccarelli - G. Carandente, *I macchiaioli*. Catalog of the exhibition, Rome, 1956.

E. Pirchan, *Gustav Klimt*. Vienna, 1956.

E.P. Richardson, *Painting in America; The Story of 450 Years*. New York, 1956.

R. Mesuret, *Pierre-Henri de Valenciennes*. Catalog of the exhibition, Toulouse, 1956-57.

G.C. Groce - D.H. Wallace, *The New-York Historical Society's Dictionary of Artists in America, 1564-1860*. New Haven and London, 1957.

P. Haesaerts, *James Ensor*. Brussels, 1957.

M. Valsecchi, *Maestri moderni*. II ed. Milan, 1957.

L. Degaut - D. Rouart, *Claude Monet*. Geneva, 1958.

F. Fosca, *Corot*. Brussels, 1958.

C. Sterling - H. Adhémar, *Catalogue des peintures de l'Ecole française du XIX siècle. Musée du Louvre* (4 vols.). Paris, 1958-61.

F. Bellonzi, *Pittura italiana. Dal Seicento all'Ottocento*. Milan, 1960.

O. Larkin, *Art and Life in America*. New York, 1960.

O. Benesch, *Edvard Munch*. London, 1960.

R. von Holten, *L'Art fantastique de Gustave Moreau*. Paris, 1960.

B. Molajoli, *Notizie su Capodimonte*. Naples, 1960.

Germain Bazin, *Una tradizione francese: la "vue d'Italie"*; in "L'Italia vista dai pittori francesi del XVIII e XIX secolo." Catalog of the exhibition, Rome, 1961.

Vagn Poulsen, *Dänische Maler*. Taunus, 1961.

M. Bernardi, *Fontanesi*. Milan, 1962.

A.M. Brizio, *Ottocento-Novecento*. Turin, 1962.

J. Cassou, E. Langui, N. Pevsner. *Les sources du XX siècle*. Paris.

A. Chastel, "Seurat et Gauguin," in *Art de France*. Paris, 1962.

J.T. Flexner, *That Wilder Image*. New York, 1962.

J. Rewald, *Post-Impressionism: From Van Gogh to Gauguin*. New York, 2nd ed. 1962.

B. Grimschitz, *Österreichische Malerei vom Biedermeier zur Moderne*. Vienna, 1963.

K. Andrews, *The Nazarenes: A Brotherhood of German Painters in Rome*. New York, 1964.

M. Valsecchi, *Giovanni Fattori*. Milan, 1964.

R. Cogniat, *Le siècle des impressionnistes*. Paris.

M. Denis, *Théories (1890-1910)*, I ed., 1912. Paris, 1964.

P. Signac, *D'Eugène Delacroix au néoimpressionnisme*, I ed. 1899. Paris, 1964.

S. Wichmann, *Realismus und Impressionismus in Deutschland*. Stuttgart, 1964.

A. Gardner and S. Feld, *American Paintings: A Catalogue of the Collection of The Metropolitan Museum of Art*, Vol. I. New York, 1965.

J.W. McCoubrey, *American Art, 1700-1960, Sources and Documents*. Englewood Cliffs, N.J., 1965.

M. Brion, *Art of the Romantic Era. Romanticism-Classicism-Realism*. London, 1966.

R. Causa, *Napoletani dell'800*. Naples, 1966.

N. Harris, *The Artist in American Society: The Formative Years, 1790-1860*. New York, 1966.

Bruno Toscano, *Dal romanticismo al realismo. Dal realismo all'impressionismo. Diffusione dell'impressionismo e postimpressionismo. Simbolismo e intimismo fine secolo*. Milan, 1966.

R. Barilli, *Il simbolismo nella pittura francese dell'Ottocento*. Milan, 1967.

T. Bellonzi, *Il divisionismo nella pittura italiana*. Milan, 1967.

J.T. Callow, *Kindred Spirits: Knickerbocker Writers and American Artists, 1807-1855*. Chapel Hill, N.C., 1967.

R. De Grada, *I macchiaioli*. Milan, 1967.

D. Durbé, *Courbet e il realismo francese*. Milan, 1967.

L. Herrmann, *Il paesaggio nella pittura inglese dell'Ottocento*. Milan, 1967.

A. Ottino Della Chiesa, *Il Neoclassicismo nella pittura italiana*. Milan, 1967.

Trésor des Musées Soviétiques. L'Art Russe des Scytes à nos jours. Catalog of the exhibition at the Grand Palais. Preface by M. Alpatov and D. Sarabianov, Paris, 1967.

J. Wilmerding, *A History of American Marine Painting*. Salem, Mass., 1968.

G. Briganti, *Pittura fantastica e visionaria dell'Ottocento*. Milan, 1969.

D. Durbé - A.M. Damigella, *La scuola di Barbizon*. Milan, 1969.

B. Novak, *American Painting of the Nineteenth Century*. New York, 1969.

Agenzia Novosti, Rome: 115, 256, 257, 258, 259, 260, 261.
Albright-Knox Art Gallery, Buffalo: 82.
Alinari, Florence: 181, 183.
Allen Memorial Art Museum, Oberlin, Ohio: 87.
Ancilotti, Milan: 119, 156, 157, 158, 162, 169, 172, 173, 177, 202.
Anelli, Sergio, Electa Editrice, Milan: 106, 120, 127, 130, 131, 133, 135, 136, 138, 139, 143, 144, 148, 149, 150, 154, 155, 163, 164, 174, 175, 176, 191, 193, 197, 198, 199.
Annan, Glasgow: 25, 34.
Archives Photographiques des Musées Nationaux, Paris: 37, 39, 55, 73, 81.
Archivio Electa, Milan: 111, 128, 170, 171.
Archivio Fotografico Musei Civici, Milan: 189.
Art Gallery and Museum, Glasgow: 62.
Art Institute of Chicago: 64, 84.
Balestrini, Bruno, Electa Editrice, Milan: 108, 109, 146, 167, 168, 194, 196.
Barnes Foundation, Merion, Pennsylvania: 89, 94.
Bayerisches Staatsgemäldesammlungen, Munich: 215, 218, 219, 221, 222, 223, 224.
Blomstrann, E. Irving, New Britain, Connecticut: 47.
Brooklyn Museum: 99.
Bulloz, Paris: 116, 126, 134.
Cameraphoto, Venice: 151, 153.
City Museum and Art Gallery, Birmingham, England: 32.
Coe, A.E., and Son, Norwich, England: 28, 29.
Collection of John G. Johnson, Philadelphia: 105.
Collection of Robert von Hirsch, Basel: 67.
Collection of Oskar Reinhart, Winterthur: 68, 113.
De Nittis Museum, Barletta: 123, 128.
Dinjan, A., The Hague: 245.
Dräyer, Walter, Zurich: 93.
Edizioni Fotografiche Alberto Luisa, Brescia: 129.
Erwin, Meyer, Vienna: 203, 204, 205, 206, 208, 209, 210, 211, 212, 213.
Foto Betti, Leghorn: 160, 161, 179, 180, 185.
Foto Mercurio, Milan: 57, 86, 90, 91, 107.
Foto Pius Rast, San Gallo: 140, 145.
Foto Rampazzi, Turin: 137, 190, 192, 195, 200.
Foto Ricciarini, Milan: 124.
Foto Scala, Florence: 70, 80, 95, 96, 97, 132, 187, 188.
Giraudon, Paris: 26, 40, 41, 43, 44, 45, 48, 49, 50, 51, 52, 54, 58, 59, 60, 63, 69, 72, 74, 75, 76, 79, 83, 98, 114.
Haags Gemeentemuseum, The Hague: 65, 240, 241, 246.
Kunstmuseum, Winterthur: 112.
Laing Art Gallery, Newcastle-upon-Tyne: 30.
La Scala Theater Museum, Milan: 132.
Metropolitan Museum of Art, New York: 53, 66, 88, 101.
Musée Royal des Beaux-Arts, Antwerp: 226, 227, 228, 229, 230, 231, 233, 234, 235.
Museum of Art, Cleveland: 9.

INDEX

Numbers in bold type refer to the plates.